EDOUARD VUILLARD

Painter-Decorator

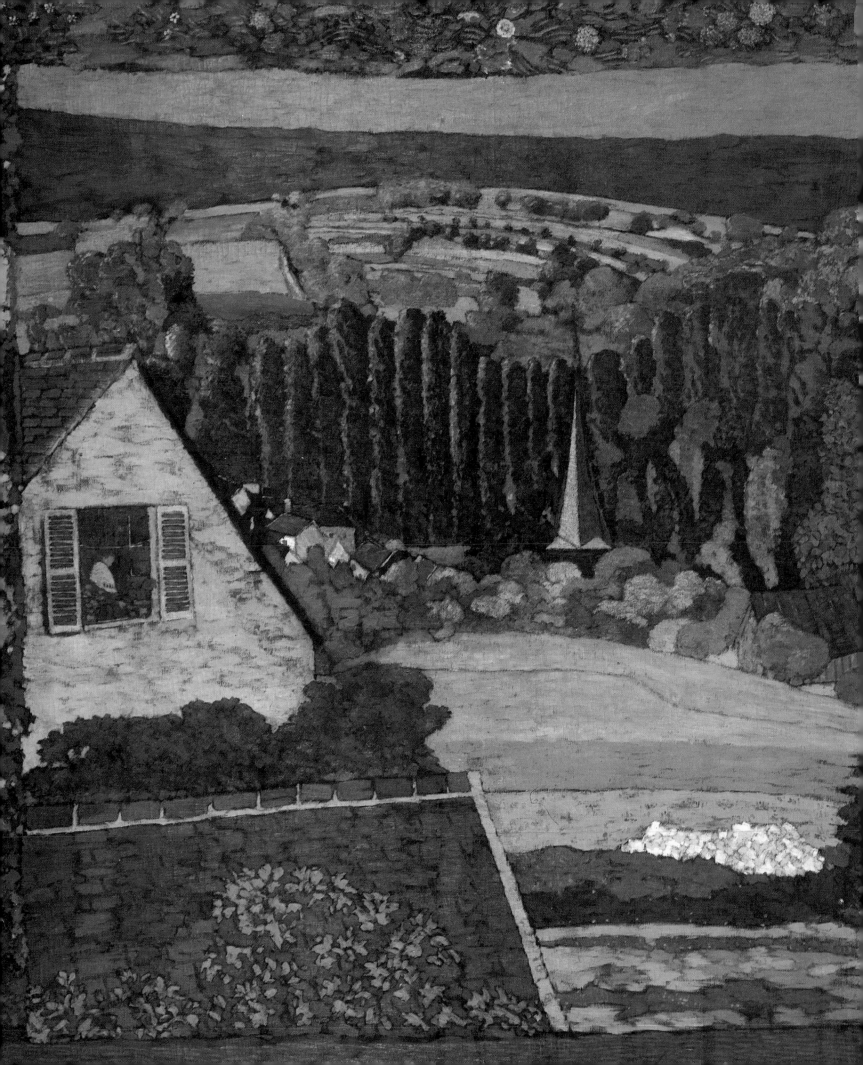

EDOUARD VUILLARD

Painter-Decorator

PATRONS AND PROJECTS, 1892–1912

Gloria Groom

Yale University Press
New Haven and London

Frontispiece: Edouard Vuillard, *Window Overlooking the Woods*
(detail), 1899, The Art Institute of Chicago.

Designed by Gillian Malpass
Set in Linotron Bembo by Best-set Typesetter Ltd, Hong Kong
Printed in Italy by Amilcare Pizzi S.p.A., Milan

Library of Congress Cataloging-in-Publication Data

Groom, Gloria Lynn.
 Edouard Vuillard : painter-decorator : patrons and projects,
1892–1912 / Gloria Lynn Groom.
 p. cm.
 Includes bibliographical references and index.
 ISBN 0-300-05555-2
 1. Vuillard, Edouard. 1868-1940–Themes, motives.
2. Artists and patrons–France. 3. Interior
architecture–France. I. Title.
 ND553.V9G76 1993 93-29680
 759.4—dc20 CIP

A catalogue record for this book is available from
The British Library

Contents

Acknowledgments

This book began as a dissertation, which was launched under the enthusiastic guidance of Richard R. Brettell, then professor in the Department of Art History at the University of Texas at Austin. Special thanks also go to Professor Anne McCauley, who saw the dissertation through its final phases and again to Richard Brettell who encouraged me to seek its publication. During the formative phases of the project, I was fortunate to receive a Samuel H. Kress Foundation Grant which funded my research in Paris. There, my early work on the project benefited greatly from the generous and always entertaining discussions with Antoine Salomon, great nephew of Vuillard and the author of the forthcoming catalogue raisonné on the artist. Thanks to Monsieur Salomon, I was able to have access to photographs and journal transcriptions which have been essential to my efforts to explore the connection between Vuillard's decorative projects and the patrons who commissioned them. Important assistance was also lent by independent curator, Juliet Wilson Bareau.

My research was greatly aided by a number of librarians and curators of institutions, professors and independent scholars in the States and abroad, including: Mme Geneviève Aitken, Paris; Mme Marie Amélie Anquetil, Musée Départemental de la Prieuré, Saint-Germain-en-Laye; François Baratte, Musée du Louvre; Mme Thérèse Burollet, Saint-Germain-en-Laye; Schuyler G. Chapin, Columbia University, New York; M. François Chapon, Bibliothèque Littéraire Jacques Doucet; André Chastel, Collège de France, Paris; Mme Birgitte Cifka, Musée des Beaux-Arts, Hungary; Mme Marina Ducrey, Galerie Paul Vallotton, Lausanne; Mme Françoise Dumas, Institut de France, Paris; Elizabeth Easton, The Brooklyn Museum; Claire Frèches, Musée d'Orsay, Paris; the late Anne-Christa Funk-Jones, Karl Ernst Osthaus Museum, Hagen; Hubert Howard, Fondazione Camillo Caetani, Rome; Carlton Lake, Humanities Research Center, Austin; Mme Claudine Lemaire, Bibliothèque Royale Albert ler, Brussels; Sasha Newman, Yale University Art Gallery, New Haven, Conn.; Michael Pantazzi, National Art Gallery of Canada, Ottawa; Mme Anne Roquebert, Musée d'Orsay; John Russell, New York; Mme Sabbagh, Versailles; Mme Marie-José Salmon, Musée Départemental de l'Oise; Mme Laurie Stein, Werkebund Archives, Berlin; M. Antoine Terrasse, Fontainebleau; Professor Nancy Troy, Northwestern University, Evanston, Illinois; Dr. Michael Valentin, Académie de Médecine, Paris; Claude Vallotton, Galerie Paul Vallotton, Lausanne; M. Vesperini, Archives Saint-Sulpice, Paris; Guy Wildenstein, Fondation Wildenstein, Paris.

A heartfelt thanks is extended to the individuals whose anecdotes and discussions about my project and about the artist (whom many knew personally) helped me not only to reconstruct the various commissions but to have a richer understanding of the tastes and décors unique to *fin-de-siècle* Paris. I would like to thank in particular Mme Georges Gruber Bernstein, M. Dominique Denis, M. Philippe Dennery, M. Jean Godebeski, Gilbert Gruet, Mme Jean Guillois, M. and Mme Simon Hodgson, M. Jean Hugo, Mme L. Klene, Mme Topazia Markievitch, Mme Colette Partouche, M. Gaston Pawlewski, M. Pierre Roussel, Robert Fizdale and the late Arthur Gold, Mme François Serrand. Special thanks go to Leila Mabilleau, daughter of Jean Schopfer (Claude Anet) and to Annette Vaillant, daughter of Alfred Natanson, both of whom shared with me their incredible visual memories of Vuillard's large-scale decorative paintings within their families' interiors.

I would also like to thank the many private collectors who have graciously allowed me to reproduce their pictures, often for the first time. Among those willing to share information and works in their collections, I wish to acknowledge Arthur G. Altschul; Ambassador Walter H. Annenberg James Crathorne; Mme Stéphane Desmarais; Ira and Virginia Jackson; Samuel Josefowitz; Françoise Marquet; Professor William Kelly Simpson.

For various arrangements and information critical to locating pictures and obtaining photographs, I wish to give warm thanks to Jean, Luc, and Yann Bellier, Galeries Bellier, Paris; Huguette Berès, Galerie Huguette Berès, Paris; Philippe Brame, Galerie Brame-Lorenceau, Paris; Guy-Patrice Dauberville, Galerie Bernheim-Jeune & Cie, Paris; Benjamin Doller, Sotheby's New York; Anne Dumas,

1 Detail of pl. 162.

London; the late Charles Durand-Ruel, Caroline Godfroy Durand-Ruel, and France Daguet, Durand-Ruel & Cie, Paris; Marianne and Walter Feilchenfeldt, Zurich; Deborah Goodman, New York; Jean Edmonson, Acquavella Gallery, New York; Martha Graves, Christie's New York; Margrit Hahnloser, Zurich; Waring Hopkins, Galerie Hopkins-Thomas, Paris; Ay-Whang Hsia, Wildenstein & Cie; Tzila Krugier, Jan Krugier Gallery, New York; Marc Larock, Galerie Katia Granoff, Paris; Desmond Concoran, The Lefevre Gallery, London; Christian Neff, J.P.L. Fine Arts, London; Lynne Palmer, University of California, Berkeley; Luisa E. Sabin, B.G. Cantor Collections, New York; Berthe Sanders, The David A. Rockefeller Collection, New York; Susan Stein, The Metropolitan Museum of Art, New York; Verena Steiner-Jaeggli, Winterthur; Dina Vierny, Galerie Dina Vierny, Paris.

At The Art Institute of Chicago, my work on this book received incredible support from my colleagues. I am particularly thankful for the assistance of Geri Banik, Donald Beebe, Jack Brown, Helen Brunner, Anselmo Carini, Douglas Druick, Lisa Dunn, Carol Jentsch-Rutan, Mary Kuzniar, Maureen Lasko, Alan Newman, Pamela Stuedemann, and Leslie Umberger.

My manuscript was read in its entirety by Vuillard scholar, Belinda Thomson, to whom I am grateful for her insights and helpful suggestions. I am indebted also to independent scholars Jennifer Thévenot White and Marcella Lista, both of whom provided intelligent translations of Vuillard's cryptic and difficult journal entries, and to Gillian Malpass, Yale University Press, London, whose careful editing, design, and untiring encouragement made this book possible.

I extend deep gratitude to family and friends, and especially to my husband, Joe Berton, who sustained me through the joys and pains of writing and was never jealous of the many years spent with Monsieur Vuillard. And finally, a special recognition is given to our son, Alexander Edward, whose arrival happily coincided with the publication of this book.

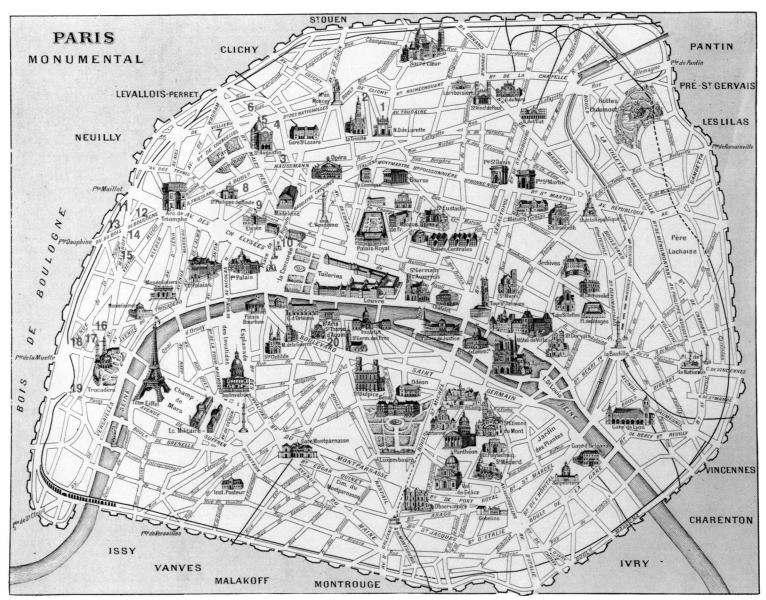

2 Map of Paris showing Vuillard's apartments and the first known locations of Vuillard's *décorations*, and the sites of the *Rue de Paris* panels.

1 Vuillard's apartment, rue de Calais, no. 26 (1907–26); *Rue de Calais*, 1908–10
2 *Place Vintimille*, triptych (1908–1911)
3 Henry Bernstein's apartment, Boulevard Haussmann, no. 157
4 Vuillard's apartment, rue des Batignolles, 1898–9
5 Dr. Henri Vaquez's apartment, avenue Général Foy, no. 27
6 Vuillard's apartment, rue Truffaut, no. 28 (1899)
7 Adam Natanson's *hôtel privée*, rue Jouffroy, no. 85 (destroyed)
8 Vuillard's apartment, rue Miromisnil, no. 6 (1890)
9 Vuillard's apartment, rue Saint-Honoré, no. 346 (1891–6); no. 342 (1896–8)
10 Thadée's and Misia's apartment, rue Saint-Florentin, no. 9
11 Princes Emmanuel and Antoine Bibesco's apartment, rue Commandant-Marchand, no. 9

12 *The Street* (avenue du Bois de Boulogne) 1906–8
13 Alexandre and Olga Natanson's *hôtel privée*, avenue du Bois de Boulogne, no. 64 (now 74 avenue Foch)
14 Paul and Léonie Desmarais's *hôtel privée*, avenue Malakoff, no. 98 (residence destroyed 1975; now avenue Raymond Poincaré)
15 Jean and Alice Schopfer's(Anet) apartment, avenue Victor Hugo, no. 132
16 *The Watercart* (place Dauphine seen from avenue Henri-Martin), 1906–8
17 Vuillard's apartment, rue de la Tour, no. 132
18 Jack Aghion's apartment, rue de la Pompe
19 *The Eiffel Tower* (rue de Passy looking up towards the Champs-de-Mars), 1906–8
20 Marguerite Chapin's apartment, rue de l'Université, no. 110

Introduction

At the third annual Salon d'Automne in 1905, among the works most commented upon were the six large-scale *panneaux décoratifs* or decorative panels by the thirty-seven year old artist Edouard Vuillard (pls. 154–8, 165–6).[1] That Vuillard's works should have received any critical attention was in itself surprising, given the sensation caused in the adjacent gallery by Henri Matisse's audacious composition *Woman with the Hat* (*Femme au chapeau*), Henri Rousseau's vast work, *The Hungry Lion* (*Le Lion ayant faim*), and other high-hued canvases by André Derain, Maurice Vlaminck, Raoul Dufy, and Georges Braque who would henceforth be known as the Fauves. The critic Louis Vauxcelles, who unwittingly baptized the movement when he referred to them as "fauves," or wild beasts, found their pictures disappointing, having nothing whatever to do with painting.[2] In contrast to what he perceived to be the savage colors of their canvases, Vauxcelles considered Vuillard's series of women in gardens and interiors "a revelation for young artists by a fresco painter at the height of his prestigious reputation."[3]

Vauxcelles was not alone in his preference for Vuillard's larger paintings showing richly patterned interiors or airy garden scenes to what art critic Camille Mauclair decried as the "chromatic assaults" on painting inflicted by Matisse and his group.[4] A similar comparison was made by the critic for *La Vie Parisienne* who recommended Vuillard's showing – "without a doubt the most important one that he has ever had" – over the "curious and shrill room in which were exhibited paintings obtained with bottle wax and parakeet feathers."[5]

Vuillard's entries for the 1905 salon were not only judged favorably as a respite from the "shrill room" next door, they were seen as a surprising *volte-face* from his better-known work as an *intimiste*, a creator of small-scale domestic interior scenes. For the first time, *le grand public* could see a substantial number of his decorative ensembles or series of paintings outside their original function as modern mural paintings for Parisian interiors.[6] The fact that these works represented two distinct projects executed almost a decade earlier and that they were stylistically, technically, and thematically very different from each

other, went unnoticed by the reviewers. No distinction seems to have been made between the four densely patterned, mauve and scarlet *Figures in an Interior* (*Figures dans un intérieur*) from 1896 and the pendants *Figures in a Landscape* (*Figures dans un paysage*) executed two years later in a predominately lime and rose palette.[7] Moreover, these were but a small percentage of the many large-scale canvases painted by the artist between 1892 and 1901 as commissioned decorative projects. For Vuillard they represented not only the most important art production of his early career, but also the direct patronage of a close circle of friends whose interiors he knew and whose aesthetic tastes he understood.

At the 1905 Salon d'Automne, through which Matisse achieved instant notoriety as the leader of a new episode in painting, the exactly contemporary Vuillard was already an established figure in the Parisian avant-garde, known for his easel paintings and color lithographs. The previous year, the Ministry of Fine Arts had purchased one of his small *intimiste* paintings, *The Luncheon* (*Le Déjeuner*), for the state collection of the Musée du Luxembourg.[8] His work as a *peintre-décorateur*, however, remained unknown outside a limited group of collectors. It was not until 1929, just eleven years before his death, that the State made its first acquisition in this domain by buying three of Vuillard's earliest decorative works, painted in 1894 and known collectively as *The Public Gardens* (*Les Jardins Publics*) (pls. 76–86).[9]

Despite the late official recognition of this aspect of his career, in 1914 art historian Achille Segard considered Vuillard's large-scale decorative panels significant enough to include in his study of the eight most important *peintres-décorateurs* of the late nineteenth and early twentieth centuries.[10] Segard, author of a history of the literary symbolists in the last two decades of the century and several monographs on impressionist and post-impressionist artists,[11] knew Vuillard and would have known at firsthand the artist's decorative projects in private homes.[12] In addition to his detailed analysis of several of Vuillard's ambitious projects, Segard provided an invaluable listing of titles, dates, and names of the original and current owners from the first decorative series

3 Detail of pl. 139.

executed in 1892 through Vuillard's first public commission to decorate the foyer of the newly constructed Théâtre des Champs-Elysées.[13] Indeed, Segard's "Annex" to his chapter on the artist reveals that in less than twenty years, and before he was forty-five years old, Vuillard had executed approximately forty-six paintings comprising twelve *décorations* – a term that had a special connotation among modern painters in late nineteenth-century France.[14]

In many ways, the 1905 Salon d'Automne marked a turning point in Vuillard's career. His exhibited pieces were a culmination and summary of the past decade of his work as a decorative artist but had little to do with his present situation. Since 1901, in fact, Vuillard had not undertaken any decorative commissions, and he would return to them only in 1907. This six-year hiatus also witnessed a change in the character of the group of patrons surrounding the artist. The patrons from the early period (1892–1901) were drawn primarily from a certain *haute bourgeoisie* involved with banking, finance, industry, medicine, and journalism. All had theatrical connections, and, most importantly, all, with one exception, had connections with the magazine *La Revue Blanche*, which was owned by the Natanson brothers. As such, they formed a tightly knit circle of friends who frequented the same galleries, theaters, and dinner parties and visited each other's summer residences. After 1905, when Vuillard was established with a commercial gallery, he was less frequently commissioned for decorative panels. Those projects he did receive came from a wider spectrum of wealthy, privileged people – collectors, salon hosts, *boulevardiers*, cosmopolitans (including princes and princesses) representing conservative Parisian culture – whose commitment to the artist is more difficult to gauge.

In contrast to the first decade of commissioned *décorations* – which reflected Vuillard's response to collectors, many of whose aesthetic tastes were in keeping with the pictorial symbolism of the 1890s – his large-scale *décorations* in the twentieth century show an evolution towards a more naturalistic subject matter and modified impressionist style. Despite Vuillard's changing attitude towards decorative painting, however, his projects were always complementary to and sometimes an exploratory prelude to his picture-making in general.

This book looks closely at the motives and meanings underlying these early decorative works and at the patrons who directly or indirectly engendered them. Who were these individuals and why did they choose to commission Vuillard? Were the paintings site-specific? What became of the *décoration* intended for one interior when it was subsequently installed in another setting? What was the prevailing "style" of these interiors and why were Vuillard's paintings perceived as appropriate *décorations* for them?

In the course of my research to answer these and other questions concerning Vuillard's early career as a *peintre-décorateur*, I was made acutely aware of one basic and overwhelming obstacle: that the decorative panels – whether single panels, pendants, or series – can no longer be seen as they were intended to be. Even during Vuillard's lifetime, the majority of these large or unusually formatted canvases were separated from the interiors for which they were conceived and sold individually or as complete series to private owners and public institutions. The possibility of ever reuniting them in an exhibition is complicated by the distemper technique (*à la colle*) that Vuillard frequently used for his large-scale paintings. This process, involving various combinations of dry pigments mixed with glue or size liquified by heat to create a scumbled, mat, and heavy surface, has led to the flaking and dispersion of the pigments and, consequently, to their inability to travel. Likewise, the interiors for which the paintings were made have undergone radical changes. While some of the apartment buildings and private houses still exist, they have been modernized from their late nineteenth-century architectural style to meet different pragmatic, financial, and aesthetic requirements.

As a result, my access to these decorative schemes and interiors has been largely figurative rather than physical, and achieved with the help of archival, notorial, and cadastral records, architectural plans, photographs, and interviews with family members.[15] I have also relied on published and unpublished correspondences, memoirs, and succession papers to determine those more abstract factors having to do with the philosophical, social, economic, and even political attitudes that helped shape the circumstances leading to the individual commissions.

Of great importance to this project have been the thirty-seven *carnets* or small notebooks known as Vuillard's "journals" which have been available to Vuillard scholars at the Institut de France in Paris since 1980.[16] Two early notebooks cover Vuillard's student years between 1887 and 1890 and personal reflections to about 1894. The remaining thirty-five, dating from the spring of 1907 until March 1940, contain his day-by-day accounts of his personal and professional activities.[17] While the journals provide dates and names that have helped establish the chronological and social framework of the commissioned projects, they are disappointingly lacking in biographical details. And while they dispel some speculations that Vuillard was inordinately attached to his mother (with whom he lived until her death in 1928, only twelve years before his own), they are exasperatingly reticent on the nature of his exciting but exhausting friendships with the vivacious Misia, wife of his best friend and supporter, Thadée Natanson, and with his later patron, Lucie, wife of the formidable picture dealer Jos Hessel. The journals offer the artist's immediate insights and a contemporary portrait gallery, but, like Vuillard himself, they are guarded, discreet, and inhibited concerning his loves and friendships.[18]

From all the available evidence, the picture of

Vuillard's patrons that emerges during the first two decades of his career is a diverse, yet at the same time, surprisingly coherent one. Most identified themselves with the tradition of "independent" painting, although what constituted that style varied according to their economic, social, and personal positions at the time of commission. Interestingly, the majority of his patrons did not share his French Catholic heritage. Of the ten collectors whose decorative commissions are studied here – seven from the 1890s and three after 1905 – only Dr. Louis-Henri Vaquez and Henry Bernstein were natives of France, and only Vaquez was Catholic, although by the time he commissioned Vuillard in 1895, he was an avowed atheist.[19]

More difficult to determine are the prevailing aesthetic "tastes" characterizing Vuillard's patronage circle, and whether those tastes played a role in determining Vuillard's choice of subject, scale, and palette and his manner of execution. That the panels – many of which were not exhibited publicly during his lifetime – were discussed and evaluated informally by the artist's friends is clear from Vuillard's journal entries. Sometimes, as was the case for the *Public Gardens* series (pls. 76–86), executed for the private residence of Alexandre Natanson, or the large panels for the luxury apartment of the Swiss journalist Jean Schopfer (pls. 165, 166, 180, 181), the *décorations* were "inaugurated" by special viewing parties. In both of these instances, however, Vuillard was asked at a later date to render the panels appropriate for a different architectural setting.

Vuillard's work as a *peintre-décorateur* was particularly subject to these *reprises* or reworkings, owing to the mobility and fragility of his social milieu, whose members frequently changed not only their residences and interior decorations but also their partners and life-styles. Sometimes, as with the earliest commissioned project of six panels for the Desmarais family (pls. 24–9) and the single panel commissioned by Jack Aghion and later purchased by the German collector Karl Ernst Osthaus (pl. 214), the *décoration*, originally conceived to be only loosely integrated into an architectural setting, was subsequently installed in a new setting designed specifically for it. In other instances, such as with Vuillard's series of decorative panels for Thadée and Misia Natanson known collectively as *The Album* (*L'Album*) (pls. 114–18), the paintings were never intended for "permanent" installation, but to be moved at whim within the Natansons' city and country residences.

Certainly, the degree to which Vuillard catered to his patrons' aesthetic interests varied in proportion to his intimacy with them. Although he painted one of his most ambitious projects, a series of eight panels on the theme of the Paris streets, *Rues de Paris* (pls. 263–6, 275–6), for the playwright Henry Bernstein, the latter was only peripherally connected to Vuillard's social network, and his relationship with the artist never went beyond that of professional acquaintance. By contrast, Vuillard quickly developed a close friendship with his next patron, the American Marguerite Chapin, to the degree that her refusal of the panel she had commissioned, *The Library* (*La Bibliothèque*) (pl. 288), was an emotionally devastating blow to him.

In 1912, the year of Mlle Chapin's refusal, Vuillard received his first public commission to paint decorative paintings for the foyer of the Théâtre des Champs-Elysées (pls. 324, 325). Although this undertaking was not the end of Vuillard's career as a maker of monumental canvases for the domestic, and now public realm, it may be considered the end of the two most fertile decades of his work in the genre that justified his inclusion in Segard's pantheon of the most successful *peintres-décorateurs*. Likewise, the unconventional formats and stylistic techniques used for the paintings completed during these years represent Vuillard's most experimental and innovative response to his patrons' aesthetic tastes – in part, and in the majority of the following case studies, due to his close associations with them.

This book does not purport to be a guided tour of beautiful but long-lost interiors. What it does present is an evocation of the period in which Vuillard worked and of the circumstances that enabled him to find a receptive audience for a new kind of painting related to a particular interior and, in many cases, to its inhabitants. In the end, the interiors and installations that were embellished by Vuillard's decorative paintings in the 1890s and early 1900s can be only partially resurrected from the past. For the history of the paintings and the special relationship that existed between Vuillard and the groups that chose him as their *peintre-décorateur* is a fascinating, but necessarily blurred one, but one that can be brought into greater focus by examining the existing physical evidence, the reports of eyewitnesses, the historian's account of the intellectual and social climate of the day, and the narrative suggested by the *décorations* themselves.

I *The Nabis, the Decorative Aesthetic, and the Circle of* La Revue Blanche

Vuillard and the Nabis

Vuillard, as his close friend Thadée Natanson would recall, was an intensely private person.[1] Although the perfect confidant, he was reserved about allowing others to have access to his intimate thoughts. He did, however, write a lot to himself, and his journals reveal a continual self-examination which was perfectly in tune with the late nineteenth-century fascination with the individual's emotional and psychological states. Yet the much-anticipated lifting in 1980 of the restrictions attached to his private journals was anticlimatic, insofar as they did not contain any revelatory details about his personal circumstances. Instead of unveiling a secret life, the journals confirmed what is apparent in his paintings: that Vuillard spent the greater part of his life in the society of others and that his life revolved around and was structured by a network of friends whose own lives were closely connected to his artistic development.

That Vuillard should even have aspired to a career as an artist was in itself remarkable. Nothing in his early education, family, social position, travel experience, or personality implied anything special about his upbringing that could be said in retrospect to have inclined him towards an artistic profession. Born in 1868 in the provincial town of Cuiseaux (near Ornans in the Jura and about three hundred miles from Paris), Vuillard was the youngest of three in a family headed by a retired French army captain turned tax collector. Vuillard's father, Joseph-Honoré Vuillard, had married a cousin, Marie-Justine-Alexandrine Michaud, twenty-seven years his junior. In 1877, the Vuillards moved to Paris where Edouard was enrolled in the Ecole Rocroy, which was run by the brothers of the Society of Mary. There he received a good but strict theological and classical education. Seven years later, *père* Vuillard died, leaving his now forty-five year old wife a small pension and three school-age children to raise. As recent monographs on the artist have shown, Mme Vuillard was not a helpless widow and clearly no novice to the clothing industry in which she worked. Her aunt had married Jean Saurel, a fabric designer whose family owned a factory at Le Fresnaye-le-Grand (Aisne) and a showroom in the Montmartre district of Paris.[2] As early as 1879, Mme Vuillard had her own corset-making business.[3] After her husband's death in 1884, she moved the business from the Opéra district to her home on the rue Danou and later expanded it into a dressmaking business on the rue du Marché-Saint-Honoré.[4]

Perhaps it was owing to Vuillard's exposure, at the age of eleven, to the workshop environment as part of his very living space that he was always to feel strongly about the nature of work, both as a practical and as a moral responsibility. As he would argue frequently in his early journal entries between 1888 and 1894, as important to him as the romantic notion of *volonté* or will was the *travail*, the *métier*, or humble task itself.

Vuillard's decision to become a painter was not related to any specific or revolutionary event. His appearance as an artist and his rapid entry into the highly complex and heterogeneous aesthetic circles in the Paris of the 1890s was, as he would later admit to his future biographer, Claude Roger-Marx, a matter of "chance associations" that bore fruit.[5] These associations had to do with painting, theater, and literature. None of these was of particular interest to him in 1884, however, when he enrolled as a day student at the prestigious Lycée Condorcet. He could not have foreseen that his enrollment there would lead to his most fortuitous encounters.[6] In contrast to the religiously run Ecole Rocroy, Condorcet, located on the passage du Havre behind the Opéra, was a liberal and progressive institution, whose curriculum and location encouraged students to take in every new intellectual, literary, and artistic attraction the city had to offer. There Vuillard's schoolmates were Maurice Denis, Aurélien Lugné-Poe, Thadée Natanson, Léon Blum, and Pierre Veber, all of whom would later play significant roles in his development as an artist. His best friend at Condorcet was Ker-Xavier Roussel, the son of a wealthy homeopathic doctor and art collector who would become Vuillard's

4 Detail of pl. 8.

6 (facing page) Edouard Vuillard, *Self-Portrait with his Friend Waroqui, c.*1889–90, oil on canvas, 82.7 × 72.4 cm., Metropolitan Museum of Art, New York.

5 Edouard Vuillard, *Still Life with Jug and Knife,* 1888, oil on canvas, 30.5 × 39.4 cm., Gift of Mary and Leigh Block, 1988.263, The Art Institute of Chicago.

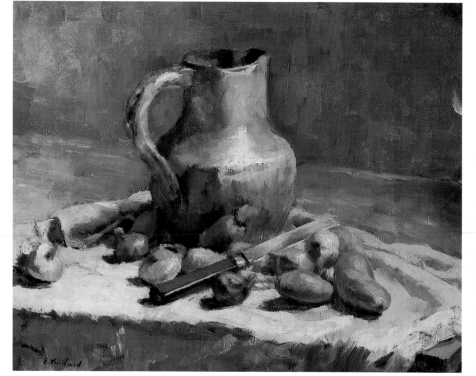

brother-in-law in 1893.[7] It was Roussel who saw Vuillard through a personal drama, when at sixteen he experienced a religious crisis "so intense he could never bear to talk about it." At this time, too, Roussel persuaded his friend to study art instead of continuing with his original intention to enroll in the military academy of Saint-Cyr, as Vuillard's brother, Alexandre, had done.[8]

According to the chronological listing for these student years made by Vuillard in his journal, even before he obtained the baccalaureate from the Lycée Condorcet in 1885, he was already attending free evening classes with Roussel at the Ecole des Gobelins.[9] There, in drawing lessons using live models, he was "corrected" (*corrigé* – a term perhaps best translated as "critiqued") by Prix de Rome winner Diogenes-Ulysées Maillart. After twice attempting and failing to be accepted into the Ecole des Beaux-Arts in 1886, Vuillard entered the Académie Julian (considered a preparatory studio for the Ecole), in the studio taught by the history painter Tony Robert-Fleury and the *éminence grise* of the official art world, Adolphe Bouguereau.[10] In July 1887, he was finally accepted into the Ecole des Beaux-Arts, although his only journal reference to this period – "course at the Ecole, Gérôme 6 weeks" – suggests that it was a brief and unmemorable learning experience.[11]

Lessons at both the Ecole des Beaux-Arts and at the Académie Julian offered traditional drawing and oil-painting techniques which Vuillard supplemented with lessons in geometry as well as drawing from casts of antique sculptures at the studio of Adolphe Yvon.[12] During this period of art training between 1887 and 1888, in addition to the requisite *académies* or life drawings from the nude, he painted a number of still lifes in the naturalist tradition of Chardin and the Dutch seventeenth-century painters that he admired (pl. 5). In the spring of 1889, his charcoal drawing of his maternal grandmother was accepted at the offical Salon des Artistes Français – a milestone event given that a career in art had not been his original intention and had been decided upon only at the end of his formal studies.[13]

The 1889 Salon, however, marked Vuillard's first and last appearance at the state-sponsored exhibitions, and he left the Ecole altogether in the fall of that year. Although he had never completely abandoned his instruction at the Académie Julian while taking courses at the Ecole, it was only in the latter part of 1888 that he and Roussel resumed regular studies at the Académie, becoming involved with the students in the other important studio there, presided over by Gustave Boulanger and Jules Lefebvre. Among these was Vuillard's former schoolmate, Maurice Denis. Through him and another friend from Condorcet, Pierre Veber, Vuillard met Paul Ranson, Henri-Gabriel Ibels, René Piot, Pierre Bonnard, and the older Paul Sérusier, the overseer or *massier* of the studio.[14] Since 1888, these artists had formed an inner circle to protest at the conservative curriculum of their classes. Steeped in symbolist (anti-naturalist) thought, Sérusier's group was concerned to communicate sensations and essences rather than to copy the appearances of things in nature. While this philosophy could be traced to the literary tradition running from Baudelaire through Mallarmé (who in 1861 remarked that an artist should be less concerned with the object to be depicted than with the "effect it produces"), the Julian artists chose Gauguin as their immediate mentor.[15] For their visual guides, they looked especially to the works of Gauguin's group of painters at Pont Aven on the Brittany coast who were introducing into their work radical new art forms based on surface and pattern which implied an idea and emotion. A trophy of their affinities with the Brittany artists was Sérusier's small painting on a cigar box which he had brought back from his "lesson" with Gauguin in the summer of 1888.[16] Entitled *The Talisman*, it served as an amulet for the new kind of painting perceived as synthetist in technique – since line and color combined for the overall effect – and symbolist in ideology – since it embodied the act of seeing with the mind's eye rather than of copying nature. In the summer of 1889, the group was able to see more of Gauguin's paintings and highly stylized zincographs of Breton subjects at the Café Volpini near the Exposition Universelle. The exhibition provided them, as Maurice Denis would recall, with "one or two very simple, incontestably true ideas at a time when we were totally without guidance."[17]

Shortly after Vuillard's arrival at the Académie in the fall of 1889 (which he soon left to do two months

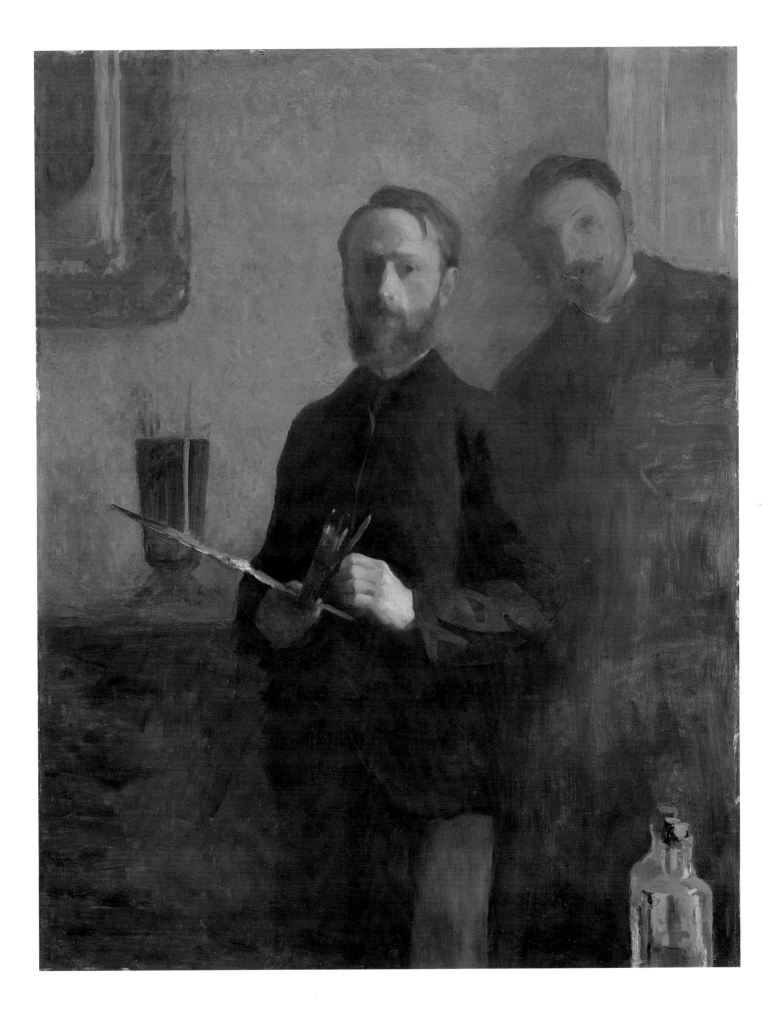

8 (facing page) Edouard Vuillard, *Bonjour M. Vuillard (Self-Portrait in a Straw Hat)*, c.1891–2, oil on canvas, 36.2 × 27.9 cm., Collection of William Kelly Simpson, New York.

7 Edouard Vuillard, *The Stevedores*, c.1890, oil on canvas, 47 × 64 cm., The Arthur G. Altschul Collection.

of military service), the Julian group began calling themselves the "Nabis," after the Hebrew word for prophets.[18] Meeting regularly at the apartment of the only married Nabi, Paul Ranson, on the boulevard Montparnasse,[19] they devised a secret language, with codes and nicknames, to set themselves apart from their Julian colleagues and from the *pelichtim*, another Hebrew-derived term they used to describe the uninitiated bourgeoisie.[20]

Among the Nabis there were those, like Ranson and Sérusier, whose personal theories on painting were supplemented by the theosophy of Edouard Schuré's *Les Grands Initiés* (1889) and by other popular symbolist texts of the day. But these interests were secondary to the Nabis' principal aim, which was to be open to all philosophies and religions. As Sérusier remarked to Denis, the appellation "Nabi" could refer both to the wisdom of the ancient sages and to the notion of being youthful seekers after a neo-Platonic brotherhood: "I dream of a future brotherhood, purified, composed only of artists, dedicated lovers of beauty and good, putting into their work and way of conducting themselves, the undefinable character that I would translate as 'Nabi'."[21]

The "undefinable character" of the Nabis at this stage in their careers, however, was less elevated than practical. Unlike the brotherhood of the English Pre-Raphaelites or of the German Nazarenes, whom they resembled in age and whose monastic model they imitated in part, the Nabis were not extremist in their views and did not use their group's title in public.[22] At best, they constituted a group of young, single (except for Ranson), predominantly Catholic, and idealistic art students who had received a liberal arts education at one or other of the three prestigious

lycées. They had been "purified" only in the sense of having rejected a salaried existence.[23]

Vuillard's own commitment to the Nabi brotherhood probably took place during the spring of 1890. His journal summary for his student years indicates that he was working from memory and producing "petites salissures" ("little bits of nothing") in 1889, but it was not until the following year, the "année de Sérusier," as he described it, that he began his most intense experimentations with the theories and teachings of the older artist.[24] The extent to which Vuillard was caught up with his friends' anti-naturalistic approach to picture-making is seen in the comparison between the still lifes and portraits executed between 1888 and 1889 and the small paintings on cardboard painted during his stay at Ranson's studio in the summer of 1890.[25] The large *Self-Portrait with his Friend Waroqui*, painted in late 1889/90 (pl. 6), is a transitional work showing both his naturalist and symbolist tendencies.[26] While the psychological intensity of the artist's gaze juxtaposed with the nonchalance of his friend's recalls Degas's early double portraits of friends and family, the mysterious quality evoked by the shadowy background from which the figures emerge suggests the influence of Eugène Carrière's symbolism. By contrast, his *Bonjour Monsieur Vuillard* (pl. 8), an obvious play (if the title is correct) on Courbet's arrogant self-portrait of some forty years earlier, can be considered a stylistic exercise similar to other one-of-a-kind paintings, like *The Stevedores* (pl. 7), painted in Ranson's studio that summer. Both show Vuillard's experiments with a modified pointillist technique that he would abandon soon afterwards.

Vuillard's transition from naturalist to Nabi artist was a short but uneasy one. Although he could appreciate the camaraderie and support that the Nabi association offered, he was unable to accept unreservedly their theoretical excesses. His early notebook jottings reveal his deep-seated doubts about his ability to find a method unique to his nature and his "horror," as he expressed it in a letter written several years later to Denis, at the thought of adopting "general ideas that I haven't discovered for myself."[27] At the same time, he longed for a methodology that would help him to consolidate the sensation with the idea. Writing in his notebook on 24 October 1890, he voiced his concerns:

What I should really be concerned with: the consolidation of an idea as a work of art, of which the *existence* would be the *product* of an *idea* (sensation and *methodology*). It is therefore necessary to have a methodology in order to produce, without *knowing* in advance what will be the result. Let's be clear: I must *imagine*, see, the lines and colors I apply and do nothing haphazardly; that's perfectly true. I must think about all my combinations. But even to attempt this work I must have a methodology in which I have faith. I have always worked *haphaz-*

8

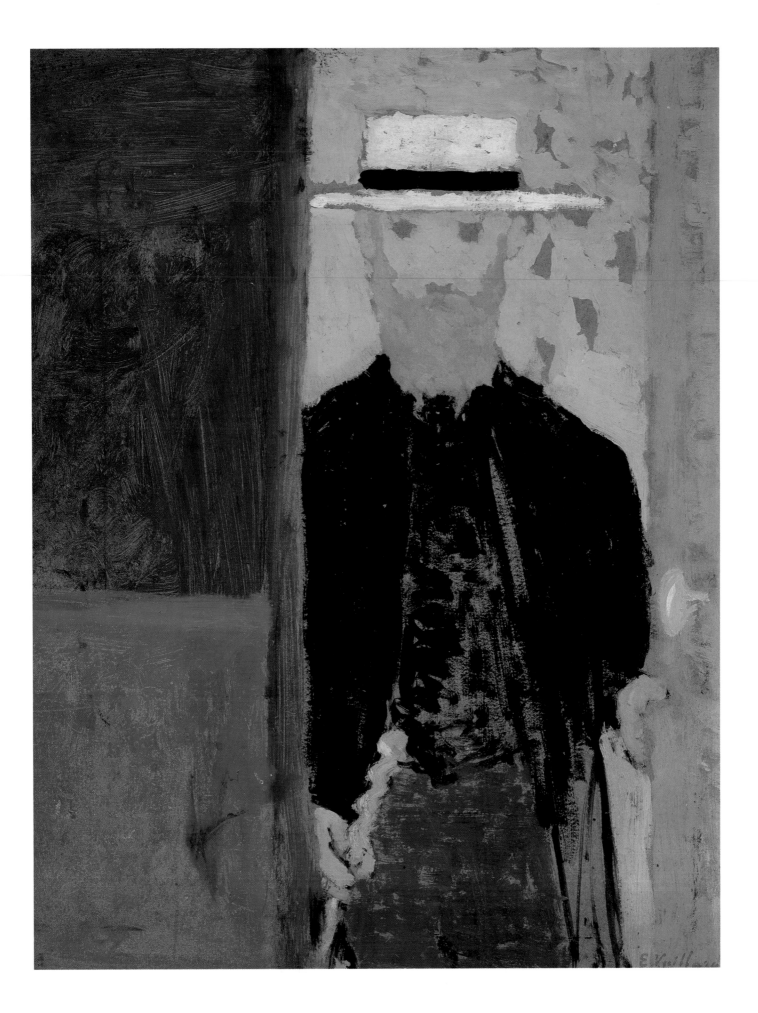

ardly and surely [illegible word] these do not belong to my work purely by *chance*. If the drawings of the Observatoire [or the Conservatoire – a training school for actors], the programs of the T. L. [Théâtre Libre], and the drawings for the pantomime all have personality, it is in spite of myself, and I have done everything possible to avoid the fault of intelligence because nothing is absolute in our theories. This is a grace.[28]

Vuillard's worries about finding an appropriate expression of his personality were typical of his self-deprecating nature. For by the time of these self-admonishing remarks, he had already achieved a consistent style that would be his trademark. Like Bonnard, the Nabi artist whose style his own most resembled at the time, Vuillard applied Sérusier's lessons about line and color to particular subject matter: the world of Parisian streets, theaters, and home life. Both artists specialized in creating witty caricature-like images and used animated patterned designs and silhouettes to activate the surface. Bonnard's poster design *France Champagne* (pl. 9), executed in 1889 but not published until 1891, is close in spirit and sensibility to the decorative exuberance of Vuillard's watercolor of the French actor Coquelin Cadet, executed in late 1890 (pl. 10). In both, the artists' choice of graphic medium helped them to articulate more readily the modern aesthetic notion of art as surface and pattern.

To a large degree, Vuillard's stylistic and thematic development as a painter, draftsman and print-maker

(he began print-making in 1891) was the result of his next important association, that with the avant-garde naturalist and symbolist theaters of André Antoine and Paul Fort respectively. By 1890, Vuillard and the Nabis were well connected to these advanced theatrical circles. The extended membership of "Nabidom" included future playwright Pierre Veber, linguist Auguste Cazalis; musician Pierre Hermant; businessman and Condorcet graduate Paul Percheron; the painters Jan Verkade and Mogens Ballin; and the former Condorcet student Aurélien Lugné-Poe, who would provide an important link between Vuillard's professional career and the larger art circles of Paris.[29] At the time of their introduction, Lugné (who had earlier added Poe to his name for its literary associations) was the stage assistant at André Antoine's Théâtre Libre. It was Lugné-Poe who hawked the paintings and drawings of his closest Nabi friends, Denis, Roussel, Bonnard, and Vuillard, and who managed to secure purchases from several of his writer and actor friends. One of his more successful undertakings was to introduce Vuillard to Coquelin Cadet, who was teaching classes at the Conservatoire de Musique et Déclamation. It was no doubt Lugné-Poe, also, who arranged for Vuillard's first commission from Coquelin for a series of twelve watercolors in brilliant orange and blue complementaries caricaturing the actor in a manner reminiscent of seventeenth-century portraits of Japanese actors – such as the previously cited *Coquelin Cadet* (pl. 10).[30] Lugné-Poe would also be responsible for his friend's participation in the modern theater as a designer of sets, programs, and costumes for the Théâtre Libre, Paul Fort's Théâtre d'Art, and, beginning in 1893, Lugné-Poe's own Théâtre de l'Oeuvre.[31]

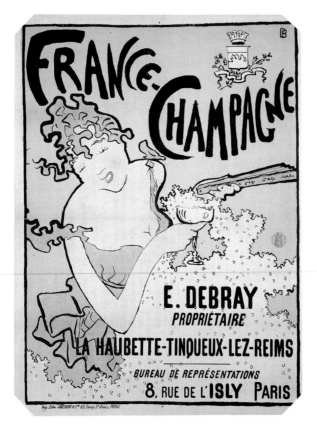

As a friend and fellow Nabi, Lugné-Poe was well aware that the Nabi style of painting – which ranged from the heavy-handed symbolism of the theosophist Ranson to the urbane satires of Ibels (who left the Nabis in 1891 to work almost exclusively as an illustrator and graphic artist), to the Gauguin-inspired *bretonneries* of Sérusier – required a public explanation and identity.[32] In response to what he considered the Nabis' too timid approach to the new mode of vision and picture-making that they espoused, Lugné-Poe urged Denis to take action. In August 1890, Lugné-Poe arranged to have an important essay by Denis published in his friend Jean Jullien's literary magazine, *Art et Critique*. In this two-part article, entitled "Définition du néo-traditionnisme," Denis, under the pseudonym Pierre Louis, penned the now-famous dictum, "Remind yourselves that a painting, before being a battle horse, a nude or any anecdote whatsoever, is essentially a flat surface covered with colors arranged in a certain order."[33] With this, Denis provided a succint statement on the principles of decorative painting as a "modern" aesthetic and a definition that can be fully understood only in the larger context of late nineteenth-century art and culture.

The Nabis and the Decorative Tradition

The most important contribution of the Nabis to the concept of painting as decoration at the end of the nineteenth century was to broaden the definition among progressive artists and critics from its traditional association with architectural embellishment and artifice to a type of painting complete in and of itself.[34]

In the Third Republic, Puvis de Chavannes had revitalized and legitimized mural painting, based on what Théophile Gautier had earlier prescribed for the genre: "a beautiful arrangement, a grand style, [and] a simple mat color."[35] Puvis de Chavannes's quasi-allegorical and softly colored figural types set into landscapes (pl. 11) were remote from paintings of history and modern life. Because his particular style seemed linked to an art that rejected optical reality, his murals as well as easel paintings were perceived by the younger generation as inherently "modern" and "decorative."[36]

By the late 1880s, the works of the impressionists Monet and Pissarro had also become progressively and consciously "flat" and "decorative" through the use of closely ranged tonal gradations of complementary and contrasting colors. At the 1889 joint retrospective exhibition of Monet and Rodin, Monet exhibited some 145 paintings from all periods of his career. There his earliest impressionist canvases could be compared with the recent Antibes and Creuse valley series which were executed with a much blonder palette of tonal gradations (pl. 12). As Steven Levine has pointed out, the criticism aimed at

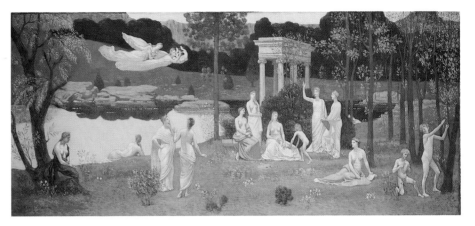

Monet's early impressionist works for their inability to depict convincing illusionistic space and for being in a negative sense "exclusively decorative and colorist," was now seen as a positive virtue within the larger issue of painting as "décor."[37] The same analogy of painting as flat surface and as décor was used to describe and appreciate Seurat's masterpiece *A Sunday on La Grande Jatte – 1884* (pl. 13). When

11 Pierre Puvis de Chavannes, *The Sacred Grove*, c.1884, oil on canvas, 93 × 231 cm., Mr. and Mrs. Potter Palmer Collection, 1922.445, The Art Institute of Chicago.

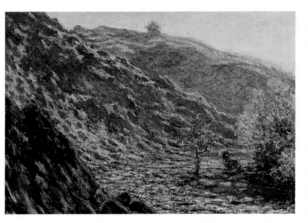

12 Claude Monet, *The Petit Creuse*, 1888/9, oil on canvas, 65.9 × 93.1 cm., Mr. and Mrs. Potter Palmer Collection, 1922.432, The Art Institute of Chicago.

13 (below) Georges Seurat, *A Sunday on La Grande Jatte – 1884*, 1884–6, 207.6 × 308 cm., Helen Birch Bartlett Memorial Collection, 1926.224, The Art Institute of Chicago.

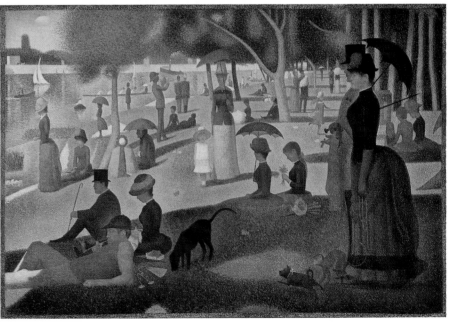

15 Maurice Denis, *Catholic Mystery (Mystère Catholique)*, 1889, oil on canvas, 97 × 143 cm., Le Musée départemental du Prieuré, Saint-Germain-en-Laye.

exhibited for the first time in 1886, it was described favorably by art critic Félix Fénéon as "an immense canvas . . . [in which] whatever part of it you examine unrolls like a monotonous and patient tapestry."[38] Like those of Puvis de Chavannes, and, to a lesser extent, of Gauguin, Seurat's decorative effects resulted from his consistent use of expressive line and color, hierarchic composition in which figures were placed parallel to the picture plane, reduced illusionism, no action and no fixed viewpoint, regular brushstrokes and little impasto – all of which helped to negate the idea of picture as window and to support the idea of a painting as surface.[39]

By the time of Denis's Nabi manifesto in 1890, the notion of "decorative," or the emphasis on two-dimensionality resulting from an increased concern for surface and pattern, was not new to painting theory. What was new was Denis's implication that the expressive arrangement of colors and lines without reference to meanings was related to the deliberate creation of flatness. According to Denis (as spokesman for the Nabis), the artist was allowed to exaggerate, emphasize, or reduce (what he termed "la déformation subjective") for the better expression of his feeling. That expression, however, was to be based on beauty, upon "a purely aesthetic and decorative conception."[40] As Joseph Mashek has argued, "the emphasis on decorativeness as a positive quality, in fact, arose as a compensatory exaggeration of the ornamental, at the expense of pictorial values."[41] More simply put, the Nabis' concern with distorting, flattening out, or losing the subject in patterns helped to distance it from the real world, thus serving the anti-naturalist intent, while at the same time, increasing the decorative effect.[42]

Common to the Nabis' new artistic expression was the need to establish themselves outside the perimeters of mere easel painting. A decorative painting suggested a connection to a larger surface, in the same way as a mural or fresco, and was thus not limited by the same conventions of picture-making as was easel painting. As part of the Nabis' efforts to change the way a painting was defined, the Nabis stressed, in their choices of *facture*, subject, and unconventional formats, what the critics referred to as the quality of "le décoratif," regardless of destination and purpose.[43] Thus Bonnard's undestined decorative four-panel series *Women in a Garden (Femmes dans un jardin)* (pl. 14), exhibited at the Salon des Indépendants in the spring of 1891, and Denis's *Catholic Mystery (Mystère Catholique)* (pl. 15) (with its affinities to the work of Puvis), also exhibited at the Indépendants, could be perceived as achieving the same goals.[44]

14 Pierre Bonnard, ·*Women in a Garden (Femmes dans un jardin)*. One of four panels for a screen, 1891, oil on paper mounted on canvas, each panel: 160 × 48 cm., Musée d'Orsay, Paris.

Vuillards Interiors and the Decorative Intent

Vuillard did not exhibit that spring, and his journal entries written in April (during the course of the exhibition) show his continuing anxiety about his lack of method and personal style, as well as his envy of Denis, whose very dogmatism seemed to immunize him from self-doubt.

Why do I still worry what my style will be? It will not be – it is. And what is meant by style, what does one understand by it? Denis, for example is a mystic. The impression of his work leads to this convenient word; but the word does nothing, it's only a coarse sign. The more the word resembles a sign, the more general it is, the more metaphysical, the more exact it will be. Is he [Denis] aware of the opinion of others when he's working? No, because, if so, he would reproduce such and such an exterior aspect of one of his works that he knows gives this impression. What a detestable obsession to classify things artificially in obscure categories of which we have only false ideas.[45]

By the time Vuillard voiced these worries, he was already embarking on a new repertoire of themes and on a style different from the idiosyncratic and naive line typical of his work in 1890. In May 1891, for example, he worked on the stage set for the two-act play *L'Intruse* by the Belgium symbolist poet Maurice Maeterlinck which was scheduled for a performance on 20 May benefiting Gauguin and Paul Verlaine.[46] It is conceivable that Maeterlinck's domestic dramas, which called for dramatic lights and the use of gestureless figures and close and darkened interiors, such as *Mystery Interior (Intérieur Mystère)* (pl. 16), may have offered Vuillard the source material for a symbolic interpretation needed for his art. As he had noted a year earlier in his journal, "A little literature is very helpful. Necessity of the literary subject (Verlaine's decadent sense) to perfect the work: impression from nature that a symbol is necessary to define it, either literary or pictorial, one that can't be expressed simply by enumerating the objects of which it is composed."[47]

The silhouetted figures in lamplit interiors that begin showing up in Vuillard's work in 1891 show his dependence on this more literal symbolism. They also reflect his more radical approach to the composition and use of artificial light than that found

in the works of the other Nabis at this time.[48] Vuillard recalled Maeterlinck's play *L'Intruse*, for example, in a small oil painting of the same title (still unidentified) that was exhibited at the first group showing of the Nabi painters in the summer of 1891 at the château of Saint-Germain-en-Laye.[49] Vuillard was represented by several drawings and *L'Intruse*, which was lent by Lugné-Poe and admired by Gustave Geffroy as "a small canvas, with such strong impressions and such beautiful lighting, that I consider M. Lugné-Poe, the owner, to be a very lucky man indeed. It is like a masterpiece, this thing."[50] The critic and friend of the Nabis Georges Roussel noted that Vuillard's painting gave a sensation of oppressive terror and compared his figures to those seemingly immobilized actors in Maeterlinck's dramas.[51] Other reviewers were less enthusiastic. Fénéon, for example, questioned the direction in which Vuillard was heading. Reviewing the exhibition for the *Chat Noir*, Fénéon described his paintings as "still indecisive, with passages of fashionable handling, of half-lights of a literary sort, and once or twice a sweet color-chord that comes off charmingly."[52]

A few months later, Vuillard was given another opportunity to exhibit with the Nabi group at the left-bank gallery named after its owner, Le Barc de Boutteville. There he exhibited similarly formatted *intimiste* paintings and drawings of women seated, involved in mending or sewing.[53] Along with works of his Nabi friends were those by other "Impressionnistes et Synthétistes," as the exhibition catalogue labeled them, including Pont Aven artists Emile Bernard and Louis Anquetin, neo-impressionists Paul Signac, Lucien Pissarro, and Charles Angrand, and the independent artist Henri de Toulouse-Lautrec. For the first time, the Nabis showed works in a variety of decorative categories, including posters, wallpapers, tapestries, wall hangings, and decorative panels. One of the few commentaries on the exhibition was published by Thadée Natanson, a

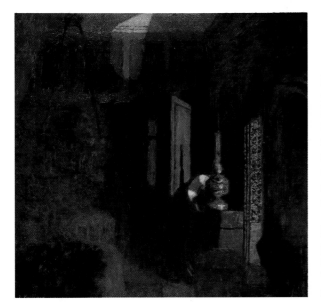

then-unknown art critic writing for a brand-new review entitled *La Revue Blanche*. Natanson approved of their efforts but questioned whether their works would have a larger aesthetic significance: "very, very curious exhibition of the 'new painters' (if they must be labeled, I would call them 'harmonists'): Maurice Denis, Bonnard, Vuillard, Cérusier [*sic*] – the oldies like Signac are holding up rather well. Interesting, interesting, but when is the masterpiece going to be produced?"[54]

The Nabis, Décoration, *and the Modern Interior*

Thadée Natanson's querulous comment referred to the nature of the Nabis' art to date which remained decidedly non-major in terms of scale and purpose. Although the historian of good taste Octave Uzanne, who also reviewed the Barc de Boutteville exhibition, commended the young artists as "having finally realized that art should be exclusively personal and decorative,"[55] none of the exhibited works represented a major commission. Instead, they were individual and individualistic expressions of the Nabis' united concern for the expansion of their art beyond easel painting, but without suggesting where that expansion would lead.

In March 1891, symbolist critic Albert Aurier wrote an important article on pictorial symbolism and Gauguin. This pointed out the dilemma posed by the new painting, which was not conventional easel painting and which, for that reason, demanded a new kind of patronage:

> Gauguin, it must be repeated, like all *Idéiste* painters, is above all a decorator. His compositions find themselves confined by the limited confines of the canvases. One would be tempted, at times, to take them for fragments of immense frescoes, and they nearly always seem ready to explode the frames that unduly limit them! . . . Come now a little common sense, you have among you a decorator of genius. Walls! walls! give him some walls![56]

In his essay, Aurier touched upon the larger issue that the Nabis would use as their battle cry: the need to integrate their new ideas about picture-making with the parallel movement that would become a general revival of arts and crafts. Although the Nabis did not see themselves merely as painters but as "Artists" in all media, painting represented their primary interest, and they now sought to integrate it into the extended sphere (largely urban) of modern living.

At the time of Thadée Natanson's comments, however, the Nabis had yet to establish their independence from other groups of avant-garde painting and to link themselves to a broader art-buying public. Thus far, interest in them had been among a small number of professionals associated with André

16 Edouard Vuillard, *Mystery Interior (Intérieur mystère)*, c.1892–3, oil on board, 35.8 × 38.1 cm., private collection.

Antoine's new theater and the short-lived Théâtre d'Art. The projects for the theatres allowed them to work in different formats and mediums and to explore different subjects. Because of their ephemeral nature, however, quickly executed and just as quickly painted over, these projects did not further the Nabis' goal of executing murals or large-scale wall paintings.[57]

In April 1892, Sérusier, the understood founder of the Nabis, went so far as to publish in the *Mercure de France* a statement that he would henceforth make only mural paintings.[58] His braggadocio, ultimately unfulfilled, was noted by one particularly disgruntled critic, Thiébault-Sisson. Reviewing Sérusier's works exhibited at the gallery of Le Barc de Boutteville the following year, he complained:

> Mr. Sérusier also pretends to be a symbolist, and his symbolism consists of sticking figures all on the same plane onto background walls of landscapes void of any perspective.
>
> Mr. Sérusier would tell me he has the perfect right to do this, and that he is solely a decorative artist . . . However, up to now, Mr. Sérusier has only done easel painting. He should comply with the requirements of easel painting.[59]

In general, Thiébault-Sissons's complaint reflected the difficulty among the art-buying public to accept the concept of a painting as decoration or a decorative panel by virtue of its formal elements alone. In part the public reluctance was due to the misunderstanding, as Aurier had noted, of what defined the large-scale or differently formatted painting that was being touted as "décoration" as opposed to easel painting. One year after Aurier's 1891 article on Gauguin's unrequited talents as a decorator and the need for a public that would allow and encourage the artist to work outside easel painting, Denis offered a paraphrase of Aurier's diatribe. Taking the tone of Sérusier's earlier call for a Nabi brotherhood, Denis gave personal testimony to what he perceived to be the moral as well as the aesthetic implications of a return to decorative art and of the new role for the modern artist.

> I can picture quite clearly the role of painting in the decoration of the modern home. Either an interior artfully executed by a painter of taste like Pierre Bonnard, with modern furnishings and wall hangings of unexpected design – an interior that is light, simple, and pleasing, neither a museum nor a bazaar. In certain spots, but sparingly, paintings of convenient dimensions and appropriate effect. I would want them to have a noble appearance, of rare and extraordinary beauty: they should contribute to the poetry of man's inner being, to the luxurious color scheme and arabesques without soul; and one should find in them a whole world of aesthetic emotions, free of literary allusions and all the more exalting for that.[60]

Rather than an explanation of artistic principles, in this article written nearly two years after his "Définition du néotraditionnisme," Denis sought to redirect attention to his group's participation in the more inclusive arena of "taste." In so doing, he consolidated new ideas about painting that tallied perfectly with prevailing social and aesthetic attitudes towards the traditional hierarchy of the decorative and fine arts and the stress on the importance of aesthetics in daily life. As Deborah Silverman has convincingly argued in her analysis of the ideology behind the emergence of art nouveau in the late nineteenth century, by the last two decades of the century, the desire for individualistic expression in art and literature had expanded into the private realm.[61] The collusion of the advanced aesthetics of picture-making with the aesthetics of an officially sanctioned "erudite aristocratic revivalism" had produced a fertile climate for the promotion of the decorative arts in general.[62]

By 1892, when Denis was writing, both the "reformed Salon" (Société National des Beaux-Arts) of the Champs-de-Mars and the Salon des Indépendants were exhibiting decorative arts alongside easel paintings. Although not the unified ensembles that would come only later with the emergence of art nouveau, these exhibitions inspired several articles lobbying for private patronage for artists working on contemporary interior decoration.[63] Writing for the conservative symbolist review, *L'Ermitage*, Alphonse Germain made it clear that the tradition of France's supremacy in decoration for the domestic space rested in the hands of patrons willing to work with able artists towards a transformation of the modern interior:

> Nothing reveals more a society's taste than its daily surroundings: but who today is concerned with giving a style to his home, with giving it a pervading personality? Who attaches importance to a homogeneous decor? to the coordination of wall hangings, rugs, and flowers? to the effects of their tones? Who considers toilet articles as more than banal ornamentation? Whoever would attempt to revive the decorative movement would merit the title of Patron of the Arts! There are still some devotees who are eagerly awaiting the opportunity to use their talent to this end; to group them with the rare beings initiated in the language of lines would provide the elements for an exhibition of interior design . . . If good taste has not ceased to exist in our society, what event could better awaken it?[64]

Like Aurier and Sérusier, Germain felt that artists should develop a decorative style that would replace imitative and manufactured styles within the modern interior. Yet in spite of the general consensus that an alternative to existing styles in interior decoration was needed, there were no clear-cut guidelines for what that style should be. The enlightened museum

administrator Roger Marx, along with members of the Union Centrale des Arts Décoratifs (UCAD) and the Société Nationale des Beaux-Arts, encouraged the reintegration of arts and crafts and proposed that artists cultivate a refinement (*raffinement*) and nobility (*noblesse*) in life and art.[65] The acceptance of "reformed art," however, was easier to achieve in the domain of objects that, unlike painting, were perceived as having practical as well as aesthetic significance. One of the most admired objects in the Salon of the Société Nationale (called the Salon du Champs-de-Mars) in 1892, for example, was the *commode* inscribed with symbolist poetry by the glassmaker and cabinet-maker from Nancy, Emile Gallé. Marx called it "exquisite with ivory marquetry, where hortensias thrust upwards among accents softened by their pale pink and blue complexion."[66] Yet, quite as sincerely, Marx had praised Gauguin's work in the same category, seeing in his crudely modelled ceramics and overtly symbolist bas-relief *Be in Love* (*Soyez Amoureuse*) (pl. 17) (exhibited in the previous Salon du Champs-de-Mars) another manifestation in the movement to refine the decorative arts.[67]

If, as Silverman has persuasively reasoned, Marx embodied French encouragement of the emergence of decorative arts, it was not in the spirit of democratization of French taste, but as a return to a tradition that had as its base cultural (aristocratic) elitism. Opposed to the prevalent consumer mentality of the increasingly bourgeois populace who lived in *maisons de rapport* (apartment houses), decorated with cheaply manufactured imitations of former styles, Marx and others sought to elevate the general taste by creating both beautiful and decorative objects that would bear comparison with the products of the fine arts.[68] In so doing, they hoped to restore the important relationship that had once existed between the interior setting and art and design.[69]

In support of these attitudes were a number of luxury publications on modern aesthetics and the artistic environment which were launched in the last two decades of the century and which reiterated the importance of the traditional view of decoration. Charles Blanc's *Grammaire des arts décoratifs: décoration intérieure de la maison* (first published in 1867 and reprinted in 1882) reestablished the laws of interior decoration upheld by the *ancien régime*. Other voices of the art establishment, such as Spire Blondel, author of *L'Art intime et le gout en France* (1884), a guidebook for "modern decoration," also called for a strict adherence to the tastes of the previous century.[70] Even Henry Havard's, *L'Art dans la maison: grammaire de l'ameublement* (1884), which recommended personal expression and freedom in matters concerning interior décor, was actually circumscribed by Havard's understanding of standards of French tastes, which were aristocratically rooted.[71]

Converging with the public decorative-arts reform movement was the move towards what has been termed "interiorization,"[72] led by notable effetes

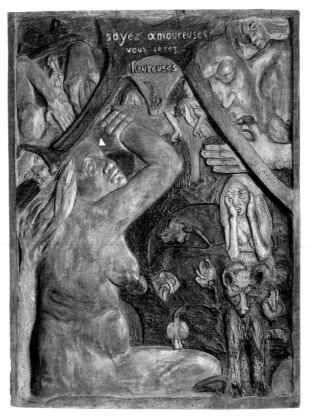

17 Paul Gauguin, *Be in Love, You will be Happy* (*Soyez amoureuses, vous serez heureuses*), 1889, painted linden-wood, 95.3 × 72.4 cm., Arthur Tracy Cabot Fund, Museum of Fine Arts, Boston.

like Jules and Edmond de Goncourt and Robert de Montesquiou, who felt that the interior should be a reflection of the personality of the owner. The "interiorization" or retreat to the interior was as much a man's affair as a woman's as men of leisure increasingly occupied womanless space and took over the responsibilities of decoration that had been primarily the woman's domaine.[73] Like the rarefied atmosphere created by Des Esseintes which is described in J.-K. Huysmans's celebrated novel *A rebours* (1884) – supposedly inspired by the de Goncourts' description of their "japanized" interior, *Maison d'un artiste* (1881) – this predominately male segment of the French literary and artistic elite adopted more and more eclectic interior decorative programs which combined the exotic and innovative with the aristocratic and precious. Catering to their tastes were periodicals such as Octave Uzanne's short-lived (1891–2) *L'Art et l'Idée*, dedicated to "the seekers, those admirers of Beauty," and to presenting its "dilettante" readers with "the new, the unedited, the exquisite, the extraordinary, the sought after . . ."[74]

The effete tastes of these "men of taste," whose preferences in interior decoration were narrowly defined by a tendency towards preciosity and a penchant for the rarified, were foreign to the painting concerns of the Nabis. Even Ranson, heir to the wealthy Houbigant family and thus freed from the need to make a living by his art, was aware that his friends' present audience lacked the Maecenas needed to finance their decorative work, and that it was possibly easier to find purchasers for their graphic

arts and smaller objects than for their full-scale painted *décorations*. In a letter to Jan Verkade written in the same month as Denis's article on the ideal interior (April 1892), Ranson complained: "There is an interest in us in the literary world – Goncourt and others – but these good men find our paintings are too expensive and they want them for nothing. (Let them go to the Devil!)"[75]

Vuillard and the Circle of La Revue Blanche

There was, however, another, relatively younger group of men of letters and entrepreneurs associated with modern theater who had become increasingly sympathetic to the Nabis' efforts. In the same year that Uzanne's *L'Art et l'Idée* first appeared, the undisputed leaders of this group, the Natanson brothers, had launched a bi-monthly periodical entitled *La Revue Blanche*, dedicated to advanced ideas ranging from art and literature to popular science and politics. Unlike Uzanne's publication, which was as ephemeral as it was elitist, the Natansons' "petite revue" lasted more than a decade, during which it produced some of the most important articles on modern thinking of any revue of its kind.

Vuillard had been introduced to Thadée in the summer of 1891 when the latter visited the studio apartment at 28 rue Pigalle that Vuillard shared with Bonnard, Denis, and Lugné-Poe.[76] Solidly built,

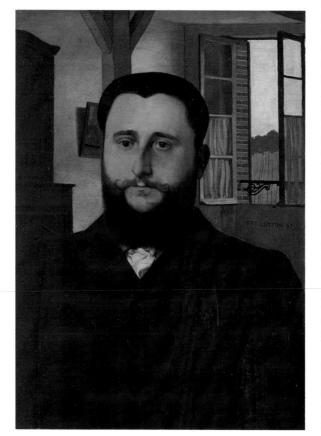

18 Félix Vallotton, *Thadée Natanson*, 1897, oil on cardboard, 66.5 × 48 cm., Musée du Petit Palais, Geneva.

with a full beard and small bright eyes, Thadée was described variously as a snob ("slow, corpulent, and serious"),[77] or as warm and friendly ("a fascinating man") (pl. 18).[78] At the time of his first meeting with Vuillard, Thadée had just left his law office, where he had worked since 1886, to indulge himself more completely in literature and more specifically with the publication *La Revue Blanche*, launched in October of that year. One class ahead of Vuillard's at Condorcet, Thadée was steeped in Mallarmé's poetic style which he tried bravely to adopt for his own works. As a *littérateur*, he was a frequent visitor to Mallarmé's *mardis*, or Tuesday salons, as well as regularly attending the Théâtre Libre and Théâtre d'Art, which he promoted as well. In 1892, for example, he arranged for the translation of Ibsen's *The Lady from the Sea* (*La Dame de la Mer*), in which Lugné-Poe would play the role of Dr. Wangel in the first French performance at the Théâtre Libre.[79] As early as 1886, his brothers, Alexandre and Alfred, had been collaborators with Lugné-Poe as a result of their involvement with the Cercle des Escholiers, an artistic association devoted to producing plays by unknown playwrights.[80] The Natansons' most serious and long-lasting literary undertaking, however, was *La Revue Blanche*, originally a Belgium-based journal with which the youngest, Alfred, had been affiliated and which Thadée and his older brother Alexandre had taken over.[81] Its relocation in Paris was a family affair: managed by Alexandre, a lawyer in the appellate court and the brother with the shrewdest head for business; edited by Thadée who had an uncanny sense of what was new and noteworthy;[82] and lent added authority by Alfred who contributed "literary and artistic news of Paris" under the pseudonym Athis.[83] Financing to a large extent this ambitious enterprise was their father, Adam Natanson, a wealthy Polish investment banker. A native of Warsaw, Adam had married the Russian Annette Reich and brought her and his four sons from Warsaw to France in 1878 where they were naturalized as French citizens.[84] When the two oldest boys, Alexandre and Thadée, reached school age, the Natansons moved from the Brittany province of Morbihan to the French capital. In Paris, evidence of their slavic origins soon disappeared in the face of the influence of their school friends and the emphasis on classical and modern French literature taught first at the Collège Saint-Louis, and subsequently, at the Lycée Condorcet.[85] From their first location in an *hôtel privé* on the place Saint-Michel, they moved to a larger residence on the avenue de Friedland, and eventually, after Madame's death in 1887, to an *hôtel privé* on the rue Jouffroy near the Parc Monceau.

The magazine that Adam helped subsidize quickly grew from the first 2,500 issues in 1891 (already a considerable run) to twice that size. As the voice of the Parisian intellectual community, it was in competition only with the *Mercure de France*.[86] Unlike its rival, the *Mercure*, or the other similar symbolist

reviews, *La Plume* and *L'Ermitage*, *La Revue Blanche* was not exclusively symbolist in its affinities, but dedicated, as the Natansons wrote in the first Paris edition, to the expression of all varieties of artistic ideas:[87] "In short, we wish to develop our personalities, and it is to determine them through their complementaries of sympathy and admiration that we respectfully solicit our masters and welcome the young gladly."[88]

The headquarters for the Natansons' journal, on the rue des Martyrs and subsequently the rue Laffitte, assured its visibility to the passersby. The location was ideal also because the Natansons were as interested in life on the boulevards – the gallery openings, operas, concerts, theaters – as they were in the intellectual talk within their offices. While the Natansons were not members of the French-born, old-family elite, they were no-less elitist in their social ambitions and strategies. As Henry Bordeaux remembered, "At *La Revue Blanche* . . . there existed an elegant and even a phony snobbishness; one talked only about racetracks and receptions."[89] According to Camille Mauclair, art critic for the *Mercure de France*, *La Revue Blanche* was run by "the imposing and snobbish Natansons . . . tough, chic, and full of lofty ambitions."[90] In Mauclair's view, the Natansons and their circle represented the worst kinds of snobs, since they adopted a trendy skepticism and political stance, ". . . verging on elegant anarchy. An intelligent group, go-getters, but from the literary point of view, barren and imcomprehensible."[91]

The brothers, however, saw themselves in a much different light – as liberal connoisseurs of all that was new, whether it be sports, food, politics, science, or art. Because of their interest in contemporary art and artists (which Mauclair did not mention), they offered opportunities and support in the pages of *La Revue Blanche* not found among similar publications at that time. The list of early contributors was a formidable one that included the young Marcel Proust, André Gide, Léon Blum, Paul (and after 1893, called Tristan) Bernard, Romain Coolus, and eventually the artists Vuillard, Bonnard, Roussel, Denis, Ibels, Félix Vallotton, and Toulouse-Lautrec.[92] In their enthusiasm, the Natansons saw themselves not only as literary agents but as knowledgeable collectors and patrons. All three brothers attended and purchased paintings from the February exhibition and auction in 1891, held to help finance Gauguin's trip to Tahiti.[93] Later, in 1898, they were the first to question the legality and morality of the original court martial of Colonel Dreyfus, and, as will be seen, used their magazine to voice those doubts. Whether for or against the brothers, witnesses to their rise to celebrity conceded that the Natansons were successful in achieving a solid footing in the intellectual and cultural landscape of Paris through their exclusive control of one of the most ambitious reviews of its kind.[94]

For Thadée, *La Revue Blanche* was an all-consuming project that became even more so after his marriage in 1893 to the well-read, musically talented, and adorable Misia Godebeska. In that year, he began the column "Petite Gazette d'Art" in which he reviewed exhibitions of his Nabi friends. For the Nabi enterprise, which by that time included Vallotton, Toulouse-Lautrec, Aristide Maillol, and Josef Rippl-Ronäi, Thadée would be a passionate advocate. Besides arranging for exhibitions of their works in the editorial offices of his journal, beginning in 1893, Thadée commissioned original lithographs (published in the monthly issues or in luxury portfolios), purchased a number of their easel paintings, and convinced his older brother to do the same. For Vuillard, the Natansons – and Thadée in particular – represented another fortuitous encounter. Only a few months after their introductory meeting in the rue Pigalle apartment in the summer of 1891, Thadée invited Vuillard to hang a small showing of his oil paintings of domestic interiors and dressmaking (*La Lampe, Couturière bleue, La Femme aux chiffons*) in the recently opened offices of *La Revue Blanche*.[95] Thadée would be among the first to respond to Denis's prophecy (which had been published in the April 1892 issue of *La Revue Blanche*) concerning the new role of painting and modern interior design.[96] As one of the most influential editors of the day, he would also answer in part his own query – "when is the masterpiece going to be produced?" – made on the occasion of the Barc de Boutteville exhibition in December 1891.[97] For it was through Thadée efforts, as Vuillard's devoted ally and unofficial agent, that the artist was ensured the opportunities for making monumental paintings over the next ten years.

2 Women at Work and at Play: The Commission for M and Mme Desmarais, 1892–1893

Thadée Natanson's prominent role in encouraging Vuillard's work on large decorative projects was usurped in 1892 by his cousin Stéphane Natanson, who was responsible for Vuillard's first essay in decorative painting for a private residence. Although Stéphane's premature death in 1904 at the age of forty-one has caused his name to be forgotten, during his short lifetime he was an active member of Parisian intellectual circles, and an *habitué* of the Théâtre Libre, Théâtre d'Art, the opera, concert halls in Montmartre and the literary cafés in the Latin Quarter.[1] A portrait of Stéphane in 1897 by Vallotton shows a young and ardent young man whose physiognomy is clearly identifiable with that of his cousin (pl. 20). Like Thadée, Stéphane had emigrated to Paris from Warsaw as a child and had followed a conventional upper-class educational and cultural route. A recent graduate of the Ecole des Beaux-Arts with a *diplôme* in architecture, he was listed as one of the earliest subscribers to his cousins' magazine.[2] In 1892, Stéphane persuaded his sister Léonie and her wealthy industrialist husband, Paul Desmarais, to commission six decorative panels from the twenty-four year old Vuillard. These panels,

known as *Gardening* (*Le Jardinage*) (pl. 27), *Stroking the Dog* (*La Caresse du chien*) (pl. 24), *Dressmaking Studio I* and *II* (*Un Atelier de Couture I* and *II*) (pls. 25, 28), *A Game of Shuttlecock* (*Un Partie de volant*) (pl. 29), and *Nursemaids and Children in a Public Park* (*Nourrices et enfants dans un jardin public*) (pl. 26), were not only Vuillard's first commissioned works of any degree of ambitiousness, they are among those panels that still exist in a series and in the family collection.

The paintings were completed by the fall of 1892 when Paul Ranson wrote enthusiastically about them to Jan Verkade, the former Nabi who had converted to Catholicism[3] and left Paris: "Vuillard has finished the large panels for the Natansons' [Desmarais'] salon. I think all six are very good. What an effort, what a task for Vuillard."[4] Ranson's letter, written in the archaizing style adopted by some members of the "brotherhood," goes on to give some interesting information about the activities and affiliations of some of the Nabi group:

> Bonnard is still very *japonard* for the *pelichtim*, very personal for the initiated: at the moment, he is finishing two decorative panels on flannel which gives them a highly original aspect. The Nabi in Tahiti [Gauguin] wrote a long letter to Kallyre Ben [Auguste] Cazalis concerning the photographs received . . . I was just visited by Mr. Prange of the Grafton Gallery in London who is inviting me to have an exhibition in England. Roger Marx has published an article on us in the *Revue Encyclopédique*. I am sending you three of the drawings reproduced. Denis has just delivered to the painter [Henri] Lerolle a very pretty little ceiling painting for the *hôtel* of this academic dauber . . . Very good your little icons from [Le Barc de] Boutteville gallery. His exhibition hasn't opened yet.[5]

From the events cited, the letter must have been written in October or November, between the publication of Roger Marx's article, "Mouvement des arts décoratifs," for the October issue of *Revue Encyclopédique*[6] and the opening of the third annual exhibition of "Impressionnistes et Synthétistes" at Le

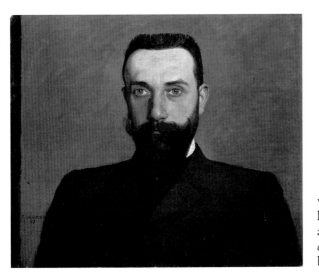

19 (facing page) Detail of pl. 29.

20 Félix Vallotton, *Stéphane Natanson*, 1897, oil on canvas, 46 × 55 cm., National Gallery of Canada, Ottawa.

Barc de Boutteville's gallery that December. Illustrated in Marx's article were works by Vuillard, Bonnard, Roussel, and others, and he linked these younger artists to Gauguin and Odilon Redon, both of whom worked in a variety of media and were considered part of the move to make art at once expressive and decorative.[7] Ranson's comments make clear that by 1892, at least, some of the Nabis had been successful in finding an audience, if not commissions, for their work. Having mentioned Vuillard's work, Ranson then cited two of Bonnard's four panels for his series *Women in a Garden (Femmes dans un jardin)* (pl. 14), which he would exhibit at the December exhibition of Le Barc de Boutteville. His casual reference to Gauguin's correspondence with Cazalis may have been made for Verkade's benefit, for although the Nabis maintained a certain reverence for the "Nabi en mission" and had made a joint purchase of a Brittany painting by him at his auction in February 1891, they had had little contact with the artist after he had left for his self-imposed exile on Tahiti in that year.[8] Finally, having touched on the international recognition that was now being given to his own work, Ranson concluded with a mention of Denis's first commissioned decorative project for a ceiling painting, *The Ladder among the Leaves (L'Echelle dans le feuillage)* (pl. 21), made for the highly successful but uninspired painter, Henri Lerolle. A relative by marriage to the composer Ernest Chausson and to Arthur Fontaine, the Ministre de Travail, Lerolle would be for Denis what Thadée

Natanson was for Vuillard, insofar as he encouraged his art and introduced him to many of his future patrons. His private mansion on the avenue Duquesne was an important headquarter for intellectual Catholics. This society, affiliated with the periodicals *L'Ermitage* and later *L'Occident*, espoused symbolist ideas in literature, art, and music that were, ideologically, conservative and Catholic.[9] Beginning with the Lerolle commission, Denis would be received into this well-to-do, staunchly conservative, and old-family milieu. By contrast, Vuillard's earliest supporters were the Jewish-born, naturalized-French Natansons – and other predominantly Jewish art historians and collectors, including Roger Marx, Arsène Alexandre, Romain Coolus, and later the Bernheims and Hessels.[10]

Despite Ranson's reference to Vuillard's work being for the Natansons, the actual owner of the panels, Stéphane's brother-in-law Paul Boutheröue Desmarais, had little in common with his relatives and was not connected with the *Revue Blanche* enterprise. Native Parisians, the Desmarais were industrialists involved with the refinement and processing of mineral and vegetable oils. When Paul's father died in 1888, Mme Desmarais established herself as Chairman of the Board and named her sons Paul and Lucien as partners in the new association (*société*) of "Desmarais Frères."[11] Three years later, at twenty-eight, Paul became a full stockholder in the firm.[12] By then, he was already married to Léonie Natanson and considered an expert in the growing field of petroleum-oil refining.[13] Léonie's family, however, was not so pleased with her choice of partner and, in fact, according to one member, was horrified to hear that she had married a man of industry, which was considered tantamount to marrying a cultural illiterate.[14] The evidence supporting the family's abstract judgments on taste and culture remains nebulous at best. While Léonie may have been more culturally informed than her husband, an anecdote recounted by Thadée's wife, Misia, about Mme Desmarais's refusal to lend Misia the money to buy Renoir's painting *The Luncheon* from the artist's retrospective exhibition in 1894, suggests that Mme Demarais's artistic preferences did not include the dominant vanguard of impressionism.[15] However, the fact that the Desmarais had commissioned an inexperienced architect to build their house and an artist relatively unknown outside the Nabi circle to provide decorations, indicates that they were not impervious to all advanced art. In fact, Paul Desmarais may have been following in the tradition of some nineteenth-century industrialists for encouraging new art, such as the Barbizon school of painters and later the impressionist group.[16] Indeed, it was to this group of men with new money and developing tastes that Denis appealed in February 1892 when he pleaded for enlightened consumers who would support the new art form associated with *décoration*: "Where is the industrialist who would wish to be associated with

21 Maurice Denis, *The Ladder among the Leaves* (*L'Echelle dans le feuillage*), 1892, oil on canvas *marouflé* to wood panel, 226 × 169 cm., Donation de la Famille Denis, Le Musée départemental de Prieuré, Saint-Germain-en-Laye.

these decorators, to take up some of the time they spend making too many paintings?"[17] While details about the genesis of the Desmarais commission are few, it is possible that Paul Desmarais accepted his brother-in-law's endorsement of a modern artist not only to please his in-laws but to prove to them that his tastes were less crude than they suspected. It is also possible that he viewed Vuillard, an artist whose name was just beginning to appear in the major press, as a financial as well as social investment.[18]

The Panels

For the Desmarais commission, Vuillard painted a series of long, horizontal vignettes, paired by subject and framing devices, showing women in country houses, city workshops, and public parks. In *Stroking the Dog* (pl. 24) and *Gardening* (pl. 27), for example, the summery scenes of slender young women in loose-fitting dresses are linked by the tiles of the courtyard. In the panels showing the dressmaking studio, a florid and patterned wallpaper ties together the colorful frieze of young women involved with the activities of dressmaking or fitting. A small child seen at one end of each pushes into (pl. 28) or out of (pl. 25) the doorway to the room. The third pair is more loosely linked and shows nursemaids and children clustered around a park bench (pl. 26), and smartly dressed Parisians playing shuttlecock on a lawn (pl. 29). Unlike the larger-scale decorative projects he would do in the following years using the glue-based tempera technique (*à la colle*) that dried mat and adhered to rather than was absorbed into the canvas, Vuillard used a mixture of thinly applied oils and heavy impasto to create the rich surface effects seen especially in the panels with seamstresses and courtyards.

Why were Vuillard's six panels so appealing to the industrialist and his wife? Although they were his first commissioned decorative projects, the panels themselves have received little historical attention. Achille Segard, in his otherwise thorough history of the decorative projects, lists them only in a footnote as "overdoors for Mme Desmarais."[19] Indeed, by 1946 the panels were considered lost, causing Claude Roger-Marx (the son of the Beaux-Arts administrator and Vuillard's earliest biographer) to complain: "What has become of the six panels [*trumeaux*] and screen Vuillard created for Mme Desmarais in 1892? We have lost knowledge of them except for an article in *Le Voltaire* and the fairly finished oil studies that the artist has kept for himself."[20] The oil studies mentioned exist in nearly complete stages and are referred to by Vuillard in his summary of events for the winter of 1892 as the "pochades et dessins" for the final "dessus de porte Desmarais."[21] They are important in what they reveal about Vuillard's working methods for the commissioned projects which were always the result of elaborate preparatory works. The pair of studies, *Stroking the Dog* and *Gardening* (pls. 24, 27), for example, are sketchlike and on a scale of about one fourth the size of the final versions. Yet a study for *Dressmaking Studio I* (pl. 23) is so close in scale, palette, and composition to the original that it may be considered a variant, possibly made for another collector.

22 Edouard Vuillard, study for *Stroking the Dog*, 1892, oil on canvas, 11.4 × 25.4 cm., formerly A. Tooth and Sons, London.

24 (following page, top) Edouard Vuillard, *Stroking the Dog* (*La Caresse du chien*), 1892, oil on canvas, 48.5 × 170 cm., Desmarais Collection, Paris.

25 (following page, center) Edouard Vuillard, *The Dressmaking Studio, I* (*Un Atelier de couture, I*), 1892, oil on canvas, 48.5 × 117 cm., Desmarais Collection, Paris.

26 (following page, bottom) Edouard Vuillard, *Nursemaids and Children in a Public Park*, (*Nourrices et enfants dans un jardin public*), 1892, oil on canvas, 48.5 × 117 cm., Desmarais Collection, Paris.

23 Edouard Vuillard, study for *The Dressmaking Studio, I*, *c.*1892, oil on canvas, 46.4 × 115.6 cm., private collection.

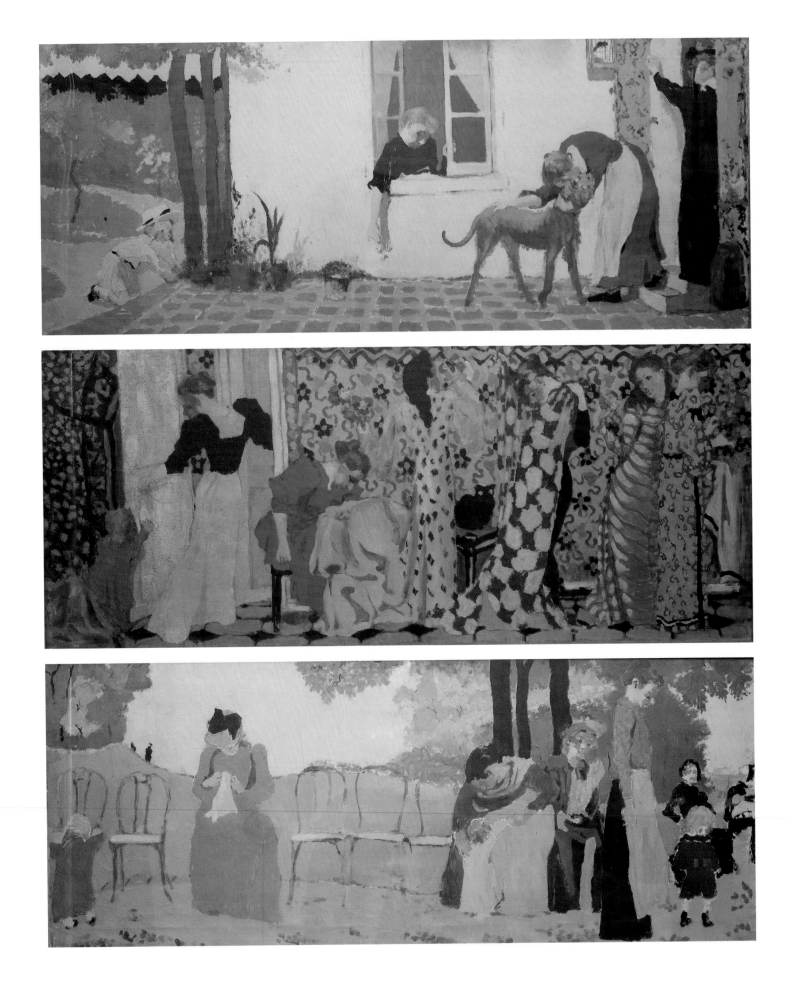

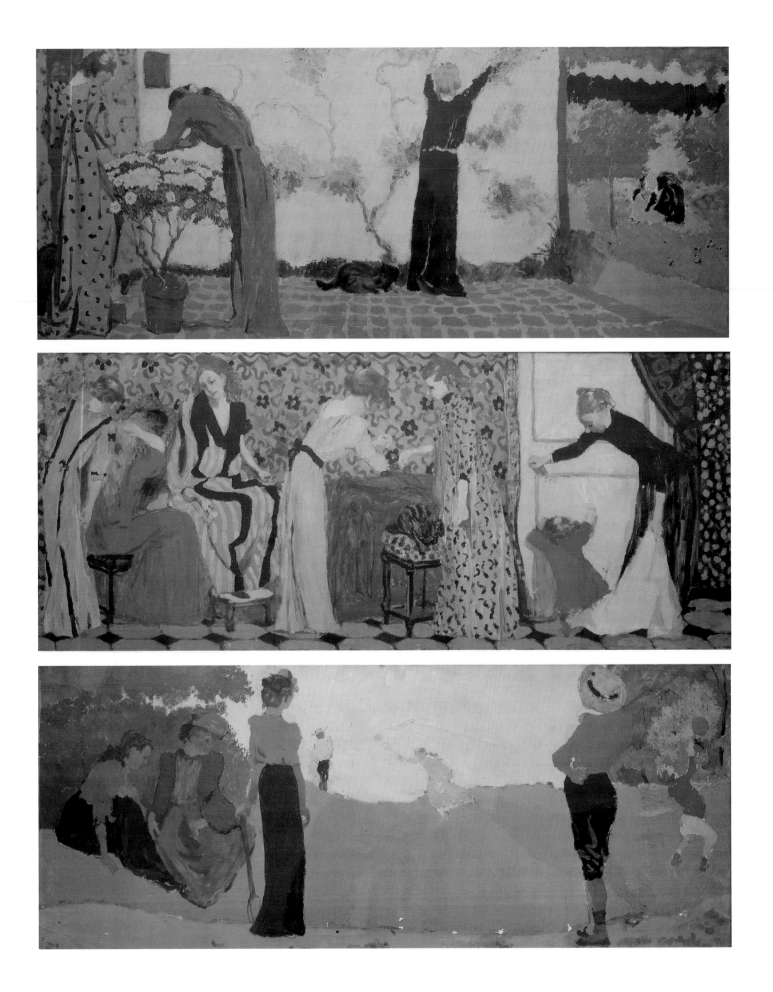

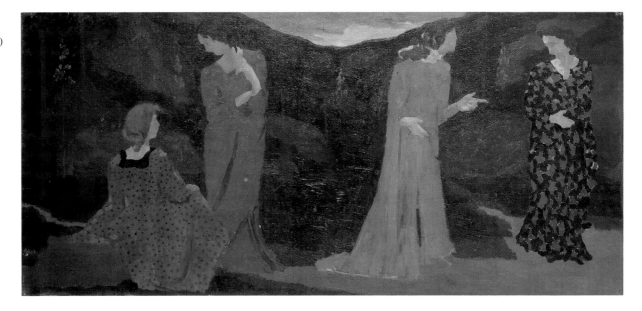

30　Ker-Xavier Roussel, *Seasons of Life* (*Saisons de la vie*), *c*.1892, oil on canvas, 60 × 130 cm., Josefowitz Collection.

The idea of painting figures parallel to the picture plane on a shallow ledge may have derived from Vuillard's participation as a set designer for the puppet-show performances during that spring of Maeterlinck's *Les Sept princesses* and *La Farce du pâte et de la tarte* (a medieval play transcribed by Ranson into modern French) at the home of the Conseiller d'Etat, François Coulon.[22] Vuillard's own caricatures of the theatre world such as *Actors on Stage at the Théâtre Libre*, *c*.1890–1 also used this format (as opposed to traditional formats for easel painting) to emphasize his decorative concerns.[23] In contrast to painted works by his Nabi colleagues at that time, however, Vuillard's execution, palette, and motifs were decidedly unconventional and personal.

The Terrace Scenes

In the first pair of panels for the Desmarais project, *Stroking the Dog* (pl. 24) and *Gardening* (pl. 27), young women are seen on a patio or terrace setting which unites one panel to the other. The scalloped edge in both is another decorative device that con-

27 (preceding page, top) Edouard Vuillard, *Gardening* (*Le Jardinage*), 1892, oil on canvas, 48.5 × 170 cm., Desmarais Collection, Paris.

28 (preceding page, center) Edouard Vuillard, *The Dressmaking Studio, II* (*Un Atelier de couture, II*) 1892, oil on canvas, 48.5 × 117 cm., Desmarais Collection, Paris.

29 (preceding page, bottom) Edouard Vuillard, *A Game of Shuttlecock* (*Une Partie de volant*), 1892, oil on canvas, 48.5 × 117 cm., Desmarais Collection, Paris.

31　Ker-Xavier Roussel, *Conversation in a Garden* (*Conversation dans un jardin*), *c*.1892, oil on canvas, 60 × 130 cm., Josefowitz Collection.

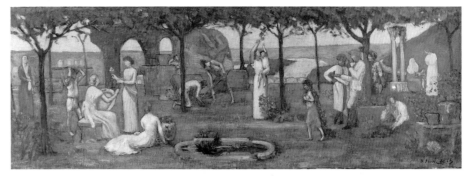

nects them. The varying heights of Vuillard's figures shown in frozen movement across the courtyard space may have been borrowed from his fellow artist Roussel, whose apparently undestined rectangular panels *Seasons of Life* (*Saisons de la vie*) and unfinished *Conversation in a Garden* (*Conversation dans un jardin*) (pls. 30, 31), featured young women in flowing gowns in a garden courtyard.[24] Both artists acknowledged the classicizing and static females of Puvis de Chavannes and may have been familiar with the older artist's oil study, *Inter artes et natura*, which had been exhibited in 1890 and showed similar, frieze-like compositions of women in semi-contemporary, semi-antique garb (pl. 32).[25] Contemporary fashion plates showing women segregated from the masculine world and going about feminine tasks while showing off the latest styles, might also have inspired Vuillard's decorative frieze of females, although Vuillard's figure types, with their awkward poses and gestures, represent more whimsical variants on the conventional poses that were typical of both fashion plates and fashionable figure paintings.[26]

In Vuillard's decorative pendants, moreover, the women represent different social registers. The girl stroking the dog wears an apron as a symbol of her servant class, in contrast to the two young women who bend over the potted plant. The woman on the far left is attired in a full gown with a deep back pleat, possibly derived from Denis's designs for medievalizing costumes for the same puppet-theater production of *Les Sept princesses*.[27] It is possible, too, that Vuillard was thinking of Watteau's painting *Gathering in a Park* (*Réunion dans un parc*) (pl. 33), and especially of the woman seen from behind and on the left, for the delicate gestures and the clothes of the elegant standing figure seen from behind in the *Gardening* panel.[28] Watteau's painting was part of the La Caze collection of eighteenth-century paintings at the Louvre which included works by Boucher and Chardin, among other masters that Vuillard was known to have admired.[29] The dresses and coiffures with blossoms (perhaps plucked from the chrysanthemum plant) worn by Vuillard's *élégantes* might also be allusions to the late nineteenth-century revival of the quattrocentro feminine ideal (among the Pre-Raphaelites in England and later the French symbolists) manifested in the fashion of the "tea gown" or *robe d'intérieur* complemented with flowers held or worn.[30] These details provide a subtle class distinction between the young women and their more plainly dressed and coiffed companions. Interestingly, in the oil sketch, Vuillard included an older woman whose heavier figure and black dress resemble Vuillard's shorthand representations of his mother. Her presence adds another possible interpretation for the scene – of a mother, daughters, and maids, and thus of youth and old age contrasted – absent in the final panels where the reason for the different types of females is not apparent. The bour-

geois status of the scene is implied by the presence of at least one servant in *Stroking the Dog*, by the well-dressed toddler sporting a ribboned *canotier* who enters from the garden at the left, and by the manicured lawn and stucco courtyard of a *villégiature* or bourgeois summer residence.

The Dressmaking Panels

In the second set of panels, surface, pattern, and texture vie with one another as women and children animate the already busily patterned scene within the dressmaking studio. The rich backdrop of dull salmon, olives, mud browns, and ochers is applied with the same vermicelli-like brushstrokes used in the brighter carmines, flame reds, jet blacks, opaline whites, delicate greens, pinks, and cinnamons of the women's gowns and dusters. If the courtyard scenes were an *andante* in the style of Puvis de Chavannes, the workshop scenes are a *vivace* with a helter-skelter composition of patterns and figures punctuated by the staccatos of workshop stools and the child in

32 Pierre Puvis de Chavannes, *Les Bienfaits de la Paix* (*Inter Arts et Natura*), 1891, oil on canvas, 64.8 × 171.4 cm., National Gallery of Canada, Ottawa.

34 (following page) Detail of pl. 27.

35 (page 27) Detail of pl. 28.

33 Jean-Antoine Watteau, *Gathering in a Park* (*Réunion dans un parc*), 1717–18, oil on canvas, 32 × 46 cm., Lacaze Collection, Musée national du Louvre, Paris.

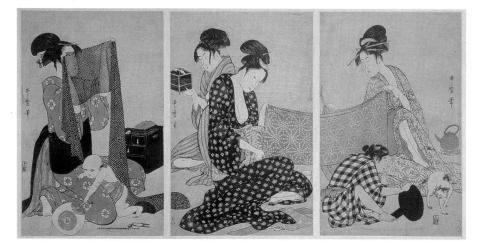

seamstresses whose curving and graceful figures seem directly related to the arabesques of the nascent art-nouveau style and its sources in the patterns of oriental porcelains and tapestries.[34] While Vuillard's seamstresses share certain attributes with the symbolists' ideal child-woman, they are a different breed

36 (above) Utamaro, *Girls Preparing Stuff for Dresses*, triptych, *c*.1794–6, woodcut print, The British Museum, London.

37 (below) Pierre Bonnard, *The Dressing Gown (Le Peignoir)*, *c*.1892, oil on fabric, 150 × 50 cm., Musée d'Orsay, Paris.

red who pushes her way into the feminine foyer in each of the interiors. These pictures of women who move gracefully about their rituals of measuring and folding cloth, and trying on the final products, are similar to a number of Vuillard's early oil paintings showing actresses in their *loge* (changing-room) in the act of dressing or being dressed. Their relaxed yet elegant gestures relate them as well to the models seen in Japanese Ukiyo-e woodcuts such as Utamaro's *Girls Preparing Stuff for Dresses* (pl. 36). Likewise, the artificial (unrealistic) chromatic range and overlapping of figures and patterned ground could have been inspired by Japanese prints, which Vuillard would have known either from the important exhibition at the Ecole des Beaux-Arts in 1890, or from Samuel Bing's Japanese art gallery and luxury publication, *Le Japon Artistique*.[31]

As shown, the theme of seamstresses appeared early in Vuillard's *oeuvre* as a means of exploiting mystery in the familiar. In addition to the paintings and drawings on this theme exhibited in the gallery at the *Revue Blanche* offices at the end of 1891, the subject of dressmaking and the seamstress dominated his entries to the second exhibition at the Barc de Bouteville gallery the following spring. Reviewing this exhibition for the *Revue Encyclopédique* in April 1892, Albert Aurier admired these women bent over their work in gaslit interiors, seeing them as possessing "the charm of the unexpected," and expressing "the bittersweet emotions of life and the tenderness of intimacy."[32] Vuillard's wash drawing, *Sewing (La Couture)*, which Aurier used to illustrate the article, shows a duo of females in a radically abstract composition (pl. 38). In contrast, the Desmarais panels represent a new concern for decorative coloration and pattern. They have little of the ritualistic and symbolist underpinnings seen in his lithographs and easel paintings of seamstresses, such as *The Seamstress (La Couturière)* or *Seamstresses by Lamplight (Les Couturières sous la lampe)* (pl. 39), possibly exhibited at the third Le Barc de Boutteville showing in November–December 1892.[33] Instead, Vuillard concentrated on the ornamental patternings of these

from Denis's pale, willowy maidens, with "gliding footsteps, slow gestures, bodies bent like lilies, wafts of incense,"[35] or the *femme fatale* of the Rose + Croix artists led by the Sar Peladan, whose exhibition at the Durand-Ruel galleries that spring had coincided with the Nabis' own at the Le Barc de Boutteville gallery.[36] The closest prototype for their undulating forms can be found in Bonnard's *parisiennes*, such as those

represented in *The Woman with a Rabbit* (*La Femme au lapin*) and *The Dressing Gown* (*Le Peignoir*) (pl. 37).

As in the scenes of women on the patio, the *atelier* or workshop contains both workers and non-workers. For these panels Vuillard turned from the country-leisure to the urban-labor environment of his mother's first-floor studio in the family apartment. As has been recently pointed out, although Vuillard's mother was registered in the professional directory as a *corsetier*, she was also a dressmaker (*couturière*).[37] The private or household *atelier* was a holdover from the traditional dressmaking trade that had preceded the invasion of ready-made clothing (*confections*) produced by factories and distributed through the *grands magasins*. Unlike in England, however, which had a female work force in factories as early as the 1850s, the garment-making industry in France was mechanized only in the 1880s. Even then, the majority of women preferred to continue in employment that extended their domestic work rather than to enter the factory. Like domestic service, work in the private workshop offered a substitute home and a more personalized environment, and this allowed it to continue to operate successfully in spite of the encroachment of mass (factory) production.[38] Mme Vuillard's family's longstanding business in textile manufacturing and her own thirty years of experience in the field would have given her an advantage over the small neighborhood *atelier*, helping to keep her workshop economically competitive with the *grands magasins*.[39]

Vuillard, too, benefited from his mother's enterprise and from the years spent in casual spectatorship of the cutting, sewing, measuring, and fitting of handmade garments. For his decorative pendants he transformed the reality of the studio into a lively arena where seamstresses are indistinguishable from their clients. The *ouvrière-patron*, or working employer, Mme Vuillard, is significantly absent from the clusters of relatively young females who make up the producers and consumers within this cottage industry. In her actual *atelier*, by 1842 at 346 rue Saint-Honoré, Mme Vuillard employed two females in addition to her daughter Marie.[40] While these girls are often recognizable in Vuillard's smaller oil paintings from 1892 to 1895, and the lithographs on the dressmaking theme datable to 1895–6,[41] in the decorative panels, Vuillard multiplied and embellished the female figures with brightly patterned dresses and stuffs, as if to mask the distinction between the employees and their upper-class clients with sufficient time and money to afford customized wardrobes. The working girls are apronless and their clients, hatless. In comparison with his smaller works on the theme which often showed his sister or an employee bent over her work, the only woman who reads definitively as "employee" in these panels is the woman leaning over her mending in *Studio I*.[42] Otherwise, one can only surmise from the gestures and poses the servers and the served. The long-haired

40 Detail of pl. 25.

42 Edouard Vuillard, *Seamstresses at the Sewing Cabinet (Ouvrières au chiffonnier)*, c.1892, oil on canvas, 48 × 36 cm., private collection.

woman standing to the right of the seated seamstress in the same panel, for example, may be a client admiring herself and her recent sartorial acquisition in a mirror. Adjacent to her, another woman (client?) holds a dress up for size. At her right a woman (client?) in a pinwheel-striped dress looks back on the scene, ignoring the young woman (seamstress?) next to her who takes fabric from the drawer of a chest. The chest reappears in the center of the second panel (pl. 25) separating the seamstress who bends over in search of a button or bobbin, and the woman (client?) in the tiger-print dress who observes her struggle. To their left, a trio of women are involved in their toilette. The leftmost figure (seamstress?) assists a seated figure (client?) with her coiffure, while another woman wearing a striped housedress may be awaiting her turn to try on the finished garment.

Vuillard was fascinated with the small-business activities under his roof, and he was a tireless observer, looking out for possible subjects in his daily life to be used in his work. On 7 September 1892, he remarked that he had everything he needed to develop and to "put into use all that I have in my notebooks and boxes [of drawings]."[43] The accompanying sketch (pl. 41), dated 25 August 1892, shows a child reaching up at a woman in a window with a flowerpot, a vignette similar to the scene in *Stroking the Dog*. It is tempting to read in this sketch the initial thoughts for some of the motifs that are repeated and embellished in the final *décorations*. The child (a little girl or little boy, since at that time it was customary for boys to wear long hair and dresses) reappears in each of the dressmaking panels as a

38 (page 28, top right) Edouard Vuillard, *La Couture*, wash drawing exhibited in the second exhibition of impressionists and symbolists at the Le Barc de Boutteville gallery (spring 1892), *Revue Encyclopédique* (April 1892), p. 485.

39 (page 28, bottom right) Edouard Vuillard, *Seamstresses by Lamplight (Couturières sous la lampe)*, 1892, oil on canvas *marouflé* to wood panel, 31.5 × 40 cm., Musée de l'Annonciade, Saint-Tropez.

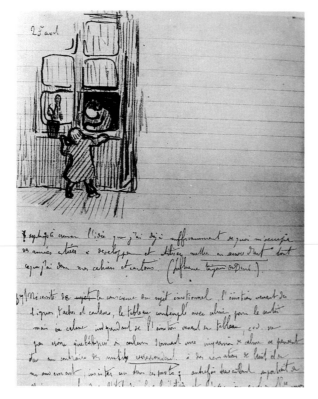

41 Page from Vuillard's journal, 25 August, c.1893, Bibliothèque de l'Institut de France, Paris.

framing device or closure of the scene. His or her presence also emphasizes the difference between the household *atelier*, where children might be allowed, and the mechanized realm of the manufacturing plant.[44] The fact that the same child reappears in a small easel painting (pl. 42), where one has a glimpse into the dressmaker's studio from a hallway similar to that of the Desmarais panels, suggests, as does the simple attire, that the child belongs to one of the workers (which is unusual, given that the majority of seamstresses were unmarried and childless[45]) and is a frequent visitor to the studio.

Vuillard would certainly have been aware of his mother's position of "servility and servitude" as a *corsetier* for a wealthier social group, despite her ownership of the business.[46] And yet in these panels, Vuillard offers no moralizing statement on the social or professional status of the *métier*. Unlike the seamstresses and working-class girls described by naturalist painters and novelists, he did not portray working women in the same moralistic light. Indeed, in comparison with Signac's nearly contemporary picture *The Finishers (Les Apprêteuses)* (E. Buhrle Collection, Zürich), in which even the colorful *facture* or surface texture painted in the divisionist technique does not soften the reality of the working seamstresses, Vuillard makes his subjects "decorative" and their work activity laborless and painless.[47]

Public Gardens and Leisure

In the last set of decorative panels from the 1892 commission, Vuillard moved away from his observ-

30

ation perch in the dressmaking studio to the open-air environment of the public park. In what are arguably the least "decorative" of the six panels, in terms of their simplified forms and duller colorations, young ladies and a gentleman watch children playing in a public garden in *A Game of Shuttlecock* (pl. 29),[48] and young governesses or nursemaids watch over their tiny charges in *Nurses and Children in a Public Park* (pl. 26). For both, smaller, vigorously painted oil-on-panel studies exist (pls. 43, 44). These are much more vibrantly colored and are closer in style to the animated seamstresses panels than the reductive, cloisonnist, and nearly monochromatic panels of the final version. The tempo in this third pair is *adagio*, with long stretches of green and white broken by the seated nursemaids in the one and the elegant spectators in the other. In both panels, the setting is non-specific, with the rush chairs that were to be found in nearly all the Parisian parks and that were rented out by *concessionnaires* to nursemaids and retired gentlemen.[49] Although the Vuillards lived near the Tuileries gardens, the panels show a less crowded city park with undulating lawns and wide paths, similar to those found in the newer Parc Monceau, near the Desmarais' first residence on the rue de Lisbonne, or in the Bois de Boulogne at the western edge of Paris.

In the late nineteenth century, "sports," as described by etymologist Emile Littré, were the English equivalent for "les exercises en plein air," and were still a luxury activity adopted mainly by the leisured class.[50] Certainly, the fashionable woman wearing a stylish hat and leaning on a racket is a representative of that set. Her slimmer skirtline alludes to the transition in fashion from the flounced bustle of the 1880s to the inverted lily-shaped skirts with tailored jackets of the 1890s that signaled a new freedom for women and their increased participation in sports. Her partner wears the knickerbockers that were also a recent fashion derived from the recreational outfits required for bicycling, a sport particular to the wealthier classes in the 1890s.[51] Watching the game and seated by the shrubs are two females, perhaps chaperones or domestics whose Sunday finery imitates that of their economic superiors. Vuillard's light-hearted scene can be contrasted to Bonnard's decorative, large-scale painting *The Game of Croquet* (*La Partie de croquet*) (pl. 45), exhibited at the Salon des Indépendants that year. In this large canvas (the largest of Bonnard's works to date, although not a commissioned decoration), a patchwork of patterns represents the Bonnard family property at Grand Lemps from which the recognizable figures of Bonnard's father, brother-in-law, and sister emerge. Though similar in subject and mood, Vuillard's narrow horizontal panel of anonymous park-goers is painted with a restrained palette of greens, reds, ochers, and grays applied with heavy, broad brushstrokes. By the simplest means, Vuillard created a rich caricature of the self-consciously proper leisure set, intended,

perhaps, as a witty dig at the burgeoning French sports ethic.[52]

In the pendant panel, *Nursemaids and Children*, an older woman sits absorbed in her crochet or knitting. Differentiated from her companions by attire and age, she is a specific type frequently caricatured in drawings and novelettes in the late nineteenth century[53] and will show up again in Vuillard's more familiar series known collectively as *The Public Gardens*. In the Desmarais panel, she sits to one side of the nursemaids, the young *gouvernantes d'enfants* for wealthy families sometimes referred to as "misses" and "fräuleins," since they were often from the Alsace or Gascogne regions. As a social type, they were part

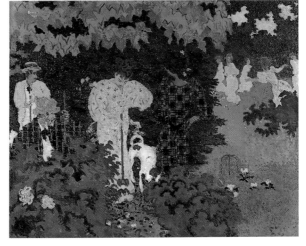

43 (top) Edouard Vuillard, study for *A Game of Shuttlecock*, 1892, oil on canvas, 11.4 × 25.4 cm., formerly A. Tooth and Sons, London.

44 *Study for Nursemaids and Children in a Public Park*, 1892, oil on board, 26.7 × 66 cm.

46 (following page) Detail of pl. 29.

47 (page 33) Detail of pl. 26.

45 Pierre Bonnard, *Sunset* or *The Game of Croquet* (*Crépuscule* ou *La Partie du croquet*), 1892, oil on canvas, 130 × 162 cm., Musée d'Orsay, Paris.

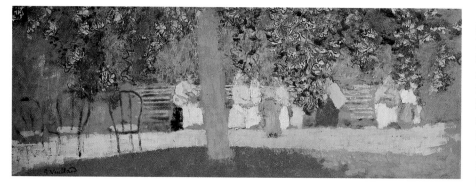

48 Edouard Vuillard,
*Nursemaids in the place
Vintimille*, c.1893, oil on
board, 22.3 × 57.5 cm.,
Galerie Schmit, Paris.

50 (below right) Edouard
Vuillard, *The Dressmakers*
(*Les Couturières*), 1893–4,
mixed media on cardboard,
35.6 × 58.4 cm., formerly
Marlborough Galleries,
London.

49 (below) Edouard
Vuillard, *The Cat (Le Chat)*.
Fifth panel of the Desmarais
screen, *The Dressmakers*,
1892, 68.5 × 37 cm., location
unknown.

of the household and, thus, less threatening than the shop employees and seamstresses traditionally associated in the popular literature with looser morals and conduct.[54] Just as he studied the seamstresses at home, so Vuillard observed these female social types on his many strolls through the Tuileries, the square de la Trinité, and other parks, noting their physiognomy in words and images that can be found in sketchbooks and random journal entries from the period 1893 to 1894.[55] Another painting, of approximately half the size of the Desmarais panel, entitled *Nursemaids, The Square Vintimille* (*Nourrices, square Vintimille*) when it was exhibited in 1938 (pl. 48), represents the same world of garden chairs, seated figures, and children as does the Desmarais panel and may have been the *plein-air* study.[56] In this smaller work, Vuillard shows a greater concern for incorporating into his color scheme the decorative patterns of sunshine and shade that would be so important later for the larger *Public Gardens* series for Alexandre Natanson.[57]

The Screen of Les Couturières, *1893*

Soon after Vuillard had completed the panels, the Desmarais commissioned a decorative five-panel screen (pls. 49, 51). For this project – his first experiment in the genre – he reused the theme of the dressmaking studio, perhaps to enable the screen to integrate with and complement the earlier panels, which would be in the same room. The screen, however, presents a more narrative and genre-like subject which has more in common with Vuillard's easel paintings of that period, such as *The Dressmakers* (pl. 50). Screens, in general, were recommended throughout the Third Republic as charming decorative devices and room dividers, and by the end of the century screens – oriental, exotic, or historical – were a standard feature in the interiors of persons of discriminating tastes.[58] For the Nabis in general, painted screens, combining the art of painting with a decorative function, had always been a popular item. Bonnard and Sérusier had both exhibited screens in the Salon des Indépendants of 1893 as undestined projects "for sale" along with their easel paintings.

With the exception of the quickly executed and forgotten sets for the Théâtre Libre and, after 1893, Lugné-Poe's Théatre de l'Oeuvre, Vuillard's screen for the Desmarais family can be considered his first monumental *décoration* using the more difficult and time-consuming process of *à la colle*.[59] Nevertheless, it was never exhibited in Vuillard's lifetime and remains a relatively unknown masterpiece. Part of the cause for its comparative obscurity is the fact that, by the middle of the twentieth century, the screen had been dismantled, detached from its frame, and sold as separate panels.[60] The original wood framework for the five panels, known only by an early photograph (pl. 52), followed the conventional altarpiece divisions of overhead panels and predella. In comparison to Sérusier's triptych of Breton girls painted that year in a traditional half-arch format (pl. 54), Vuillard's tripartite divisions for each panel and varying panel heights seem particularly audacious, despite the many experiments within this genre among other artists involved with the expanding aesthetic movement in France at this time. Perhaps, as has been suggested, the artist's unusual framing choice was inspired by the early Flemish polyptychs he saw on the trip that he took to Belgium with Roussel at the end of 1892.[61] Another more tenuous, but tempting, explanation is that Vuillard knew of the compartmentalized decorative framework in Whistler's "Peacock Room," created for the collector Frederic Leyland, which was fully illustrated and described in a memorial article published in the London-based *Art Journal* in the spring of 1892 (pl. 55).[62]

Vuillard divided his screen into five distinct panels, linked together by the sharp recession of the orange-and-yellow floor tiles. A simple paper reconstruction of the screen shows how Vuillard cleverly used the perspective to give the illusion of spatial recession even when the panels are folded.[63] Rather than painting them as a flat surface, as Bonnard probably did for his four-panel series *Women in a Garden* (pl. 14), Vuillard seems to have considered a variety of possible folding positions for these panels. Pastel studies of two other screens, similarly composed of panels of unequal height and of themes drawn from the original six-panel series, may have been proposed

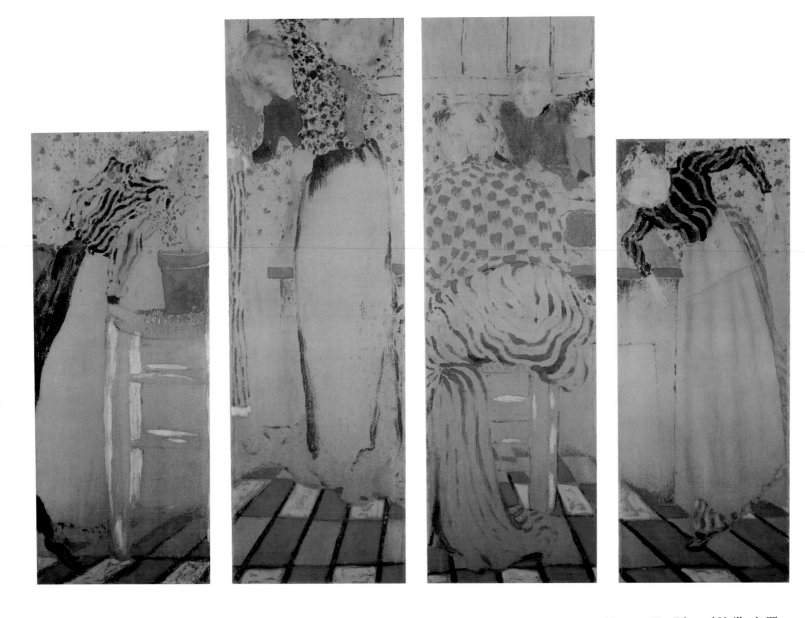

but not accepted by the artist or patron for the screen project. In one, a young female servant or nurse-maid, similar to the woman wearing the apron in *Stroking the Dog*, plays ball with a young child in a garden setting. The fashionable women strolling off at the far left side recall the women at the chrysanthemum plant in the panel *Gardening*. In another study, a dressmaker kneels to adjust the sleeve of her customer's patterned gown (pl. 53) and, by that action, is accommodated within the shorter panel, in the same manner as one sees in the final dressmaking screen.[64]

Unlike the earlier decorative panels painted in oil, Vuillard used very little pigment for the screen and limited his palette to grays and oranges, with only a few streaks of blacks and specks of reds heightened with white gouache on the buff-colored linen that is allowed to show throughout. The figures in four of the five panels bend over, reach up, or sit, as if to adjust themselves to their vertical compartments. In

the fifth and smallest panel (pl. 49), a cat, seated by a high stool with a ball of yarn, recalls Manet's water-colored, etched, and lithographed feline images,[65] which were probably inspired by Ukiyo-e prints. Vuillard drew a similar vignette of a cat atop a table in his journal that summer with the question: "Why is it always in familiar places that one's spirit and sensibility find the greatest degree of novelty? Novelty is always necessary to life, to consciousness." A little later in the same journal entry he noted: "But in places that are unfamiliar, the distraction is much more dangerous," as if to remind himself of the need to work from observed and familiar subjects rather than from invented and exotic ones.[66]

For the Desmarais screen, Vuillard returned to the subject of the private workshop environment. Contrary to the earlier series of panels, however, where the working class was only suggested inside the riotously patterned interior, the women wear aprons over plain straight skirts and work in a studio unin-

51 Edouard Vuillard, *The Dressmakers* (the Desmarais screen) (*Les Couturières*). Four panels of a five-panel screen, c.1892–3. *The Dressmaker* (*La Couturière*), 95 × 38 cm.; *The Fitting* (*L'Essayage*), 120 × 38 cm.; *The Apprentices* (*Les Petits mains*), 120 × 38 cm.; *The Lost Bobbin* (*La Bobine perdu*), 95 × 38 cm. Distemper on linen laid down on canvas, private collection.

52　The Desmarais screen,
photograph showing the five
vertical panels and five upper
panels in the original frame
(now lost). Antoine Salomon
Archives, Paris.

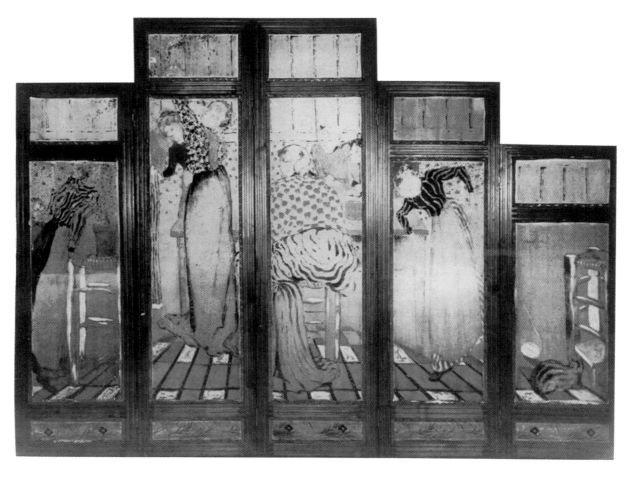

53　Edouard Vuillard,
Project for a Screen, c.1892–3,
pastel, 39.5 × 55.5 cm.,
Galerie Hopkins-Thomas,
Paris.

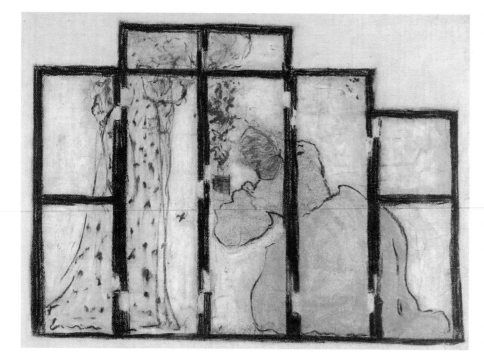

terrupted by clients. The high wooden stools figure more prominently as symbols of the work environment. Within this workspace, Vuillard introduced the broad back of his mother, who dominates the third panel, while in the panel to her right, Vuillard's sister Marie leans towards her in the same obsequious manner seen in Vuillard's many portrait–genre scenes of his mother and sister that he made between 1891 and 1893 (pl. 56).[67] Although the screen represents a working environment that Mme Desmarais would not have been familiar with, the delicate palette and arabesques of the female figures neutralize any literal reading of the scene and its association with forced-work activity resulting from economic hardship.

Installation and Reinstallation

The absence of visual records has impeded a clear picture of the original destination of the Desmarais panels. In Ranson's 1892 letter they were described as overdoors for a "chic bourgeois salon." Their only known location, however, was in the *bureau-cabinet de toilette* or combination office/dressing-room of Mme Desmarais. Most descriptive accounts repeat the information first given by Claude Roger-Marx in 1946: that the panels were executed in 1892 for the Desmarais' *hôtel privé*, built by Stéphane Natanson at 98 avenue Malakoff (since 1936, the avenue Raymond Poincaré).[68] In 1892, however, the Desmarais were living at 43 rue de Lisbonne in the Parc Monceau district.[69] The property for the elegant three-story town house that Stéphane built for them in the sixteenth *arrondissement* on the corner of the avenues

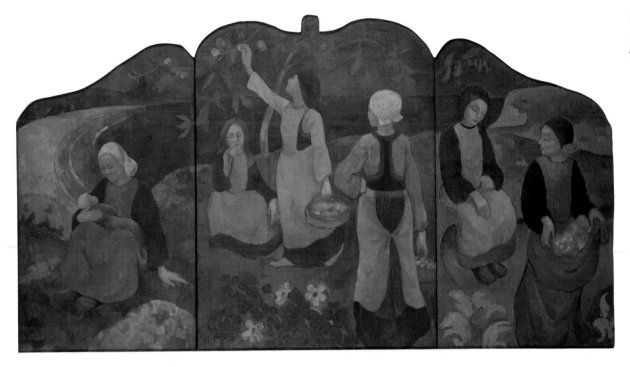

54 Paul Sérusier, *Apple Picking* (*La Cuillette de pommes*), 1891, triptych, oil on canvas.

Malakoff and Victor Hugo was not zoned until 1901, when Stéphane applied for the rights to build a *hôtel privé*."[70] Vuillard's paintings, therefore, must have been installed either at the Desmarais apartment on the rue de Lisbonne, or in their country estate near Chantilly.[71] As in the case of so many of Vuillard's early projects, the history of this commission is obscured by the limited biographical information on the Desmarais family and the lack of contemporary descriptions and photographs of the panels as they looked in, possibly, their first residence on the rue de Lisbonne (demolished in 1910) or in their second home on the avenue Malakoff (demolished in 1975).[72] When asked about the discrepancy between the 1892 dating for the panels and their installation in the *hôtel privé* built a decade later, one of the present family members has suggested that Vuillard may have completed two paintings on the theme of seamstresses by 1892–3 and finished the others at a later date, according to Stéphane's instructions.[73] Such an explanation is contradicted, however, by the fact that the six panels were ready as early as August 1892, when Roger Marx admired them, as a "series of six *trumeaux* of the freshest inspiration, and the most ornamental originality."[74]

For Stéphane, the commission to design a *hôtel* for his sister and brother-in-law was a major project – the first and last in his short career. Two years earlier, he had submitted for his senior project at the Ecole a floor plan for an *hôtel* to house "an artistic and literary circle."[75] Not surprisingly, given his familial and social connections to Bonnard, Vuillard, Roussel, and others from the Nabi group, Stéphane's description of the project recalls Sérusier's earlier dream for a "brotherhood" of artists:

55 (far left) *The Peacock Room*, line drawing of the dining-room of Frederic Leyland (at Prince's Gate, London), by James McNeil Whistler, *The Art Journal*, v. 44 (May 1892).

56 Edouard Vuillard, *Mother and Sister of the Artist*, *c.*1893, oil on canvas, 46.3 × 56.5 cm., Gift of Mrs. Saidie A. May, The Museum of Modern Art, New York.

The circle, composed of amateurs of art and artists who wish to encourage the development of fine arts through exhibitions of painting and sculpture and musical auditions, would also be a meeting place where the members could enjoy all desirable amenities and comforts.[76]

The "desired comfort" for this model club included rooms for a large reception hall (for conversation among the members), a concert hall that doubled as a theatre and gallery, library, offices, small apartments for members, hair salon, rooms for billiards and other games, as well as a gymnasium with hydrotherapeutic baths.[77] The home actually realized by Stéphane for his sister and her husband was no less splendid, and upon its completion in 1903 it was awarded the "Year's Best" in the newly formed "Facade Competition" (pl. 57). The description accompanying Stéphane's award bears reprinting here, since it tells as much about the building as it does about the architect, who died shortly after its completion:

Mr. Natanson, who had received an award for the attractive facade of his *hôtel privé*, avenue Malakoff, was an extremely talented architect. He died young, at the height of his career; he had real flair, impeccable taste, and we had great expectations for such an artist.

The facade is framed by two pavilions. It has a raised ground floor, a second floor and a third floor under the roof. At the left is a high carriage entrance. The building is entirely of freestone, including the banisters around the attic which support the roof and the two large skylights of the pavilions. The decoration is sober and adds to the total effect of elegance and harmony. It is indeed the facade of a beautiful *hôtel privé* which decorates without ostentatiousness this rich neighborhood.[78]

Indeed, when compared with other residences recently constructed in the area, such as Charles Plumet's flamboyant medievalizing-cum-art-nouveau *hôtel particulier* on the corner of the Bois de Boulogne

and avenue Malakoff, Stéphane's building seemed a model of restrained elegance.[79] Divided into the conventional public, private, and service areas, the Desmarais' three-story mansion contained three salons, two offices, and a painting gallery with Louis-Seize woodwork on the *rez-de-chaussée*. (A glimpse of the aristocratic furnishings and Savonnerie carpeting is offered in an unpublished pastel-and-gouache double portrait by Vuillard showing Mme Desmarais and her infant son, Stéphane, painted shortly after his birth in 1905; see pl. 58).[80] On the second floor were twelve rooms with bathroom facilities to serve the out-of-town guests and service crew. It was on the second floor (*premier étage*), however, that magnificence and modernity were combined. Entering from the spiral staircase, one passed into the courtyard preceding the swimming pool. Considering that it was not until 1899 that plumbing (running water to all floors) was available to the middle-class Parisian, this was a surprising innovation in turn-of-the-century Paris. The primitive state of plumbing was then, as it is now, a much discussed feature of French culture. As Miss F. Riley put it in her article of 1903 entitled "An American Home in Paris,"

It is only of late years that even the more pretentious homes in Paris would create any enthusiasm in the minds of Americans, accustomed as they are to many conveniences which are considered great luxuries in France. It is no unusual

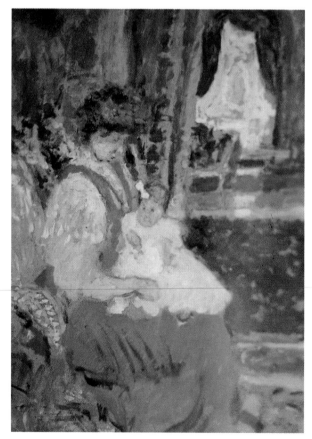

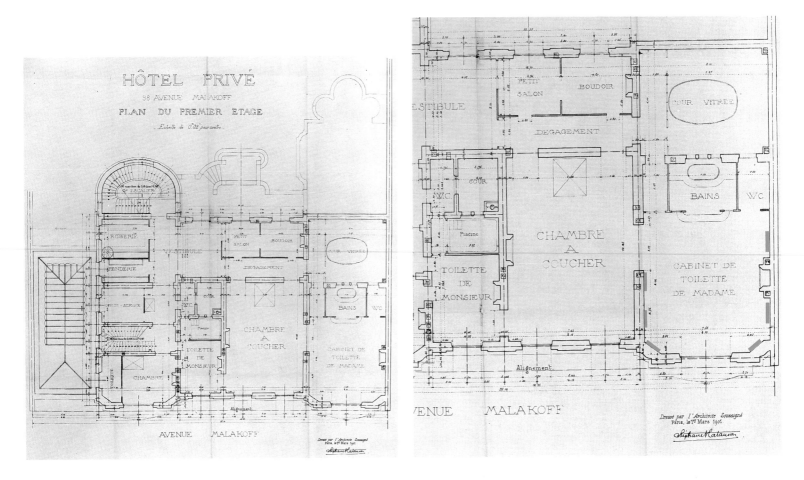

thing to see a cart with a yellow painted bath tub and a tank of hot water stop before houses in fashionable quarters.[81]

Attached to this innovative pool area which included changing-rooms and toilets, was Monsieur's bedroom and personal changing-room. On the opposite side of the floor was Mme Desmarais's domain, beginning with a *petit salon* attached to a boudoir, which opened into a large space containing the *cour vitrée*, or glassed-in courtyard (pl. 59). From these one entered the *bains*, attached to a changing-room with toilet facilities, through which one could pass to go to Madame's even larger *cabinet de toilette*, or dressing-room, where the panels are traditionally thought to have been installed (pl. 60).[82]

The *cabinet de toilette* was historically and quintessentially a French room, along with the boudoir and morning-room. As the place for all private affairs and the female equivalent of the male library or study, its optimum décor, according to Henry Havard's *L'Art dans la maison* (1887), was small and finished works of art (no sketches or unfinished paintings), "delicate miniatures, enclosed morsels, and so intricately painted that one can still be interested even when seeing them at an elbow's length."[83] The de Goncourts' influential book on eighteenth-century painting (1865 and reprinted in 1875, 1882, and 1894) had helped fuel a vogue for small, intimate boudoir pic-

tures, in the tradition of the eighteenth century's *fantaisies*.[84] While it is easy to imagine Vuillard's small-scale panels of feminine scenes as appropriate modern versions of the traditional decoration for this room, the contemporary floor plans for the Desmarais residence (pls. 59, 60) provide no indication that the panels were intended as part of the architectural design. Rosaline Bacou's study of Nabi decorative projects (1964) describes Vuillard's paintings as "fitted into the mahogany woodwork which decorated the office/dressing-room."[85] Yet if the panels were indeed fitted into the woodwork as Bacou asserted, one would expect to find corresponding dimensions in the plan to accommodate the three-feet-long panels. Until further evidence is found, one can only accept what has traditionally been ascribed as the placement for the panels and imagine them as a decorative frieze above the cornice or as overdoors within the *bureau/cabinet de toilette* with the screen of the seamstresses as an additional (and vertical) *décoration*.

The importance of the panels and the screen for the Desmarais family has been largely ignored, since there is little factual or descriptive information about their history or the people who commissioned them. In part, the scarcity of contemporary descriptions can be explained by the destination of the panels and screen within the non-public quarters of the Desmarais household.[86] The Desmarais, moreover,

59 (above left) Detail of the first floor (with glassed-in courtyard) of 98 avenue Malakoff, Archives de la Seine, Paris.

60 Detail of floor plan, first-floor dressing-room, 98 Avenue Malakoff, Archives de la Seine, Paris. The red areas indicate the probable position of the panels.

39

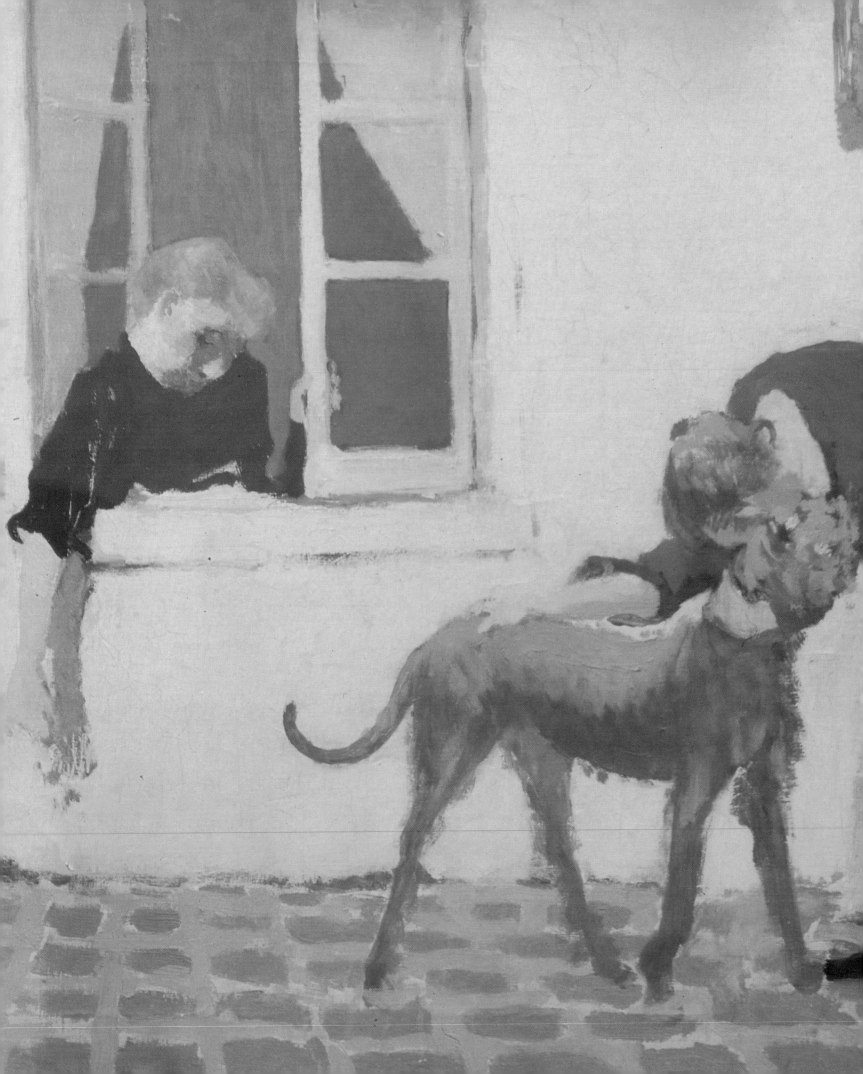

were peripheral to the circle of Vuillard and the Natansons. Stéphane alone provided the connection, and his death in 1904 seems to have broken that link. At the end of that year, one of the Natansons' friends, the playwright Romain Coolus, wrote to Alexandre Natanson's wife, Olga, "I shall greatly enjoy starting off the year with Fred [Alfred] Natanson and his wife [Marthe Mellot]. That will bring back memories, although melancholic – of old get-togethers, now scorned, of New Year's Eve at rue de la Faisanderie [where Stéphane lived with his parents]. But they were charming and cordial . . ."[87]

Though Vuillard's journals mention the Desmarais only a few times between 1907 and Vuillard's own death in 1940, their commission was important for the challenge with which it presented him. In fulfilling the commission for the panels and screens, Vuillard made his first important step towards defining a decorative style and thematic repertoire for himself. One can recall his earlier remark in his journal made in regard to his methodology (October 1890): "But why my discomfort each time I begin a series? It's important that I no longer have this concern for *originalité* . . . to *free myself* first and to rid myself of some of the most generalized ideas . . ."[88] With the Desmarais panels, he resolved this dilemma by choosing his immediate surroundings as a decorative motif and presenting in a new way scenes of contemporary urban and suburban leisure that had already been successfully exploited by the impressionists.

As an ensemble or series, the Desmarais panels and screen represent the embryonic stage of a new direction for Vuillard's art in general. The themes of the dressmakers, young women in interiors, public and domestic gardens, nannies and children would be reconsidered and developed in easel paintings and in large-scale *décorations* alike. The fact that Vuillard kept all of the oil studies in his studio until his death in 1940 suggests that he, too, realized their importance as "motifs." In these six panels, as well as in the decorative screen, the broader social meaning of the scenes has been transformed and made to conform to certain ideas about decorative painting. The panels signalled Vuillard's development of the image of woman as both ornamental and expressive – a theme that had already been popularized (by the Pre-Raphaelites, impressionists, symbolists, and society painters), and that he would continue to explore in the 1890s in a number of commissioned projects for the Natansons' circle.

Two years after the Desmarais commission, while walking through the Musée Cluny, Vuillard remembered with pleasure making a small subject into a

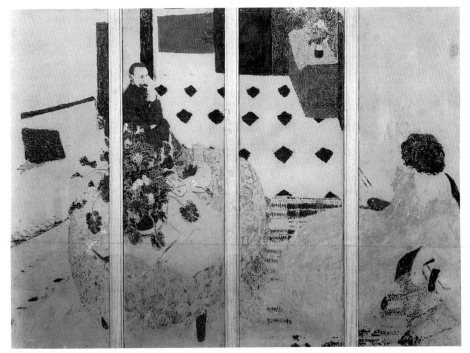

significant work of art, noting in his journal: "And Denis made this remark: how it suffices to enlarge a little drawing after Michelangelo. And recently the example of [Jean-Louis] Forain at the Café Riche, and myself with Mme Desmarais's screen. I am doing that without even thinking about it!!!!!"[89]

Coda: The Final Project for the Desmarais Family

Vuillard's last commissioned project for the Demarais family was completed a few years later (c.1896–8). The four-panel folding screen (pl. 62) was more pointedly a request at Stéphane's bidding, since it portrayed him sitting across from his brother Thadée's wife, Misia, in a simply furnished and nondescript interior.[90] The radical perspective of the tilted table and figures against the horizontal band of lozenge-shaped tiles and the confrontational poses recall the pictures of his mother and sister of the early nineties. The round table with the bouquet of flowers spreading wildy out in all directions, however, mirrors that found in the five-panel series that he completed for Thadée and Misia in 1895. Likewise, the portrait-like figures are also prototypes for a modern genre painting which, as will be seen, would become a more important element of Vuillard's decorative *oeuvre* after 1897.

62 Edouard Vuillard, four-panel screen showing Stéphane Natanson and Misia, distemper on canvas (remounted as a wall painting), 120 × 170 cm., private collection, London.

61 Detail of pl. 24.

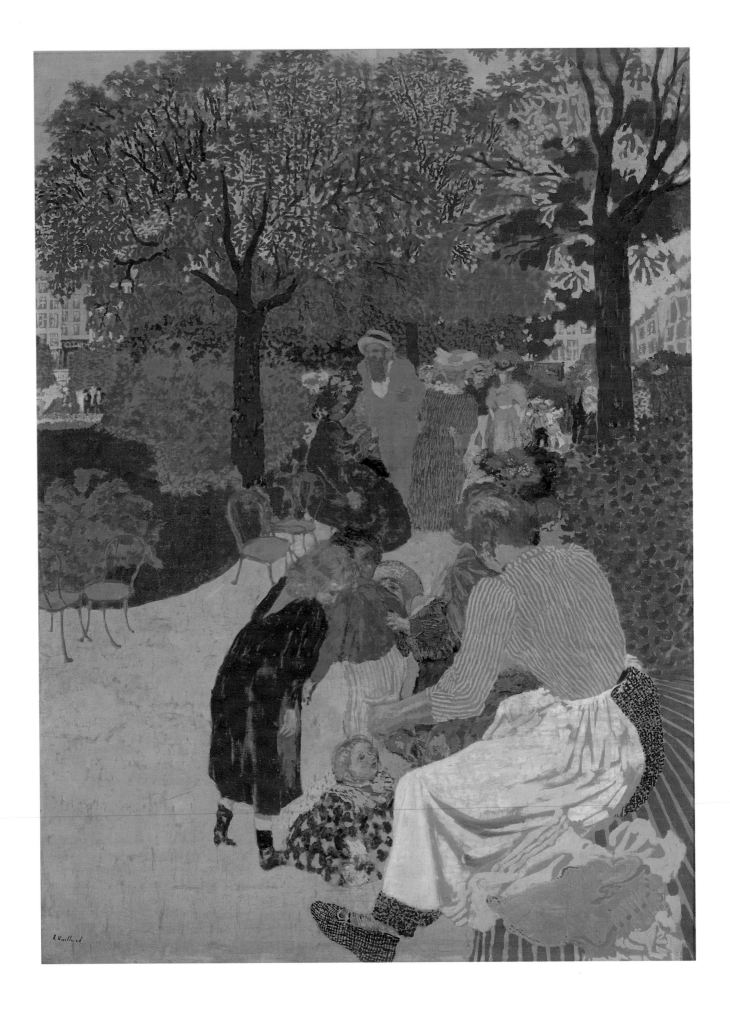

3 *Women, Children, and Public Gardens:*
The Commissions for Thadée and Alexandre Natanson,
1893–1894

The Park, *1893–4*

By 1893, Vuillard was engaged in a variety of artistic projects. Writing that summer to Alfred, the youngest Natanson, he expressed his amazement and near-guilt at his steady work and progress:

> I am very content, too content perhaps, in my small studio on the rue Pigalle . . . I paint, I read, I paint again, and I read again; I imagine that I am discovering the things that before stupefied me, and I allow myself even to go with the movements of pride which worry me a little . . . I have really nothing to complain about, and if I pay for that with certain moments of black hypochondria, it's only just.[1]

To a large degree, Vuillard's increased workload was due to Aurélien Lugné-Poe, the friend who had formed his own theatrical company, the Théâtre de l'Oeuvre, in the spring of 1893.[2] Vuillard, who is purported to have suggested the name, was, with art critic Camille Mauclair, a co-founder and the Nabi member most involved in designing sets and programs.[3] Not surprisingly, Lugné-Poe's repertoire of foreign and primarily Scandanavian authors during the first season was spiritually close to the aesthetics of the theater critics who wrote for the Natansons' *La Revue Blanche* and who inevitably reviewed them. Reinforcing the connection were the lithographic theater programs designed by Vuillard which were frequently double sheets publicizing both the performance and the magazine.[4] Vuillard's increased exposure during 1893–4 as an unofficial artistic director at the Théâtre l'Oeuvre not only consolidated his status among a certain literary elite, but provided him with consistent work.

That spring also, Vuillard participated in the third exhibition of "Impressionist and Synthetist Art" at the Le Barc de Boutteville gallery which Thadée reviewed in his new column "Petite Gazette d'Art." Despite the fact that Thadée had been actively sponsoring Vuillard since late 1891, this was his first mention of his friend for *La Revue Blanche*. In it, he praised Vuillard's small oil-on-board painting *Two Little Girls* (*Les Deux fillettes*) but chided the artist for his general elusiveness, warning that Vuillard could no longer refuse to exhibit, "since one would suspect him of coquetry – or rather, we should so suspect him if we did not know that his scruples are quite genuine."[5] Thadée knew quite well, however, that Vuillard's "genuine scruples" were due as much to the fact that he was busy finishing the screen for Mme Desmarais and commencing work on a large decorative panel *The Park* (*Le Square*) (pl. 63), destined for the apartment of Thadée and his bride, Misia, as to his reluctance to exhibit in larger public exhibitions. Misia Natanson was to become an imposing figure, not only in Thadée's life but in the history of Parisian literary and artistic circles. For while Thadée is best remembered today as the first husband of Misia, her fame extended into the twentieth century through her association with Diaghilev and the Ballets Russes, her tumultuous relationship with Coco Chanel, and her marriage to the celebrated mural painter, José-Marie Sert.[6]

Born in St. Petersburg in 1872, Misia was the daughter of Cyprien Godebeski, a highly successful sculptor specializing in realistic statuary and funerary sculpture,[7] and Sophie Gervais, whose father was the famous cellist Frantz Gervais. The Godebeskis were actually related to the Natansons by marriage, since Cyprien's second wife, the wealthy widow Matylda Natanson, was the sister-in-law of Adam Natanson, Thadée's father.[8] According to Robert Fizdale and the late Arthur Gold, who turned Misia's selective and semi-fictionalized account of her life (beginning with her birthdate, which she adjusted from 1872 to 1877) into a lively biography, Misia was born and raised in luxurious conditions provided by a rich grandmother at Ixelles, near Brussels, with whom she spent her childhood.[9] Returning to Paris, she lived on the rue de Vaugirard before she was enrolled

63 Edouard Vuillard, *The Park* (*Le Square*), 1893–4, distemper on canvas, 210.8 × 159.4 cm., private collection, New York.

by her father in the dismally severe convent of the Sisters of the Sacred Heart. At seventeen, Misia rebelled against her strict Catholic upbringing by moving to London, where she unconventionally rented a small apartment and supported herself by giving piano lessons. Returning to Paris in 1891, she again did the unconventional by setting up house in a small apartment off the place de Clichy. At that time, she was reintroduced to her second cousins, the Natanson brothers, whom she had not seen since she was a little girl. Thadée was immediately smitten by his kittenish and seductive relative, who was not only a skilled pianist (and student of Gabriel Fauré) but an intelligent and self-sufficient woman unlike any of the *parisiennes* he had heretofore known. In 1892, the year before their marriage, Misia performed in a concert honoring the poet-composer-singer Maurice Rollinat, founder along with Rodolphe Salis of the Chat Noir cabaret. Vuillard, who with Bonnard frequently met Thadée and others from the offices of *La Revue Blanche* at the popular nightclub after hours, would have known of this recital and of the young pianist hailed as a budding artist with whom his friend was infatuated.[10]

Thadée and Misia's marriage took place on 25 April 1893 at the Belgian mansion of her grandmother.[11] Back in Paris, Misia became the center of attention among the younger artists, writers, and journalists who were involved with her husband's magazine and who frequented their small but perfectly located apartment overlooking the place de la Concorde. The apartment at 9 rue Saint-Florentin, in fact, became the official "annex" to *La Revue Blanche*,[12] and the Natansons' commission of a large decorative panel from their artist friend may have been a kind of wedding gift to themselves. For Vuillard, who lived nearby on the rue Saint-Honoré, their marriage was a particularly propitious union. His friendship and collaboration with the Natanson *ménage* resulted in some of his most significant works and would last until their divorce in 1904, only a few months after the closing of the offices of *La Revue Blanche*.

For his first commission for the Natansons, *The Park* (pl. 63), Vuillard painted a seven-foot-high canvas showing a city square filled with near-life-size figures of children, mothers, fathers, and an elderly woman dressed in black.[13] Whereas the five panels making up the Desmarais screen were relatively thinly painted in oils, *The Park* represents the first large-scale *décoration* done in the time-consuming process of *peinture à la colle*. As seen, Vuillard was already experienced in the distemper technique from his work on scenery backdrops for the Théâtre de l'Oeuvre in 1893–4. But these were temporary decorative projects, quickly painted on cardboard in *colle de peaux*, which was an easier medium to handle than the hot, glue-based one.[14] As described in detail by Vuillard's nephew by marriage, Jacques Salomon, the method of applying powdered colors mixed with

hot glue and water required much preparation but rapid application. Adding colors next to each other before the first was allowed to dry (wet to wet) or mixing pigments on the canvas, for example, was not possible with *à la colle* technique. For the most part, according to Salomon, Vuillard used brown, almost transparent sheets of Tottin glue which he bought at the corner drugstore or the artist supply shop. These he would soak for twelve hours in a double boiler in four to five times their volume of water, until they dissolved. Colors would be prepared at this time, mixed with the medium in separate pots, and kept warm to prevent them from thickening. Once applied, the color took only five to fifteen minutes to dry (and the water to evaporate). Any corrections required remixing color and reworking an area, until, as Salomon recorded, "it was literally encrusted with paint . . . Often as the water evaporated, his glue would thicken and get sticky; but, when carried away by his work, he would use it as it was, delighted with a *matière* which became, as he said, hard as a rock, even cracking when he laid it on over layers which had not had time to dry."[15] This method, adapted from Vuillard's early work in the theater at first for economical reasons and then because of the specialness of the effects, remained his special domain and set his large-scale decorative works apart from those of his colleagues. Unlike some of the paintings he executed in this medium and retouched or repainted with occasionally disastrous results, *The Park* was not reworked and has consequently retained its original freshness. The painting was not exhibited until the sale of Thadée's collection in June 1908. Félix Fénéon, who wrote the entries for the painting (presumably done with knowledge of both the work and Thadée's opinions) described the work glowingly with an inventory of the many incidents making up the single decorative expression:

> Beneath trees now tired by the summer, the population of a Parisian square. In the foreground, a housemaid [*bonne*] in apron and striped uniform, sitting on a bench, watches over a whole pack of children at play, among them a baby squatting on the ground and a little girl in her school overall. In the middle ground, some iron chairs; a conversation is in progress between an old lady and a man in a battered straw hat.[16] To the right, people spread up to the houses which border the square. To the left, a parterre of flowers and beyond it a little frieze of people sitting down and beyond that, once again, the houses that overlook the square.[17]

It was, as Fénéon described it, a scene alive with participants in the most Parisian of activities – the Sunday promenade. Instead of a recognizable public park or garden favored by the impressionists (one can cite as obvious examples, Monet's *Parisians Enjoying the Parc Monceau* (pl. 64) and Manet's *Music in the Tuileries* (pl. 65). Vuillard's setting is one of the twenty-four city squares that had been created from

backyard or in the semi-private realm of a city square filled, in the main, with well-to-do Parisians. As in Monet's picture, where the viewer is led into the painting by the garden bench angled off towards the middle ground, Vuillard's large figures pushed to the foreground of the canvas pull the viewer into the scene. Coloristically, however, Vuillard makes an audacious deviation from Monet's *plein-air* palette. Instead of Monet's green metal park bench, Vuillard paints his with pink stripes to complement the brilliant raspberry-and-white striped blouse of the

Haussmann's remodeling plan – the patches of "green and trees" between the boulevards, such as the square des Batignolles or the square de la Trinité.[18] The narrow ledge upon which Vuillard assembled the figures in the Desmarais panels of 1892 is now a vertical column of a subtle recessive space achieved by the diminishing figure scale as well as the increasingly lighter palette for the people, foliage, and buildings in the distance. A relatively large pen-and-ink sketch probably datable to this period, entitled *The Chestnut Tree* (*Le Marronnier*) (pl. 66) shows an unpeopled intersection in a public square and may have been an early stage of the final decorative panel. Even in this early conception, Vuillard is careful to delineate the various textures of foliage (trees, shrubs, and ground cover) open path and the fancy grillwork of the apartment houses to animate and emphasize the surface.[19]

The deliberate flatness and decorative contours linking figures and foliage in *The Park* relate it to another masterpiece of decorative effects by Monet entitled *The Luncheon* (*Le Déjeuner*) (pl. 67), exhibited in 1877 at the second impressionist exhibition as a "panneau décoratif," primarily on the merits of its large size.[20] Vuillard would have been aware of this painting, since it was one of the sixty-seven impressionist works comprising the bequest of the impressionist painter Gustave Caillebotte (d. 1894) to the Musée du Luxembourg which was under heated debate in the summer of 1894.[21] Both Vuillard and Monet's large-scale paintings are about domestic pleasures, whether they take place in the privacy of a

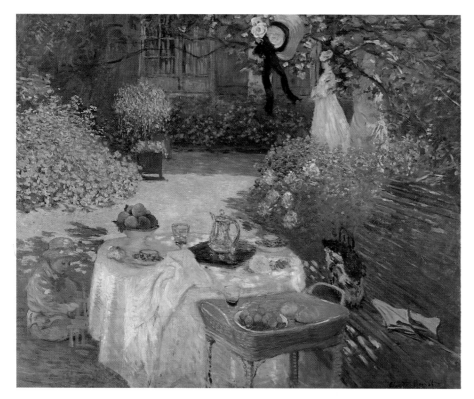

bordering the scene. (Vuillard would use this color scheme in a smaller work from *c*.1894 entitled *The Tuileries Gardens, Paris*, pl. 70.) As if to anchor the otherwise busily patterned and high-hued composition, Vuillard dressed the little girl standing over the crawling baby in the center of the park and the elderly lady conversing with the straw-hatted and bearded gentleman in solid, flat, and drab tones. An interesting comparison can be made between Vuillard's *Square* and a scene of the Tuileries gardens by his brother-in-law, Roussel (pl. 68). Like Vuillard's public realm, Roussel's park scene shows little landscape. The seated and standing figures (who make no contact with the viewer) are likewise compressed into the rectangular format. But while Roussel adapted the Nabis' techniques of painting with a loaded brush to block out and simplify silhouetted forms, Vuillard picked out physiognomic and sartorial details. To an even greater degree than Roussel's small oil-on-panel park scene, Vuillard's favoring of the decorative intent over conventional picture-making is everywhere apparent. The figures are only partially modeled, and there is a calculated flatness achieved by the arabesqued outlines of the chairs and the flat bands of treetops through which one sees the outlying residences. Using the distemper technique, he gave a mat and textured surface to a palette of muted variations on tawny reds, blues, and greens intertwined with pinks and yellows, with a pathway of one large, unbroken patch of beige.

Despite its scale, nothing is known of the painting's installation within the Natansons' "annex." The fact that contemporary photographs exist of the Natanson's apartment in 1895 showing Vuillard's second series of decorative paintings (*The Album*, to be examined in chapter four),[23] but not *The Park*, may indicate that this monumental *décoration* was not a permanent fixture there. It is possible that it was hung in their country home, La Grangette, at Valvins to the southwest of Paris.[24] It seems odd, indeed, given the ambitious scale and degree of finish of this painting, that no contemporary descriptions of how it would have looked in either location have come to light. Fénéon, who would have known the painting in its original context, regarded it highly and summarized its importance as the template – the "dictionary of the ornamental motifs" – of subsequent paintings of public parks. To him it represented "the first and no doubt the most audacious of a series of large paintings in the same medium [*peinture à la colle*], all of them painted as mural decorations."[25] Fénéon's comments doubtlessly referred to the nine panels treating a similar impressionist subject but on a much more ambitious scale, commissioned by Alexandre Natanson the following year, and possibly motivated by the success of this *décoration* for his younger brother.

67 Claude Monet, *The Luncheon (Le Déjeuner)*, *c*.1873, oil on canvas, 160 × 201 cm., Musée d'Orsay, Paris.

68 Ker-Xavier Roussel, *Public Parks – The Tuileries (Le Jardin public)*, 1893, oil on parqueted panel, 27.5 × 17.5 cm.

woman seated there.[22] The imaginative free play of colors that was merely hinted at in the earlier Desmarais panels is achieved here by an uncanny repetition of unusual patterns throughout. The pink-and-white stripes, for example, are echoed by the blouse of the woman standing in front of the bearded man beside the path and in the delicately outlined ground foliage trimming the shrubs in the left background. One's eye is teased as well by the criss-crossed patterns of the seated nursemaid's skirt and shoes in the foreground, and by the tiny crossed lines suggesting window panels in the residences

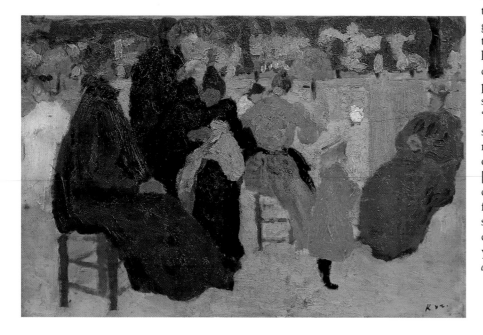

* * *

The Public Gardens, *1894*

By 1894, Lugné-Poe's Théâtre de l'Oeuvre on the rue Turgot was in full flower, presenting such notable foreign authors as Henrik Ibsen, Maurice Maeterlinck, Gerhardt Hauptmann, and Bjornstjerne Bjornsen, all associated with a certain type of literary symbolism. As the artist who was the most interested in the company and, citing Lugné-Poe, its "best adviser," Vuillard designed several sets and illustrated at least five theater programs that year.[26] In January 1894, one of his first color lithographs, *The Seamstress* (*La Couturière*), appeared on the cover of *La Revue Blanche*, followed a few months later by the publication and posting throughout Paris of his first and only poster, for the "liqueur apéritif" made from meat extracts and recommended for cyclists (hence the name *Bécane*, or bicycle) (pl. 69). In May that same year, he sent paintings, drawings, and lithographs to an important Nabi group exhibition in Toulouse organized by Arthur Huc in the office of his newspaper, *La Depêche.*[27]

In his journal, however, Vuillard listed only the decorative panels for Alexandre Natanson as the primary artistic activity that year.[28] Indeed, the series of panels known as *The Public Gardens* (*Les Jardins publics*) consisting of a tripytch, *The Nursemaids* (*Les Nourrices*) (pl. 76), *The Conversation* (*La Conversation*) (pl. 77), and *The Red Sunshade* (*L'Ombrelle rouge*) (pl. 78); and three pairs of panels, *The Two Schoolboys* (*Les Deux écoliers*) (pl. 79) and *Under the Trees* (*Sous les arbres*) (pl. 80); *Little Girls Playing* (*Les Fillettes*

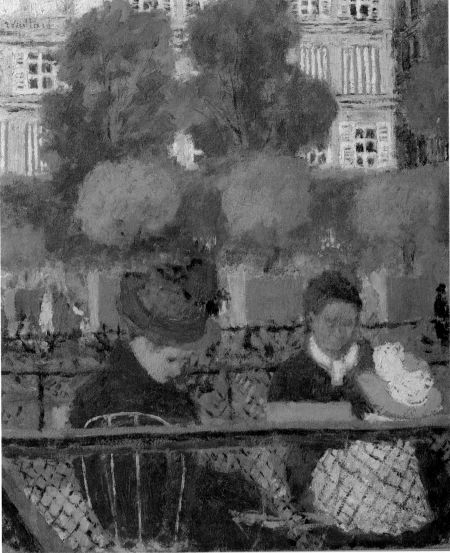

jouant) (pl. 81) and *Asking Questions* (*L'Interrogatoire*) (pl. 82); *The Walk* (*La Promenade*) (pl. 85) and *The First Steps* (*Les Premiers pas*) (pl. 86, destroyed), sealed his reputation as a *peintre-décorateur*. Because all eight of the existing panels are in public collections, they are also the works by which this aspect of his career is best known today.[29]

70 (above) Edouard Vuillard, *The Tuileries Gardens, Paris, c.*1897, oil on cardboard *marouflé* to wood, 38.8 × 33 cm., Gift of Mr. and Mrs. Paul Mellon, Yale University Art Gallery, New Haven, Conn.

The Alexandre Natansons

Vuillard received the commission in September 1893, but it was a little over a year before the paintings were ready to be installed in the Natansons' smart new town house built by Alexandre's parents-in-law for his wife, Olga Kahn.[30] The four-story mansion still stands today (pl. 71) in the *beaux quartiers*, or chic residential area west of the avenue des Champs-Elysées on the leafy thoroughfare of the avenue du Bois de Boulogne (now avenue Foch), eulogized in Proust's *A la Recherche du temps perdu*.[31] The inhabitants of this *hôtel particulier* were no less Proustian

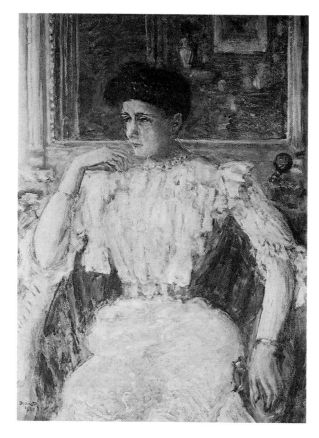

72 Pierre Bonnard, *Olga Natanson*, 1900, oil on cardboard, 79 × 58 cm., private collection.

69 (preceding page, bottom left) Edouard Vuillard, *Bécane*, c.1894, color lithograph, 80.8 × 60.4 cm., Gift of Mrs. Cyrus H. Adams, 1960.545, The Art Institute of Chicago.

71 (preceding page, bottom right) Modern photograph of 60 avenue du Bois de Boulogne (now 74 avenue Foch).

73 Félix Vallotton, *Alexandre Natanson*, 1899, oil on canvas, 81 × 65 cm., private collection.

in character. Described as a "beauty with a simple mind," Olga could have easily fit Proust's description of the irrepressible Odette (pl. 72), and it has been suggested that Alexandre was one of several personalities inspiring the character of Odette's wealthy Jewish dilettante husband, Swann.

The phenomenon of the Jewish art patron at the end of the century has been only touched upon in art-historical studies. Albert Boime's study of enterpreneurial patronage is one of the few attempts made by historians or art historians to define the symbiotic relationship that existed between the independent artist and the Jewish businessman during that period.[32] Both, Boime concluded, were relegated to the marginal fringes of French society. Only the wealthiest, like Proust's Swann, the first Jew to be allowed into the prestigious Jockey Club, could overcome the prejudices built into the top social strata. Alexandre seems to have relished that challenge. By the time he commissioned Vuillard, he owned a successful law practice, had earned a position in the appellate court, and had taken over his father's real-estate investments and speculative ventures. In addition to his involvement with the Cercle des Escholiers (1886–9) and *La Revue Blanche*, Alexandre launched the gossipy bi-monthly *Cri de Paris* in 1897, and in 1911, the fashion and society magazine *Feminina*. With his risk-taking philanthropic and entrepreneurial activities in the arts and finance, Alexandre represented the enlightened businessman who was well aware of the path to social success.

Vallotton's portrait of him executed in 1899 captures his acuity, showing him unblinkingly posed, highly refined, and alert (pl. 73).[33] Yet Alexandre's and the family's achievements were often viewed negatively, and they were seen as intruders in to French society, despite their adopted citizenships. In 1897, in fact, both Alexandre and Thadée appeared as characters in Camille Mauclair's novel *Le Soleil des morts*, thinly disguised as the "magazine angels," the Soldmanns, and described as "leading elitist snobs who ferret around for novelty and prestige of sorts, hobnobbing with artists and intellectuals."[34]

While Mauclair's venomous slur is possibly attributable to current antisemitic attitudes, other contemporary accounts suggest that the Natansons, especially the powerful Alexandre, were regarded as interlopers in the tightly structured, traditional French literary elite. André Gide, a collaborator on *La Revue Blanche* and a member of Denis's neo-Catholic intellectual circle, for example, made no attempt to hide his contempt for Alexandre's elevated sense of self concerning his talent for launching young artists. In a journal entry for December 1908, Gide recorded verbatim Alexandre's avowal of a complete disregard for commitment and an insatiable appetite for the new: "With me, one never knows, with me, you can only be sure of one thing: that is that I will never stay too long with the same affair."[35]

If one accepts Boime's argument – that, in general, Jewish businessmen felt at home with artists who were also struggling to gain a foothold of acceptance in the closed circles of Parisian society – then Alexandre and Vuillard were symbiotically linked.[36] While

this may be an exaggeration, it is certain that, by 1900, the gulf between Vuillard's promoters and future dealers, the Natansons, Hessels, and Bernheims, on the one side, and the predominantly Catholic, old-moneyed French families who patronized Denis, Roussel, and fellow Nabi Aristide Maillol on the other, was a large one that deepened with the national crisis of the Dreyfus Affair.[37] As shown by Ranson's letter to Verkade outlining his friends' activities in 1892, their commissions and projects identified them with particular groups of collectors. Vuillard, for example, was well aware of his particular attraction and attachment to the wealthy Jewish sector. (Much later in life he mused that in *that* context he resembled Rembrandt.[38]) An interesting sociological comment appears in his journal entry for 7 November 1894, following an invitation to Henri Lerolle's residence, an event that he compared with the theatricality of Lugné-Poe's circle:

> Yesterday afternoon Lerolle and his sister-in-law – the calm impression given by these likeable people, reserved but congenial, not too many trifling matters. Set that against the evening at Lugné-Poe's theater – all those sensual Jewesses, their silks shimmering in the shadows.[39]

While Vuillard's comments echoed the popular fascination even among antisemitics (as expressed in theater, literature, and art) with *la juive* whose sensuous beauty was considered both admirable and troubling,[40] they also indicate that, by 1894, he had gained entry into a variety of social milieus. According to Mauclair, who reviewed the exhibition "Portraits du prochain siècle" which took place during the summer of 1893, Vuillard, who was represented by a portrait of Lugné-Poe, was "one of today's future masters and a true artist of the twentieth century."[41] He was, in the words of John Russell,

> an artist very much in touch with his time. He knew the best actors and the best actresses, he heard the best conversation, and he was a freeman of that perennial and in large degree Jewish department of Parisian society in which the doctor, the merchant banker, the editor of the best new magazine, the playwright, the amusing kept woman and the rising politician enjoy one another's company.[42]

Alexandre's reasons for commissioning Vuillard may have been his sincere appreciation of the artist or because he sensed a wise investment. His home on the avenue du Bois de Boulogne, the legacy of his wife's family, was a symbol of his cultural and social ambitions, as might have been his commissioning of Vuillard. It is also possible that Alexandre envied Thadée's relationship with the artists associated with the magazine, and felt the need to become more a part of their circle.[43] Whatever Alexandre's motives, for Vuillard the commission to make monumental

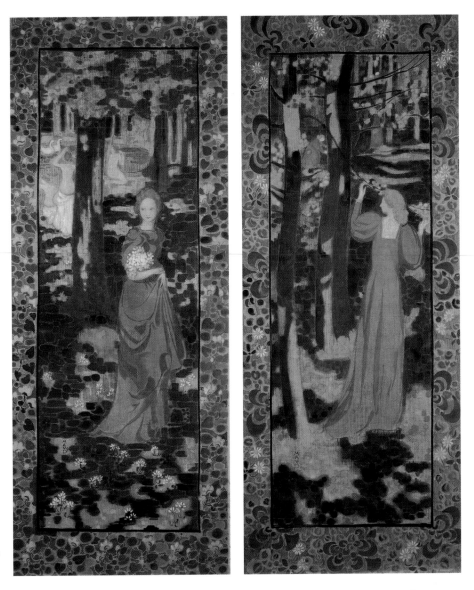

74 Maurice Denis, *Spring* (*Le Printemps*), 1894, oil on panel, 230 × 100 cm.

75 Maurice Denis, *Autumn* (*L'Automne*), 1894, 230 × 100 cm.

wall paintings for the interior of an influential *financier* who would undoubtedly be host to any number of celebrities from *tout Paris* would have been a heady challenge.

The Panels: Parks and Playgrounds

In conceiving the Natansons' ensemble, Vuillard renewed a subject that had been celebrated in poetry and art beginning in the mid-nineteenth century, but its spiritual source was in the eighteenth century, whose art and literature had found new admirers. Vuillard, too, admired the graceful expressions of eighteenth-century painters. On 7 July 1894, for example, he noted in his journal his pleasure "au coeur" in seeing Watteau's *Gathering in a Park* (pl. 33) at the Louvre (a painting that has already been mentioned as a possible source for the fashionable ladies in the Desmarais panels).[44]

In his park series for Alexandre, however, Vuillard

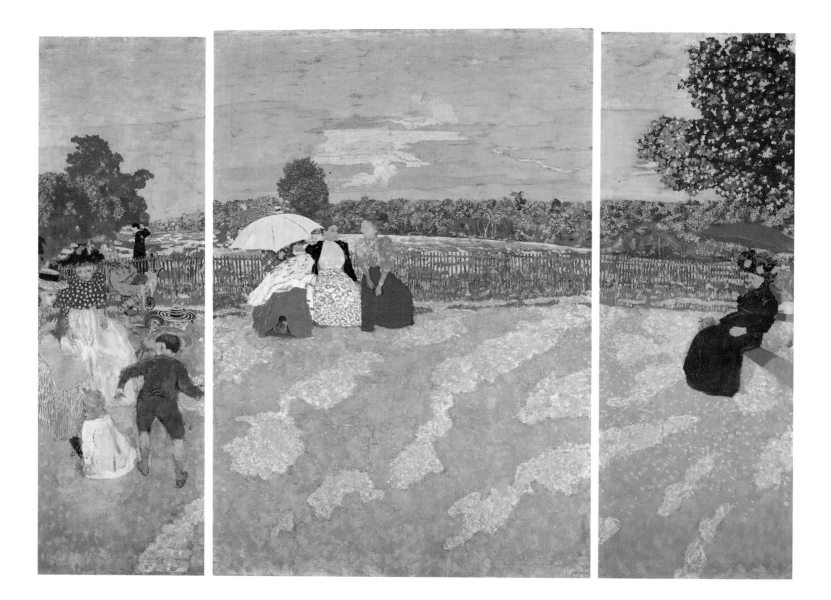

76 Edouard Vuillard, *The Nursemaids (Les Nourrices)*, 1894, distemper on canvas, 213.5 × 73 cm., Musée d'Orsay, Paris.

77 Edouard Vuillard, *The Conversation (La Conversation)*, 1894, distemper on canvas, 213 × 154 cm., Musée d'Orsay, Paris.

78 Edouard Vuillard, *The Red Sunshade (L'Ombrelle rouge)*, 1894, distemper on canvas, 214 × 81 cm., Musée d'Orsay, Paris.

moved away from the Verlainesque melancholy of an earlier generation.[45] His were not evocations of the languid, half-sad, half-gay themes of courtly love popular among the decadents (and performed in verse and music at the salon of the society artist Mme Lemaire, for example),[46] but of the leisure and care-taking activities of the modern mother. One has only to compare Vuillard's park imagery with Maurice Denis's panels *Spring (Le Printemps)* (pl. 74) and *Autumn (L'Automne)* (pl. 75) – one of two vertical door decorations painted that year for the Toulousian collector Arthur Huc – to appreciate the artists' very different approaches to *décoration*. Whereas Vuillard begins with the real park inhabitants whose "types" he appropriates and exploits for the decorative expression, Denis begins with the symbolist ideal of the child-woman clothed in a Botticelli-like gown whom he sets into an idealized and virginal evocation of the Tuileries gardens. For Denis, the conception of decorative painting grew from a need to express a unity of (spiritual) idea and compositional order,

while for Vuillard, the genesis of the expression was the subject (nature) and its decorative possibilities.

In this series, as in the Desmarais panels, Vuillard avoided overt references to place, choosing not one but an amalgam of several public gardens. Obeying Mallarmé's principle of suggestion through "infinite nuance," he included only subtle allusions to the square de Trinité, and the various city parks, such as the Tuileries, Palais Royal, Luxembourg, Parc Monceau, Versailles, and Bois de Boulogne.[47] These parks, some of which were created in the course of Baron Haussmann's construction of large and homogenous city blocks during the Second Empire, were perceived as both natural and cultural oases within the increasingly congested urban environment. Despite their limited size (the three largest parks of Paris could fit easily into London's Regent's Park), the parks or *jardins* of Paris were world-renowned. "Paris loves trees and children," wrote one American visitor, "– one cannot think for two minutes of either subject without finding the other

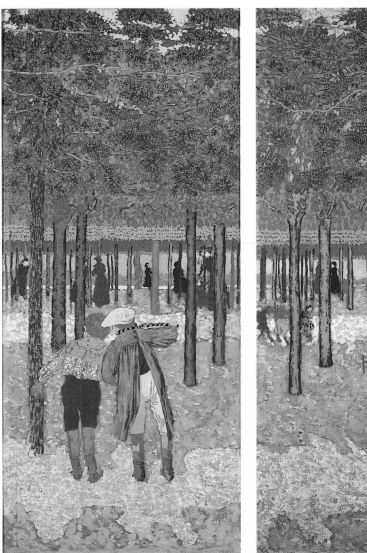

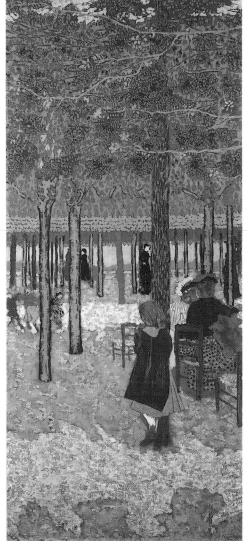

79 Edouard Vuillard, *The Two Schoolboys* (*Les Deux Ecoliers*), 1894, distemper on canvas, 214 × 98 cm., Musées Royaux des Beaux-Arts de Belgique, Brussels.

80 Edouard Vuillard, *Under the Trees* (*Sous les arbres*), 1894, distemper on canvas, 214.6 × 97.7 cm., Cleveland Museum of Art.

85 (page 53, top left) Edouard Vuillard, *The Walk* or *The Promenade* (*La Promenade*), 1894, distemper on canvas, 212 × 96 cm., Robert Lee Blaffer Memorial Collection, Museum of Fine Arts, Houston, Texas.

86 (page 53, top right) Edouard Vuillard, *First Steps* (*Les Premiers pas*), 1894, distemper on canvas, 212 × 67 cm. (destroyed.)

83 (page 53, bottom left) Edouard Vuillard, *Woman in a Park* (*Femme dans un jardin*), *c.*1894, distemper on canvas, 188 × 85 cm., private collection, Paris.

84 (page 53, bottom center) Edouard Vuillard, *In the Luxembourg Gardens* (*Au Luxembourg*), 1894, distemper on canvas, 210.5 × 80.3 cm., Galerie Rosengart, Lucerne.

equally present to the mind."[48] Contemporary guidebooks provided precise descriptions of the most important statuary, architectural structures, *allées*, botanical highlights, and even the social make-up of the visitors which distinguished the fashionable parks from the less fashionable ones. By far the most popular promenading site and, according to Baedeker, "the especial paradise of nursemaids and children" was the Tuileries.[49] After the ravages of the Commune, the gardens by Le Nôtre were enlarged, and, by 1889, additional gardens had been planted on the site of the former palace.[50] The many turn-of-the-century guidebooks on Paris speak of the enchantment these gardens held for the modern visitor there. As one American observed of the Tuileries, "The garden seems so large, so full of surprising hidden corners and unexpected stairways, that its strict groundplan – sixteen carefully spaced and shaped gardens of trees, separated by arrow-straight walks – is not immediately discernible."[51] Vuillard's panel of the schoolboys (pl. 79) and its pendant of

little girls playing hide-and-seek, *Under the Trees* (pl. 80), evoke the feeling of those dense trees and hidden "arrow-straight" paths. The decorative lavender shadows alternating with undulating zones of lighter tones hint at what another author observed poetically as "the deeper and wider shade of some bigger trees, and the swinging tresselation when the breeze blew among the shadows," making up the "inalienable heritage of the Paris child."[52]

In his discussion of Manet's monumental park scene, *Music in the Tuileries* (pl. 65), T.J. Clarke described the public life in that park as "narrow and definite," in contrast to the life at the Bois de Vincinnes to the east of Paris, or the Parc Buttes-Chaumont to the south, both of which were frequented by the Parisian working classes.[53] At the Tuileries, a park in the French style dating from the Renaissance, the variety of social types was kept to a minimum, since the *petit bourgeois* and middle classes conformed to the standards of their upper-class compatriots with whom they shared the park. In *The*

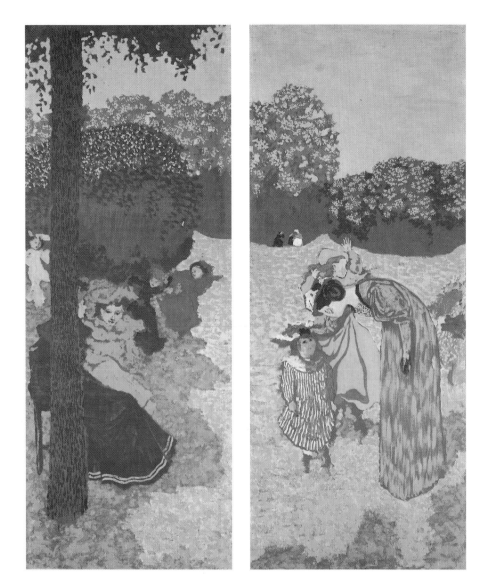

Vuillard, the Tuileries were a source of renewal, and, like Watteau, whose favorite park was the Luxembourg, he was continually inspired by the pictorial possibilities of the *promeneurs* in garden settings. On 30 August 1894, while still at work on the panels, he noted his disappointment in his paintings in progress. Escaping from his studio that afternoon, he went to the Tuileries, where he "rediscovered, as if by magic, on the day I felt most hopeless, the feelings that first guided my work."[58]

That Vuillard experimented with the theme of public parks before arriving at the final series is suggested by several similarly formatted panels also painted in distemper. In what was probably an early version for the series (pl. 83), the low iron railing, the variety of trees, and the slightly elevated landscape suggest the Parc Monceau, described by Baedeker as "tastefully laid out in English style, accessible to carriages as well as pedestrians."[59] In another, like-wise vertical variant, *In the Luxembourg Gardens (Au Luxembourg)* (pl. 84), a woman in a striped dress is seen half-hidden by a tree, while to her left are two little girls in a composition similar to *Little Girls Playing*.[60] The deep recession of the pathway into the landscape, however, signifies a specific region, showing as it does the incline of the Luxembourg gardens leading from the lower to the upper terrace and the once-royal palaces. For the Natanson series, as will be seen, Vuillard eliminated any such precise references that might detract from the decorative purpose.[61]

Among the early sketches (*croquis*) for the series is a sheet of studies showing a little boy almost identical in gesture and attire to the child on the right in *The Two Schoolboys* (pl. 87). Adjacent to the drawing of the little boy is a much paler, self-contained vertical vignette of woman seated on a park bench with a child at her feet which is a study for the lefthand panel of the triptych, *The Nursemaids* (pl. 76). Behind them, a wooden fence divides the park from the outer landscape and distant building.[62] In the final painting, however, the building is left out. While Vuillard may have felt that the building would have disrupted the otherwise unbroken line of the fence and the undulating horizon line which connects the three panels, it is also likely that he wanted to avoid topographical specificity.[63]

In contrast to the flat bands of densely patterned foliage topping the two panels that might be dubbed Vuillard's "Tuileries" parkscapes, the triptych evokes the spaciousness of the Bois de Boulogne (or "Bois," as it is known to Parisians), lying outside the *enceinte* or city walls (at the end of the long avenue where the Natansons lived), and may suggest, as Claude Roger-Marx has speculated, the "hills of Saint-Cloud which one can see from the pathways along the racecourses [at Longchamp]."[64] Supporting this topographical suggestion is the fact that Adam, Alexandre's father, also owned a neo-classical *petit château* at Longchamp (possibly similar to the one

81 Edouard Vuillard, *Little Girls Playing (Fillettes jouant)*, 1894, distemper on canvas, 212 × 84 cm., Musée d'Orsay, Paris.

82 Edouard Vuillard, *Asking Questions (L'Intérrogatoire)*, 1894, distemper on canvas, 212 × 96 cm., Musée d'Orsay, Paris.

87 (facing page, bottom right) Edouard Vuillard, sheet of studies for *The Public Gardens*, pen and black pencil, red, yellow, blue and black crayon, 24.5 × 8.6 cm., Everett V. Meeks, B.A., 1901 Fund, Yale University Art Gallery, New Haven, Conn.

Two Schoolboys and *Under the Trees*, the spreading chestnut trees are characteristic of the Tuileries, and the children are middle-to-upper-class citizens, dressed fashionably in soft woolen hats and knickers, or lace-collared dresses.[54]

From 1893 until 1898 the Vuillards lived on the rue Saint-Honoré, just one street away from the short rue d'Algers running north of the Tuileries.[55] During his work on the panels in the summer of 1894, Vuillard noted in his journal several trips to the Tuileries and to the Louvre. In July 1894, for example, he visited the Louvre with Bonnard. Although disappointed with the Italian quattrocento painters (whom Denis and Sérusier would rediscover shortly afterwards), he admired the new installation of Le Sueur and other French paintings of the seventeenth century.[56] A few weeks later, he drew in his journal pen-and-ink vignettes of women and a man observed walking in a tree-lined park similar to those seen in *Under the Trees* and *The Two Schoolboys*, with the note: "Watteau. Faces, serious expressions".[57] For

featured in the sheet of drawings) which had earlier served as his holiday residence.[65]

Like the Tuileries, the Bois de Boulogne was a notable leisure site and, since its opening in the 1860s, rivaled even the Champs-Elysées as the location for the habitual promenade of elegant Paris. From his apartment on the rue Saint-Honoré, Vuillard could get to the park by the *chemin de ceinture* (the local train or carriage which ran around the inner periphery of the city walls), or the train from Saint-Lazare going to the western suburbs. The park's proximity to the Natansons' home made this an accessible location. Furthermore, the 21,000-acre park boasted many entertainments, including the eighteenth-century pavilion of the Bagatelle, housing the stunning art collection of Sir Richard Wallace, several fancy cafés (one of which Vuillard painted in 1895), and the celebrated racecourse of Longchamp.[66] Vuillard no doubt conceived the project as much to appeal to the Natanson daughters as to Alexandre, and it is not unthinkable that at least one of the three Natanson daughters born by 1894, Evelyn (b. 1891), Bolette (b. 1892), and Georgette (b. 1893), was included among the park scenes, which show children of various ages, and, in the panel *The Walk* (pl. 85), a newborn in the arms of a younger girl.[67]

Nursemaids and Nannies, Mothers and Children

As has been discussed, Vuillard's emotional and artistic stability was linked to places where people (and things) were most familiar and were engaged in everyday activities: women talking, whispering, gossiping on a bench (pl. 77), children playing (pl.

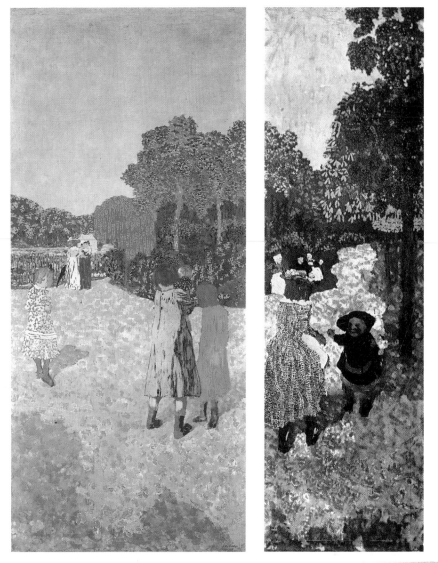

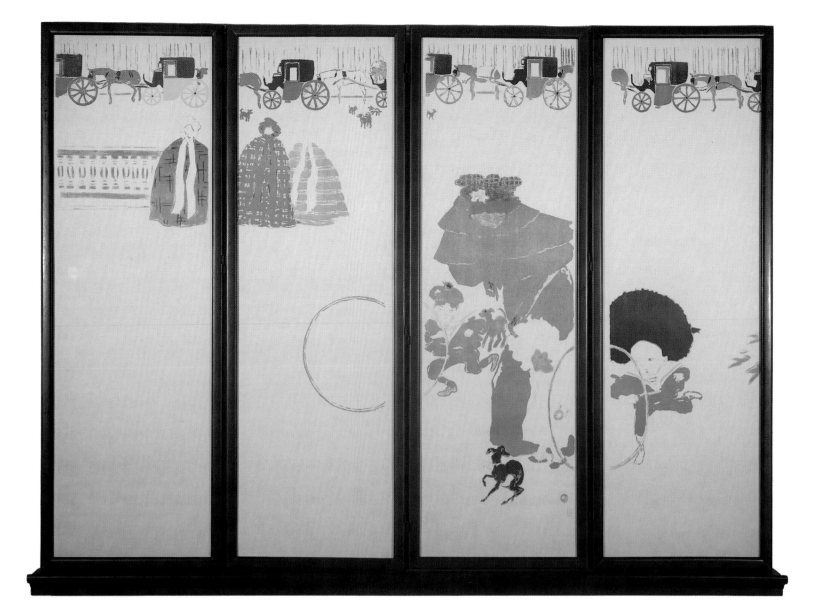

88 Pierre Bonnard,
*Promenade of the Nursemaids, a
Frieze of Fiacres*, 1894–5,
lithograph, each panel: 147 ×
45 cm., Ira and Virginia
Jackson.

89 Pierre-Auguste Renoir,
*In the Luxembourg Gardens
(Au Luxembourg)*, *c*.1883, 64
× 53 cm., private collection.

81), an old woman talking to her dog, two women walking away from a girl holding a baby in her arms, a baby taking his first steps, mothers and nursemaids under trees (pl. 76), and two *gamins*, or street urchins, conspiring to carry out some prank (pl. 79). This is a world devoid of the masculine signs of business and industry associated with modern (and capitalist) Paris.

Apart from the fact that mothers and children in public gardens would have been readily available models for the artist during a normal workday (at a time when he could not afford to hire models), there are several reasons why the park, in its capacity as the setting for "the children's hour" rather than for the fashionable promenade, may have been an attractive subject for Vuillard.[68] The cult of the child had, since Jean-Jacques Rousseau, been a frequent theme in literature. By the end of the eighteenth century, bourgeois ideologies prescribing the institution of family-motherhood-childhood had replaced the aristocratic notion of family as dynasty.[69] In 1877, Victor Hugo published a selection of poems, *L'Art d'être grand-père* (*The Art of Being a Grandfather*), in which he claimed to have been "vanquished by a small child," referring to what he saw as the divine innocence of all the children that he observed in the Tuileries and Jardin des Plantes.[70] By the end of the nineties, Hugo's equation of innocence and childhood had made its way into the vanguard of writing and art, as seen by the number of references in *La Revue Blanche* and the *Mercure de France* to those little people as yet untainted by the conventions of society.[71] The *ombres chinoises*, or shadow-puppet shows, popularized by Henri Rivière's circle and performed at cabarets like the Chat Noir, the puppet shows of the Nabis (Ranson's *Guignols pour les grands enfants*, for example), and the marionettes of Juliet Gauthier and Maurice Bouchor were deliberately childlike to provide unconventional and "fresh" ways of expressing advanced thinking and modern literary

ideas.[72] Gauguin, for example, incorporated the fables of La Fontaine into his writings and symbolist paintings and wrote about wanting to go back to the "hobbyhorse" ("dada") of his childhood, to the unhindered creativity of his earliest days.[73] This same pitting of worldly sophistication against artistic creativity was expressed by the critics who admired Vuillard's lithographed theater programs for their naive graphic style, "as if drawn by a child,"[74] just as they admired Verlaine's poetry for its childlike soul and innocence.[75]

For Vuillard and Bonnard, especially, the child, was one of their most frequently used motifs during the 1890s. In the same year that Vuillard painted

could look to a wealth of other examples from the previous artistic generation.[77] But Vuillard's park scenes, populated by people from different classes, shift the social angle slightly from those of his impressionist predecessors such as Renoir, whose painting *In the Luxembourg Gardens* (pl. 89) showed upper-class children playing with hoops and sand pails accompanied by their chic young *mamans*, or

91 (above) Edouard Manet, *Children in the Tuileries (Enfants au Tuileries)*, c.1861–2, oil on 38 × 46.5 cm., Rhode Island School of Design.

the panels for Alexandre, Bonnard executed a four-panel screen painted in distemper, *Promenade of the Nursemaids, a Frieze of Fiacres*, which was popular enough to be published three years later in a lithographed version (pl. 88). Bonnard's grouping of the woman and children in the last two panels, in fact, bears a striking resemblance to Vuillard's composition in *Little Girls Playing* (pl. 81). Likewise, the three women seated on the bench in the central panel of Vuillard's triptych are similar to the beribboned nursemaids arranged in a frieze across the left half of Bonnard's screen. Both artists drew their subject and style from the simplified silhouettes of the puppets, caricatures, and other contemporary images of Parisian *gamins* by Vallotton, Henri Ibels, and the older artist, Jean-Louis Forain.[76]

For the theme of public parks and women, Vuillard

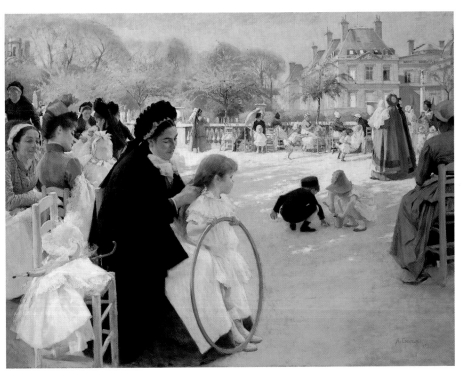

93 Félix Vallotton, *The Luxembourg Gardens*, 1895, oil on canvas, 54 × 73 cm., private collection.

90 (preceding page, left) Louis Béroud, *The Carrousel Gardens and the Richelieu Pavilion in Paris*, 1883, oil on canvas, 118 × 91 cm., The B. Gerald Cantor Collection, New York.

92 (preceding page bottom) Albert Edelfeldt, *The Luxembourg Gardens*, 1887, oil on canvas, 144 × 188 cm., Helsinki, Ateneumin Taidemeuseo.

from Manet's picture of finely dressed children at play in what is recognizably the Tuileries (pl. 91).[78] More often than not, the imagery popularized by lesser-known Salon artists, such as Louis Béroud (*The Carrousel Gardens and the Richelieu Pavilion in Paris*, pl. 90) or Finnish artist Albert Edelfeldt (*The Luxembourg Gardens*, pl. 92), presented sentimental narratives and easily readable types.[79] Even Vallotton, who once stated that he did not like to paint children, gave them priority when he introduced them into his scene of the Luxembourg gardens in the company of their well-dressed chaperones and parents and of the other recognizable characters to be found in parks on weekend afternoons (pl. 93).[80] In Vallotton's

painting, moreover, the row of well-known statues representing "famous women," which separated the wooded areas from the grand basin of the Luxembourg, firmly established the setting.

In addition to fine-arts imagery, advertisements for children's clothes produced by department stores such as Au Bon Marché and La Samaritaine often depicted smartly dressed children playing with balls, boats, or hoops in identifiable public parks.[81] Popular, too, were colored engravings of scenes of children with their mothers or nursemaids in the parks in family magazines such as *L'Illustration* or *Le Monde Illustré* (pl. 94).[82] By the turn of the century, the same preoccupation was evident in postcards showing children posed with their mothers and nurses (pl. 95). These, like the advertisements and illustrated journals (and, to a lesser extent, paintings), described and prescribed a way of life that was well dressed, well groomed, orderly, and innocent.[83]

While Vuillard's panels contain similar park imagery, they avoid both the sentimentality, the topographical specificity, and the accoutrements (such as the black beribboned nursemaids of Edelfeldt's and Vallotton's depictions) standard to the iconography of the theme. Indeed, only in the *Nursemaids* panel does he include even the ubiquitous pram, here tucked discreetly behind the seated women. Otherwise, the panels are devoid of carriages, hoops, and balls, leaving one to guess what games the children play and what holds their interest as they twist and frolic in laughter.

Within this seemingly objectified realm, Vuillard showed by gesture and attire a variety of social types. In the same way that he fixed upon seamstresses for a decorative form and subject, his journals reveal his interest as well in the social phenomenon presented by the nursemaids and nannies. On consecutive days during July of 1894, while he was working on the panels, a nursemaid unabashedly sat down next to where he was sitting in the square de la Trinité. Overcoming his embarrassment, he annotated the encounter with a small drawing of a nursemaid holding a baby and the observations:

I went down to the square. The same woman who was there yesterday came to sit down on my bench;

94 Maurice Bonvoisin ("Mars"), *Scenes from the Parc Monceau*, colored engraving for *L'Illustration* (April 1886).

95 (far right) *Nursemaids in the Luxembourg Gardens (Les Nourrices au jardin du Luxembourg)*, photograph, c.1905, Collection Debuisson, Paris.

somewhat embarrassed. dress with patterned little squares, stiff creases, like paper. An old black blouse, folds without roundness. White apron. Quality of the small, dry creases. Hair like dried algae, stiff. dull complexion, mouth purplish-blue today.[84]

In the final panel, however, such physiognomic and sartorial details are generalized to produce a nursemaid type. The same can be said for the elderly woman dressed in black in the panel to the right of that with the gossiping nursemaids, *The Red Sunshade* (pl. 78). She, too, is a particular social type found in popular literature and can be compared with a slightly later photograph of "an elderly woman with a mysterious past" (pl. 96), used to illustrate a lengthy article in the popular *Revue Illustrée* on the different kinds of "dames du Luxembourg."[85] She may also be, as has been suggested, the signifier of "Old Age" in a triptych reading from left to right as the stages of life.[86] Although a narrative is suggested by these panels, the thin, black, inverted contour of this elderly woman, her bowed head withdrawn beneath her sunshade is a dramatic contrast to the hatless, talkative figures enjoying the sunlight in the adjacent panels. As a decorative device, too, her L-shaped form serves to close off the triptych.

The many studies of women in walking-dresses and hats that Vuillard made in his journals and sketchbooks between 1893 and 1894 reflect his particular interest in the ornamental quality of the feminine arena – a prejudice he realized worked against his appreciation of the male figure:

I ought to have had a varied multitude of objects represented in my paintings, but I never put men into them, I realize. On the other hand, when my purpose tends to men, I always see terrible caricatures [*d'infâmes charges*]; I have the feeling only of ridiculous objects. Never [so] in front of women, where I always find a way to isolate a few elements that satisfy the painter in me. But the one is not uglier than the other – only in my imagination.[87]

Vuillard continued this entry with a discussion on the relative merits of the picturesque and the merely ordinary, and on the role of the imagination:

In truth, it is not so much the observations that I *don't* make about this or that subject (the chosen group, for example, landscapes and other things, quite apart from last year's work and small paintings), as it is imagining them that seems difficult. When I want to imagine a composition for the Natansons, for example, I can think only of feminine objects. That is somewhat embarrassing and proves that I am not indifferent to the subject.[88]

Having reasoned through his bias towards feminine imagery, Vuillard then defended himself with another remark that argues against any such predisposition:

These days, in front of landscapes, trees, and variegated, notched, and carved foliage, I have thought about combining them. This tells me that it is not woman herself that I admire when I want to compose, because I have this same feeling when contemplating other objects.[89]

After a lengthy rumination on the pictorial potential of a given motif, he concluded that the important thing for his art was that, no matter what the subject, the choice of that subject be based on firsthand observation:

However, as I have confidence only in ideas and reasons when they are controlled by direct impressions from nature, I must be nourished with new observations from real life. I have tried this and I'm surprised by the possibilities for discovery revealed to me.[90]

The predominance of the female as the object of observation in his work was not unique in the iconography of the 1890s, especially among the Nabis and symbolists. Most of the special lithographs that Thadée commissioned between 1893 and 1894 for *La Revue Blanche* showed women alone, with other women, or with children.[91] The absence, whether emotional or physical, of the male figure was a phenomenon also explored in the theater of Ibsen and Strindberg, whose domestic dramas such as *The Wild Duck* and *The Father*, respectively, dealt with paternity questions, pitting the female of the household, with her children as virtuous weapons,

96 *The Old Woman with a Mysterious Past* (*La Vieille dame au passé mysterieux*), vignette illustrating article by Hamon, "Les Dames de Luxembourg," *Revue Illustré*, 1904.

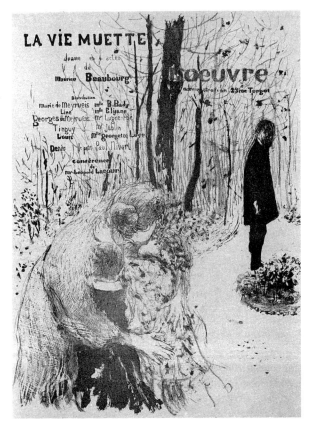

97 Edouard Vuillard, *The Wordless Life* (*La Vie muette*), program for the Théâtre de l'Oeuvre, 31 × 23 cm., Smith College Museum of Art, Northampton, Ma.

57

100 Edouard Vuillard, sheet of studies I for *The Public Gardens*, pen and ink touched with pastel. From left to right: 1-A *The Walk*; 1-B unidentified; 1-C *Asking Questions*; 1-D *Little Girls Playing*; 1-E *The Two Schoolboys*; 1-F *Under the Trees*; 1-G installation plan.

101 Edouard Vuillard, sheet of studies II (left half) for *The Public Gardens*, pastel. From left to right: 2-A *The Nursemaids*; 2-B *Conversation*; 2-C *The Red Umbrellas*.

and by the most recent and definitive study (which included several unpublished drawings) as nine panels and two overdoors.[108] According to the available evidence, the panels were installed on the *rez-de-chaussée* in the Natansons' salon or dining-room.[109] Jean Schopfer, another art commentator and an important future patron of Vuillard, described the panels as part of a "decoration of an entire drawing-room on canvas, with size colors,"[110] and Jacques-Emile Blanche referred to them as paintings that "light up the dining-room wall better than the gayest *voiles de gênes.*"[111]

Unfortunately, the rooms of the current residence have been substantially altered, so the exact disposition of the panels cannot be known. In her study of the commission (*Revue du Louvre*, 1979), Frèches-Thory published for the first time a revelatory notebook page of sketches in pen and pastel discovered in the Vuillard Archives of Antoine Salomon (pl. 100).[112] The sketches showed various preliminary ideas for the panels: from left to right, *The Walk* (1-A); an unidentified panel (1-B); *Asking Questions* (1-C); *Little Girls Playing* (1-D); *The Two Schoolboys* (1-E); *Under the Trees* (1-F); and a plan for the installation (1-G). A second notebook page, folded in four, included Vuillard's plan for the installation with the basic colors sketched in pastel (pls. 101, 102). Most useful is the small diagram in the upper right of the

sheet of pen-and-ink studies which indicates the placement of panels and identifies each panel by width. One knows, for example, that Vuillard intended the panels to be installed on each of the four walls of a large rectangular space containing a doorway and a large window or *porte-fenêtre* on the smaller walls (pl. 103). Given the large dimensions of the panels, and comparing them with the substantial rectangular surface indicated in Vuillard's drawings

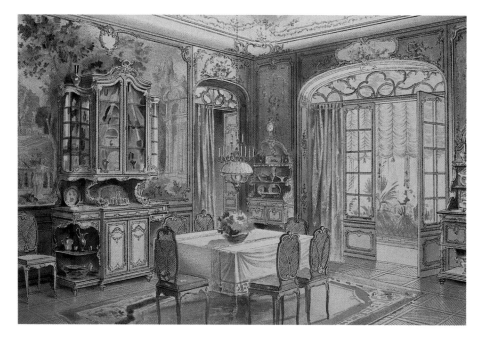

104 A. Simoneton, *Modern Dining-Room* (*Salle à manger moderne*), *c*.1891, *La Décoration Intérieur* (1894–5), plate xiv.

105 Photograph of Paul Durand-Ruel's dining-room on the rue de Rome with panels by Monet, 1883–5, Durand-Ruel Archives, Paris.

communion – even more so than the drawing-room – and modern society has, generally speaking, thoroughly grasped this fact ... While this dining room is, in reality but one apartment, it is composed of three rooms entirely separated from each other by tapestry curtains. The room which one enters first is that in which the meals are served. When the repast is at an end the company passes through the hangings to the end of the room, where the men remain to smoke, while the ladies proceed immediately into the third room, in which tea, coffee, and liqueurs are served.[114]

Understandably, only a small segment of Parisian society could afford or allow themselves to arrange their interiors in such a manner. Mazade, for example, illustrated his article on the "modern" dining-room with photographs of the Renaissance-style dark-paneled and sideboarded dining-room that had been in vogue since Balzac's time. Other interiors featured in prints, magazines, and books promoted the aristocratic ambience of the leisured connoisseur and showed invariably the semi-private and male areas of the house, such as libraries, studies, or *ateliers*.[115] Dining-rooms and salons were rarely featured, perhaps because they represented the reception, and therefore public, rooms where formality and convention would most likely be maintained.[116] As Anne Martin-Fugière has pointed out in her study of the bourgeoisie in nineteenth-century France, the upper-class bourgeois woman was not likely to tolerate such extremes of styles or eccentricities of tastes in her household. These were reserved for the bachelor and effete, or for the lower classes and *mondains*.[117] Lacking a national style, the typical bourgeois *parisienne* of the 1880s and 1890s would rely instead on albums with richly colored pull-out plates, such as Adrien Simoneton's *La Décoration intérieure* (1893–5), recommending French versions of period rooms (such as Gothic for the dining-room), or rooms with a Japanese or English flavor resulting from pasticing some of the more salient characteristics of each, such as fans, porcelains, and wallpaper designs (pl. 104).[118]

for the perimeters of the room (pl. 103), it is possible that the room was a dining-room with an adjoining *petit salon* used as a parlor or study, a combination not uncommon in Parisian apartments and houses.[113] As described by Fernand Mazade, a playwright associated with André Antoine's Théâtre Libre in 1893, the typical French dining-room of the *bonne bourgeoisie*, or upper middle class, in the last decade of the century was

pleasing to the eye and comfortable withal ... The dining room is the room for intimate family

The extent to which traditional styles of furnishings prevailed among upper-class and intellectual circles is confirmed by contemporary literature and memoirs from the nineties.[119] Prince André Poniatowski, related to the Natansons by marriage and Alexandre's neighbor on the avenue du Bois de Boulogne (where Vuillard and Bonnard visited him on 31 October 1894), described in his autobiographical account (*D'Un Siècle à l'autre*, 1948) the confusion caused by his choice of pictures:

the chairs and hanging were rather classical, the paintings and the drawings were by Renoir, Degas, Vallotton, Cottet, or Maufra, which led the numerous artists or literary men who visited us to smile when looking at our furniture, while the

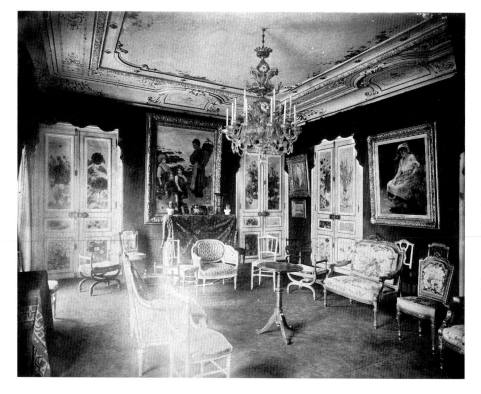

society people got heated up about our choice of paintings.[120]

The mixing of contemporary paintings with conventional decor was one way of retaining traditional French standards while embracing the new aesthetics. A similar combination of paintings with conventional interior decor could be found, for example, in the home of Paul Durand-Ruel, one of the first dealers for and champions of the impressionists, who commissioned Monet in 1882 to paint still lifes that were fitted into the eighteenth-century paneling of the doors of his salon and dining-room, respectively. While the Durand-Ruel ensemble (pl. 105) reflected the revival of the rococo aesthetic among promoters of the Decorative Arts Reform movement, it seems not to have been published during the nineteenth century, when its effects might have encouraged others to follow suit.

The tastes of Alexandre and his wife were decidedly old French. While it is possible that the presence of

Olga's mother, who continued to live with them after their marriage, may have discouraged any radical change in their inherited furnishings and décor, they seem to have fostered the association of their interior with a strong upper-class and traditional French aesthetic. Indeed, five years later the magazine owned and edited by Alexandre, the *Cri de Paris*, recommended the Louis-Quinze style as the best for a dining-room.[121] Their own dining-room seems to have held with tradition. Gide, visiting the avenue du Bois de Boulogne mansion by mistake in 1907, was given a tour of the house by its owner who made sure that Gide admired the *peintures* as well as the dining-room *panneaux*, "all sculpted out of pure wood" (without specifying whether these contained the large-scale decorative paintings).[122] In Bonnard's portrait of the four Natanson daughters (pl. 106), executed just before the Natansons moved from the avenue du Bois to a sumptous Second Empire residence on the Champs-Elysées, one sees either the salon or *petit salon*, decorated in elegant white and gold-trimmed *boiseries* in the richly carved Louis-Seize interior, which may be the sculpted panels referred to by Gide.[123] By contrast, a contemporary photograph of the painting *Asking Questions* (pl. 107) shows the painting hung in a room with unpaneled walls that were painted or papered with a solid light color. The paneled doors and high corniced ceiling visible in the photo seem the only vestiges of what may have once been a stricter adherence to the Louis-Seize style. As indicated by the photograph, *Asking Questions* was simply banded with a narrow wooden frame and affixed to the wall, about three and a half to four feet off the ground (judging by the height of the table on which were arranged photographs and a vase). To the left, a large *portière* covered a door. Another heavy curtain on the right may have been simply a decorative device used to divide the panels and break up the wall surface.

The nine panels (all approximately 84½ inches in height) were grouped in three pairs separated by windows, doors, and possibly a chimney, with the triptych of *The Nursemaids*, *The Conversation*, and *The Red Sunshade* placed on the long unbroken wall with edges almost but not quite touching.[124] Opposite it were *The Two Schoolboys* and *Under the Trees*. Flanking the dooway were *The First Steps* and *The Walk*, with *Little Girls Playing* and *Asking Questions* on the opposite wall, on either side of a large double window. Vuillard's pen-and-paste drawing for *Asking Questions* (pl. 100, 1-C) reveals that he originally conceived the woman to face outwards, reversing this figure in the final painting so that she leans inwards to form parentheses with the companion panel, *Little Girls Playing* (1-D).

Reconstructing the ensemble according to Vuillard's specifications, one sees that the panels were grouped according to their decorative elements to link them visually if not physically. For although the pendants could be easily fused to form a diptych

106 Pierre Bonnard, *The Four Natanson Daughters*, 1908, oil on canvas, 124 × 139 cm., private collection.

107 Photograph of *Asking Questions*, 60 avenue du Bois de Boulogne, before 1908, Salomon Archives, Paris.

108a and b Edouard Vuillard, *Landscape (Paysage)*, *c.*1894, distemper on canvas, Donation Baderou, Musée des Beaux-Arts de Rouen.

and continuous scene, Vuillard intended them to be spaced at quite a distance. The sheet of pastel studies (pls. 101 and 102) indicates not only the artist's plans for the installation, but also the way the colors would work together. This sheet is doubly important, since it provides a miniature *ébauche* for the lost panel, *First Steps* (102, 2-E), known only by a black-and-white photograph published in the catalogue for the sale of Alexandre's collection in 1929.[125]

The overdoor panels mentioned in Segard's inventory and several times in Vuillard's journal entries for 1894 have never been identified in the Vuillard literature. Nor were they included in the 1929 sale or in the second sale in 1934, when the last of the panels were dispersed.[126] That these were originally part of the decorative project can be seen in the photograph of the panel, *Asking Questions* (pl. 107), where the bottom edge of another panel, presumably of foliage, is visible. On 6 November 1894, Vuillard noted having "worked on the overdoors all morning" and having finished two panels on the Friday of that week.[127] Two horizontal panels painted *à la colle* with dimensions approximating an overdoor (pl. 108) have the same motifs of foliage broken with patches of sky and may have been part of the Natanson ensemble.[128] A case can be made, too, for a set of very curious vertical panels, signed and dated "Vuillard 1901" in a Paris private collection (pl. 110).[129] Turned horizontally, the panels depict the same branches, leaves, and sky that top the panels *Two Schoolboys* and *Under the Trees*. Indeed, what seems an unusual horizontal spreading of branches for the overdoor seen in the photograph of the Natanson interior becomes readable when placed horizontally above the vertical panels whose palette, technique, and composition closely match that of the vertical diptych. Whether these are datable to 1894 or were done at the time of the second installation in 1908, when Vuillard recorded working on "dessus des portes," cannot be determined from the existing documentation. It is possible that Vuillard signed and dated them at a later date, changing their format so that they could be sold as pendants.[130]

While Vuillard's journal entries indicate that he held several informal showings of the panels in his studio before their installation, the formal inauguration of the panels was an expensive soirée hosted by Alexandre and Olga in February 1895. For this event, Alexandre hired Toulouse-Lautrec to design the invitations (which *Le Figaro* nastily predicted

109 Henri de Toulouse-Lautrec, *An Invitation for Alexandre Natanson*, 1895, lithograph, printed in black, 34.0 × 17.9 cm. (sheet), The Mr. and Mrs. Carter H. Harrison Collection, The Art Institute of Chicago.

would be written in Hebrew) and serve as bartender for the "American Bar" (pl. 109).[131] Vuillard recalled the guests at the soirée as being so involved with drinking and talking that they failed to notice his paintings on the walls. Far from being an insult, this was taken by Vuillard as a great compliment and a sign that his *décorations* were a success, since they did not impose themselves on the surroundings but maintained, as he remarked, citing Degas's phrase, "cet air irrespirable."[132] Even the symbolist poet Mallarmé, unable to attend the inauguration party, was inspired by these "évocations" when he saw them shortly afterwards. Writing to the artist in uncharacteristicly simple prose, he said,

> I have seen the panels of the avenue du Bois. I am disgusted with myself for not having found an hour's time to see them before. I need, I have an absolute need to tell you how happy I am to have seen them and how deeply you have moved me . . . I cannot say more.[133]

Reinstallation, 1908

In the spring of 1908, Alexandre moved his family into the fourth-floor apartment of a former *hôtel privé* on the Champs-Elysées.[134] As Gide remembered, Alexandre took him there shortly before the family's move to show off his latest residential purchase:

> Going down the Champs-Elysées – he had me admire the old Hôtel Dufayet that he had just bought and where he is creating an underground theater – a house on which he's spending 700,000 francs – which, he pointed out, "is not a trifle." However, he was extremely kind. But with him, I don't know quite how to act – but I do know that I cannot be natural."[135]

That year, Vuillard was called in to reinstall the panels in their new location in a gallery described by Annette Vaillant as a "miniature galerie des glâces."[136] At this time, Vuillard seems to have made a set of overdoors, adding to the other (still unidentified) set from the earlier commission.[137] Writing in his journal for 20 May, he noted that he was working "fervently and irritably" on the panels for Alexandre, studying old drawings, photographs, and journal notes from 1894 to remind himself and to recapture the "analogous disposition for the thought process, [a] good state."[138] Implicit in this is Vuillard's need to remember the situation and the inspiration behind the panels in order to redo them some fourteen years later.

The second installation of panels and overdoors was finished by December 1908. Attending a "sumptuous" dinner party at the Natansons on 15 December, Vuillard could admire at last the "bon effet" of his paintings.[139] In this new location, the panels functioned differently, but were no less modern, and were admired by a younger generation of artists, including Jacques Copeau, Raymond Radigot, and Francis Poulenc.[140] By 1913, Alexandre was already thinking about selling the panels, in view of his impending move to a smaller apartment on the avenue de Courcelles.[141] For whatever reasons, the panels were not sold and moved to this new apartment in 1914. The absence of journal comments regarding this move suggests that Vuillard was not involved with the reinstallation. In 1929, all nine panels (but no overdoors) were put up for auction in the sale of Alexandre's collection, when the triptych was purchased at 200,000 francs for the Musée de Luxembourg.[142] Curiously, these were not exhibited as "panneaux décoratifs," nor was there a mention of

their original setting as there was for Vuillard's two decorative paintings also offered in the auction, *The First Fruits* and *Window Overlooking the Woods*, painted for Adam Natanson (see pls. 196, 197).[143]

Although Vuillard never reused the theme of public gardens for a decorative project, the series for Alexandre Natanson was a significant achievement. In these panels of children and parks he further defined his conception of the decorative and the themes appropriate to it. Denis, the other successful *peintre-décorateur* from the Nabi group in the 1890s, had created ceiling paintings for Henri Lerolle and for Lerolle's brother-in-law Ernest Chausson, but Vuillard's nine-panel, large-scale project was an even more ambitious undertaking.[144]

Despite their imposing scale and number, the sky-blue and sea-green tapestry-like qualities of the *Public Gardens* series would have met his own criteria that a *décoration* be neither too literary nor "objectively too precise." The subjects of women and children at play would also have been in keeping with the admonitions of Charles Blanc, Edith Wharton, and other aestheticians of interior design, such as Henry Havard, who recommended for the dining-room "paintings of a high quality and subjects easy to understand," or Mazade, who endorsed pictures of bright and light tints, "calculated to charm and enliven, rather than to instruct or to stir the feeling."[145] These painted "évocations" of city parks would have provided a delightful eating and family space for the Natanson girls and their friends. Like Monet's decorative still lifes of flowers and fruits painted on canvas and fitted into the ornately carved doors of Paul Durand-Ruel's dining-room (pl. 105), the scenes of promenades and playtimes in sunny public gardens would have been appropriate illustrations for the Natanson children, as well as modern, nostalgic, and flattering (because of their aristocratic connotations) for Alexandre and his wife.[146]

Of all his early projects, Vuillard's panels for Alexandre were the most viewed and are arguably his most successful in this genre, embodying a consistency of technique and idea that he attempted to regain in future decorative projects.[147] As he would do with many of his early decorative projects, Vuillard reassessed these works in light of his current situation throughout his career. In July 1936, four months after Alexandre's death, looking at the early sketches and notes that he had used for the panels, Vuillard was struck by the "spirit of 1891–4" that had guided their creation.[148]

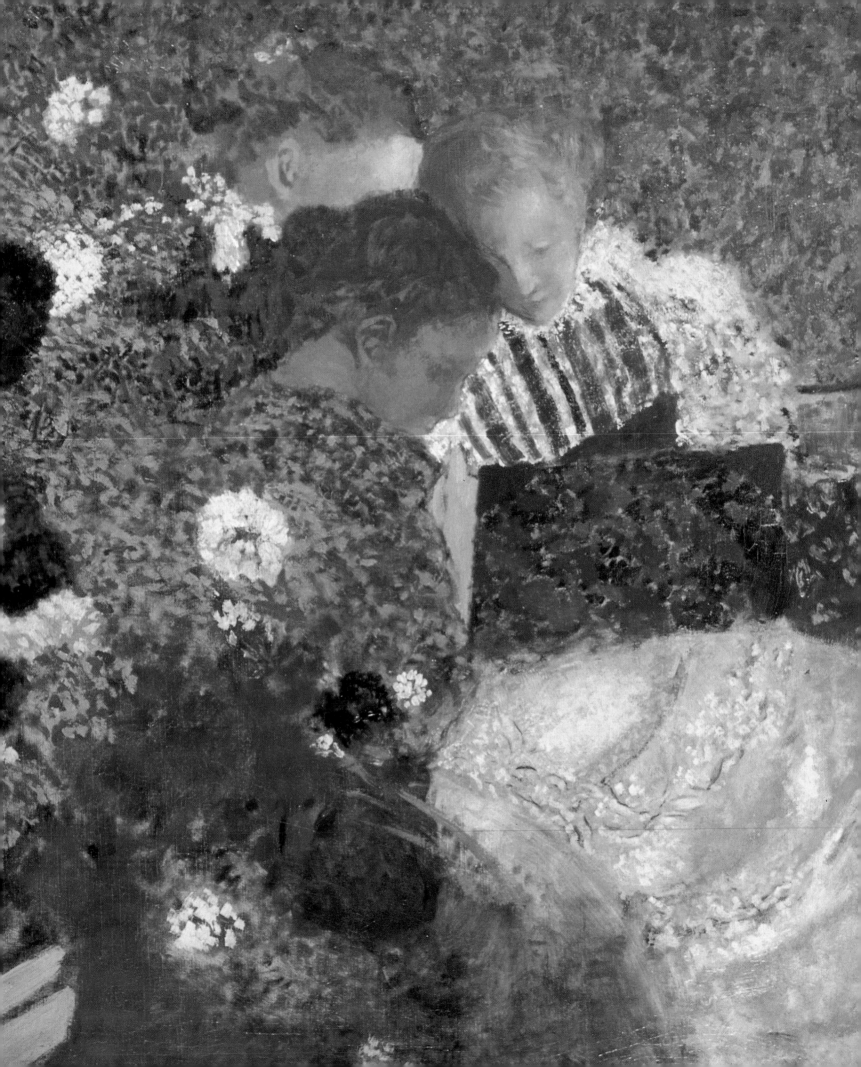

4 Feminine Elegance and Flowers: The Decorative Projects for the Thadée Natansons and Dr. Vaquez, 1895–1896

The Thadée and Misia Natanson Commission, 1895

Soon after completing the *Public Gardens* panels for Alexandre and Olga, at the end of 1894, Vuillard began work on another series of decorative panels for Thadée and Misia. Known collectively as *The Album* (*L'Album*), the panels depicted women and flowers. Their exuberant colors belied the artist's current personal problems, caused by his sister's difficult pregnancy and precarious health, which had put his family under great strain from November 1894 until well into the next year. Writing to Alfred Natanson in November 1894, Vuillard spoke candidly of his fears and anguish: "My poor sister has suffered a serious [health] crisis, and we have been on the brink of thinking her lost. She's a little better now, but not completely out of danger... I've gone through a terrifying crisis of devastation and revolt against people and things."[1] In the spring of 1895, he again wrote to Alfred that he was doing nothing except watching the leaves fall, and that after the disaster of a breached trust – possibly related to a romantic disappointment – he was finding it difficult to have the courage to work and socialize:

> Do you know what its like to have been as confident as possible, then suddenly not to have those points of certainty that one had assigned to oneself, to see how much one was mistaken not to have seen everything as relative to something else, and that especially, when dealing with matters of the heart.[2]

Apart from these cryptic remarks, however, one knows little about the personal crisis. Vuillard's journal summary of the important events for 1895, moreover, begins not with a reference to himself, but to his sister's marriage ("complications du mariage Roussel").[3] The "complications" referred to were probably as much due to Roussel's extramarital ac-

tivities as to Marie's illness – a supposition supported by another remark for 1895 made at the end of Vuillard's Notebook I (1907–8) concerning the "difficultés de Ker."[4]

In his sketchbook datable to 1894, Vuillard's pen-and-ink drawings show his brother Alexandre, his mother, and Roussel in various states of sitting,

111 (facing page) Detail of pl. 114.

112 Edouard Vuillard, page from the *Cahier Saint-Honoré*, showing medical paraphenalia.

waiting, or conversing with the doctor (pl. 112).[5] Included in these vignettes are a variety of objects, such as the bedsheets, blankets, and doctor's paraphernalia, which Vuillard must have had ample time to examine during this period.[6] He was a keen observer of the details of domestic life, and the comments in his journal at this time reveal his sensitivity towards the class distinctions reflected in such details. Like Delacroix, whose aesthetic principles he admired, he perceived that the modesty of his domestic situation held a special meaning for him. An illuminating comparison can be made between the ardent feelings both artists had on the subject of the "humble" as a credo for their art and life. In his journal entry of 18 May 1850, for example, Delacroix justified his preference for an unpretentious life-style:

But the fact of the matter is that I like living in a modest sort of way. I loathe and detest show and ostentation; things do not appeal to me when they are new; I like old houses and old furniture; I like the place where I live and the things that I use to speak to me of all they have been and seen, and of the people and events that they have known.[7]

Vuillard enlarged upon this idea in an important journal entry for October 1894, describing the objects in his bedroom, their associative and decorative possibilities, and the aesthetic satisfaction he derived from them:

This morning in my bed, upon wakening, I was looking at the different objects that surrounded me, the ceiling painted white, the ornament in the middle, with vaguely eighteenth-century arabesques, the mirrored armoire opposite, the grooves, the molding of the woodwork, of the window, their proportions, the *curtains*, the chair in front of them with its back of carved wood, the paper on the wall, the knobs of the open door, glass and copper, the wood of the bed, the wood of the screen, the hinges, my clothes at the foot of the bed; the four elegant green leaves in a pot, the inkwell, the books, the curtains of the other window, the walls of the court through it . . . When it comes to the curtains, differences and patterns obtained by the greater or lesser spacing of the threads. Comparing the qualities of each of these objects to that alone I feel pleased. Then I was struck by the abundance of ornament in all these objects. They are what one calls in bad taste, and if they were not familiar to me they might be unbearable. It's an opportunity to think about this label "in bad taste" that I am quick to say and that keeps me from looking. There I was *looking* and nothing shocked my nerves on the surface; I took an interest in each of their qualities, and that was enough to push away distaste.[8]

The passage reveals also the artist's concern for intuitive more than descriptive observation of objects.[9]

Later in the same entry, Vuillard stated his conviction that one should not be swayed by the impression of a thing, be it vulgar or beautiful, but by its essential character, which is the more difficult quality to assess.[10] The passage concludes with a reiteration of his interest in the pictorial potential of the inanimate and animate making up his immediate surroundings:

Truly, this morning the result of all these observations wasn't distaste, [but] an acceptance that, if stronger, might have given me even more fertile ideas. And another thing, in the middle of all these objects, I was astonished to see Mama enter in a blue *peignoir* with white stripes. To sum, not one of these inanimate objects had any simple ornamental connection with another, the whole was as disparate as possible. All the same, there was a vivid atmosphere, and it gave off an impression that was not at all disagreeable. The arrival of Mama was surprising – a living person. For the painter, the differences of shapes, of forms, were of interest enough.[11]

As if to illustrate this passage Vuillard made several sheets of studies (pl. 113), showing his mother at the bureau, a chair "with a carved wood back," a profile of Roussel, and other details of the wallpaper and doorknobs that he had reappraised in writing. It is, in fact, Vuillard's exploration into the nature of ordinary things that invites the viewer's reflection upon the extraordinary character of his works. Certainly, it is this quality that resonates in Vuillard's

113 Edouard Vuillard, page from journal, MS 5396, *carnet* 2, Bibliothèque de l'Institut de France, Paris.

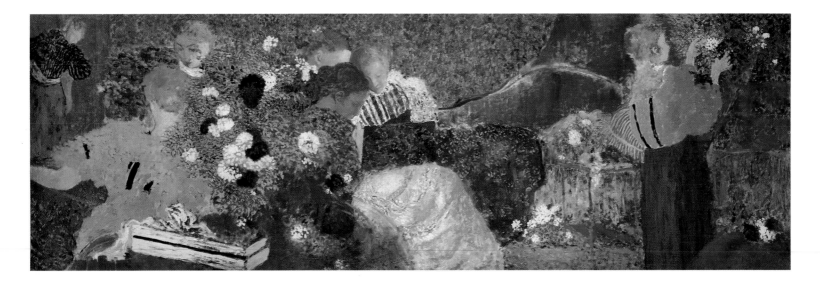

interior scenes in the 1890s which are dominated by his mother's workspace and the rue Saint-Florentin apartment of Thadée and Misia. After his own interior on the rue Saint-Honoré, in fact, it was the Natansons' unconventionally exotic, comfortable, and carefree salon, frequented by a wide social circle of writers, artists, and musicians, that is most often represented in his paintings, pastels, and lithographs. And it was for that same fourth-floor apartment that he painted the *Album* panels.

The Commissioners: Thadée and Misia Natanson

Unlike his first project, *The Park*, completed for the Natansons in 1893–4, in the five panels completed in 1895, Vuillard returned to oil and worked on smaller but dissimilar formats. As a series, these share only the general theme of interiors with young women and flowers vying with the floral patterns of the wallpaper backgrounds, without the repetitive motifs and continuous linear and textural elements linking the *Public Gardens* panels. The two rectangular panels, *The Stoneware Vase* (*Le Pot de grès*) (pl. 115) and *The Vanity Table* (*La Table de toilette*) (pl. 116), have the same dimensions and can be considered the only pendants of the set. These, together with the largest panel, *The Album* (*L'Album*) (pl. 114) and smallest panel, *The Striped Blouse* (*Le Corsage rayé*) (pl. 118), have titles descriptive of the particular feminine accessories represented.[12] The exception is the vertical panel, *The Embroidery* (*La Tapisserie*) (pl. 117), whose title alludes to the activity performed by two women seated near an open window.[13]

It is conceivable that Vuillard's choice of a collective title derived from the album of prints published that year by the Editions du *Revue Blanche*, containing frontispieces by Roussel, Denis, Ranson, Bonnard, Vuillard, Vallotton, and Toulouse-Lautrec which had appeared in the magazine from July 1893

to December 1895.[14] If so, his choices of format and loosely connected themes may have been intended to resemble a portfolio arrangement, wherain individual prints with a general rather than specific connection are brought together. But this would not explain why Vuillard, who had recently won acclaim for his ambitious, large-scale series of women and children in city parks, returned to the more overtly decorative theme of women and flowers in interiors. What is the significance of the choice of subjects for the artist and for his patrons, and how did these paintings of unequal size and only loosely related subjects find accommodation as *décorations* within the Natansons' apartment?

For the *Album* project, Vuillard had the advantage of great familiarity with both the interior and inhabitants.[15] Given the fact that the Natansons were not only his intimate friends and patrons, but influential members within advanced art circles, it is likely that Vuillard's decisions concerning the subject, format, and palette were made in consultation with them. As art editor and co-owner of *La Revue Blanche*, Thadée had become a well-known and controversial figure in the Parisian social network. In 1894, after the trial of the supposed anarchists, the "Procès de trente," he had hired the acquitted Félix Fénéon to head the magazine's editorial department – a move that strengthened the magazine's ties to the liberal left.[16] In fact, the magazine came to be associated with the youthful, primarily Jewish intelligentsia, a kind of "Jérusalem nouvelle," as Pierre Véber jokingly referred to it.[17] Despite Fénéon's appointment as editor, after 1894 the magazine was more *mondaine* than political, and its major artistic promotion was devoted to the younger artists from the Nabi milieu.[18] Well aware of that bias, Camille Pissarro complained in a letter to his son, Lucien, that the magazine, which he termed the "organ of the new generation," supported only the younger artists ("the Yap").[19] While Pissarro, himself a Jew, could not be accused of racism in his remarks, the same

114 Edouard Vuillard, *The Album* (*L'Album*), 1895, oil on canvas, 65 × 306 cm., private collection, California.

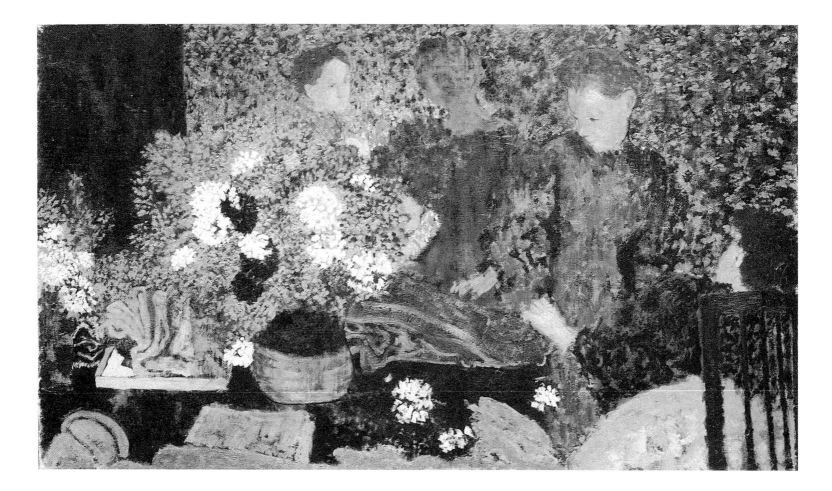

115 Edouard Vuillard, *The Stoneware Vase* (*Le Pot de grès*), 1895, oil on canvas, 65 × 116 cm., private collection, Paris.

cannot be said of Henri de Berenger's description of the same "organ" as "the Jewish-university group," representing "the latent sophistry of a Sorbonne education and all the double-sidedness of the Jewish mentality."[20] The fact that the Natansons' publication was so successful (allowing them to move its offices from the rue des Martyrs to the more desirable rue Laffitte within a year after it had opened) provoked further resentment and perhaps prompted Edmond de Goncourt's suspicion, recorded in his journal for 26 January 1896, that Jewish writers were using their critical views as a kind of blackmail: "One can well imagine, that with the help of their elders who provide the money for almost all newspapers, they will control French literature within twenty-five years."[21] Although de Goncourt's remarks are not specifically directed to the Natansons' review, his mention of patriarchal support comes close to describing the financial set-up that made possible the Natansons' publication.

Equally well known and controversial was Misia, who was fast becoming the magazine's darling. Not only did she involve herself directly with the editorial process and selection of artists and writers, she held informal soirées on Thursday evenings at her apartment, the "annex," for contributors and subscribers. The room in which these were held served as reception hall, music-room, and office and was a far cry

from the gold-and-white elegance of her brother-in-law's *hôtel* on the avenue du Bois de Boulogne. Misia made of point of not emulating the older Natansons' reserved formality and conventional manners. Just as she had disdained her "respectable" cousin, Mme Desmarais, for refusing to lend her money towards the purchase of a painting by Renoir, so she was unwilling to tolerate the conventional manners of the boring *bon tons*. At her soirées she cultivated the talented and the entertaining for her edification and amusement.[22] Even Proust, a contemporary of Thadée and one of the early contributors to *La Revue Blanche*, regarded the Natansons' apartment as exotic but forbidden territory (although he seems to have used Misia as one of the models for the music-loving Mme Verdurin in *A la Recherche du temps perdu*).[23]

The efforts of Thadée and Misia to champion the Nabis was particularly directed towards the "non-religious" or "secular" Nabis – Bonnard, Roussel, Vallotton, Vuillard, and their friend, Toulouse-Lautrec.[24] Reciprocally, these artists elevated the Natansons' status in the art world by portraying them in their paintings, posters, and prints throughout the 1890s. One of the best known of these, Toulouse-Lautrec's four-color poster advertising *La Revue Blanche*, showed a more mature vision of Misia as "la femme nouvelle" – active, public, and mobile –

wearing a green-and-red polka-dot and fur-trimmed skating outfit (pl. 119).[25] Although Vuillard never produced a poster for the magazine (as did Bonnard, for example), he was, as shown, the first to receive an invitation to exhibit in its editorial office at the end of 1891, the first to make a frontispiece print for it (July–August 1893), and the only Nabi artist asked to execute large-scale decorative paintings for the owners' apartment.

The Panels: Women and Flowers as Decoration

Vuillard's choice of women and flowers, seen in all five of the panels (although less prominently in the vertical panel, *The Embroidery*), adhered to the conventional relationship between females as preferred subjects for decoration and the distinctly nineteenth-century metaphor of women as bouquets. At the beginning of his journal entry for October 1894, in which he expressed his enthusiasm for the pictorial potential offered by his immediate environment, he remarked upon the dangerous facility of finding the ornamental in flowers:

> On the table at noon the chrysanthemums, violet and white. An ornamental motif that is at once serious and pleasing. Decoration for a desk.

Flowers after all are a common, simple ornament, I don't mean to say that I scorn them, but they don't demand much effort to grasp their appearance, their forms and colors; it's properly the true natural ornament. Their ornamental sense is primitive, simple, interesting enough in the quality of their forms and colors: quite on the contrary a painting, which is also made up of forms and colors, demands of the spirit that contemplates it a more complex effort of the imagination. For other objects – a figure, a pot, for example – their ornamental interest is less brutal, there are no vivid colors, no multiple repetitions of like forms (like petals). What danger there is in attaching more importance to ideas than to the cause that gives birth to them.[26]

Vuilllard's thematic choice of woman and flowers, "the true natural ornament," may also have evolved from the porcelain service he had executed in April–May 1895 using similar subjects of fashionable young women surrounded by floral motifs. The service had been commissioned by the Swiss-born Jean Schopfer (1866–1931), former tennis champion, journalist, art critic, and regular contributor to *La Revue Blanche*.[27] Vuillard would have known Schopfer earlier, either at the Lycée Condorcet (where he was in the class ahead of Vuillard) or at the salon he hosted after 1890 with his brother on the quai Voltaire, frequented by

116 Edouard Vuillard, *The Vanity Table* (*La Table de toilette*), 1895, oil on canvas, 65 × 116 cm., private collection.

117　Edouard Vuillard, *The Embroidery* (*La Tapisserie*), 1895, oil on canvas, 176 × 65 cm., John Hay Whitney Collection, Museum of Modern Art, New York.

118 (facing page)　Edouard Vuillard, *The Striped Blouse* (*Le Corsage rayé*), 1895, oil on canvas, 65 × 58 cm., Collection of Mr. and Mrs. Paul Mellon, National Gallery of Art, Washington, D.C.

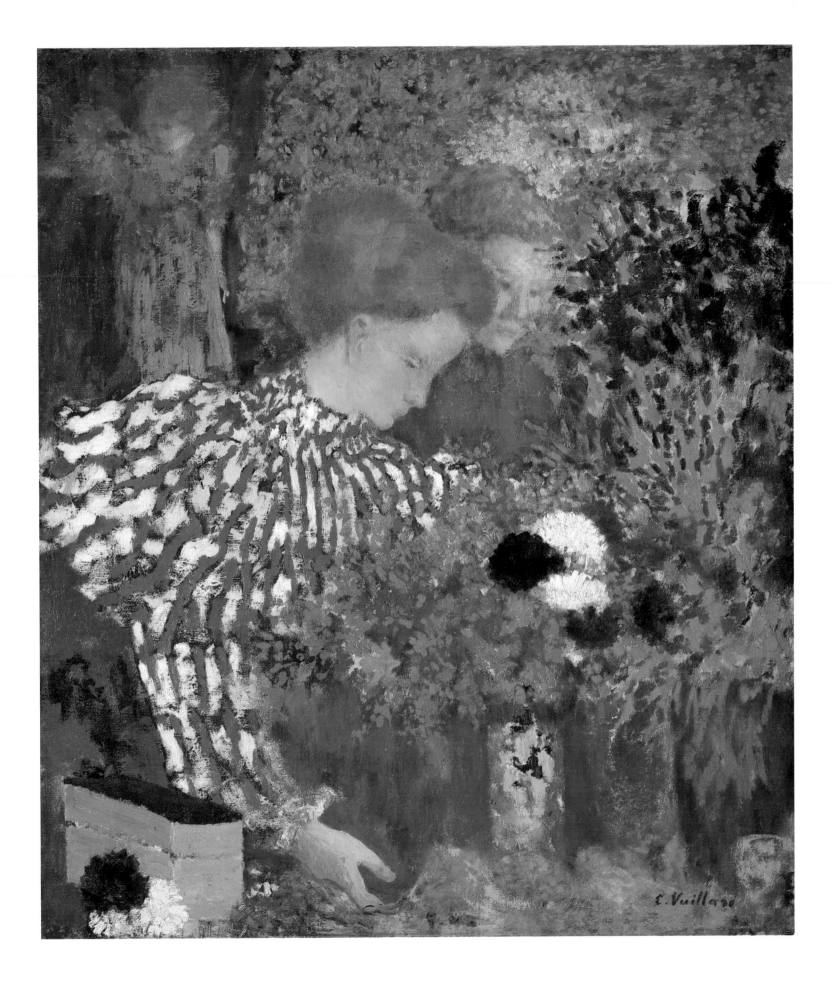

careful not to treat them as might have done a portrait painter or a designer of fashion plates. He has only taken so much of them as can be taken for decorative purposes.[30]

Examples from each of the eight sets had been showcased two years earlier in the dining-room designed by Henry van de Velde for the "Maison de l'Art Nouveau" which the Japanese art expert and entrepreneur Samuel Bing had opened in December 1895 (pl. 124).[31] Also displayed at the inaugural exhibition were Vuillard's five panels for *The Album*, in what was described as a "small antechamber."[32] Vuillard's invitation to exhibit existing works and to collaborate on the interior decoration in Bing's international shop-cum-gallery may have been the result of his earlier and highly successful collaboration with Bing to design a stained-glass window to be

Thadée, Romain Coolus, Lucien Muhlfeld, Pierre Veber, Léon Blum, Tristan Bernard, and others from the group that would later visit the Natansons' "annex."[28]

The commission for the ninety-six-piece porcelain service required Vuillard to make eight different groups of watercolors which were transferred onto plates, saucers, gravy-boats, and platters by the painter and ceramist Georges Rasetti (pls. 120, 121).[29] Basically, the designs consisted of full- or half-length female figures in the center of plates or platters with borders of floral motifs or variations on striped and stippled patterns derived from the figures' blouses and dresses (pl. 121). Vuillard's feminine imagery ranged from young ladies seen in *profil perdu*, coyly peeping out from bouquets of flowers, to more salacious depictions of almost bare-breasted women similar to Manet's half-length portraits of women with flowered hats or against floral backdrops (pls. 122, 123). Writing in 1897 on "Modern Decoration" for the American review, *The Architectural Record* (an opportunity no doubt resulting from his new transatlantic connection that followed his marriage in 1895 to the American Alice Nye Wetherbee), Schopfer saw them as a successful response to the challenge for artists to find modern equivalents for traditional decorative art (pl. 121):

For the central motive [sic] of the decoration he has taken women – not Louis XVII shepherdesses, but women of the present day. He has, however, been

121 Two of the decorative porcelain plates commissioned by Jean Schopfer, *c.*1895, *The Architectural Record* (January-March 1897).

executed by Tiffany's of New York.[33] Vuillard's design for this project, *The Chestnut Trees* (*Les Marronniers*) (pl. 125), combined the subject of children and parks with a bird's-eye view of the city square that he would use in later decorative ensembles.[34] His and the other glassworks by the Nabi group commissioned by Bing were exhibited in the Salon des Indépendants in April 1895. Reviewing the exhibition for *La Revue Blanche* that spring, Jacques-Emile Blanche admired both these works and the artists who made them, concluding: "Among so many temperaments sharing this unconscious love of ornamentation, one could find perhaps a formula for the freshest and the highest art for contemporary life."[35]

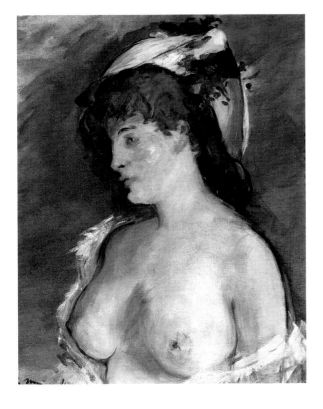

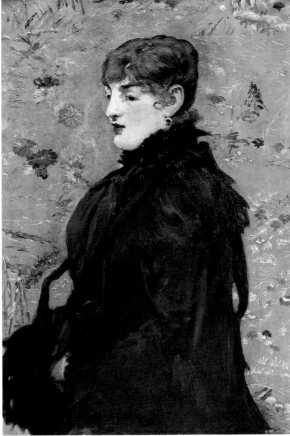

It would be interesting to know exactly when Vuillard received the invitation to participate in the room display for Bing's December opening, and if,

122 (far left) Edouard Manet, *Blonde with Bare Breasts* (*La Blonde aux seins nus*), *c.*1878, oil on canvas, 62 × 51.5 cm., Musée d'Orsay, Paris.

123 Edouard Manet, *Autumn: Study of Meryl Laurent* (*L'Autumne: Etude de Meryl Laurent*), oil on canvas, 72 × 51.5 cm., Musée des Beaux-Arts, Nancy.

124 Photograph of the dining-room at Samuel Bing's "Maison de l'Art Nouveau," showing decorated porcelain service by Vuillard, 1895.

125 Edouard Vuillard, *The Chestnut Trees (Les Marronniers)* Design for a stained-glass window, 1895, distemper on artist's board, 110 × 70 cm., Josefowitz Collection.

in fact, the panels for *The Album* were originally conceived with the gallery interior, as well as that of the rue Saint-Florentin apartment, in mind. Vuillard claims to have finished the panels for Thadée and Misia in November of 1895.[36] Curiously, his journal chronology of important events for the year makes no mention of either Bing or his much-publicized exhibition. Also surprising, given the elaborate criticism or praise directed at the rooms decorated by Henry van de Velde, Henri Ibels, Paul Ranson, Denis, Albert Besnard, and others, was the scarce mention of the small room presumably dominated by Vuillard's five panels.[37] Edmond Cousturier's review of Bing's inaugural exhibition, published in the Natansons' magazine, referred to the panels only as "scenes of women in interiors," of muted and subtle harmonies.[38] Arsène Alexandre remarked that Vuillard's panels, "discreet and harmonious," were located in a room adjoining the oval salon (with the painted rotunda by Albert Besnard) and lit badly by an "absurd chandelier where giant flies turn, lighting us with their transparent *derrières*."[39]

Despite their varying formats and only loosely related subjects, the panels were perceived from the beginning as an ensemble. The five panels were the first of all Vuillard's decorative projets to be sold, however, and were listed in Segard's inventory as having been "separated into diverse collections," notably with Jacques-Emile Blanche and the dealer Jos Hessel.[40]

In the catalogue accompanying the sale of Thadée's collection in 1908, Fénéon described the paintings as a "series" revolving around the largest painting (pl. 114) whose essential characteristic was the concern for the "plastic value of the arabesque" and not the definition (*détermination*) of the objects: "The pleasure of naming the objects does play a role, no doubt, with the person who makes the images, but it is not the essential, which is abstract."[41] The abstract qualities that linked them to music were acknowledged by Thadée who described the paintings in 1897 as:

A muted symphony, where relationships never seen before harmonize and vibrate deeper and

deeper as they are contemplated – melodious outbursts, postures skilfully linked, composed according to those which were caught by his [Vuillard's] tenderness, and recalled by the memory that moved him. It is a brilliant profusion of colorful harmonious splendors upon which a tender soul drapes itself.[42]

Whereas Thadée glossed over subject matter to emphasize the Baudelarian/Mallarmean concept of synaesthesia (correspondences of senses – in this case the impression of color and the impression of music), Fénéon's entries for the individual panels offer straightforward (and thus more useful) information as to the number and location of each figure, and the "formal element particular to each," such as the "large black splotch broken only by a lively red arabesque" in *The Embroidery* (pl. 117), or "the yellow and pink clash of color at top right [and the] *tache* woven with red and beige" in *The Striped Blouse* (pl. 118).[43]

To some critics who had seen these panels over a decade earlier at Bing's 1895 exhibition, they had seemed confused and disjointed. Camille Mauclair thought Vuillard was heading in the wrong direction and compared his earlier works, those "small and exquisite japanizing canvases," to the present display of "several disjointed panels with no relationship to

76

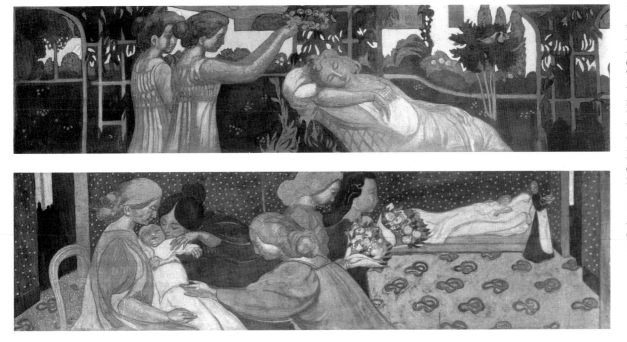

126 Maurice Denis, *The Announcement of the Engagement (La Couronne de Fiançailles)*, 1895, distemper on canvas, 52 × 197 cm. This and *The Birth* (pl. 127) were studies for the murals making up the bedroom suite "Lives and Loves of a Woman," exhibited at Bing's "Maison de l'Art Nouveau," December 1895. Le Musée départemental du Prieuré, Saint-Germain-en-Laye.

127 Maurice Denis, *The Birth (La Naissance)*, 1895, distemper on canvas, 52 × 197 cm.

the atmosphere of the room, and which, by a super-position of ungracious blobs, reproduce the trite subject of women emerging from an insipid tangle of flowers."[44]

What is interesting is that Mauclair, a proponent of the Decorative Arts Reform Movement, exact contemporary and one-time defender of the Nabis, objected to the mundaneness of the motif itself, consisting (with the exception of *The Embroidery*) of heads and torsos of bourgeois or working-class girls. Indeed, Vuillard's oddly formatted and congested panels required quite a different appreciation than the earlier works, such as *Mystery Interior (Intérieur mystère)* (pl. 16), which lent themselves more freely to literary (and psychoanalytical) interpretation.[45] Nor did the women represented fit the child-woman ideal seen in Denis's decorative frieze for a bedroom suite (exhibited also at Bing's Maison de l'Art Nouveau), which was based on Schumann's song cycle *The Lives and Loves of a Woman* and was des-cribed by Gustave Geffroy as showing "sweet figures of young girls, women, mothers, in supple lines and accentuated colors..." (pls. 126, 127).[46] Whereas Denis's imagery, in general, derived from his dictum that there should be a single dominant rhythm that can be simplified both to clarify the decorative effect and to give primacy to the object, Vuillard was moving towards an art that, to an even greater extent than with his *Public Gardens* series, favored what he referred to as the *grossier*, or humble, subject as the motif and means of the decorative expression, over the literary and idealized one.[47]

Within the series, the three panels that are the-matically and compositionally similar, *The Album*, *The Stoneware Vase*, and *The Vanity Table* (pls. 114, 115, 116), show profusions of chrysanthemum-like blossoms from which young girls with striped, stippled, and checkered blouses emerge. All three share the *repoussoir* device of an exaggeratedly inclined table laden with objects in the foreground, whose recession into the background space is blocked by the flatness of the all-over patterned surface. The space suggested by the overlapping of those feminine shapes on this first plane is negated by both the absence of modeling and of differentiation between the colors and textures of animate and inanimate objects. The heads of the women in the second plane are obscured by the large vases and floral bouquets, while the women at either side are radically cut off by the edges of the canvas. In these congested interiors, the women are neither participants in the narrative nor pure staffage figures. Seen in *profil perdu* or from behind (the least personal of poses) or with heads bent and shadowed, they make no contact with the viewer. They are equal to the other objects and ab-sorbed into their environment, just as the nineteenth-century woman was, with few exceptions, defined by her environment, which was, in turn, often asso-ciated with feminine elegance and flowers.

Recent studies on the role of woman and decoration in the late nineteenth century have pointed out that it was artists in particular, as well as the male majority in general, who wanted to see the woman in the home. Usually depicted as a fragile object, she was used by artists in a decorative sense to adorn the household, similar to the inanimate mannequins of the fashion establishment.[48] In his widely read *L'Art dans la maison* (1879), Jacob von Falke argued that the household was the "peculiar province of the woman." Her work there was important and should not be trivialized, since the man's mind is taken up elsewhere. Writers on art and interior decorations,

77

entrepris; les monuments commémoratifs se multipliaient sur les places publiques. Partout s'ouvraient des expositions d'art moderne et rétrospectif.

Pour les particuliers, sous l'influence de ces causes diverses, augmentation de la richesse et éducation du goût, ils s'inquiétaient enfin de mettre plus de goût et de choix dans l'arrangement et la décoration de leurs demeures. Le salon, principale pièce de la maison dans notre vie sociale, perdait son aspect compassé et froid. C'est par là que commençaient les recherches de décoration intime. Puis, toutes les pièces de l'appartement participaient au goût nouveau. Les lourdes formes du temps de Louis-Philippe et du Second Empire, l'acajou plaqué et les capitonnages boudinés disparaissaient peu à peu. Ils étaient remplacés par des objets anciens ou imités de l'ancien. Car, faute d'un style contemporain, il fallait bien recourir à l'art du passé.

Alors, des artistes et des hommes de lettres, le goût de la collection passait chez les bourgeois. Riches ou pauvres s'efforçaient de grouper autour d'eux quelque chose de ce bric-à-brac dont l'étalage était comme un brevet de distinction exposé aux yeux. Le moyen âge, d'abord, fut en faveur, car c'est par lui qu'avaient commencé les peintres et les poètes. Il y eut force salles à manger Henri II et, dans le salon, si l'on pouvait installer une chaire plus ou moins gothique, quelques escabeaux, des ornements d'église, on croyait faire preuve d'un goût savant et délicat. Du moyen âge,

by Denis, Rippl-Ronäi, and Ranson. Deborah Silverman has pointed out that, while the movers and shakers of the arts-and-crafts revival in the last two decades of the century focussed on the feminine interior and the woman who occupied that space, the very shape of woman suggested natural forms and was therefore a useful motif for those advocating a return to a "rococo elegance."[52] Even the liberal-minded Schopfer admired Vuillard's porcelain service because its subject reduced women to their essential decorative significance, comprised of:

> large spotted sleeves, silk blouses of assorted patterns, the low bodices, the large bows and the ribbons with which our women folk bedeck their persons; the immense hats with feathers, the waving plumes with which they crown themselves – in fact, all the frivolous and charming side of feminine life of the present day.[53]

The equation of women with nature and especially flowers was a large part of the aesthetic revival. Paintings, posters, and illustrations such as the vignette accompanying Gustave Larroumet's previously cited article on "L'Art décoratif et les

such as von Falke, perpetuated the "aesthetic mission" of the woman as mistress over the domestic interior where she was best suited.[49]

Conversely, the domestic environment was seen as reflecting the woman's essential character. As Gustave Larroumet explained in an article recommending women's participation in the revival of decorative arts: "Thus, the interior design of the *home* is up to her [the woman]; it is whatever she makes of it – agreeable or dreary, elegant or vulgar. An interior reveals nothing of the man who lives there, but always the character and tastes of the woman who conceived it."[50] For Octave Uzanne, the role of women, especially among the middle classes, was to make the interior a happy and comfortable realm. In his analysis of the various "types" of women, he concluded that the "gentilles bourgeoises du juste milieu" are exceptionally gifted for the art of coquetry, and for the creation of picturesque comfort within "their nest": "Even when they remain enmeshed [*tapiés*] in their interiors, they attempt to fill their solitude with bright and cheerful knick-knacks . . ."[51]

The women in the panels for Thadée and Misia are indeed "tapiées" or absorbed into the interior. They are not on display as in fashion plates. They have not the air of coquettishness or availability, or even the aestheticized qualities of the women and child-women seen in Pre-Raphaelite and later Nabi works

132 Pierre Bonnard (?), vignette, *La Revue Blanche*, v. 11 (1896), p. 135.

femmes'' (pl. 128), often paired plants (nature) and females (animal) to express the same idea.[54] Vuillard's young women, however, are not merely decorative elements and embellishments of space, but serve as purveyors of mood. Within the compressed space, they contribute to the sensuousness and, paradoxically, the ethereality of the everyday objects represented.

The smallest painting, *The Striped Blouse* (pl. 118), is compositionally the simplest of the five and has its legacy in Courbet's *The Trellis* (*Le Trellis*) (pl. 129), Degas's *Woman Leaning near a Vase of Flowers* (pl. 130), and other paintings from the mid- to late century that juxtaposed feminine and floral elegance for a desired mood effect.[55] Of the two women in the foreground of this panel, the one closest to the viewer is completely absorbed psychologically and compositionally into the environment. She recalls the child-like women paired with evocative floating floral arrangements in the pastels by Odilon Redon, whose work Vuillard admired. Vuillard's unusual palette, in fact, may also have been a result of his growing friendship with the older artist and his increased exposure to Redon's pastel still lifes, a number of which were exhibited in Redon's first important retrospective held at the Durand-Ruel gallery in the spring of 1894.[56] Although the earliest correspondence between Redon and Vuillard dates to 1901, it is likely that Redon, who visited the Nabis'

exhibitions at the Le Barc de Boutteville gallery, and who was one of the participants in Paul Fort's Théâtre d'Art in 1891–2 when the Nabis were most active, knew Vuillard much earlier.[57] A curious vignette by Bonnard or Vuillard, pairing women and flowers, appears as the headpiece for a review of a new album of lithographs by Redon, *La Tentation de St. Antoine* (pl. 132). Published in 1896, this album completed the trilogy inspired by Flaubert's exotic prose, but had little to do with the imagery of the vignette announcing it.[58]

Only one of Vuillard's five panels, *The Embroidery* (pl. 117), shows women at work. In this vertical panel, the most narrative of the five, Vuillard returned to the subject of the seamstress. Unlike the insistent airlessness of the accompanying panels, the opposition between the lighted outdoors and the windowlit interior in *The Embroidery* renders it the most readable of the five. Coloristically, as well, the warm palette used to model the figures in half-lights and distinguish the inanimate from animate objects is drawn less from his previous paintings of the dressmaking studio than the tradition of Dutch seventeenth-century genre painting, showing women absorbed in needlework at an open window – a theme Vuillard would return to the following year in his lithographic program for Ibsen's *Les Soutiens de la société* performed at the Théâtre de l'Oeuvre in June 1896.[59] In the nineteenth century, its precedent can be seen in the genre-like paintings of earlier *intimistes*, such as François Bonvin, Théodore Ribot, or Henri Fantin-Latour. The latter's painting, *The Embroiderers* (*Les Brodeuses*, sometimes called *Deux Soeurs*), which Vuillard would have known through the related lithograph, *L'Intérieur*, published in 1894 in the art magazine *L'Epreuve* (pl. 133), seems particularly close in spirit to Vuillard's seamstresses.[60]

In general, however, the five panels for the *Album* series represented a shift in the decorative treatment of people and things seen in previous *décorations*. More than any of his commissioned projects thus far, the *Album* panels adhere most overtly to the tenets of symbolist thinking and to what Segard called the creation of "aesthetic fictions."[61] Segard, writing in 1913–14, from firsthand knowledge of both the artist's *oeuvre* and his circle of friends, considered Vuillard's *décorations* to be appreciated among only a limited segment of the general public. Raising the question, "Is it the property of decorative painting to address itself to everyone?" he answered:

> It is out of the question that these paintings would please the working class [*collectivités*] without education, but it is sufficient that the *élites* can find pleasure for themselves in the atmosphere created by these paintings, which on the walls of their interiors are undeniably decorative.[62]

According to Segard, the masses would not be able to understand the subtleties in Vuillard's style and technique that made them so unlike conven-

133 Henri Fantin-Latour, *Les Brodeuses* or *L'Intérieur*, lithograph published in *L'Epreuve*, August-September, 1895.

tional painting. Segard's assessment of the appeal of Vuillard's decorative *oeuvre* up to 1913 for a select audience offers another barometer with which to measure the probable reception of these early projects. When Segard remarked, for example, that the paintings "have a secret soul, a power of suggestion, a propagandistic force even more persuasive because they are so discreet," and described the paintings as emanating from "the waves that cannot resonate except in the most sensitive of the nervous organisms, but that nevertheless inscribe themselves onto certain senses, like they inscribe themselves across space on the ultra-sensitive bands of immaterial airwaves propelled into space," he was drawing upon popular scientific and psychological theories, especially those put forth by Dr. Jean-Martin Charcot on the malady of excessive stimulation, known as *neurasthénia*.[63] The condition, synonymous with nervous exhaustion caused by excess of stimulation (*surmenage cérébral*), was also a fashionable illness for the intellectual elite, whose perceptions, as seen in Huysmans's fictional character Des Esseintes, were prone to be more elevated than those of ordinary men and women.[64] Vuillard, too, frequently recorded his own emotional as well as physical states using the same vocabulary. In his bedroom analysis, for example, he had remarked that certain objects considered in bad taste were not too shocking to his nerves.[65] According to Segard's general argument, the *Album* panels, with their eccentric and meandering lines, unusually sensuous and finely nuanced color, would have satisfied the aesthetic notions of the *élites*. The sug-

gestive and near-hallucinatory (dream-like) quality of Vuillard's imagery, and the implied correspondence between the senses – fragrances and perfumes corresponding with the tactile qualities of the flowers and bodies – would have been perfectly compatible with the Natansons' symbolist-based aesthetics. The same qualitities that critics outside the Natansons' milieu saw as "confused and disturbed" would have been perceived by the inner circle of Vuillard's patronage group to be artistic extensions of their own heightened sensibilities.

The "Annex" on the Rue Saint-Florentin

Unlike his brother, Alexandre, and his father, both of whom owned private houses, Thadée and his bride, Misia, lived in a rented apartment,[66] a not unusual circumstance among upper-middle-class Parisians. By the last third of the century, the *maison à loyer* had triumphed over the *hotel privé*, which was reserved for the very wealthy.[67] In many instances, apartments built exclusively for multi-family dwellings with *beaux-arts* facades or carved out of larger private residences were luxury dwellings, equipped with elevators, gas, and other modern conveniences.[68] The Natansons' apartment was of a different sort. Instead of the conventional arrangement providing for separate rooms and distinct areas for reception and private activities, the Natansons lived in one relatively large and open space, adjoined by several small alcoved areas, as seen in Vuillard's most important portrait of the apartment, *Room with Three Lamps (Salon aux trois lampes)* (pl. 134).

134 Edouard Vuillard, *Room with Three Lamps (Salon aux trois lampes)*, 1898, distemper on canvas, 56 × 94 cm., private collection, Zurich.

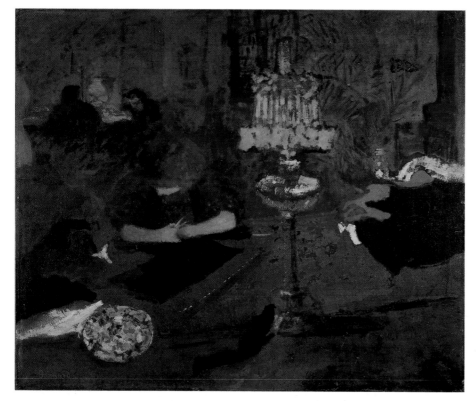

135 (above) Pierre Bonnard, *Figure by the Lamp* (*Figure à la lampe*), 1898, oil on cardboard, 61.5 × 75 cm., Kunstmuseum, Berne.

136 (below) Edouard Vuillard, *Misia and Cipa at Luncheon*, c.1897, oil on canvas, private collection.

dicate that the space was once divided into rooms with specific functions, it is possible that by the time the Natansons moved there some thirty years later, the rooms had been remodeled. If so, this would account for the absence of the coved ceilings and the *faux* Louis-Quinze *boiserie* that was common to upper-income residences in the Second Empire. By the time Vuillard was frequenting the Natansons' apartment, whatever woodwork may have originally divided the dado and cornice areas had been taken down and covered over with a sinuous floral frieze around the cornice and decorative wallpaper stretching from floor to ceiling and across joints, all of which created the illusion of a much larger space.

In a period when the world of the bourgeois (non-worker) woman and wife was defined by the only place assigned to her, the home, the Natansons' apartment was unusually unordered, with no dis-

Cadastral (property) records for 1862 show the eighteenth-century building at 9 rue Saint-Florentin to have consisted of a double edifice around a courtyard, with the principal building facing the street and consisting of three stories, with a fourth-floor attic room under the mansard roof.[69] Between 1862 and 1876, the building at the back of the courtyard and the right wing building were increased from three to four stories.[70] Judging by the disposition of windows, it is possible that the Natansons' "annex" was located on the fourth floor of the *bâtiment du fond*, described as having five windows looking onto the courtyard.[71]

Although the early records for this location in-

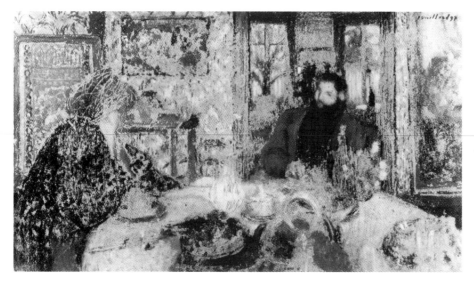

tinctions made between the masculine (office, library, and den) and feminine (kitchen, dining-room, boudoir, and nursery) spaces.[72] Photographs by Vuillard and Alfred Natanson and other images of

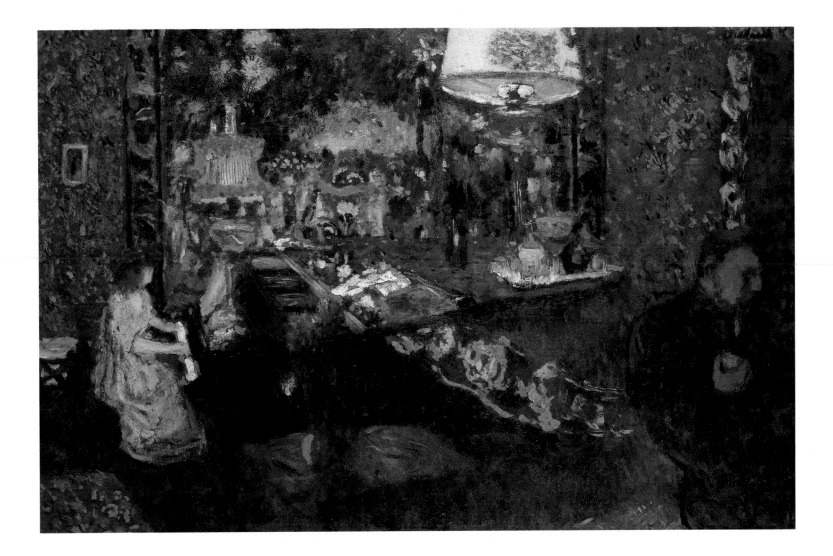

the apartment by Vuillard (pls. 136, 139), Bonnard (pl. 135), Vallotton, and Toulouse-Lautrec from the last half of the 1890s attest to the layout, which was essentially one large space serving as informal parlor, salon, and music-room combination.[73] In the most famous of the paintings of the Natansons, the *Room with Three Lamps* (pl. 134), the artist's wide-angle panoramic sweep shows not only the three brass oil lamps and their fringed covers, but also the decoration of ferns, flowers in a *jardinière* and on sculpture podiums (tripods), rustic potteries on the mantlepiece, firescreens, a bentwood rocker, a cushioned sofa, and a grand piano draped with a Spanish shawl in front of a large decorative tapestry.[74] The view of the apartment in a photograph taken by Alfred Natanson shows a very congested section of the salon in which Thadée is seen with pen and paper in hand in the first plane underneath the spreading leaves of the giant fern (pl. 138). In the background, Misia is seated next to the fireplace, whose mantlepiece is decorated with Chinese vases and draped with fabric.[75] The bentwood rocker with upholstered seat is seen prominently at left. In this cut-off view, one has a glimpse also of the alcove covered with wallpaper and the decorative frieze, which is reflected in the mirror.

The large rectangle forming the apartment proper was subdivided into an area for the pantry and dining-room which is seen in Vuillard's portrait of Misia and her half-brother Cipa at the table (pl. 136).[76] A photograph (pl. 141) and a painting by Vuillard of Misia and her niece Mimi (Cipa's daugter) (pl. 143) show what appears to be another room or bedroom, but is actually another section of the salon. Here the wallpaper vies with the paisley fabrics on the daybed and the different fabrics lining the three-paneled screen.

The loft-like apartment in which the Natansons lived for almost a decade was devoid of the aristocratic or traditional pretensions of Misia's artistic but solidly *haut bourgeois* family home in the fashionable Parc Monceau district. Misia recalled its "monumental staircase, thick red velvet drapes held by gold ropes, a large salon hung with red damask under a ceiling on the cornice of which was inscribed in Gothic lettering, "Love Nature better than Art: Art more than Glory. Art is the Means. Nature is the Principle,"[77] and a dining-room furnished *à l'Italienne*, with Cor-

139 Edouard Vuillard, *Misia at the Piano (Misia au piano)*, 1899, oil on cardboard, 55 × 80 cm., Josefowitz Collection.

137 (facing page, top right) Edouard Vuillard, *The Natansons' Salon*, c.1898, pen and indian ink, 10.8 × 14 cm., private collection.

138 (facing page, bottom right) Alfred Natanson, *Thadée and Misia, rue Saint-Florentin*, c.1898, photograph, Bibliothèque Nationale, Paris.

doban leathered walls and the boudoir *à la Chinoise*, with two hissing black bronze gas lamps shaped like dragons.[78] Thadée's father's home on the rue Jouffroy, in the same upper-class district, was less dramatically but no less ostentatiously furnished in the Bourbon Louis style, as were his other properties at Cannes, Longchamp, and, for a brief period, at the Château de Méréville.[79]

Given their respective childhood environments, it is possible that Thadée and Misia wanted to free themselves and their surroundings from the conventional tastes of their legacy.[80] Before her marriage, Misia had lived alone in apartments in London (1887) and in Paris (1889–90), both of which she decorated with bright wallpapers and rattan furnishings purchased on installment from department stores.[81] From these experiences, she acquired a taste for decorating and for the cluttered but comfortable informality more characteristic of the English style in general. Although Misia said it was the Belgium art-nouveau enthusiast Henry van de Velde who had introduced her to the principles of modern painting and design, her own apartments reflected a personal decorative style.[82] In the rue Saint-Florentin apartment, for example, the eclectic furnishings and wallcoverings were only vaguely linked with the ensembles showcased in Bing's gallery on the rue de Provence.[83] What was presumably Misia's choice of bright yellow-orange and blue patterned floral wallpaper and loud floral and paisley fabric applied to all available surfaces and upholstery, drew upon the earlier aesthetic movement in England, the

"Morrisian Method," as it came to be called (after the founder of the Arts and Crafts Movement), which was disseminated internationally by the late 1880s (pl. 140).[84] It has also been suggested that Misia's wallpaper was handblocked (rather than hand-painted) and decidedly more expensive than the machineprinted, manufactured ones similar to those shown by William Morris and Walter Crane at Bing's Maison de l'Art Nouveau.[85]

The "Relative" Installation of the Album Panels, Rue Saint-Florentin

Even with the contemporary photographs of the Natansons' Paris interior in the 1890s, it is not easy to

143 Edouard Vuillard,
Woman in Blue with Child
(Misia with Mimi Godebski
in the salon of the rue Saint-
Florentin apartment), 1899,
oil on cardboard, 48.6 × 56.5
cm., Glasgow Art Gallery
and Museum.

recontruct how the five panels for *The Album* would have been installed in this seemingly haphazardly organized interior. Vuillard's decision to create panels that varied in format, palette, and even subject may have been in part a response to that unstructured environment. Unlike the earlier panels for the Desmarais mansion, described as overdoors and *trumeaux*, and purportedly intended for the specific location of Madame's *cabinet de toilette*, or the commission for the suite of nine panels for Alexandre's dining-room/salon, the variously sized panels comprising *The Album* were informally placed or hung over the wallpaper. A photograph of Misia standing beside a sideboard in what would have been the pantry area shows the unframed vertical panel *The Embroidery* not so much hung as stuck upon the plinth forming the baseboard (pl. 142). In this casually posed photograph, one has the impression that the panel was not a permanent but a temporary fixture, placed there as a decorative foil for Misia, whose striped house-dress and polka-dot bow reflect her unusual tastes in fashion that so fascinated Vuillard and the other artists in her circle.[86] Indeed, the flat

lacework of her collar may have been yet another calculated decorative detail for this pose and photograph, to simulate the lacework of the Paris porcelain and English teapots atop the sideboard.[87]

The other panels were likewise never hung as a group. Of the five, only the rectangular paintings, *The Vanity Table* and *The Stoneware Vase*, could be considered as pendants.[88] Linked by similar colors, textures, and compositions, they form a decorative frieze, although no evidence exists to suggest that they were ever hung as a pair. In the previously mentioned painting by Vuillard showing Misia and her half-brother Cipa at the table in that informal dining and pantry area, *The Stoneware Vase* is hung unframed on the wall above their heads (pl. 141).[89] The same painting from the *Album* group reappears with a cooler palette in another work from 1897, *Misia and Vallotton in the Dining Area* (pl. 144), unframed and unpretentiously displayed upon the fabric wallpaper. Misia sits in profile and facing right, holding a blue-and-white porcelain coffee bowl, while Vallotton, in profile and turned in the other direction, stands behind her with his arms

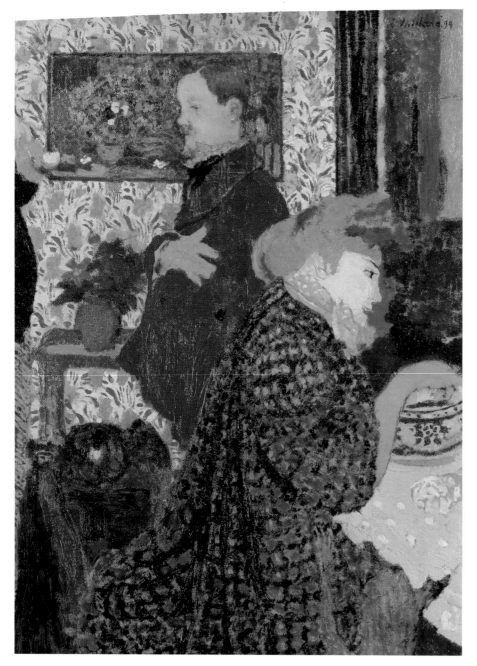

perties of mural painting, and without the necessity of adhering to any architectural scheme. In Vallotton's small gouache painting from 1899, *Woman in a Purple Dress by Lamplight* (*Femme en robe violette sous la lampe*) (pl. 146), for example, Vuillard's decorative painting from 1897, *Large Interior with Six Figures* (pl. 162) is shown unframed on the walls of Vallotton's rue Jacob apartment.[92] In another of Vallotton's larger Nabi-period masterpieces, *The Red Room* (*La Chambre rouge*) (pl. 147), the same unframed painting is shown reflected in the mirror above the chimney on the opposite side of the room.[93] Vallotton altered the perspective so that Vuillard's large horizontal painting appears to be framed between the stage-like curtains that are actually part of the mantle decoration. Similarly, several times Bonnard painted his future wife, Marthe Méligny, in the interior of his apartment on the rue Drouai, "decorated" with one of the four decorative panels (left unframed) executed in 1891 on the theme of "Women in a Garden" (pl. 145).[94]

As shown, a *décoration* was defined not only by its formal and thematic characteristics, but by its framing device or lack of it. When Bonnard's decorative paintings and lithographic screen were exhibited at the Durand-Ruel gallery at the beginning of 1896, Camille Mauclair criticized the artist's use of traditional frames which evoked easel painting and thus a different set of artistic principles: "Then when

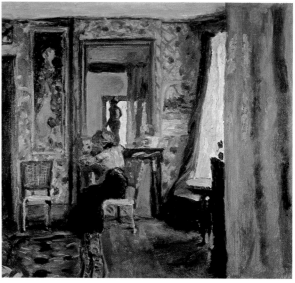

144 (above) Edouard Vuillard, *Misia and Vallotton in the Dining Area*, c.1899, oil on cardboard, 72.1 × 51.4 cm., Collection of William Kelly Simpson, New York.

145 Pierre Bonnard, *Woman in an Interior* (*Femme dans un intérieur*), c.1908, panel from the series *Femmes au jardin*, 1891, 45.6 × 50.5 cm., private collection.

folded across his chest. (The painting is actually a triple portrait, with Thadée's presence suggested by the bulging stomach and pipe at the far left of the painting.) Vallotton's head intersects with the decorative painting and blocks all but the vase in the panel. Underneath this is the "real" painted vase, so that the decorative painting is seen as an accessory to the portrait, and not a *décoration* for the room itself.[90]

The fact that these panels were left unframed reflected a practice that was not uncommon in the last decades of the nineteenth century, when the unframed painting as *décoration* was perceived to function as part of the wall surface, or at least was more closely related to it.[91] In the work of the Nabis, this relationship could exist without the formal pro-

will these painters understand that the presentation of a rectangular frame isolated on the wall excludes any sort of deformation and simplification, which are essential to mural decorations, to tapestry, and to the frise?"[95] Mauclair had voiced the same complaint against the pictures of Maurice Denis, whose paintings shown at the eighth exhibition of Le Barc le Boutteville in December 1894 were attacked for being framed *décorations*: "And does one put in a frame a

work painted in solid flat colors [*à plat*] and having the feeling of tapestry with tones laid side by side? A decoration is not a painting, and so there it is, the difference that not one of the young painters realizes."[96] From the vocabulary used in Salon reviews and announcements, one can deduce that in the majority of cases, decorative paintings were either completed by painted frames or other schemes integrated to the painted surface, or were left unframed altogether. A notice to artists published in *La Revue Blanche*, for example, called for decorative paintings to be included in an upcoming exhibition at Bing's Maison de l'Art Nouveau on the theme of "Toiles sans cadres."[97]

Whether any of Vuillard's *Album* panels were framed remains unclear. What is clear is that they were never hung permanently as an ensemble (as in the case of *The Public Gardens*), but as temporary *décorations* that could be moved around within the rue Saint-Florentin apartment. In Vuillard's portrait of Misia at the piano with Cipa (pl. 148), the largest panel is seen reflected in the mirrored fireplace. In another painting from that same year, however, *The Bare Arms* (*Les Bras nus*, location unknown), a tapestry with decorative borders has replaced the painting in the mirror reflection. The largest panel,

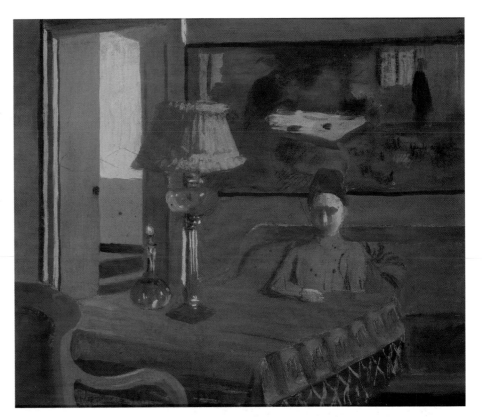

146 Félix Vallotton, *Woman in a Purple Dress by Lamplight* (*Femme en robe violette sous la lampe*), 1898, gouache on board, 29.5 × 36 cm., private collection, Winterthur.

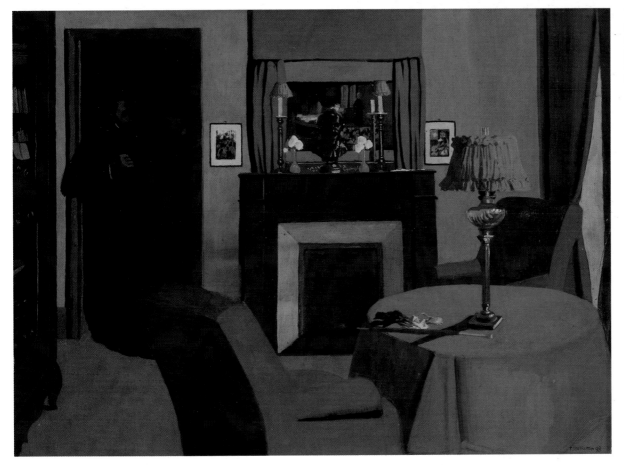

147 Félix Vallotton, *The Red Room* (*La Chambre rouge*), 1898, gouache on cardboard, 49 × 67.5 cm., Musée Cantonal des Beaux-Arts, Lausanne.

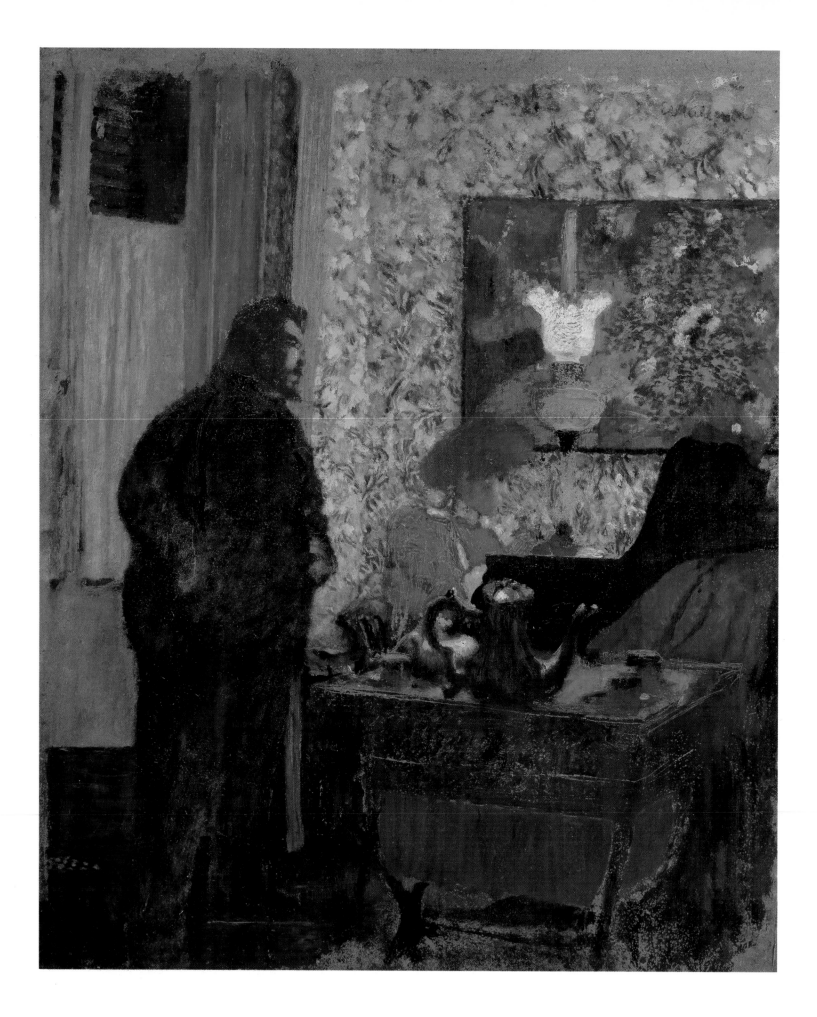

The Album, seems to have been moved about not only within the Natansons apartment, but to their summer home, La Grangette at Valvins, and after 1897, Le Relais at Villeneuve-sur-Yonne. One sees *The Album* hung unframed over a shelf in a photograph of Olga Natanson in the billiard-room of her in-laws Villeneuve residence (pl. 149). Even in this seasonal home, Misia's decorating mania is evident in the English-style floral-patterned wallpaper and the shelf with discreetly placed vases, so that the installation for the painting resembles that of the busily patterned Paris apartment. In this recreation room most commonly reserved for larger country homes and villas, Vuillard's long horizontal painting functioned as it does in its present location, to set off a mantle (pl. 150) (or, as in the case of the Natansons' billiard-room, a ledge) and the select group of porcelain dishes and art objects adorning it.[98] The addition of a heavy gilt frame in its present-day installation confuses once again the issue taken up by Mauclair in his exhibition reviews, concerning the picture as *décoration* or large-scale easel painting.

Based on the information provided by the paintings and photographs, it seems reasonable to conclude that the *Album* panels substituted for and were sometimes replaced by tapestries, which were also easily transportable. Tapestries, which had inspired Vuillard's *Public Gardens* series, continued to play an important role in his conception of what painting as *décoration* should be. Although executed in oils, the five panels share a felted quality resulting from the densely patterned composition of closely ranged tonalities that fuse the figures to other objects, as if they were woven into the background. The tapestry-like quality of Vuillard's paintings may have been in part inspired by the Natanson family collections, which included ancient and modern tapestries. Judging from Vuillard's paintings of the Natanson interiors, these works in fabric, like those in oil, were moved periodically from the city apartment to the country homes.[99] In his painting, *Woman in White with a Red Shawl Playing the Piano (Femme en blanc avec un sautoir rouge jouant de piano)* (private collection, Paris), a tapestry with Gothic-like imagery, and thus different from that shown in Vuillard's 1898 painting of the Paris interior, *Room with Three Lamps* (pl. 134), serves as wall covering at the Villeneuve house. One can compare this tapestry with one seen in Vuillard's painting *Misia at the Piano* (pl. 139), or with a double portrait of Misia and Thadée (private collection), where the blue-and-green floral border of a scene with cut-out doll figures may easily be Vuillard's reinterpretation of a sixteenth-century tapestry.[100]

It is unfortunate that no descriptions exist of these tapestries and the tapestry-like *décorations* of *The Album* in any of their respective installations.[101] As *décorations*, Vuillard's paintings seem to have functioned less as murals than as temporary and portable wall hangings to be changed according to the owners' whims. In this way, they fulfilled Lucien Muhlfeld's

149 Photograph of Thadée and his sister-in-law, Olga Natanson, in the billiard-room Villeneuve-sur-Yonne, *c.*1900, Salomon Archives, Paris.

recommendations for *décorations*, published in *La Revue Blanche* for October 1893 – that they be portable and moveable on screens or with pulleys, according to the need for more or less space by the apartment dweller.[102] Like the firescreens, folding screens, plants, and tapestries, Vuillard's five panels were appropriate to the Natansons' mobile life-style. Whether in the Paris apartment or at Le Relais, they contradicted what Sérusier would state in 1903 was the role of decorative painting, to be "intimately related to architecture, its elder sister."[103] Indeed, the panels for *The Album* can be better understood by Sérusier's definition for an *easel* painting as "a small piece of a movable painting . . . [having] no links whatsoever with its environment . . ." The panels lay outside what Sérusier called "true painting," which he equated with decoration, since, "like any living organism, [it] can survive only in the milieu to which it is adapted . . ."[104]

The milieu to which Vuillard's panels were first adapted as shown in *Room with Three Lamps* presented

148 (facing page) Edouard Vuillard, *Misia at the Piano with Cipa Godebeski*, *c.*1897, oil on cardboard, 63.5 × 56 cm., Kunsthalle Karlsruhe, Germany.

150 Photograph of the panel, *The Album* in present location.

154 Edouard Vuillard, *The Piano* (*Le Piano*), also called *Music* (*La Musique*), 1896, distemper on canvas, 210 × 153 cm., Musée du Petit Palais, Paris.

155 Edouard Vuillard, *The Reader* (*La Liseuse*), also called *The Salon* (*Le Salon*), 1896, distemper on canvas, 210 × 153 cm., Petit Palais, Paris.

tufted rose-colored cushions of a sofa seen at the far left in both. In the panel *The Reader* (pl. 155), the function of this pouf-like object is less obvious than that of the adjacent sofa, upholstered in plaid fabric, upon which the woman sits. Is the strange framed object over the sofa a decorative fabric panel hung on or set into the wall? Or is it a mirror reflecting the wallpaper on the opposite side of the room? Equally enigmatic is the space suggested beyond the figures standing in the open doorway, through which one glimpses more floral wallpaper. As in Manet's double image of Suzon, the barmaid in the *A Bar at the Folies-Bergère*, which was exhibited at the Durand-Ruel gallery in April 1896 (pl. 156),[132] there is a disturbing disjuncture between Vuillard's two female figures. Despite the fact that one knows that the two women are not mirror images in Vuillard's painting, there is the same sense of a dislocation of logical space that is seen in Manet's distortion of the full frontal figure of the barmaid and her reflected image. In Vuillard's panel, the women, who are logically overlapped in three-dimensional space, are made to exist in the

same plane and thus imitate the relationship of figures and reflections. The ingredients found in seventeenth-century Dutch genre painting by Terborch and de Hooch – women absorbed in their activity, a glimpse into a room beyond, a meditation or emphasis on household objects – have been re-combined in a highly charged ornamental setting that has little to do with real figures in a real space.

The dislocations of space are even more pro-nounced in the pendant panel, *The Piano* (pl. 154). From the woman seated at the table laden with fabrics and ornamented boxes in the foreground, the viewer's eye is led diagonally to the seated figures around the piano. The space, which seems to recede logically from the table to the sideboard with scal-loped edges behind the piano, is disrupted by the patterned dresses of the women sitting adjacent to the pianist which appear also beneath the piano, thus giving them impossibly elongated torsos. There is no delineation of the separate figures in the group around the piano to identify clearly their placement in that space. The women at the sideboard with backs

to the viewer disappear. Likewise, the books atop the piano to the right of the vase read less as three-dimensional objects than as a block of brilliantly colored stripes. There are no diagonal perspectival lines to give a sense of real space, so that the figures seem to be on a platform at the front edge of the room. Pictorial space is articulated by three or four shallow layers behind and before the central object, shown in contrasting patterns, textures, and densities of color. Perhaps the most confusing spatial heresy of all results from the large (larger, for example, than the woman sitting in the foreground area nearest to the viewer) porcelain *jardinière* of chrysanthemums. The blossoms that free themselves from the mass of the bouquet, moreover, become a part of the obsessively patterned background. That same meshing of "real" and wallpapered floral arrangements can be seen also in *The Reader*, wherein the single strands of blossoms contained in the slender vase on the delicate tripodal table become part of the background design.

The two smaller vertical paintings for the library have more legible compositions and are connected by the bookcase and the variegated oriental rug running from panel to panel. The ornamental bookbindings (considered by Edith Wharton to be essential elements for the library or study, "as decorative as fine tapestry"[133]) are echoed in the panel of *The Worktable* by the striped fabric held by the young woman in the foreground. A third of the bookcase (seen in the bottom right of *The Worktable* and at the middle left in *The Library*) consists of a shelf area skirted to prevent dust from gathering on the portfolios and other rarer books that would be stored there. As in the larger panels, the cushions or stuffs in the foreground plane announce the figural activity within the rooms. And, as in the paintings representing the salon, the figures are seen standing, sitting, and bending over their work, as if to avoid making direct contact with the viewer.

The four panels are linked most obviously by the *mille-fleur* patterning of the wallpaper – what Curt Schweicher, in his analysis of the panels, calls the "hero" of the series – and the "transgressing borders"

of the chartreuse-and-mauve gridwork running across the top of each.[134] These bands have both an architectural and a pictorial reference, as a decorative frieze and as the ornamental edge or frame for the pictures. Segard compared the busily flowered background wallpaper surrounding the central figures to Persian miniatures, "fine and miniscule in their detail."[135] Although one can read the tilted tables, chairs, and other objects in this congested space as owing something to the skewed and flattened architecture found in mid-fifteenth-century interiors illustrating Persian myths and histories, Vuillard's sources are more likely to have been the late fifteenth-century tapestries that he knew from his visits to the Musée de Cluny.[136] In both *The Reader* and *The Piano*, for example, the composition, based on a large, centralized block of solid colors surrounded by broken color of equally intense hues, recalls the relationship of subject to the *mille-fleur* decorative backgrounds of the Unicorn tapestries (pl. 159).

As in medieval and early Renaissance tapestries, the viewer's eye is attracted to not one but several

157 Edouard Vuillard, *The Worktable (La Table de travail)*, also called *Dressmaking (La Couture)*, 1896, distemper on canvas, 210 × 75 cm., Musée du Petit Palais, Paris.

158 Edouard Vuillard, *The Library (La Bibliothèque)*, also called *Choosing a Book (Le Choix des livres)*, 1896, distemper on canvas, 210 × 75 cm., Musée du Petit Palais, Paris.

156 Edouard Manet, *A Bar at the Folies-Bergère (Le Bar au Folies-Bergère)*, 1881–2, oil on canvas, 96 × 130 cm., The Courtauld Galleries, London.

Although no descriptions or photographs exist to allow even the most hypothetical reconstruction of the way the paintings were hung in the Vaquez apartment, it seems doubtful that the doctor's working environment would have resembled the highly feminized world of these flowered and cushioned realms. Vuillard's inspiration may have been his intimate relationship with the Natansons' rue Saint-Florentin apartment, where one could find the same patterned wallpaper, the grand piano, the cushions, and the brightly striped and stippled rugs. As shown above, Vuillard depicted Misia enmeshed with her environment in several paintings, such as *Misia and Thadée* (pl. 161), where she can be compared to the figure seated at the table in *The Piano*. Vuillard's many portraits of Thadée, moreover, frequently showed him reading or writing with head bent in concentration, similar to the man at the desk in *The Worktable*. The similar positioning of the man at the desk and the one in the library constituted an acceptable visual code for representations of the male in his private arena, as confirmed by the illustrated journals of the period featuring *hommes de lettres* or other notables.[139] What remains unanswered, however, is why Vuillard would have chosen this unusually sensuous and feminized setting for the bachelor doctor.

Claude Roger-Marx described the visual effects of the Vaquez panels as being similar to looking in a mirror and seeing the figures reflected from life.[140] If, as Roger-Marx's description suggests, art imitates life, was it the doctor's wish to be surrounded by child-women occupied in roles having to do with the

159 Anonymous, *The Sense of Hearing* (*L'Ouïe*), fifteenth century, tapestry from the series *The Woman with the Unicorn*, 370 × 290 cm., Musée de Cluny, Paris.

160 Edouard Vuillard, *Interior in Rose, I* (*Intérieur au tenture rose*), color lithograph from the album *Paysages et intérieurs*, 1899, 88 × 193 cm., Gift of Walter S. Brewster, 1936.198, The Art Institute of Chicago.

areas of the composition. The effect of the all-over patterning of the walls can be compared with the staccato-like effect of Vuillard's lithographed interiors, such as *Interior with Pink Wallpaper* (*La Tenture Rose*) *I* and *II*, executed for Vollard in 1897–8 and published in his 1899 album, *Paysages et intérieurs* (pl. 160).[137] The sense of mystery inherent in these works on paper and found in other smaller easel paintings of uninhabited interiors with half-open doors is less dramatic in the Vaquez panels, where the figures perform genre-like activities in a recognizable domestic setting that is flooded with light. This light, however, comes from an unseen source and not from the suspended light fixtures or table lamps that served as mediators of a certain mood in Vuillard's lithographs, paintings, theater programs, and stage decors at this time.[138]

"arts de agrément" and household duties, evoking the household mistress, daughters, or simply the "angel of the house" that he did not have? These young women are not servants; their fashionable coiffures and dresses with delicate accessories suggest their bourgeois status and, at the same time, enhance their role as decorative objects.

As proposed earlier, Vuillard's preferences for the seamstress as subject was in part a solution to his inability to afford models during the first decade of his career. In the Vaquez panels, the women may, indeed, have been inspired by those working at his mother's workshop, or, as their undifferentiated facial characteristics suggest, they may have been invented like the rooms themselves, drawn from Vuillard's many other studies of interior elements and the female form and costume. Their pacific attitudes and performance of domestic duties are far from the characteristics of the threatening *femme nouvelle*, and reflect instead the artist's familiarity with the equation of women with interiors. Like the modern heroines of Zola's popular novels, these women are associated with society's ideal of the self-sacrificing woman and the attributes of work, sobriety, honesty, and order.[141] It is interesting, too, to think of them in relation to women's place in society and, more pointedly, to the conventional relationship of women to the medical profession. Jean-Pierre Peter's study, "Les Médecins et les femmes," for example, has shown that in the majority of cases, women were expected to be sick, hypertensive, weak, and fragile, as well as strong and stable in their role as producer and conserver of humanity.[142] After 1860 and until the beginning of the twentieth century, the *grand médecin notable* was among the most important figures in Parisian feminine society. If the woman was expected to be weak, the doctor was all-knowing – the intermediary for, and supporter of, the "female condition." Indeed, it is Peter's contention that, as the century progressed, women came to depend more on doctors, who, in turn, through their authority over them, perpetuated the idea of the weaker sex as intuitive, not active, as temperamental, not intellectual.[143] While it is not the intention of this study, which is focussed on Vuillard's decorative paintings, to cast Dr. Vaquez in a negative (e.g., antifeminist) light, from the perspective of a late nineteenth-century observer, it is not unthinkable that the doctor may have approved of Vuillard's theme of young household mistresses and seen them as comforting reassurances of a "woman's place."[144] Dr. Vaquez's decision in middle age to marry his nurse, Marie Bernoval, described as plain, good-humored, and completely removed from any of her husband's aesthetic interests, may have been a strategic move on his part to provide himself with the comfort of a traditional and, therefore, non-threatening companion and housekeeper.[145]

*　　　*　　　*

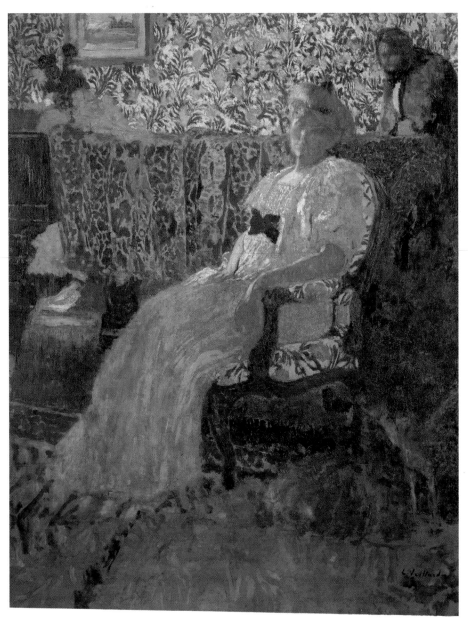

161　Edouard Vuillard, *Misia and Thadée Natanson*, c.1897, oil on paper mounted on canvas, 104 × 71.1 cm.

Installation

In Segard's opinion, the most successful of Vuillard's decorative projects were those destined for a library or study, "the rooms of repose where, in the intervals of his studies, the intellectual voyager comforts himself with the gentle sensations for which nature provides the source."[146] In the Vaquez panels, where the only male figure sits at his desk absorbed in cerebral activity and oblivious to the women engaged in quiet, domestic activities, the divisions between the feminine and masculine temperaments are clearly defined. It is all the more disappointing that no photographs or descriptions exist for the actual disposition of this room. Unlike the panels for *The Album*, which Vuillard often included as pictures within pictures of the Natanson interior, there are no known paintings of the Vaquez interior to give an

idea of how the panels were hung within the library-study, so they could become, as Roger-Marx remarked, like "reflections in a mirror." They would also have served as tapestry-like wall hangings to soften and animate the bachelor's interior.

The panels were exhibited in the 1905 Salon d'Automne along with the paintings for Jean Schopfer (1898, pls. 165, 166). There André Gide, making his début as an art critic for the *Gazette des Beaux-Arts*, referred to their muffled and quiet qualities, resulting from the colors that come forward only to fall "delightfully into the background."[147] The reviews of the panels in this Salon were mixed, insofar as the "tapestry" effect was concerned. Some, like Francis Monod, writing for *Art et Décoration*, were entirely enthusiastic about the similarities in decorative effects with tapestry: "In the panels exhibited here . . . developed in muted harmonies of such imagination . . . that they seem to present the color, the fabric of ten to twenty decorative tapestries, the rarest in the world."[148] Toulet, reviewing for the popular *Vie Parisienne*, wrote of the public's admiration for Vuillard's panels because of their resemblance to tapestry, going so far as to recommend that they be used for that purpose:

> It's entirely true [the tapestry-like quality of Vuillard's panels] . . . But what's wrong with that? If we had them made in this manner, on the banks of the illustrious and smelly Bièvre [the river along which the Gobelins tapestry manufacturers were located] – where there are still excellent workers – perhaps we could finally obtain a modern "décoration."[149]

Only a handful of critics, were put off by the obvious allusions to tapestries. Maurice Guillemot, for example, felt that by straying from his usual method to make a *trompe l'oeil* of tapestry, Vuillard ruined the decorative effect.[150] As noted in the introduction for this book which began with the 1905 Salon d'Automne, both the negative and positive critiques of Vuillard's works were highly generalized, and could easily have been referring to the other two decorative panels exhibited, showing outdoor leisure activities and executed by Vuillard in 1898 for Jean Schopfer.

In 1907, two years after having exhibited the panels publicly, Vuillard recorded having placed certain "panels" in the dining-room and salon of the doctor.[151] Was this a reference to these interiors, or to a different set of *décorations*? Or did it concern another decorative project that the doctor seems to have commissioned and cancelled by November 1908?[152] In 1928, the four panels were reinstalled in the living-room of the doctor's new residence on the square Debussy in the eighteenth *arrondissement*. They remained there until Vaquez's death in 1936, when they were offered to and refused by the Louvre and subsequently given to the Petit Palais.[153] In this last and final public installation, they are hung as a series on the same smooth beige wall – an installation that has been both criticized and praised. While Jacques Salomon judged the museum environment to be intrusive upon the paintings' function and significance as backdrops for domestic activities,[154] Claude Roger-Marx, who would undoubtedly have seen the panels in their original settings, felt that the paintings were much easier to appreciate in the museum context, away from both the busyness and business of the household:

> In these echoing spaces, trodden only by the stranger's foot, in these galleries where the walls are everything, and it is only the walls that speak, where the visitors are observers not doers, there, assuredly, such evocations are in their true place, and there they exercise the spell with which their creator furnished them.[155]

Neither the Vaquez nor the Natanson panels, however, were intended for the museum's "echoing spaces" and "stranger's foot," but for a specific setting and familiar audience. In Segard's words, they [the Vaquez panels] were made "apropros of reality. They do not pretend to recopy that reality. They propose instead an initial theme and serve as a guide to our pleasure."[156] As Vuillard's easel paintings of the Natansons' "annex" reveal, their salon was perceived as music chamber, library, drawing-room – in short, as a refuge from the harrying exterior world of finance and industry. In the case of Dr. Vaquez, who, in addition to his medical responsibilities, was a stockholder and investor in railroads and raw materials in Eastern Europe and South America, his domestic space may well have provided an intellectual and spiritual retreat.[157] For both interiors, Vuillard's subtle harmonies of home activities would have been appropriate decorations, contributing to the aura of a private oasis.

Vuillard's Large Interior with Six Figures, *1897*

Before closing the chapter on Vuillard's decorative paintings of feminine figures in interiors, another decorative, albeit uncommissioned, painting from this period, entitled *Large Interior with Six Figures* (*Grand Intérieur aux six personnages*) (pl. 162) merits attention for its similarities as well as differences within the genre.

Unlike the previously described panels, in which the palette is muted and repetitive, the decorative function of this large horizontal panel, executed in 1897, is less pronounced. The open, proscenium-like composition allows the viewer to be the *voyeur* in a room in which the figures interact as if players in a domestic drama by the Belgian and Scandinavian playwrights whose importance to Vuillard's imagery has already been discussed.[158] Equally vague are the architectural and compositional divisions across

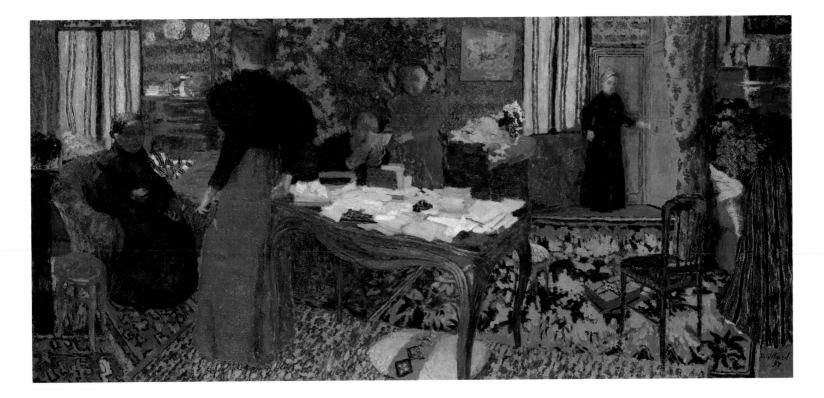

which the figures and objects are stretched. The desk, seemingly lit by an unseen source, is in the center and is brightest element, as well as the largest one, anchoring the scene. The vertiginous effect of the overlapping rugs with their different patterns adds to the confusion of the room. Although it invites a narrative, taking place in a logically arranged and recognizable space, it is more a collage of domestic elements.

Various identifications have been suggested for the interior, ranging from Redon's home on the avenue Wagram (with Redon at the desk surrounded by members of his family), or, as has been most recently proposed, Mallarmé's summer home at Valvins next to the Natansons' residence.[159] Yet the only male figure, seated at the large desk, resembles Vuillard's brother-in-law, and it is perhaps Marie Roussel who is shown from behind in the foreground in confrontation with the seated female figure, who seems physically similar to Madame Vuillard.[160] In the end, however, the participants do not disclose who they are or why they are brought together in this invented or real setting of ambitious scale.[161]

Vuillard completed the picture in time for the large group exhibition of the Nabis (which included Bonnard, Denis, Ibels, Lacombe, Ranson, [Georges] Rasetti, Roussel, Sérusier, and Vallotton) held at the Vollard gallery in April 1897.[162] When a collector offered to buy the painting at an unreasonably low price, Vallotton convinced Vuillard not to sell. Touched by Vallotton's appreciation, Vuillard gave

him the painting which he immediately hung in his apartment at ll rue Jacob and which, as mentioned above, he painted into several small canvases (pls. 146, 147).

Given Vuillard's reputation at that time and the ambitious scale of the painting, it is surprising that it went unpurchased as a decorative painting and apparently unnoticed by the reviewers of the Vollard exhibition. It is possible that the *Large Interior* was originally intended for a known interior and that the project was annulled or rejected. If so, then the significance of the figures and setting may have been lost on the buyers at the Vollard gallery. The lack of attention given to this painting and the low purchase offer it received may have been the consequences of its too-narrative subject matter.[163] In any case, the portrait-like character of this large genre scene was possibly too specific and too personalized for it to be thought of as a *décoration* in any general sense.

The *Large Interior* marks a transition point in Vuillard's evolution as a decorative painter from the purely ornamental and repetitive concerns evident in the Natanson and Vaquez panels to a concern for the relative clarity of the genre-like subject depicted. In this regard, it announces his next commissioned paintings for Jean Schopfer which would take the aesthetic of the *Large Interior* one step further by including portrait-like images of recognizable people and places that would be thematically related to the commissioner of the panels as documents and as *décorations*.

162 Edouard Vuillard, *Large Interior with Six Figures* (*Grand intérieur aux six personnages*) 1897–8, oil on canvas, 88 × 193 cm., Kunsthaus, Zurich.

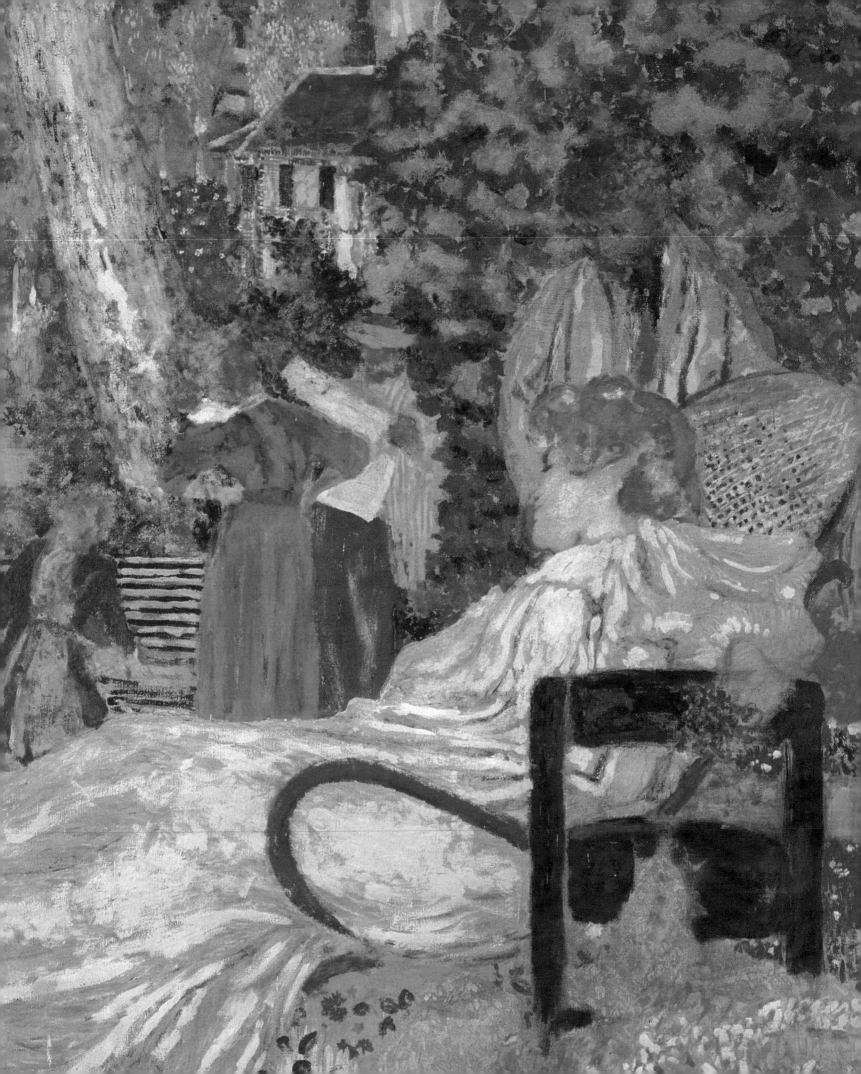

5 Portraiture as Decoration: The Commissions for Jean Schopfer, 1898 and 1901

Figures in the Gardens of Villeneuve-sur-Yonne, 1898

By 1897, Vuillard had all but ceased his activities as set and program designer for Lugné-Poe's Théâtre de l'Oeuvre, although he continued to regard opening-night performances as a cultural and social commitment.[1] His previous worries – the "histoires sentimentales" and the complications within the marriage of Roussel and his sister – seemed to have abated, giving way to a more regular life-style characterized by periods of intense professional activity followed by escapes to the countryside, most often to visit Thadée and Misia at Le Relais, their eighteenth-century coach-house near the village of Villeneuve on the Yonne river.[2] Among the highlights of 1897, Vuillard listed in his journal the Nabis' important group exhibition at Vollard's gallery on the rue Laffitte in Paris and the commission for lithographs that Vollard had given him (some of which he exhibited at the same exhibition).[3] Vollard, who had "discovered" Cézanne in 1895 and presented his works in the artist's first one-man exhibition, had taken over the exhibitions of the *jeunes* after the death of Le Barc de Boutteville in 1896. His personal investment in the younger artists, however, was limited to their work in the graphic arts.[4] Vuillard's journal entry refers to the color lithograph "Jeu d'Enfants" in the *Album d'estampes originales*, which Vollard commissioned after the exhibition, and for which Vuillard returned to the theme of children in public gardens, and to the series of twelve lithographs, *Landscapes and Interiors* (*Paysages et intérieurs*), published two years later.[5]

The final item listed in Vuillard's journal summary for the year – "Villeneuve-sur-Yonne" – referred to his stays with the Natansons that summer and fall. The Natansons' simple but spacious, square, two-story residence, in the wine-growing area of Dijon, two and a half hours by train from Paris, had replaced their former home at Valvins, near Fountainebleau, as the summering spot and suburban "annex" for the members of the *Revue Blanche* circle. For Vuillard,

the prolonged *villégiatures* or summer vacations with the Natansons were especially important, not only as welcome breaks from his bachelor life and his work, but also as study sessions providing source material for paintings and prints. Whereas in his decorative paintings from 1892 to 1896, he responded to his immediate urban surroundings – the dressmaking workshop, the public gardens, and the wallpapered and airless apartment interiors – the decorative paintings after 1898 were often set in the sunlit rural realms of his friends' properties outside the capital.[6]

Among the frequent guests to Villeneuve were artists Bonnard, Vallotton, and Toulouse-Lautrec, playwright Romain Coolus, and the Jean Schopfers. Schopfer has already been introduced as the commissioner of the porcelain service and the author of one of the first important articles about Vuillard's decorative projects for *The Architectural Record*.[7] The son of a Swiss banker who had come to Paris with his brother to study, Schopfer, by the age of twenty-four, had graduated from the Ecole du Louvre with a degree in art history, won the French Open Tennis Championship, and been hired as a journalist for the prestigious daily, *Le Temps*.[8] His marriage in 1895 to the beautiful and wealthy American Alice Nye Wetherbee (in a ceremony described by the New York press as one of the prettiest ever) crowned what was already a successful social and professional career.[9] On the occasion of their move to a luxury apartment house on the avenue de VictorHugo in March 1897, Schopfer commissioned (with the money earned from his tennis playing, according to one source, but more probably with his wife's money[10]) a decorative project from the twenty-nine year old Vuillard.

Schopfer's command of several languages, his career as an international journalist, his reputation as a sportsman, and his advantageous marriage gave him access to the intellectual, as well as aristocratic, elite.[11] Misia's anecdotal biographical memoir recalls how Schopfer came to a reception at her house wearing tails, while all the other guests were in *smoking*. When asked why he was so dressed up, he

163 Detail of pl. 166.

answered proudly that he was invited afterwards to see the princesse Murat, by whose circle, he added, Misia and her group would never be received.[12] Vuillard's friendship with Schopfer predates both such social and financial successes, and his commission of the porcelain service in 1895. According to Pierre Veber, Schopfer's classmate at the Sorbonne who regarded his friend as a "garçon merveilleux," Schopfer and his brother, Louis, hosted tri-weekly informal gatherings attended by Thadée Natanson, Lucien Muhlfeld, and Tristan Bernard, with less regular appearances by Vuillard and Denis.[13] From the beginning, Schopfer was a contributor to the Natansons' *Revue Blanche*, although, unlike Thadée, he did not write specifically about any of his artist friends. In the only instance of a personal review – in his article on "Modern Decoration" – Schopfer's artistic views were clearly slanted in favor of Vuillard.[14] After lamenting the general confusion and banality of the state of the decorative arts, Schopfer noted its adverse impact on present-day society:

Thus, an examination of our apartments would lead to the following conclusions: that modern society, confused and divided, has not yet succeeded in forming an idea of its tastes and requirements, and that, finding it impossible to discover any new form of decoration, it is reduced to live, so to speak, in other people's houses, and to reviving in its own behalf furniture and decorations made for other circles, and which were perfect only because they corresponded exactly to the needs and tastes of their day.[15]

His arguments, supporting Vuillard's paintings as appropriate modern decoration, implied an understanding of the vocabulary of the Nabis and of the critics who supported them. Singling out Vuillard's work in this genre as the most promising among the younger creators, he expressed his hope for the future:

We cannot doubt but that these efforts will inspire others, and in this manner step by step, we shall see the decorative arts spring up again with new life: the taste of the public as well as of artists will become more and more refined, and on each side a desire will be felt to cut away from the past and to give a new society a new frame and a new decoration.[16]

But Schopfer's "new society" was far from revolutionary. In the same essay that he acknowledged Bing's efforts to commission artists to design furnishings and art objects in total freedom, he warned against the danger of becoming overly eccentric in the name of originality and the coherent ensemble. A little later in the same article, Schopfer's words recalled the same contradiction that has been cited as common to *fin-de-siècle* aesthetic viewpoints. While he longed for a modern style, he looked back nostalgically to the unified interiors of the *ancien régime*, which, he be-

lieved, "in spite of its affectations and its deformities, will remain the most perfect style that a refined society has ever produced."[17]

Schopfer's relationship with Vuillard seems to have evolved from early acquaintance to friendship, then to artistic collaboration. Writing to Vuillard in 1896 to request an oil, watercolor, or gouache design for a plate to be illustrated in the *Revue Franco-Américaine*, Schopfer closed with the familiar, "bien affecteusement à vous."[18] Certainly by 1898, when the decorative panels were commissioned, Vuillard was not only a colleague but a reliable investment, having played a significant role at Bing's inaugural exhibition and earned prestigious exposure from Vollard's gallery exhibition and from the lithographic albums published by Vollard. In the summer of 1897, Jean, his wife, Alice, and his brother Louis and his wife were guests at the Natansons' Villeneuve residence. The following year, Vuillard listed as significant events in his journal a trip to Venice and Florence with Denis and Schopfer, and the *panneaux Schopfer*.[19] It is probable that Vuillard received the commission for the two large *décorations* – *Woman Reading on a Bench* (*Femme lisant sur un banc*), also called *In Front of the House* (*Devant la maison*), (pl. 165) and *Woman Seated in a Garden* (*Femme assise dans un jardin*) (pl. 166) – during the summer of 1897, worked on them during the winter, and completed them – as is indicated by one of the panels being signed and dated "mai '98" – the following spring.[20] For Vuillard, the paintings seem to have held special importance: they were the only artistic activities listed in his journal for a busy year that included not just the well-publicized set for a puppet-show production of Alfred Jarry's *Ubu Roi*,[21] but also his participation in the second major Nabi exhibition at the Vollard gallery,[22] in an exhibition of modern art at Oslo (Kristiana) and Stockholm (with works by Van Gogh, Gauguin, and Bonnard),[23] and in the first annual exhibition of the International Society of Painters, Sculptors and Engravers at Knightsbridge in London.[24] At this time, too, Vuillard was asked by Mallarmé to illustrate his recently completed poem, *Hérodiade*.[25]

But the lion's share of his energies was reserved undoubtedly for the Schopfer commission. The large (229 × 168 cm.) panels were equivalent in scale and format to the panel *The Park*, commissioned by Thadée and Misia in 1893–4. Instead of an anonymous city park, however, the Schopfer pendants showed two views of the Natansons' house and property. In the left panel, *Woman Reading* (pl. 165), Bonnard and his future wife, Marthe Méligny, are shown seated in front of the house, with green shutters and red brick covered with patches of ivy. Marthe, on a green metal bench, reads from an illustrated fashion magazine. Bonnard, whose back is turned towards the viewer, sits next to her on a folding chair, leaning over to play with a small dog. In the distance, other guests stroll away from

the viewer into the background of hills and smaller houses.

In the pendant, *Woman Seated* (pl. 166), Misia lounges in the garden behind her house, whose green shutters and red brick are seen tucked away in the distance. She sits in a bentwood rocker similar to that found in her Paris residence. Behind her stands her half-brother, Cipa, the smaller figure who appears in the previously cited *At the Piano* (pl. 148) as her shadowy alter ego. Behind and to the right of Cipa, a couple discusses an item from an unfolded newpaper. Elsewhere a woman wearing a purple-and-pink ensemble sits alone. Another woman, watched over by a standing male figure, lounges under her parasol, while another couple strolls away along the path.

Both paintings have a palette of gray tonalities. The mauve and acidic greens of the panels for Dr. Vaquez reappear and are now toned down with grays and whites applied liberally throughout. The pastel greens and blues of the *Public Gardens* series are electrified by the addition of pinks and mauves used consistently throughout the canvases. Touches of pure white and black pigments are used to highlight and define certain details, such as Bonnard's ear and beard and, in the pendant, the area around the dog at Misia's feet. Vuillard's biographers were unanimous in judging the two panels to be the most successful of his *décorations*. Claude Roger-Marx regarded them as the "culmination" of Vuillard's talents as a decorative painter, and Jacques Salomon deemed them "the pure essence of Vuillard" and "masterpieces of decorative painting in our time."[26]

But to appreciate fully these accolades, it is necessary to retrace the steps in Vuillard's career leading to the change in his choices of subject matter and in his ideas regarding "le décoratif." The Schopfer panels, for example, differ from the only other example of Vuillard's early large-scale paintings set out of doors, *The Park* and *Public Gardens*, in their personalized subject matter and approximate renderings of places and persons. Unlike the nine-panel series for Alexandre Natanson, the invented realms of the panels for Dr. Vaquez, or the series, *The Album*, the Villeneuve pendants are believable both in the treatment of the landscape and placement of figures within that setting. More so than the more insistently decorative *Public Gardens*, the space in these panels is both open, as in impressionist landscapes, and closed, as in a tapestry.

The diminishing scale of the figures in the background gives the illusion of space – a space that is "flattened" by the vibrant pigments used in the background as well as in the foreground areas of each painting. Other subtle devices are used in both canvases to prevent the landscape from receding too much into illusionistic space and thus negating its decorative function. The large-scale figures of the seated couple and the lounging Misia are not modeled in light and shadow. Although their size draws the

viewer into the scenes represented, there is no change in color intensity from the foreground to background to further the illusion of deep space. The surface is emphasized instead by the triangles and trapezoids of pure color used to define the clothes worn by the figures in the background. The patterns resulting from these, in fact, are similar to the shawls and dresses of the strollers blocked out in color inks for lithographs such as *The Avenue* (pl. 164) that Vuillard was working on at that time for Vollard's album, *Paysages et intérieurs*.[27]

164 Edouard Vuillard, *The Avenue*, color lithograph for the album *Paysages et intérieurs*, 1899, 41.6 × 48 cm. (sheet), Gift of Walter S. Brewster, 1936.194, The Art Institute of Chicago.

In comparison with Vuillard's previous commissioned projects, the Schopfer panels introduce portraiture and genre-like scenes into large-scale decorative schemes. In the panel of Bonnard and Marthe, for example, the illustration on the page of Marthe's magazine is highlighted with broad white strokes, as if to heighten the realism and at the same time provide another decorative complement to her speckled blouse.[28] (The very suggestion that Marthe studies a fashion magazine is a playful jab at her reputedly eccentric taste in clothes which would not have gone unnoticed by those who knew her.[29]) The painting reads from lower left corner to the horizon line of trees and houses. While seemingly casual, the work is anchored by traditional perspective – in this case, two definite and parallel diagonals. One of these begins with Bonnard's bowed head and continues along the edge of Marthe's magazine to the edge of the brick facade and to the foliage just beyond. The second diagonal angle of the newspaper parallels Bonnard's striped pants. His bent knee and the incline of his torso emphasize the diagonal leading the eye to the dog – a barely discernible shape under the dainty metal table. He, in turn, points with his entire body to the smallest and most distant figure in mauve and white at the far right edge of the composition. In the middle of these diagonals, to the right of center, is the woman seen from the back wearing the butterfly-shaped, mauve-and-white chevron-patterned shawl who serves to stabilize the landscape.

165 (following page) Edouard Vuillard, *Woman Reading on a Bench (Femme lisant sur un banc)*, also called *In Front of the House (Devant la maison)*, 1898, distemper on canvas, 214 × 161 cm., private collection.

166 (page 103) Edouard Vuillard, *Woman Seated in a Garden (Femme assise dans un jardin)* 1898, distemper on canvas, 214 × 161 cm., private collection.

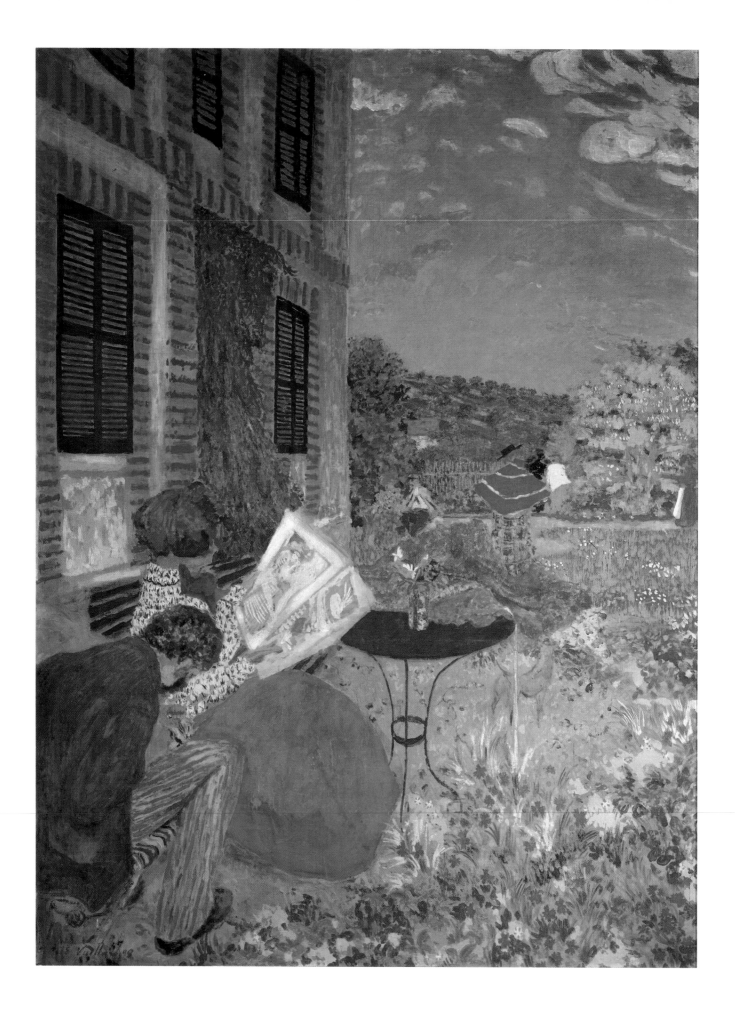

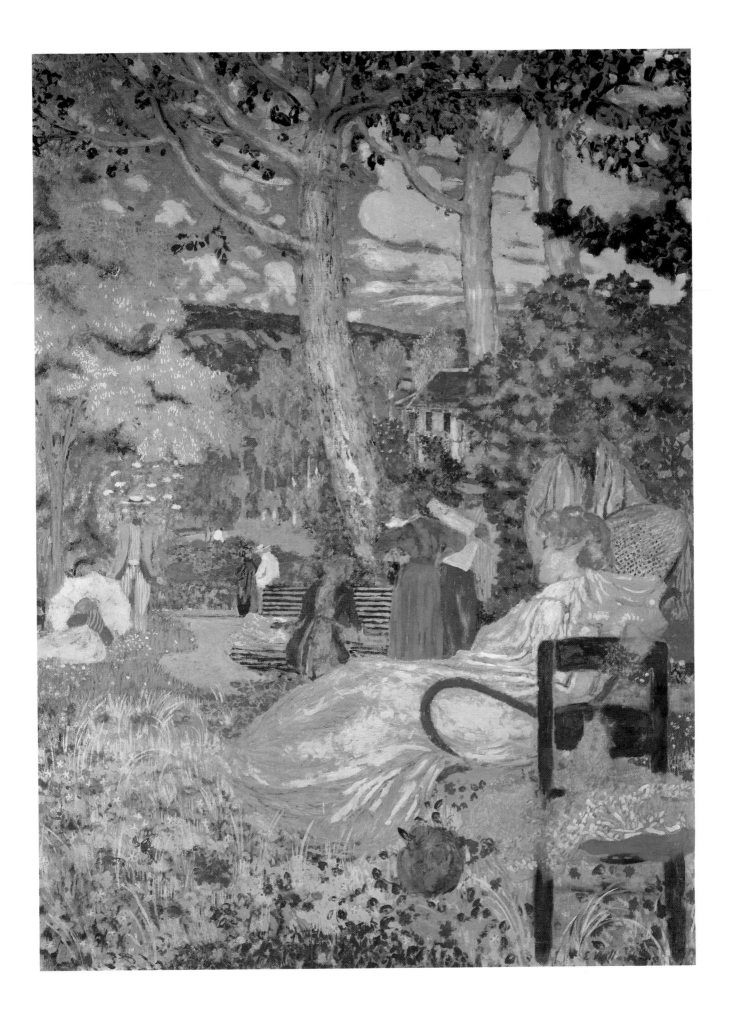

In contrast to the linear structure inherent in the modified two-point perspective of the lefthand panel, the pendant of the seated Misia is a symphony of curves in which the elements seem to revolve around each other. The curved path and the bentwood rocker echo Misia's pose and the rounded form of the small lap dog at her feet. The figures walk away from or towards the winding garden path, or stand along it. Although there is more spatial confusion and less linear perspective here than in the pendant, the whole is calmer and more restful. The painting reads from the lower right corner, beginning with the empty chair, to the expansive figure of Misia, to the winding path with strollers on either side, to the patchwork of hills and back to the screen of giant trees which hides the brick rectangle of Le Relais.

Compared with the closed and gridded interiors for Dr. Vaquez or the claustrophobic panels for *The Album*, the Schopfer panels present a new kind of

168 Claude Monet, *The Turkeys (Les Dindons)*, 1877, oil on canvas, 172 × 175 cm., Musée d'Orsay, Paris.

167 (below) Claude Monet, *The Hunt (La Chasse)*, 1877, oil on canvas, 173 × 140 cm., private collection, France.

plein-air painting. Although sunless and shadowless, the landscapes, as Claude Roger-Marx remarked, "exude summer."[30] They seem closer in subject to Monet's paintings from the late 1870s and early 1880s than they do to paintings by Vuillard's contemporaries. One can, in fact, compare them with Monet's decorative ensemble of four nearly square canvases of almost the same scale, painted in 1876. The panels, titled *The Turkeys (Les Dindons)* (pl. 168), *The Hunt (La Chasse)* (pl. 167), *Corner of a Garden at Montgeron (Coin de jardin à Montgeron)*, and *Lake at Montgeron (L'Etang à Montgeron)* (Hermitage Museum, St. Petersburg), were commissioned by his important patron, the department-store magnate, Ernest Hoschedé. The subject was the landscape and the activities associated with the Hoschedé property at the Château de Rottenbourg in Montgeron.[31] Vuillard would have known two of the Hoschedé series, *The Turkeys* and *The Hunt*, from the sale of their second owner, Théodore Duret, at the Galerie Georges Petit in 1894. These showed almost life-size figures in a landscape with a raked horizon similar to that in Vuillard's pendants of Villeneuve.[32] Like the Monet panels, which showed approximations of people and places familiar to the Hoschedé circle, the subjects of the Schopfer panels would have been recognizable to their circle. Monet's and Vuillard's decorative "effects," however, are only superficially

similar. Whereas Monet's paintings displayed a blond-blue palette, Vuillard's colors ranged from dusty beiges to chalky chartreuse, to the electric pinkish-mauve used in the womens' dresses and accessories. Likewise, Monet's oil-painting technique, using closely modulated tones applied with tightly interconnected brushstrokes, created a very different surface effect from Vuillard's use of *à la colle* technique. Not only did this medium dry quickly,

with the final colors appearing lighter than their original application, but it allowed Vuillard to paint and retouch the colors to render the desired texture and mat effect.

Exploiting this technique, Vuillard applied his brushstrokes so that the background figures have the same texture as the foliage into which they are integrated. And yet, in comparison with Monet's woven brushstrokes applied with a rigorous evenness throughout, Vuillard's much broader strokes are uneven and seemingly undirected, despite their "woven" quality. The face of Cipa, for example, is dotted with green, as if to blend it with the khaki-colored foliage. Misia's visage is also difficult to read, and made up of light-and-dark tonalities. She is recognizable by her coiffure, clothes, and pose more than by any specific facial characteristic. The more varied *facture* breaks up the surface and adds texture to certain areas such as the figure of Misia, where broad sweeping strokes are employed to suggest her diaphanous gown. What appears as the transparent quality of Misia's summer frock is the area where the paint is applied most thickly. Likewise, the clouds perceived in the grayed sky are actually amoeba-like heavy clumps of color that stand out from the more thinly covered canvas.

A drawing from Vuillard's sketchbook (pl. 169) suggests that at one time he conceived of the panels as a large, single scene connected by the metal picket fence, which is visible only in the lefthand panel of the final pair.[33] In the drawing, the foliage in the left panel along the facade concealed the stricter lines of brick and shutters so that the contrast between the sharp diagonals of the left panel and the more circular composition of the pendant are less evident. The figure of Bonnard was left out entirely. The sketch also reveals that the righthand side originally had one tall tree instead of three to divide the composition equally. Moreover, the foreground chair, which plays such an important role in the Misia panel where it competes with the mauve cushion and the brownish purple of the bentwood rocker, was originally a *repoussoir* device placed at the left rather than right edge. In the finished paintings, Vuillard took the smaller elements of the bench and the metal chair and gave them equal status with the figures. By pushing the figures from the foreground (where they were lined up in the drawing) into the middle and background, and by raising the horizon line, Vuillard increased the landscape space into which the figures are integrated. At the same time, the recession into that space was decreased, emphasizing the paintings' flat surface patterns and their destination as wall *décoration*. Even with these changes for the full-scale paintings, however, both halves of the composition remained remarkably unchanged from the drawing taken *sur le vif*.

Did Schopfer commission the paintings after the drawing? Was the drawing made directly for the commissioned project, or was it one of several com-

pleted that summer and subsequently changed to suit the apartment for which the paintings were commissioned? Was it Schopfer's request to have the paintings separated? There is no extension or seam to indicate that the canvas had been cut or extended to accommodate a separation. Yet the fact that Vuillard painted a third *décoration* for the Schopfers in 1901 (pls. 180, 181), with a scale twice the width of the first two panels and comprised of two equally independent scenes, suggests that Schopfer may have known of this early conceptual drawing when he ordered the third panel to complete the ensemble.

It seems uncharacteristic of Schopfer, self-confident and ever-conscious of his standing in society, not to insist on the inclusion of his own portrait and property in the paintings. From his extensive art-history training and his particular interest in western and non-western art and decoration, he was no doubt aware of the aristocratic tradition of commissioning artists to make tapestries or murals with imagery specific to the owner's family and property. One can think of, for example, Jean-Baptiste Oudry's scenes from the royal hunts from the mid-eighteenth century, complete with portraits of the king's dogs, that were translated into tapestries by the Gobelins Manufacturers. In the nineteenth century, this tradition was continued by Salon painters like Paul Baudry, Tony Robert-Fleury (Vuillard's teacher), and Luc Olivier Merson, as well as by progressive artists like Puvis de Chavannes and Monet. One of the four *décorations* painted by Monet for the Hoschedés, for example, represented a scene from a hunting party hosted by the Hoschedés that the artist had attended during one of his stays (pl. 167).[34] Among Vuillard's immediate contemporaries were a number of artists involved in painting monumental decorative ensembles whose subjects also depended

169 Edouard Vuillard, *In Front of the House* and *Woman Seated in a Garden*, *c.*1898, pen-and-ink study, formerly single sheet torn in two and rejoined, Salomon Archives, Paris.

105

170 Maurice Denis, *The Legend of Saint Hubert* (*La Légende de Saint Hubert*), 1897–8. One of a series of panels for the Baron Denys Cochin, private collection.

172 Georges d'Espagnat, decorative panel for Dr. Viau, boulevard Haussman, *Art et Décoration* (July–1899), p. 123.

173 Georges d'Espagnat, scenes of the Durand-Ruel children at their family château, Bénavent, for the Durand-Ruel residence, rue de Rome, 1897.

upon the conventional association of patron with property. In 1898, Maurice Denis completed a seven-panel decorative ensemble for the *hôtel particulier* of the baron Denys Cochin, a conservative politician and writer whom Denis had met through Henri Lerolle's salon. The theme of Denis's work was the "Legend of St. Hubert," a subject concerned with the search for spiritual truth and implicitly Christian in tenor (pl. 170). Not only did Denis base his composition on the hunting parties that he had attended while a guest at the baron's château in Beauvois, he included portraits of the baron's family in medieval garb.[35] That same year, Denis was commissioned to paint a mural-like painting for the *hôtel particulier* of the Ernest Chaussons, relatives of the Lerolles. The resulting large-scale painting, *Annunciation at Fiesole* (*Annonciation à Fiésole*), was set in a landscape near the Chaussons' Italian villa and included portraits of their three children.[36]

Georges d'Espagnat, another artist contemporary with but outside the Nabi group, specialized in this kind of personalized decorative painting, and between 1896 and 1901, completed a number of ensembles, some of which were published in decorative-arts reviews.[37] None other than Octave Maus, champion of the neo-impressionists and organizer of the Belgium vanguard exhibitions, "Les XX," praised d'Espagnat's 1896 ensemble for the dining-room of Dr. Viau's boulevard Haussmann apartment which

showed in the background his family's property at Vilenne (pl. 172).[38] In March 1898, as part of d'Espagnat's retrospective exhibition at the Durand-Ruel gallery, he exhibited panels showing Joseph Durand-Ruel's children at the family château, Bé-navent, commissioned for the château itself, as well as a series of decorative paintings, commissioned for the doors of the dining-room in the Durand-Ruels' Paris residence (pl. 173).[39] All of d'Espagnat's projects looked back to the rococo tradition of decorative panels, with simple, lighthearted compositions, soft tones, little or no chiaroscuro, and a relatively even surface texture.

By contrast, Vuillard's panels of the gardens at Villeneuve are more complicated compositionally and have more to do with his own life than with that of the man who commissioned them. Vuillard's biographers agree that the true inspiration for the panels was the artist's heightened affection for Misia during the summer of 1897 and the days at Villeneuve spent "more or less under Misia's spell."[40] Certainly, Misia had a lot to do with Vuillard's increased sense of belonging and happiness during the summer and fall sojourns at Villeneuve from 1897 to 1899. His letters to Vallotton from Villeneuve, urging him to come and visit, are full of compliments to Misia and her husband and to the happy family they make. In October 1897, after two weeks at Le Relais, Vuillard wrote to Vallotton in Paris (on *Revue Blanche* letter-

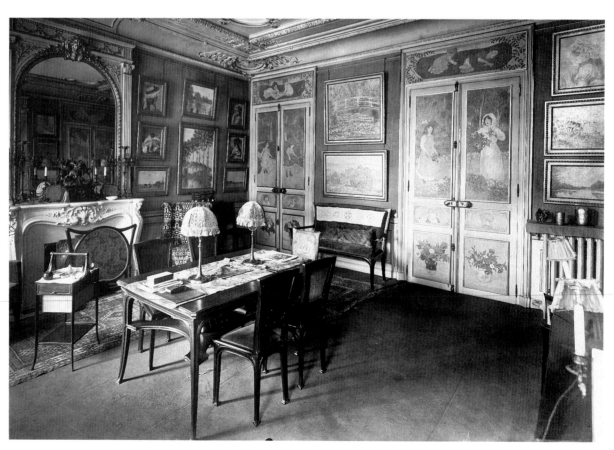

head), saying that he was sad to see the time go so quickly: "There is always [our] painting to bother us, but the kindness of Thadée and Misia more than makes up for any damage . . ."[41] Misia, flattered by Vuillard's attentions, flirted shamelessly with her friend, adding to that same letter the teasing postscript, "As you can see, my dear Vallotton, Vuillard is acting as my husband, naturally with no good intentions and no honor."[42] Vuillard was not immune to Misia's flirtations, and, as Misia remembered, burst into tears on the eve of one of their returns to Paris – "the most beautiful declaration of love that I have ever had."[43]

Photographs taken during that summer by Alfred Natanson show Misia with Thadée, Cipa, Marthe Mellot (Alfred Natanson's wife), Stéphane Natanson, Vallotton, and Vuillard, sprawled in bourgeois finery on the lawns of Le Relais (pl. 174), lounging in garden chairs, and in other casual poses.[44] Although Vuillard had also acquired a handheld box camera, the Kodak Model 96 in that year (an ordinary model with bellows, available by 1895), no photographs have been found that might have been used as sources for the 1898 Schopfer panels.[45] Instead, drawings, such as the charcoal sketch of Bonnard seated and reading a book (Alfred Ayrton Collection), perhaps used for the figure of Bonnard in the panel *Woman Reading*, or the compositional sketch (pl. 169), suggest a more traditional working method.

Closely related in spirit to the panel of Misia in the garden were the other portraits of Misia painted that summer by Vuillard and by the other *habitué* at Le Relais, Toulouse-Lautrec. While numerous of Vuillard's Misia paintings during the nineties show her as she appears in the Villeneuve panel – lounging or deep in meditation (pl. 161), attitudes symbolic of her muse-like status – Toulouse-Lautrec's representation of Misia reading in the garden is quite different in sentiment (pl. 171). In this portrait, in which she is wearing a summery cotton frock similar to the one she wears in the Schopfer panel, she is shown seated with knitted brows. Instead of meditating, she is sneering with an impish, coarse expression, made coarser by the addition of a double, rather than dimpled, chin.[46] Vuillard's softer image of her looks back to Mary Cassatt's portraits of her sister reading in the garden (pl. 175), or to Monet's several portraits from the late 1870s and early 1880s of his future wife, Alice Hoschedé (widow of Ernest Hoschedé), in the gardens at Vétheuil.[47] The similarities between Vuillard's Misia portrait and Cassatt's *Woman Reading in a Garden*, 1880 (private collection) and Monet's *Alice Hoschedé in the Garden* (1881) can be seen not only in the subject matter and blond palettes, but also in the way the natural elements, such as the framing of the compositions by the cut-off and curved trees, were made to complement the seated women.

Vuillard's return to impressionist themes and a lighter palette may have been stimulated by exhibitions of Monet's works along with those of the other impressionists, Renoir, Pissarro, and Sisley, at the Durand-Ruel gallery that spring.[48] Their group was also spotlighted at the beginning of 1897, when a large number of early impressionist paintings from the Caillebotte Bequest were exhibited at the Musée du Luxembourg in anticipation of their acceptance into the national collections. Writing about the exhibition of Nabi artists at the Durand-Ruel gallery in

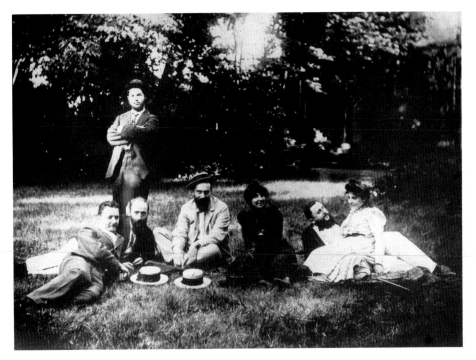

174 (above) Photograph by Alfred Natanson showing a picnic at Villeneuve-sur-Yonne, *c.*1898. Left to right: Félix Vallotton, Vuillard, Stéphane Natanson, Marthe Mellot, Misia, and, standing, Misia's half-brother, Cipa Godebeski. Salomon Archives, Paris.

175 (left) Mary Cassatt *Woman Reading in a Garden*, 1880, 90.2 × 65 cm., Gift of Mrs. Albert J. Beveridge in Memory of her aunt, Delia Spencer Field, 1938.18, The Art Institute of Chicago.

171 (facing page, far left centre) Henri de Toulouse-Lautrec, *Madame Misia Natanson*, 1897, oil mixed with turpentine (*à l'essence*) on cardboard, 56 × 46 cm., private collection, New York.

1899, Thadée linked Bonnard, Denis, Ibels, Ranson, Roussel, Sérusier, Vallotton, and Vuillard to the previous generation and commended their love for impressionism and their admiration for Cézanne. Singling out Vuillard, "who is with Bonnard and perhaps Roussel the best in terms of painting . . . ," Thadée discussed the changes apparent in his paintings exhibited that year:

It could be that one is especially alerted this year [in Vuillard's works] to a particular evolution of his talent: he remains the most delicious and elegantly refined of sensual analyists, but one sees that he is trying to give a more general and wider range to the expression of his ideas.[49]

The key words in Thadée's commentary, "general and wider range," are significant in view of Vuillard's paintings after 1898, which tended towards a more impressionist subject matter and airier compositions. Whether or not he was consciously borrowing from these older masters, Vuillard's decorative works in the next decade continued to exhibit certain affinities with the impressionists' subjects, colors, and compositions, albeit tempered by his highly personal handling of those elements.

The Third Schopfer Panel: The Luncheon at Vasouy, 1901

Three years later, on 18 December 1901, Schopfer and his wife celebrated the installation of the third and last commission from Vuillard, *The Luncheon at Vasouy (Déjeuner à Vasouy)* (pl. 179) with a special evening party.[50] More so than the pendants, the third painting, measuring twice the length, offered near life-size and portrait-like figures from Vuillard's circle. And if it had seemed odd that Bonnard rather than Schopfer, and Misia rather than Schopfer's wife, were most prominent in the first set of decorative panels, the final panel compensated, at least in part, for that slight. Dominating the right half of the composition is a full-length portrait of Alice Schopfer wearing a diaphanous white muslin dress. She is shown talking animatedly to Bonnard, whose head is turned towards her, in what is Vuillard's first attempt to incorporate a full-length frontal male figure into a decorative composition.[51] Moving clockwise around the luncheon table, the diminished figure of Jean Schopfer, wearing a mustard yellow suit and *canotier*, stands directly behind his wife. At the far end of the table, Misia, in her signature gauzy summer dress and hat, chats with playwright and journalist Romain Coolus. The humorist-playwright Tristan Bernard stands in the right foreground, distinguishable by his bushy brown beard and large frame which will identify him again in Vuillard's later decorative panels, *The Haystack (La Meule)* (pl. 243) and *The Library (La Bibliothèque)* (pl. 288) of 1907 and 1911 respectively.[52]

Behind him and facing out is Schopfer's younger brother, Louis, dressed identically to his brother on the opposite side of the table. (Photographs of the brothers from this time show the keen family resemblance [pl. 176a,b].) Seated in front of Louis is his wife, called "Bob."[53] Below Bob's hat brim can be seen the silhouette of Lise Blum, the wife of Léon, a literary critic for *La Revue Blanche*, essayist, and in 1901, a fledgling politician.

The panel has been known in the Vuillard literature as the *Luncheon at Villeneuve-sur-Yonne*, instead of by its correct location, Vasouy in Normandy.[54] Part of the confusion resulted from the changes made to the painting in 1935, when Vuillard repainted and

divided the panel as a favor to Schopfer's widow and second wife, Clarisse Langlois (pls. 180, 181). In the original version (known only from black-and-white photographs published in Roger-Marx's biography of the artist [pls. 177, 178] and from a photograph of the panel as it was first installed in the Schopfers' apartment [pl. 179]), the red-brick building adjacent to the table and the presence of Bonnard and Misia suggest a Villeneuve setting. Yet Vuillard's journal chronology for the summer of 1901, listing "La Terrasse à Vasouy. panneaux Schopfer," leaves no question as to the exact location for this second *décoration*.[55] Less than two miles from Honfleur, the resort town of Vasouy was the summer home of the dealer Jos Hessel and his wife, Lucie. A new vacation spot for Vuillard, it and the Hessels' various summer

176a and b Photographs of Jean (left) and Louis (right) Schopfer, c.1900, collection of Mme Jean Mabilleau, Paris.

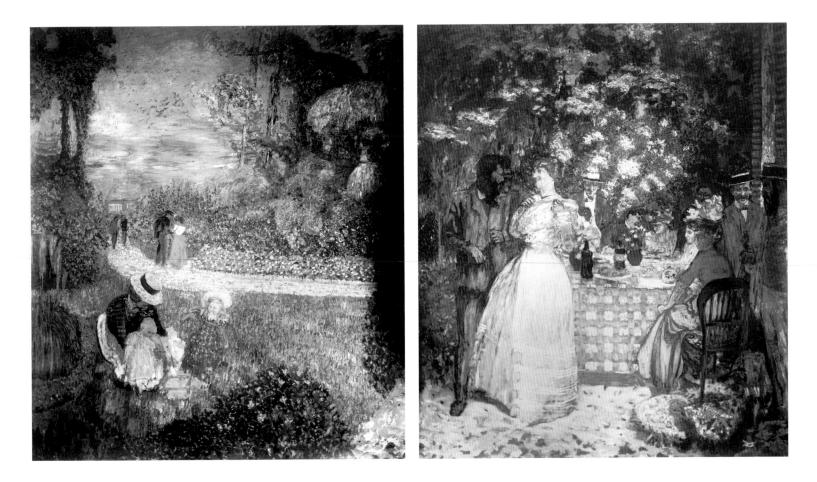

residences would replace Villeneuve in his regular summer itineraries, just as Lucie would replace Misia as Vuillard's model, muse, and closest friend.[56] At the time of the second Schopfer commission, however, Vuillard's journal entries indicate that he was a newcomer to the Hessel's circle.[57] Perhaps that is why Lucie does not appear in the original version (pl. 178) but was later painted in at the righthand side of the table to replace Lise Blum.[58] Lucie's collie Basto was also painted at this later date into the right foreground. Apart from significant retouching to the figures and background, no other alterations in the guest list were made to the righthand side of the luncheon table in the 1935 version.

The left half of the panel was also changed from its original composition. In the 1901 painting, couples stroll and converse with one another along the sinuous path set into a carefully manicured lawn and garden, similar to the setting of the 1898 panel showing Misia lounging in her garden (pl. 177). Schopfer's sister-in-law ("Bob") is shown squatting down to play with her daughter, Hélène (called "Biche"), and Anne, the baby daughter of Jean and Alice. When, in 1935, Vuillard agreed to cut the panel in two, he added to this half the standing figure of a woman in a white dress, large straw hat and carrying a red book in her left hand (pl. 180). Other changes can be found in the firmer outline of the path, the more defined foliage, and the addition of a large tree at the lefthand

margin to frame and strengthen the composition and reinforce its new function as an independent canvas. To each of the panels, Vuillard added a wedge of gray to suggest both the continuation of the step or a separate surface in the right-hand panel, and the spatial discontinuity between the two events being represented; but at the same time to suggest a unity

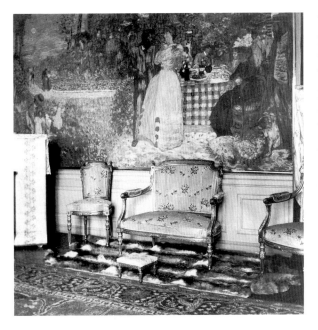

177 *The Luncheon at Vasouy*, 1901 (left half), distemper on canvas (dimensions not known). Photograph taken before repainting and addition of woman in white.

178 *The Luncheon at Vasouy*, 1901 (right half), distemper on canvas (dimensions not known). Photograph taken before repainting. From left to right: Bonnard, Alice Wetherbee Schopfer, Jean Schopfer, Romain Coolus, Misia, Léon Blum, Lise Blum, Mme Louis Schopfer, Louis Schopfer, and Tristan Bernard.

180 (following page) *The Luncheon at Vasouy* 1901–36 (left half), 1901 and 136, distemper on canvas, 2,184 × 1,829 cm., National Gallery, London.

179 Photograph showing installation of the panel *The Luncheon at Vasouy*, c.1901–2, at 132 avenue Victor Hugo, Salomon Archives, Paris.

109

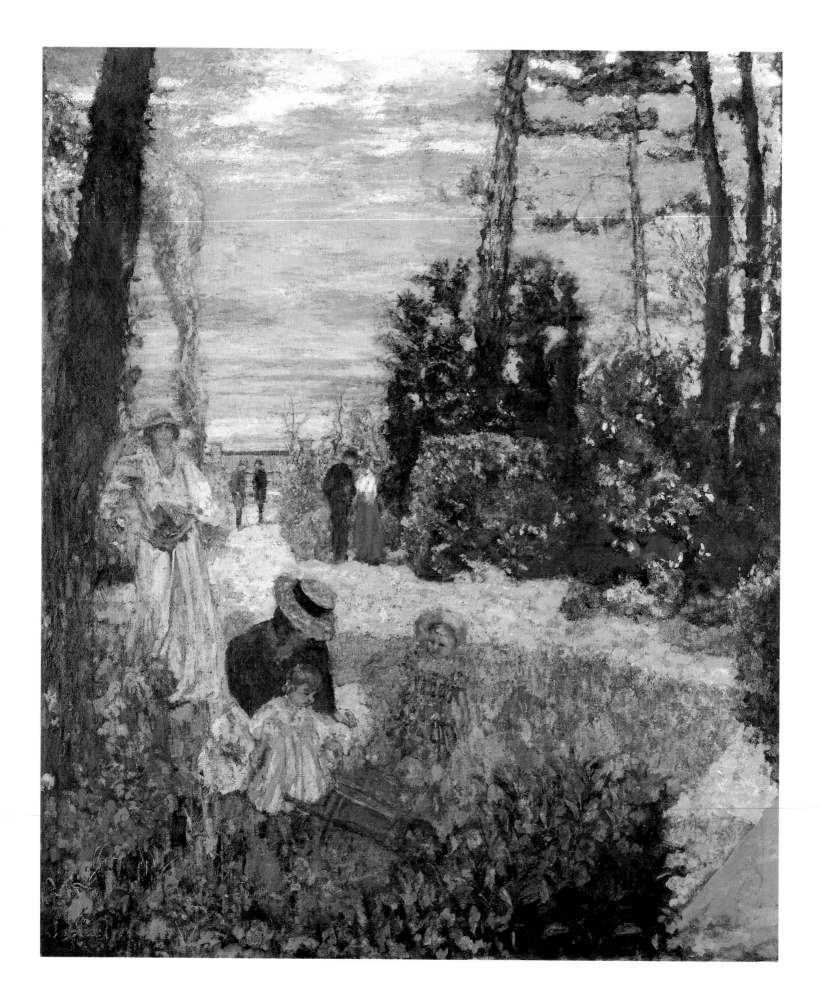

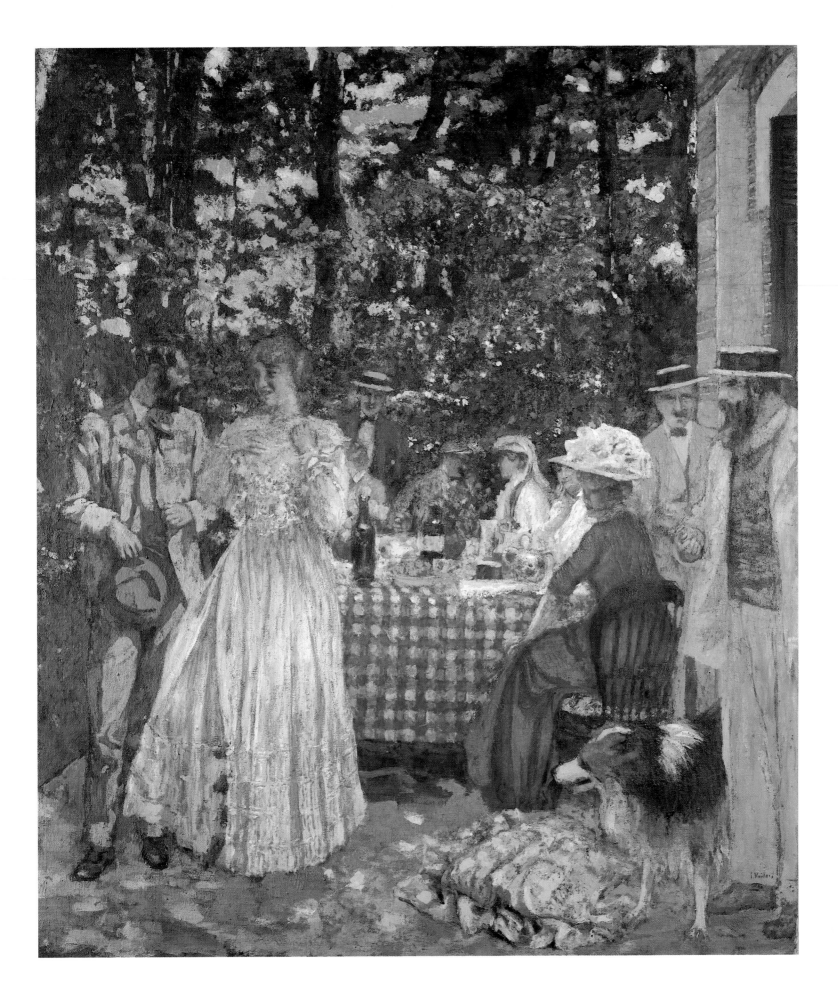

181 (preceding page) *The Luncheon at Vasouy*, 1901–1936 (right half), 1901 and 1936, distemper on canvas, 2,184 × 1,829 cm., National Gallery, London.

183 (right, top) Pierre Bonnard, *The Bourgeois Afternoon* (*L'Après-midi bourgeois*) or *The Terrasse Family* (*La Famille Terrasse*), 1900, oil on canvas, 139 × 212 cm., Musée d'Orsay, Paris.

184 (right, bottom) Pierre Auguste Renoir, *The Luncheon of the Boating Party* (*Le Déjeuner des canotiers*), 1880–1, oil on canvas, 130 × 173 cm., The Phillips Collection, Washington, D.C.

182 (below) Pierre Bonnard, *The Garden at Basset* (*La Verdure au Basset*), 1898, oil on canvas, 168 × 228 cm., Musée d'Orsay, Paris.

between the pendants stronger than they had as a single panel. Perhaps Vuillard, who by 1935 had watched as many of his decorative "series" paintings were separated and sold individually, wanted to insist upon the connection between the two panels.[59]

Segard, describing the painting before it was separated and repainted, saw the luncheon scene as a sort of "sentimental transformation" ("transfiguration sentimentale") drawn from memory and only approximating figures and objects.[60] In contradistinction to Manet's large portrait-*décoration*, *Music in the Tuileries* (pl. 65), where many parts of the picture are left sketchy and unresolved but the portraits are highly finished,[61] Segard observed that, with the exception of Tristan Bernard (whom he identified), facial details were completely absent:

> The faces no longer exist: they are colored spots . . . In a way, even the drawing no longer exists, unless one accepts that the drawing in itself consists only of facial features conforming to a defined goal. In this case, the drawing is very beautiful because it is highly expressive, although it is not precise, nor fluid, nor picturesque, and even though it does not imitate the exact shape, nor does it attempt to copy reality accurately.[62]

To understand Segard's arguments, it is necessary to return to photographs of the painting as it looked before 1935, where faces – especially of the figures in the foreground, Bonnard, Alice, and "Bob" Schopfer – are made up of staccato-like brushstrokes and are less clearly portrait-like than in the 1935 version. The technique Vuillard used in the earlier version, which Segard described as "très en tapisserie," was altered in 1935 by the addition of

contoured brushstrokes to strengthen certain areas in the faces.[63] While in the final version, Misia is seen only in *profil perdu* and Coolus's facial characteristics are hidden in the shadow cast by the soft cap (a later addition), the portraits of the luncheon party in general are more clearly defined. It is probable that Vuillard was working from photographic sources. In the right half of the 1935 version, for example, the life-size figures are modeled by sharp contrasts of light and dark. The colored shadows are sharper and flatter than those seen in the *Public Gardens* series and suggest that for the final version, he may have returned to photographs from this or another summer outing with the Hessels as *aides-mémoire* for an alternative group portrait.

How different is Vuillard's large-scale *décoration-cum*-society portrait from Bonnard's monumental *plein-air* painting completed the previous year, *Afternoon of a Bourgeois Family* (*L'Après-midi d'un famille bourgeoise*), showing Bonnard's sister-in-law's family at their summer home at Grand-Lemps (pl. 183). In this work, highly criticized for its irreverent and caricatural quality when it was exhibited at the Salon des Indépendants in 1901, Bonnard painted his brother-in-law, the musician Charles Terrasse, who looks on with *ennui* at his well-dressed, well-behaved, and *comme il faut* family circle.[64] By contrast, Vuillard's approach to a similar subject is photographic in pose

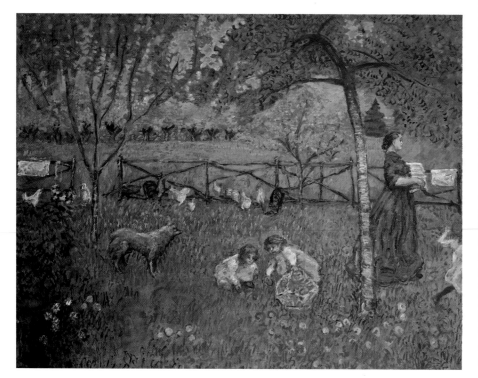

and expression, and the subject is approvingly, not sarcastically, interpreted. One can compare the left-hand of Vuillard's painting, showing the trio of children and mother, with another Bonnard *décoration* from 1901, *The Garden at Basset* (*La Verdure au Basset*) (pl. 182), for a similar antithetical relationship between caricature and modern genre. Closer in spirit to Vuillard's luncheon party are the early out-of-doors leisure scenes by Renoir and Monet. Vuillard's panel, for example, shares the interest in light patterns and the conversational tone pervading Renoir's well-known dining scene, *The Luncheon of the Boating Party* (*Le Déjeuner des canotiers*) (pl. 184) which had been exhibited the previous year at the Durand-Ruel gallery.[65] In the left half of the panel, Vuillard's double portrait of Bonnard and Alice Schopfer recalls also Monet's early full-scale portrait of Bazille and an unidentified woman in the forest of Fontainebleau, *Bazille and Camille* (*Les Promeneurs*) (pl. 185), while the scene at the left, showing Schopfer's daughter and niece in the garden, looks back to Monet's paintings of the mid-seventies, depicting his son Jean absorbed in play in the garden at Vétheuil. After a decade of being misunderstood by the general public and overlooked by the Nabis in favor of the innovations of symbolism and synthetism, the impressionists were enjoying the rewards of their labors among a wider spectrum of society. In his lengthy article, "Spéculations sur la peinture à propos de Corot et les Impressionnistes," for *La Revue Blanche* in 1899, written on the occasion of an exhibition of Durand-Ruel's permanent collection of the works of Monet, Renoir, Sisley, and Pissarro, Thadée traced the evolution of *plein-air* painting up through the works of these artists.[66] In the following year, he devoted a column to "M. Renoir et la beauté."[67] For his part, Vuillard seems to have become more and more interested in the older painters' works, especially Monet's which he could see in private collections, museums, and gallery exhibitions.

Apart from subject and generalized themes, however, Vuillard's borrowing was superficial. His large-scale canvases differed significantly in scale, placing of figures, medium, and paint application. The impressionists were criticized for creating canvases that had to be viewed from afar in order for the subject matter to be comprehended, but Vuillard's brushwork and use of the distemper technique rendered the monumental luncheon scenes even more "abstract" at close range. The textural surface as well differed from that of the impressionists, in that Vuillard was covering canvases with broadly applied brushstrokes for the ground, which he worked and reworked with the hot-glue-and-dry-pigment method to produce a scumbled and heavier surface, which was appropriate for a wall or backdrop but would have not been suitable for smaller canvases. The *Luncheon* was a vast evocation of the Schopfers' summer experiences. Undoubtedly, too, this portrait of well-dressed Parisians enjoying the pleasures of a

villégiature served as a symbol of their economic and social status.[68] While not a window onto nature, the picture, dominating one of the Schopfers' living-room walls, was a reminder of their social well-being and would have been a lively and appropriate *plein-air* backdrop for the young, urban, and upwardly mobile Schopfer *ménage*.

185 Claude Monet, *Bazille and Camille* (*Les Promeneurs*) 1865. Fragment of *Déjeuner sur l'herbe* (separated by the artist), oil on canvas, 93 × 69 cm., Ailsa Mellon Bruce Collection, National Gallery of Art, Washington, D.C.

Installation and Reinstallation of the Schopfer Panels

The earlier pendants and the larger panel were probably installed in the *grand*, and possibly *petit*, *salons* on the first floor (*premier étage*) of a recently renovated

It is unfortunate that no contemporary descriptions of any of Schopfer's residences have been found to help gauge the reception of Vuillard's large luncheon scene as a *décoration*. Denis mentioned in his journal having attended the Schopfers' inaugural party in 1901, with no further comment regarding the painting's effect as interior décor. In 1926, Count Kessler, the urbane German art collector (owner of Seurat's *Models [Poseuses]*, which hung in his Weimar house decorated by Henry van de Velde, pl. 224), had lunch with the Schopfers on the rue du Bac. Although he noted in his diary, "Pretty tastefully furnished ground-floor apartment with fine Persian faiences and pictures by Vuillard and Bonnard," he made no distinction between Vuillard's monumental luncheon scene and the other portraits, nudes, and easel pictures in Schopfer's collection.[91] One cannot help but wonder, for example, what the second Mme Schopfer felt about having this almost life-size image of her husband's former wife join them at their meals!

Vuillard's commissioned panels for Schopfer raise questions concerning the nature of *décoration* as opposed to large-scale easel painting, and particularly genre painting and portraiture. One remembers Vuillard's personal note, made during work on the *Public Gardens* panels, that, "for a decoration for an apartment, a subject that's objectively precise could easily become unbearable," and his concern for the general and not specific expression. As shown, in the first set of pendants from 1898, Vuillard obscured through gesture and pose the most precise details of his portraits of Bonnard and Misia, which Signac saw not as portraits but as painted complements to the fabrics and upholsterings. The large-scale painting of the luncheon party on the other hand, represented a more specific society and event. The fact that Vuillard subsequently altered the portraits to suggest another group of people also indicates to what degree his approximations of people and place were "objectively too precise."

Interestingly, some ten months before his visit to the artist's *atelier* in December 1898, Signac remarked in his journal that Vuillard's figure paintings were based too much in fantasy. In what must have been a reference to the artist's easel paintings exhibited at the Vollard gallery, he complained:

The people in his pictures are not properly defined. As he's an admirable draughtsman, it must be that he just *doesn't want* to give them mouths and hands and feet. His finished pictures are like sketches. If he had to work on a big scale he'd have to be more exact – and what would become of him then?[92]

With the second commissioned panel for Schopfer, Vuillard seems to have accepted Signac's challenge to paint in a more "exact" manner in order to accommodate the larger surfaces. And it was possibly the fact that the figures were "properly defined," rather than absorbed into a fantasy – and that he established his subjects with their characteristic attitudes just as a photographic snapshot would – that rendered them untransferrable from one owner to another, and, therefore, inappropriate as modern decorations. Anne McCauley has argued that, throughout the nineteenth century, portraiture retained its traditional status as the art genre that could reproduce reality most faithfully. Thus, portraiture continued to be judged subjectively, the judgement being based on the identity of the sitter.[93] Vuillard distorted the physical likeness but did not negate it entirely. Unlike Denis's large-scale decorative panels in which the portraits of his patron were hidden in allegory, or, in the case of the Baron Cochin commission, in medievalizing garb (pl. 170), *The Luncheon at Vasouy* presented modern-life situations as if in a photographic mural. A too personalized *décoration*, as will be seen, contradicted the definition of the genre itself. And while size *was* a distinguishing feature of decorative painting as opposed to easel painting, in contrast to the panels for *The Album*, which were easily transferrable from one interior to another, the *Luncheon* panel demanded more from the interior and from the audience and was, consequently, a less appropriate *décoration* for the highly mobile and volatile life style of one of Vuillard's early patrons.

194 Detail of pl. 180.

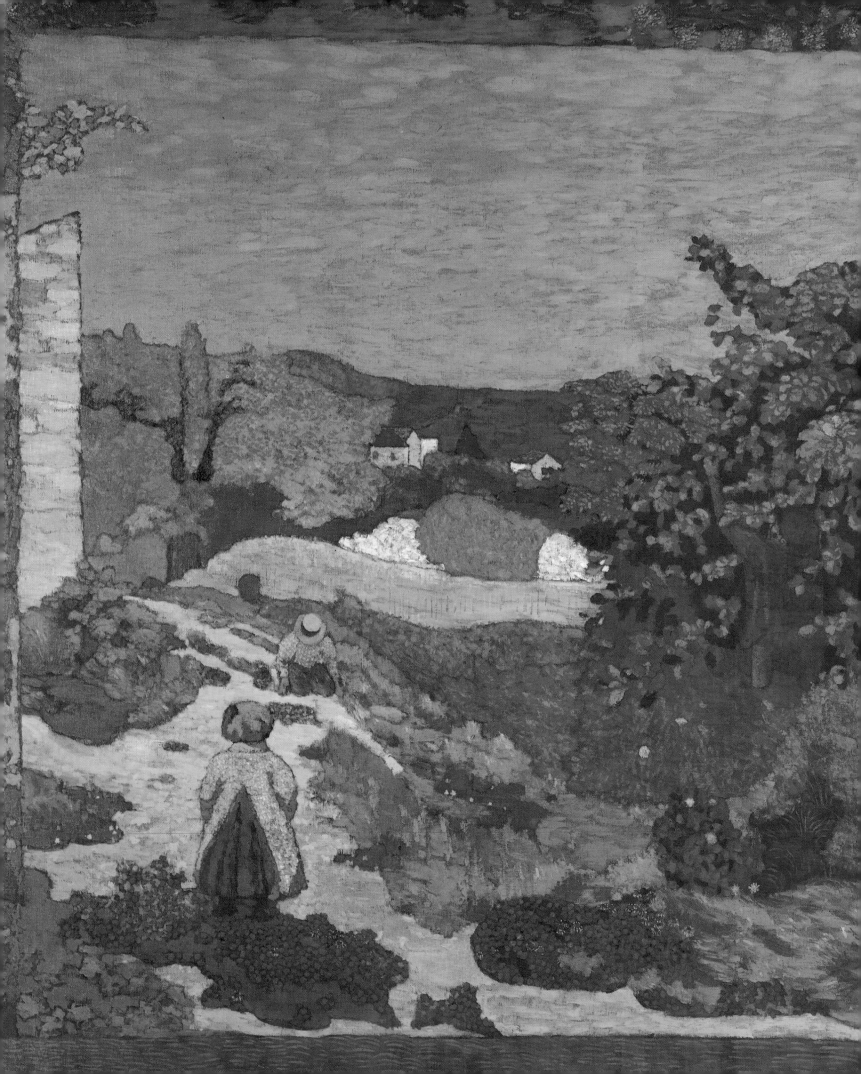

6 Landscape as Decoration – Transformations of Place: The Commissions for Adam Natanson and Jack Aghion, 1899

The two important artistic events listed by Vuillard in his journal summary for the year 1899 were the exhibition of modern art at the Durand-Ruel gallery and a commission for decorative paintings for the patriarch of the Natanson family, Adam.[1] In the exhibition "L'Ecole moderne,"[2] which was to be the Nabis' last group showing at the Durand-Ruel gallery, the Nabis (Bonnard, Denis, Ibels, Hermann-Paul, Ranson, Rippl-Ronäi, Roussel, Sérusier, Vallotton, Vuillard) were displayed in one room, with Signac's circle (Louis Angrand, Henri Cross, Maximilien Luce, Henri Petit-Jean, Van Rysselberghe) in another, and the circle of artists affiliated with the Pont Aven and Rose + Croix artists (Daniel de Monfreid, Roussel-Masure, Louis Valtat, Emile Bernard, Charles Filiger, Antoine de la Rochefoucauld) in a third. Included in this last gallery were the sculptors Charpentier, Lacombe, and Minne and independent artists Albert André, d'Espagnat, and Redon, whose works did not fit into any one category (although by then Redon was closely linked to the Nabis). For Signac, who organized the exhibition, the event marked the triumph of symbolism and synthetism by those artists "who, in the last fifteen years, have exhibited outside the salons."[3] In his preface to the catalogue, André Mellerio, critic and author of *Le Mouvement idéaliste en peinture* (1896) reiterated the dominant impulse towards "le décoratif" among artists whose emphasis on surface and pattern derived from Seurat, Gauguin, and the others who "enthralled with the decorative aspect, sought a balance of colors and shapes to compose a surface pleasing to the eye as well as meaningful. They thought that a tradition had existed amongst the great masters, and they tried to understand and revive it."[4] Vuillard, listed in the catalogue at 56 rue des Batignolles (where he lived briefly from 1898 to the spring of 1899), exhibited four "scènes d'intérieur," designated "not for sale".[5] These pictures of the artist's family at lunch and quiet domestic interiors were viewed by the majority of the critics as among the best of the paintings by the younger artists. Signac, in fact, called the room containing Vuillard's works, "la salle des saints!" adding that it represented a victory for Vuillard, so capable of beautifully expressing "the sweetness and joy of things."[6] For the critic Yvanhoe Rambosson, writing for *La Plume*, Vuillard's works showed him moving in a new direction towards an increased refinement of color which concealed the "gaucherie" of his Nabi beginnings.[7] Even Antoine de la Rouchefoucauld, artist, aristocrat, and principal financial backer for the Rose + Croix artists, found Vuillard's work superior to that of his Nabi colleagues. In a letter to Emile Bernard (in Egypt), he praised Vuillard as a real painter, "gifted with great qualities of finesse and refinement." In contrast, he regarded Denis (the other Nabi receiving substantial critical attention), as over-earnest in his objectivity, resulting in a loss of "the nobility and unassuming grace of earlier works."[8]

Thadée Natanson, who reviewed the exhibition under the portentous phrase, "Une Date de l'histoire de la peinture française," tried, as the title suggests, to trace the lineage of the symbolists and neo-impressionists from Goya, Ingres, Courbet, and Delacroix through the impressionists to Moreau, Redon, and other members of the *ecole moderne* who had recently been exhibited. After a perfunctory description of the works by each exhibitor, Thadée paired those of Bonnard and Vuillard as the most outstanding of the show: "C'est le rare et c'est l'exquis. C'est l'inimitable."[9]

Denis, on the other hand, viewed the exhibition and Vuillard's participation quite differently. In his journal he listed the two distinct factions that he felt had developed from the original Académie Julian group. On the one side, he placed Bonnard, Vallotton, Vuillard; on the other, Ranson, Sérusier, and himself. As Denis perceived the situation, the first group was characterized by the use of small formats, somber palettes, and subjects drawn directly from nature or adapted from memory; a disregard for the human figure; and a predilection for a complicated surface

195 Detail of pl. 196.

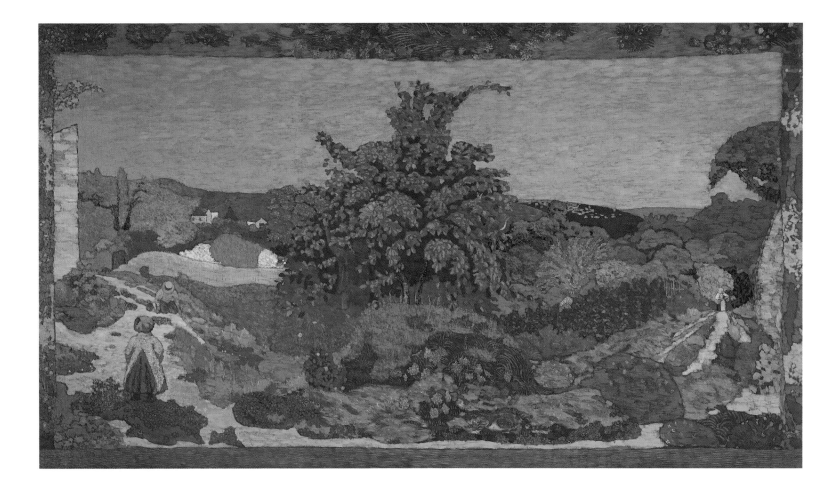

196 Edouard Vuillard, *The First Fruits*, 1899, oil on canvas, 248 × 432 cm., Norton Simon Foundation, Pasadena, California.

("matière compliquée"), which appealed to the "goût sémite," or Semitic taste. Because of this, he felt the works of Vuillard, Bonnard, and Vallotton would be better served, not in a public exhibition space, but in a small and dimly lit apartment. Countering that aesthetic were the artists of his own group who stressed the use of pure colors, a symbolist approach to the subject, and a reliance on history, models, geometry, and perspective. His group placed more value on the human figure and preferred simple materials to create a smooth, even surface – all of which appealed to the "goût latin."[10]

For Denis, there was a moral and technical distinction between his paintings of maternity, virginal women, or more overtly Catholic themes such as the large decorative panel *Legend of St. Hubert* (pl. 170), built up as a simple linear construction using clear pigments, and the still lifes, domestic scenes, or vignettes of contemporary life painted with heavier and more complex modulations of pigments seen in the works of Vuillard's group. Denis's two trips to Italy in 1895 and again with Gide in 1897 had convinced him of the dangers of an aesthetic system based on instinct and visual impressions rather than on intellectual reflection. Writing to Vuillard in February 1898, he voiced his objection to the idea that the artist make works of art necessarily producing "an immediate pleasure, a pleasing exterior . . . That is where the

error lies, a fashion, an exaggerated reaction against academic decadence, and it is important that we realize it."[11] The adjective Denis used to distinguish the two strands of Nabidom, "Latin" vs. "Semitic," are not neutral or casual choices. Certainly "Latin" alludes implicitly to the "classic," "Mediterranean," and by inference "Catholic" tastes as compared to Semitic or foreign tastes. These remarks should be looked at not only in view of the aesthetic choices offered by the retrospective exhibition at the Durand-Ruel gallery, but also in view of the reinvigorated Catholicism coupled with rampant antisemitism marking the French Republic of the 1890s.[12] The controversy begun in 1894 and surrounding the conviction of the Jewish army officer, Captain Alfred Dreyfus, wrongly acused of passing documents to the German Army headquarters, had exploded by the beginning of 1898 into a highly emotive issue that nearly cleaved the nation. The resulting political and ideological conflicts did not spare the intellectual and artistic circles – a tragedy seen most poignantly in the literature on arch-antisemite Degas. Writing in his journal for December 1898, Signac, a Dreyfusard (pro-Dreyfus) noted wearily that

The "Libre Parole" [an antisemitic review] opened a subscription for the benefit of the widow of Colonel Henry [the French officer who committed

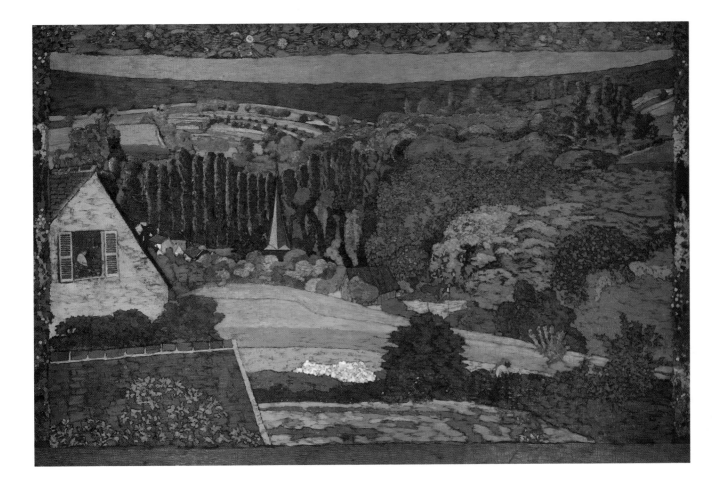

197 Edouard Vuillard, *Window Overlooking the Woods*, 1899, oil on canvas, 249.2 × 378.5 cm., L.L. and A.S. Coburn Fund, Martha E. Leverone Fund, Charles Norton Owen Fund, and anonymous restricted gifts, 1981.77, The Art Institute of Chicago.

suicide in prison in August 1898 after confessing to the forgery of documents used in evidence against Dreyfus], and in four days had collected more than 70,000 francs. The money keeps flowing in, with cries of death against the Jews and those who attempt to react against antisemitism. What have we come to? To try to forget and escape from all that muck, I spend my afternoon at the Panthéon in front of the new *décorations* of Puvis.[13]

Denis, who had previously been sympathetic to *La Revue Blanche*, in which he had published articles and a lithograph, cut off all relations with the Natansons' magazine. Writing to Vuillard from Rome in February 1898, he voiced his anger at the *Revue*'s editorial office for their brazen endorsement of Zola's pro-Dreyfus manifesto against the French government.[14] At the least, Denis argued, the board should have submitted signatures (for the endorsement of Zola) that were "of non-Jewish origin and of French nationality."[15] Vuillard's response to his friend's complaints was remarkably non-committal given his close social and professional association with the Natansons' and their magazine. In fact, he ignored Denis's angry (and zenophobic) rhetoric altogether, referring only obliquely to the "affair" and the violent outbursts engendered by it – "People beside themselves with anger."[16] It is typical of Vuillard's temperament that he was able to hold

to the middle road and thus sustain his longstanding friendship both with Denis (whose daughter, Bernadette, born at the height of the controversy in 1899, was his godchild) and with the Natanson families.

Insofar as the Natansons' patronage of Vuillard was concerned, however, by the end of the decade Vuillard was but one of a variety of artists whose works they collected. Despite Thadée's admiration for Vuillard's showing at the Durand-Ruel exhibition, for example, neither he nor any other members of his family purchased any of the artist's works from it, although Stéphane Natanson bought a painting by Vallotton, Alfred bought one of the four easel paintings exhibited by Bonnard, and Thadée himself purchased one of Redon's *noirs*, entitled *La Chaîne*.[17] It is likely, however, that Thadée and his wife, who were living with Thadée's father at that time, had a significant part in convincing him to commission Vuillard to paint two monumental *décorations* for the library of his rue Jouffroy residence.[18]

The Ile-de-France Pendants for Adam Natanson, 1899

Known as *The First Fruits* (*Les Premiers fruits*) (pl. 196) and *Window Overlooking the Woods* (*Fenêtre sur le bois*) (pl. 197), the pendants were among the largest works

of Vuillard's career and the last of the commissioned *décorations* for the Natanson family.[19]

According to Annette Vaillant, Alfred's daughter and Adam's grandchild, *grand-papa* was a straight-laced conservative with an interior décor "typical of that generation: walls loaded with gilt frames, art objects of dubious value."[20] Widowed shortly after he had brought his family to Paris, Adam's chief amusement as a retired banker was investing in real-estate properties to which he would transplant his family for short periods of time. One of these was the eighteenth-century Château de Méréville, which Adam bought in 1889 and sold in 1890[21] – a "dilapidated old castle," adorned with four monumental decorative paintings by the eighteenth-century master of "ruin paintings," Hubert Robert (all four now at The Art Institute of Chicago) (pl. 198).[22] Certainly, given Adam's penchant for living in once-royal residences – a "petit château" at Longchamp (already mentioned as a possible motif in the central panel of the triptych of the *Public Gardens* series), a mansion at Ranville in Normandy (where Alexandre was married), and an estate at Croix-des-Gardes near Cannes – the Robert panels would have appealed to Adam's aristocratic pretensions.

The landscapes that Vuillard painted for the eldest Natanson's Parisian *hôtel particulier* on the rue Jouffroy had little to do with Adam's pretensions or properties. As was the case with the Schopfer panels, which depicted the summer houses of the Natansons (1898) and the Hessels (1901), Vuillard's motifs for Adam's panels were essentially drawn from his own biography. Instead of a château and formal garden, he chose the village and surrounding hills of L'Etang-la-Ville, a suburb lying nine kilometers west of Paris,

where his sister, her husband, and their one-year-old daughter Annette (born November 1898) had recently rented a house, La Coulette.[23] He represented the landscape around the Roussels' residence unfolding as if seen from open windows, the ledges of which are suggested by the clay-colored border along the bottom of both canvases. On the remaining sides, garlands of vines and blossoms in shades of green, earth colors, and ochers complete the decorative frame. The view in *Window Overlooking the Woods* includes a yellow house, at left, with open shutters that reveal a woman watering her geraniums. She, too, looks out onto the landscape and towards a tiny figure picking grapes (pl. 197). The only other person present in this verdant countryside is the man walking his horse in the middle ground, a bright speck of pinkish red and white. Towards the center of the canvas, the white stucco structures of the little town tucked in between the hills are lit by an unseen sun, which enlivens and opens up the otherwise tightly constructed and banded landscape. In the center of the composition, next to the steel gray church steeple, Vuillard added midnight blue, creating a cavernous surround. With the exception of this deeper spatial illusion, and the spire piercing the middle ground, the composition is basically a series of softly rounded, green overlapping tiers.

In the larger of the two canvases, *The First Fruits*, the landscape has the same rolling, hilly terrain, and, like its pendant, it eschews complicated illusionistic devices in favor of flat decorative schemes. *The First Fruits*, however, has a simpler composition: it is divided into equal parts by a tree centered on the vertical and horizontal axes. The bright pink *tablier* or pinafore of the little girl at the bottom left is a rich accent against the otherwise muffled green tones, which camouflage a kneeling laborer (pl. 195). In comparison to *Window Overlooking the Woods*, in which the rooftops and church spire are emblematic of village life, the manmade structures are almost hidden in this pastoral scene.

Like the pendants for Schopfer painted in the previous year and stimulated by his visits to the Natansons' house at Villeneuve, Vuillard's choice of landscape motif for Adam's pendants was inspired by extended stays in the country at his sister's home. His visits became more frequent after the birth of Annette, whose childhood Vuillard recorded in many paintings and pastels. Yet unlike the Schopfer pendants which showed members of his circle in a *villégiature* setting, the Ile-de-France paintings are relatively anonymous and decidedly rural in the types of people they show. Between 1899 and 1901, Vuillard made a number of painted studies on cardboard or canvas on the theme of the open window overlooking the countryside at the Natansons' home at Villeneuve, at the Roussels' home at L'Etang-la-Ville, and from the window of Vallotton's parental home in Lausanne.[24] Related to *Window Overlooking the Woods*, for example, are a number of small-scale oil paintings and

the Vines (*Dans les vignes*) (pl. 202), has many of the same elements seen in *Window Overlooking the Woods*, although the results are quite different. On the other hand, a small oil-on-board study with an ornamental border (pl. 204) is close enough in composition and palette to be considered the final oil sketch for *The First Fruits*.[25] As holds true for nearly all of Vuillard's *oeuvre*, for whatever purpose and on whatever scale, he did not invent but paraphrased what he could see firsthand. In one painting, *At the Window* (pl. 203), his sister, Marie, shown in silhouette and in the shadow, watches her baby crawl from the house to the sunshine outside. Indeed, Marie may have been the model for the woman watering her geraniums in *Window Overlooking the Woods*, just as the figure of Annette may have inspired that of the little girl wearing the pinafore in the pendant.

Technically, the oil-on-canvas images represented a change from his customary use of distemper for monumental works. Examination of the surface of the *Window* panel suggests that Vuillard exploited the relative facility of the oil medium and worked quickly with little repainting. In marked contrast to the worked and reworked surfaces of the panels for Dr. Vaquez and Schopfer, the landscapes are composed of relatively evenly applied colors painted over the dark ground of the canvas with little blending or

200 (above) Edouard Vuillard, *Landscape, House on the Left* or *The Red Roofs*, 1900, oil on cardboard, 51 × 41.5 cm., Tate Gallery, London.

sketches such as *Landscape, House on the Left* (pl. 200) and *Hillside of L'Etang-la-Ville* (pl. 201) which show a view from the balcony of the Roussels' villa. Another relatively large, almost pure landscape painting accented by the figure of a woman grapepicker, *Among*

202 (right) Edouard Vuillard, *Among the Vines* (*Dans les vignes*), c.1899, oil on cardboard, 48 × 61 cm.

201 Edouard Vuillard, *Hillside of L'Etang-la-Ville* (*Campagne à l'Etang-la-Ville*), c.1899, oil on cardboard, 57 × 78.5 cm., Kunstmuseum Winterthur.

overpainting.[26] In *Window Overlooking the Woods* in particular, Vuillard exploited the darker ground to suggest three-dimensional modeling in some areas and to add textural interest to the whole. One sees this especially in certain segments of leaves (at the lower left) and bushes (along the path at the right) (pl. 206) where the overlay of greens and yellows appears outlined by the darker color, producing a mosaic or stained-glass window effect by a very simple means. Vuillard, who, two years earlier, had executed a stained-glass design for Tiffany using the

motif of chestnut leaves (pl. 125), would have been aware of the decorative effect achieved by the darker outlining, although the patterned appearance of the stained-glass window was achieved technically by the reverse process (outlining the flat areas with colors).

In addition to his newfound interest in landscape painting, Vuillard's choice of thematic and decorative devices may have been in part inspired by his renewed interest in impressionist landscapes. As mentioned, Monet and Renoir had been featured at the Durand-Ruel gallery in 1898. In April 1899, shortly after the close of the "Ecole moderne" exhibition, the gallery held an even larger retrospective of the impressionist artists Monet, Pissarro, Renoir, and Sisley, with twenty-six paintings by their acknowledged mentor Corot.[27] In July of that year, numerous landscapes were included among the works by Cézanne that were exhibited at the sale of Dr. Victor Choquet, the artist's most important early collector. Thadée Natanson purchased a landscape, *Hillside at Auvers* (*Colline à Auvers*) (pl. 205),[28] and it is tempting to think that Vuillard might have known and had in mind this work while working on his own hillside views for the rue Jouffroy residence where Thadée and Misia were living at that time. In contrast to his work on the Schopfer panels, which resulted in a textured surface of variously applied brushstrokes, Vuillard's brushwork in the smaller areas of leaves and bushes of *Window Overlooking the Woods* recalls the short and regular *taches* used by Cézanne when he painted side by side with Pissarro at Auvers in the 1870s.[29] The forceful blocking out of the meadow and the added volume and structure rendered by the stepped levels of houses and hills in Vuillard's painting evoke the structural concerns that the older artist explored in his early Ile-de-France landscapes. Indeed, in June 1908, when Thadée was forced to sell *Hillside at Auvers* along with his collection of Nabi paintings, Fénéon's description for the catalogue recalled many of the topographical and atmospheric elements found in *Window Overlooking the Woods*:

> Between these trees and at the limits of a forest crowning a hill, the walls and rooftops of a village slope down from the distant bell tower in the foreground to the right. The rendering of the greens, the gray clouds that impair the purity of the sky, the special quality of the extremely transparent atmosphere place the scene at the beginning of summer with rain in the air ... The general harmony embraces an infinite number of green shades in such a way that the most dense and dark which fill the middle of the composition, vie with the clearer and more vibrant tones.[30]

Vuillard's Décorations *as Painted Tapestry*

As Cézanne had done in his landscape at Auvers, Vuillard reordered the hillside around L'Etang-la-

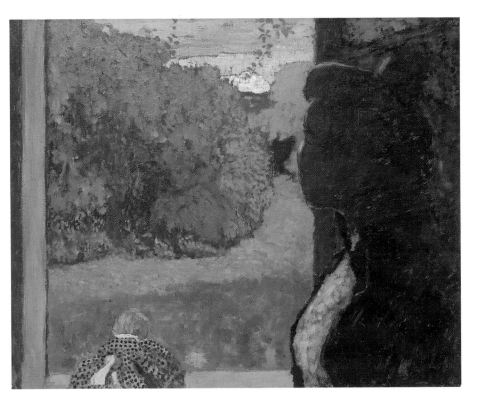

Ville so that the seemingly accessible (recessive) space is conflated into flat and decorative patterns. Above the landscape, staccato-like brushstrokes over a smooth, gray-brown undercoat describe the sky. The gentle swag of the horizon line in the *Window* panel resembles the give of a tapestry or fabric nailed to a wall – an association strengthened by the overall textural and tapestry-like quality of these strokes. Vuillard's large-scale paintings for Vaquez and Schopfer had already been equated with woven fabrics by virtue of their dense patterning and closely ranged colorations. Others from the Nabi group, such as Denis, Maillol, Ranson, and Rippl-Ronäi, were more explicitly involved with embroidery,

203 Edouard Vuillard, *At the Window*, c.1900, oil on canvas, 62 × 49 cm., San Francisco Museum of Art, California.

204 Edouard Vuillard, *Sunny Road* (*La Route ensoleillée*), c.1899, oil on board, 21 × 36 cm.

205 Paul Cézanne, *Hillside at Auvers (Colline à Auvers)*, 1879–82, oil on canvas, 46 × 55 cm., Ashmolean Museum, Oxford.

206 Detail of pl. 197.

weaving, and tapestries (or *broderies*, as most were more properly described), which they exhibited in addition to their painted works.[31] In 1897, H. Fiérens-Gevaert wrote on modern "Tapisseries et broderies" in *Art et Décoration*, illustrated with Ranson's cartoon for the tapestry, *Spring (Le Printemps)* (pl. 207) which had been exhibited at the Salon de Champs-de-Mars. In the same year, Lucien Mayne wrote a long article devoted to modern tapestry manufactured by the Gobelins.[32]

As he possibly did for the *Public Gardens* series, Vuillard may have applied Charles Blanc's general precepts for creating a successful tapestry, outlined in *Grammaire des arts du dessins* (1867), which called for a limited amount of sky area to suppress the effects of perspective, and for an even distribution of colors from top to bottom.[33] Certainly, the rich floral borders Vuillard introduced into Adam Natanson's panels have as their precedents the *verdures* (tapestries representing pastoral subjects or leafy plants) of the sixteenth and early seventeenth centuries. The small study for *The First Fruits* (pl. 204) suggests that, from an early stage, Vuillard included the garland border in a way similar to that used by Denis five years earlier in the decorative panels *Spring* and *Autumn* (pls. 74, 75). He may have drawn inspiration also

207 Paul Ranson, *Spring (Le Printemps)*, tapestry, repr. in *Art et Décoration*, 1897.

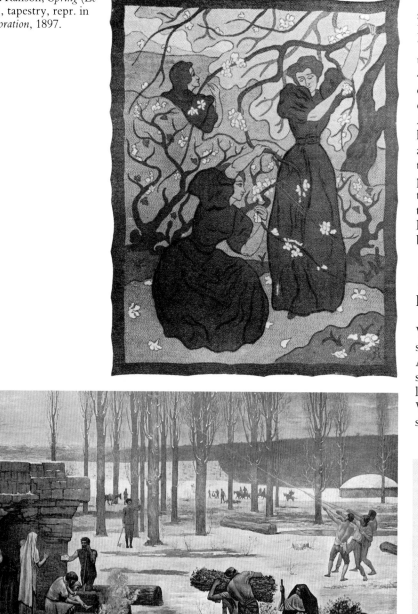

Perhaps it was this quality of Vuillard's painting style that held the most appeal for the elderly Adam Natanson who owned several *verdures*, including a "tapestry with a blue background" listed in the inventory of his possessions drawn up after his death on 4 June 1906.[37] Certainly, when compared to another large-scale and apparently non-commissioned canvas, *The Small House at L'Etang-la-Ville (La Maisonnette à L'Etang-la-Ville; c.1898–9)* (pl. 210) – a highly abstract composition painted *à la colle* with a palette of bright blues and reddish pinks – the two panels are readable and conservative. It is even possible that Vuillard's deliberate borrowings from the rules for tapestry and his return to an oil-painting technique in the Ile-de-France *décorations* was a calculated decision on his part to accommodate them better to Adam's conservative tastes.

Vuillard's Decorative Landscapes and the Intimiste *Aesthetic*

While simulating tapestry, Vuillard's garlanded frame surrounded a landscape approximating a specific site. An early postcard (pl. 209), for example, shows the same church in front of the lines of poplars at L'Etang-la-Ville that is seen in *Window Overlooking the Wood*. Writing about this panel in the catalogue entry for the sale of Thadée's collection, Fénéon commented that,

208 Pierre Puvis de Chavannes, *Winter (L'Hiver)*, 1897, mural painting for the grand staircase, Hôtel de Ville, Paris.

209 Postcard (*c.*1910) showing church at L'Etang-la-Ville.

from the garlanded borders of Puvis de Chavanne's murals *Summer* and *Winter* (pl. 208) for the Hotel de Ville (studies for which were exhibited at the Durand-Ruel gallery in June–July 1899).[34] By adhering to a tapestry aesthetic, moreover, Vuillard avoided the "literal precision" that he felt would be "unbearable" in apartment *décoration*. When the two panels were first exhibited in 1904 at the Salon d'Automne in Paris, they were entitled *Verdures*.[35] Four years later, they were shown in the Munich Secession as *Dekoratives Panneau*, before being put up for sale a few months later in the auction of Thadee's collection with the titles by which they are now known.[36]

130

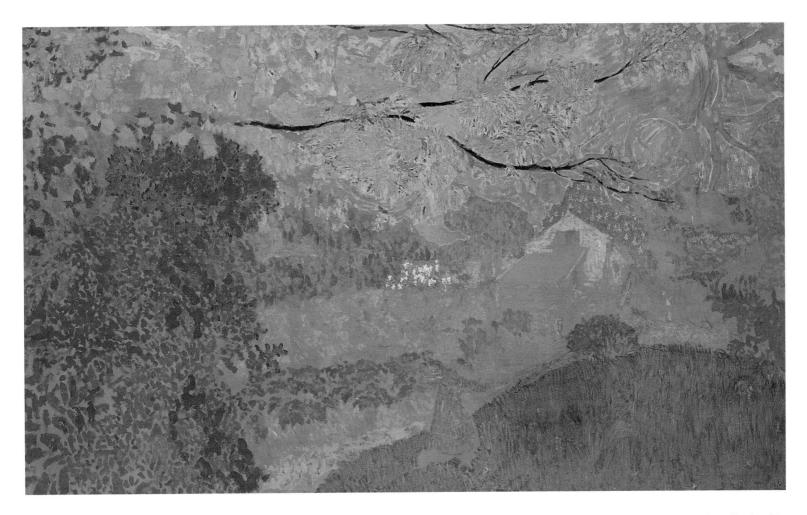

"while it is perhaps naive to speak of a painting done 'après nature,' no *promeneur* familiar with the outskirts of Paris could fail to recognize the villages and the rolling countryside."[38]

This pairing of the invented and real, of the impressionist and symbolist aesthetic at work in Vuillard's paintings of rural imagery is perhaps best described by Segard, who perceived the artist as being unable to transcend an urban conception of rural life. In this discussion of the panels for Adam, Segard compared Vuillard's enormous "countryscapes," used to decorate "big city apartments," to a contemporary work by another *peintre-décorateur* highlighted in his two-volume study, Henri Martin. Segard described Martin's large horizontal panel *The Harvesters* (*Les Faucheurs*) (pl. 211) for the Salle des Illustres (Gallery of Famous Men) in the Capitole (town hall) of the artist's native Toulouse as an empathetic response to the rural landscape and to those who labor in it.[39] By contrast, Vuillard's landscape panels represented an intellectualized metaphor for the natural:

> One senses that this landscape has been seen by someone accustomed to self-analysis and a coming to terms with his emotions. One feels that the work has been painted in a large town and for a metropolitan apartment. One does not sense the rustic odor of the earth that one rediscovers in

certain pictures of peasant painters – who never refine their emotions and who candidly express their attachment for the countryside where they are painting and their love for the earth and for its things. The vision of nature that M. Vuillard presents for us is the possible reward of an intellectual work that one engages upon in its viewing and contemplation. It is the reward associated with the state of the mind of a city-dweller.[40]

It was not that Segard was critical of Vuillard's

210 Edouard Vuillard, *The Small House at L'Etang-la-Ville (La Maisonette à L'Etang-la-Ville)*, 1899, oil on canvas, 157 × 255 cm., Musée départemental de l'Oise.

211 Henri Martin, *The Harvesters (Les Faucheurs)*, 1903. Central panel of three for the town hall of Toulouse.

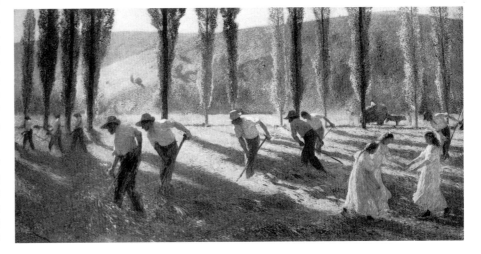

artistic talents or sincerity of expression: rather, he wished to make the distinction between the conception of a landscape "closely associated with the state of mind of a city-dweller" and that of the artist familiar with rural life. Martin, as Segard perceived it, transferred the direct sensation of natural motifs into an artistic expression. By comparison, Vuillard's mental process were "finer, more penetrating, more self-conscious, more attached to the suggestion of the *au-delà* of immediate realities than the direct appearance of those realities."[41] Vuillard's emotional and philosophical distance from the countryside, at least to the degree that Segard understood it, had close parallels, in fact, to Delacroix's personal theory of landscape painting. In a journal entry written in 1853, for example, the older artist reiterated his view that the artist must distance himself from the landscape in order to render it on canvas:

> Jean-Jacques [Rousseau] was right when he said that the joys of liberty are best described from a prison cell, and that the way to paint a fine landscape is to live in a stuffy town where one's only glimpse of the sky is through an attic window about the chimney-pots. When a landscape is in front of my eyes, and I am surrounded by trees and pleasant places, my own landscape becomes heavy – too much worked; possibly pure in details, but out of harmony with the subject.[42]

Although Vuillard would certainly not have agreed with the prison-cell analogy, he might have agreed with the general tenor of Delacroix's remarks that the landscape should be rethought and reconceived rather than expressed firsthand, especially for decorative works. For Vuillard, it was not the subject *per se* that was significant, but it helped to impose a general harmony of color and line necessary to the decorative expression. Like Delacroix, Vuillard's decorative landscapes were reinterpreted and reworked from the landscape of direct observation to gain the "harmony with the subject," which was more important than exact depiction.

Vuillard, Segard observed, "merely indicates his preferences [for the landscape] and invites us to participate."[43] Again using Martin as the counterpoint, Segard noted that Vuillard's work as a decorative artist appealed to a particular elite and not to the general public, while Martin was able to represent the rural community with a veracity appreciable at a very basic (and public) level. Instead of a painted expression of man in harmony with rural life, Vuillard used the landscape as a foil for a library decoration – to enhance the "haven of meditation."[44]

Installation and Reinstallations

The absence of documentation on Adam's rue Jouffroy *hôtel particulier* (since demolished to make way for an office building[45]) make it impossible to determine how Vuillard's paintings were installed in the "haven of medition." As with most of his decorative series, the pendants were probably glued unstretched to the interior walls or attached by their stretcher bars to the wooden moldings. The twenty-one-inch difference between the widths of *The First Fruits* and the smaller *Window* was likely calculated so that the painting could fit the exact wall measurements.

The installation there was a brief one, however. In 1904, Adam sold his house to move into his son Alfred's apartment at 92 boulevard Malesherbes near the Parc Monceau.[46] Possibly coinciding with the move, Adam allowed the panels to be exhibited in the Salon d'Automne, where they were described by Jacques-Emile Blanche as fulfilling the modern artistic ideal: "Painting contributing simply, as furniture or fabrics, to enhance the home of the most modest of citizens."[47] Implied by Blanche's qualifier "modest" is the notion that Vuillard's large-scale paintings were appropriate to the apartment interior of the middle-class inhabitant. Also suggested is the equation of Vuillard's work with that of the *ébeniste* or "woodsculptor" who has a *métier* or craft, as the title *Verdure* suggests, which contradicts what Segard saw as the elitist quality of Vuillard's works.[48] And yet, as Silverman has argued, the handmade, hand-carved, and handpainted were symptomatic of the renaissance of the daily objects and artforms associated with the *ancien régime* – which were valued in the nineteenth century as protection against the encroachment of the machine-made.[49] Both Segard and Blanche perceived Vuillard's decorative panels as a special kind of painting, and would agree that it was perhaps superior to easel painting because of, not despite, its appropriateness to a private sector.

Although visual evidence for the location of the panels at the rue Jouffroy residence are lacking, their subsequent installation in the home of Alfred Natanson is well documented. A photograph taken a few months after Adam's death, in 1906, shows Marthe, Alfred's actress wife, seated in a bentwood rocker in the library at a heavy oak table facing *Window Overlooking the Woods* (pl. 212). In another photograph from the same period, their daughter, Annette, is shown seated in the dining-room in front of *The First Fruits*, hung on the left wall above the paneled wainscotting (pl. 213). In both locations, the panels were placed so that the bottom edge would match the eye level of the person seated at the table who would in turn have only a partial, not panoramic, view. Fénéon's entry on the paintings for the 1908 sale catalogue of Thadée's collection drew attention to the special charm of the isolated fragments:

> One of the particularities of this decoration is that it juxtaposes to certain areas so broadly treated a multitude of ornamental details that have received the painter's most minute attention, such as the wildflowers in the countryside or the polka-dotted scarf of a peasant.[50]

212 Photograph of *Window Overlooking the Woods* installed in the library at 92 boulevard Malesherbes, *c.*1906, Salomon Archives, Paris.

213 Photograph of *The First Fruits* installed in the dining-room at 92 boulevard Malesherbes, *c.*1906, Salomon Archives, Paris.

The variations and accents within the otherwise "broadly treated" whole kept the paintings from being too flat and prevented any comparison with mural or panoramic wallpaper or "paintings in imitation of tapestry."[51] Certainly, to Annette Natanson, who grew up with the panels at the boulevard Malesherbes apartment, the paintings were tantamount to a living storybook. Recalling her impressions she remembered in particular *Window Overlooking the Woods*:

> that immense panel in which I lose myself to my daydreams, unconscious of the fact that my grandpapa Natanson – always so sober and severe – had commissioned it from Vuillard . . . Paying no attention to my grandpapa, I amuse myself by pushing my detestable spinach with my fork and finally, I escape into the painted landscape which is more real than real, absolutely actual, and unlimited – with its poplars and its hillsides. The pointed steeple of the little church, and, in the middle ground a little white house in its wonderful whiteness with its shutters closed to the thickened atmosphere of a summer day. House of the Ogre or House of Little Red Riding Hood, its window is bathed in a fuller light and opens to a woman who tends her geraniums. Is it me she calls or that laborer at work – the happy man of the country, whose thirst is quenched with a glass of red wine.[52]

It is not clear from Annette's description of dining in front of the decorative landscape, if the *décoration* was hung in the library first (as in pl. 212) and subsequently moved to the dining-room, or vice-versa, or whether the library served a double function as the children's room. What is clear is that Annette and Fénéon, both *habitués* of the Roussels' property at L'Etang-la-Ville, perceived Vuillard's painted version as an evocation of a real place in a way that Segard did not.[53]

The panels remained with Alfred's family until Adam's death in 1906, when the family moved to a smaller apartment in the same street, at 169 boulevard Malesherbes. At that time, the panels were sent to the Munich Secession exhibition, temporarily stored, and eventually sold to Alexandre Natanson (at the 1908 sale of Thadée's collection) for 1,200 francs (*The First Fruits*) and 1,000 francs (*Window*).[54] Shortly afterwards, the Alexandre Natansons moved to their Champs-Elysées residence and were forced to lend the monumental works to Léon Blum who had recently moved to a large and spacious modern-style apartment (actually part of an artists' cooperative) on the boulevard Montparnasse.[55] There, the panels were installed in the *cabinet de travail* or study, a former artist's studio described by Annette Vaillant as "an immense two-story studio."[56] In the "only authorized biography" of Blum, the author, none other than Thadée himself, described the way the panels looked in the "largest and most stately room":

> A huge oaken table unusually covered with legal papers and political leaflets looked almost insignifi-

cant in this hall of books. Just a few knickknacks here and there to break the severity of the room, and two mural paintings, full of the grace and tenderness of Vaillard [*sic*] at his best, completed the setting of Léon Blum's favorite place of rest and study.[57]

The Blums purchased the panels officially only in 1929, when several "Important Works by Vuillard" from Alexandre's collection, including two "Decorations Having Ornamented a Library," were put up for sale.[58] In 1935, both panels were installed in the Blums' next apartment on the quai Bourbon, where they remained together until their dispersal in 1950, following Blum's death.[59]

Unlike the large *Luncheon at Vasouy* panel with portrait-like and life-size figures (one of whom, Blum's wife, was subsequently painted out), the landscapes for Adam Natanson were undemanding, since they were primarily landscapes and since they were closer to painted tapestries than to modern painting. With the exception of their size, which made them difficult to hang as pendants, the panels, as Segard described them, were "easily adapted to the wall like a tapestry that one fixes with four nails and which seems to have been placed there permanently at whatever place one installs it."[60] With their tiny figures, embedded in zones of tawny browns, grays, and muted greens, they were perceived as tapestries, as *verdures* that would not have conflicted with Adam's aesthetic tastes.[61] In each location, however, the panels were lived with and experienced differently by their respective owners.

A Forgotten Décoration: The Aghion Commission

Although he could not know it, by the close of the century Vuillard was at the peak of his career as a *peintre-décorateur*. Writing to his brother in the summer of 1899, Vallotton described Vuillard as being "in his glory. He is earning a lot of money and refuses to sell."[62] It is possible that Vallotton's remarks referred not only to his friend's monumental landscape panels for Adam Natanson, but also to a little-known panel, *The Promenade* (pl. 214) for an even less-known member of the *Revue Blanche* circle, Jack Aghion. Segard's inventory lists the work as *A Walk in the Vineyards (Promenade dans les vignes)* and as a "panneau décoratif pour Jack Aghion, 1896."[63] Like so many of Vuillard's projects executed for the very mobile Natanson circle, the painting did not remain long with the Aghions. But unlike Vuillard's other commissioned *décorations*, which were eventually separated and adapted to different interior settings, the Aghion panel was reinstalled as the primary *décoration* in a totally unified art-nouveau interior designed by Henry van de Velde for the German collector and patron Karl Ernst Osthaus.[64] The panel

214 Edouard Vuillard, *The Promenade*, *c.*1898–9, oil on canvas, 260.5 × 249 cm., Los Angeles County Museum of Art.

then raises the question that has already been asked several times in relation to Vuillard's decorative career: what was the role of decorative painting in what might be termed the "relative ensemble" of the pre-existing interior as opposed to the total ensemble of the modern style? It raises as well the issue touched upon throughout the preceding case studies: what was the role of a *décoration* once removed from the original domestic environment and put into another, entirely different private setting?

Placement of this painting within Vuillard's *oeuvre* is confused by several factors, beginning with the subject, which has been variously described as *Autumn outside Paris (Herbst vor Paris)*, Segard's title, *Promenade dans les vignes*, and the most recent Franco-American title, *Le Picque-Nique*.[65] While at first glance the group appears to be made up of picnickers, a closer look reveals that there is no sign of any luncheon, and the autumnal season, suggested by the warmer palette, graying skies, and the wrapped-up figures, seems an unlikely time for a "déjeuner sur l'herbe." The figures do not impose themselves or offer themselves up for any narrative reading. Segard's title, which could be translated loosely to mean "excursion" or "out walking" (as the panel *La Promenade*, part of the *Public Gardens* series, is often translated), seems closest to the activity represented. But the 1896 date Segard ascribes to it is questionable, since Vuillard's first mention of "panneau Aghion" is not until 1900, in conjunction with the April group exhibition of Nabi artists at the Bernheim-Jeune gallery.[66] Three months after the close of the exhibition, Vuillard wrote enthusiastically to Vallotton about the recent installation for "les panneaux Aghion," asking him and Ranson to contribute other "ornaments":

> Painting seems to be smiling on me. It's about time! I was getting discouraged. We have installed the Aghion panels, and you know that you and Ranson are going to be asked if you want to do the *décorations* at the two extremities of the room – which will echo the shades of the paintings and give an overall decorative cohesion to this wonderful room.[67]

From the letter, one learns not only that Vuillard has been commissioned to do a panel (as he lists in his journal entry) or "panels" as he suggests in this letter, but also of his confidence in Aghion's ability to afford additional works by other artists.[68] Indeed, Aghion played an important role as a Maecenas and promoter of modern art during the last two decades of the century, making the scant biographical information about him all the more frustrating. Egyptian-born, Jewish, naturalized French, Oxford-educated, and independently wealthy, Jack Aghion (1863–1918) was a dilettante collector of impressionist and post-impressionist paintings. More significantly for Vuillard, he was the husband of Marguerite Bernheim, whose brothers Josse and Gaston – owners of the Bernheim-Jeune gallery – would sign contracts

with Vuillard, Bonnard, and Vallotton, and exhibit their work.[69] Jack Aghion was also related by marriage to Vallotton, who had wed the elder Bernheim daughter, Gabriella Rodriguez, in the spring of 1899. In a letter to his brother written shortly before his marriage, Vallotton gave a chillingly objective description of both his future bride and her family:

> Her name is Gabriella Rodriguez, thirty-five years old, the daughter of Mr. Bernheim who lives at 51 rue Pierre-Charon. They are most honorable and rich. The two brothers keep up the house on [the] rue Laffitte. The other sister is married to a Mr. Aghion, who is very rich and has not much else to recommend him.[70]

Despite Vallotton's disparaging remark about his future brother-in-law, Aghion seems to have had connections with the Natansons' circle. He was certainly a subscriber to their magazine and a supporter of Lugné-Poe's Théâtre de l'Oeuvre. It is possible that Vuillard met Aghion shortly after Vallotton's marriage when he may have joined his artist friend and his bride at the Bernheims' summer home.[71] Six months after the Rodriguez-Vallotton marriage, Vuillard wrote to Vallotton urging a meeting at the Bernheims' summer residence at Etretat where he hoped they would renew their friendship. At the close of the letter he requested Vallotton to put in a good word for him to his wife's brothers, Josse and Gaston, and to their older cousin, Jos Hessel, who, at that time, was running the gallery.[72] Given that, in 1899, both Bonnard, unofficially, and Vallotton, officially, had contracted with the Bernheim-Jeune gallery, it is not unlikely that Vuillard was hoping for a similar financial arrangement.

Vuillard's involvement with the Bernheims' brother-in-law coincided with the latter's most active period (1899–1902) as a collector and novice dealer of modern art.[73] In 1901, for example, when the Bernheim-Jeune gallery mounted a Van Gogh retrospective, Aghion lent six paintings from his collection.[74] Although Vuillard's journals do not list Aghion among his buyers for 1900, dealer records indicate Aghion's purchases of works by Vuillard, Bonnard, Denis, and Roussel – among the Nabis – as well as by Renoir and Van Gogh from the Vollard gallery between 1899 and 1901.[75] When Aghion's collection was auctioned after his death in 1918, Vuillard was the only Nabi artist represented (by four early interiors) among other works by Boudin, Caillebotte, Van Gogh, Pissarro, and Sisley.[76]

The Panel: The Promenade

Like the large-scale landscapes for Adam Natanson, the panel for Jack Aghion is also painted in oils laid over a dark ground that shows through in the thinly painted areas. The dainty tree, recalling the decor-

ative devices of Japanese prints and oriental por-
celains, divides the hillside diagonally. As in the
Schopfer panel, the diagonal emphasis respects both
recession and flatness of surface. A smaller easel
painting for this landscape with just the tree as subject
(pl. 215) shows Vuillard's continued use of *plein-air*
studies and his particular interest in the decorative
possibilities of the fragment (in this case of the land-
scape). In the finished *décoration*, the tree has been
further reduced to ornament. The autumnal sky is
comprised of a weave of brushstrokes with a "border"
of gray similar to the swagging horizon line of the
Adam panels. Behind the tree are three young girls
wearing triangular capes and a woman in a white
skirt. To the far left, another female figure wearing a
bright orange shawl or jacket descends from the hill-
side. At the upper right, two female figures seemingly
frozen in motion face away from the viewer and
from the two male figures dressed in black who
recline at their feet (pl. 216). In the left-hand side,
especially, the figures are in competition with the
rust brown and red-orange vertical strokes of paint
applied with almost constructive uniformity for the
leaves and outlying fields, while at the extreme left a
flatter brown suggests a distant valley into which
two of the *promeneurs* descend. In contrast, the
unpeopled landscape on the right is composed of a
kaleidoscope of multicolored ornamental fragments
creating a surface as dream-like and delicate as a
Redon pastel.

Part of the difficulty in reading the painting stems
from Vuillard's palette of closely knit colors ranging

from olives, ochers, and yellows to hotter oranges
and pinks that are applied thinly in short, regular
strokes to fuse the men, women, and children into
the *facture* of the expansive landscape. The vertical
brushstrokes of red-orange spotting the radiating
branches of the tree partially obscure the trio of
young girls and the white-skirted female standing to
their right and in the center of the canvas. Likewise,
the standing female wearing a large bowed ribbon
around her neck is barely discernible behind her com-
panion, from whose brown-olive skirt she emerges.

There is little interaction among the members of
this outing. Despite the suggestions of familial
intimacy and conversation between the figures, the
men grouped together do not converse, nor do the
women's gestures suggest their relationship to
the younger girls. Spatial relationships among the
group are equally ambiguous. And yet, in contrast
to the women and the interiors depicted in the
panels for Dr. Vaquez which might be considered
imaginative inventions of a theme based in reality,
the sources for the Aghion panel exist in photographs

216 Detail of pl. 214.

215 Edouard Vuillard, *The
Garden. c.*1899, oil on canvas,
60.9 × 45.7 cm., private
collection.

137

7 Of Lilies, Haystacks, and Garden Paths: The Commission for the Bibesco Princes, 1899–1900 and 1907–1908

The Auction of Thadée's Art Collection and the End of an Era

If the Ile-de-France landscapes for Adam Natanson and the panel *Promenade* can be considered Vuillard's last "Nabi-esque" *décorations* – that is, works with intimate, evocative, and complicated surfaces (according to Denis's evaluation) and having what Segard termed a "cerebral quality" – the paintings after 1900 show Vuillard evolving towards a decorative style appropriate to the tastes in painting and interior décor of a different clientele.

On 13 June 1908, Thadée Natanson was forced to auction off his art collection at the Hôtel Drouot.[1] The majority of the sixty-one paintings were works by the "secular" Nabis – Bonnard, Roussel, Vallotton and Vuillard – and were datable to 1893–1900, when Thadée had been most actively promoting them through the pages of *La Revue Blanche*.[2] For some, the bankruptcy sale (as it was understood to be by those with inside knowledge) provided the occasion not only to see a considerable body of works representing the vanguard of the previous decade but to rub against what one journalist described as the "uncommon crowd."[3] For others, like Jacques Daurelle, a regular writer for the *Mercure de France*, the auction was too insular an affair:

> One must admit that *amateurs* [collectors] and the public were not enthusiastic about the Thadée Natanson collection. Had it not been for the family and friends of the collector, the works of Messrs Bonnard, Vuillard and Roussel would not even have sold for 150 francs. The auctioneer obtained 60,000 francs thanks to a devoted circle.[4]

Despite Daurelle's exaggerated (and possibly antisemitic) remarks, the majority of purchases were indeed made by a relatively small group who had been involved with the Natansons' now-defunct *Revue Blanche*. Gide, literary critic for the *Revue* since 1900, bought both Bonnard's and Vuillard's portraits of Thadée. Another portrait of Thadée by Vallotton (pl. 18) was purchased by Thadée's friend Octave

Mirbeau for the substantial price of 2,050 francs.[5] Even Fénéon, who had never shown an interest in the Nabis' work, preferring that of Seurat and his circle, bought two easel paintings by Vuillard.[6]

The familial aspect of the sale was underscored by Mirbeau's introductory essay to the catalogue in which he reminisced about the intimate relationship between the collector and the artists he had discovered and promoted through his magazine:

> All these objects were collected by someone who loved them and proved it, since he is the first person who dared, and perhaps the only one who, until now, knew how to talk about them. For my part, I cannot, nor do I wish to say any more about Vuillard, Bonnard, Roussel, or Vallotton than what Thadée Natanson has written in these pages of *La Revue Blanche*, often intricate, always ingenious and especially perspicacious.[7]

Of the twenty-six works by Vuillard included in the sale, Mirbeau singled out his decorative panels for Thadée and Misia: *The Park*, 1893–4; the five-panel series *The Album* of 1895; and the monumental landscapes *The First Fruits* and *Window Overlooking the Woods*.[8] For Mirbeau, these works from the first decade of Vuillard's career showed the artist's voluptous and sensuous use of color and what Mirbeau saw as his "deliberately abstract credo."[9] Speaking directly to the large-scale decorative paintings, Mirbeau concluded that Vuillard "is never more at ease and never more appealing than when his imagination – I would like to call it musical – is given free rein on large areas. He needs walls to work his magic."[10]

By the time of Thadée's sale, however, Vuillard's decorative style had undergone a dramatic change and the network of patrons originally generated by the Natansons had been ruptured. By 1908, only one of Vuillard's eight commissioned projects, the series of four panels for Dr. Vaquez (1896), remained in its original setting. The dispersal of Vuillard's *décorations* from their intended interiors and owners paralleled the artist's own parting of ways with his early collector-patrons. The once tightly knit group that

229 Detail of pl. 250.

had been cultivated by the Natansons was already breaking up when, in April 1903, the rue Laffitte office of *La Revue Blanche* was suddenly and without warning closed. Although the magazine was never completely profitable, the specific reasons for the shutdown are unclear. Some surmised that the Natansons were financially unable to keep it going.[11] In the same letter that Maillol had written to the Hungarian Nabi, Rippl-Rónäi, describing Schopfer's financial ruin, he reported, "The Natansons have also made some bad business deals. This is why they are not responding [to Rippl-Rónäi's letters]. *La Revue Blanche* is finished."[12] This explanation is countered by a recent study which cites the magazine's "openness" to differing philosophies and ideologies as one of the causes of its downfall, along with the progressive withdrawal from its activities by the Natansons themselves.[13] As early as 1899, Vallotton lamented to Alfred that he missed seeing them at the offices.[14] By then, Alexandre had transferred his publishing interests to the sporting journal, the *Vie en grand air*, and to the *Cri de Paris*, which from 1897 he had directed from above the *Revue Blanche* offices.[15] Thadée, too, had distanced himself from the review, sharing his beloved "Petite Gazette d'Art" with Schopfer, Edmond Cousturier, and Félicien Fagus.

Thadée's reasons for extricating himself completely from the family publishing concerns were more serious than mere lack of interest. Since Zola's trial for the pro-Dreyfus pamphlet *J'accuse*, in 1898, Thadée, one of the founding members of the League of the Rights of Man had thrown himself and his editorial interests into the ring of protest. His political interests were rekindled in 1899 when he led an impassioned crusade for the retrial and acquittal of Dreyfus (which was not to be successful until 1906 when the French captain was officially exonerated and reinstated). To the surprise of his family, Thadée opted out of the cultural sphere to become a committed human-rights activist. To their even greater surprise and dismay, he began investing their savings in a number of well-meaning but, in the end, financially disastrous enterprises, including the establishment of tram lines in Toulon, and of hydroelectric plants (using *houille blanc*, or white coal) and workers' residences on his father's property near Cannes. As Misia remembered bitterly, for Thadée, "Money meant nothing to him except as a means to the triumph of a cause that he was burning to support."[16]

More damaging than Thadée's financial losses, however, were his prolonged trips away from Misia. Lonely and worried about her future with a man she knew to be devoid of business acumen, Misia was, as she tells it, helpless to ward off the advances of the fifty-year-old millionaire, Alfred Edwards. Misia first met Edwards in 1900 at an opening at the Théâtre de Paris benefiting Thadée's League which she attended with Mirbeau in Thadée's absense. Edwards, owner of the Théâtre de Paris, the widely circulated daily newspaper *Le Matin*, and a number of

other important enterprises, was one of the richest and most powerful men in Paris.[17] Though divorced and remarried, Edwards, of whom Lucien Daudet said he changed his "wives like his shirts, and was rolling in gold and jewels,"[18] fell obsessively in love with the twenty-eight year old Misia. Wasting no time, he invited Misia and Thadée to dinner the next night, at which time he began his machiavellian plot to undo both their marriages.

In order to get Thadée out of the picture, Edwards offered him a directorship over coal mines in Koloshvar, Hungary, which Thadée, embattled and indebted, was forced to accept.[19] Misia, in turn, gradually succumbed to her amoral and powerful suitor and became his mistress. Before making that decision, however, she often turned to Vuillard to be the confidant to her emotional crisis, asking him to join her in Switzerland in the spring of 1900 and later that year at the Hôtel de Cannes near the Natansons' property at La Croix des Gardes.[20] Three years later, the dilemma still unresolved, Misia persuaded both Vuillard and Thadée to go with her to Vienna, where she hoped (unsuccessfully, as it turned out) to "escape" the decisive moment with Edwards.[21] By 1903, she was officially Edwards's mistress, living intermittently at his residences at Corbeil, on the rue de Rivoli, or in a smaller rented apartment on the ground floor at the Hôtel de Rhin on the place Vendôme.[22] In April 1904, after what must have been an awkward if not cruel interval for Vuillard, whose loyalties would have been torn between his two closest friends, Misia filed for a divorce from Thadée and in less than a year married Edwards.[23]

After the divorce, Thadée lived on the rue de Constantine behind the Invalides where he was listed as an "industrialist." By 1907, he had moved to an apartment overlooking the square Henri-Laborde near the place Saint-Augustin,[24] where Vuillard painted him

230 Edouard Vuillard, *Thadée Natanson* (self-portrait with Thadée Natanson and Ker-Xavier Roussel), 1907–8, distemper on canvas, 200 × 200 cm., Musée d'Orsay, Paris.

seated in an overstuffed chair, in the library (pl. 230). One of Vuillard's first large-scale works since the Schopfer *Luncheon* panel to be painted with the glue-distemper technique, the picture is actually a triple portrait, with Thadée flanked by Roussel at the far left, almost cut off by the frame, and Vuillard's own image reflected in the mirror of the armoire.[25] The narrative suggested by this portrait can be compared with the very different story suggested by Renoir's contemporary portrait of Misia during the period in which she possessed "everything materially possible" (pl. 231).[26] While Thadée is seated in a modestly furnished apartment, casually dressed and engrossed in intellectual pursuits, a man "conscious of his worth and importance,"[27] Misia as the new Mme Edwards languishes on a sofa and confronts the viewer boldly with the assurance of her recently acquired wealth and status.

Vuillard and the Art Dealers: A New Beginning

Since Vuillard remained loyal to Thadée, his relationship with Misia after the divorce was necessarily altered. Gone were the cozy evenings in the Natansons' rue Saint-Florentin apartment and the easy summer days at Le Relais. In their place, Vuillard's social calendar was now filled by another circle of collector-acquaintances, centering on his new friends and business partners, the brothers Josse and Gaston Bernheim and their second cousin, Jos Hessel. The Bernheims have already been mentioned as relatives through marriage with Vallotton and owners of the gallery to which Vuillard would contract his works. They had inherited the gallery on the rue Laffitte from their father, Alexandre, who had been a friend of Courbet and champion of the Barbizon painters. Taking over the gallery in 1899, when Alexandre retired, the Bernheims continued their father's successful marketing strategy of representing popular Salon artists and the impressionists, while adding a mix of established "moderns," such as Vuillard, Bonnard, and Vallotton.[28]

By 1900, in fact, the former Nabis were enjoying the benefits of an expanding market for commercial galleries. Almost all had joined league with or had at least exhibited at the Bernheim-Jeune gallery[29] or its closest competitors, the Vollard, Durand-Ruel, and Druet galleries. Vuillard's motivation to sign on with the Bernheims may have stemmed from his desire for a secure income as he witnessed the dissolution of what had been for almost a decade a system of direct patronage. This, together with the growing sense of isolation he felt as a "célibataire" (a status he lamented in his journals) and his financial responsibilities towards his now-retired mother, may have made the Bernheims' proposition of regular customers and exhibition space even more attractive.

Other personal reasons may also have pushed him in the Bernheims' direction. Like Vallotton, whose

marriage to the Bernheims' older sister in 1899 allowed him to abandon print-making to devote himself entirely to painting,[30] Vuillard's relationship to his dealers involved emotional attachments – in his case, to Lucie Hessel, the Bernheims' cousin, and wife of the gallery's manager, Jos. In the summer of 1900, Vallotton had invited Vuillard and the Hessels to the Vallottons' summer home, Château Romanel, in Switzerland (pl. 239). Although Vuillard had officially met Lucie several years earlier,[31] it was at Romanel that they began their intimate and long-lasting friendship. Handsome, intelligent, and known to be as generous as she was formidable, Lucie eventually became Vuillard's closest companion and, to an even greater degree than Misia in the previous decade, his muse and mentor. Despite the fact that his journals do not reveal the degree of intimacy between the two, some scholars have suggested that Vuillard and Lucie (nicknamed by Tristan Bernard,

231 Pierre Auguste Renoir, *Misia Natanson*, 1904, oil on canvas, 92.1 × 59.4 cm., National Gallery, London.

"Le Dragon," after a popular operetta at the time, "Le Dragon de Villars") were indeed lovers, and that the intensity of their petty squabbles was "no doubt in part due to the pressure of their clandestine involvement."[32] What seems clear from Vuillard's frequent journal references to Lucie (by 1908, he was visiting her almost every day), is that she was both a positive and a negative force in his life.

An interesting assessment of Lucie's personality, is found on an undated note inserted into Vuillard's journal for 1907–8. Written by a different hand than Vuillard's, it seems to be the outline for a biography on him, presumably by Claude Roger-Marx, who was acknowledged by Vuillard to be working on a biographical study at the end of his life.[33] The sheet comprises a list of both the external and internal influences upon his art. Under the larger category, "aesthetic creative influences," is written "Chapter of Friendship (especially Bonnard, Ker [Roussel], Denis, [Pierre] Hermant)"; and "family relations: what they mean for me: the mother, her role, influence on life and character . . ."[34] Lucie's name appears under a separate subheading with the description: "As for Lucie, *guiding light that she is* – domination – bewitchment . . . and totally dazzled by her."[35]

Lucie's dominion over Vuillard as the harshest critic of his choices in art and personal affairs seems to have been offset by her ability to provide a stable "familial" situation for him.[36] Writing enthusiastically to Vallotton in July 1901 of the family-like atmosphere he had experienced while vacationing with his mother in Normandy, first with the Hessels and subsequently with the Odilon Redons, he added apologetically, "This will perhaps appear dull to you who have everything – wife, home, countryside, good neighbors."[37] For Vuillard, whose life was summarized in the same biographical sketch (possibly by Claude Roger-Marx) as being a constant battle between "social amiability and extremely unsocial shyness," Lucie provided the necessary buffer zone. With Mme Hessel as escort, Vuillard could, as he wrote in his journal on the opening day of his exhibition at the Bernheim-Jeune gallery in February 1908, watch *le monde* "from under her hat brim."[38]

Vuillard's relationship with Lucie's husband, Jos, was equally complex.[39] A Belgian-born Frenchman (naturalized in 1891) and former journalist for *Le Temps*, Jos was a shrewd businessman with a penchant for gambling and risk-taking.[40] He could be, in the words of Tristan Bernard, a convivial and self-confident *bon vivant* who "considered the rain to be a personal offense."[41] But to others, as Annette Vaillant remembered, he could be a tyrant, "with the eye of a vulture, a weak handshake, . . . a small, bent man, potbellied, with brief periods of merriness, but more often disturbingly silent . . ."[42] Instead of interfering with Lucie's possessive, quasi-maternal interest in Vuillard, Jos welcomed his wife's friendship with the artist (and his employee) as a blind for his own

marital indiscretions.[43] Indeed Vuillard's relationship to the Hessels paralleled, and justified to a certain degree, the current vogue for plays such as Paul Bourget's *Le Divorce*, the hit of the 1908 season, and Léon Blum's controversial essay *Du Mariage*, published in 1907. Both men saw conventional matrimony as endangered, necessarily doomed to fail since it was based on privation of liberty.[44] Their arguments hit at a particularly liberal and vulnerable time, when divorce (which since the lifting of the law of 1884 had become increasingly easy to obtain) was becoming high fashion among the fashionable (witness both Misia and Schopfer). In Lucie's case, however, divorce was never an issue nor a consideration, despite the strained situation between her and Jos. Moreover, in spite of the odd and potentially embarrassing arrangement among Vuillard, his dealer, and his dealer's socialite wife, the Hessels played a highly influential role in his artistic and personal life for the next four decades.[45]

It was during the early flowering of his friendship with Lucie that Vuillard explored the "intimate portrait" style that he would further develop in pastels, oil paintings, and larger-scale works painted in distemper for the rest of his career. After 1901, for example, he painted Lucie in the rue de Rivoli apartment (where he came so frequently that the Hessels' butler dubbed Vuillard the "house painter") (pl. 232), in his studio, or at her various summer houses in Normandy. In 1907, six years after his introduction to Lucie, Vuillard celebrated her role as muse and companion in two decorative panels, *The Haystack* (*La Meule*) (pl. 243) and *The Alley* (*L'Allée*) (pl. 244) Commissioned by the Bibesco Princes who were themselves quite removed from the social world of the Hessels, these panels marked Vuillard's return to large-scale *décoration* after a seven-year hiatus.

Vuillard and the Bibesco Princes

Vuillard's apparent lack of decorative commissions from the years between the Schopfer and the Bibesco projects is not explained by his journals, which he temporarily suspended between 1896 and March 1907.[46] In lieu of decorative projects, he worked on a number of portrait commissions from wealthy collectors like the Prince de Wagram, Gustave Fayet (at Béziers), and the Arthur Fontaines.[47] Vuillard was also an active participant in a number of important modern-art exhibitions: in Paris – at the Salon des Indépendants (1901, 1903, 1904, 1906), the Salon d'Automne (1903–6), and in both group (1901, 1903, 1904, 1906, 1907) and one-artist exhibitions (1906) at the Bernheim-Jeune gallery – and in Europe in Le Havre (1906), Brussels (1901, 1904), The Hague (1901), Munich (1906), Budapest (1903), Venice (1904, 1907), and Berlin and Vienna (1903, 1906 for both).[48] With the exception of the large-scale decorative panels from the previous decade, which Vuillard exhibited at the Salon d'Automne in 1904 and 1905,

and in Berlin in 1906, most of the works exhibited in these years consisted of recent pictures of less ambitious scale. It may be that Vuillard, like Matisse, who signed on with the Bernheims in 1909 with their stipulation that the gallery would buy only works of specific formats, had signed a contract with the Bernheims that was just as precise in its conditions.[49] This, plus the increased number of portrait commissions, would help explain the absence not only of any large canvases by Vuillard for this period but also of works of unconventional format and medium.

Vuillard's recommencement of his journal in the spring of 1907 coincided with his return to larger formats and *à la colle* technique, both of which he used for the triple portrait of Thadée, Roussel, and himself (pl. 230). His pleasure in undertaking commissioned decorative paintings again is evident in his journal entry for 5 November of that year. After learning from his mother of Emmanuel Bibesco's desire for new panels, he noted: "I went to bed excited about the prospects."[50]

The Romanian princes Emmanuel and Antoine Bibesco have already been introduced as friends of Schopfer and as the eventual owners of the pendants *Woman Reading on a Bench* and *Woman Seated in a Garden*.[51] Ten years Vuillard's junior, the Bibescos came of age when the influence of *La Revue Blanche* was at its height.[52] As friends and clients, they were important links between Vuillard's earlier career, marked by the direct patronage of the Natanson family and their connections, and his career and clients after 1900. Graduates of the Lycée Condorcet and the Sorbonne, by 1900 both brothers held sinecurial positions in the Romanian Embassy in Paris, but like the Polish-born banking family, the Natansons, and the Swiss-born Schopfer (whose father was also a banker), their main interests revolved around vanguard theater, literature, and art in the French capital. Cousins to the de Noailles, the Caraman-Chimays, and Marthe Lahovary (later Princesse Georges Bibesco[53]), the brothers boasted ancestral descent from the Prince of Wallachia in the twelfth century and were the grandsons of the reigning king of Wallachia (pls. 233, 234).[54] As the youngest heirs to that noble family and title, Emmanuel and Antoine were members of the new Parisian *gratin* (upper crust), growing up around the Bois de Boulogne who sought publicity and who moved imperturbably between the different social registers in a way that their counterparts in Proust's fabled "Faubourg" (Saint-Germaine) did not.

Of the two brothers, Emmanuel, who at an early age was already beginning to show the symptoms of the viral disease that would later result in total paralysis, was the most serious art connoisseur. His passion for art led him to seek out vanguard artists and purchase works that he paid for with his father's money. In January 1900, for example, he bought six of Gauguin's paintings without ever having met him. Two months later, he wrote to the artist, offering to

232 Edouard Vuillard, *Lucie Hessel, in the Small Salon, rue de Rivoli*, 1903–4, oil on cardboard, 74 × 63.5 cm., private collection.

buy his all of his Tahiti works at prices higher than his dealer, Vollard, would pay, in return for exclusive rights (an offer that even the financially destitute Gauguin would not accept).[55]

Emmanuel's younger brother, on the other hand, was less interested in the acquisition of art than in living artfully. Compared with Emmanuel described by the Princesse Marthe Bibesco as "sober and reserved," Antoine was a *bon vivant*, "covered with women."[56] Proust, friend and jealous observer of Antoine's social successes, described him variously as "one of the most marvelously intelligent men that I have had the fortune to know"; "the most intelligent and the most exquisite of men;" and even more indulgently, given Antoine's Romanian birthright, as "the most intelligent of Frenchmen."[57] Like so many wealthy intellectuals who considered themselves *littérateurs*, Antoine aspired to be a playwright. On 6 October 1904, he succeeded in having his first theatrical foray, a domestic drama entitled *Le Jaloux*, performed in Lugné-Poe's Théâtre de l'Oeuvre.

233 J.C. Chaplain, medallion of Prince Emmanuel Bibesco, 1891.

234 Photograph of Prince Antoine Bibesco, Mante/Proust Collection.

235 Aristide Maillol, *Music* or *The Concert of Women*, tapestry.

In the Parisian high society where his relationship with the Montesquious, Caraman-Chimay, Murat, and de Noailles give him a place of honor, he is much sought after, but more greatly dreaded. For his delicious sense of humor is cruel. It is certainly not something easily digestible that will be performed this evening for the first time at the Théâtre de l'Oeuvre.[58]

Although Vuillard would probably have gotten to know Antoine and his brother through their mutual interest in modern theater, their introduction can, in fact, be traced back to the previous decade, to February 1895, when the Bibescos were recorded as having attended Alexandre Natanson's inaugural soirée for the *Public Gardens* panels. That same year, Vuillard introduced the Bibescos to Aristide Maillol, then a painter and tapestry-maker whose career Emmanuel took it upon himself to launch. He presented Maillol to his mother, Princesse Hélène Bibesco, who commissioned two large tapestries from the artist, *Music* (or *The Concert of Women*) (pl. 235) and *Music for a Bored Princess*, and who helped to finance his tapestry-making studio at Banyuls in the Pyrenees on the French border.[59] Six years later, in February 1901, Vuillard and Bonnard accompanied the Bibesco brothers on an art-and-architecture sight-seeing trip to southern Spain and Portugal, where they picked up special yarns that the Bibescos' mother had sent from Romania to deliver to Maillol's Banyul studio.[60] In photographs taken by Emmanuel (and perhaps Vuillard), the foursome is shown at the various stopping grounds in Tours, Zaragoza, Granada, Sevilla, Toledo, and Madrid (pls. 236, 237).[61] It was probably around the time of this trip that Emmanuel purchased his first large-scale decorative painting from Vuillard, *The Lilies* (pl. 240), for his family's *hôtel* at 69 rue de Courcelles.[62] A year later, and prior to the Schopfers' divorce in January 1903, when Schopfer wrote to Vuillard asking him to

A published announcement in *Le Figaro* for the opening-night performance, reflected as much on Antoine's personality and social pedigree as on the play:

"safeguard the last big panel" (*The Luncheon at Vasouy*), he noted also his regret that he could not keep the two earlier pendants "that he loved so much" (*Woman Reading on a Bench* and *Woman Seated in Garden*).[63] He had forfeited them to Alice, who gave or sold them to Emmanuel and Antoine Bibesco sometime after the divorce and before the Bibescos lent them to the Thirteenth Secessionist Exhibition (1906) in Berlin. There they were described as "panneaux décoratifs" and as "six of his [Vuillard's] *décorations* from the collection of the princes Bibescos," and as showing "garden scenes with modern people, rooms where bunches of flowers and charming heads of women blend together into one *mélange*."[64] Since no catalogue exists for the French section of the exhibition, it is not possible to know if the six panels mentioned were actually *décorations* or if this was a generic term used to group the smaller still lifes and interior scenes in the Bibescos' collection at that period. At the time of the Berlin exhibition, the Bibescos owned only three decorative panels – the pendants from the earlier Schopfer commission (1898) and the panel *The Lilies*. In the next year they increased that number to five with the commission of *The Alley* and *The Haystack*. Exhibited among the "oeuvres récents" at the Bernheims' gallery in February 1908, these works of approximately the same format as the earlier (Schopfer) panels completed the Bibescos' collection of Vuillard *décorations* spanning a decade of his career – from the last projects before the closing of *La Revue Blanche* to the recommencement and redirection of his decorative career in 1907.[65]

The Lilies, *1899–1900 and 1908*

A recent study of this relatively unknown work has revealed that the almost four-foot tall panel painted *à la colle* was repainted and dramatically altered by the artist in 1908 to become *Woman Waving at the Passerby* (*Femme saluant les passants*) (pl. 240).[66] In its first incarnation, known through a photograph of the painting taken around 1908 (pl. 238), *The Lilies* showed Misia in the right foreground waving to Vallotton amidst the dense foliage of the surrounding vineyards of the Natansons' Villeneuve home, Le Relais. It may well have been the project Vuillard was working on when he wrote to Vallotton from Villeneuve in November 1899:

Thank you for your letter and photos. They made me very happy and helped me to understand even better the futility of certain ideas for paintings . . . News from here? We are in a near perfect Thélème. Everyone is working and in good spirits, even me, until a few hours ago when I took a sudden dislike to my panel. I have worked it too much and the result is not to my liking. I was rather pleased with it at first, *and as you are somewhat the inspiration for it,*

I had been thinking of you quite a lot, your manner rather than your facial features, and that made me feel a bit wiser. [My emphasis.][67]

In his choice of Vallotton's mannered pose and generalized facial features, Vuillard may have relied on imagery from the same group of photographs taken at Villeneuve in 1899 (pl. 218) and used for *The Promenade* for Jack Aghion. In other images of Vallotton, such as a photograph from the summer of 1900, when Vuillard joined Vallotton and the Hessels in Romanel, Switzerland (pl. 239), or the long horizontal panel of the Vallotton family *Family in the Garden* (pl. 241), he wears the same soft hunting hat

236 (below) Photograph of Vuillard and Antoine Bibesco on the train from Cordoue to Bobadilla, February 1901, Fondation Dina Vierny/ Musée Maillol, Paris.

237 (bottom) Photograph taken by Emmanuel Bibesco of Vuillard, Antoine Bibesco, and Bonnard on the esplanade at Sevilla, February 1901, Fondation Dina Vierny/Musée Maillol, Paris.

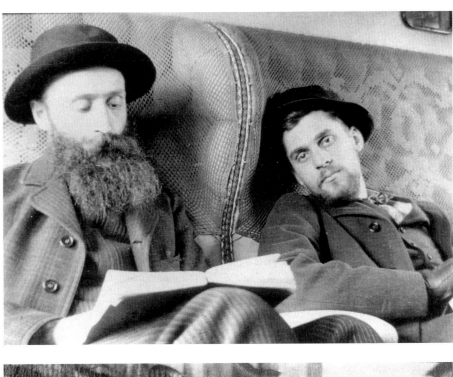

238 Edouard Vuillard, *The Lilies, Misia and Vallotton at Villeneuve-sur-Yonne (Les Lilas)*, 1899–1900, distemper on canvas, 240 × 155 cm. First state, Salomon Archives, Paris.

240 (far right) Edouard Vuillard, *The Lilies (Les Lilas)*, or *Woman Waving at the Passersby (Femme saluant les promeneurs)*, 1899–1900, 1908, distemper on canvas, 240 × 155 cm. Final state, private collection.

239 Photograph of Lucie and Jos Hessel with the Vallottons at La Naz, Switzerland, 1900. Vallotton Archives, Galerie Paul Vallotton, Lausanne.

and breeches seen in *The Lilies*. Misia, too, wears the loose-fitting plaid housedress that seems to have been her "rural" signature, and that is seen in a number of photographs, paintings, and *décorations* such as *The Small House at L'Etang-la-Ville* (pl. 210) and *Woman in the Fields* (pl. 221), from the Villeneuve years. Like the landscape panels for Adam Natanson, *The Lilies* fits into the family of works inspired by Vuillard's visits to Villeneuve and around the Roussels' home at L'Etang-la-Ville.[68]

Most noticeable of the changes between *The Lilies* of 1899–1900 and the final version is the replacement of the figure of Vallotton with two smaller figures seen from behind (pl. 240). Instead of Misia greeting Vallotton, the subject became "a young woman in a dark dress splashed with yellow gesturing towards the passersby."[69] Although Vallotton is still identifiable by his soft cap and cane, in the 1908 version he is a much-reduced figure pushed to the edge of the frame at the far left of the composition and depicted with a woman.

According to Bareau's study of the commission, the Bibescos purchased *The Lilies* soon after it was completed in 1900 and later requested retouches in order to integrate this panel with *The Alley* and *The Haystack*, commissioned eight years later.[70] It is also possible that Vuillard's dramatic retouching (described by Segard as heightened with pastel[71]) may have been intended to alter and obscure the portrait-like images of Misia and Vallotton, in the same way that he had altered the portraits of the partipants in the final version of *The Luncheon at Vasouy*. Given the subjects of the second set of panels for the Bibescos, drawn, as will be shown, from Vuillard's post-Misia circle, it is also possible that Vuillard had a particular reason to modify the narrative suggested by the Vallotton/Misia coupling. A smaller painting, en-

241 Edouard Vuillard, *The Vallotton Family in the Garden*, c.1899–1900, oil on paper, 26.8 × 111 cm., Staatsgalerie, Stuttgart.

titled *Young Woman in a Forest* (*Jeune femme dans un forêt*) (pl. 242), shows a woman (presumably Misia) whose clothes and pose are similar to those assumed by Misia in related works from 1898 to 1900, and may represent an intermediary stage for the transformation of the genre-like *Lilies* panel into the more anonymous *décoration*.

Whatever the subsequent changes made in the Misia and Vallotton panel, these cannot explain why the Bibescos, whose circle was international, and whose teas at the Hôtel Ritz and departures on excursions were social occasions worthy of mention in *Gil Blas* and *Figaro Illustré*, would have purchased or commissioned this work and two other large-scale paintings showing thinly disguised portraits of people from Vuillard's intimate circle.[72]

The Haystack *and* The Alley, *1907–1908*

In 1907, the Bibescos moved from the family *hôtel* to a ground-floor apartment on the rue Commandant-Marchand. Their move may have been precipitated by Alexandre Bibesco's engagement (and, in the following year, scandalous marriage) to a young actress from the Théâtre Ambigü.[73] The pendants were commissioned at the beginning of November 1907, perhaps as a housewarming gift to themselves (as Vuillard's panels for Thadée and Schopfer may have been in 1895 and 1898 respectively) and to complete the ensemble that had been started with the three earlier panels.

For Vuillard, Emmanuel's call on 5 November of that year confirming the commission represented a

243 (following page) Edouard Vuillard, *The Haystack (La Meule)*, 1907–8 (repainted in 1928–38), distemper on canvas, 235 × 165 cm., Musée des Beaux-Arts, Dijon, on deposit from the Réunion des Musées Nationaux Français.

242 Edouard Vuillard, *Young Woman in a Forest* (*Jeune femme dans un forêt*), c.1898, 42.1 × 56 cm., Galerie Huguette Berès, Paris.

259 Photograph of Antoine Bibesco at 45 quai Bourbon, with the panel *Woman Reading on a Bench*, c.1950, collection of James Crathorne, London.

260 Photograph of panel *Woman Seated in a Garden* at 45 quai Bourbon, n.d., collection of James Crathorne, London.

before Antoine's death in 1951 and noted "a room so beautiful that it took my breath away with the full-length Vuillard panels obviously painted to fit the wall."[134]

The large-scale distemper works exhibited in February 1908 which Bibesco did not choose to keep in his collection marked a new development in Vuillard's aesthetic away from the genre scenes, still lifes, and intimate portraits that had been central to his previous work. What Denis had decried as Vuillard's dangerous proclivity to preciosity, or "gourmandize,"[135] was, in fact, an outgrowth of his deliberate move away from the theorizing influences of the Nabis' "deformations," and an attempt to "de-prettify," to some extent, his subject by relying to a greater extent on models (or photographs) and by responding more spontaneously to nature.

With the portrait of Olga and Alexandre (*The Tennis Court*) and the pendants for the Bibescos, Vuillard experimented in merging the aesthetics of portraiture with painting as decoration. Earlier, Thadée had remarked in a review of the Nabi exhibition held at the Bernheim-Jeune gallery in April 1900, "Tomorrow he [Vuillard] may vary his model and not be so limited."[136] In the Bibesco panels,

as distinct from his earlier decorative paintings for Thadée, Vaquez, and even Schopfer in 1898, in which background and figure were often confused in favor of overall patterning, Vuillard created a greater feeling of deep space by setting the figures against the naturalistic background of tennis nets or entangled trees. Both *The Haystack* and *The Alley*, in particular, were painted with Vuillard's now much looser brushwork, which he used to draw in the design as well as to cover large areas of canvas. Unlike the Villeneuve pendants of 1898 or the large landscapes of 1899 for Adam Natanson, the Bibesco panels are less obviously paired and are not conventionally decorative or ornamental. The two later paintings, in comparison with the earlier panel *The Lilies*, subsequently reworked so that it would fit with them (both in theme and palette), attest to his increasing indifference to the motif as symbol and to repetitive (sometimes claustrophobic) surface patterns. Instead, they show him moving towards the use of milder colors subordinated one to another, more pronounced light effects, and a matter-of-fact approach to subjects that were decidedly non-decorative when compared with his earlier works in the genre.

164

8 Of Avenues, Streets, and Squares:
The Commission for Henry Bernstein, 1908–1910

In November of 1908, nine months after exhibiting the three panels painted for Antoine and Emmanuel Bibesco at the Bernheim-Jeune gallery, Vuillard exhibited at the same gallery four decorative panels grouped as *Paris Streets* (*Rues de Paris*).[1] On the opening day, which fell on Vuillard's fortieth birthday, he noted casually "My forty years. Go to the Bernheims to see my exhibition."[2] But his forty-first year seems to have been, if not one of crisis, at least one of re-evaluation and decision-making. His anxieties about money and work put forth in his journal recall those he had voiced sixteen years earlier, stemming from the need to reconcile his artistic vision and technique with the necessity of producing and marketing his works.[3] In addition, as he had noted in his journal earlier that year, he was concerned about his health and his financial dependence on the Bernheims:

> . . . worried about my idleness. Not able to think tranquilly. However, have recovered my liking for analysis. That is enough to give me hope. It's a matter of my relationship with my work or rather of my preoccupations and relations with the public. Art dealers or others. Tormented by the lack of discipline so necessary for me. Health and independence. Need to earn a proper living. The present situation is unsatisfactory. It requires compromises that expose me to all sorts of trials and tribulations in spite of appearances. Need to take these matters *seriously* in hand – importance of good health today as well as in the past.[4]

Vuillard's relationship with the Bernheim brothers was not, as Segard described it, a blissful arrangement, allowing the artist "absolute liberty to accept any commission while freeing him entirely from any obligations to their clientele."[5] Although they may not have prevented him from accepting other commissions, Vuillard was frequently angry at their surveillance and felt that his obligations to them compromised both his production and his creativity.[6] Vuillard may have hinted at his underlying ambivalence towards the Bernheims in a portrait study (pl. 261) for a larger oil painted in 1907–8 (Marion

Koogler McNay Art Museum, San Antonio). In the final version, the impeccably attired brothers strike self consciously relaxed poses in their sumptuously appointed new gallery on the rue de Richepanse. The picture belies the fact that they deal in pictures for their living and is much different in meaning than the near-caricatural St. Louis study which shows Gaston

261 Edouard Vuillard, *Josse and Gaston Bernheim*, c.1907, oil on canvas, 73.2 × 66 cm., Gift of Mr. and Mrs. Richard K. Weil, 66.1953, Saint Louis Art Museum.

262 Edouard Vuillard, *View from the Artist's Window, rue de la Tour*, 1906, distemper on paper laid down on canvas, 71.5 × 157.5 cm., Milwaukee Art Center.

(facing page, left to right)

263 Edouard Vuillard, *The Water Cart (La Voiture d'arrosage)*, 1908, distemper on brown paper laid down on canvas, 194 × 65.1 cm., private collection.

264 Edouard Vuillard, *The Eiffel Tower (La Tour Eiffel)*, 1908, distemper on brown paper laid down on canvas, 194 × 65.1 cm., private collection.

265 Edouard Vuillard, *The Street (La Rue)*, 1908. Distemper on brown paper laid down on canvas, 194 × 65.1 cm., private collection.

266 Edouard Vuillard, *Child Playing in the Gutter (L'Enfant au ruisseau)*, 1908, distemper on brown paper laid down on canvas, 194 × 65.1 cm., private collection.

before a desk buried in papers while his brother, Josse, keeps a predatory eye out for potential buyers from his perch on the arm of a chair. In this earlier version, the Bernheims ignore completely a customer already in their gallery and barely visible behind them, who examines the lower-ticket items of prints and posters. The portrait-like quality of this painting seems unequal to the emphasis Vuillard places on the fiery red-orange upholsterings and hot yellow lights – possibly Vuillard's intentional jab at the artificiality of the Bernheims' appearances which mask their hard-sell business techniques.[7]

On 3 July 1908, after much hesitation, Vuillard decided to "go to the Bernheims" to demand a new contract, noting as his "deep-seated reason" his "desire for liberty."[8] The conditions of his contract, redrawn by Fénéon, are not known. Like Bonnard, who seems to have renegotiated his contract with the Bernheims in 1906, and Matisse, who had no less than five contracts with the gallery, it is possible that Vuillard modified both the number of works to be handled and the terms of his salary.[9] The success of the negotiation is reflected in his journal remark that day describing the Bernheims' "kindness and their regrets," and later, in his summary for the year, "a new business arrangement with the Bernheims beginning in July."[10]

Also listed for July was his move to the rue de Calais near the place de Clichy. As has been mentioned, Vuillard was, with few exceptions, a life-long resident of the right-bank neighborhood around the place des Batignolles. For one short period, between October 1904 and July 1908, Vuillard and his mother lived in the Passy district in the *seizième*. At first, Vuillard had been delighted with the change in neigh-

borhoods: writing to Thadée soon after signing the lease, he voiced his satisfaction at having left behind the dark courtyards of the apartment on the rue Truffaut for the new larger and taller apartment, with "windows that I couldn't have hoped for, giving onto open spaces occupied by flower shops and greenhouses, and bordered in the distance by big trees. These greenhouses, the people unrolling straw mats and the palm trees remind me of Cannes."[11] Vuillard's summery view of his new surroundings is reflected in the large, apparently undestined panel *View from the Artist's Window, rue de la Tour* (pl. 262).

The Passy period of Vuillard's life is more significantly remembered, however, by the four panels exhibited in November 1908 at the Bernheim-Jeune gallery as "Rues de Paris," with the individual titles *The Water Cart (La Voiture d'arrosage)* (pl. 263), *The Eiffel Tower (La Tour Eiffel)* (pl. 264), *The Street (La Rue)* (pl. 265), and *Child Playing in a Gutter (L'Enfant au ruisseau)* (pl. 266).[12] At the end of the exhibition, the thirty-two year old dramatist Henry Bernstein bought the paintings from the Bernheims and commissioned the artist to paint four additional panels of the same format also showing scenes of Parisian streets. For the second set of *Paris Streets*, Vuillard focussed not on the Passy area, but on the city viewed from the vantage point of a newly leased apartment on the rue de Calais (pl. 273) overlooking the place Vintimille (pls. 275–7).

The Domestic Drama of Henry Bernstein

All eight of the Bernstein panels painted in 1908 and 1909–10 were executed *à la colle* on paper and

glued (by the *marouflage* process) to a canvas support. Over six feet tall and narrow, they are also notable within Vuillard's decorative career for their very impressionist subject matter and vigorous open paint handling. The theme of urban streets was an unconventional one for Vuillard and an oddly conservative choice for Bernstein, a socialite and one of the most hotly debated talents in the boulevard theaters. Inside and outside theatrical circles, Bernstein was known for his difficult personality, radical social and political views, and excessive indulgence in women, horse-racing, and gambling. Indeed, Bernstein represents one of Vuillard's least likely admirers, and the ensemble, now divided between a private and a public collection, is one of the least studied of his career.

Twelve years younger than Vuillard, Bernstein came from a wealthy and distinguished family. His mother, Ida Seligman, was the daughter of a wealthy New York banker of Bavarian descent and a cousin to the New York Guggenheims.[13] The father, Marcel Bernstein, was a petroleum magnate, banker, and head of a lumber company, who had made a fortune in diamonds after emigrating from what is now Poland to Antwerp.[14] By 1874, Marcel was married and living in Paris. He soon became editor of the prestigious *Journal des Debats* and was assimilated, because of his cousin Charles Ephrussi, into a clique of intellectuals and art collectors that included Paul Bérard, Gustave Dreyfus, and Charles Deudon. Through this circle he began to collect impression-

ist art and was a frequent visitor to Manet's rue d'Amsterdam studio.[15] In 1881, Marcel commissioned Manet (who was by then also his neighbor at his villa near Versailles) to paint his five-year-old son, Henry, in a sailor suit (pl. 267).[16] Even at this tender age, Henry struck the aging Manet as "vivacious and assured."[17] Together with Marcel Bernstein's collection of paintings by Fantin-Latour, Cézanne, Van Gogh, Sisley, and Renoir, among others, the dapper portrait of himself by a famous

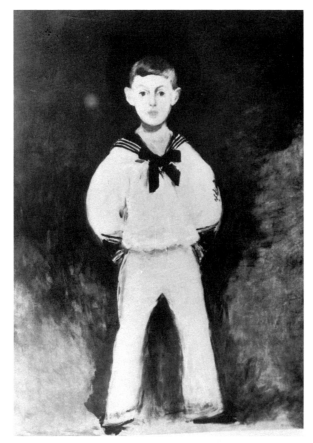

267 Edouard Manet, *Henry Bernstein*, 1882, oil on canvas, 135 × 97 cm., private collection.

artist made up Henry's earliest recollections of life in the family *hôtel* on the avenue d'Iéna.[18]

According to Henry's daughter and co-author of a biography of her father entitled *Bernstein le Magnifique*, Henry rebelled early against his *haut bourgeois* upbringing. While still an adolescent at the Lycée Condorcet, he robbed his father's coin collection in order to play the horses, the beginning of a lifelong habit. To avoid the draft in January 1896, Henry used his father's influence to enroll as a non-college student at Cambridge, where his fondness for women and sports earned him the epithet "Lord Bernstein."[19] When Marcel died four months later, the younger Bernstein returned home, only to leave for Brussels a year later with his current mistress, days before he was to turn twenty-one and come into his inheritance. Dodging his military service once again (an incident that would return to haunt him), Bernstein

remained in Brussels until 1900, when he moved back to Paris and persuaded the director André Antoine to produce his three-act drama *Le Marché* at his theater.[20] The play was a surprising success and Bernstein's career was launched.

Although Bernstein purchased the *Paris Streets* panels directly from the Bernheims, he may have known of Vuillard and his work in the decorative arena through another aspiring playwright, Antoine Bibesco. In addition to their shared theatrical interests, both were anglophiles, members of the prestigious Yacht Club, and successful womanizers.[21] Stylistically, the dialogues for their plays shared a certain volatile and yet highly mannered language described by Claude Roger-Marx as "torrential, I would say noisy and more rapid than deep."[22] Their close friendship during the early years of the decade is hinted at in Proust's letters to Antoine, full of petty jealousy over Antoine's interest in Bernstein.[23] By 1906, however, it was Proust who was corresponding regularly with the young playwright and Antoine who had distanced himself – probably, as Bernstein's daughter speculates, because of Bernstein's rapid rise to stardom and his disregard for Antoine's playwriting efforts.[24]

Vuillard's own connections to the modern theater had not weakened but shifted. As shown, his early patrons were with few exceptions writers for the symbolist theater, represented by Paul Fort's Théâtre d'Art, Antoine's Théâtre Libre, and Lugné-Poe's Théâtre de l'Oeuvre. By 1900, Vuillard's involvement was as a faithful spectator for plays performed in the mainstream theaters of the boulevards and written by his close friends Tristan Bernard, Romain Coolus, Antoine Bibesco, Octave Mirbeau, and Thadée (who co-wrote with Mirbeau *Le Foyer* in 1908).[25]

Almost all of these productions dealt with modern sexual relationships.[26] Bernstein's plays, in particular, focussed on the sordid intrigues between the sexes and the hypocrisy inherent in acceptable social behavior.[27] His preference for crisp titles – *La Rafale* (*The Squall*, 1905), *La Griffe* (*The Claw*, 1906), *La Lutte* (*The Struggle*, 1908), and *Le Bercail* (*Family Circle*, 1908) – both provoked and explained the social commentary marking his works. Despite their raw and sometimes violent dialogues, however, Bernstein's plays were so popular that every night from 1904 to 1914, at least one was performed in Paris. By November 1908, when Bernstein bought the first four panels from the Bernheims and commissioned the second set, he was enjoying the *succès de scandale* caused by his three-act drama *L'Israël*, which had opened a month earlier at the Théâtre Réjane."[28] More so than any of his earlier works, this story of a young nobleman who commits suicide when he learns that his true father is a Jew, exploited the public sentiment for the still-volatile "Jewish question" among the old-familied elite.[29] Disappointingly, Vuillard, whose clientele continued to

be predominantly Jewish, made no comment on this disturbing social drama by his new patron.[30]

It is also regrettable that Vuillard made no reference in his journal to a number of personal injuries to his close friends for which Bernstein was indirectly or directly responsible. In 1907, for example, Bernstein used his clout as a member of the Société des Auteurs (a prestigious organization serving as a kind of playwrights' union and buffer between theater owners and authors) to blackball Tristan Bernard from the society.[31] That same year, Bernstein delivered an even more cruel snub to Misia, who had become, since her marriage to Edwards, a member of the "cercle Bernsteinian."[32] Edwards had fallen passionately in love with a young actress named Geneviève Lantelme.[33] Misia, in a desperate attempt to make her husband jealous, invited Bernstein to her hotel at Baden-Baden. While Misia's invitation sprang from her attraction to Bernstein's "histoires passionées," his acceptance of Misia's offer was a matter of coquetry and male pride.[34] Once at the hotel, Bernstein reacted coldly to Misia's amorous attentions, and could hardly wait to return to his mistress at that time, the famous courtesan Liane de Pougny. As Liane recalled, the "Misia-Bernstein affair" lasted three short nights, after which they separated "extremely unhappy with each other. When they met again, they acted hurt and distant."[35] Misia's memoirs do not mention Bernstein's callousness nor the failed seduction attempt. They are silent also about an afternoon duel on 4 December 1907, which she persuaded her estranged husband Thadée to fight in her honor against Bernstein. (The duel was called off when Thadée managed to graze the dramatist's arm.[36]) That same month, Bernstein delivered a counterblow to Thadée when he again used his influence with the Société des Auteurs to have his play Le Voleur replace Thadée's and Mirbeau's three-act drama Le Foyer at the Théâtre de Renaissance.[37] Given Vuillard's friendship with each of Bernstein's victims, one wonders what the artist thought of his client's moral conduct and whether his journal references to "histoires Misia" between 1906 and 1907 and to "l'affaire Bernstein" after 1908 are not veiled allusions to these or similar events.[38]

Paris Streets: The First Series, Passy, 1907–8

At the time of Vuillard's fall exhibition at the Bernheim-Jeune gallery, the panels belonged to the Bernheims, who had purchased them from the artist in July 1908 for the sum of 1,000 francs (600 francs for The Street and The Water Cart and 400 francs for The Eiffel Tower and Child Playing in a Gutter).[39] When the panels were exhibited four months later and designated "à vendre," Bernstein bought them at the considerably inflated prices of 2,000 francs and 1,250 francs respectively.[40] Bernstein's commission of four additional panels at the time of his initial

purchase indicates that he was, at any rate, undaunted by the price tag.[41]

Like several of Vuillard's commissioned projects (for Thadée and Misia, Schopfer, and the Bibescos), Bernstein's commission seems to have been motivated in part by his move from the family home at 103 avenue des Champs-Elysées to a bachelor apartment at 157 boulevard Haussmann.[42] As shown above, Vuillard's conceptualization of the Paris Streets project seems also to have resulted from the geographical changes affecting his own life. As he wrote to Thadée upon his move to the rue de la Tour apartment in the Passy district in 1904, his first impressions of the neighborhood were favorable. Once an eighteenth-century hamlet noted for its ferruginous waters, "The Plain of Passy" had been incorporated into the metropolitan area only in the middle of the nineteenth century. It became the favorite neighborhood for an increasingly aristocratic segment from the city center, who were attracted to its village-like atmosphere and proximity to the Bois de Boulogne. By the end of the century, the social make-up of Passy was fast approaching the faubourg of Proust's Le Côté de Guermantes formerly identified with the Saint-Germain quarter.[43] At the same time, apart from a few notable exceptions such as the hôtel of Boni de Castellane and that of the Princesse Edmond de Polignac (née Winnaretta Singer), the predominant architectural style of Passy was decidedly bourgeois, with smaller houses and their gardens wedged between luxury apartment houses constructed in the 1880s.[44]

Vuillard's growing dissatisfaction with the Passy area, however, seems to have stemmed less from the neighborhood's architectural sameness than from the geographical and psychological drawbacks of living so far from the commercial center. In addition to being further from the galleries (near the Opéra and Montmartre districts) or from his studio (until 1909 at 233bis rue du Faubourg-Saint-Honoré), the artist was also inconveniently located with relation to his friends. By 1908, Thadée was living on the place Henri-Laborde next to the place Saint-Augustin; Bonnard had rented studio space at 60 rue Douai near the place de Clichy (and by 1909 on rue Lepic); and Lucie Hessel was living near the Tuileries gardens on the rue de Rivoli. In 1909, Lucie, too, would move north to an apartment on the rue de Naples in the Batignolles quarter.[45] Distanced from his intimate circle of friends, Vuillard was, at the same time, too close to the Bernheims and their customers. More than once he noted in his journals his disdain for the haut bourgeois community in which he lived but to which he did not belong. On Tuesday, 5 November 1907, for example, he was discomforted by a chance meeting in the street with the Bernheims, whose recently built mansion on the avenue Henri-Martin was only a few blocks from his own apartment: "Return home for lunch. Ran into the Bernheims; the hotels on the rue de la Faisanderie; the rich and their

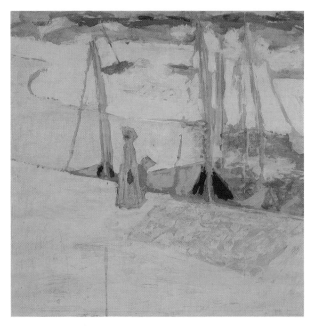

fantasies . . . bourgeois pleasures and sensual voluptuousness. The orgies that wear you out. I have a desire to go to L'Etang."[46]

As noted in the previous chapter, 1907–8 marked a return for Vuillard to large-scale painting. It was also a transition period for the artist. The very different style and composition of his *Paris Streets* panels and the related works from this period may have resulted from his growing desire to liberate himself from technical constraints. Certainly, the panels represent thematic liberation from the many portrait commissions Vuillard received between 1905 and 1908. For despite his insistence that he painted not portraits but "people at home,"[47] Vuillard's journal bears out that he was many times discomforted by these "at home" visits which necessarily placed him in a situation of subservience *vis-à-vis* his wealthier clients.

With the *Paris Streets* panels, Vuillard countered the image of the Passy quarter as a place for "the rich and their fantasies," both compositionally and thematically. Common to all four panels, for example, is a compositional formula consisting of a relatively empty foreground with buildings pushed to the extreme background. In each, Vuillard assumed an eye-level focal point marked by buildings or trees slightly higher than the midpoint of each composition. The lines of sidewalk and street divide the picture vertically and further emphasize the deep perspective leading from foreground to background. This device and the life-size scale increase one's sense of an immediate and direct experience, transforming an ordi-

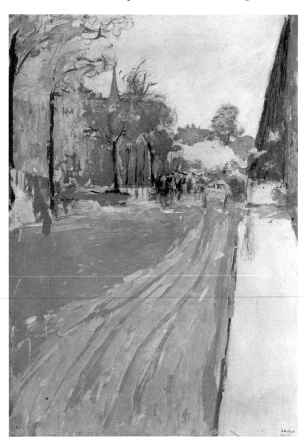

nary sidewalk into an extraordinary image of urban space. One has the impression that these were scenes unfolding in front of the artist as he walked with pencil in hand. Unlike his previous decorative paintings, *The Haystack* and *The Alley*, for which he had relied on photographic images, Vuillard makes no mention in his journals of using photographic *aide-mémoires* for the *Paris Streets* panels. The numerous thumbnail sketches and vigorously painted sketches (pl. 268), moreover, support the assumption that the scenes were conceived and realized from direct observation.[48] The lighter palette, the bold, almost violently brushed surfaces, and the cheap brown-paper support (which he later glued to canvas) makes them resemble his airy seaside paintings, such as *View of Pouliguen* (*Vue de Pouliguen*) (pl. 269) and others of the Brittany coast painted during holidays spent with the Hessels in the summer of 1908 and exhibited in that same November with the *Paris Streets* panels.[49]

With the Bernstein panels, especially, Vuillard returned to an airy subject and palette dear to the early impressionist painters. As if accepting Degas's challenge to show the "monument or houses from below, from above, up close, as one see them in strolling on the streets,"[50] Vuillard's relatively anonymous streets, with tell-tale landmarks of the right bank appearing in the background, are shown at the level of the *promeneur*, or the artist himself. *The Street* (pl. 265), for example, has been identified as the end of the avenue du Bois de Boulogne, leading to the place de l'Etoile and the Arc de Triomphe; *The Eiffel Tower* (pl. 264) as showing the rue de Passy from the junction of the rue de la Tour (where Vuillard lived) looking up towards the Champ-de-Mars; and *The Water Cart* (pl. 263) as showing the Métro station of the place Dauphine, seen in the distance at the junction of avenue Henri-Martin.

Unlike the street views by the impressionist artist Pissarro, whose *Place du Havre* series focussed on the ant-like activities of the bustling urban square (pl. 270), or Caillebotte, whose monumental street-level scene, *Paris Street; Rainy Day* (pl. 271), showed the social prestige of the street *vis-à-vis* its inhabitants, Vuillard eulogized the rural aspects of the city's arteries. Whereas Caillebotte offers a wide-angle view that eclipses the urban activity into the trapezoidal space of the busy intersection near the Gare Saint-Lazare, Vuillard presents an exaggeratedly elongated city block which, with the exception of the Eiffel Tower, has no defining features. Vuillard does not set himself up as a *flâneur*, a specifically Parisian type associated with modern social life and the metropolis in the Third Republic,[51] but a private *documentaliste* to the more recently developed suburban avenues.

Closer to Vuillard's city routes and use of a decorative format and abrupt perspective are Bonnard's decorative screens and paintings of street subjects from the 1890s and early 1900s. It has even been suggested that Vuillard's cityscapes were inspired by Bonnard's triptych *The Ages of Life* (*Les Ages de la vie*), which hung in the Hessels' salon on the rue de

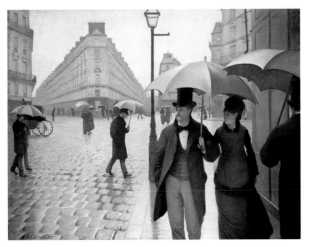

Rivoli and later at their home on the rue de Naples.[52] One can think, too, of Bonnard's vertical panel *Rue Tholozé* (also called *Moulin de la Galette*) (pl. 272) and his lithographs for the album *Some Aspects of Life in Paris* (*Quelques aspects de la vie de Paris*) from the same years.[53] Vuillard had also earlier experimented with a dramatic vanishing point in the lithograph, *The Avenue*, published in Vollard's album *Paysages et intérieurs* in 1899 (pl. 164). Yet, whereas in both Bonnard's painting and Vuillard's lithographic "street scenes," people move busily or dreamily through a space that is "closed," by size and composition; in the *Paris Streets* panels the feeling is one of expansive, deep, but inaccessible space.

Until the Bernstein project, Vuillard's out-of-doors *décorations* had shown *villégiatures*, suburban residences, and city parks whose specific subjects reflected either the property or personalities related to his experience or that of the person commissioning

272 Pierre Bonnard, *Rue Tholozé* or *Moulin de la Galette*, c.1898, oil on canvas, 64.9 × 33 cm., Collection William Kelly Simpson, New York.

270 Camille Pissarro, *Place du Havre*, 1893, oil on canvas, 60.1 × 73.5 cm., Potter Palmer Collection, 1922.434, The Art Institute of Chicago.

271 Gustave Caillebotte, *Paris Street; Rainy Day*, 1877, oil on canvas, 212.2 × 276.2 cm., Charles H. and Mary F.S. Worcester Collection, 1964.336, The Art Institute of Chicago.

274 Gustave Caillebotte, *The Man on the Balcony* (*L'Homme au balcon*), *c.*1880, oil on canvas, 116 × 90 cm., private collection, Paris.

273 Edouard Vuillard, *Rue de Calais*, 1909–10, distemper on cardboard, 198.7 × 48.6 cm., private collection.

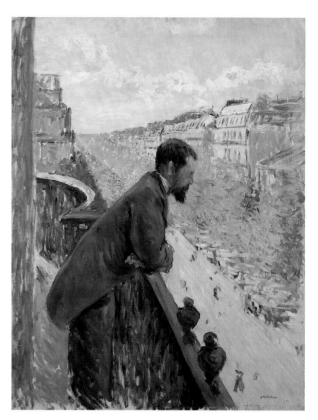

the panel. In the first four panels of the *Paris Streets* series, which were seemingly uncommissioned, Vuillard eschews the recognizable and biographical. Instead of picturesque sites or passersby, Vuillard's subject is a sleepy neighborhood street whose wealthy status is not immediately obvious. Instead of concentrating on the opulent, high-rent residences lining the avenues in the Passy quarter, he focusses on the streets themselves as rural passageways. In *The Street*, for example, the avenue du Bois is represented not as the fashionable promenade dotted with expensive grilled gates and carriages, but as a nearly deserted road bordered on the right by a high stone wall girdling a private mansion. In *The Water Cart*, no women on bicycles, automobiles (fashionable among the upper-middle classes by 1905), or horse-drawn omnibuses are allowed to invade the gently sloping roadway traversed by only a horse-drawn water cart.[54]

Equally selective is Vuillard's viewpoint for *The Eiffel Tower*, in which the top third of the monument on the horizon at the far left rises above the buildings. Vuillard's incorporation of an urban icon in this work can be compared with Bonnard's narrow cityscape *Rue Tholozé or Moulin de la Galette*, in which the celebrated dance hall is centered at the apex of the converging lines of the rue Lepic (pl. 272). Vuillard, by contrast, focusses not on the city symbol but on creating a luminous surface pattern of white in which the brown cardboard is allowed to show through to suggest the sidewalk lining the rue de Passy. In the third panel (pl. 266), a small child bends over the *ruisseau*, a word that in French can mean either "gutter," connoting the modern convenience for funneling water through the city streets, or "stream," alluding to the waterways or irrigation ditches in the still-rural neighborhood.[55] The ambiguity of the title and the child's attire – which reveals little about her social background – reinforce the evocation of a rural atmosphere for this scene. Squatting in intense concentration over her play and oblivious to her surroundings, she is the quintessential "child," codified by both Bonnard and Vuillard during their earliest years as Nabi artists.[56] In the *Paris Streets* panels, the random houses, the horse and buggy, and, in this fourth panel, the child, seem to have been selected as pictorial accents rather than as narrative intruders upon these otherwise quiet streets.

Paris Streets: The Second Series, Place Vintimille, 1909–10

As shown, Vuillard's insistence on the naturalistic aspects – the muted and unpicturesque quality of the Passy streets as seen in the first set of panels – may have been a means of disassociating his art (as were the panels *The Haystack* and *The Alley*) from what critics saw (negatively) as the technical perfection and preciosity of his earlier decorative style. One might

also read the relatively abandoned streets and melancholy mood of these panels as Vuillard's subtle indictment of the Passy quarter, where he never felt comfortable. By 1908, he was preparing to move back to the Batignolles neighborhood. Throughout the month of May, Vuillard wandered, as his journal indicates, around the rue Turin, the rue de la Bruyère, and the place de Clichy in search of an apartment for himself and his mother near to their previous address on the rue Truffaut. On 18 July 1908, Vuillard noted his relief at finding a home at 26 rue de Calais, where he would live for the next eighteen years:

> Got up at 9:30, the move all ready. Telephoned the Bernheims. Leave rue de la Tour at 11:30 with the intention of never returning to this neighborhood. Pleasure in being again at Clichy. Go to lunch with mother at Bonvin's. Telephone Fred [Alfred Natanson] and Thadée. Return rue de Calais. Apartment pleases me. Still not discouraged.[57]

Once installed in the fifth-floor apartment, Vuillard had only to look out his window onto the small oval of the public garden on the place Vintimille for a wealth of motifs.[58] Vuillard's changed focus and attitude towards his subject matter is witnessed by the richly colored *Place Vintimille* panels and the detailed, animated sidewalk of *Rue de Calais* (pl. 273).[59] Gone are the long trenches of unpeopled space. Like Bonnard, who used the colorful Parisian "types" as patterns to activate his compositions, Vuillard enlisted

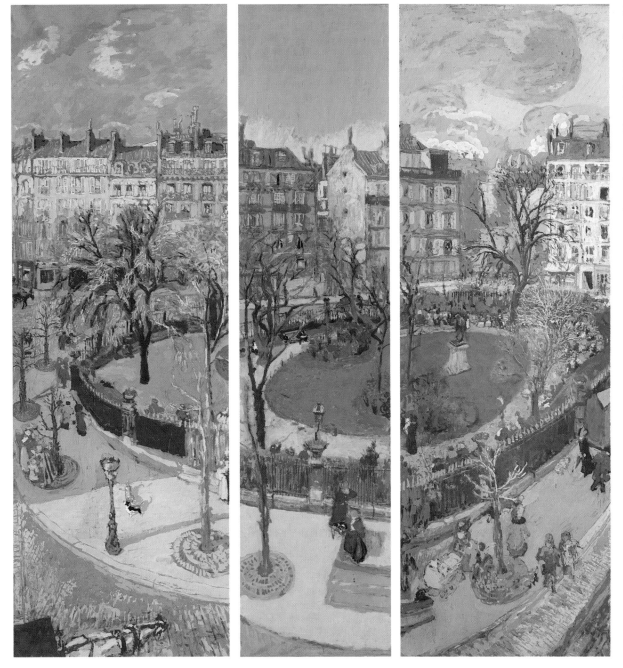

275 Edouard Vuillard, *Place Vintimille*, 1909–10, distemper on cardboard, 200 × 69.5 cm. Left panel of the triptych showing the rue de Bruxelles. Solomon Guggenheim Museum, New York.

276 Edouard Vuillard, *Place Vintimille*, 1909–10, distemper on cardboard, 200 × 49 cm. Center panel of the triptych. Private collection.

277 Edouard Vuillard, *Place Vintimille*, 1909–10, distemper on cardboard, 200 × 69.5 cm. Right panel of the triptych showing the rue de Douai. Solomon Guggenheim Museum, New York.

the life of the sidewalks, streets, and squares as decorative foils. In the *Rue de Calais*, the balcony grill, which serves as part of the upper border, and the aggressive stone and metalwork of the apartment buildings recall Caillebotte's balcony in paintings like *Man on the Balcony* (*L'Homme au balcon*) (pl. 274), in which the *grands boulevards* are seen from an intermediary position between the *flâneur* and bourgeois apartment-dweller.[60] Vuillard's space in *Rue de Calais*, however, is even more complex, showing not one but three balconies: Vuillard's own (in the first plane) and those across the street from his apartment. As he did for the first four *Paris Streets* panels, Vuillard made large-scale studies for these works in pastel and *à la colle*. One of these, in particular (pl. 278), is a nearly exact version of *Rue de Calais*, shortened by a foot at the top.[61] With its long diagonal of the city sidewalk and cobblestone street, *Rue de Calais* may have been intended as a transitional panel between the earlier scenes of near-empty streets and the animated panels of the *Place Vintimille* triptych. In the left panel, to the left of the square, is the rue de Bruxelles (as seen from Vuillard's window) and in the right panel, the rue Douai. Despite their obvious similarities, the two outer panels, five inches wider than the central panel, have different horizon lines and were never intended as pendants. Vuillard's original intention for the *Place Vintimille* triptych is seen in three nearly full-scale pastel studies (pl. 280). In addition to the pastel, two fully evolved oil sketches

280 Edouard Vuillard, *La Place Vintimille*, triptych, 1906–8, pastel on cardboard laid on wood, left panel: 185.2 × 68 cm.; center panel: 188.8 × 49.2 cm.; right panel: 185.2 × 79 cm., private collection, Dallas.

278 (preceding page, right) Edouard Vuillard, *Rue de Calais* (also known as *Rue Lepic*), 1908, distemper on canvas, 165.1 × 47 cm., The Armand Hammer Foundation, Los Angeles.

279 Photograph by Vuillard of the place Vintimille, c.1910–12.

exist for the outer panels but not for the central one (which might possibly explain the latter's less finished quality).[62]

A photograph taken by Vuillard suggests that the artist may also have used photographic aids to achieve the general perspective of his *Place Vintimille* (pl. 279).[63] From his fifth-floor vantage point, he was able to take in a broader spectrum of the city space than he could in the first set of *Paris Streets* panels. In the later paintings, he used also a higher-keyed palette and smaller flickering brushstrokes to convey a sense of the activity of the familiar city-park environment, with nannies and their wards, old women seated on benches, horse-drawn carriages, men reading newspapers, and couples *en promenade*. By pick-

ing out certain individuals – for instance, the person seated on the park bench in the lefthand panel – highlighting certain clothes, and using the lamplights as accents, Vuillard added ryhthmic patterns to balance and enhance *le décoratif*. It was to this world of feverish activity that he would return again and again over the next three decades for drawings, pastels, and paintings, making his name synonymous with the place Vintimille.[64]

Despite Vuillard's elation at being back "home" in the Batignolles quarter and despite what was presumably his early start on the second set of panels, he did not deliver them to Bernstein until March 1910.[65] The delay may have stemmed in part from his removal of his studio in 1909 from the rue

du Faubourg-Saint-Honoré to a larger space on the boulevard Malesherbes. As his journal entries reveal, most of the work on the *Place Vintimille* and *Rue de Calais* compositions was accomplished during the winter of 1909–10. The journals show also that in these panels he was particularly concerned with evoking the changing climatic conditions of sunlight, gray skies, and rain (from left to right), and with expressing, as he put it, "the idea of harmony."[66] On 3 December 1909, he visited Monet at Giverny with Bonnard, commenting on Monet's grace, hospitality, and painting – "his newness still for me."[67] Two days later, Vuillard entered a tantalizing reference to his conversation with Monet: "Project for the Bernstein paintings. Memories of Monet. General ideas. Difficulty to finish."[68] As if encouraged by the master impressionist, Vuillard began noting regularly the changing climatic conditions and effects: "The weather is improving. Go to Lucie's. Small pastels, rain on the sidewalks. Lack imagination for the colors of the pastels."[69] A few months later in February 1910, he noted work on the "houses in the sun," and on 13 March 1910: "new people on the sidewalks for the large panels."[70] In the triptych especially, one sees the concern of the naturalist to depict a specific time and place vying with the decorative impulse. The result is a perfectly balanced composition both coloristically and structurally. The sharp diagonal of sunlight at the left rakes across the scene for a brief moment to become less visible in the slightly darker central panel, and hidden completely behind grayed skies in the panel on the far right.

In September 1909, Vuillard exhibited pastel and distemper sketches – what he referred to as "*badigeons* [literally 'whitewashes'] and pastels" – for the triptych at the Bernheim-Jeune gallery.[71] Shortly afterwards, in October, he visited Bernstein in his apartment on the boulevard Haussmann. There he saw his earlier "Passy" panels embedded in a décor of lacquer furniture in a brightly lit room, and surrounded by a group of people in evening wear. His journal entry that day reveals that once again he was discomforted by the ostentatiousness of the place and people:

Go to Bernsteins. Light-filled interior, gray paintings [or gray paint on walls?], lacquer. M. Bathon and Mme Mayer. All in evening dress with [illegible word]. A bit discomforted by these novelties. Especially to see my paintings play a role in this milieu . . . Left embarrassed at 11 p.m.[72]

Perhaps Vuillard's awareness of the vast differences in taste and temperament between himself and his patron made his work on the second project all the more unsettling. While Vuillard's journals do not mention any direct intervention on the part of the playwright, references to the panels in process reveal that he was either exhilarated or paralyzed with doubt.[73] On 15 November 1909, he went again to Bernstein's apartment and enjoyed a "pleasant-enough chat about painting."[74] Three weeks later, on

Thursday, 2 December, Vuillard bought the heavy brown paper (sometimes referred to as cardboard) for the final panels, and on the 15th of that month he went again to Bernstein's to measure the space.[75] On Christmas Day, Bernstein returned the earlier set of panels to Vuillard's studio, presumably so that Vuillard could make the necessary retouches both to harmonize them with and to adjust them to the new series.[76] It may have been that Vuillard kept both sets of panels in his studio during the next three months while he worked on the second set, which he finished at the end of March.[77] On several occasions prior to completing the panels, Vuillard invited Lucie Hessel to his studio, where, typically, he was either elated or crushed by her judgments.[78] By Saturday, 19 March, he noted his fatigue and desire to finish the panels, and the following day spent all morning measuring them in order to be able to glue them to canvas.[79] On 25 March 1910, the night before he was to deliver the panels to Bernstein's apartment, Vuillard went to dinner at Marcelle Aron's home and noted Bernstein, "poker player," and a "violent scene with Lucie."[80] As always, Vuillard's coded remarks are only partly intelligible, and one is left to speculate whether Bernstein's gambling had anything to do with Lucie's temper on this particular occasion, and, if so, whether this was the cause for his waking up "tormented" the next morning. Despite his ill humor, he retouched his paintings ("petites retouches misérables"), lunched with Gaston Bernheim and his wife, and arranged for his panels to be transported to Bernstein. Arriving at Bernstein's apartment, he was greeted by the playwright wearing only a bathrobe. The awkward situation disturbed Vuillard, causing him to leave "unnerved, wanting almost to cry."[81] This strange confession made by a bachelor of the most discreet habits, whose personal notes obfuscate any possible "intimacies," between himself and others, might well have been his shorthand for a very devastating episode. Whether Bernstein was being immodest (was there someone else with him that day?) or Vuillard, overly prudish cannot be gleaned from his meager journal notations. Nor can one know what was intended by Bernstein's envoy of flowers to the artist two months later.[82] As late as 29 November of that year, however, Vuillard noted that the "question règlement Bernstein" was still unresolved.[83]

Installation and Reinstallation

Despite Bernstein's public notoriety, no photographs or descriptive accounts exist to suggest how the six-foot-tall views of Paris streets looked against the lacquered and stark white walls of the boulevard Haussmann apartment. Bernstein's daughter has described it as having been a sort of bachelor's pad, consisting of a vestibule, salon, dining-room, office, bedroom, dressing-room, bathroom, and kitchen:

"The entire décor in good taste, beige silk on the walls, thick curtains, English furniture of Chinese lacquer, Coromandel screens, and eight panels by Vuillard as doorways."[84] Mme Gruber has subsequently suggested that the eight panels hung on double doors facing into the salon on one side and into the dining-room on the other.[85] This arrangement, however, would not explain the obvious triptych format for the *Place Vintimille* panels that were specially commissioned by Bernstein in 1908, nor Vuillard's need to measure the spaces in Bernstein's apartment. It is possible that the first series of uncommissioned panels may have served indeed as door panels and that the three slightly larger panels were for a more architecturally specific installation. This would account, too, for the differences in dimensions between the two sets of panels.

That Bernstein's interior was quintessentially modern is known from the numerous commentaries citing his décor as the latest in fashion. In 1912, a reporter for *Le Temps* described Bernstein's *cabinet de travail* as "asiatically furnished, where the pale silk screens diffuse a soft light."[86] A more comprehensive account of Bernstein's material possessions was provided that same year by an anonymous journalist for the *Cri de Paris* who felt that Bernstein's tastes in interior decoration were directly proportional to his modernistic tendencies as a dramatist:

> You can tell a man's character by the way he decorates his home. On Mr. Bernstein's walls there are works by Cézanne, Renoir, Vuillard, Roussel. His taste is revolutionary. He has elaborate electric chandeliers with invisible light bulbs, which reflect the light onto the ceiling; his deep armchairs come from England. He likes comfort. He has Chinese folding screens, Ming dynasty vases, Japanese stoneware. He adores the Far East. He is a voluptuous anarchist and a trifle Chinese. He is the archetype of the modern man.[87]

Jacques-Emile Blanche, the society portraitist of decidedly conservative tastes, was equally enthusiastic about Bernstein's décor. Since Blanche's own interior, on the street in Auteuil named after his doctor father, contained Venetian black-and-gold lacquer furniture, Chinese tapestries and curtains, paintings by the modern muralist José-Marie Sert, an Adam-style chimney, etc., his admiration for Bernstein's taste may have stemmed from the cosmopolitan sources of inspiration they shared.[88] Indeed, Blanche's description of Bernstein's "masterpiece" interior is more concerned with Bernstein the collector than with the architectural or decorative ensemble. This is also implied by his comment on Bernstein's predominantly black-and-white color scheme, which Blanche associates not with modernity but with the aesthetics of the *ancien régime*:

> A masterpiece of interior design where black and white subtly produce an effect of richness and sumptuousness comparable to the most elaborate Louis-Quatorze style. The Coromandel lacquerwork, the eighteenth-century English lacquers, the black Wedgwood so rare today, find their place with the gray and silver lamé material and Chinese paintings.[89]

Art critic and historian Gustave Coquiot, however, was less enthusiastic about Bernstein's decorating flair and saw the black and white as an American intrusion upon French tastes. Countering Blanche's effusive praise, he remarked that it was only Bernstein's fabulous art collection that made remarkable an otherwise unremarkable interior – one he considered slavishly bound to the current vogue of "noir et blanc" imposed by the Americans on "the first and foremost decorators of the world."[90] Considering that the pervasive fashion of the moment was for light-colored interiors, Coquiot's (perhaps xenophobic) remarks sound old-fashioned. Writing as early as 1907, for the popular weekly the *Revue Bleue*, Jacques Lux discussed the modern trend in decorating which emphasized the light and clarity of the impressionists' legacy, after which "oil paintings have been relegated to the specialist's picture galleries, banished from Parisian salons whose white-painted walls allow only pastels, gouaches, watercolors."[91] In this context, the light tonalities, loose brushwork, and *plein-air* subjects of *Paris Streets* would have been perfectly in keeping with the new aesthetic. They would also have acted as neutral zones of color in relation to Bernstein's other artworks, which in 1910 included (in addition to the previously mentioned Asiatic objects) several of Bonnard's iridescent pastorals and glowing nudes from 1907–8, and one of Monet's paintings of water and fog, *Charing Cross Bridge, London*.[92] The bulk of Bernstein's modern art collection seems to have been accumulated in a short period, beginning with his acquisition in 1908 of the four *Paris Streets* panels. Between 1909 and 1910, he purchased at least five Bonnard paintings from the Bernheim-Jeune gallery.[93] By 1910, Bernstein was also buying works by Matisse and Picasso. These would seem to have been purchased for speculation, since he liquidated them and other recent purchases a year later at the Hôtel Drouot. Although Bernstein included in the auction of his collection two small pictures and a large gouache on paper, *In Front of the Door (Devant la Porte)*, by Vuillard, he kept the eight decorative panels, along with other paintings by Cézanne, Renoir, and Bonnard.[94]

By that time, however, Vuillard had little artistic involvement with the playwright. It is likely, as his daughter believes, that Bernstein's respect for Vuillard was not reciprocated.[95] Clearly the jaunty and self-confident Henry shown in a portrait by Renoir of 1911, when he was at the height of his collecting career (pl. 281), was of a personality and temperament diametrically opposed to Vuillard's. Vuillard's subsequent journal references to "l'affaire Bernstein," in fact, could well have had to do with another scandal in Bernstein's life occasioned by his play

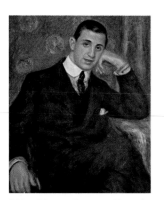

281 Pierre-Auguste Renoir, *Henry Bernstein*, 1910, oil on canvas, 80 × 63.5 cm., private collection.

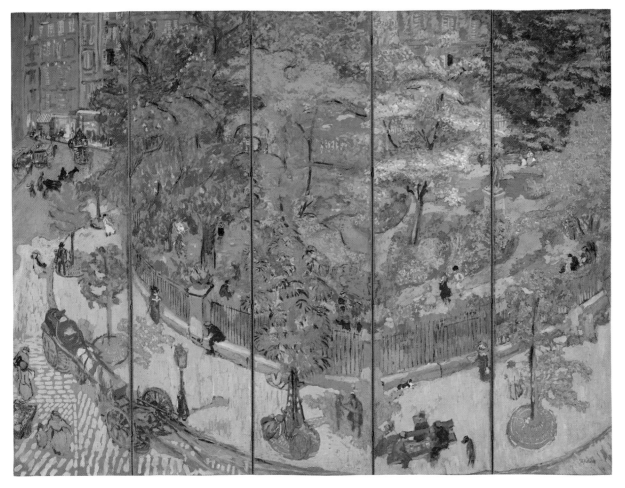

282 Edouard Vuillard, *Place Vintimille*, 1911, distemper on paper laid down on canvas, each panel 230 × 60 cm., private collection. Five-panel screen for Miss Marguerite Chapin.

Après Moi (opened by Bernstein in February 1911 and withdrawn in March), or with the antisemitic pamphlet "Le Juifs célèbrent au théâtre français l'apothéose du Juif déserteur Bernstein," circulated in February 1911 protesting against Bernstein's play on the grounds that Bernstein was a traitor to France.[96] Written by one Gustave Téry, the pamphlet cited as proof of Bernstein's duplicitous character, a letter from a youthful Bernstein voicing his objections to the French military. The controversy refueled antisemitism in pre-war Paris, and throughout February 1911, the *colonnes Morris* (the famous green, wrought-iron columns dotting the sidewalks of Paris then and now which serve as a kind of bulletin board for publicity posters and other announcements) were dubbed "Colonnes Bernstein," with posters against "Le Juif déserteur."[97] In defense of Bernstein, a petition was circulated within the theater world. It received unprecedented support from all the liberal-minded intellectuals of the day, including many who would have had good reason to withhold their signatures, such as Thadée Natanson, Tristan Bernard, Octave Mirbeau, Misia, and Vuillard (out of solidarity with his friends).

Bernstein's personal situation after this last scandal was one of relative calm. In 1915, he married the wealthy Antoinette Martin-Pottier. Two years later, the Bernsteins moved with their baby daughter (Georges, now Mme Gruber) to Pau where they remained until after the war. Returning to Paris, they took an apartment at 110 rue de l'Université where, as confirmed by Mme Gruber, the *Paris Streets* panels were installed in the dining-room. In 1940, when the Germans invaded Paris, Bernstein escaped to the United States where he stayed until after the war. It is likely that the panels then passed into American collections before being sold in 1948 to the Thannhausers, who gave the two place Vintimille panels to the Guggenheim museum in 1973.[98]

Like the earlier *Public Gardens* series which marked a turning point in Vuillard's career as a young Nabi artist, the *Paris Streets* series represented a new sensibility towards the observed and recreated that can be seen in other works between 1909 and 1910. The Passy panels, especially, represented a brief experimental phase, during which he introduced a much looser brushwork and an open composition that would not be repeated in his large-scale *décorations*, whether commissioned or undestined.[99] The *Place Vintimille* panels, on the other hand, would be a touchstone for other small- and large-scale works on similar themes. Among the most beautiful of these reincarnations was the five-panel screen (pl. 282) executed a year after the Bernstein triptych of panels for his next important patron, Marguerite Chapin.

9 An American Princess and the "Féerie bourgeoise": The Commission for Mlle Chapin, 1910–1911

The thirteen-foot-tall *à la colle* panel known as *The Library* (*La Bibliothèque*) (pl. 288) is perhaps Vuillard's most enigmatic and least-appreciated *décoration*. Likewise, its owner, the young American ex-patriot Marguerite Chapin, or "Mlle Chapin," as Vuillard referred to her, is rarely mentioned in the Vuillard literature. Between 1910 and 1912, however, Marguerite's role as Vuillard's patron and friend was an important one: in addition to *The Library*, Vuillard painted for her the five-panel screen *La Place Vintimille* (1911–12) (pl. 282), and at least two oil paintings (pls. 284, 312). From its inception, *The Library* was an ambitious and controversial undertaking, which was ultimately rejected both by its owner and by the artist as a "failed" *décoration*. Yet it is Vuillard's most fascinating failure and one of the most overt testimonies to his peculiar interest in what Claude Roger-Marx termed his *attendrissement* towards the human comedy of the *haute bourgeoisie* (*la féerie bourgeoise*) as the subject of large-scale pictures.[1]

Among those who did not regard *The Library* as a failure was Segard, who would have seen the painting in Vuillard's studio when he interviewed the artist for his 1914 study. For Segard, it was a masterwork and revelatory example of Vuillard's brilliance as a *peintre-décorateur*. In comparison to the few lines devoted to the Bibesco and Bernstein projects, Segard wrote at length on the composite imagery making up the painting, which he concluded, was "without a subject":

Represented are two groups of people, seated and talking in an interior next to several bookcases where the books are visible, in front of a tripartite wall hanging with a decorative composition executed in the manner of a tapestry and representing Adam and Eve in the Earthly Paradise.

Above this wall hanging and stretching the width of the panel is a decorative frieze showing standing figures in attitudes that resemble classical art. Two fluted columns, cut off by the frieze of the *boiserie*, and their composite capitals accent the references to antiquity in this composition of absolutely modern sensibilities.

The wallcovering is carried out in blues and the background color for Adam and Eve is in grays and yellows deepened with blue. Of the three women at our right, one wears brownish-red and is seated in a blue armchair; the second wears near black, and the third, behind the others wears a yellow skirt and blue blouse.

At the left the bearded man is dressed in a dark, almost black shade of green; the young woman behind him wears yet another shade of dark green, and the little girl in front of them both is dressed in a shade of bottle green. Multicolored magazines are strewn across the rug of blue-gray tonalities. The resulting ensemble has a grayish-yellow, brownish-red and gray tonal quality, shot through (*pénétrés*) with blue. The total effect is one of muted and simple richness, without artificial brilliance, without refinement, without the picturesque and, ultimately, without a subject.[2]

Segard's detailed account makes no attempt to interpret or find a common thread among the abundance of images. For him the work embodied "modern sensibilities," not because of any thematic potential, but because of its overwhelming scale, complicated palette, and the overall effect or impact of the painting. Making an attempt to define the painting as a genre subject or a society portrait, Segard considered it a picture resonating with symbols but not a subject. Even the title is ambiguous, referring in French both to the room for books and to the bookcases that Segard saw as the backdrop and unifying factor in this work.[3]

Marguerite Chapin, an American Princess

Vuillard's first meeting with Mlle Chapin took place on 11 March 1910, in her newly rented apartment on the rue de l'Université, where he had been invited for lunch along with Bonnard and Emmanuel Bibesco. Bonnard already knew Marguerite and had painted her portrait which Vuillard admired that day as "classic, clear, well composed with light touches."[4]

283 Detail of pl. 288.

284 Edouard Vuillard, *Interior with a Lady and Dog* (portrait of Marguerite Chapin), 1910, oil on millboard, 59 × 73.6 cm., Fitzwilliam Museum, Cambridge.

Vuillard also approved of Marguerite's apartment, which was "almost bare," with "pretty delicate things." His journal entry that day ended with yet another positive remark concerning a "proposition" or possible collaboration with the young American.[5]

The "propositioner", Miss Marguerite Gilbert Chapin, was a cultivated American, seventeen years Vuillard's junior. On her father's side, she descended from the Deacon Samuel Chapin, founder of Springfield, Massachussetts, and the subject of Augustus Saint-Gaudens's commemorative monument *The Puritan* (1883–6). On her mother's side, she was the great-granddaughter of a shipbuilder from Bordeaux who had settled in New York at the end of the nineteenth century.[6] Marguerite learned French early in life and later took up Italian and German which she hoped would help her pursue a career in voice. In 1900, the nineteen-year-old Marguerite left home for Paris, where she lived with her mother's relatives at 101 avenue des Champs-Elysées and later at 44 avenue d'Iéna.[7] A tall brunette with the striking features of the New England aristocracy, Marguerite was, like a heroine from a Henry James novel, quick to assimilate both the professional and social advan-

tages of her adopted home. She became the youngest student to be accepted for private voice lessons taught by Jean de Reske, brother of Caruso and at that time voice master for the Paris Opéra. In October 1911, her marriage to Roffredo Caetani, Prince of Bassiano and future Duke of Sermonetta, gave her a title and social prestige. She expanded her status as society matron around 1917 when she and Roffredo moved to the Villa Romaine at Versailles. There she hosted Sunday salons that were attended by noted intellectuals, including Gide, Paul Claudel, Paul Valéry, Max Jacob, Francis Jammes, Jean Paulhan, and André Malraux.[8] As Misia and Thadée had done through *La Revue Blanche*, she helped introduce her friends' works to a larger public, and at the same time made her mark in intellectural history, by founding and editing the small but important literary review, *Le Commerce* (1923–7), and its Italian equivalent, *Botteghe Oscure* (1935–57).[9]

At the time of Vuillard's introduction to Mlle Chapin in March 1910, however, the twenty-nine year old was still single and without a defined social niche. It is possible that her interest in Bonnard and Vuillard may have come through their mutual friends, the Bibescos or Bernstein, whose decorative

180

panels she would have known.[10] Like Bonnard, from whom Marguerite had initially commissioned a portrait before ordering a large decorative panel, *In the Boat* (*En Barque*, pl. 318), Vuillard's first assignment was the "portrait Chapin" that he listed in his journal as one of the year's artistic activities along with the four panels for Henry Bernstein.[11]

In contrast to his usual discomfiture in the homes of wealthy clients, Vuillard's journals indicate that he enjoyed his sittings with the young American. On Thursday, 14 April 1910, a little over a month after their introductory luncheon, he noted: "To Mlle Chapin's. Make a start on something. Charming forms," and the following day, he recorded that he was "in the right mood for work. An hour's session. Begin to paint. Charm."[12] The resulting picture is not just a portrait of Marguerite, but an intimate genre scene in which Vuillard's patron is shown bending over to pet her little fox terrier in a densely furnished and richly upholstered dark green salon (pl. 284). The claustrophobic quality of this small canvas, achieved through the compression of space and the general tonal harmonies, recalls Vuillard's earlier *intimiste* works from the late 1890s in which figures are cushioned and absorbed by the fabrics and general bric-a-brac making up the décor. The painting has more in common, however, with a number of the larger *intimiste* portraits Vuillard painted after 1905, such as *Mme Gangnat and her Children* (*c.*1909) (pl. 285), and *Portrait of the Bernheim Wives and their Children, Jean and Claude* (pl. 286), a style of portraiture which would characterize the majority of the artist's commissioned likenesses after 1920.[13]

Although the title, *Interior with a Lady and her Dog*, reveals little about the location where it was painted,

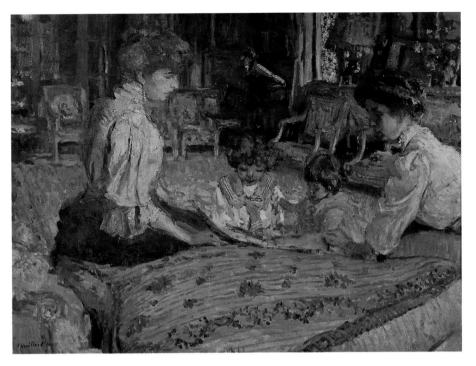

it seems unlikely that this room, with its green velvet walls, overstuffed and antimacassared chair, framed photographs, prints, and other objects evoking a conventional and well-lived-in bourgeois home would have been the "almost bare" apartment on the rue de l'Université that Vuillard had admired on the occasion of his first lunch with Marguerite. More likely, Vuillard painted her in the *petit salon* or library of her relatives' apartment on the avenue d'Iéna, at which address she is listed in the 1910 *Annuaire* and where the gallery owner Ambroise Vollard wrote to her in June 1911 to remind her of an unpaid invoice.[14] Certainly, she continued to be associated with that residence, and she may have commissioned the picture not only as a portrait but as a document and *souvenir* of the apartment so linked with her early Parisian experience.[15] Less than two months after his introduction to Marguerite, on 4 May 1910, Vuillard delivered the portrait to her apartment and stayed for lunch.[16] It was not until after the summer holidays, on 14 October 1910, that he met again with his young patron and five days later noted in his journal the commission for a "projet de panneau."[17]

The Evolution of La Bibliothèque: Theme and Variation

As his journal entries reveal, over the next five months Vuillard was largely preoccupied with the conception of the Chapin project.[18] His involvement with his new patron did not go unnoticed by Lucie, who, from the beginning, seems to have voiced what Vuillard discreetly referred to as her "feelings against Mlle Chapin."[19] Despite Lucie's disparagement and

286 Edouard Vuillard, *The Bernheim Wives and their Children, Jean and Claude*, 1905, oil on cardboard, 58 × 78 cm., Bernheim-Jeune Collection, Paris.

285 Edouard Vuillard, *Mme Gangnat and her Children*, *c.*1909, oil on canvas, 86 × 77 cm., location unknown.

288 (facing page) Edouard Vuillard, *The Library* (*La Bibliothèque*), 1911, (repainted 1914), distemper on canvas, 400 × 300 cm., Musée d'Orsay, Paris.

287 Photograph of Vuillard's studio, boulevard Malesherbes, showing the panel *The Library* in progress, Salomon Archives, Paris.

perhaps displeasure, the Chapin project seems to have unleashed new creative energies in the artist, and he was elated to be following through new ideas for what he considered to be a major undertaking. By 10 December 1910, he had decided upon the "precise idea for the panel, the idea for work and for the composition."[20] His conception of the project was dramatically different from his most recent *plein-air* panels for the Bibescos and Bernstein, as it was drawn from numerous visits to the Louvre which he continued with more frequency that December. After one visit on 30 December, for example, he noted his "child-like enthusiasm" and his admiration for the proportions, forms, and colors of Veronese's paintings, the Renaissance sculptures, and the classical antiquities, all of which gave him ideas for the decorative project.[21]

That same day he was "surprised" to find Mlle Chapin and Thadée at the Schopfer residence on the rue du Bac. By this time, Schopfer had remarried and sufficiently recuperated his finances to afford a ground-floor apartment leading out into the garden of the eighteenth-century Hôtel Doudeauville in the Faubourg Saint-Germain.[22] The large panel *Luncheon at Vasouy*, which Schopfer had asked Vuillard to store temporarily, was now reinstalled in the dining-room, where the decorated plates from the 1895

commission were also on display. In addition to these earlier decorative projects, Marguerite would have seen at the Schopfers' that day the recently commissioned decorative panels by Roussel, *The Fall of Icarus* (*La Chute d'Icare*), *Nausicaa* (pl. 191), and *Venus*, installed above the bookcases in the bedroom and living-room.[23]

What transpired between Vuillard and his former and current patrons at the chance meeting is not known. Vuillard's journal entries, habitually devoid of details regarding relationships and encounters, are equally reticent on this occasion. His "surprise" at seeing Marguerite at Schopfer's apartment, may have been his concern to find his new patron on friendly terms with Schopfer, whose reputation for womanizing had not decreased with his second marriage.[24] It was perhaps the very contrast between the glib, self-confident, and English-speaking Schopfer and himself that may have thrown Vuillard off guard.[25] For what is clear throughout his journal entries during his work for Marguerite is his attraction to her and the fact that he was both excited and intimidated by his feelings.[26] At forty-two, Vuillard seems also to have been particularly aware of his bachelor state. This, coupled with his health and money concerns, and the ongoing difficulties with Lucie would have made him all the more vulnerable to the attentions of the attractive American.[27] In December 1910, before the unplanned meeting at Schopfer's for example, he lunched with Marguerite and noted discreetly in his journal, "diplomatic chat, Fénéon [and] a few flirtatious exchanges with Mlle Chapin."[28] No doubt he and Marguerite also exchanged ideas for the panel. Indeed, Marguerite's opinions may have influenced to some extent the enormous scale and the completely untypical (for Vuillard) subject, inspired not by the streets and parks of Paris, or by his friends' *villégiatures* but by the art of the past.

Antiquity

Vuillard had long regarded the Louvre galleries as a supplement to his ongoing education, whether it be in copying works of the masters he most admired – Delacroix, Rembrandt, Chardin, Watteau, Leseuer, Leonardo – or in comparing his own evolution as an artist with the qualities that he most cherished in the earlier masters. In early March of 1910, prior to his first meeting with Marguerite, he spent a "happy visit" at the Louvre, admiring Watteau, Chardin, Veronese, and Rembrandt.[29] What is novel about Vuillard's activities during his work on the Chapin commission is his renewed interest in the Greek and Roman sculpture collections.[30] In December of that year, Vuillard noted his visit to the Salle des Antiquités, where he saw the marbles and the "small gallery with Olympia and the frieze."[31] At the beginning of January 1911, he recorded having visited

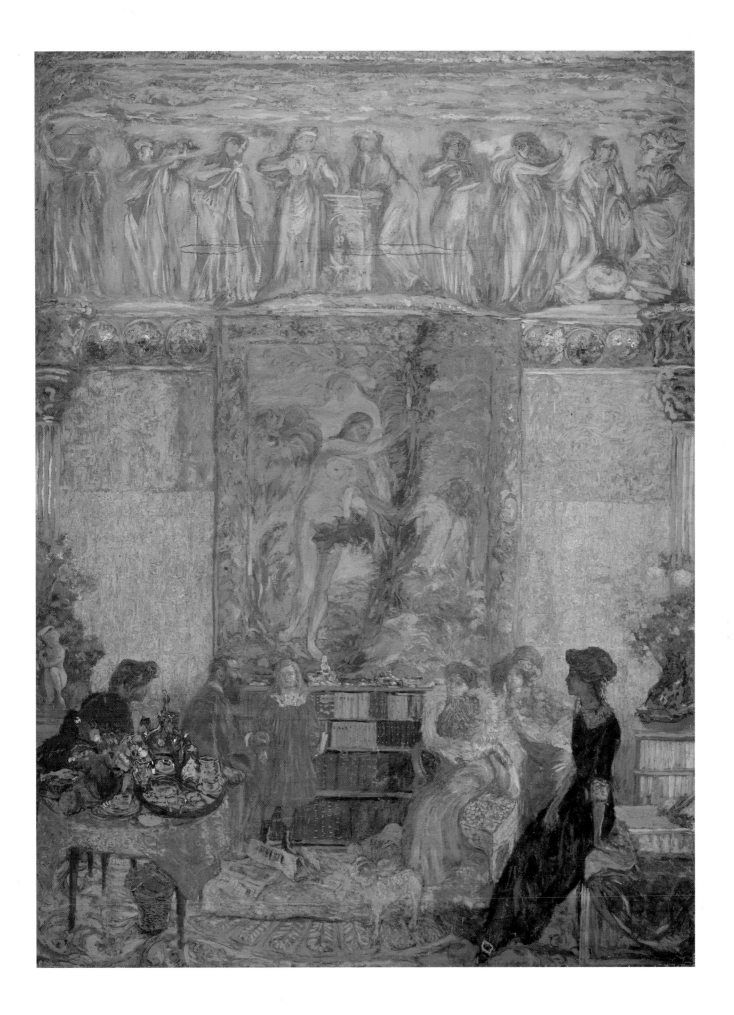

the same gallery, where he copied "the frieze."[32] Over the next few days, he arranged his materials – charcoal, canvas, colors, *blanc de meudon* – for the preparatory studies, and by 6 January, he had decided on the large gray paper which he would, at this point, hang on a canvas of the same scale.[33] A photograph showing the panel in progress in Vuillard's boulevard Malesherbes studio (pl. 287) suggests that the height of the painting was determined as much by the available space in Vuillard's studio as by Mlle Chapin's interior.

With his studio organized and materials purchased, Vuillard returned on the next day to the Salle des Antiquités, where he admired the "antique bas-reliefs, Greek lines – charming proportions."[34] Later that day, he paid a visit to Mlle Chapin, of which he remarked, "Charming welcome. Pleasant hour."[35] Two days later, he purchased a ladder and began the preparatory study (*pochade*) for "la frise" which would occupy the top third of *The Library*. For the painted classical frieze, however, Vuillard did not draw from the more obvious prototypes of ancient architecture at the Louvre. He looked down, not up, at a bas-relief sculptural decoration from a Roman funerary sculpture known as "The Sarcophagus of the Muses" ("Le Sarcophage des Muses") (pl. 289). Located in the central room of the Salle des Antiquités, the sarcophagus was and is still considered to be among the major sepulchral monuments from the period and described as "one of the most beautiful and best-preserved of the museum."[36] Vuillard chose the most important side of the sarcophagus depicting the nine Muses who presided over the arts and sciences. With the exception of subtle changes in attributes and poses, Vuillard's muses, wearing draped and slimly fitted gowns and painted *en grisaille*, are almost identical to the lively maidens in the Roman original. Not copied was the scene on the sarcophagus lid of the bacchanale of maenads caressing aging satyrs which was described in a contemporary guidebook as alluding to the "joys of future life."[37]

Vuillard's unprecedented use (at least, in his own decorative career) of the *grisaille* technique and his renewed interest in copying at the Louvre twenty years after his period as a student may be due to his brief involvement with the art school opened by Paul Ranson and his wife, France, in December 1908 and taught by Denis, Bonnard, Roussel, Sérusier, Vallotton, Maillol, Georges Lacombe, and Van Rysselberghe.[38] Vuillard's journals indicate that he was only actively involved for a few months and then infrequently over the next few years when classes moved from the rue Henri-Monnier near Montmartre to the rue Joseph-Bara near Montparnasse.[39] Even during this brief period, however, one can imagine that he took his responsibilities as a teacher/corrector seriously and may have wanted to re-acquaint himself with the techniques and the discipline of drawing both from life and from antique sculpture.[40] As shown elsewhere, classicizing motifs and the use of *grisaille* was enjoying a renaissance among modern painters such as Denis whose decorative overdoors painted *en grisaille* for the Bellevue mansion of Gabriel Thomas in 1908 Vuillard greatly admired.[41]

In November 1910, shortly after Marguerite commissioned the panel, Vuillard and Fénéon visited Matisse's studio in the suburb of Issy-les-Moulineaux. There Vuillard saw that what he described that night in his journal as a *grisaille* by Puvis de Chavannes. Although his opinion of this work was "not very enthusiastic [-ally painted?], cold,"[42] his own choice of techniques may have been motivated by his desire to challenge the older master and enliven a genre traditionally associated with the academic tradition.

Renaissance and Baroque

Below the classical frieze, Vuillard painted a band of decorative medallions. These spots of yellow and red among the otherwise predominately blue tonalities of the interior recall the ornamental borders used in architectural schemes from the Renaissance onwards to separate minor motifs (medallions, trophies, floral decorations, or illusionistic architectural moldings) from the primary (traditionally figural) imagery. A vigorously brushed gouache study for *The Library* (pl. 290) reveals that from an early stage Vuillard had conceived the three-tiered division and T-shaped grid for the final composition. This, too, may have been inspired by his frequent trips to both the Salle des Antiquités and galleries of Renaissance sculpture at the Louvre. On 24 February 1911, for example, he remarked that for the first time he was able to appreciate fully the architecture of Michelangelo for the Medici and that of the French Renaissance sculptor Germain Pilon:

> Look at photos. Architecture of Michelangelo, inventiveness of proportions. The Medici in their decorative schemes are pleasing to me for the first

289 *Sarcophagus of the Muses*, 150 BC, Musée National du Louvre, Paris.

time . . . Go to the Louvre as usual, Renaissance sculpture, Germain Pilon. Slave. Door. Ornaments on the doorways . . . Temple d'Angina.[43]

Vuillard's circuit in the Louvre that day can be surmised in part by comparing his comments with a contemporary floor plan of the collections (pl. 291).[44] Entering through the principal entrance in what was known as the "new Louvre," he would pass through the gallery of antique sculptures leading to the Galeries Mollien and Denon (2,1), in which the sarcophagus of the Muses was located. He also may have entered from the courtyard of the original royal residence of Louis XIV (Pavillon des Arts) into the galleries devoted to medieval and Renaissance sculpture (55–61). From his comments, it is certain that he visited the Salle Jean Goujon (60), named after the celebrated sixteenth-century French sculptor, and containing several works by Germain Pilon, Goujon's successor and equal.[45] One can speculate, in fact, that Vuillard was perhaps thinking of Pilon's decorative chimney for the Château de Villeroy with a bust of Henri II (pl. 292) in this room when he decided upon the grandiose proportions and tripartite hierarchy of the frieze, tapestry, and horizontal base (of the bookshelves) for the Chapin panel.[46]

The Goujon gallery led into the Michelangelo gallery named in reference to the marble statues of his two fettered slaves intended for the tomb of Pope Julius II. Vuillard's notations of "slave" and "doorway" ornaments no doubt referred to these works which flanked the entrance to the next gallery. Continuing a clockwise route around the old Louvre (pl. 291), he would have entered the Salle des Cariatides

which featured the sumptuous architectural decorations remaining from its original purpose as an antechamber of the apartments of Catherine de Médicis. It was perhaps a photograph or postcard of this gallery (named after the four caryatids by Jean Goujon at one end of the gallery) which led Vuillard to re-evaluate the Medicis' decorative tastes. Vuillard frequently acknowledged photographs as *aides-mémoire*, for example those used for the Bibesco panels and possibly for the *Place Vintimille* panels for Henry Bernstein. The photographs mentioned in this journal reference, however, were probably purchased at galleries, like Braun or Durand-Ruel, specializing in art reproductions.[47] Like the Japanese prints and sketchbooks he is known to have owned and drawn from in his earliest Nabi works, fine-art reproductions, in the form of photographs and postcards, were part of Vuillard's studio décor, allowing him, as he wrote to Vallotton in 1905, "to satisfy for the time being the need for age-old idolatries."[48]

Vuillard was clearly not alone in making use of reproductions of works by Renaissance masters for inspiration. Found among Bonnard's studio papers, for example, was a postcard datable to *c.*1908 from the Palais de Fontainebleau of the frescoes by Primaticcio and the caryatids by Jean Goujon.[49] In paintings such as *The Three Graces* (*Les Trois Graces*) (pl. 294), a decorative panel commissioned by the Bernheim brothers in 1908 for their home on the avenue Henri-Martin, Bonnard quoted directly from a Rubens painting that was probably known both from the original and from reproductions that he owned.[50] Both artists were seeking to expand their repertoires for decorative art beyond the quotidian and contemporary. Although Segard does not include Bonnard in his publication of 1914, Bonnard's career

291 Floor plan of the ground floor of the Louvre and courtyard, showing galleries of antique and Renaissance sculpture, 1909.

290 Edouard Vuillard, study for *The Library*, gouache and tempera, 52 × 40 cm., private collection.

292 Germain Pilon, chimney ensemble for the Château de Villeroy.

(pl. 293), *The Trip* (*Le Voyage*), *The Fountain* (*La Fontaine*), and *The Game* (*Le Jeu*). The pastoral imagery of each of these large panels was surrounded by a bright orange border exploding with monkeys and fantastical creatures like those of medieval marginalia. Vuillard, who attended the black-tie soirée in honor of the paintings, would have been impressed and perhaps awed by his friend's palette and almost surrealistic imagery (pl. 297).[52] One of the primary differences between the two artists, who remained admiring of each other's works, was their attitude towards the real and the invented. Whereas Bonnard gave expression to fantasy and whim, Vuillard did not invent but borrowed, incorporated, and translated – albeit with humor and inventiveness – to arrive at his decorative compositions.

Vuillard's reliance on both the works of earlier masters and photographic reproductions can be seen

294 (far right) Pierre Bonnard, *The Three Graces* (*Les Trois Grâces*), 1908, oil on canvas, 208 × 125 cm.

293 Pierre Bonnard, *Enjoyment* (*Le Plaisir*), 1908–10, oil on canvas, 251.5 × 467.7 cm., J. Paul Getty Museum, Malibu.

as a *peintre-décorateur* makes an interesting parallel to Vuillard's. By the time Segard was writing, the artist had completed a number of important decorative ensembles, including works for his dealers, the Hessels (1900), for Ivan Morosoff's Moscow residence in 1911, and for the Bernheims (1912).[51] Outstanding among these, however, was the decorative ensemble for Misia's salon in her apartment at 29 quai Voltaire, where she lived after her divorce from Edwards. Bonnard's panels, exhibited at the Salon d'Automne in 1910, showed quasi-mythological figures and various themes: *Enjoyment* (*Le Plaisir*)

also in the central image of the broadly brushed couple in *The Library* which Segard described as "representing Adam and Eve in the Earthly Paradise." Segard's assessment was only partially correct, however, since Vuillard's painted tapestry was based directly on Titian's *Adam and Eve*, and on the Rubens copy after it, which hung together in the Prado Museum in Madrid (pls. 295, 296).[53] Vuillard would have seen these paintings on his second trip to Spain in September 1909 (the first was made in 1901 with the Bibescos and Bonnard), when he visited the Prado with the Hessels and sent Roussel a postcard of the Titian painting with the message that the Prado was still "a marvelous museum."[54] It is entirely possible that Vuillard bought an extra copy of this postcard for himself to pin up in his studio or that he remembered that particular image when he conceived the "idée précise" for the Chapin *décoration*.[55]

In the end, however, Vuillard's debt to both masters is evident – incorporating the sinewy corporal types of the Titian (as opposed to the fleshier body types in the Rubens) and Rubens's lighter palette of greens, blues, and pink flesh tones. On 15 and 16

June 1909, before going to Spain, Vuillard had toured Rubens's house and museum in Antwerp and studied his works at the Musée Royale des Beaux-Arts in Brussels.[56] On 29 June, a little over a week after his return to Paris, he went to see Denis at Saint-

Germain-en-Laye and enjoyed an "animated chat about Rubens."[57]

In *The Library*, Vuillard altered traditional representations of the temptation story by turning Adam inwards, facing away from the viewer.[58] Vuillard's Adam recoils from Eve as if powerless to stop her act, while Eve, who thrusts her arm upwards to the forbidden fruit, is more closely related to the robust and powerful feminine entity seen in both the Rubens and the Titian. While the subject of Vuillard's tapestry variation is the confrontation of the couple, Vuillard diminishes Adam's role, as if reluctant to exert the full erotic force of his action. Instead of the full-figured Adam who forcefully reaches out at Eve's breast to stop her, Vuillard's Adam is a startled but passive figure, half hidden by foliage.[59]

Vuillard's transformation of the iconography and figure types characteristic of Renaissance and Baroque

297 Pierre Bonnard, *Misia Godebeski* (Mme Edwards), 1908–9, oil on canvas, 145 × 114 cm., Fondazione Thyssen-Bornemisza.

295 (above, left) Titian, *Adam and Eve*, c.1550, oil on canvas, 240 × 186 cm., Prado Museum, Madrid.

296 (left) Rubens, copy after Titian's *Adam and Eve*, 1628, oil on canvas, 237 × 184 cm., Prado Museum, Madrid.

298 Edgar Degas, *Female Torso* (*Torse de femme*), c.1889, monotype in brown ink on Japanese rice paper, Cabinet des Estampes, Bibliothèque Nationale, Paris.

tone monotype, *Torso of a Woman* (*Torse de Femme*) (pl. 298) is a copy or memory image of the same Titian painting which Degas would have seen in the Prado during his visit to Madrid in 1889.[61] In the same year as Bonnard's decorative panel for the Bernheims, inspired by Rubens's painting of the Three Graces, Renoir borrowed from the same master's well-known picture in the Prado, *The Judgment of Paris*, for the figural types and basic composition of his modern version bearing the same title.[62] Vuillard would have had other examples of modern reworkings of past art even closer to home in the work of his brother-in-law. By 1905, Roussel was working almost exclusively with themes drawn from classicizing pastorals and mythologies. One of these, entitled *Le Triton* of 1906–9 (pl. 299), is similar in composition and palette to Vuillard's painted tapestry.[63] Given their close relationship, it is possible that Vuillard may have also looked to this or other contemporary works by Roussel when he transformed the violent narrative of the Titian and Rubens pictures into the decorative centerpiece of Mlle Chapin's *haute bourgeoise* interior.[64]

Vuillard's reinterpretation of a painting into a tapestry design can be linked to a renewed interest in decorative tapestries and tapestry-making at that time. Part of this interest may have been sparked by the appointment of his friend Gustave Geffroy to the directorship of the state tapestry manufacturers, the Gobelins, an appointment that Vuillard recorded in his journal on 6 February 1908.[65] One of Geffroy's first projects was to commission contemporary artists to design models for tapestry projects which were made up into near-perfect copies by the Gobelins.[66] After a visit to Redon on 20 November 1908, Vuillard recorded his opinion of the artist's tapestry designs for Geffroy, noting, "His medallion in Savonnerie after Redon which enchants me."[67] Several critics, including Claude Roger-Marx, felt that Vuillard should also have been among Geffroy's choices for tapestry designers (which, in addition to Redon, included Monet, Jules Chéret, Félix Braquemond, Denis, and Maillol).[68] Certainly, the tapestry aesthetic so important to Vuillard's early decorative projects continued to interest and inspire him. In January 1911, he noted having seen the exhibition of Maillol's tapestries at the Bernheim's gallery.[69] Two months later, Vuillard's visit to the Gobelins factory seems to have helped unblock his creative energies for work on the Chapin panel: "Very upset with my panel. Go to the Gobelins, great over-excitement. Geffroy confirmed my ideas about this story. Ferrare tapestry." His concluding remark in this entry, "the *métier* of workers," is revealing in that it implies his continuing concern for and belief in the *métier*, the craft or skill, as an ingredient of creativity and production.[70]

painting into a modern vernacular was not unprecedented in advanced art of the time and may be linked to the previously mentioned return to classicism and, with this, a reaction against the amorphousness of earlier impressionist and symbolist art.[60] Richard Thomson has pointed out that Degas's large brown-

299 Ker-Xavier Roussel, *The Triton* (*Le Triton*) c.1906–9, oil on canvas, 66 × 81 cm.

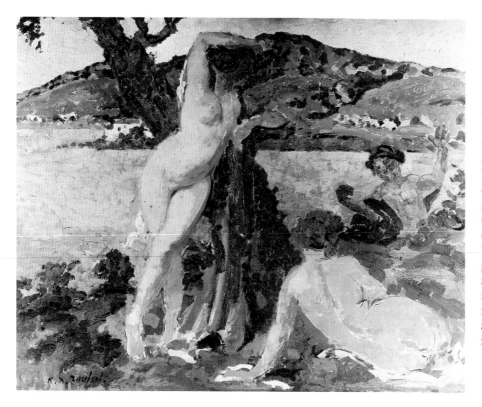

* * *

March of 1911 (pl. 300).[74] Like Watteau's humanized statues that preside over the *fêtes galantes*, Vuillard transformed the marble prototype into a dainty, flesh-like figure who watches the fashionable group below.

At the lower level, near-life-size figures, a dog, low bookcases, and other everyday objects form a *tableau vivant* of contemporary life. Immediately recognizable among the participants is Vuillard's friend, the heavy-set and bearded Tristan Bernard who had featured three years earlier in the panel *The Haystack* for the Bibescos (pl. 243). As indicated, Tristan's relationship with Lucie's first cousin, Marcelle Aron, made him a charter member of the Hessels' inner circle, at their home, or at Marcelle's rue de Courcelles apartment.[75] A painting by Vuillard of Marcelle's salon, in fact, appears in the lefthand corner of the photograph showing the large decorative panel in progress in his studio (pl. 287). In the several pastel, gouache, oil, and distemper representations of Marcelle's salon executed between 1905 and 1912, such as *Mme Aron in her Salon* (pl. 301), Vuillard emphasized the dazzling blues and extravagant architectural trappings that resemble the iridescent tones and overblown proportions seen in the interior for the Chapin panel.[76]

Whether or not he had Marcelle's apartment in mind when he painted Tristan's distinctive profile against the shelves of evenly arranged books remains speculative. Once again, Vuillard centered Tristan

300 Jules Gasson, *Crouching Aphrodite* 1882 (dimensions and location unknown).

301 Edouard Vuillard, *Mme Aron in her Salon*, 1904 and 1934, gouache and oil on paper, mounted on wood, 55.3 × 62 cm., National Gallery of Canada, Ottawa.

La Vie Moderne

Overlapping the medallion border and the uppermost frieze of marble bas-reliefs, the vertical rectangle of the painting cum tapestry reinforces what is already a rich mixture of fabric and trompe-l'oeil architecture, giving the illusion of nobility and wealth that Claude Roger-Marx called the artist's "féerie bourgeoise." The evocation of sumptuosity in the grand tradition is carried further by the strangely iridescent blue material upon which the tapestry seems to float. Is this embossed wallpaper or flocked fabric? Is it the dainty orientalizing woodblocked papers in vogue in upper-class American homes by the turn of the century?[71] Or is it meant to evoke the French enameled zinc plates imitating Dutch tiles or the blue tiles used by 1895 to create a modern interior decoration in Parisian houses and apartments?[72] The mat surface resulting from the use of the *à la colle* technique prevents identifying this material by texture alone. Easier to designate are the two engaged and fluted columns with capitals (which are not identical) composed of a variety of organic and figural motifs that frame the tapestry and blue-squared wall covering.[73] Vuillard's debt to the Louvre is again seen in the figure that appears at the base of the lefthand column behind which elegant flowers emerge. This figure of a small crouching female may, in fact, be a direct quotation from the popular *Crouching Aphrodite* which Vuillard copied at the Louvre in February and

303 Jules Cayron, *The Introduction (La Présentation)*, 1904, oil on canvas, size unknown, location unknown.

304 Lucien Simon, *Evening Party in the Studio (Soirée dans l'Atelier)*, Salon of 1905, size unknown, *Art et Décoration*, v. 17 (1905), p. 179.

305 (facing page, top left) Edouard Vuillard, *The Painter Ker-Xavier Roussel and his Daughter*, c.1903, oil on cardboard, 58.1 × 55.6 cm., New York Room of Contemporary Art Fund, Albright-Knox Museum, Buffalo.

306 (facing page, bottom left) Pierre Bonnard, *In the Balcony Box (Au Loge)* (portrait of Suzanne and Mathilde Bernheim), 1908, oil on canvas, 91 × 120 cm., Musée d'Orsay, Paris.

308 (facing page, bottom right) Photograph of the Tanagra figurines known as "Les Deux Femmes," seen in the display where they had been recently installed in the Salle des Antiquités, at the Louvre.

302 Adrien Marie, "Avril-Les Oeufs de Pacques," one of 12 illustrations for the album *L'Agenda-Foyer du Petit-Saint-Thomas*, advertised in the column "L'Art Partout," *La Vie Moderne*, no. 37 (20 December, 1879).

in the company of females. By 1911, Tristan was, with Porto-Riche and Sacha Guitry, among the most popular of the *boulevardiers* and the author of many bourgeois farces. Well known for his biting wit and repartee, he was a sought-after dinner guest. In the *Library* panel, his gesture and massive beard evoke a modern Homeric figure in a painting destined for a library. Yet Tristan does not read, nor is he being read to. Instead, he puts his hand on the little girl's arm as if to stop her from leaving. Has the little girl, who holds a book in her left hand, just given a recitation? And can their interaction (Tristan crossing his hand over her arm) be seen as an extension or parallel to Adam's beckoning of Eve in the scene directly above their heads? Or, is Tristan simply bidding the child goodnight?

The child's presence and pairing with Tristan (who had three sons and no daughters[77]) is also enigmatic, given the purpose for which and the patron for whom Vuillard made this monumental painting. Certainly, by the last three decades of the nineteenth century, mothers (rather than nurses and nannies) assumed a more direct role in the upbringing of their offspring and were frequently portrayed with their children in moralizing illustrations in magazines written specifically for parents to read to their young. Engravings such as *Les Oeufs de Pâques (The Easter Eggs)*, one of the illustrations for an almanac published by the family magazine *Le Petit-Saint-Thomas*, emphasized the doll-like qualities of the child (pl. 302) *vis-à-vis* her elders. The child as novelty is similarly

expressed in an early twentieth-century painting entitled *La Présentation* by Jules Cayron, a popular Salon artist and student of Alfred Stevens and Jules Lefebvre (pl. 303). In Cayron's childhood scene, the child is a prize object passed among the guests before being sent to the separate world of the nursery.

The child in Vuillard's decorative panel, however, has little interaction with the grown-ups in the room. Psychologically separated from her surroundings, she is similar to the little girl at the center of Lucien Simon's much acclaimed society portrait *Evening Party in the Studio (Soirée dans l'atelier)* (pl. 304) exhibited at the Salon of 1905. Simon's painting, composed of recognizable portraits of well-known artists, was praised for its informality and factualness and was seen as an evocation of the "truly French grace." The latter quality especially was seen to reside in the little girl, "with pale gold hair, dressed in light blue, the smile, as it were, on the canvas's face . . ."[78] But whereas in Simon's highly decorative portrait there is social interaction between the adults and the older girl who attends to her younger sibling, *The Library* shows no anecdote or familial interaction to justify the girl's inclusion in the after-tea or after-dinner party assembly. Instead, she is a Pierrot-like figure, who seems oddly out of place at the center stage in this heavily charged atmosphere. In March 1911,

Vuillard noted in his journal that he had used photographs of his niece Annette "for the little girl at center."[79] Pastels and paintings such as that shown in plate 305, showing Annette with long blond hair in the rue de Calais apartment, suggest that she provided the general type that Vuillard modified for the final painting without explanation for her inclusion or narrative intent.

To the right of "Annette," for example, are two *élégantes*. According to Antoine Salomon, they represent Mathilde and Suzanne Bernheim, the wives and cousins to Josse and Gaston, respectively.[80] Celebrated beauties and society matrons, they, like Misia, were painted by a number of artists.[81] In 1908, Renoir had painted the sisters-in-law in their Louis-Seize living-room on the avenue Henri-Martin. Two years later, Bonnard painted them in their box at the Opéra looking bored and beautiful (pl. 306). Vuillard had also painted the Bernheim wives, relaxing with their children (pl. 286) and entertaining in their salon

(pl. 307).[82] In the latter gouache-and-tempera study, one of the Bernheim wives is shown leaning against the fireplace mantel in a painting-filled salon.[83] Both this study and the photograph of the Chapin decorative panel in progress in Vuillard's studio (pl. 287) indicate that at an early stage he envisioned interlocking these two figures into the arabesque that he would further exaggerate in the final painting in order to fuse them both psychologically and compositionally. In contrast to the stiffer figures of Tristan and the little girl, their entwined bodies and casual poses resemble the graceful terra cotta figurines from

307 Edouard Vuillard, *The Bernheim Brothers and their Wives, Avenue Henri Martin*, c.1907, oil on cardboard, 57 × 72.5 cm.

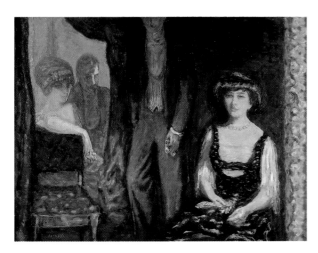

Tanagra, such as *Deux femmes* (pl. 308), which Vuillard would have known from their new installation in a glass display case within the Salle des Antiquités.[84] Vuillard may also have been looking at the little Maillol figurines which he kept on his mantelpiece and included in numerous still lifes such as *Still Life: Hydrangeas* (pl. 309).[85]

For both the gouache and large-scale decorative panel, Vuillard was interested in the pictorial, or decorative possibilities of his dealers' attractive wives and the way in which fashions can be used to describe a woman's personality and life-style. Dressed almost identically in lace-bodiced blouses with tulip-shaped, peach-colored skirts, their feather boas and the elaborate hat worn by the standing Bernheim wife suggest that they are only visiting after tea or dinner. On Easter Day, 1911, shortly before finishing the panel, Vuillard noted in his journal that he had used his mother's feather boa in his "panneau."[86] No doubt the boa was an accessory

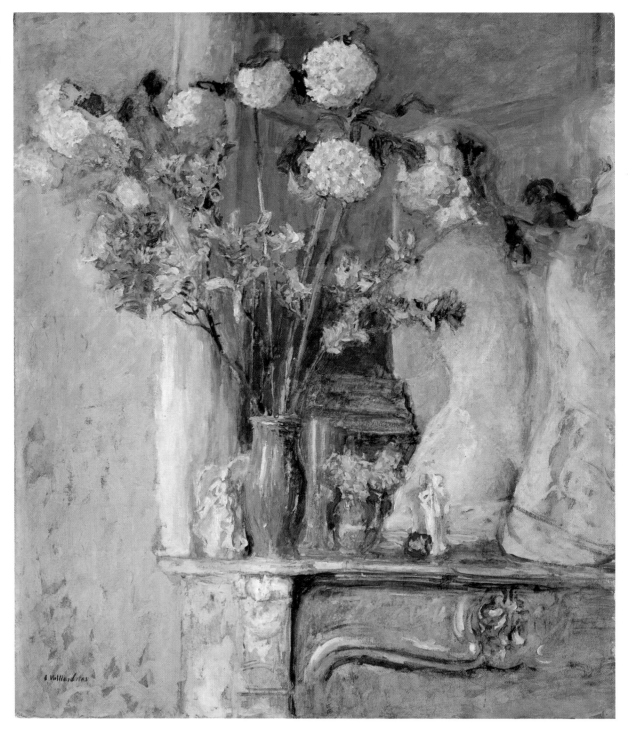

309 Edouard Vuillard, *Still Life: Hydrangeas*, 1905, oil on cardboard, 73.7 × 64.5 cm., Gift of Mr. and Mrs. Sterling Morton, 1954.4, The Art Institute of Chicago.

frequently worn by the Bernheim wives, and Vuillard's recourse to his mother's may have been to supplement his study of this highly decorative object from whatever formal or informal sittings with his dealers' wives he may already have had. In the final version of *The Library*, the boa's opaline feathers serve as a compositional ploy to exaggerate further the wasp waists of the Bernheim wives, and they heighten the illusion of wealth and status in this evocation of the artist's "féerie bourgeoise."

A curious note recorded in his journal in December 1910, after a dinner party at the Bernheims, mentions their "marvelous Renoirs," followed by another suggestive remark: "Painting filled with women . . . idea for the panel of Mlle Chapin."[87] His entry for the following day began with his note of "employment of the sketch from the night before,"[88] presumably made at the Bernheims' dinner party, may indicate that the Bernheim women contributed to his "idea for the panel." Indeed, the tripartite "composition" of the frieze of Renoir nudes in the Bernheims' main salon, the neo-classical columns,

and the Louis-Seize furnishing seen in the photograph of this room (pl. 311) may have been the inspiration for the elaborate setting of *The Library*.

Contrasting dramatically with the splendidly attired Bernheims is Marguerite, standing in the immediate right foreground. As seen in both the gouache study and the photograph of the panel in his studio, Vuillard first blocked in the general composition and then fleshed out the tapestry design and the portrait of his patron. In contrast to the gouache, where Marguerite is shown as a dark figure turned outwards, in the final painting, she is shown in profile and leaning on a low table or banquette, with her fox terrier standing alertly at her feet. Set apart from the group, she looks onto the scene in the tradition of donor figures seen in Renaissance and Baroque altarpieces. Her shadowed figure contrasts to the central group of figures lit by an unseen light source. Contrasting as well with the feather boas and expensive outfits worn by the Bernheim wives is Marguerite's severely cut, dark green dress (described by Segard as "almost black"), set off only by the lace collar, cuff, and the conspicuous gold buckle of her shoe (Vuillard's visual pun on her Puritan roots?).[89] In surrounding Marguerite with various classical and "museum-like" objects, Vuillard may have had in mind Degas's pastel *Mary Cassatt in the Louvre*, showing the accomplished American as a visitor contemplating the Etruscan sarcophagus in the museum (pl. 310). In *The Library*, however, Marguerite does not look at the art objects but at the people. Whereas the fixed gazes of her guests do not communicate with one another, Marguerite casts a watchful eye over the group. Her stern expression is similar to the portrait sketch Vuillard painted of her *c*.1910, in which she stares out icily (pl. 312). The artist's painted

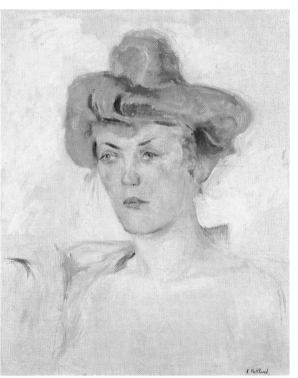

311 (above) Photograph of a portion of the salon of the Bernheim *hôtel* at 107 avenue de Henri-Martin, showing the Renoir wall.

312 Edouard Vuillard, *Marguerite Chapin*, *c*.1910, oil on canvas, 53 × 44 cm.

likeness of Marguerite, however, did not reflect his mental image of the woman described in his journal as having "light eyes, sensual mouth."[90] Although Marguerite was obviously sketched into the panel at an early stage, additional work on her figure and that of her dog seems to have been done at the end of his work on the panel. On 6 April 1911, two weeks before delivering the completed *décoration*, for example, Vuillard noted in his journal "a new drawing. Proportion [for] Mlle Chapin," and the following

310 Degas, *Mary Cassatt in the Louvre*, etching, 26.7 × 23 cm. (plate), Milwaukee Museum of Art.

193

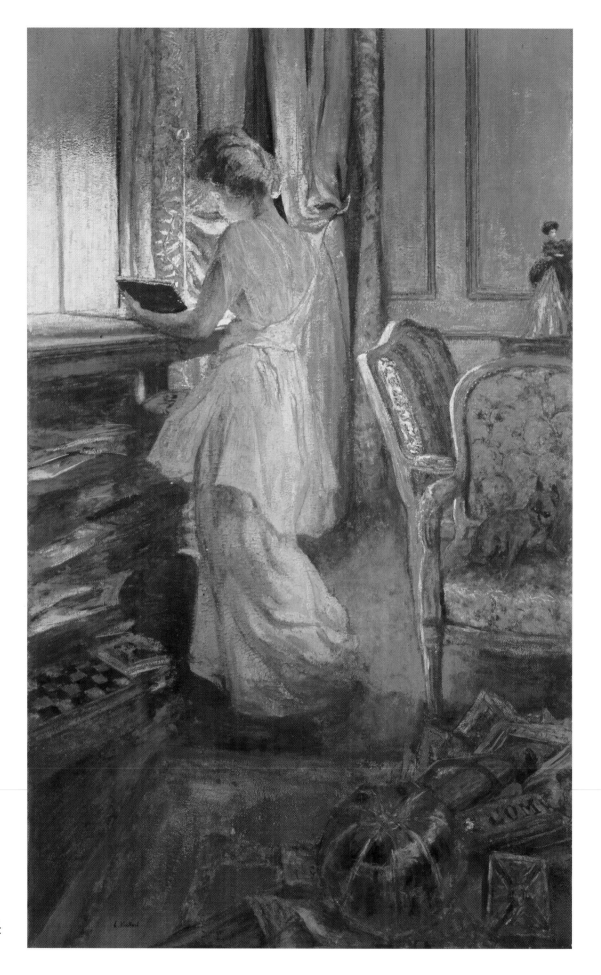

313 Edouard Vuillard,
*Reine Natanson, c.*1913–14,
distemper on canvas, 140 ×
84 cm., private collection.

day, "a good peaceful session, slow, re-do silhouette of Mlle Chapin."[91] A week later, seemingly satisfied with his efforts, Vuillard concluded the sessions by painting her terrier.[92] Marguerite's figure, in the final painting, is turned so that she looks into the room and across to the woman, also dressed in a dark color, who is slightly inclined as if attending to the tea. Since this smaller figure is not shown in the gouache study and not mentioned in Segard's otherwise detailed description of the panel, she may have been added later, in 1913 after the painting was returned to Vuillard's studio.

Besides the variety of people inhabiting or visiting the salon, Vuillard included objects alluding to frivolity and comfort, and to the extravagance and practicality associated with *la vie moderne*. On several occasions during the time that he worked on the Chapin panel, he noted his interest in recreating textures, fabrics, and general effects: "take up work again," he noted on 7 April 1911, "push along the details, imagination to give values, strokes [for the] Savonnerie, and a little bit of fruit ornamentation, lace effects, border of the tapestry, concerned about the effect of the silk, drawing."[93]

Contrasting to his need to duplicate the effects of expensive tapestries and silk dresses, he included newspapers, illustrated journals, and Marguerite's beige-and-tan-colored terrier, as allusions to popular art and informal living. In the still lifes at the left, Vuillard ingeniously allowed the precious materials of the rug and the highly polished tea service on the satin tablecloth to vie with the practical and mundane objects of newspapers and the overflowing waste-paper basket (pl. 283), recalling his earlier (1894) journal comments on the importance of "sujet humbles" for *décorations*. Vuillard would master the pictorial conceit of the unexpected "humble" motif in future works: in genre-like scenes of the Hessels at home, such as *Around the Table* (*Autour de la Table*); in his large-scale decorative portraits painted in distemper, such as the portrait of Théodore Duret (1912); and in his portrait of Reine Natanson (pl. 313), showing Thadée's second wife in evening gown and pearls, standing on a floor covered with her husband's books and manuscripts. It was Vuillard's type of attention to the details of the quotidian, and fascination with symbols of wealth, together with life's necessities that prompted the poet Anna de Noailles twenty years later to scream half-jokingly to her chambermaid when Vuillard was beginning her portrait: "Quick, take away the jar of vaseline, the *maître* would be capable of painting it!"[94]

Installation

Vuillard's work on the project for Mlle Chapin lasted a little over six months. As was typical, the commission was not only an affair between himself and Marguerite, but a *cause célèbre* warranting the opinions of other artists and friends. On 21 March 1911, Vallotton visited Vuillard's studio to see the work in progress and reported to his brother that his friend was "submerged in making a huge *décoration*, which is starting out very good; he is very absorbed [by this], and we talked scarcely of anything else."[95] Towards the end of April, a week before completing the painting, Vuillard recorded the comments of visitors to his studio on the boulevard Malesherbes, as well as his own enthusiastic or negative assessment of his progress:

Saturday, 22 April: After lunch, took Pierre [Veber], Adrian [?] and Mme Ranson to see my panel. Made no impression on A.... Visit from [Romain] Coolus, painting had no effect, subject doesn't interest him.
Sunday, 23 April: Work in the studio on right bookcase; visits from Jos Hessel; compliments.
Monday, 24 April: ... retouched left statue, roses all over. Visit from Fénéon and Gaston [Bernheim]. No enthusiasm.
Tuesday, 25 April: Morning in the studio. Short session. Visits [from Arthur] Fontaine, Mme Chausson, [Georges] Viau, Misia, Paul [Hermant] ... Visit from Tristan [Bernard], use of paint. Marcelle [Aron], interested. Mme Erlanger, Clarisse Anet [Schopfer's second wife], Marthe [Mellot, Alfred Natanson's wife], tall French woman [?], the [Alfred] Savoirs.
Wednesday, 26 April: Studio 11 a.m., Mr. Elias Julien, German critic.[96]

On 27 April, Vuillard transported the painting to Mlle Chapin's apartment at 11 rue de l'Université to determine its final placement, and noted the "nice chat with Mlle Chapin during the installation."[97] Apart from his mention of several unfortunate "errors in measurements" which necessitated remeasuring the room, nothing is known about the disposition of the panel within Marguerite's library. A comparison between mid-nineteenth-century floor plans of the eighteenth-century *hôtel* and blueprints of 1980 (pls. 314, 315) indicates that the dimensions of the individual rooms have remained relatively unchanged.[98] Entering through a *porte-cochère* (pl. 316), one crossed the brick courtyard to reach Marguerite's apartment located on the ground floor underneath the grand spiral staircase in the hallway of the back building. Unfortunately, since Marguerite's years of residency do not coincide with the dates of either floor plan, it is not possible to know which room served as the library. The 4.30-meter-high walls indicated in the modern blueprint would easily have accommodated Vuillard's panel which was placed in one of the four back rooms whose french doors led to the "charming sun-lit garden" that Vuillard mentioned several times in his journal (pl. 317).[99] It is probable that the nearly nine-foot-wide painting was placed on the west wall of the salon, the only room whose function seems

314 (right) Photograph of the plan of the Hôtel d'Albert, 11 rue de l'Université, *c.*1850, Série topographique, VA 2701 Bibliothèque Nationale, Paris. The probable position of *The Library*, in the salon, is indicated in red.

316 (far right) Elevation of facade for building at 11 rue de l'Université, 1850. Série topographique, VA 2701, Bibliothèque Nationale, Paris.

317 (far right, bottom) Contemporary photograph of the garden designed by Le Nôtre at 11 rue de l'Université.

315 Contemporary floor plan for the apartments of Mlle Chapin: *rez-de chaussée*. The probable position of *The Library*, in the salon, is indicated in red.

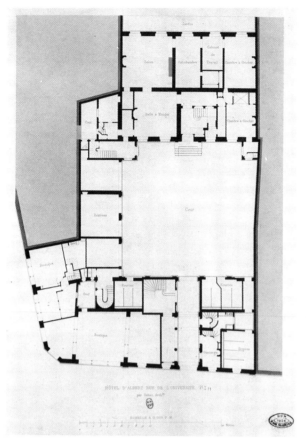

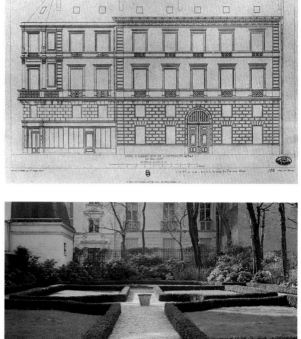

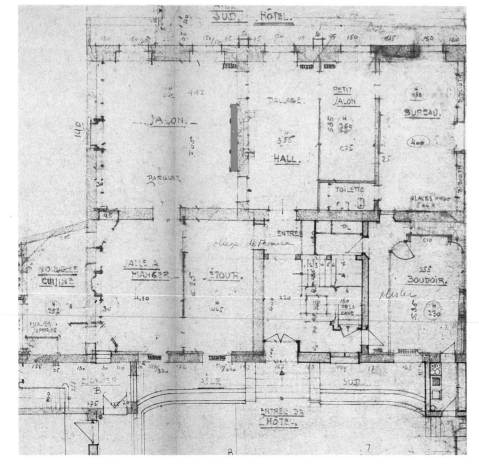

not to have changed between the 1850 floor plan and the modern blueprint.[100]

In a smaller room in the apartment, possibly the ante-chamber, Bonnard installed his decorative panel *In the Boat* (*En Barque*, pl. 318).[101] Bonnard's panel for Mlle Chapin did not take up the arcadian themes of his panels for Misia Natanson, but it was no less idyllic and audacious. A comparison of Bonnard's response to Marguerite's commission and Vuillard's, in fact, is a study in contrasts. Bonnard's *The Boat* is a perfectly square panel, two-thirds of which is filled with tropical vegetation and sunny skies.[102] The palette and mood are summery and the perspective dizzying, with carefree children appearing to spill out into the viewer's space from their top-heavy vessel. By contrast, Vuillard's richly decorated interior is a balanced composition divided vertically into three registers with subtle and not-so-subtle references to classical and Renaissance art.

Vuillard was well aware of the gulf separating his work from his friend's, and on several occasions in his journals he compared the "freshness" of Bonnard's light-filled *décoration* for Marguerite with his own.[103] When *The Library* was finally installed, however, even Vuillard's critical eye was satisfied, and he remarked on 5 May after the final installation, "not a bad impression of my painting."[104] Although he did not record his patron's response, Marguerite was undoubtedly happy with the results and immediately commissioned him to paint the five-panel

196

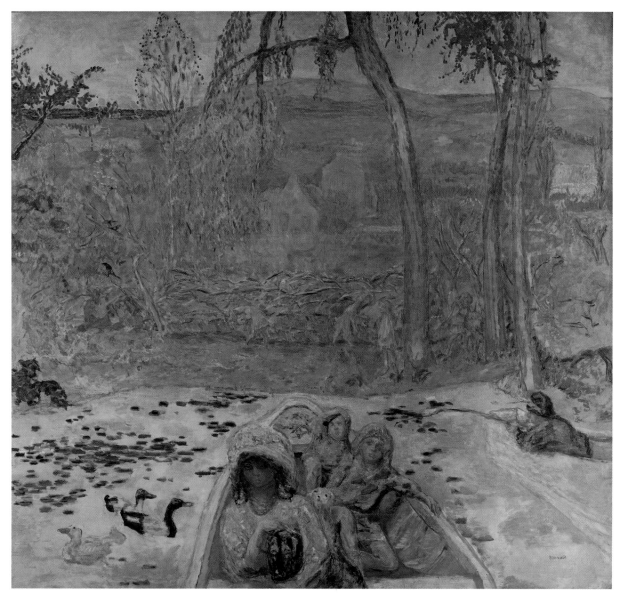

318 Pierre Bonnard, *In the Boat* (*En Barque*), oil on canvas, 278 × 301 cm., 1910, Musée d'Orsay, Paris.

screen *La Place Vintimille* (pl. 282). For this, Vuillard reused the theme of the triptych for Henry Bernstein, painting the square in the fullness of spring rather than in the grayer winter months.[105] Owing, no doubt, to his familiarity with the subject for this second commission, Vuillard's work on "mon paravent" or "mon paravent Mlle Chapin," as he referred to it in the several journal references, progressed quickly and was ready to be mounted onto a wood support and backed with wallpaper by the end of May.[106]

Reception and Rejection of The Library

Throughout the winter and spring of 1911, Vuillard's artistic activities had revolved around his work for Mlle Chapin, and this had resulted in a deepening of his feeling towards her.[107] On one of his last visits to

her apartment to measure the space for *The Library*, Vuillard noted his self-consciousness in her company: "Miss Chapin – charming. Feel her at a distance from my ladder."[108] Later that day, after spending the evening at Lucie's, he recorded her displeasure ("always abrasive") and what possibly could have been her taunting accusations of his involvement with Marguerite ("she tells me of 'l'amour Chapin'").[109] The spell that Marguerite seems to have cast over Vuillard at that time, however, was dramatically broken in October 1911, when he returned from vacation to find a letter from Fénéon informing him of Marguerite's forthcoming marriage and her plan to return *The Library* panel. The pain and confusion he felt at receiving the news secondhand from Fénéon is evident in his journal entry that day: "remain alone, overwhelmed by my thoughts about my panel rejected by Mlle Chapin. Horrible silence and insane laughter. Try to figure

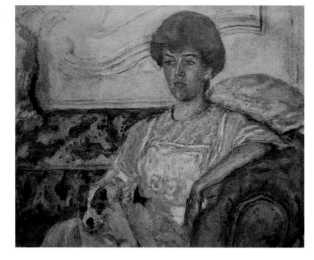

out why she didn't keep it."[110] The next day, Vuillard received a message from Marguerite announcing her engagement to Roffredo di Caetani, the Prince di Bassiano – a decision that was apparently a surprise to everyone.[111] According to one account, her future husband had met Marguerite at the Opéra only a few weeks prior to the wedding and fallen helplessly in love with her.[112] A less romantic version of the story, however, is that Roffredo was eager to marry the wealthy American heiress as much to "redorer le blazon" (literally "regild the family shield") and reinvigorate his financially weakened lineage, as for love.[113]

Marguerite's failure to give Vuillard advance warning of her plans to return the large panel may have been due to her abbreviated courtship with Roffredo. Nothing in Vuillard's journal references indicates that her abrupt change of mind resulted from a change of aesthetics or loyalties. On the contrary, Marguerite's commission of the five-panel screen and Lucie's jealousy on Marguerite's account suggest that their collaboration and friendship was a solid one. More likely, Marguerite's decision to abandon the panel was a concession to her husband, a dilettante composer who had inherited little more than the family title and collection of medieval swords and armor.[114] Vuillard's almost life-size group portrait with its decidedly *haut bourgeois* cast may have been offensive to the Prince's pretensions, or, quite possibly, might not have been able to be accommodated in the apartment that he and his armor collection now cohabited.

Neither Vuillard's correspondence nor his journal entries comment on what must have been an extremely frustrating episode in his professional and personal life.[115] Five days after he received Marguerite's news, he noted sadly that he had seen his panel, "on the ground, hooks taken off," in the salerooms at the Hôtel Drouot.[116] At the auction, the painting was purchased jointly by Hessel and the Bernheim brothers but returned to Vuillard's studio.[117] In his usual fashion, the artist continued to rethink and

retouch the "panneau Chapin," considering it a failure.[118] Although the painting was exhibited along with the five–panel screen *La Place Vintimille* (apparently kept by the Princesse di Bassiano) in the spring of 1912 at the Bernheim-Jeune gallery, *The Library* was returned, unsold, to the artist's studio.[119] In May 1913, Vuillard noted having retouched the background of the panel in view of an upcoming exhibition at the Manzi gallery.[120] It is possible that he added the seated woman on the left at this time, to balance the symmetry between the groups of people on either side of the composition.[121] After dropping off the painting at Manzi's, Vuillard recorded his "disillusionment, confusion," and his opinion of the painting's "lack of originality and of coloristic significance, meanness, effect of a lifeless studio."[122] In 1917, Jos Hessel bought out the Bernheims share of the painting to gain full ownership. *The Library* was not seen again until 1933–4, when it was exhibited in New York and Paris as 'a decorative panel for a library.'[123] Two years later, the state purchased it from Hessel for 45,000 francs, along with Roussel's large-scale decorative panel of 1906–7 *Les Filles du Leucippe* (originally commissioned for the Bernheims), which was to hang with it in the Luxembourg museum.[124]

Vuillard's difficulties with Mlle Chapin (as he continued to refer to her even after her marriage) were eventually resolved. In 1913, when Marguerite's first child, Leila, was born, the Bassianos moved to the Villa Romaine at Versailles. During the war, they lived at Roffredo's family property outside Rome. Returning to France and to the Versailles residence in 1919, where Bonnard painted her in all her regal bearing and wealth (pl. 319),[125] Marguerite soon started up her Sunday literary salons which Vuillard sometimes attended on his way to visit the Roussels at L'Etang-la-Ville or Maillol at nearby Marly.[126] Although, by the 1920s, Marguerite was collecting the art of the Italian futurists and surrealists, she continued to acquire works by Vuillard and commissioned him to paint a portrait of her children Leila and Camillo under the chestnut trees at the Villa Romaine.[127] But Vuillard's frustration over the unsuccessful project was remembered. In March 1915, while working on a decorative frieze showing children in imitation of putti playing among the artists's materials and newspapers (pl. 320), he was reminded of his rejected *décoration* for Marguerite: "The only real problem is with the will – why was I stopped [from working] on the Chapin panel? . . . think about those things that recall sensations, the truth of details – the precise study of the object."[128]

In its conception and scale, *The Library* was a more ambitious undertaking than anything Vuillard had attempted, and, perhaps, because of its multiple and seemingly disjointed themes, it fell short of its purpose as *décoration*. In his evaluation of this work, Segard mentioned Vuillard's "return to a symbolist aesthetic" – a comment prompted, no doubt, by the

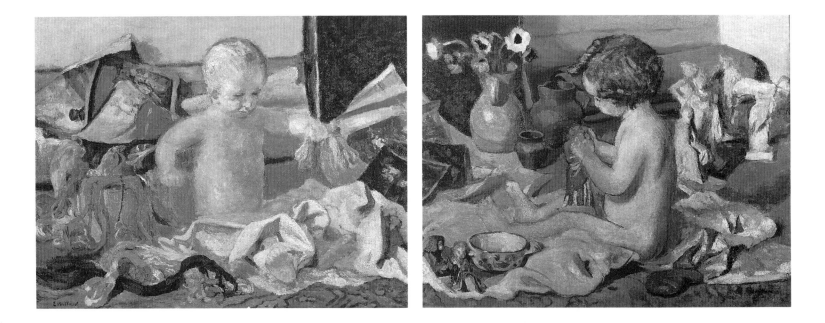

various ideas and associations Vuillard sought to achieve in this tapestry-like amalgam of the classical and the modern. Unlike his earlier symbolist-inspired works, *The Library* lacks the qualities of suggestiveness and mystery. Figures and objects are combined in an invented architectural realm, resulting in an allegory of bourgeois values in western culture, or even, in "la féerie bourgeoise." But there is no mood or empathy apparent. In the tradition of the conversation piece, the scene hints at but does not offer a narrative, just as the figures, sometimes recognizable as people in Vuillard's circle, are inexplicable in this setting. Is it a collage reflecting the French *douceur de vivre*? Or was it the artist's visual response to "les riches et leurs fantasies" – a phrase that he had earlier used to describe the Bernheims' circle?

When later in life Gaston Bernheim asked him how it was possible to bear his dreary apartment furnishings, Vuillard is said to have been quick to reply: "I have everything [I need] in myself. Those who do not have this internal wealth need that which beauti-

ful works made by people like me can give them."[129] Considering that Vuillard may have based the Chapin painting on several known settings, including the Bernheims' Renoir-filled interior, his statement could be read as a put-down and a comment on Gaston's decidedly materialistic attitudes. The fact that Vuillard used the exclusionary "people like me" to answer Gaston, an artist himself, may also have been intended to drive home the real difference between his values and those of his dealers. Whatever Vuillard's purpose, the statement is important as a confirmation of the artist's deep attachment to the environment that was most familiar to him. It is equally appropriate given his later career as a society portraitist and recorder of social manners; for his reply reinforces a belief that appears throughout his journal entries: while he could paint decorative paintings for the "bourgeois spectacle," he was acutely aware of his marginal place within that theater.

320a and b Edouard Vuillard, *Putti Playing*, *c.*1915–16, oil on paper, 41.5 × 55.6 cm., private collection.

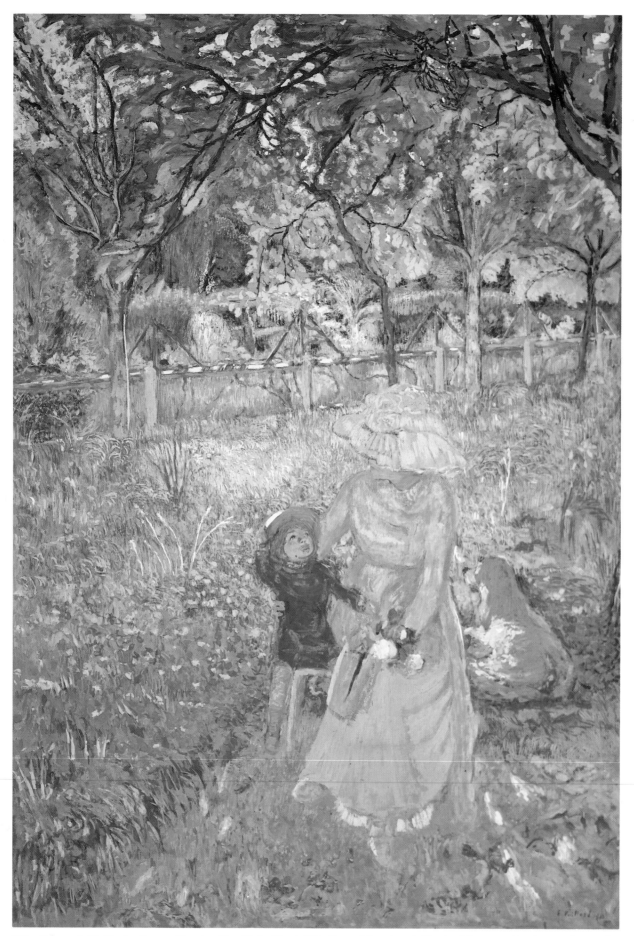

321 Edouard Vuillard, *Sunny Morning* (*Le Matin Ensoleillé*) (Lucy Hessel and Denise Natanson in the garden at Les Pavillons, Villerville), 1910, distemper on canvas, 203 × 142 cm., private collection, London.

10 Painting as Decoration and Decoration as Painting: Vuillard's Theatrical Projects, 1912–1913

If Vuillard had created in the Chapin panel an operatic *tableau vivant* of bourgeois society, over the next two years his work would become "theatrical" in a more literal sense. Shortly after *The Library* and the five-panel screen *La Place Vintimille* were exhibited at the Bernheim-Jeune gallery in April 1912, Vuillard was commissioned by Gabriel Thomas, President of the Société de Théâtre des Champs-Elysées (and already introduced above as the owner of Denis's panels *Eternal Spring*), to "decorate" the foyer of the new Théâtre des Champs-Elysées.[1] The theater, which had been in progress over the past two years, was nearing completion. Although privately owned, the theater, was, in the words of a contemporary, "a building destined for the public, open to social life."[2] Indeed, the opening of this grand performance hall on the avenue Montaigne in between the Champs-Elysées and the place de l'Alma was a well-attended event,[3] and Vuillard's participation in it threw him into the social limelight.

The theater had been conceived over a long period which had begun with the musician Gabriel Astruc's plans for a modern performance hall for his Société de Musique. It had subsequently been taken over by Gabriel Thomas, who moved it from Astruc's original location on the avenue des Champs-Elysées and enlarged the plans to include a large theater (*grand salon*) and a smaller one. Between Astruc's directorship in 1906 and the time Vuillard was called in, it had been designed and redesigned under several different architects: Roger Bouvard (1906–8), Henry van de Velde (1910 to 3 July 1911), and finally taken over and completed by the brothers Gustave and Auguste Perret.[4]

The first of the *décorateurs* to be commissioned was the sculptor Antoine Bourdelle (for a quasi-symbolist frieze around the balcony, and to decorate the facade and galleries) and the art-nouveau master René Lalique (for the glass dome of the main theater). Not surprisingly, Thomas's first choice, in 1910, for a *peintre-décorateur* was his close friend Maurice Denis, whom he commissioned to paint a circular band around the cupola of the large theater. Denis, who

had dreamed of creating a public decoration since 1907, when he had exhibited at the Salon "a large canvas with large-scale figures,"[5] embarked immediately on a monumental endeavor which resulted in a 372-meter surface filled with figures on the theme of the "synthesis of the History of Music" (pl. 323).[6] While Denis and Vuillard differed widely in their ideas about what a *décoration* should be, their continued admiration for each other can be seen in Denis's journal remarks about his project: "I receive compliments even from Vuillard," and Vuillard's own journal comments after seeing Denis's achievement: "an enormous work, well done."[7]

Roussel was also asked to create a painted curtain with an exceptionally large format (7.54 × 8.12 m.) for the smaller of the two theaters, the Théâtre de Comédie.[8] For this, likewise his first public commission, he chose a neo-classical theme linked to the origins of modern theater, *The Procession of Bacchus* (*Le Cortège de Bacchus*) (pl. 322), and one already familiar in his work in smaller formats.

Vuillard, among the last to be commissioned, was assigned the foyer area of the smaller Théâtre de Comédie.[9] While it is clear from his journals that his conception for the project originated with him and was only approved by Thomas, he had no say as to

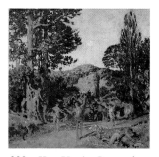

322 Ker-Xavier Roussel, sketch for a painted curtain, *The Procession of Bacchus* (*Le Cortège de Bacchus*), for the Théâtre de Comédie (Théâtre des Champs-Elysées), 1911–12.

323 Maurice Denis, portion of his decorated cupola for the Théâtre des Champs-Elysées, 1911.

Vuillard treated each surface as an individual decorative panel and not as an ensemble.

At first, Vuillard, too, seems to have struggled with the idea of creating an allegory of theater with classical figural types. By 26 September 1912, he had resolved the potential problem, noting in his journal, "decision of the morning. Abandon of antique subjects," and a few weeks later, "description of the theater foyer – decide on modern subjects."[10] For his "modern subjects," Vuillard chose scenes from theatrical performances currently running in Paris (in late 1912 and the first months of 1913, when he worked on the panels) which he could and did observe first hand. For classical theater, he chose a scene from Molière's *Le Malade Imaginaire* which had opened on 5 November 1912 at the Théâtre de l'Odéon (pl. 324). Representing modern comedy was a painting inspired by the second act of Tristan Bernard's farce *Le Petit Café* which had successfully running since November 1911 at the Théâtre du Palais-Royal (pl. 325). The three narrow, vertical panels or *trumeaux* were likewise based on contemporary performances – a scene from *Faust* which had opened at the Théâtre de l'Odéon, 6 January 1913, a

the formats of the surfaces he was commissioned to cover, which consisted of a narrow horizontal panel, three vertical panels and larger, mural-like surfaces. As he had done for several of his decorative projects,

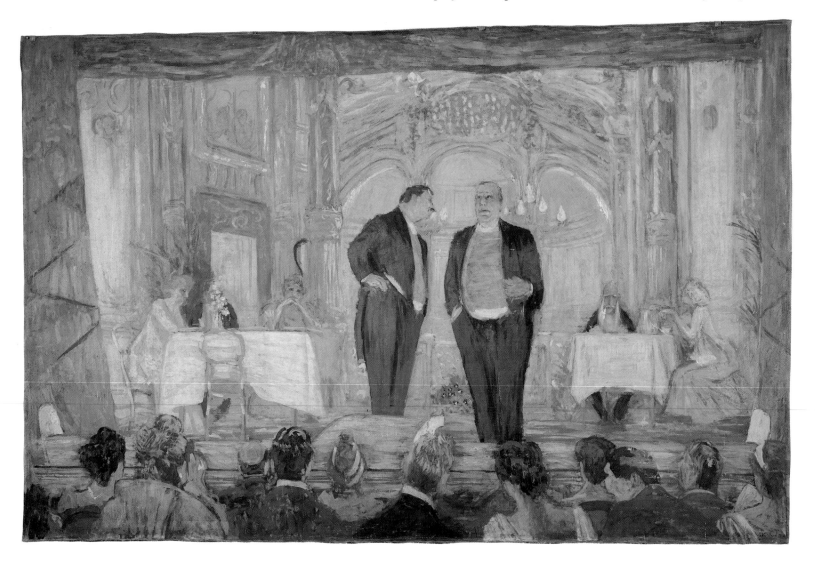

scene from the opera by Debussy of Maeterlinck's *Pélléas et Mélisandre* that had been recreated on 28 January 1913 at the Opéra-Comique, and a vignette drawn from the marionnette theaters on the Champs-Elysées.[11] The additional decorations consisted of a long overdoor panel showing a still life of programs and flowers, and two nearly square portraits of the actor Lugné-Poe in his dressing-room and another of an unidentified actress, formerly thought to be Lugné-Poe's wife, Suzanne Desprès.

Twenty years after having made his first sets for the theaters of Antoine, Paul Fort, and Lugné-Poe, Vuillard found himself again involved with painting theater scenes – but with entirely different aims. Whereas for Henri de Regnier's symbolist drama *La Gardienne* (June, 1894), he had painted a gauze curtain behind which actors silently moved, now he turned reportage into *décoration*. In many ways, his work for the Champs-Elysées theater paralleled his portrait commissions, which required several sittings within the owner's home. This time, however, the "sittings" took place from his seat at the Théâtre de l'Odéon, where he attended the Molière performance nine times during its one-month run, and at the Théâtre du Palais-Royal, where he saw Tristan's three-act comedy numerous times during October 1912 and February 1913.[12]

In the largest of the *décorations*, *The Small Café* (*Le Petit Café*) (pl. 325), Vuillard was entirely at home with his subject. He had already used the theme of a crowded café or restaurant in gouaches and distemper works showing the Café d'Armonville in the Bois de Boulogne and the Café Wepler near his home on the rue de Calais. He borrowed from Degas the pictorial conceit of setting the larger figures on the proscenium above several rows of much smaller spectators whose rhythmically tilting heads enliven the foreground arena. The play itself is a typical Bernardian farce, telling the story of Albert, a waiter in a small café, whose *patron* Philibert, upon finding out that Albert would receive a fortune the next day, cons him into signing a contract that stipulates that he will employ Albert to work there for the next twenty years at the elevated salary of 5,000 francs a year. Assuming that Albert would leave his waiter's position once he was rich, he added to the contract a penalty of 200,000 francs against the first one to break the agreement. Albert dupes everyone (after he learns of his own duping) by remaining a waiter by day and becoming a dandy by night. Vuillard elected to paint the conversation between Philibert and a friend, M. Gallo, in the fancy restaurant where the now-rich Albert spends his after-hours. In depicting each of these principals, Vuillard exploited the distorted perspective of the scene as viewed from his seat within the audience to exaggerate further their facial expressions and bulging waistcoats. Comparing the stage characters represented in the photograph (pl. 326) with those seen in the posh restaurant in Vuillard's panel (pl. 325), one sees how closely Vuillard observed his

characters. Easily recognizable, for example, is the most "caricatural" of the group, the elderly man with the long sideburns who sits with the attractive young woman, at the left in the photograph and on the far right in the painting.[13]

That Vuillard chose to paint a large-scale bourgeois farce for the small foyer where people convened for food, drinks, smoking, and conversation before, during, and after the performances was not an uncalculated decision for the artist, who was already recognized as one of the most significant painters of modern bourgeois life. The fact that these paintings were commissiond and approved in the first place is a tribute to the commissioners, who accepted for their "Palais-Théâtre," as it was called affectionately at the time, not only the themes of classical theater afforded by Denis, Roussel, and Bourdelle, but those alluding to the lighthearted slapstick comedy (of Molière and Bernard) equally associated with the history of modern French theater."

At the same time that Vuillard was assiduously attending the performances of *Le Petit Café* for his many pastels and oil sketches (Musée de Bremen), other theater-goers were enjoying seeing his *décoration Sunny Morning* (*Matin Ensoleillée*) (pl. 321) on the stage of another bourgeois farce by Vuillard's friend, Sacha Guitry, *La Prise de Berg-op-Zoom* (pl. 327),[14] which had opened in October 1912 at the Théâtre de Vandeville. The panel (which appeared in the first and last acts of Guitry's play) had been exhibited at the Bernheims' gallery in 1911 and showed Lucie, half hidden by her hat, her collie Basto, and Denise Natanson (the daughter of Alfred and the sister of Annette) at the Hessels' rented summer house,

324 (facing page, top) Edouard Vuillard, *Le Malade Imaginaire*, decorative panel for the foyer of the Théâtre de Comédie (Théâtre des Champs-Elysées), 1912–13, distemper on canvas, 188 × 290 cm.

325 (facing page, bottom) Edouard Vuillard, *Le Petit Café*, decorative panel for the foyer of the Théâtre de Comédie (Théâtre des Champs-Elysées), 1912–13, distemper on canvas, 180 × 280 cm.

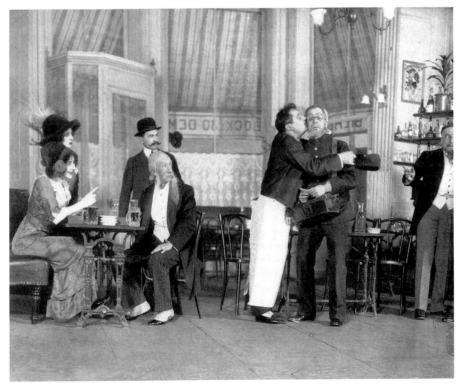

326 Photograph of Act I of *Le Petit Café* by Tristan Bernard, Théâtre du Palais-Royal, repr. in *Le Théâtre*, no. 309 (November 1911), p. 9.

327 Photograph of Act IV of *La Prise de Berg-op-zoom*, comedy in four acts by Sacha Guitry, Théâtre de Vaudeville, repr. in *Le Théâtre*, no. 332 (October 1912), p. 10.

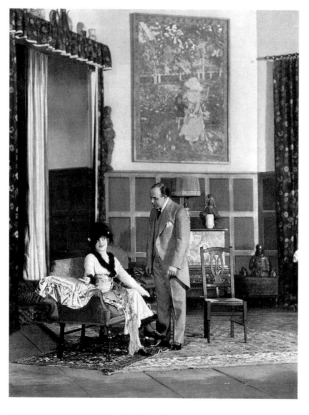

328 Photograph of Act I of *Un Beau Mariage*, comedy in three acts by Sacha Guitry, Théâtre de la Renaissance, repr. in *Le Théâtre*, no. 309 (November 1911), p. 5.

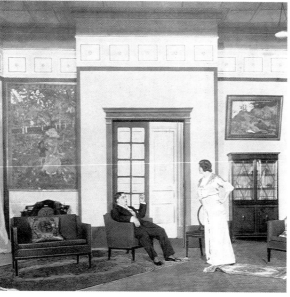

of Bonnard, a figure of Van Dongen, the nymphs of Roussel and two works by Vuillard, including a large distemper painting *Le Matin ensoleillée*".[16] When the same critic asked Gaston Bernheim how an actor could afford such expensive paintings, he replied:

> Lysés [Charlotte Lysés, Sacha's actress wife] and Sacha create the principal characters, Bonnard and Vuillard create a pleasant atmosphere around them.[17]

The desired "pleasant atmosphere" ("atmosphère sympathique") of Sacha's play is far removed from the work of Paul Fort or Lugné-Poe in which the individual actor would be absorbed into the overall mood of text and image. In contrast to these earlier décors, which were quickly discarded or painted over, in the boulevard theater of the twentieth century, Vuillard's large-scale painting, never intended for the stage, could be viewed by a far greater public than could ever be expected at the Bernheim-Jeune gallery.

As seen in the photograph of act I from *Le Beau Mariage* in which Sacha (as Maurice) confronts Charlotte (as Simonne), the Roussel and Van Dongan paintings were hung as easel paintings, cantilevered out from the wall. Vuillard's however, was hung as a *décoration*, framed by the alcove, and seen as an integral part of the temporary stage interior. Vuillard was well aware of this second usage for his unsold *décoration*, and on 16 October 1911, after he had attended Sacha's play, he remarked: "first act. My painting did not make a bad impression."[18]

In its second reinstallation as part of the set for Sacha's *La Prise de Berg-op-Zoom*, it was hung as an easel painting with a painted frame (pl. 327) in an eclectically appointed pseudo-Gothic salon-cum-*atelier*, intended to evoke the interior of Monsieur Vannire, "a big boy who likes to have fun and who is a bit of an eccentric. For instance, he likes making silhouettes out of wood and painting; he is a real character and lover of life."[19] In the photograph of a scene from act IV, Monsier (played by Baron fils) holds the model "Lulu" on his knee as he is surprised by his wife (Charlotte Lysés) and the police commissioner (Sacha). The only painting that Sacha borrowed for this performance, it may have been used to suggest the work of the would-be artist M. Vannaire, whose collecting tastes included medieval wood sculpture, decorative plates and pewter, and porcelain drinking steins.[20] In choosing Vuillard's panel as the primary décor for a contemporary interior, Sacha hoped to create the impression of a "home," be it the "artistic interior" of M. Vannaire or the fashionable salon of M. Maurice. Indeed, by that time, Jacques-Emile Blanche's earlier prophesy that soon "no modern furniture would be complete without Vuillard's decorative painting," seems to have been fulfilled with only slight modifications.[21]

With the Théâtre des Champs-Elysées project, Vuillard had come full circle in twenty-two years. And it is interesting that, having begun with Denis

Pavillons, near Honfleur.[15] Unsold after the exhibition, it was available in the Bernheims' gallery for Sacha to "borrow" for his own use.

The 1912 performance of Guitry's play was actually the second stage appearance for the painting. A year earlier, he had borrowed it as part of a "bourgeois décor" (along with works by Bonnard, Roussel, and Van Dongen) for his three-act comedy *Un Beau Mariage* (pl. 328), performed at the Théâtre de la Renaissance. As described by one critic writing about the "Décor d'un beau mariage," Sacha went to the Bernheim-Jeune gallery where he chose: "the flowers

and Roussel as painter and stage designer for the vanguard theater, his last "official" decorative project, coming but two years before his death was also a collaboration with Bonnard, Roussel, and Denis, for the Théâtre de Chaillot.[22]

Vuillard's Achievement as a Peintre-Décorateur: A Reassessment

In the fall of 1912, while Vuillard was busy attending the Molière and Bernard plays as well as at least three of the performances of *La Prise de Berg-op-Zoom*, he received a nomination, along with Roussel and Bonnard, to become a Chevalier of the Légion d'Honneur. He is unusually silent about the nomination in his journal, and it seems that Roussel, with the approval of both his friends, refused for all three.[23] Their decision may have sprung from their reaction (perhaps negative) at seeing their friend Maurice Denis receive the honor two years earlier. Whatever the reasons, it was not a rebellious or spiteful act. As one insider noted: "They refused nicely with a courteous manner; without wanting to be, their gesture was a manifesto. And they even thanked them in all friendliness."[24] Their decision fueled popular opinion, however, most of which was opposed to the refusal. Even among other artists, who saw the rejection of "La Croix" as an act of solidarity with Cézanne, Monet, and others whose names and talents had been overlooked in this respect, many felt that Vuillard and his friends should have accepted if only to encourage the Ministry of Fine Arts to continue to recognize artists other than academic ones and to discourage the giving of the "ruban" to conservative and uninspired flower painters. In the words of one critic, "Their refusal risks discouraging the government officials who have good intentions. Now they will return to honoring the Madeleine Lemaires [a fashionable society painter]."[25]

One wonders if it were not modesty, or rather fear of publicity, that kept Vuillard from accepting the honor. If his friends had accepted, would he have done so as well? His desire to maintain a balance between anonymity and fame is a continual leitmotif in his journals, set against the reality of his active social life revolving around the Hessels' circle. Although his retrospective at the Bernheims' gallery in 1912 would be his last one-man exhibition until 1938, his later career was one of even greater contact with the influential and the *mondain*, as he received more and more commissions for large-scale portraits and decorative paintings. And when his friend and sympathetic critic, Claude Roger-Marx, approached him about writing a monographic study of his life and work, Vuillard accepted on condition "that it not be published until after his death."[26]

Segard's insightful study on the artist's decorative works is the exception to Vuillard's reclusiveness, and Vuillard's cooperation may have been owing to Segard's more democratic approach of writing equally in-depth studies of the works of eight artists, while providing only summary information on the artists' personal lives and artistic evolution. Likewise, Vuillard's admiration for and appreciation of Jacques-Emile Blanche's article on "La Peinture moderne" (published in 1913 on the occasion of the sale of the collection of Henri Rouart) was also owing to Blanche's generous remarks about the place that Vuillard and his artist friends would hold for future generations:

> The painter of Parisian interiors will have been M. Vuillard. He created fragile curios, occasionally decorative panels akin to posters, prints, ornamental borders of *cretonne*, but with such immediacy and talent that his works will have real documentary value for future generations, along with those of his comrade Pierre Bonnard, perhaps more painter than he – and Maurice Denis, the accredited decorator of our churches, theaters, and public monuments, as well as of children's bedrooms. Maurice Denis is to Puvis what Vuillard is to Degas.[27]

Blanche concluded by remarking that these artists "know how to please," with an art responding perfectly to "the desires of the collectors in their time."[28] While Vuillard would undoubtedly have appreciated such high praise, he might have agreed only partially with Blanche's comparison of his career to Degas's. For unlike Degas, who it is said, refused to undertake decorative commissions because he felt a decoration by definition should have an integral, not temporary existence within the architectural interior,[29] Vuillard considered painting as decoration to be an essential aspect of his work. Although Bonnard and Denis were also deeply involved with the notion of *décoration* for the modern (and generally urban) interior, Vuillard, especially, understood its primary function and limitations. During the twenty years of his decorative career covered in this book and in Segard's study, Vuillard's large-scale, unusually formatted paintings executed for the most part *à la colle* challenged traditional notions of monumental painting and were perceived as new kind of interior décor. Included in this novelty was the idea that Vuillard's *décorations* were not exclusively architecturally specific, although they were specific to the interior for which they were originally conceived.

In the preceding twelve case studies of very different projects, the idea of a decorative painting having an integral function in the room, has been shown to have figured largely in Vuillard's intentions for his patrons. Even with the supposedly movable scheme for Thadée and Misia, the variously sized panels were created for the open spaces and alcoves of the loft-like room and their hot pink-and-orange palettes were intended to integrate with the Natansons' helter-skelter floral wallpaper. The present-day framing and installation on ice-blue walls of *The*

Album (pl. 150) had little to do with Vuillard's conception.

And yet the ideal of a decorative ensemble was constantly being undermined by economic and social realities. Vuillard seems to have been justly sympathetic to these demands and was ever-willing to redo, retouch, and even cut down projects to fit his patrons' different circumstances. The results, however, were never so felicitous as the original conception. Even though Mina Curtiss described Schopfer's two panels in Antoine Bibesco's quai Voltaire apartment as "being in a room so beautiful that it took my breath away, with full-length Vuillard panels obviously painted to fit the wall,"[30] she was admiring of Antoine's integration of the panels into his own interior and not the artist's vision of them in the Schopfers' eclectic setting.

It may have been that Vuillard's ideas about decorative painting for a specific interior changed as he saw his projects moved, reframed, or dispersed. Certainly, the consistent effort of the nine-panel series, the *Public Gardens*, was never repeated. Although Alexandre Natanson and his wife had requested an aristocratic kind of décor, they lacked the permanancy and consistency traditionally attached to that style of living. Unlike Denis, whose decorations for the Baron Cochin, and, until recently, for Gabriel Thomas have remained in their original private homes, Vuillard's patrons were highly mobile and not bound by tradition.

Looking at the evolution of Vuillard's decorative career from the work for the Natansons to that for the Bibescos and Bernstein, it seems he gradually became more aware of the need for flexbility in his themes, broadening them and painting in formats that could more readily be transferred from one interior to another. Perhaps, indeed, he learned to negotiate these concerns with his patrons so that the probability of change was built into his conception at the outset. This would help explain the crossovers between the *Place Vintimille* works for Henry Bernstein and the very similar theme used in the screen for Marguerite Chapin. Rather than allowing the interior to dictate completely his conception, Vuillard may have experienced the need to work in the direction of his artistic interests in general, which were evolving towards a greater naturalism. Nor did he fall into the trap of painting as design for the total interior recommended by the art-nouveau enthusiasts. Vuillard's only direct association with the unified decorative interior of art nouveau was, as seen above, the result of a later decision to incorporate an earlier *décoration* into a modern-style home in western Germany, which Vuillard never knew. Although Vuillard's name is frequently mentioned as a precursor of the art-nouveau movement in the early nineties, his statement to Van de Velde in 1906, that he was "not very enthusiastic about the productions of the so-called *modern style*," indicates his position on the fringes of that artistic wave.[31]

An assessment of the two phases of Vuillard's decorative career covered by this and Segard's study attests less to his achievement in bringing about a change in interior decoration at the end of the century than to his commitment and contribution to modern aesthetics. Whether it be in the symbolist-inspired panels for the Natansons and Vaquez interiors, or the portrait-like and highly impressionist works he developed later for the Bibescos and Bernstein, or the extraordinarily ambitious and complex picture-allegory for the future Princesse di Bassiano, Vuillard never stopped questioning the conventional precepts for the scale, technique, and subject appropriate to modern decoration. On 26 April 1912, a day before his retrospective closed, he dined with Alexandre, Thadée, and Fred Natanson and noted that night in his journal his renewed excitement and sense of discovery: "at last, understanding of the question of color *à propos décoration*."[32] And yet, as late as January 1938, while working on his decorative painting *Comedy* (*La Comédie*) for the Théâtre de Chaillot (Trocadéro), Vuillard noted his impressions anew, remarking on the walls, which he felt demanded clear colors, and the influence of Puvis de Chavannes and Veronese, concluding: "*Décorations*. Something different than easel painting!"[33]

Unlike Denis, who codified and developed a more formulaic decorative style based on classical and biblical themes, Vuillard continued to innovate compositionally and thematically in his search for the appropriate decorative expression for his different patrons. While the early decorative projects were, in Segard's words, "intellectualized" and inaccessible to the larger public, as Vuillard's own audience grew beyond the borders of the Natanson and *Revue Blanche* circle to that of the cosmospolitan *haut bourgeois* Bernheims and Hessels, his style changed, resulting in more expansive, open, and light-filled compositions which blurred the boundaries of decorative, portrait, and genre painting.

Although Blanche termed Vuillard the "painter of the Parisian interior," the majority of his patrons, as shown, were non-French and non-Catholic. Perhaps Vuillard's attraction for these people was his very rootedness in the French tradition, and his sensitivity to people, places, and things that were synonymous with French material and cultural wealth. It is interesting, too, that with the exception of Misia and Marguerite Chapin, all of his patrons were male, yet his style was frequently referred to as "feminine." Although he managed to transcend the fallacy inherent in the French tradition of monumental painting, which for Van de Velde was always undermined by a certain "boudoir quality," his small and large-scale works were, according to Van de Velde, essentially *intimiste* and thus lay outside the sweeping monumentality of a *décoration* by Matisse or the heroic gesture of a mural by Hodler.[34] It is true that Vuillard never received commissions for the formal ensembles in palatial residences such as that of the Prince de

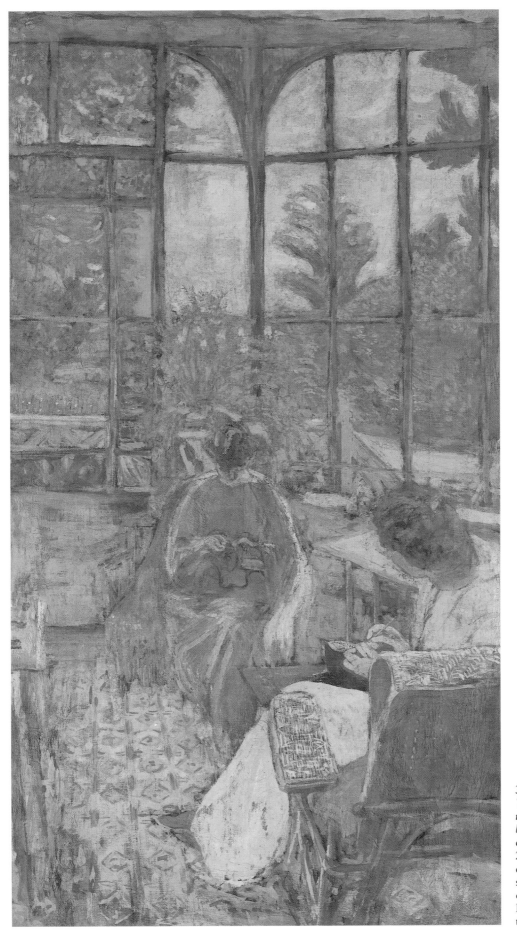

329 Edouard Vuillard,
*Two Women Embroidering
under a Veranda (Deux femmes
brodant sous une véranda)*,
distemper on canvas,
200 × 90 cm., Musée
d'Orsay, Paris. One of the
seven decorative panels
commissioned for Bois
Lurette, the summer home of
the Bernheim families.

Wagram in Paris or Ivan Morosoff's Moscow residence which Denis, Matisse, Roussel, and even Bonnard would be asked to decorate. Nor was he ever commissioned to make panels for the Bernheims' majestic and aristocratically furnished *hôtel* in the Passy district, as were Bonnard and Roussel. Instead, he was commissioned in 1911 and 1912 by his dealers to paint seven large (almost all eight feet) panels for their summer home, Bois Lurette, at Villers-sur-Mer where they did not want to leave "real" paintings (pl. 329). Yet in this temporary residence, the Bernheims chose Vuillard because they desired, like Sacha Guitry, who borrowed *Sunny Morning* for his temporary stage interiors, color, lights, and art that would provide a "home-like" atmosphere.[35]

To twentieth-century eyes, which could not have seen Vuillard's paintings in the interiors that have been described throughout this study, it is not the ensemble but the internal workings of the individual paintings – seen in these large-scale canvases in which space is flattened by complex, nuanced color fields and abstracted forms – that render them intelligible as *décorations*. They are not only decorative but they communicate through color, anticipating in many ways the quiet and evocative surfaces of Monet's late murals of the waterlilies, and, later, the canvases of the color-field painters. Like Rothko, who explained that he used monumental canvases because he wanted his painting to be "intimate and human,"[36] Vuillard created mural-size *décorations* of relatively mundane subjects – city streets and parks, seamstresses, women in interiors, and bourgeois leisure indoors and out-of-doors – to express a much more complex and ambitious concern for the possibilities of the painted surface as both backdrop and prime object for a specific urban dweller.

It was the relationship and collaboration, in varying degrees, depending on the commissioner – whether close friends like the Natansons or clients like Henry Bernstein – that made these projects possible. All were intended for a distinct personality and setting. The success of these works outside those settings attests to Vuillard's ability to adapt but not subordinate his art to what he understood about that location.

It was the subsequent physical changes in these spaces, the moves from one apartment to another, and the consequent weakening of the ties – in many cases between the family-like relationships that for Vuillard were all important – that eventually led to the dispersal of the panels from their original settings and, as has been shown, from their intended meanings.

Epilogue

Vuillard's only other one-man retrospective after the one of 1912 was held in May–June 1938 (a few months after he let himself be elected to the Académie des Beaux-Arts[37]) in the Pavillon Marsan at the Musée des Arts Décoratifs. Exhibited were over three hundred works, including many panels from different decorative projects, by this time dispersed and listed under new owners.[38] Four years later, on the occasion of Roussel's gift to the state of a small collection of Vuillard's paintings and studies, the writer and statesman Paul Morand gave a fitting testimony to the merit of the decorative paintings from the first twenty years of the artist's career:

> It is said that his drawings, watercolors, and pastels currently exhibited at the Orangerie are the prefiguration of a room devoted to Vuillard at the Musée d'Art Moderne. For the moment, they are more a comment than a life's work. A Vuillard room would have to have the large panels that mark the height of his genius, those owned by Claude Anet, Antoine Bibesco, Vacquez [*sic*], Natanson, and Léon Blum. Let us hope they will not cross the waters.[39]

Although Morand's wish that Vuillard's decorative panels be reunited in a French museum was never realized, today whether in public or private collections, the works are vital both for an understanding of Vuillard's aspirations to make a new kind of painting that would be appropriate decoration for the modern interior, and, as Blanche had prophesized in 1913, as valuable documents of an epoch.[40]

Notes

Introduction

1 Société du Salon d'Automne, *Catalogue de peinture, dessin, sculpture, gravure . . .*, Grand Palais des Champs-Elysées, Paris (18 October–25 November 1905):

> nos. 1595 –6 panneau décoratif (paysage avec figures)
> nos. 1597 –1600 panneau décoratif (figures dans un intérieur à Vaquez)
> no. 1601 motifs de la décoration de table (appt. à M. Jean Schopfer)

2 See Jean Leymarie, *Fauves and Fauvisme*, trans. of *Le Fauvisme* [Paris, 1959] (Geneva and New York: Skira and Rizzoli, 1987), p. 62.

3 ". . . une révélation pour les jeunes par un fresquiste à la hauteur de sa prestigieuse réputation" (Louis Vauxcelles, *Gil Blas* [27 May 1905]). It is interesting that Vauxcelles used the term *fresquiste*, or painter of frescos. Henry Havard, aesthetician, social historian, and Director of the Ecole des Beaux-Arts, who will be further discussed in the course of this book, stated that the word was not known outside Emile Littré's *Dictionnaire de la langue française* (1863); see Havard, *Dictionnaire de l'ameublement et de la décoration depuis le XIIIe siècle jusqu'à nos jours*, rev. enl. ed. (Paris: Maison Quantin, Librairies-imprimeries réunies, 1888), v. 2, p. 966.

4 Camille Mauclair, "Le Salon d'Automne," *Revue Bleue: revue politique et littéraire*, v. 4 (21 October 1905), p. 523: "Je ne connais pas un décorateur plus doué. Auprès de tous ces peintres M. Edouard Vuillard contraste par ses dons vraiment admirables . . . M. Vuillard, M. Bussy, Mlle. Dufau, sont à peu près les seuls ici à rappeler cette notion du goût dont personne ne semble avoir souci, et qu'on sacrifie à un désir de violence, de tapage, sans résultat d'ailleurs, car cette débauche d'effets rouges, bleus, jaunes et violets, qui d'abord surprend l'oeil et donne en ce Salon l'illusion de la richesse de coloris, finit par lasser et équivaut à une grisaille par la monotonie des brutalités chromatiques." See also the two-page satirical illustration of the most notable or notorious entries in the Salon, in *L'Illustration*, v. 21 (1 November 1905), p. 291, repr. in Yann Le Pichon, *Le Monde du Douanier Rousseau* (Paris: Laffont, 1981), p. 152.

5 P.-J. Toulet, "Au Salon d'Automne," *La Vie Parisienne* (11 November 1905).

6 In the second Salon d'Automne (1904), Vuillard had exhibited two monumental canvases under the collective title *Verdures*, executed in 1899 for Adam Natanson. See Société du Salon d'Automne, *Catalogue de peinture, dessin, sculpture, gravure . . .*, Paris (15 October–15 November 1904), nos. 1287–8. Although they were twice the size of the

panels exhibited in 1905, they received surprisingly little critical attention. For discussion of the paintings, see below, ch. 6.

7 See above, n. 1.

8 Purchased from the Salon d'Automn, 1903, for the Musée du Luxembourg and transferred from the Musée National d'Art Moderne to the Louvre in 1977 (RF 1977-363).

9 *Les Nourrices* (*The Nursemaids*), *La Conversation* (*The Conversation*), and *L'Ombrelle rouge* (*The Red Sunshade*). See below, ch. 3.

10 Achille Segard, *Les Peintres d'aujourd'hui: les décorateurs*, 2 vols. (Paris; Ollendorf, 1914), v. 1: Albert Besnard, Gaston La Touche, Jules Chéret, Paul Baudouin; v. 2: Henri Martin, Aman-Jean, Maurice Denis, Edouard Vuillard. Of the painters chosen for Segard's study, only Maurice Denis was part of the original group of artists who had studied together at the Académie Julian in 1888–90. His work, stemming from the theories of Sérusier via Gauguin will be further discussed in the succeeding chapters, especially as they compare with Vuillard's work in the decorative genre. Most of the artists Segard included were represented in the Musée du Luxembourg and were known for their public decorative projects. Aman-Jean's speciality was women and flowers; Gaston La Touche popularized an updated version of the *fêtes galantes*; and Jules Chéret was the undisputed master of the poster-art translated into paintings for many private and public residences, including the Hôtel de Ville and the department store of Le Printemps. Henri Martin, a prolific and often-commissioned decorator, worked in a relaxed pointillist style for important public projects, such as the Hôtel de Ville, the Sorbonne, and the Capitole de Toulouse. Martin's murals for the latter are compared with Vuillard's commissioned landscapes for Adam Natanson below, ch. 6, pp. 131–2.

11 See Segard's book on the literary symbolists, *Itinéraire fantaisiste* (Paris: Ollendorf, 1899). See also his articles on contemporary painters and decorators: "Lucien Simon," *International Studio*, v. 47 (1912), pp. 89–101; "Fresques inédites de Puvis de Chavannes," *Arts* (March 1914).

12 In his journal for 19 April 1913 (see below, n. 17, for explanation of the journal), Vuillard mentions Segard's visit to his studio, noting, "vieux souvenirs" – possibly after an interview with Segard. That he was aware of Segard's writing is confirmed by his journal entry for 7 June 1914 (after publication of Segard's book), "article d'A. Segard sur moi rappelle préoccupation d'autrefois" (Journal, MS 5397, *carnet* 3).

13 Segard, *Les Peintres d'aujourd'hui*, 1914, v. 2, pp. 247–303, 320–2. See also Juliet Bareau, "Edouard

Vuillard et les Princes Bibesco," *Revue de l'Art*, no. 74 (1986), p. 46, for an annotated version of Segard's inventory.

14 Several more general studies have been published on Vuillard's decorative projects, including Rosaline Bacou, "Décors d'appartements au temps des Nabis," *Art de France*, v. 4 (1964), pp. 196–205, and James Dugdale, "Vuillard the Decorator – The First Phase: The 1890s," *Apollo*, v. 36 (February 1965), pp. 94–101, and his "Vuillard the Decorator – Last Phase: The Third Claude Anet Panel and the Public Commissions," *Apollo*, v. 68 (1967), pp. 272–7. For two important studies of specific commissions, see Claire Frèches-Thory, "Les *Jardins Publics* de Vuillard," *Revue du Louvre*, v. 4 (1979), pp. 305–12 (written on the occasion of the Radot donation of two paintings from the series: *Les Fillettes jouant* [RF 1978-46] and *L'Interrogatoire* [RF 1978-47]); and Bareau, "Vuillard et les Princes Bibesco," 1986, pp. 37–46.

15 Soon to be available is the catalogue raisonné in preparation by Vuillard's great-nephew, Antoine Salomon. This will cover the artist's *oeuvre* in all media, together with a study of the correspondence and photographs (after 1895) by the artist, the majority of which has remained in the family archives, hereafter referred to as Salomon Archives.

16 Recent Vuillard scholars who have consulted Vuillard's journals for their studies include: Belinda Thomson, *Vuillard* (New York: Abbeville Press, 1988); Elizabeth Easton, *The Intimate Interiors of Edouard Vuillard*, exh. cat., Museum of Fine Arts, Houston (Washington, D.C.: Smithsonian Press, 1989–90); Anne Dumas and Guy Cogeval, *Vuillard*, exh. cat., Musée des Beaux-Arts, Lyon (Paris: Flammarion, 1990–1); Belinda Thomson, *Vuillard*, exh. cat., Glasgow Art Gallery and Museum, Kelvingrove (London: The South Bank Centre, 1991–2).

17 MS 5396: "croquis et esquisses au crayon et à la plume; notes," 2 vols (v. 1: 1890; v. 2: 1890–1905); MS 5397: 9 *carnets*, 1907–16; MS 5398: 11 *carnets*, 1924–6; MS 5399: 13 *carnets*, 1929–40. These will be cited as "Journal," followed by the manuscript number, *carnet* number, and page number (when indicated), recto or verso. There are also several loose pages which will be indicated with their corresponding manuscript and notebook number. I am grateful to Antoine Salomon for having allowed me to consult the typed transcripts in the Salomon Archives to compare with Vuillard's often indecipherable handwriting.

18 Vuillard reread and annotated his journals throughout his life. He frequently underlined the decorative projects in blue or red pencil, as though signalling them as his most important artistic activities. Frustrating are his omissions, his use of

209

a single letter for proper names, and his unflagging discretion when referring to his personal and professional life.

19 Typescript manuscript of genealogy for the Vaquez, Bénard and Delavallée families, by Mme Jean Guillois, daughter of Mme René Bénard, second cousin to Dr. Vaquez (dated 25 November 1977) p. 1.

1 The Nabis, the Decorative Aesthetic, and the Circle of La Revue Blanche

1 See Thadée Natanson, "Vuillard as I knew Him," Eng. trans. and abridgment of two articles on Vuillard in his *Peints à leur Tour* (Paris, 1948), in John Russell, *Vuillard* (Greenwich, Conn.: New York Graphic Society, 1971), pp. 105–17, esp. p. 110.

2 Thomson, *Vuillard*, 1988, p. 10.

3 See Easton, *Intimate Interiors*, 1989, pp. 27–8. See also Claude Roger-Marx, *Vuillard: His Life and Work*, trans. E.B. d'Auvergne (London: Editions de la Maison Française, 1946), p. 9, and Patricia Ciaffa, *The Portraits of Edouard Vuillard*, diss., Columbia University (Ann Arbor: University Microfilms International, 1985), pp. 191–2.

4 Easton, *Intimate Interiors*, 1989, p. 67.

5 Roger-Marx, *Vuillard*, 1946, p. 17.

6 Russell, *Vuillard*, 1971, p. 12.

7 Roussel married Marie, Vuillard's older sister; see Jeanne Alice Gass Stump, *The Art of Ker-Xavier Roussel*, diss., unsigned, University of Kansas (Ann Arbor: University Microfilms International, 1983), pp. 49–50. Professor Stump is the only scholar who has provided a context for Roussel, who was not only a relative to Vuillard but an integral member of the Nabi movement and a catalyst for their group.

8 Jacques Salomon, *Auprès de Vuillard* (Paris: La Palme, 1953), p. 19, cites his conversation and walk with Vuillard, and how the artist stopped dead in his tracks to point out the exact spot at the passage du Havre where he had made his decision. Later, it would be Vuillard who would see Roussel through his many marital and emotional problems; see below, ch. 4, p. 67.

9 Ciaffa, *Portraits* 1985, pp. 13–18, Stump, *Roussel*, 1972, p. 50, is unique in stating that Vuillard was too poor to attend the regular day classes at Maillart's studio and so took advantage of the Gobelins night classes.

10 Roger-Marx, *Vuillard*, 1946, p. 22, and Ciaffa, *Portraits*, 1985, p. 15.

11 Roger-Marx, *Vuillard*, 1946, p. 11, claims Vuillard was frightened off by the barrack-like atmosphere of Gérôme's studio. Roger-Marx cites two charcoal nudes done during a brief period of lessons under Gérôme. Perhaps one of these is the academic male nude charcoal drawing in the collection of the Art Institute of Chicago. On the verso is a very sensitive chiaroscuro charcoal drawing of his mother's aunt, Saurel (acc. no. 1979.651). See also Pierre Veber, "My Friend Vuillard," trans. from the French (*Nouvelle Revue Française*, April 1938), in Russell, *Vuillard*, 1971, p. 100.

12 Journal, MS 5396, *carnet* 2, p. 12r. For what follows concerning Vuillard's student training, see Thomson, *Vuillard*, 1988, pp. 12–18, *et passim*. See also Vuillard's early (1888) commentaries on the Louvre collection from Cranach to Millet, in Easton, *Intimate Interiors*, 1989, Appendix B: "Vuillard's Visits to the Louvre," p. 145.

13 See Société des Artistes Français, *Explication des ouvrages de peinture, sculpture, architecture, gravure et lithographie* (Paris: Paul Dupont, 1889), no. 3946, and *Catalogue illustré du Salon des Artistes Français* (Paris: Librairie d'Art Ludovic Basket, 1889), no. 3946, "Portrait." Vuillard is listed at 10 rue de Miromisnil and as a student of Bouguereau and Robert-Fleury but not of Gérôme. It was customary for an art student to sign his professor's name, and it was perhaps due to the solid academic reputations and position of his instructors at both institutions (who were also committee directors for the Société des Artistes Français) that his early drawing was accepted. See also another version of his grandmother's portrait in John Russell, *E. Vuillard: Drawings, 1885–1930* (New York: Arts Federation, 1974), n.p., "Grandmother Michaud," dated 1885, (?)pastel, 48 × 40 cm. For a discussion of the politics of the art studio at this time, see John Milner, *The Studios of Paris: The Capital of Art in the Late Nineteenth Century* (New Haven and London: Yale University Press, 1988), esp. pp. 49–50, 119.

14 Salomon, *Auprès de Vuillard*, 1953, p. 20. Roussel, who was one year older than Vuillard, opted to volunteer for his military service in exchange for a reduced term. Thomson, *Vuillard*, 1988, p. 18, explains Vuillard's later introduction to Serusier's group by the independent studios and their different locations.

15 George L. Mauner, *The Nabis: Their History and their Art, 1886–1896* (New York and London: Garland Publishing, Inc., 1978), pp. 58–9.

16 Inscribed, "Fait en octobre 88 sous la direction de Gauguin par Paul Sérusier à Pont Aven," 27 × 22 cm., unsigned, Musée de la Prieuré, Saint-Germain-en-Laye. The dialogue between Sérusier and Gauguin was published by Denis (as "Maud") for the first time in *L'Occident* (October 1903), p. 160.

17 Maurice Denis, "L'Epoque du symbolisme," *Gazette des Beaux-Arts*, v. 11 (March 1934), p. 165.

18 Or "Nebiim" for the plural, according to Dom Willibrod Verkade, *Yesterdays of an Artist-Monk*, trans. John L. Stoddard (New York: P.J. Kennedy & Sons, [1930]), p. 72. Robert Wang's dissertation on the Nabis and graphic art claims that it was Sérusier who chose the name Nabi at the suggestion of his poet friend, Auguste Cazalis, who drew it from "Nebiim," used in Ledrawn's *Historie d'Israël*; see Robert Wang, *The Graphic Art of the Nabis 1888–1900*, diss., University of Pittsburgh, 1974 (Ann Arbor: University Microfilms International, 1984), p. 34. Although the original artists at the Académie Julian had been meeting since November 1888, it was not until Vuillard and Roussel joined the group that they gave themselves a name and began treating themselves as a secret society; see Mauner, *The Nabis*, 1978, pp. 6–7.

19 Ranson's wife, France, known as the "Lumière du Temple," was the only woman permitted at these meetings.

20 Agnes Humbert, *Les Nabis et leur époque* (Geneva: P. Caillier, 1954), pp. 40–1, 44. Thus Denis was the "Nabi aux belles icônes," Bonnard "the Nabi Japonard," because of his love of everything Japanese and his incorporation of Japanese asymmetry and colors into his own works, and Sérusier the "Nabi à la barbe rutilante." Roger-Marx, *Vuillard*, 1946, p. 12, explains Vuillard's sobriquet, "Nabi Zoave," as an allusion to his "unkempt *barbiche*," and perhaps because it was red like the trousers of the Zoaves.

21 "Je t'envie quand tu parles d'un nouveau frère [E. Vuillard] que Jahve a dirigé vers nous. Qu'il soit le bienvenu. Je rêve pour l'avenir d'une confrérie épurée uniquement composée d'artistes persuadés, anxieux du beau et du bien, mettant dans leurs oeuvres et leur conduite le caractère indéfinissable que je traduis par Nabi. Je suis sûr que tu me comprends" (Paul Sérusier writing to Denis in the summer of 1890, in Sérusier, *ABC de la peinture suivi d'une correspondance inédite* [Paris: Librairie Floury, 1950], p. 40).

22 Mauner, *The Nabis*, 1978, p. 52, n. 35.

23 With the exception of Vuillard, Bonnard, and Denis, the Nabis came from upper-middle-class backgrounds. Auguste Cazalis, Paul Percheron, Henri Ibels, Paul Ranson, Sérusier (heir to the wealthy Houbigant family), and Georges Lacombe (a sculptor who joined the Nabi group after 1892) did not need to live off their art productions. See Humbert, *Les Nabis et leur époque*, 1954, pp. 63 and 103 *passim*.

24 Journal, MS 5397, *carnet* 1 [1905], p. 77v, cited in Easton, *Intimate Interiors*, 1989, Appendix A: "Vuillard's Chronologies," p. 143. In November 1908, perhaps in view of the exhibition he was planning at the Bernheim-Jeune gallery, Vuillard jotted down a skeletal chronology for his life, begining in November 1885 with his graduation from the Lycée Condorcet.

25 Vuillard's summary for his twenty-second year lists: "Sérusier rue Miromesnil [where his family had moved], mansarde, atelier de Ranson" (Journal, MS 5396, *carnet* 2, p. 78r, in Easton, *Intimate Interiors*, 1989, Appendix A, p. 143).

26 In December 1888, Vuillard noted having received Mang[uin] and Waro[quy] in his home (Journal, MS 5396, *carnet* 1, p. 20r; see Easton, *Intimate Interiors*, 1989, p. 143). (Although Easton does not indicate illustrations, in the actual *carnet*, the listing is accompanied by perspectival diagrams and a sketch of a seated figure [Waroqui?].) In his chronology for 1889, Vuillard lists "Portrait Waroquy dans la chambre de bonne maman" (Journal, MS 5397, *carnet* 8, p. 12, November 1908), and in 1889, "Portrait Waro. dessin salon" (Journal, MS 5396, *carnet* 2, p. 77v). Vuillard's juxtaposition of himself and his friend in this painting is similar to that in Degas's photograph of Renoir and Mallarmé, in Antoine Terrasse, *Degas et la photographie* (Paris: Denoël, 1983), p. 38, no. 12.

27 Letter to Denis in Rome, 19 February 1898, in Denis, *Journal* (Paris: La Colombe, Editions du Vieux Colombier, 1957), v. 1, p. 137, first published and trans. in Roger-Marx, *Vuillard*, 1946, p. 19: "J'ai une horreur ou plutôt une peur bleue des idées générales auxquelles je ne suis pas arrivé par moi-même, mais je ne nie pas leur valeur."

28 "Ce qui doit m'occuper réellement: la production d'une idée en oeuvre d'art. Son *existence* en effet sera le *produit* d'une *idée* (sensation et mecanisme *méthodique*). Il faut donc avoir une méthode pour la production dont on ne peut *connaître* par avance les résultats. Entendons-nous. Je dois *imaginer*, voir, les lignes, les couleurs que je pose et rien faire au hasard, cela est parfaitement juste. je dois reflechir toutes mes combinations. Mais justement pour la possibilité de ce travail, il me faut une méthode dont je suis convaincu. J'ai toujours travaillé *au hasard* et sûrement [illegible word] ceux-ci ne sont pas mon oeuvre uniquement à cause de *ce hasard*, les dessins de l'Observatoire, les programmes du T.L. [Théâtre Libre], les dessins de la pantomime s'ils ont une personnalité c'est malgré moi, et je fais tout pour les tuer. faute d'intelligence parce qu'il n'y a rien d'absolu dans nos théories. C'est une grâce." Journal, MS 5396, *carnet* 2, p. 22v: 2 October 1890). Vuillard's reference to the Observatoire is to the National

School of Theater and the training ground for the Théâtre Français, the theatrical equivalent of the Ecole des Beaux-Arts. It may refer also to the Théâtre de Bodinière (named after the Secretary General to the Théâtre Français), a rehearsal space for new plays and new talents.

29 Humbert, *Les Nabis et leur époque*, 1954, pp. 40–62, *et passim*; see also Wang, *The Graphic Art of the Nabis*, 1984, p. 38.

30 See Aurélian Lugné-Poe, *Le Sot de tremplin; Souvenirs et impressions du théâtre*, v. 1 of *La Parade* (Paris: Librairie Gallimard NRF, 1930) 4th ed., p. 41. By October 1890, he had already designed at least two program covers. In one of these, thought to be the artist's first essay at lithography for Maurice Biollay's one-act play *Monsieur Bûte*, Vuillard's deliberate primitivizing and expressive lines recall Van Gogh's pen-and-ink drawings and the zincographs of Gauguin and Bernard from the "Volpini Suite" of 1889 (reproduced and catalogued in Boyer, *The Nabis and the Parisian Avant-Garde*, 1988, p. 147, no. 149). The popular actor and creator of the role of Cyrano, Coquelin Cadet (Ernest Coquelin [1848–1909]) was also a popular salon guest at at Nina de Villard's salon, where he knew Mallarmé and Degas; see Sophie Monneret, *L'Impressionisme et son epoque: dictionnaire international illustré* (Paris: Denoël, 1979), v. 2, p. 444. With Coquelin Cadet's assistance, Vuillard was able to have a small showing of his works; see letter from Maurice Denis to Lugné-Poe in his *Le Sot du tremplin*, 1930, Appendix, p. 251.

31 Russell, *Vuillard*, 1971, pp. 25–6, *et passim*.

32 In the early summer of 1890, Denis reported to Sérusier Lugné-Poe's concerns that they gain a public image: "Il insiste pour qu'il y ait un mouvement d'ensemble: il souhaite que nous réunissions nos études dans un local (comme ton atelier, qui est à proximité du boulevard, si cela se pouvait?) pour les montrer, non au public, mais à un public très spécial. Il s'étonne, avec son bon sens pratique, de nos scrupules, de notre peur d'affirmer des oeuvres incomplètes" (Sérusier, *ABC de la peinture*, 1950, p. 51).

33 The entire essay was published in two parts under the pseudonym Pierre Louis in the issues of 23 and 30 August of *Art et Critique* (1890). "Se rappeler qu'un tableau avant d'être un cheval de bataille, une femme nue, ou une quelconque anecdote est essentiellement une surface plane recouverte de couleurs en un certain ordre assemblées" (Pierre Louis [Maurice Denis], "Définition du néo-traditionnisme," *Art et Critique* [23 August 1890], p. 540). For a cogent assessment of Denis's "Théories" in the context of cubism and expressionism in the next decades, see Joseph Mashek, "The Carpet Paradigm: Critical Prolegomena to a Theory of Flatness," *Arts Magazine*, v. 51, no. 1 (September 1975), pp. 93–5.

34 *Ibid.* See also Robert Herbert, "The Decorative and the Natural in Monet's Cathedrals," in John Rewald and Frances Weitzenhoffer, *Aspects of Monet*, papers presented at a symposium held in Paris, September 1981) (New York: Harry N. Abrams, Inc., Publishers, 1984), pp. 161–75, and Steven Levine, "Decor/Decorative/Decoration in Monet's Arts, v. 51 (February Art," 1977), pp. 136–9.

35 "La peinture murale veut d'autres habitudes et des façons différentes: avec elle tous les petits mérites de clair-obscur, de transparence, et de touche, disparaissent: une belle ordonnance, un grand style, une couleur simple et mate, voilà ce qu'elle exige . . ." (Théophile Gautier, *L'Art Moderne* [Paris, 1856] v. 2, cited in George Manning

36 Tapley, *The Mural Paintings of Puvis de Chavannes*, diss., University of Minnesota, 1979 [Ann Arbor: University Microfilms International, 1981], pp. 56–7).

Puvis de Chavanne's landscapes with figures were often described as "ideal landscapes," or "*paysages élyséens*," without comment on the figural subject matter. See A. de Champeaux, *Histoire de la peinture décorative* (Paris: Librairie Renouard, Henri Laurens, Editeur, 1890), p. 343, referring to the artist's mural for the *Grande salle des récompenses* of the "Nouvelle Sorbonne." Puvis de Chavanne's works done with a soft palette were referred to as *peintures décolorées* and his easel and decorative paintings were described as *murales, fresques,* and *peintures monumentales*. Denis's painting *Homère parcourant les champs*, a student work from 1889, embodies the ideas about line and form in "Théories," and at the same time bears a striking resemblance to Puvis de Chavanne's panel for the cycle *The Life of Saint Geneviève*, destined for the Panthéon, exhibited in 1876, and reproduced as an example of "modern mural painting" in de Champeaux's *Histoire*, 1890, p. 341.

37 Armand Silvestre, "Exposition de la rue de Peletier," *L'Opinion Nationale* (2 April 1876), cited in Levine, "Decor/Decorative/Decoration in Claude Monet's Art," 1977, p. 136.

38 Félix Fénéon, "VIII Exposition impressionniste," *La Vogue* (13–20 June 1886), reprinted in his *Oeuvres plus que complètes*, ed., Joan U. Halperin (Geneva: Librairie Droz, 1970), v. 1, p. 45.

39 For the terms impressionism and symbolism as they were perceived by artists and art critics and their relationship to decorative principles, see Richard Shiff, *Cézanne and the End of Impressionism: a Study of the Theory, Technique, and Critical Evaluation of Modern Art* (Chicago and London: The University of Chicago Press, 1984). For an excellent and concise definition of terms bandied about by the symbolists of the late 1880s and 1890s, see Vojtech Jirat-Wasiunynski, "Paul Gauguin's Paintings, 1886–1891: Cloisonism, Synthetism, and Symbolism," *RACAR*, v. 9 (1982), pp. 35–46.

40 "La déformation objective, qui s'appuyait sur une conception purement esthétique et décorative, sur les principes techniques de colorations et de composition, et la déformation subjective qui faisait entrer dans le jeu la sensation personnelle de l'artiste." The artist was allowed to exaggerate, emphasize, or reduce for the better expression of his feeling: "Avant d'extérioriser ses sensations telles quelles, il faudrait en déterminer la valeur, du point de vue de la beauté." (*Art et Critique* [23 August 1890], p. 541).

41 Mashek, "The Carpet Paradigm," 1975, p. 82.

42 As Mashek termed it, the move towards flatness emphasized the "reality of the surface" (*ibid.*, p. 95).

43 A similar definition was expressed by the art critic, Edouard Rod in his review of Puvis de Chavanne's works exhibited at the Salon Nationale des Beaux-Arts in 1891: 'At first the décorative quality was only sought in certain limited situations, when it was required by the destination of the canvases themselves. It was then modified in the most radical way: It seemed no longer to look for its effect in the richness of movements, but in their simplicity; not in the complication of lines, but in their majesty; not in the contrast of colors, but in their harmony." See Edouard Rod, "Les Salons de 1891," *Gazette des Beaux-Arts*, v. 5 (1891), pp. 447–8, cited and trans. in Tapley, *The Mural Paintings of Puvis de Chavannes*, 1981, p. 183.

44 So successful was this painting that Denis was asked to make copies for the playwright Jules Claretie and art critic Gustave Geffroy; see Suzanne Barazzetti-Demoulin, *Maurice Denis* (Paris: Grasset, 1945), p. 142. See also Mauner, *The Nabis*, 1978, p. 214.

45 "Pourquoi ce souci encore, quel sera mon genre? Il ne sera pas, il est. Et qu'est-ce que ce genre que veut dire ce mot, que met-on là-dessous. Denis par exemple est un mystique. L'impression de son oeuvre aboutit à ce mot commode; mais le mot ne fait rien c'est qu'il n'est qu'un signe grossier, plus le signe sera général, de métaphysique, plus il sera juste. A-t-il [Denis] conscience de cette opinion des autres en travaillant, non car alors il reproduirait telle ou telle extériorité d'une de ses oeuvres qu'il sait donner cette impression. Détestable manie de classer artificiellement dans les cases mal visibles dont on n'a que de fausses idées" (Journal, MS 5396, *carnet 2*, p. 32r: 2 April 1891). It is interesting that both artists secretly envied each other's work. In the fall of 1890, Denis wrote to Lugné-Poe, "J'envie le bonheur de Vuillard qui ne fait que la peinture qu'il veut, et cependant en tire profit. Ceci en confession secrète" (Lugné-Poe, *Le Sot de tremplin*, 1930, Appendix, p. 254).

46 Gauguin had already left for Tahiti, and Verlaine, refusing to take the seat of honor, sulked outside the theater. See Gertrude Jasper, *Adventure in the Theatre: Lugné-Poe and the Théâtre de l'Oeuvre to 1899* (New Brunswick: Rutgers University Press, 1947) p. 54. *L'Intruse* was acted out by members of the Théâtre d'Art and Lugné-Poe for the Odéon. Other perfomances included Verlaine's one-act play *Les Uns les autres*, with actors from the Comédie Française and Odéon; Charles Morice's *Cherubin*; Catulle Mendès's *Le Soleil de Minuit*, a monotone recitation of Mallarmé's translation of *The Raven* by Edgar Allen Poe and a recitation by Paul Mounet of Baudelaire's *Fleurs de Mal*. For two varying views of the performance, see Hippolyte Lemaire, "Théâtre Vaudeville: Représentation au bénéfice de MM. Paul Verlaine et Paul Gauguin," *Le Monde illustré* (30 May 1891), p. 431, and Gaston Calmette, "Pour Verlaine et Gauguin," *Le Figaro* (14 May 1891), p. 2. Unfortunately, this set, like all Vuillard's projects as a set designer, has been destroyed. For the best discussion of Nabi theater projects, see Geneviève Aitken, "Les Peintres et le théâtre français autour de 1900 à Paris," Ph.D. diss., Université de la Sorbonne, 1976, Archives de l'Ecole du Louvre (esp. pp. 15–37 and 190–1), and her most recent *Artistes et Théâtres d'Avant-Garde: Programmes de Théâtre Illustrés 1890–1990*, exh. cat., Musée de Pully, 1991.

47 "Un peu de littérature est une grande aide – Nécessité du sujet littéraire (sens décadent Verlaine) pour parfaire l'oeuvre: impression devant la nature que pour définir il faudra un symbole soit littéraire soit pictural et qui ne peut s'exprimer simplement par l'énumération des objets qui l'ont [?] déterminé" (Journal, MS 5396, *carnet 1*, p. 20v: 6 September 1890, illustrated with decorative borders, perhaps preliminary designs for theater programs).

48 See George L. Mauner, "Vuillard's Mother and Sister Paintings and the Symbolist Théâtre," *Arts Canada*, v. 28 (December 1971–January 1972), pp. 124–6.

49 It was Denis who arranged this exhibition space for his group to show a modest number of works in a small room adjacent to larger rooms dominated by the oil paintings, tapestries, miniatures, and other *objets d'art* of the arch-academic Edouard Detaille and his group, the Cercle de l'Union Artistique (familiarly called "Mirlitons"). For a

thorough analysis of this group and their installation strategies, see Martha Ward, "Impressionist Installations and Private Exhibitions," *The Art Bulletin*, v. 73 (December 1991), pp. 605–8. Besides proximity and familiarity with the site (the Denis family lived in that suburb), Denis may have favored the contrast that his group's showing of small oil paintings, pastels, pen-and-ink book illustrations, theater programs, and decorative paintings would make with Detaille's painting of *The Last Germinal of the 10th Regiment of Hussards, 1812*. According to Denis, the exhibition was a success, with Vuillard, Ibels, Ranson, and himself receiving the most critical attention. Writing to Lugné-Poe about the exhibition, Denis boasted, "I have already described to you, about the small corner where we were placed, in good light, and discreetly apart. I've also told you that this little room was always full, and that the success of the exhibition was for us. It is necessary to add that the press was also as welcoming as possible. The most remarked upon painters are: Vuillard, Ibels, you and me" (30 September 1891, in Mauner, *The Nabis*, 1978, Appendix, p. 65). See also the letter from Ranson (*ibid.*, p. 69), who described the exhibition to Verkade as a mixed success with no real financial benefit.

50 Gustave Geffroy, "De Paris à Saint-Germain-en Laye," *Journal des Artistes*, v. 10 (September 1891), p. 303.

51 Georges Roussel, "Les Impressionnistes-symbolistes à l'exposition de Saint-Germain," *La Plume*, no. 59 (1 October 1891), p. 341. Lugné-Poe was also called to submit a review in Jean Jullien's *Art et Critique* which repeated nearly word for word the essay by Roussel, which had actually been written for Roussel by Denis; see Lugné-Poe, *Le Sot de tremplin*, 1930, pp. 213–14.

52 Félix Fénéon, "Quelques peintres idéistes," *Le Chat Noir* (19 September 1891), p. 202. Alphonse Germain sarcastically dubbed the Nabis "jeunes déformateurs" and "synthésophiles" (referring to their adherence to the "synthetist" school of artists at Pont-Aven) in a special September number of *La Plume*; see Alphonse Germain, "Théories de déformateurs: exposé et réputation," *La Plume*, v. 3 (1 September 1891), pp. 289–90 *passim*.

53 "Galerie de Le Barc de Boutteville, catalogue de la 3ème exposition des peintres Impressionnistes et synthétistes," in Theodore Reff, (ed.), *Post-Impressionist Group Exhibitions* (New York and London: Garland Publishing, Inc., 1982), n.p.

54 ". . . très, très curieuse exposition des 'nouveaux peintres' (s'il faillait les étiqueter, je dirais *harmonistes*): Maurice Denis, Bonnard, Vuillard, Cérusier [*sic*] – Des 'vieux' comme Signac se tiennent assez bien.–Intéressant, intéressant, mais à quand le chef-d'oeuvre?" (Thadée Natanson, "Petite Gazette d'Art: Expositions," *La Revue Blanche* v. 2 [January 1892], p. 64).

55 'Ces nouveaux venus qui sentent enfin que l'art doit être exclusivement personnel et décoratif et qui sortent de la tradition pour revenir à un vague état primitif qui apporterait, s'ils réussissaient, une heureuse diversion dans la banalité de nos Expositions annuelles" (Octave Uzanne, "Les Idées du jour et les choses d'art," *L'Art et l'idée: Revue contemporaine de la dilettantisme littéraire et de la curiosité*, v. 1 [January 1892], p. 74).

56 G[eorge] Albert Aurier, "Le Symbolisme en peinture: Paul Gauguin," *Le Mercure de France* v. 2 (March 1891), translated in Marla Prather and Charles F. Stuckey, *Gauguin: A Retrospective* (New York: Hugh Levin, 1987), p. 156.

57 In February, for example, Ranson, Sérusier, Bonnard, and Vuillard collaborated on the backdrop for a performance of Rimbaud's *Le Bateau Ivre* at Paul Fort's Théâtre d'Art (15–25 January 1892); cited in Mauner, *The Nabis*, 1978, pp. 87–8.

58 "Paul Séruzier [*sic*] abandonne le tableau pour la décoration. Il s'est décidé à couvrir de fresques tous les murs qu'on lui confiera" (in Remy de Gourmont, "Choses d'art," *Le Mercure de France* [June 1892], p. 186, cited in Carole Boyle-Turner, *Paul Sérusier* (Ann Arbor: UMI Research Press, 1980), p. 82). Sérusier did decorate the studio of Georges Lacombe in Versaille in February, 1893 (see Musée des Jacobins, *Paul Sérusier*), and painted murals for the dining-room of his mistress, Gabriela Zapolska, in 1894 and 1895; see Boyle-Turner, *Paul Sérusier*, 1980, p. 100. These were unpublicized and possibly unpaid commissions.

59 "M. Sérusier se prétend, lui aussi, symboliste et son symbolisme consiste à plaquer sur des fonds de muraille ou à entasser dans ses paysages dénués de perspective des personnages tous au même plan.

"M. Sérusier me dira qu'il en a le droit et qu'il se réclame uniquement de l'art décoratif . . . Or M. Sérusier n'a fait jusqu'ici que des tableaux. Qu'il se conforme aux nécessités du tableau" (Thiébault-Sisson, "Chez le Barc de Boutteville," *L'Echo de Paris*, no. 3 [December 1893], p. 2).

60 "J'imagine assez nettement, le rôle du tableau dans la décoration de la maison moderne. Soit un intérieur précieusement disposé par un peintre de goût comme Pierre Bonnard: avec des meubles de style neuf et des tentures de dessin imprévu; un intérieur clair, simple, et plaisant, ni un musée, ni un bazar. A certaines places, mais en petit nombre, des tableaux de dimensions convenables et d'effet approprié. Je les veux de noble apparence, de beauté rare et fabuleux: qu'ils ajoutent au luxe des colorations et des arabesques sans âme, la poésie de la vie intérieure: et qu'on y trouve tout un monde d'émotions esthétiques, pures sans doute d'alliages littéraires et d'autant plus hautes" (Pierre Louis [Maurice Denis], "Notes sur l'exposition des Indépendants," *La Revue Blanche*, v. 3 [April 1892], p. 232).

61 Deborah Silverman, "The Paris Exhibition of 1889: Architecture and the Crisis of Bourgeois Individualism," *Oppositions*, no. 8 (Spring 1977), pp. 72–91. Beginning with the triumph of the Eiffel Tower at the 1889 Exposition Universelle, Silverman traces the changes in social values which posed the problem, "how an ethos of privacy on a mentality of individualism were to respond to the challenge posed by the advent of a new world of technological structures" (p. 89).

62 Deborah Silverman, *Art Nouveau in Fin-de-Siècle France: Politics, Psychology and Style* (Berkeley: University of California Press, 1989), pp. 9–10. Whereas in the previous decade the aesthetic ideologies of the Third Republic's administration encouraged the decoration of government institutions such as *mairies* (city wards), hospitals, universities, and the great Hôtel de Ville project which employed a pantheon of accredited Salon artists, after the Exposition Universelle in 1889 (marked by the greatest public monument of all, the Eiffel Tower), the decade of the 1890s was characterized by an ideological and aesthetic standpoint calling for modern art forms that addressed themselves to the abstract notions of privacy and interiority.

63 On the "reformed Salon," see T. de Wyzewa, "Le Nouveau Salon du Champs-de-Mars," *L'Art dans les deux mondes* (13 June 1891), pp. 39–41.

64 "Rien ne révèle mieux la somme de goût d'une société que les cadres où se déroulent les existences; eh bien, qui se soucie aujourd'hui de styliser sa demeure, de lui imprimer un caractère d'ensemble? Qui attache importance à l'homogénéité de l'ameublement? à la concordance des tentures, des tapis et des fleurs, à l'affectivité de leurs nuances? Qui proscrit les objets de toilette à l'ornementation banale? Combien il mériterait de l'Art le Mécène qui tenterait de fomenter un mouvement de retour au décoratif! Ils sont encore quelques dévoués qui n'attendent qu'une occasion de mettre leur talent au service de pareille cause; les grouper avec les rares initiés au langage des lignes fournirait les éléments d'une exposition de la décoration de l'intérieur . . . Si le goût n'est pas éteint en notre race, quelle manifestation le peut mieux éveiller?" (Alphonse Germain, "La Décoration de l'Intérieur," *L'Ermitage* [March 1892], pp. 65–7). Although Germain promoted a new role for painting, he deplored the tendency to imitate the *décorations* of, for example, Puvis de Chavannes or to pass off large history paintings as *décorations*: "Or, une toile n'est pas décorative parce que kilométrique, et le marouflage ne fait pas la fresque, cette 'baie sur l'idéal' . . . pas plus que les figures *vetues en colonnes* ne constituent le bas-relief" (*ibid.*, p. 67).

65 See, for example, Roger Marx's important article, "L'Art industriel au prochain salon," *Le Voltaire* (15 September 1892): "C'en est fait, désormais, de la vaine distinction entre les Beaux-Arts et les arts décoratifs ou industriels. Quiconque poursuit dans quelque domaine que ce soit la réalisation du beau, fait de l'art et mérite le titre d'artiste . . ." For Marx's ideologies and a "social art," see Silverman, *Art Nouveau in Fin-de-Siècle France*, 1989, pp. 9–10.

66 Roger Marx, "Les Arts décoratifs et industriels aux Salons du Palais de l'Industrie et du Champs-de-Mars," *Revue Encyclopédique*, v. 1 (September 1891), p. 588.

67 *Ibid.*, pp. 586–7. See also Victor Champier's favorable response to Gauguin's ceramics in "Les Arts fraternels au Salon du Champ-de-Mars," *Revue des Arts Décoratifs*, v. 12 (1891–2), p. 14. Ironically, Gauguin, always conscious of the press, must not have seen the reviews of the objects he prized as much as he did his paintings. "To think," he wrote Daniel de Monfreid from his new home in Mataiea in late spring/early summer 1892, "that I was born to practice an art trade and that I could not succeed. Windows, furniture, faience, etc. My real aptitudes are for these things rather than for painting in the strict sense of the word" (in Maurice Malingue, ed., *Paul Gauguin: Letters to his Wife and Friends*, trans. Henry J. Stenning [Cleveland and New York: The World Publishing Company, 1949], p. 174).

68 See affirmation of those attitudes and how they contributed to art nouveau in Silverman, *Art Nouveau in Fin-de-Siècle France*, 1989, ch. 7, "Esprit Nouveau: Politicians, Amateurs and Artisans," pp. 134–41, et passim.

69 Silverman points out that the Crafts Union of the 1860s, headed by Roger Marx and other enlightened Republicans, dropped the word "Industriel" from their name in the early 1880s to disassociate their production from the idea of manufactured and thus, morally and aesthetically inferior work; *ibid.*, pp. 110–11.

70 Spire Blondel, *L'Art intime et le goût en France* (Paris: Ed. Rouveyre et G. Blond, 1884). Blondel, who praised the de Goncourts' *Maison d'un Artiste*, was a member of the Union Centrale des Arts Décoratifs, and, like Blanc, was a principal contributor to the *Gazette des Beaux-Arts*. He was also the author of *L'Histoire des éventails, Dictionnaire*

des arts décoratifs, and *Les Arts décoratifs pendant la revolution*.

71 Havard's treatise was recommended by Roger Marx as the starting point for breaking down the arbitrary lines between high and decorative arts. Yet his assessment, first published in *Le Voltaire* (19 November 1890) and excerpted in Champier, "Les Arts fraternels au Salon du Champ-de-Mars," 1891–2, p. 6, shows that his appreciation was based on the influence of the treasury of the past on modern style, not the innovations of the present.

72 My introduction to this term came from an unpublished paper given by Nancy Troy, "Interiorization in French Art and Design of the 1890s," at a CAA session, "Images of Public and Private Life in European Art" (San Francisco, California, 27 February 1981), which Professor Troy kindly made available to me.

73 See Rosalind H. Williams, *Dream Worlds: Mass Consumption in Late Nineteenth-Century France* (Los Angeles and London: University of Chicago Press, 1982), esp. pp. 107–53. See also Ward, "Impressionist Installations and Private Exhibitions," 1991, pp. 605–18, for descriptions of installations by (male) gallery owners and artists conceived to imitate a domestic environment.

74 ". . . les chercheurs, les enthousiastes du Beau"; it promised to present "du neuf, de l'inédit, de l'exquis, de l'extraordinaire, du recherché pour ses dilettantes lecteurs" (Uzanne, préface, *L'Art et l'Idée* [January 1892], p. i).

75 Letter to Verkade (4 February 1892), in Mauner, *The Nabis*, 1978, Appendix, p. 279. Note the meaning of "Nabi" has been extended to anyone sharing their views or joining their weekly meetings. By 1892, the group that exhibited together at the Le Barc de Boutteville gallery had grown to include Verkade's friend from Copenhagen, Mogen Ballins, Félix Vallotton, and the sculptor Georges Lacombe.

76 Commentary preceding Pierre Veber, "My Friend Vuillard" (trans. from his "Mon Ami Vuillard," in *Les Nouvelles Littéraires* [30 April 1938]), in Russell, *Vuillard*, 1971, p. 99.

77 "Lent, corpulent et grave" (Léon Daudet, *Au Temps de Judas*, cited in A.B. Jackson, *La Revue Blanche, 1889–1903: Origine, influence, bibliographie* [Paris: M.J. Minard, 1960], p. 29).

78 "Un homme séduisant" (Annette Vaillant, "Livret de famille," *L'Oeil*, no. 24 [December 1956], p. 32).

79 *La Dame de la Mer* was first performed at the Théâtre Libre in December 1892; see Russell, *Vuillard*, 1971, p. 31.

80 For the Natansons' earliest involvement with theater, see Aitken, *Artists et Théâtres d'Avant-Garde*, 1991, p. 51.

81 See Jackson, *La Revue Blanche*, 1960, pp. 3–15. The magazine was first printed in Liège and edited out of the family residence of Alfred's classmate Paul Leclerq in Paris, on the Champs-Elysées.

82 Correspondence with Annette Vaillant, daughter of Alfred Natanson, 14 February 1985. See also her *Le Pain polka* (Paris: Mercure de France, 1974), p. 65, and "Livret de famille," 1953, pp. 32–3, in which she refers to her uncles as "Alexandre the Great" and "Thadée the Proud," and to her father as "Alfred the Good." At the Lycée Condorcet Thadée had known Mallarmé and had become a faithful "Mardist," or attender of Mallarmé's Tuesday *salons*. He had also been initiated in Hegel and the Russian realist novelists of the nineteenth century. See also the description in *Bonnard, Vuillard et les Nabis, 1888–1903*, Musée National d'Art Moderne, Paris, 1955, no. 31, and

Jackson, *La Revue Blanche*, 1960, pp. 29 and 60.

83 Alfred also went under the pseudonyms "Amerillot" and "Jean Lureau"; see *ibid.*, p. 30. Described as the most modest and good-natured of the Natansons, he became Vuillard's close friend after 1891, and it was Vuillard who introduced him to his future wife, the actress Marthe Mellot; see Vaillant, *Le Pain polka*, 1974, p. 75.

84 A fourth son, Léon, committed suicide at the age of twenty-three; see Jackson, 1960, p. 31. According to Annette Vaillant, her grandfather, Adam, met his future wife, the sixteen-year-old Annette, at Odessa; see Vaillant, "Livret de famille," p. 25.

85 Vaillant, *Le Pain polka*, p. 65, and her "Livret de famille," pp. 24–35. Because the brothers were basically *hommes des lettres*, their biographies are difficult to trace. Useful for this study were Alexandre's nomination papers for the Légion d'Honneur, Archives Nationales (S.I. 162 BB₃₃ 49, "Candidatures, 1875–1909, avocats").

86 See Jackson, *La Revue Blanche*, 1960, pp. 5, 146.

87 Mallarmé, for example, was later to dub *La Revue Blanche* the friendly magazine, "l'amicale à tous prête, *Revue Blanche*"; see Stéphane Mallarmé, "Variations sur un sujet," cited in Henri Mondor, *Vie de Mallarmé* (Paris: Gallimard NRF, 1941), p. 773.

88 "Très simplement, nous voulons développer ici nos personnalités et c'est pour les préciser par leurs complémentaires d'admiration ou de sympathie que nous sollicitons respecteusement nos maîtres et que nous accueillons volontiers de jeunes" (*La Revue Blanche*, v. 1 (October 1891), p. 1, English trans. in Bret Waller and Grace Seiberling, *Artists of La Revue Blanche*, exh. cat., Memorial Art Gallery of the University of Rochester, 1984, pp. 30–4).

89 "A La Revue blanche . . . c'était le snobisme élégant et même poseur; on n'avait parlé que de courses et de réceptions" (Henry Bordeux, *Histoire d'une vie*, as quoted in Émilien Cardon, *Le Snobisme et les lettres françaises de Paul Bourget à Marcel Proust, 1884–1914* [Paris: Librairie Armand Colin, 1966, p. 176, n. 24]).

90 ". . . des imposants et snobs Natansons – on était rosse, chic et plein d'ambitions boulevardières" (Camille Mauclair, *Servitude et grandeur*, quoted in Jackson *La Revue Blanche*, 1960, and cited in Cardon, *Le Snobisme et les lettres françaises*, 1966, p. 176, n. 24).

91 ". . . jusqu'à l'anarchisme élégant. Milieu intelligent, riche en éléments d'arrivisme, littérairement aussi stérilisant que compréhensif" (*ibid.*).

92 For the artists of the magazine, see Waller and Seiberling, *Artists of La Revue Blanche*, 1984, and George Bernier, *La Revue Blanche: Paris in the Days of Post-Impressionism and Symbolism* (New York: Wildenstein Foundation, 1983). The latter provides valuable visual information about the household of Thadée Natanson that is especially important for a study of Vuillard's 1895 project for Thadée. See also Evelyn Nattier-Natanson, *Les Amitiés de la "Revue Blanche" et quelques autres* (Vincennes: Les Editions du Donjon, 1959), pp. 61–70, for an introduction to the Natansons' review.

93 "Extrait du procès verbal inédit de la vente exposé" [23 February 1891] in *Exposition Centennaire de Gauguin*, Orangerie des Tuileries, Paris, 1949. The paintings purchased were: *Les Lutteurs*, by Alfred Natanson for 250 france (p. 10 [p.v. no. 22]); *Etude de femme* (tableau), by Alfred for 250 francs (p. 9 [p.v. no. 10]); *Les Baigneurs*, by Alexandre for 360 francs (p. 9 [p.v. no. 11]); and *Le Petit ruisseau*, by Alexandre for 250 francs (p. 10 [p.v. no. 27]).

94 See for example, André Gide's remarks on the literary and artistic role of *La Revue Blanche*: 'Il n'est sans doute aucun peintre, aucun écrivain de réelle valeur aujourd'hui reconnu qui ne doive aux frères Natanson et à Félix Fénéon un ample tribut de reconnaissance." Cited in Jackson, *La Revue Blanche*, 1960, p. 5. Gide's personal opinion of the Natanson brothers, however, was not always as generous; see below, ch. 3, pp. 48, 65.

95 This was to be Vuillard's only one-man show until 1906. See Lucien Muhlfeld, "Notes sur la peinture," *La Revue Blanche* (June 1893), p. 459, comparing Vuillard's paintings from 1893 with his earlier works. Muhlfeld stresses that Vuillard is not a mystique nor a literary symbolist, and that his subjects are not less real than a Dutch or Flemish master: 'Ceux qui virent la seule exposition un peu considérable de ses peintures à l'ancienne *Revue Blanche* [first location on the rue des Martyrs], s'en souviennent: c'était *Le Chocolat, La Couturière rouge, La Femme aux chiffons, La Lampe*." Muhlfeld's remarks are of interest in view of Vuillard's first important decorative commission in 1892 for the Desmarais, in which he reconceived the theme of dressmaking; see below, ch. 2.

96 See above, n. 60.

97 Thadée Natanson, "Petite Gazette d'Art: Expositions," *La Revue Blanche*, v. 2 (January 1892), p. 64.

2 Women at Work and at Play

1 Correspondence with Annette Vaillant, 14 February 1985. One of Romain Coolus's earliest articles for the Natansons' magazine, "Il trouva de la pitié," was dedicated to Stéphane; see *La Revue Blanche* (January, 1893), pp. 154–8.

2 According to the Hungarian artist Josef Rippl Ronaï, it was Stéphane rather than Thadée who did the most for the Nabi artists in the beginning; see Jozsef Rippl-Ronaï *Emlekezesei* (Budapest: Szepirodalmi Konyvkiado, 1957), p. 57, cited in Mauner, *The Nabis*, 1978, p. 86. This statement, however, by an artist who was a latecomer to the Nabi group, is not born out by other evidence.

3 Verkade, a Dutch Protestant, was baptized as a Catholic at Saint Wolff in Belgium in the summer of 1893 and on 29 April 1894 Verkade began his study as a noviate at the Monastery of Beuron, Germany. Among those associated with the Nabi circle who converted to Catholicism were the literary symbolists Adolphe Retté, J.-K. Huysmans and Paul Claudel and painters Mogen Ballins (1893) and Paul Percheron (1892, who later returned to Protestantism). See Humbert, *Les Nabis*, 1954, pp. 54–9 *et passim*. For Verkade and Ballins's conversion, see Verkade, *Yesterdays of an Artist-Monk*, 1936, pp. 159–62.

4 "Vuillard a terminé des grands panneaux pour le salon des Natanson; à mon avis ils sont tous les 6 très bien. Quel effort, quel travail pour Vuillard" (letter from Ranson to Verkade, [October–November] 1892, cited in Mauner, *The Nabis*, 1978, "Appendix," p. 282).

5 "Bonnard est toujours très Japonard pour les *pelichtim*, très personnel pour ceux qui comprennent: en ce moment il termine deux panneaux décoratifs sur étoffe molletonnée d'un très curieux effect. Le Nabi en mission à Tahiti écrit une longue lettre à Kallyre Ben [Auguste] Cazalis au sujet de photographies envoyées . . . je viens de recevoir la visite de Mr. Prange de la Grafton Galerie de Londres qui m'invite à exposer en Angleterre: Roger Marx a fait paraître sur nous un grand article dans *La Revue encyclopédique*. Je

t'envoie 3 des dessins reproduits. Denis vient de livrer au peintre Lerolle un fort joli petit plafond destiné à l'hôtel de cet académique barbouilleur . . . Fort bien tes petites icônes de chez Boutteville. Son exposition n'est pas encore ouverte'' (*ibid.*, p. 282).

6 Roger Marx, "Mouvement des arts décoratifs," *La Revue Encyclopédique*, v. 2, no. 45 (15 October), 1892, p. 1488.

7 *Ibid.*, p. 1488. According to Ted Gott, the Nabis would have known Redon since the older artist frequented the Barc de Boutteville gallery and attended the literary dinners of the "Tête de Bois" where Sérusier and Denis were often guests (correspondence, 11 June 1989).

8 See "Procès verbal de la vente de tableaux de Paul Gauguin" (Hôtel Drouot, Paris, 23 February 1891), in *Exposition Centenaire de Gauguin*, 1949, p. 10, [p.v., no. 23]. Roussel's purchase for 280 francs, *Les Petites filles*, was made on behalf of Vuillard, Henri Roussel [Ker-Xavier's half-brother, a doctor], the architect Frédéric Henry, composer Pierre Hermant, Paul Percheron and Julien Magnin, brother of Albert. The painting was later passed among the Nabis' studios and apartments. Roussel seems to have inherited it (letters from Frédéric Henry to Vuillard, 20 October 1905 and 24 December 1905, in the Salomon Archives, Paris. Gauguin was always politely condescending towards the Nabis, referring to them as "les collegiens" in a preface for the exhibition of Armand Seguin at the Barc de Boutteville gallery; see the reprint of the preface in "Armand Seguin," *Mercure de France*, v. 13 (February 1895), p. 223.

9 Though Ranson referred to him as an "academic dauber," Lerolle was commissioned for a number of public mural projects, including the Hôtel de Ville and the Scholarum Cantorum (Music Conservatory). He would later suscribe to the rabidly antisemitic magazine, *Le Ralliement*; see Thomson, *Vuillard*, 1988, p. 60. For the conservative Catholic intellectual circle to which both Lerolle and Denis belonged, see Marlais, *Conservative Echoes*, 1992, pp. 209–19.

10 Segard related how, at the beginning of Vuillard's career, Marx admired the pastels and oil studies of nudes in Vuillard's studio and purchased several (*Les Peintres d'aujourd'hui*, v. 2, p. 302, n. 1). For the collection of Arsène Alexandre, see Galerie Georges Petit, *Catalogue des tableaux modernes: aquarelles, pastels, dessins . . .* (Paris, 18–19 March 1903), nos. 74–9. See also Segard, *Les Peintres d'aujourd'hui*, 1914, v. 2, p. 302, n. 1, who asserts that Jos Hessel, Vuillard's future dealer, also acquired several of Vuillard's early works in about 1892. Hessel did not, however, befriend the artist until later.

11 Mme Pauline Mélanie Chenie, property-owner and businesswoman, 166 boulevard Haussman. The offices of Desmarais Freres operated first out of her home and subsequently at 42 rue des Mathurins ("Acte de la Société 'Desmarais Frères,' microfilm 261 (130/AQ/104), Archives Nationales, Paris").

12 "Acte de la Société," 23 July 1891, for Paul's contribution of one million francs to the association. Another sister, Marthe Boutheroüe Desmarais, married to M. Stefan Ribes, Stockbroker (*assise d'agent de change*), living in the Desmarais family *hôtel privée* at 166 boulevard Haussman, joined as a new associate in July 1897 (*ibid.*, "Prorogation de la Société 'Desmarais Frères', Document no. 4, 5 July 1897").

13 Paul was also an active member of committees in the Ministry of Commerce, with subsidiary refineries and depôts in Spain, and in 1900 participated on the Committee for the Exposition Universelle with an exhibition of mineral oils, commended for its artistic touch. See his letter of recommendation and nomination for the Légion d'Honneur, Paris, "Candidature-industriels, (1859–1909), document dated 8 August 1900, S.I. 162 BB³³ 87, Archives Nationales, Paris.

14 Correspondence with Annette Vaillant, 25 September 1988.

15 Misia Sert, *Misia* (Paris: Gallimard, 1952), p. 56. The name "Desmarais" does not appear in any of the new subscriptions to *La Revue Blanche*, for example. Curiously, there is a "Mme Stéphane Natanson," which may be a conflation of two names from the same family. Stéphane's father's name was Simon; see "Liste des abonnements" (1 October 1891 and 1 January 1892), n.p.

16 For an introduction to the influence of businessmen-entrepreneurs to art patronage in the mid- to late nineteenth century, see Albert Boime, "Entrepreneurial Patronage in Nineteenth-Century France," in Edward C. Carter, Robert Forster, Joseph Moody (eds.), *Enterprise and Entrepreneurs in Nineteenth- and Twentieth-Century France* (Baltimore: The John Hopkins University Press, 1976), pp. 137–91, esp. pp. 144–72. Malcolm Gee's otherwise comprehensive study of the *mécènes* of the first third of the twentieth century, *Dealers, Critics, and Collectors of Modern Painting: Aspects of the Parisian Art Market Between 1910 and 1930* (New York and London: Garland Publishing, Inc., 1981), esp. pp. 154–204, does not mention Jewishness as a factor in art and commerce during the late nineteenth and early twentieth centuries.

17 "Où est l'industriel qui voudra bien s'ajoindre le precieux concours de ces decorateurs, pour leur prendre un peu de temps qu'ils se consacrent a faire beaucoup trop de tableaux?" (Pierre Louis [Maurice Denis], "Pour les jeunes peintres," *Art et Critique* [20 February 1892], p. 94).

18 It was at the turn of the century that the wealthy financiers and industrialists portrayed in Zola's fiction, gained power among the blue-blood and old-money families, encouraged by their inter-marriage with daughters of the new rich, and, as Henry James and Edith Wharton would record, in particular with wealthy American entrepreneurs; see James Laver, *Tastes and Fashions from the French Revolution until Today* (London: George G. Harrap & Co., 1937), pp. 98–100.

19 Segard, *Les Peintres d'aujourd'hui*, 1914, v. 2, p. 320.

20 Roger-Marx, *Vuillard*, 1946, p. 120.

21 "92 – hiver triste, dessins et pochades, dessus de porte Desmarais. Kerr et Caro [another artist] Voyage en Belgique, Hollande et Londres." *Journal* MS 5396, carnet 2, p. 78 recto. *Pochade* translates as an oil sketch but can be considered a rapidly painted work complete in itself, as these large-scale oils are.

22 For *La Farce du pâte*, Vuillard painted backdrops of Paris in the middle ages. Verkade gives the account of the evening which was preceded by a lot of rehearsals, at the Coulon residence, 86 rue de la Faisanderie. "Since the actors were only little marionnettes, Sérusier, his brother and the daughter of the director Lamoureux read the text aloud. Sérusier and Vuillard had made the decorations for the little stage, and I had painted the curtain. Since State Consellor lived in Passy, the preparations and rehearsals consumed much time; but the representation was a great success . . . ," Verkade, *Yesterdays of an Artist-Monk*, 1936, p. 122; See also Humbert, *Les Nabis*, 1954, pp. 106–10.

23 See Boyer, *The Nabis*, 1988, no. 154.

24 See *Edouard Vuillard – K.-X. Roussel*, exh. cat. (Paris: Orangerie des Tuileries, 1968), nos. 209–10.

25 See Tapley, *The Mural Paintings of Puvis de Chavannes*, 1981, pp. 181, 183, *et passim*.

26 For a discussion on the fashion plate and popular imagery in *fin-de-siècle* illustrated magazines, see Valerie Steele, *Paris Fashion: A Cultural History* (New York and Oxford: Oxford University Press, 1988), pp. 122–32.

27 These were the same costumes that had been executed by France Ranson and Vuillard's sister, Marie. See Humbert, *Les Nabis*, 1954, p. 149 and fig. 43.

28 See Thomson, *Vuillard*, 1988, p. 40, who makes this comparison for Vuillard's *Public Parks* series of panels. On 13 July 1894, Vuillard wrote of his admiration for this painting: "Retour par la Salle Lacaze [see below, n. 29], Quel plaisir devant de la peinture décidément cela me plaît à coeur. La réunion dans un parc! . . ." (Journal, MS 5397, carnet 1, p. 43, reprinted in Easton, *Intimate Interiors*, 1989, "Appendix B," p. 146).

29 The La Caze collection, bequeathed to the Louvre in 1869 by Dr. La Caze, showcased French paintings of the time of Louis XIV and the rococo period, with some paintings by Tintoretto, Velázquez, and Ribera. Vuillard later painted a decorative ensemble for the Swiss collector Bauer in which this gallery features prominently; see Charlotte Thornton, "*Au Louvre*: The Creative Process of Edouard Vuillard," M.A. thesis, University of Texas at Austin, 1989. Vuillard may also have seen the other collections of eighteenth-century art, especially the Watteaus in the Wallace collection, which were housed in part in the Bagatelle in the Bois de Boulogne until 1890. For further discussion on Vuillard's park subjects, see below, ch. 3.

30 See Laver, *Tastes and Fashions*, 1937, "The New Woman," pp. 94–5: "There were ultra-refined dandies [in the 1890s] like the Comte de Montesquiou and women who walked about with flowers in their hands, with scarves on their shoulders, and hair dressed *à la Botticelli*. There was a preference for the fluid line, broken curves, forms of drooping plants such as the lily and the convolvulus – all, in fact, that goes to make up the elements of *l'art nouveau*." Of course, one can also think of Manet's *Woman with a Parakeet*, Whistler's *Princesse de porcelaine*, and many of the women painted by Alfred Stevens, for similarities in attire and coiffure. In the majority of scenes of the aestheticized female, however, the women confront the viewer or are engaged in a narrative scenes, whereas Vuillard's women are turned completely away or in three-quarter view. See also a description of the nondescript "tea-gown" and its popularity at the turn of the century in Steele, *Paris Fashion*, 1988, pp. 189–91.

31 Bing's revue, *Le Japon Artistique*, subtitled *Documents d'Art et d'Industrie*, featured large plates of Hiroshige and Utamaro prints; see Gabriel Weisberg, *Japonisme: Japanese influence on French Art, 1854–1910* (Cleveland Museum of Art, 1975), p. 3. Prints were available also through the *grands magasins* such as Le Printemps and Galeries Lafayette. For the Nabis' collections of Japanese prints and sketchbooks, see Ursula Perruchi-Petri, "Les Nabis et le Japan," *Japonisme in Art: An International Symposium*, Society for the Study of Japonisme (Kodansha International, Ltd., 1980), p. 3. Perruchi suggests that Toyokuni, Kunisada, Kuniyoshi, and Gakutei served as Vuillard's inspiration for patterned backdrops against patterned

costumes of figures.

32 G[eorge]-Albert Aurier, "Les Symbolistes," *Revue Encyclopédique*, v. 2 (April 1892), pp. 474–86. See catalogue for exhibition and Vuillard's entries: 180, *Déjeuner*; 181, *Sous la lampe*; 182, *Femme couchée*; 183, *Ravadeuses*; 185, *Effet du soir* (pastel); 186, *Figure de Femme* (watercolor); see "Catalogue de l'exposition de peintres impressionnistes et symbolistes, (3ème)," in Theodore Reff (ed.), *Post-Impressionist Group Exhibitions* (New York and London: Garland Publishing, Inc., 1982), n.p.

33 For the symbolists' use of "mystère," see Robert Goldwater, *Symbolism* (New York: Harper and Row, 1979), pp. 115–97.

34 For a discussion of the "aestheticized women," see Robin Spencer, *The Aesthetic Movement* (London: Studio Vista, 1972), pp. 7–44.

35 Gustave Geffroy, "Chez le Barc de Boutteville," v. 2, p. 378, in his *La Vie Artistique* (Paris: E. Dentu, 1893).

36 The February–March exhibition of the Salon de la Rose + Croix, featured Alexandre Séon, Ferdinand Knopff, Carlos Schwabe, Aman-Jean, Henri Martin, and Armand Point, all of whom specialized in the depiction of ethereal and mysterious women; see John Rewald, *Post-Impressionism: From Van Gogh to Gauguin* (New York: The Museum of Modern Art distributed by Doubleday & Co., 2d ed., 1962), p. 462.

37 For an overview of the seamstress trade in the last three decades of the nineteenth century, see Easton, *Intimate Interiors*, 1989, pp. 26–35.

38 See Louise A. Tilly and Joan W. Scott, *Woman, Work and Family* (New York: Holt, Rinehart & Winston, 1978), p. 50. The combination of rapid urbanization and slow industrialization produced special working conditions, high rents, and low incomes for the working classes that resulted in the "persistance, indeed expansion, of the traditional household." See George D. Sussman, "The End of the Wet-Nursing Business in France, 1874–1914," in Robert Wheaton and Tamara A. Haraven (eds.), *Family and Sexuality in French History* (Philadelphia: University of Pennsylvania Press, 1980), p. 247.

39 See above, ch. 1, p. 5. For a history of the *grands magasins* beginning in 1872 with Au Bon Marché, see Robert Burnand, *La Vie quotidienne en France, 1870–1914* (Paris: Hachette, 1947), p. 176; see also Michael B. Miller, *The Bon Marché: Bourgeois Culture and the Department Store, 1869–1920* (Princeton, N.J.: Princeton University Press, 1981), pp. 190–1, for the causes and effects behind the rise to power of the larger department stores in the nineteenth century and the first quarter of the twentieth century. According to Miller's thesis, the smaller independent shopkeepers banded together against the mass bureaucratic consequences of department stores. As one disgruntled consumer lamented, "We have arrived at a day when precut clothes are less expensive than uncut cloth . . . In the past a dress a woman made was like her biography. Now . . . the same design and the same cut of clothing cover women who certainly are not of the same upbringing, that is to say, of the same soul . . ." ("Les Grands bazars", *Le Figaro*, 23 March 1881, cited in *ibid.*, p. 192).

40 See, in particular, Easton, *Intimate Interiors*, 1989, pp. 26–55.

41 See, for example, Vuillard's lithographs of Marie and her mother in Claude Roger-Marx, *L'Oeuvre gravée de Vuillard* (Monte Carlo: Sauret, [1948]), nos. 8, 9, 10.

42 Compare, for example, this figure with an oil-on-canvas painting, *La Couturière* (St. Louis Art Museum, 78.1975) described in St. Louis Art Museum, *Bulletin* (March–April 1976), pp. 22–3.

43 ". . . examiner l'idée que j'ai déjà suffisamment de quoi m'occuper des années entières à développer et utiliser mettre en oeuvre d'art tout ce que j'ai dans mes cahiers et cartons." Interestingly, he added after this passage "(influence toujours de Denis)," as though Denis were the catalyst for the idea of revising from the objective world; see Journal, MS 5396, *carnet* 2, pp. 55v (ill.), 56r.

44 Many woman preferred to work for a larger store from *ateliers*. These were not considered store employees; see Miller, *The Bon Marché*, 1981, p. 193. The women were not boarded in their workplace (as were other woman in the garment-making industry) and thus may have been allowed to take their children with them; see Theresa M. McBride, "'Woman's Work': Mistress and Servant in the Nineteenth Century," in Briston D. Gooch (ed.), *Proceedings of the Third Annual Meeting of the Western Society for French History* (December 1975) (Lubbock: Western Society for French History at Texas A & M University, 1976), pp. 390–7.

45 Sometimes workers were unmarried mothers. In such cases, the child was generally sent to a relative's home or to a wet nurse outside the city; see Sussman, "The End of the Wet-Nursing Business in France," 1980, pp. 224–8. In another painting by Vuillard, *Le Petit livreur* (1892, oil on cardboard, 39 × 24 cm., private collection), the child can be identified as a schoolboy wearing the black apron once worn by all schoolboys. Since he carries fabric or a garment, he can be considered an insider to the workshop; see reproduction in Salomon, *Vuillard*, 1968, p. 52.

46 According to Gee, *Dealers, Critics, and Collectors*, 1981, p. 158, the term *corsetier* was understood as a profession combining "servility and servitude," allowing constant contact with the wealthier social classes.

47 For Signac's painting based on a scene from a naturalist novel, *Apprêteuses et garneuses (Finishers and Trimmers)*, see Françoise Cachin, *Paul Signac*, trans. Michael Bullock (Greenwich, Connecticut: New York Graphic Society, [1982]), pp. 23, 26.

48 Shuttlecock is the children's game originating in the eighteenth century. Badminton (also translated as *volant*) was an invention by an Englishman in 1882, and only later introduced to France; see *The New Encyclopedia Britannica: Micropaedia* (Chicago/Auckland/Geneva, and others: Encyclopaedia Britannica, Inc., 1988) 15th ed., v. 1, p. 786. The awkward pose of the little girl in the panel *A Game of Shuttlecock* is repeated in a rare color lithograph, *La Petite fille au volant* (one state only), 1899, in Roger-Marx, *L'Oeuvre gravée*, [1948], no. 46.

49 Barbara McManus, *Royal Palaces and Parks of France* (Boston: L.C. Page & Co., 1910), p. 130.

50 Pierre Larousse, *Grand Dictionnaire universel du XIXe siècle* (Paris: Librairie Larousse, 1873), v. 14, p. 1030. Sports were late to come to France. The first organized game of *longue paume* (the closest to our modern tennis) was played in the Jardin des Tuileries in July 1889, presided over by President Adolphe Carnet (d. 1894). Sports became part of the school curriculum only in the late 1880s with the reforms of Jules Simon, who began the Union for Sports (1881). Not until November 1890, did the Lycée Condorcet establish the "Fondation de la Société d'exercices physiques du Lycée Condorcet"; see *Encyclopédie des Sports* (Paris: Librairie de France, 1925), pp. 128, 159.

51 See Eugen Weber, *France: Fin de siècle* (Cambridge, Mass. and Oxford: Belknap Press of Harvard University Press, 1985), pp. 197–204 *passim*.

52 Vuillard's intimist *décoration* can be compared also to Fernand Knopff's large-scale pastel *Memories*, exhibited at the Exposition Universelle in Paris in 1889, which showed seven young women (all portraits of his sister) holding tennis rackets in an atmosphere of hushed silence; see Jeffrey W. Howe, *The Symbolist Art of Fernand Knopff*, rev. diss., 1979 (Ann Arbor: UMI Research Press, 1982), pp. 75–84, *et passim*. Bourgeois games were also themes enjoyed by the impressionists. One can think of Manet's *La Partie de Croquet* (1871) which showed relatives and friends arranged in a frieze-like composition. This was exhibited at the Manet retrospective held in the Durand-Ruel galleries in 1883 and was among those refused by the Fine Arts administration from the Gustave Caillebotte bequest in 1894, see Denis Rouart and Daniel Wildenstein, *Edouard Manet: Catalogue raisonné*, 1975, v. 1: *Peintures* (Lausanne and Paris: Bibliothèque des Arts, 1975), p. 154, no. 173.

53 See, for example, George Lud[ovic] Hamon, "Les Dames du Luxembourg: photographies instantanées" [2ème partie], *Revue Illustré* (1 November 1904), no. 22, n.p., and below, ch. 3, pl. 96.

54 On shopgirls and their reputations, see Theresa M. McBride, "A Woman's World: Department Stores and the Evolution of Women's Employment, 1870–1920," *French Historical Studies* (Fall 1978), pp. 679–81.

55 See the facsimile of Vuillard's sketchbook (*c.*1894–5), in Jacques Salomon and Annette Vaillant (eds.), *Edouard Vuillard: Cahier de dessins* (Paris: Quatre Chemins, [1950]), n.p.

56 See *Edouard Vuillard – K.-X. Roussel*,1968, p. 78, no. 50. See also Roussel's wood panels, *Le Jardin public* (pl. 68) and *Au Jardin*, repr. in Galerie Bellier, *Oeuvres choisies, XIX–XX siècles* (Paris, summer-fall 1988), no. 52.

57 One of the most curious analogies with Vuillard's "nanny" panels is Roussel's squared-off drawing (perhaps intended for a decorative project?) combining the three themes of Vuillard's panels: women on a patio with potted plants; women in princess-style gowns, combing their hair or sewing; and children playing. Roussel even included Mme Vuillard and Marie in this rather unsuccessful hodge-podge of figures and activities; see Sotheby's, London, *Impressionist and Modern Drawing and Paintings* (7 July 1960), lot 110: "Femmes et enfants dans un parc," *c.*1892, pen and ink on tracing paper, 18.4 × 27.3 cm.

58 For further description of the vogue for decorative screens in late nineteenth-century France and England, see Michael Komanecky, "A Perfect Gem of Art," in National Gallery of Art, Washington, *The Folding Screen* (Washington, 1984), pp. 41–119 *passim*. As practical art objects, screens were popular and marketable items in the same way that the impressionist fans by Degas, Cézanne and Pissarro had been twenty years before; see Siegfried Wichmann, *Japonisme: The Japanese Influence on Western Art in the 19th and 20th Centuries* (New York: Harmony Books, 1981): "The Fan," pp. 162–9.

59 "Paravent. mariage de Mimi [Marie]. Série de petites peintures, l'Oeuvre. Mort de bonne maman en janvier" (Journal, MS 5396, *carnet* 2, p. 78r.

60 I have retained the titles for the four central panels as they appeared in the auction catalogue, Sotheby's, New York, *Impressionist and Modern Paintings* [Property from the estate of Anne Burnette Tandy, Ft. Worth] (5 November 1981), lot 210. The panels were most recently exhibited in Dumas and Cogeval, *Vuillard*, 1991, no. 42, repr. pp. 64–5.

61 See Thomson, *Vuillard*, 1988, p. 36, who believes the journey was precipitated by Roussel's romantic problems. The two left Paris for a three-week trip in late November. After stopping in Anvers, they stayed eight or nine days with Verkade's parents in Holland before going on to London; see the letter from around late December 1892, cited in Mauner, *The Nabis*, 1978, "Appendix," p. 284.

62 Lionel Robinson, "The Private Art Collections of London: The Late Mr. Frederic Leyland's in Prince's Gate" (second paper), *Art Journal*, v. 44 (May 1892), pp. 134–8: "It is impossible not to make some reference to Mr. Whistler's 'Peacock Room' in any notice of Mr. Leyland's house. It was a feature which people came from afar to see; and it undoubtedly presents such an original scheme of decoration that it ought, if possible, to be preserved in order to show to future generations the taste, the genius, and the boldness of our own."

63 See Janet Adams, "The Ornamental Background," in *The Folding Image*, 1984, p. 78. Adam's observations are based on the idea that the paintings were installed first in the avenue Malakoff *hôtel privé*.

64 For discussion of the latter "Projet de paravent," see Troy, "Interiorization in French Art and Design of the 1890s," unpubl. paper, 1981.

65 See, for example, Manet's etching *Les Chats* (1868), in J.C. Harris, *Edouard Manet, Graphic Work: A Definitive Catalogue Raisonné* (New York: Collector's Editions, 1970) no. 64. See also Denis's portrait of Mme Ranson and her cat (*c.*1892), illustrated in *Symbolistes et Nabis: Maurice Denis et son temps*, exh. cat. (Saint-Germain-en-Laye: Musée Départemental de Prieuré, [1980]), no. 79.

66 *Journal*, MS 5396, *carnet* 2, p. 76r [folded blank sheet]: 2 August 1893, with sketch of cat on a table: "Pourquoi est-ce dans les lieux familiers que l'esprit et la sensibilité trouvent le plus véritablement nouveau? . . . Le nouveau est toujours nécessaire à la vie, à la conscience . . . Or dans les lieux non-familiers, la distraction est bien dangereuse."

67 Vuillard used analogous scenarios in his first lithographic works *Le Pliage du linge* (no. 6), *Intérieur aux cinq poses* (no. 7), *Intérieur au paravent* (no. 8), in Roger-Marx, *L'Oeuvre gravée*, [1948]. All are based on the motifs of seamstresses and decorative folding screens, only now seen in mysteriously lit interiors. See also Mauner, "Vuillard's Mother and Sister Paintings," 1971–2, pp. 124–6.

68 This information is repeated, for example, in Roger-Marx, *Vuillard*, 1946, p. 119; Bacou, "Décors d'appartements au temps de Nabis," 1964, p. 190; Dugdale, "Vuillard the Decorator: the First Phase," 1965, p. 94; *Edouard Vuillard – K.-X. Roussel*, 1968, p. 73; Russell, *Vuillard*, 1971, pp. 30–1.

69 See *Didot-Paris* (Paris: Société Firmin-Didot) 1895, 1896, 1897, and 1899. Stéphane is listed at 49 rue de la Faisanderie (house of his father, Simon Natanson).

70 "Bâtiment à l'usage d'hôtel privé." Stéphane's official letter to the Prefect of the Seine (30 March 1901), includes the architectural plan for the new building that he asks authorization to build on the property already owned by M. Paul Desmarais at 96 and 98 avenue Malakoff: "Je soussigné Natanson, Stéphane, Architecte demeurant à Paris 81, rue de la Faisanderie chargé par Monsieur Paul Desmarais demeurant [etc.] . . ." (Archives de la Seine, Paris, VO11, pièce 96). As late as 1895, the property at 94–8 avenue Malakoff was still owned by a M. Pastereau, who apparently sold it to Paul

Desmarais by April 1901 when the latter filled out the official request for building rights on the property encompassing 94, 96, and 98 avenue Malakoff; see "Demande en Autorisation de Construire, 6 avril 1901" (Archives de la Seine, VO11 Malakoff, 94–96–98, pièce 2647).

71 Conversation with Mme Stéphane Desmarais, Paris, 13 September 1983.

72 See Archives de la Seine, Cadastre QP 13, rue de Lisbonne, 42, 43, 44, "Démolition totale." The panels were reinstalled in their château in Chantilly. According to the present Mme Stéphane Desmarais, they were removed during the war "à cause des allemands qui ont chassé mon mari" (conversation with Mme Stéphane Desmarais, 14 September 1983). Today, the panels decorate the staircase of the Desmarais family château in Burgundy.

73 Conversation with Mme Stéphane Desmarais, 13 September 1983.

74 "M. Vuillard is the author of six pieces [*série de trumeaux*] of the freshest inspiration and the highest ornamental quality" (Roger Marx, "L'Art décoratif et les 'symbolistes,'" *Le Voltaire*, (23 August 1892), excerpted and translated in Roger-Marx, *Vuillard*, 1946, p. 205, n. 7: "We shall not desist from reciting all that decorative art is entitled to demand from artists who are increasingly attentive to the rhythm of a line, to the qualities of an arabesque, to the alternations of calm and movement, of the full and the empty, in the establishment of a composition." ("Nous ne nous lasserons pas de répéter tout ce que l'art décoratif est en droit d'attendre d'artistes attentifs plus que jamais aux rythmes d'une ligne à la qualité d'une arabesque, aux alterances de calme et de mouvement, de plein et de vide, dans l'établissement d'une composition"). See also Roger Marx, "Mouvement des arts décoratifs," *Revue Encyclopédique*, October 1893, p. 1488: "Vuillard a parachevé des trumeaux." It is not certain, however, whether the panels were exhibited at the second Nabi group showing at the château of Saint-Germain-en-Laye, or whether Roger Marx saw them in Vuillard's studio. Thomson, *Vuillard*, 1988, p. 36, asserts that the panels were never exhibited.

75 "Examen du diplôme d'architecte 1869–1934: Concours d'Emulation, Mémoires explicatifs de leurs projects . . . ," Archives Nationales, AJ 52 488 (IV) 1890.

76 "Le cercle, composé d'amateurs d'art et d'artistes, destiné à favoriser le développement des beaux-arts par des expositions de peinture et de sculpture et des auditions musicales, servirait en même temps de lieu de réunion aux membres du cercle, qui devront y trouver les agréments et tout le confort désirable" (*ibid.*).

77 The building would have separate apartments for club members, equipped with electric lamps and a steam-powered heating system (*ibid.*).

78 "M. Natanson, dont on a primé la belle façade d'hôtel privé, avenue Malakoff, était un architecte de réel talent. Il est mort tout jeune, en pleine effervescence d'art; son style a très grand air, son goût est impeccable, et on avait tout à attendre d'un tel artiste. La façade est encadrée entre deux pavillons; elle se compose d'un rez-de-chaussée surélevé, d'un premier étage et d'un second étage dans le toit, avec, à gauche, une haute porte cochère. Elle est entièrement en pierre de taille, ainsi que l'attique en balustrade qui supporte le toit et les deux grandes lucarnes des pavillons. L'ornementation est sobre et bien à sa place, l'ensemble très distingué et très harmonieux: c'est bien la façade d'un bel hôtel privé et elle orne sans ostentation ce

riche quartier" (Anon., "Les Concours de façades de la ville de Paris 1898–1905", *Habitation Pratique* [1903], p. 19). See also the photograph of the house in Anon., "Le Concours de façades," *Revue Universelle* (1905), p. 279.

79 See Charles Plumet, "Hôtel Particulier, 39 ave du Bois de Boulogne et 90 ave Malakoff," *L'Architecture*, 1901, pl. 4.

80 I am grateful to Mme Stéphane André, daughter of Mme Stéphane Desmarais, for having allowed me to visit her and to see this charming work. The righthand pastel shows Mme Desmarais playing with her son on the Savonnerie carpet.

81 F. Riley, "An American Home in Paris," *The Architectural Record*, v. 13 (February 1903), p. 97.

82 For "bains" many times decorated to look like Turkish baths, see César Daly's treatise of modern housing, *L'Architecture privée au XIX siècle* (Paris, 1864), in Helen Lipstadt, "Housing the Middle Classes: César Daly and the Ideal Home", *Oppositions*, no. 8 (Spring 1977), p. 39. See also Paul Frantz Marcou, "The Modern House in Paris," *The Architectural Record*, v. 2 (1893), pp. 325f.

83 "Des miniatures délicates, des morceaux serrés, poussés, auxquels on puisse encore s'intéresser en les ayant à un pied du visage" (Havard, *L'Art dans la maison*, 1887, v. 1, p. 198. See also "Drawing Room, Boudoir and Morning Room," in Edith Wharton and Ogden Codman, Jr., *The Decoration of Houses* (New York: W.W. Norton & Co., 1978) [reprint of the 1902 ed., first published in New York: Charles Scribner's Sons, 1898], pp. 122–33, who also combined the morning room and *cabinet de toilette* under the same descriptive purpose, and recommended that small objects, prints, mezzotints, and gouaches be included in its decoration.

84 For a discussion of how small boudoir pictures of genre subjects contributed to the vogue of the *esthètes* in the early part of the century, continued by the de Goncourts and Houssaye, see Carol Duncan, *The Pursuit of Pleasure: The Rococo Revival in French Romantic Art* (New York and London: Garland Publishing, Inc., 1976), pp. 73–84 *passim*. See also Edmond and Jules de Goncourt's lament of the destruction of aristocratic houses in their *Histoire de la société française pendant le Directoire*, Paris, 1880, pp. 110–11, cited in Mario Praz, *An Illustrated History of Furnishing*, trans. William Weaver (New York: George Braziller, 1964), p. 35.

85 "Encastrés dans une boiserie d'acajou décoraient le bureau-cabinet de toilette" (Bacou, "Décors d'appartements aux temps de Nabis," p. 193). As shown, Roger Marx called them *trumeaux*, a generic term meaning overdoor, between-window, overwindow, or door-jamb panels; see Marx, "Mouvement des arts décoratifs", 1893, p. 1488. Unfortunately, Marx mentions them only along with Ranson's murals for an unidentified bathroom.

86 Marcou, "The Modern House in Paris," pp. 326–7, described the *cabinet de toilette* of Madame as ". . . a momentous matter. It is there that Madame adorns . . . The *toilette-boudoir*, as we find it in the house of which we speak, is reserved for intimates; it is an elegant little room, which by its intermediate position between the closed bedroom and the drawing room, which is open to all, well indicates the place occupied in the family's estimation by those whose privilege it is to be admitted there . . . Only the initiated enter the boudoir, and Madame is always 'at home' to them."

87 "J'aurai grand plaisir à commencer l'année avec le Fred [Alfred Natanson] et son épouse [Marthe

Mellot]. Cela nous évoquera–non sans mélancolie–les anciennes réunions, maintenant dédaignées[?] de 31 Décembre rue de la Faisanderie. Mais c'était charmant et amical . . ." (letter dated 30 December 1904, Humanities Research Center, University of Texas at Austin).

88 See Journal, MS 5396, *carnet* 2: October 1890 [loose sheet].

89 "Et Denis faisant cette réflexion: comme il suffit d'aggrandir un petit dessin à propos de Michel-Ange. Et dernièrement l'exemple de Forain au café Riche et moi-même dans mon paravent de Mme Desmarais. J'ai fait cela sans y penser!!!!!!!!" (Journal, MS 5396, *carnet* 2, p. 44r: 16 July 1894). The entry begins with the observation: "Peu importe l'objet, c'est son sujet qui est tout . . ."

90 Apparently this screen also had a multi-level original frame which has since been dismounted; see illustration and discussion in Komanecky, "A Perfect Gem of Art," in *The Folding Image*, 1984, no. 7, pp. 146–8.

3 Women, Children, and Public Gardens

1 "Je suis content, trop content peut-être dans mon petit atelier de la rue Pigalle . . . Je peins, je lis, je repeins et je relis, je me figure que je découvre des choses auxquelles j'étais resté bouché, je me laisse, même aller à des mouvements d'orgeuil qui m'inquiètent un peu . . . je n'ai vraiment pas à me plaindre et si je paie cela par certain instants d'hypocondrie noire ce n'est que justice" (letter to Alfred Natanson, postmarked "Paris, 6, août 1893." Unpubl. MS private collection).

2 Lugné-Poe's theatre was launched by his successful but controversial production of *Pelléas and Melisande* on 17 May 1893.

3 Vuillard executed both the program and stage set for Ibsen's *Rosmersholm*, 6 October 1893, which was followed by Gerhardt Hauptmann's *Solitary Souls* (13 December 1893). For Vuillard's participation in Lugné-Poe's enterprise, see Aitken, *Artistes et Théâtres d'Avant-Garde*, 1991–2, nos. 58–63, 65, 67, 85, 89, 107.

4 *Ibid.*, p. 55.

5 "M. Vuillard qui ne peut continuer beaucoup plus longtemps à se refuser à des expositions, car, on serait tenté de le taxer de coquetterie – si l'on était aussi assuré de la sincérité de sa réserve." Thadée Natanson, "Exposition," *La Revue Blanche*, v. 4 (April 1894), p. 276.

6 Sert, *Misia*, 1952, p. 145. According to Annette Vaillant (*Vuillard et son Kodak*, Lefevre Gallery, London, 5–26 March 1964, p. 20), Misia was a siren, muse, and "Queen of the Nabis."

7 Among Cyprien's achievements were the tomb sculptures for Berlioz (d. 1869) Théophile Gautier (d. 1872), and Ernest Renan (d. 1892); see Baedeker, *Paris and Environs* (Leipzig: Karl Baedeker, 1891, 10th. rev. ed.), p. 21.

8 Arthur Gold and Robert Fizdale, *Misia: The Life of Misia Sert* (New York: Alfred A. Knopf, 1980), p. 5. Misia's own story recounts how her mother, suspecting her husband of adultery, left in the middle of a snowstorm for her own mother's home, and was half frozen and in labor by the time she arrived. Only the baby, Misia, survived; see Sert, *Misia*, pp. 28–30. See also Vaillant, *Le Pain polka*, 1974, p. 68.

9 Gold and Fizdale, *Misia*, 1980, pp. 16–18.

10 Lucien Muhlfeld, "Notes dramatiques," *La Revue Blanche*, v. 2 (15 February 1892), p. 128, quoted and trans. in Gold and Fizdale, *Misia*, 1980, p. 31. Marcel Guicheteau, *Paul Sérusier* (Paris: Editions Side, 1976), p. 57, states that the Nabis frequently

went to the Chat Noir.

11 The marriage was later legalized and registered in Paris when they remarried on 28 October 1899. Misia was twenty or twenty-one (and not fifteen as she remembered) when she married; see "Extrait de minutes des actes de mariage du 17ème arr.," document no. 171, [Natanson], Mairie du 17ème arrondissement. Misia and Thadée had spent their second summer together in Norway, where they had gone with Lugné-Poe with the express purpose of meeting Ibsen; see Lugné-Poe, *Le Sot de tremplin*, 1930, p. 233.

12 For anecdotes about the "annex," see Waller and Seiberling, *Artists of La Revue Blanche*, 1984, p. 10, and Gold and Fizdale, *Misia*, 1980, pp. 37–40 *passim*. I am grateful to Elizabeth Easton and Juliet Bareau, who independently arrived at the exact address for the apartment which is otherwise not found in the Vuillard literature; see below, ch. 4, p. 81.

13 See also in Andrew Carduff Ritchie, *Edouard Vuillard* (New York: Museum of Modern Art, 1954), p. 37.

14 Dugdale, "Vuillard the Decorator – First Phase," 1965, pp. 96–7, distinguishes between the medium used in theater scenery and that made with rabbit glue or size mixed with distemper for the later decorative projects.

15 Jacques Salomon, *Vuillard témoinage* (Paris: Albin Michel, 1945), p. 127, cited and trans. in Charles H. Olin and Alexandra Riddleberger, "The Special Problems and Treatment of a Painting Executed in Hot Glue Medium, *The Public Gardens* by Edouard Vuillard," *RPEPRINTS* (May 1980), p. 98.

16 The bearded man looks suspiciously like Vuillard's friend, the playwright, Tristan Bernard, whose earliest work, *Les Pieds nickelés* (1893), had just been published in *La Revue Blanche*. His distinctive shaggy head reappears in several of Vuillard's decorative projects, notably *The Haystack* (*La Meule*) and *The Library* (*La Bibliothèque*); see below, chs. 7 and 9.

17 "Sous les arbres que l'été fatigue, la population d'un square parisien. Au premier plan, une bonne en caraco et tablier, assise sur un banc, surveille les jeux d'une marmaille, parmi laquelle un mioche accroupi, une fillette en tablier scolaire. Au second plan, des chaises de fer et un groupe où une conversation s'engage entre une vieille dame assise, ses compagnes et un homme couvert d'un paillasson. A droite, des promeneurs s'étagent jusqu'aux maisons en bordure. A gauche, au dessus d'un parterre, une petite frise de gens assis et, de nouveau, des maisons fermant l'horizon" ([Félix Fénéon], entry for no. 22, *Collection Thadée Natanson*, Exposition privée dans la Galerie Bernheim Jeune, 15 rue de Richepanse, 10–11 juin 1908; exposition publique à l'Hôtel Drouot, 12 juin. Vente, Hôtel Drouot, 13 June 1908. English translation from Russell, *Vuillard*, 1971, p. 50).

18 For the Square de la Trinité and other Haussmannian city parks, see John Russell, *Paris* (New York: Harry N. Abrams, 1986); pp. 213–19 *passim*.

19 An interesting comparison between the concern for "déformation" and *naïveté* seen in his early Nabi works, and his concern for a more general decorative effect, can be made with this and another early work, *Femmes au jardin*, formerly owned by Paul Ranson and reproduced in Mauner, *The Nabis*, 1978, fig. 59.

20 Listed in *Catalogue de la 2ème exposition de peinture*, April 1876, ll rue le Peletier [Galerie Durand-Ruel, Paris], no. 162, as "Panneau décoratif." See Charles S. Moffett, *et al.*, *The New Painting: Impressionism 1874–1886* (The Fine Arts Museums of San Francisco, 1986), p. 161. See also Robert L.

Herbert, *Impressionism: Art, Leisure, and Society* (New Haven and London: Yale University Press, 1988), pp. 261–2 for Monet's profitable garden paintings.

21 For a bibliography and discussion of the Caillebotte Bequest which was not officially accepted until 1897, see Kirk Varnedoe, *Gustave Caillebotte* (New Haven and London: Yale University Press, 1987), "Appendix B," pp. 197–204.

22 The striped blouse recalls Bazille's portraits of young women in outdoor settings such as his *View of the Village*, 1868, Musée Fabre, Montpellier. For a discussion of Monet's paintings with Manet's *Déjeuner sur l'herbe* and as precursor to later concerns for decorative effects, see Herbert, *Impressionism*, 1988, pp. 141–52.

23 See, for example, Jacques Salomon, "Vuillard and His Kodak," in *Vuillard et son Kodak*, 1964, pp. 2–3.

24 Valvins, where the Natansons lived next door to Mallarmé, lay southwest of Paris, near Fontainebleau. In 1897, the Natansons purchased an eighteenth-century mansion, Le Relais, at Villeneuve-sur-Yonne, which would become the third "annex." See below, ch. 5.

25 "A noter que cette peinture est la première et sans doute la plus hardie d'une importante suite de peintures du même métier et de la même intention décorative. En particulier, elle a servi comme de palette à l'ensemble de celles dont les motifs sont empruntés à divers *Jardins de Paris*" ([Félix Fénéon] *Collection Thadée Natanson*, p. 22, trans. in Russell, *Vuillard*, 1971, pp. 50–1).

26 See Waller and Seiberling, *Artists of La Revue Blanche*, 1984, nos. 94–102, 104–5, and 109, and Aitken, *Artistes et Théâtres d'Avant-Garde*, 1991, pp. 61–4, nos. 63–8. In July 1894, Vuillard executed a "mysterious automnal décor," for Henri de Régnier's *La Gardienne*; see Romain Coolus, "Notes dramatiques," *La Revue Blanche* (July 1894), pp. 81–2.

27 Boyer, *The Nabis*, 1988, pl. 101, cat. 164, and no. 175, figs. 55–8. According to Boyer, the purpose of the *Dépêche de Toulouse* exhibition was to introduce avant-garde artistic currents from Paris to the townspeople. The very rare catalogue for the exhibition opening 20 May listed seventeen original lithographs by a variety of artists: Louis Anquetin, Pierre Bonnard, Maurice Denis, Emile Grasset, Henri-Gabriel Ibels, Achille Lauge, Maxime Maufra, Charles Maurin, Hermann-Paul, Henri Rachou, Richard Ranft, Paul Ranson, Ker-Xavier Roussel, Paul Sérusier, Henri Toulouse-Lautrec, Félix Vallotton, and Edouard Vuillard (nos. 88–91). See also the anonymous announcement of the exhibition's success and a list of the participating artists in the *Journal des Artistes* (23 September 1894), p. 726.

28 "Histoires sentimentales, septembre-août *panneaux d'Alexandre Natanson*. [illegible word]" (Journal MS 5397, *carnet* 2, p. 78r [1908] for 1894).

29 The missing panel, "*Les Premiers pas au jardin du Luxembourg* sur bois [*sic*] 212 × 84, Mr. Gaston Hemmindinger," is listed in *Répétoire des biens spoliés en France pendant la guerre de 1939–1945*, v. 2, ch. 1, no. 3093: 3093.33740; see Frèches-Thory, "Les *Jardins publics* de Vuillard," 1979, p. 312, n. 15. Unlike the Desmarais panels, the Alexandre commission has been more substantially documented by journal entries, preparatory studies, and some photographs in the Salomon Archives. The panels forming the triptych were purchased for the Luxembourg museum in 1929, at the sale of Alexandre's collection (see *Collection Alexandre Natanson. Tableaux modernes, oeuvres importantes de Edouard Vuillard . . .* [Paris, Hôtel Drouot, 16 May

1929]: *Les Nourrices* [lot 118; Lux. inv. 1790 P]; *La Conversation*, [lot. 125; Lux. inv. 1791 P]; *L'Ombrelle rouge*, [lot 117; Lux. inv. 1792 P]). The Bequest of Mme Radot (d. March 1978) added to the triptych *Les Fillettes jouant* (lot 120), RF 1978-46, and *L'Interrogatoire* (lot 124), RF 1978-47.

30 The house, constructed in cut stone (*pierre taillé*), was built in 1879, ten years before Alexandre and Olga were married; see Frèches-Thory, "*Les Jardins publics* de Vuillard," 1979, p. 305. According to Annette Vaillant, *Le Pain polka*, 1974, p. 24, Alexandre's mother-in-law, Madame Kahn, had been a society woman and heiress to the Maison Laferrière, the *couturières* to Empress Eugénie and Princesse Mathilde.

31 The avenue, opened by Haussmann, was called l'avenue de l'Impératrice (1870–5), then avenue d'Ulrich, then avenue du Bois de Boulogne until 1929, when it received the name of the French maréchal, Ferdinand Foch (1851–1929). Among the illustrious names living on the avenue during Alexandre's residency were the Shah of Persia (no. 27), Henry Bataille (no. 46), and Count Boni de Castellane in his sumptuous "Palais Rose" (no. 50). After Alexandre's move in 1908, number 60 was inhabited by the playwright, Georges Feydeau; see Jacques Hillairet, *Dictionnaire historique des rues de Paris* (Paris: Editions de Minuit, 1964), v. 1, pp. 532–3.

32 Boime, "Entrepreneurial Patronage," 1976, pp. 186–7.

33 Vaillant, *Le Pain polka*, 1974, p. 68, described her aunt as having very blue eyes a delicate mouth, a tiny nose, with a temperament "aussi vive, gaie et peu intelligente jusqu'à son extrême vieillesse." For a description of Alexandre, see Jackson, *La Revue Blanche*, 1960, pp. 28–30.

34 Camille Mauclair, *Le Soleil des morts*, first published 1897, reprinted, with presentation by Raymond Trousson (Paris/Geneva: Slatkine Reprints, 1979), p. 121, cited in Bernier, *La Revue Blanche*, 1983, p. 28. See also Mondor, *La Vie de Mallarmé*, 1941, p. 793, and Emile Cardon, *Le Snobisme et les lettres françaises* (Paris: Librairie Armand Colin, 1966), pp. 175–6, n. 24.

35 "Avec moi, on ne peut jamais savoir, avec moi, on n'est jamais sûr que d'une chose: c'est que je ne m'occuperai jamais longtemps de la même affaire" (André Gide, *Journal, 1889–1939* (Paris: Bibliothèque de la Pléiade, 1939), p. 270: 24 December 1908). Gide did not publish in the magazine until January 1895, with the prose poem "Paludes" ("Fragments") (*La Revue Blanche*, v. 9, p. 36). Although he was highly critical of the Natansons in general, he later served briefly as literature critic for *La Revue Blanche*, replacing Léon Blum in 1900. At the sale of Thadée's collection in June 1908, he purchased Vuillard's portrait of Thadée; see Joan U. Halperin (ed.), *Félix Fénéon: Oeuvres plus que complètes* (Geneva: Librairie Droz, 1970), p. 264, no. 8.

36 Boime, "Entrepreneurial Patronage," 1975, pp. 186–7.

37 See, for example, Linda Nochlin, "Degas and the Dreyfus Affair: A Portrait of the Artist as an Anti-Semite," in Norma Kleeblatt (ed.), *The Dreyfus Affair: Art, Truth, Justice* (New York: The Jewish Museum, 1987), pp. 96–116.

38 Salomon, *Vuillard*, 1968, p. 31; see Vuillard's comparison of his career with Rembrandt's: "Lui aussi n'a peint que les Juifs!"

39 Journal, MS 5396, *carnet* 2, p. 54r: "Hier après-midi Lerolle et sa belle soeur. Impression calme de ces gens aimables, reservés mais sympathiques, pas trop de choses odieuses." Cited and translated in Thomson, *Vuillard*, 1988, p. 85.

40 For the perception of the Jewish woman in the period during and directly after the fall of the United Savings Bank (l'Union générale) in 1882, see Jeannine Verdès-Leroux, *Scandale financier et antisémitisme catholique: Le krache de l'Union générale* (Paris: Editions du Centurion, 1969), pp. 131–4.

41 Camille Mauclair, "Exposition des portraits du prochain siècle," *Essais d'art* (October 1893), p. 120.

42 Russell, *Vuillard*, 1971, p. 58.

43 In November, 1894, Alexandre contributed his first art essay to *La Revue Blanche*, "Réflexions sur l'artiste," a generalized and highly idealistic apology for artistic genius, and the notion that the work of art "est un moment de supériorité" (*La Revue Blanche*, v. 7 [1894], p. 408).

44 Journal, MS 5396, *carnet* 2: 7 July 1894; see above, ch. 2, p. 25.

45 The comparison of Vuillard with Verlaine was made on the occasion of Vuillard's exhibition of small interior scenes at the Le Barc de Boutteville gallery in 1892, causing Albert Aurier to label Vuillard an "intimiste Verlainien"; see Charles Chadwick, *Verlaine* (London: The Athlone Press, 1973), p. 22, and André Billy, *L'Epoque 1900, 1885–1905* (Paris: Editions Jules Tallandier, 1951), p. 332.

46 *Ibid.*, pp. 331–2.

47 Emily Ballew, "Edouard Vuillard's 'Jardins publics': The Subtle Evocation of a Subject," M.A. thesis, Rice University, Houston, 1990, pp. 42–5, has used Vuillard's journal entries to map out what might have been his route between the Louvre, the Tuileries, the place de la Trinité, and the Bois de Boulogne.

48 Adam, *A Book about Paris*, 1926, p. 160. The authors continue the comparison of trees and children, concluding: "But she [Paris] brings up her trees better than her children, for she does not spoil them. She lops them, and prunes them, and stakes them against the wind, and generally sergeant-majors them for their own good. Her children she indulges – they are rarer than her trees, and not so easily or so plentifully produced, let alone so cheaply brought to a fruitful maturity..."

49 See Baedecker, *Paris and Environs*, 1891, p. 151.

50 Herbert, *Impressionism*, 1988, pp. 141–52 *passim*.

51 Blake Ehrlich, *Paris on the Seine* (New York: Athenum, 1926), p. 201.

52 Adam, *A Book About Paris*, 1926, p. 163.

53 See T.J. Clark, *The Painting of Modern Life: Paris in the Art of Manet and his Followers* (New York: Alfred A. Knopf, 1985), pp. 64 and 279, n. 102, explaining that Manet's *Musique dans les Tuileries*, ostensibly a *plein-air* work, was executed in the studio using his friends as models; see Metropolitan Museum of Art, *Manet* (New York, 1983), no. 3, and Herbert, *Impressionism*, pp. 37–8.

54 As one contemporary observer wryly put it: "The children are all legitimists in the Luxembourg gardens, whereas they are all Red Republicans in the Tuileries"; quoted in McManus, *Royal Palaces and Parks of France*, 1910, p. 157.

55 For Vuillard's various residences drawn from his journal entries, see Appendix A, "Vuillard's Chronologies," in Easton, *Intimate Interiors*, 1989, pp. 143–4.

56 "Après-midi promenade au Louvre avec Bonnard dans les dessins d'abord. Ennui rapide devant les italiens. Quel mensonge que d'appeler cela des primitifs. Quoi de plus rhétorique, de moins ému que Credi, Botticelli... Intérêt reprend un peu devant Léonard au moins cette rhétorique sert-elle là à la emotion, se rapprochant du reste des véritables primitifs. Satisfaction dans la nouvelle salle française, quelle différence d'expression" (Journal, MS 5396, *carnet* 2, p. 42v: 13 July 1894 ["Afternoon excursion to the Louvre with Bonnard to see the drawings first. Immediately boredom with the Italians. What a lie to call them 'primitives.' Nothing can be more rhetorical and less moving than Credi, Botticelli... Interest heightens somewhat before Leonardo: at least this creates an emotion, and somewhat approaches the true primitives. Satisfaction in the new French room, what a difference in expression"]). See also Appendix B in Easton, *Intimate Interiors*, 1989, pp. 145–6. In the "new French room," Vuillard was probably looking at the twenty-one large paintings by Le Sueur based on the Life of St. Bruno, located in Room XII; see Baedecker, *Paris and Environs*, 1891, p. 131.

57 "Hier, visite au Louvre. Watteau. Figures expressions sérieuses. Rencontre Miquen [his brother, Alexandre] en sortant. Allons au café" (Journal, MS 5396, *carnet* 2, p. 47v: August 1894).

58 "Hier désespoir devant les toiles à en pleurer. L'après-midi enfin distrait par cette crise des minuties qui ne sont pas toujours la cause de ce désespoir, je vais aux Tuileries et retrouve par enchantement, le jour où je suis le plus désespéré, les émotions qui au début de mon travail me guidaient. Impossibilité d'inscrire toutes les idées qui me sont passées par la tête à ce sujet" (Journal, MS 5396, *carnet* 2, p. 47v: 30 August [1894]).

59 Baedecker, *Paris and Environs*, 1891, p. 166. For *Woman in a Park*, see Françoise Cachin, "Un Défenseur oublié de l'art moderne," *L'Oeil* (June 1962), p. 51.

60 See *Il Giardino del Luxembourg*, reproduced in Palazzo Reale, *Mostra di Edouard Vuillard* (Milan, 1959), no. 21, as formerly in the collection of the Princesse Bassiano. The catalogue erroneously describes it as having been part of the decorative ensemble for Alexandre Natanson. All of the eight existing panels for that commission are signed and dated: "Edouard Vuillard 1894." For the patronage of the Princesse Bassiano see below, ch. 9.

61 The only panel given a specific title is the lost painting, *Le Premier Pas, au jardin du Luxembourg*. The titles, however, seem to have been added in 1929, when Alexandre sold the series (16 May 1929, nos. 117–25).

62 Ballew, "Vuillard's 'Jardins Publics,'" 1989, pp. 49–52, has studied the use of these kinds of fences in the parks that Vuillard would have visited for his series and has concluded that it was probably temporary.

63 A watercolor that is almost identical to the center panel of the triptych, *The Conversation*, shows the same women and fences without the building; cf. black chalk and watercolor for *The Conversation*, 29.5 × 27.7 cm., sold in Stuttgart, 29 November 1965, no. 2035.

64 Roger-Marx, *Vuillard*, 1946, p. 121.

65 As noted, Adam was a financial speculator and investor in properties for profit and amusement. His was a decidedly aristocratic nature, and he owned several grand estates for short periods of time. According to Annette Vaillant, in addition to their Paris residence, and Georgian *petit château* at Longchamp (later destroyed by the perfumer, Coty), Adam rented briefly a château at Méréville, owned a house at Ranville, as well as an estate near Cannes in Saint-Croix where their mother died in 1887. Adam also built for himself a town house on the rue Ampère in Paris, but when a worker fell off the scaffolding and was killed, Adam's wife refused to move in, and the house was abandoned; see Vaillant, *Le Pain polka*, 1974, pp. 67–8.

66 See Catherine Legrand, "Le Café du Bois de Boulogne d'Edouard Vuillard," *Revue du Louvre* (1987), pp. 326–8, on the occasion of the acquisition of the distemper and gouache drawing by the Musée des Beaux-Arts de Besançon. It is even thinkable that the schematic rendering of the square building may represent a lateral view of the Bagatelle.

67 Ballew, "Vuillard's 'Jardins publics,'" 1989, p. 38, believes the panel *Asking Questions* shows Olga Natanson and one of her daughters. According to Annette Vaillant (*Le Pain polka*, 1974, p. 24), Bolette Natanson was named after a heroine in Ibsen's *La Dame de la mer*, which Thadée had helped to get translated. The panel, *First Steps*, evokes the open spaces of the suburban park, and Vuillard might have used Bolette, the next-to-youngest daughter, as his subject. Interestingly, the girls in the foreground grouped to the right in *The Walk* are of a different social class than their companion in the middle ground. Whereas in the other panels the children play, talk, whisper, and interact with their mothers and nursemaids, in *The Walk*, the more modestly dressed girls stand apart from each other, in confrontation or indifference.

68 For a discussion of the "children's hour," see Ballew, "Vuillard's *Jardins Publics*,'" 1989, pp. 92–3. For Vuillard's use of models, see Ciaffa, *Portraits*, 1985, p. 86. Later Vuillard would pose his friends, or work from photographs and quick sketches of them, for his subjects.

69 See Carol Duncan, "Happy Mothers and Other New Ideas in French Art," *Art Bulletin*, 56 (no. 101), pp. 570–83. See also the insightful analysis of Vigée-Lebrun's self-portrait with her daughter, in Griselda Pollock, *Vision and Difference: Feminity, Feminism and Histories of Art* (London: Routledge, 1988), pp. 46–9.

70 See Michelle Perrot, *From the Fires of Revolution to the Great War*, (trans. A. Goldhammer), v. 4, in Philippe Ariés and Georges Duby (eds.), *A History of Private Life* (Cambridge, MA: The Belknap Press of Havard University Press, 1990), pp. 336–7.

71 For example, T. Rzewuski, "Les Enfants," *La Revue Blanche*, v. 5 (July–August 1893), pp. 70ff.; Victor Barrucand, "Enfant égaré," *La Revue Blanche*, v. 11 (October 1895), pp. 36–41; Paul Adam, "Critique des moeurs: des enfants," pp. 405–17, and "Nibs", the supplement, illustrated by Bonnard, Toulouse-Lautrec, *et al.*, which featured silly stories and deliberately naive drawings.

72 For the Nabis' illustrations for sheet-music covers, programs, and other theater-related endeavors, see Boyer, *The Nabis*, 1988, nos. 33–5, and 89. See also Octave Uzanne, "Le Petit Théâtre des Marionnettes: Maurice Bouchor," *L'Art et l'Idée* (January 1892), p. 12.

73 See Paul Gauguin, *Paul Gauguin's Intimate Journals*, trans. Van Wyck Brooks (Bloomington, Indiana: Midland Book Edition, 1958), p. 41.

74 Charles Martel, *La Justice* (7 October 1893), describing Vuillard's program for *Rosmersholm* (October 1893), cited in Aitken, *Artistes et Théâtres d'Avant-Garde*, 1991, p. 10.

75 "C'est un barbare, un sauvage, un enfant . . . - seulement cet enfant a une musique dans l'âme et, à certains jours, il entend des voix que nul avant lui n'avait entendues" (see Jules Lemaître, published essay on Verlaine for *La Revue Bleue* [January 1888], reprinted in 1889 as volume four of a series, *Les Contemporains* [Chadwick, *Verlaine*, 1973, p. 116]).

76 See Waller and Seiberling, *Artists of La Revue Blanche*, nos. 53–8, and Aitken, *Artistes et Théâtres d'Avant-Garde*, 1991, pp. 93–9, for the Nabis' earliest involvement in puppet theaters at the home of Conseiller Coulon and in 1896–8 at the Théâtre de Pantins, founded by Bonnard and Alfred Jarry.

77 Robert Herbert, in his *Impressionism: Art, Leisure, and Parisian Society* (1988), has devoted an entire chapter to the significance of public and private gardens and of women in gardened settings in early impressionist paintings.

78 For Manet's *Children in the Tuileries*, see J.W. Bareau, *Manet by Himself* (New York: Hugh Levin, 1991), p. 101, no. 63.

79 One can think also of Whistler's lithographic series of children in the Luxembourg gardens, *Nursemaids, Les bonnes du Luxembourg* (1894), described as "the Gardens seen from a height- . . . In the middle distance on the left a flight of steps, with statues on pedestals, rise to the terrace . . ."; and his *The Terrace, Luxembourg* (1894), nos. 48 and 55 in Thomas R. Way, *Mr. Whistler's Lithographs* (London: George Bell & Sons, 1896).

80 Unlike Vallotton, who later wrote Vuillard that in comparison to Bonnard who "did" (painted) children in his paintings, he considered children "des petites bêtes que leur faiblesse seule empêche de mordre, c'est bien joli cependant mais j'aime autant les chats" (unpublished MS, Lausanne, 21 August 1896 or January 1896. See also Sasha Newman, *Vallotton*, exh. cat. (New Haven, Conn.: Yale University Art Gallery, 1991–2), p. 73, no. 8, pl. 86.

81 Miller, *The Bon Marché*, 1981, p. 111.

82 See *Grandes et petites heures du Parc Monceau*, exh. cat. (Paris: Musée Cernuschi, 13 June–26 July 1981), nos. 137–138.

83 *Grandes et petites heures du Parc Monceau*, 1981, no. 126. See also Octave Uzanne, *Etudes de la sociologie féminine: Parisiennes de ce temps en leurs divers milieux, états et conditions* (Paris: Mercure de France, 1910), pp. 315–17. Uzanne applauds the simplicity and maternal grace characteristic of young bourgeois mothers, who, in doing their little *devoirs* (such as wiping the child's nose), are both beautiful and coquettish.

84 "Je descends au square. La même femme qu'hier vient s'asseoir sur mon banc, un peu troublé. Robe à petits carreaux, plis sans souplesse, comme du papier. Corsage noir vieux plis sans rondeur. Tablier blanc. Qualité des plis petits et secs. cheveux comme des algues détrempées, durs. Teint mat. Bouche violacée aujourd'hui" (Journal, MS 5396, *carnet* 2, p. 45v: 24 July 1894). See citation and translation in Thomson, *Vuillard*, 1988, p. 40.

85 Hamon, "Les Dames du Luxembourg," *Revue Illustrée*, no. 22 (1904), n.p.

86 See Ballew, "Vuillard's 'Jardins publics,'" 1989, pp. 105–6, for another interpretation of the triptych.

87 "Je devrais avoir une multitude variée d'objets représentés dans mes peintures, or je n'introduis jamais de personnages hommes, je constate. D'autre part quand mon attention se porte sur les hommes, je vois toujours d'infâmes charges, je n'ai qu'un sentiment d'objets ridicules. Jamais devant les femmes où je trouve toujours moyen d'isoler quelques éléments qui satisfont en moi le peintre. Or les uns [hommes] ne sont pas plus laids que les autres [femmes] ils ne sont que dans mon imagination."

88 ". . . A la vérité ce n'est pas tant les observations que je ne fais pas devant n'importe quel objet (réunion électorale, paysages et autres choses surtout en dehors de l'année dernière et des petits tableaux) c'est l'imagination qui m'en semble difficile. Quand je veux imaginer par exemple une composition pour les Natanson, je ne puis penser à d'autres objets qu'à des feminins[.] Cela est gênant et prouve que je ne suis pas indifférent au sujet."

89 "Ces temps-ci, devant les paysages, les arbres, les feuillages bariolés, dentelés, découpés, j'ai pensé à les réunir. Cela me montre que ce n'est pas la femme même que j'admire quand je veux composer puisque je trouve ce même sentiment en contemplant d'autres objets."

90 "Seulement, comme je n'ai confiance dans les idées et raisonnements que sont contrôlés par des impressions directes de la nature, il me faut me nourrir de nouvelles observations poussées de ce côté. Je l'ai essayé et je suis étonné de la perspective de découvertes que cela me découvre" (Journal, MS 5396, *carnet* 2, pp. 46r and 46v: 27 July 1894).

91 See Ballew, "Vuillard's 'Jardins publics,'" 1989, p. 96.

92 In Ibsen's *The Wild Duck*, performed at Antoine's Théâtre Libre in 1894, the father actually causes the little girl to commit suicide by his refusal to accept her when he finds out she is not his own. In Strindberg's *The Father*, the father goes crazy and kills himself when he learns that he cannot ever know if he is indeed the father of the family he worked so hard to provide for.

93 For an insightful interpretation of this lithograph, see Ciaffa, *Portraits*, 1985, p. 237.

94 Maurice Denis married his "icon", Marthe Meurthe, in June, and Roussel married Vuillard's sister in July of the same year. By 1893, Bonnard was with Marthe Méligny, who would be his lifetime companion. Sérusier's "siren" was the Polish writer and artist, Gabriella Zapolska, who returned to Poland in 1895, where she introduced symbolism to Polish intellectual circles; see Boyle-Turner, *Paul Sérusier*, 1980, pp. 93–4. In November 1894, Pierre Veber, Vuillard's school friend, married the sister of Tristan Bernard; see Journal, MS 5396, *carnet* 2, p. 54: 6 November 1894, and Saloman, *Vuillard témoignage*, 1945, p. 49.

95 Mauner, *The Nabis*, 1978, p. 289, "Appendix," letter to Verkade, 1 January 1894: "Tu sais qu'il y a des mariés parmi eux [the Nabis]. Cela ne change rien, du reste, à notre vie. Moi je suis terriblement célibataire et, je le dis avec un peu de peine, car j'ai de vagues tendances à trouver cela monstreux."

96 "Il y a deux occupations en moi: l'étude de la perception extérieure remplie d'expériences pénibles et dangereuses pour mon humeur et mes nerfs. l'étude de la décoration picturale rarement possible du reste bien plus bornée mais qui devrait me donner la tranquillité d'un ouvrier – repenser souvent aux tapisseries de Cluny . . ." (Journal, MS 5396, *carnet* 2, p. 44r: 16 July 1894. Salomon (*Vuillard*, 1968, p. 52), claims that Vuillard told him he studied the reproductions of the fourteenth-century tapestries from the tower of the Garde Robe in the Palais des Papes in Avignon, although the influence of these and *mille fleurs* tapestries seems greater in the later series of paintings for Thadée and for Dr. Vaquez; see below , ch. 4.

97 Earlier, Vuillard had written: "Esclave de certaines dimensions de certaines matières (carton, huile) quand l'idée me vient de travailler. Dérouté devant les sensations ou impressions *nouvelles* au moment de leur appliquer la même méthode de travail qu'aux anciennes. Paresse à tenter une réalisation nouvelle. Cela me fait entrevoir que chaque fois que je travaille d'une façon suivie l'année dernière, par exemple, à pareille époque – je perds rapidement l'idée fécondante, consciente

de mon travail, pour prendre des habitudes où se complaît ma paresse et où mon intelligence s'endort" (Journal, MS 5396, carnet 2, p. 41v: 10 July 1894).

98 Entry dated 20 July 1824, in The Journal of Eugène Delacroix, trans. of Journal: notes et éclaircissements [par P. Flat et R. Piot, Paris: Plon, 1893–5] by Walter Pach (New York: Crown Publishers, 1948), p. 99. Delacroix's theories assumed an even greater importance with the publication of Signac's D'Eugène Delacroix au Néo-impressionnisme, first published in series by La Revue Blanche (1, 15 May and 1 July 1898). In 1929, Vuillard, along with Roussel and Denis, became members of "Les Amis de Delacroix"; see Stump, Roussel, 1972, p. 45.

99 Charles Blanc, Grammaire des arts décoratifs: décoration intérieure de la maison, 1875 (3rd ed., Paris: Renouard, 1886) pp. 75–6.

100 "Vraiment comme décoration d'appartement un sujet objectivement trop précis deviendrait facilement insupportable. On se lassera moins vite d'une étoffe de dessins sans trop de précision littéraire . . . Se servir d'un modèle pour soutenir son imagination. L'imagination généralise toujours" (Journal, MS 5396, carnet 2, cited and trans. in Thomson, Vuillard, 1988, p. 40).

101 "Visite hier à Cluny. Les tapisseries et les enluminures de missal. Calendriers. Dans les tapisseries je pense qu'en aggrandissant purement et simplement mon petit panneau cela ferait le sujet d'une décoration. Sujets humbles des ces décorations de Cluny! Expression d'un sentiment intime sur une plus grande surface, voilà tout! La même chose qu'un Chardin par exemple. Différence d'avec les italiens. Voilà des tapisseries aussi importantes savantes qu'un Véronèse. Pourquoi sont-ils si inconnus. Petit morceau très ancien, en teintes plates grossières, d'un charme de couleur très puissant couleurs tranchées sur fond clair. Cela me fait penser à certaines de mes machines" (Journal, MS 5396, carnet, 2, p. 44v: 16 July 1894, partially cited and trans. in Easton, Intimate Interiors, 1989, p. 109.

102 Charles Blanc, Art in Ornament and Dress (trans. of L'Art dans la parure et dans le vêtement, part 1 of his Grammaire des arts décoratifs 1875, 1886 (London: Chapman and Hall, 1877), pp. 35–6.

103 See Salomon, Vuillard, 1968, p. 21, who describes his palette in these panels as comprising "les verts anglais, le bleu charron, et le blanc de Meudon en pain."

104 Maillol, who joined the Nabi circle in 1892 when he settled permanently in Paris, was known primarily as a painter and tapestry-maker until after 1897, when his failing eyesight decided him to take up sculpting. For his tapestries, see Wendy Slatkin, Aristide Maillol in the 1890s (Studies in the fine arts. The avant-garde, no. 30) (Ann Arbor, Mi: UMI Research Press, 1982, 1976), pp. 51–72.

105 Vuillard would have known of these, since the cartons were exhibited in 1894 at the Galerie Durand-Ruel, and the paintings at the Hôtel de Ville were considered the high point of the Ministry's failed attempt to include all officially approved Salon artists in the project. According to Salomon (Vuillard, 1968, p. 52), Vuillard was studying also the Puvis de Chavannes cycle (of the Life of Saint Geneviève) at the Panthéon at this time. I am grateful to M. Clibère, Conseiller, Hotel de Ville, and to Claude Segond, Service de Protocol, for allowing me access to see these murals.

106 "Recu l'argent d'Alex. Toile 9m 50en 2m 40de large a 3,80 = 36f 10, lin 1f 10, encre de chine, 60 total, 375f 80" (Journal, MS 5396, carnet 2, p. 49: 21 August 1894). See Salomon, Vuillard témoignage,

1945, p. 37, and his Vuillard, 1968, p. 60. for Vuillard's payment.

107 "Je verrai Alexandre, j'espère, d'ici deux ou trois jours à la Revue et pourrai m'entendre avec lui pour l'achèvement de notre petite décoration" (extract from a letter, dated "Samedi 15 déc 1894," from E. Vuillard, 346 rue Saint-Honoré to Olga Natanson, in Autographes, Lettres-Documents-Photos [Geneva: L'Autographe], 28 June 1989, no. 338 [private collection]).

108 Segard, Les Peintres d'aujourd'hui, 1914, v. 2, p. 320; Salomon, Vuillard témoignage, 1945, p. 37. See also, Roger-Marx, Vuillard, 1946, p. 121; André Chastel, Vuillard, 1868–1940 (Paris: H. Floury, 1946), p. 53; Bacou, "Décors d'appartements au temps de Nabis," 1964, p. 194; Dugdale, "Vuillard, the Decorator – The First Phase," 1965, p. 97; Edouard Vuillard – K.-X. Roussel, 1968, nos. 51–4; Russell, Vuillard, 1971, p. 49; Vaillant, Le Pain polka, 1974, p. 127; Frèches-Thory, "Les Jardins publics de Vuillard," 1979, pp. 307–8.

109 Ibid., Frèches-Thory, however, did not have access to a contemporary description of the house when the panels were installed. The information comes from the listing of the house when Alexander sold it in 1909 (see "Commission des Contributions Directes: Tableau Statistique, 1911, Propriété de M. Natanson," Archives de la Seine). Annette Vaillant remembers the dining-room as being on the ground floor facing the street and separated from the avenue "par un jardinet de cailleux, emprisonné dans sa grille de lierre"; see Vaillant, Le Pain polka, 1974, p. 24.

110 Jean Schopfer, "Modern Decoration," The Architectural Record, v. 6 (January–March 1897), p. 253.

111 Jacques-Emile Blanche, "Salon d'Automne," Mercure de France, v. 12 (December 1904), p. 683.

112 Frèches-Thory was the first to reconstruct the original sequence of The Public Gardens. Since that time, her research has been expanded by two very different approaches for understanding the cycle: William H. Robinson, "Vuillard's Under the Trees from the Nabi Cycle The Public Gardens," Bulletin of the Cleveland Museum of Art, v. 79, no. 4 (April 1992), pp. 111–27, links the cycle to other three-dimensional panoramas, in photography and painting, such as Willem Mesdag's famous Maritime Panorama which Robinson believes Vuillard would have seen on his trip to Belgium and Holland (with Roussel) in 1892. An evocative film-study reconstructs, with computer-aided imagery and materials from the Salomon Archives, the cycle as it looked in the Natanson's home; see Alain Joubert, Les Jardins publics: Les Allées du souvenir, video, (Paris: Musée d'Orsay, 1992).

113 Frèches-Thory, "Les Jardins publics de Vuillard," 1979, pp. 307, 308, "Schema I," "Schema II," figs. 2, 3; p. 309, figs. II: 3–4. Frèches-Thory's study also corrects a common mistake concerning the panel Les Premiers pas, which has sometimes been confused with Les Nourrices; see Roger-Marx, Vuillard, 1946, p. 121, and Russell, Vuillard, 1971, p. 37.

114 Fernand Mazade, "A French Dining Room of the Upper Middle-class Type," The Architectural Record, v. 5 (July–September 1895), pp. 36–7. See also for Mazade, Aitken, Artistes et Théâtres d'Avant Garde, 1991, p. 28.

115 See, for example, informal photographs showing men of letters in their studies, especially the photos by Dornac of famous Parisians – Anatole France, Vincent d'Indy, Gustave Geffroy and Marcel Prévost in Gothic or Renaissance furnishings reproduced in Revue Encyclopédique. See also Roux Servine, "Ernest Reyer à la Cigale," Revue Illustrée, no. 8 (April 1903), and Ernest Gaubert, "Pierre

Loüys," Revue Illustrée, no. 7 (15 March 1904).

116 See Weisberg, Japonisme 1854–1910, 1975, p. 145.

117 Anne Martin-Fugier, "La Maîtresse de maison," in Jean Aron (ed.), Misérable et glorieuse, la femme au XIX siècle (Paris: Librairie Arthème Fayard, 1980), p. 183.

118 Adrien Simoneton, La Décoration intérieur (Paris: Guerinet, 1894–1895), pl. XII, "Salle à Manger Gothique"; pl. XIII, "Salle à manger Louis XV"; and pl. XIV, "Salle à manger moderne," showing orientalizing details and wallpapers in a Louis-Quinze room. This, of course, would have been reserved for the wealthier bourgeoisie. As noted by Praz, An Illustrated History of Furnishing, 1964, p. 376, the Japanesing style was to the nineteenth century haute bourgeoisie what the Chinese-style salon was to the nobility of the eighteenth century.

119 Among many examples: Tristan Bernard's Mémoire d'un jeune homme rangé (1899); Gide's Si le Grain ne meurt pas (1926); Renard's Poil de Carotte (1894); and, later, Simone de Beauvoir's Mémoire d'une jeune fille rangée (1909).

120 "Les sièges et les tentures était de style plutôt classique, les tableaux et les dessins déjà à Renoir, de Degas, de Vallotton, de Cottet ou de Maufra, ce qui fait que les nombreux artistes ou hommes de lettres qui nous visitaient, regardaient nos meubles en souriant tandis que les gens du monde s'échauffaient à la vue de nos tableaux" Prince André Poniatowski, D'Un Siècle à l'autre (Paris: Presses de la Cité, 1948), p. 348. Vuillard recorded, in fact, having visited the prince in late October 1894: "après-midi Poniatowski et Bonnard, encadreur de Po. Mouclier [Marc Mouclier], sa femme" (Journal, MS 5396, carnet 2, p. 53r), and again with Bonnard on 2 November 1894: "mercredi lecture de Balzac, . . . visite chez Poniatowski, Avenue de Bois" (Journal, MS 5396, carnet 2, p. 53r).

121 Of course, there is the possibility that the author of the column signed "Smart" had his tongue in his cheek when he started that, "Le meilleur style pour une salle à manger est encore le style Louis XV, qui a plus le mérite de ne pas rappeler un anachronisme . . . Seule le Louis XV, avec des gracieux contours, ses arabesques de pièces montées semble parfaitement convenir" (from "La Salle à Manger," a two-part series by "Smart," in Cri de Paris (January 1899), p. 7).

122 See Gide, Journal, 1939, p. 229: 7 January 1907, who, thinking he was going to Thadée's, knocked at Alexandre's door: "entendant ma voix il accourt et tout aussitôt son effusante amabilité me submerge . . . Il me fait admirer ses peintures, un portrait de Monticelli entre toutes qui est vraiment une oeuvre admirable; puis les panneaux de la salle à manger, sculptés tous en bois – puis m'entraîne dans sa voiture et souhaite que j'aie quelque service à lui demander, tant il serait heureux de m'obliger . . ." Gide omits any reference to the Natanson décorations. It is possible that the panels had already been dismantled in preparation for Alexandre's move to the Champs-Elysées residence.

123 For description of the painting, Les Quatre jeunes filles, see Vaillant, "Livret de famille," 1958, p. 32; Hôtel Drouot, Paris, Collection Alexandre Natanson, 1929, no. 89.

124 Using a recently established concordance between Vuillard's measurements for the widths of each panel and the panels as they measure today (published in Robinson, "Vuillard's Under the Trees," v. 79, no. 4 [April 1992], p. 117, fig. 4), the paintings can be identified, and their arrangement in the room partially reconstructed. Ballew, "Vuillard's 'Jardins publics,'" 1989, pp. 13–14, who also includes a diagram based on Vuillard's sketchbook,

has noted that in both instances when panels flank a door or window, the panel to the left is slightly smaller.

125 On the verso of this sheet are unrelated minuscule pen-and-ink *croquis* depicting a house and what looks like the head of a disciple copied from a painting (Rembrandt? Le Sueur?), or perhaps from one of the actors from Lugné-Poe's Théâtre de l'Oeuvre.

126 Hôtel Drouot, Paris, *Collection Alexandre Natanson*, 1929, nos. 117–25; Hôtel Drouot, Paris, *Collection Alexandre Natanson*, 1934, nos. 168A (*Fillettes jouant*), and 168B (*L'Interrogatoire*). The question of the overdoor panels remains unresolved. Segard, *Les Peintres d'aujourd'hui*, 1914, v. 2, p. 320, is the only reference to list the overdoors, presumably when he saw them at the second residence. But Annette Vaillant, who remembers quite clearly the panels in the avenue des Champs-Elysées apartment, does not remember ever having seen the overdoor panels (correspondence, 6 April 1989). See also Bareau, "Vuillard et les Princes Bibesco," 1986, p. 46 and n. 4.

127 "Travaillé aux dessus de porte tout la matinée – après-midi mariage de Veber. Exposition d'Ibels" (Journal, MS 5396, *carnet* 2, p. 54r); and 9 November 1894: "travaillé toute la matinée finis deux dessus de porte" (*ibid.*, p. 55r).

128 A possible overdoor panel, formerly Galerie Cailleux, Paris, was sold at Versailles (Hôtel Drouot), November 1978, although, according to A. Salomon (correspondence, 23 September 1980), it does not seem to correspond with the panels glimpsed on either side of *Asking Questions*.

129 The two paintings, which are framed together with a simple *baguette*, are approximately 100 × 35 cm. each, which makes one dimension very close to the 98 cm. width of the vertical panels from the series.

130 Another painting, entitled *Verdure*, with a similar format (118.1 × 73.7 cm., private collection) seems related to the panels of the *Public Gardens* series; see *Edouard Vuillard, 1868–1940: Centennial Exhibition*, intro. by George Mauner (Pennsylvania State University: 7 April–12 May 1968), no. 25: *Landscape*. I am grateful to Professor George Mauner for having brought this decoration to my attention.

131 See Bernier, *La Revue Blanche*, 1983, pp. 28–33.

132 Salomon, *Vuillard*, 1968, p. 60.

133 "J'ai vu les panneaux de l'avenue du Bois . . . Je me dégoute profondément de n'avoir pas su trouver une heure pour les voir plus tôt. J'ai besoin, un besoin absolu de vous dire combien je suis heureux de les avoir vus et quelle belle évocation vous m'avez procurée . . . Je ne puis vous dire plus. Votre ami, Stéphane" (see letter dated "dimanche" in Bernier, *La Revue Blanche*, 1983, p. 10).

134 After the death of Mme Kahn, Alexandre became the owner of the house (Succession de 30 juillet 1907, revenu 55.000 francs) before moving into the Champs-Elysées apartment (see Archives de la Seine, Cadastres, "1901 Kahn Vve y demeurant, 1909 Alex Natanson et sa dame Née Cahn y demeurant").

135 "Descendant les Champs Elysées – il me fait admirer l'ancien Hôtel Dufayet qu'il vient d'acheter et où il creuse un théâtre en profondeur – une maison où il dépense sept cent mille francs – de qui, me fait-il remarquer, 'n'est pas une obole.' Au demeurant, [il était] d'une obligeance extrême. Mais avec lui, je ne sais quel personnage jouer – et je ne peux pourtant être naturel" (Gide, *Journal*, 1939, p. 270: 24 December 1908).

136 Vaillant, *Le Pain polka*, 1974, pp. 127–8, and Journal, MS 5397, *carnet* 2, n.p.: 17 February

[1908]: "Vais avec Olga Avenue Champs-Elysées voir emplacement de mes panneaux." Beginning in February, Vuillard measured the walls and took the panels to be stretched or tightened and eventually reframed; see 24 February [1908]: "Alexandre vient me prendre en auto pour aller aux Champs Elysées. Discussion de l'emplacement de panneaux"; [12 March 1908]: "Vais chez Guichardy qui ne peut pas se charger de la tension de vieux panneaux"; [1 April 1908]; "retouche panneaux de la salle à manger . . ." It was not until three months later, however, that he was able to discuss his fee with Olga and to decide on a day for the reinstallation; see Journal, 3 April 1908: "beau temps. descends à pied avec Cremnitz et Pierre jusque chez Alexandre avenue des Champs-Elysées. règle prix du *portrait* et conviens un jour pour placement tableaux."

137 'Chez Alexandre, accrocher les tableaux intérêt de cette besogne. bonne humeur. Thadée. déjeuner agréable, prends mésure pour les *dessus des portes* . . . Alexandre me donne chèque de 2000F" (Journal, MS 5397, *carnet* 2, n.p.: 6 April 1908).

138 ". . . rentre éreinté. travaille tous le temps avec peine et énervement aux panneaux d'Alexandre." See also Journal, 20 May 1908: "matinée passée à méditer. Reprends anciennes notes de 94 sur les panneaux d'Alexandre. retrouve dispositions analogues de mécanisme de pensée, bon état."

139 "Dîner chez Alex somptueux. bon effet de mes peintures" (Journal MS 5397, *carnet* 2, n.p.: 'jeudi' [December 1908]).

140 Nattier-Natanson, *Les Amitiés de "La Revue Blanche"*, 1959, pp. 183–5.

141 Journal, MS 5397, *carnet* 3, n.p.: 1 November [1913]: "Jos [probably Bernheim] question vend les tableaux d'Alexandre Natanson".

142 This was the first of Vuillard's decorative paintings to enter a French museum. The panels were exhibited only once before the sale in 1929; see *Exposition Vuillard*, Galeries Bernheim-Jeune, 19 May–26 June 1906, no. 26, as "Neuf panneaux décoratifs."

143 See Hotel Drouot, Paris, *Collection Alexandre Natanson*, 1929, section, "Peintures décoratives par Edouard Vuillard," which include the two works, each described as "Peinture décorative ayant orné une bibliothèque," for Adam Natanson; see below, ch. 6.

144 Denis's ceiling painting for Ernest Chausson, *April*, was exhibited in the spring of 1894 at the Salon des Indépendants before its installation at the Chausson *hôtel*, rue de Courcelles; see Bacou, "Décors d'appartements au temps de Nabis," 1964, p. 201.

145 Havard, *L'Art dans la maison*, 1884, p. 157: 'les paysages, les natures mortes, sont des specialités qui conviennent mieux à la salle à manger. Evitons surtout, qu'une composition énigmatique se dresse, comme un point d'interrogation fatal, devant un honnête homme qui dîne,"

146 Mazade, "A French Dining Room of the Upper Middle-Class Type," 1895, pp. 36–7. The dining-room is generally located on the ground floor, looking out onto a garden, so that "daylight reaches them through brightly-colored stained glass windows, bearing pictures of birds, flowers and other objects calculated to charm and enliven, rather than to instruct or to stir the feeling . . ."

147 Vuillard would recall the panels later while working on other out-of-door and large-scale decorations in 1910; see Journal, MS 5397, *carnet* 2, n.p.: 5 August 1910: "essais de grand panneau d'après d'Annette avec Maman. Souvenirs des panneaux d'Alexandre."

148 "Mots sur l'esprit 1891–94" (Journal, MS 5399, 17

July 1936). Although Vuillard reused the theme of mothers and children in public gardens in his lithographs and easel painting for 1895–6 (see, for example, his color lithographs *Le Jardin de Tuileries* (1895) and *Jeu d'enfants* (1899) for *Paysage et intérieurs* (1899), in Roger-Marx, *L'Oeuvre gravé de Vuillard* [1948], nos. 33 and 34), the theme was never repeated for his large-scale decorative paintings.

4 Feminine Elegance and Flowers

1 "Ma pauvre soeur a été atteinte de crises graves et nous avons été sur le point de la croire perdue. Elle va un peu mieux maintenant, mais tout danger n'est pas passé . . . J'ai traversé une crise épouvantable de désolation et de révolte contre les choses et les gens" (letter to Alfred Natanson dated 24 November 1894, in Denise Mellot, "Vuillard dans ses lettres", *Arts* (2 April 1948), p. 8, col. 1.

2 "Savez-vous ce que c'est d'avoir été confiant au possible, de n'avoir tout d'un coup plus des points de repère qu'on s'était assigné, de voir combien on s'est trompé en ne regardant pas toute chose comme relative aux autres, et cela surtout dans les affections de coeur" (letter postmarked 22 April 1895, in Mellot, "Vuillard dans ses lettres," p. 8, col. 2. See also Ciaffa, *Portraits*, 1985, pp. 45–8). It is even possible that Misia was the object of his unrequited love. In a listing of important dates, Vuillard noted for 1895: "panneau de Thadée. histoires de Misia" (Journal, MS 5396, *carnet* 2, p. 78r).

3 "Complications du mariage Roussel. Panneau de Thadée. (Novembre) L'Atelier boulevard de Clichy. Vaquez. Mort de ma tante Saurel. [illegible word] à Berck chez Malaquin" (Journal, MS 5397, *carnet* 2, p. 13r). Louis Malaquin was a schoolchum of the Nabis, who was put in a sanatorium at Berck-sur-Mer, where Vuillard, Denis, Bonnard, and Lugné-Poe would go to visit him; see Lugné-Poe, *Le Sot de Tremplin*, 1930, p. 69. By that time Vuillard had moved out of the rue Pigalle apartment to another studio two doors down, which he could now afford to rent exclusively; see Thomson, *Vuillard*, 1988, p. 32.

4 For 1895 (Journal, MS 5397, *carnet* 2, p. 13v). Vuillard's genre-like portrait of Marie and Roussel from the end of 1894, *Married Life* (*La Vie conjugale*) (private collection, London, reproduced in Russell, *Vuillard*, 1971, no. 29) shows how sensitive Vuillard was to their psychological drama.

5 See Salomon and Vaillant, *Vuillard: Cahier de dessins*, [1950]. Sometimes called "Album Rue St. Honoré." Several of the folded double sheets from the original sketchbook have been dispersed into the art market as independent drawings; see correspondence of J.W. Bareau with D. Druick, 13 November 1987, Departmental files, The Art Institute of Chicago.

6 In his November letter to Alfred Natanson, Vuillard wrote that he had stayed up all night watching over her: "Je vous écrit à côté de son lit de malade où j'ai pensé à vous toute la nuit . . ." (Mellot, "Vuillard dans ses lettres", 1948, p. 8, col. 1).

7 See Pach, *Journal of Eugène Delacroix*, p. 223.

8 "Le matin dans mon lit en me réveillant je regardais les objects différents qui m'entouraient, le plafond peint en blanc; l'ornement du milieu arabesques vaguement XVIIIe siècle, l'armoire à glace en face, les rainures, moulures du bois, celles de la fenêtre, leurs proportions, les *rideaux*, la chaise par devant à dossier bois sculpté, le papier du mur, les boutons de la porte ouverte, verre et

cuivre, le bois du lit, le bois du paravent, les charnières, mes vêtements au pied du lit; les quatre feuilles vertes élégantes dans un pot, l'encrier, les livres, les rideaux de l'autre fenêtre, les murs de la cour au travers . . . Quant aux rideaux, différences et dessins obtenus par le plus ou moins d'écartement des fils. Comparant les qualités de chacun de ces objets à cela seul j'éprouve un plaisir. Puis j'étais frappé de l'abondance d'ornements de tous ces objets. Ils sont ce qu'on appelle de mauvais goût et ils ne me seraient pas familiers qu'ils me seraient peut être insupportables. C'est l'occasion de réfléchir sur cette appellation que je dis rapidement "de mauvais goût" et qui m'empêche de regarder. Là je *regardais* et cela ne choquait pas mes nerfs superficiellement je prenais intérêt à chacun de leurs caractères, et cela suffisait à éloigner le dégoût" (Journal, MS 5396, *carnet*, 2, pp. 51v–52r: 26 October 1894, cited and trans. in Easton, *Intimate Interiors*, 1989, p. 78).

9 What Kirk Varnedoe terms a concern for the "intellectual fabrication of ideal forms and abstract schemata," *Northern Light: Nordic Art at the Turn of the Century* (New Haven and London: Yale University Press, 1988), p. 34. Although discussing the qualities of modern art in late nineteenth-century Scandinivia, Varnedoe's insights are useful for an understanding of the combination of realist-symbolist attitudes towards the visible world that can be perceived in Vuillard's art and writings.

10 Journal, MS 5396, *carnet* 2, pp. 51v and 52r: "Ne pas se laisser aller à ces impressions de petit maître comme on aurait dit autrefois; tâcher au contraire à en comprendre le caractère; c'est aussi difficile . . . mais très instructif de comprendre une chose vulgaire, (Je ne dis plus simple) une chose commune qu'une belle chose consacrée qui vous a ému."

11 "Vraiment ce matin le résultat de toutes ces observations n'était pas un dégoût, une acception qui plus forte m'eût peut-être donné des idées plus fécondes. Autre chose encore, j'ai été étonné de voir arriver au milieu de ces objets maman dans un peignoir bleu à raies blanches. Somme toute pas un de ces objets inanimés n'avait un rapport ornemental simple avec un autre, l'ensemble était disparate au dernier point. Pourtant cela était dans une atmosphère vive et une impression particulière s'en dégageait qui ne m'était pas désagréable. L'arrivée de maman là dedans était surprenante, une personne vivante. En tant que peintre les différences de taches, de formes suffisent pour intéresser" (Journal, MS 5396, *carnet* 2, p. 52r, cited and trans. in Easton, *Intimate Interiors*, 1989, pp. 78–9).

12 Since Vuillard referred to the paintings only as the *panneaux pour Thadée* (Journal, MS 5396, *carnet* 2, p. 78), I have adopted the titles used in the catalogue accompanying the sale of Thadée's collection, 13 June 1908: no. 51, *L'Album*; no. 52, *Le Pot de grès* (also called *Among the Flowers*, in Roger-Marx, *Vuillard*, 1946, p. 133, and *Le Déjeuner fleuri*; in Durand-Ruel Galleries, *Exhibition for the Benefit of the Children's Aid Society Homemaker Service* [New York, 1944], no. 22); no. 53, *La Table de toilette* (also called *Conversation*, in Roger-Marx, *Vuillard*, 1946, p. 133, and *Fleurs dans un vase émaillé*, in Durand-Ruel Galleries, *Exhibition for the Benefit of the Children's Aid Society Homemaker Service*, 1944, no. 21); no. 55, *La Corsage rayé*.

13 Hôtel Drouot, Paris, *Collection Thadée Natanson*, 1908, no. 55, *La Tapisserie* (also called *Les Brodeuses, à la fenêtre* or *Embroiderers at the Window*, in John Rewald, *John Hay Whitney Collection*

[Washington, D.C.: National Gallery of Art, 1983], no. 43).

14 See Waller and Seiberling, *Artists of La Revue Blanche*, 1984, p. 33 and no. 62.

15 In a letter written to Alfred Natanson on 2 April 1895, for example, Vuillard writes: "J'ai été hier voir une exposition où j'ai vu Thadée et sa figure pleine et bonne, aujourd'hui je vais voir Vallotton . . ." (in Mellot, "Vuillard dans ses lettres," 1948, p. 8).

16 For Thadée's part in the anarchist cause, see Richard Whelan, "'Le Roi' Fénéon and the Neo-Impressionists," *Portfolio* (March–April 1981), pp. 52–4 *et passim*. See also Jackson, *La Revue Blanche*, 1960, pp. 95–100 *passim*.

17 Causing Veber, as he later wrote decidedly tongue-in-cheek, to modify his signature to read "V. Reb-Périre"; see his "Une Génération: Souvenirs," *La Revue de France*, no. 15 (July 1936), pp. 274 and 265–74 *passim*.

18 Fénéon, who championed the neo-impressionists in the 1880s (most of whom, like Paul Signac, Maximillian Luce, and Armand Petit-Jean, were sympathetic to the anarchist-communist cause), wrote little about art for *La Revue Blanche*, and with the exception of an early article for the *Chat Noir* magazine, did not review any of the Nabi exhibitions; see Halperin, *Oeuvres plus que complètes*, 1970, pp. xxxv–xlix.

19 Letter dated 16 April 1896, in Camille Pissarro, *Letters to his Son, Lucien*, ed. John Rewald (Santa Barbara and Salt Lake City: Peregrine Smith, 1981), p. 368.

20 "Il y a le groupe Judéo-universitaire représenté par *La Revue Blanche* . . . Toute la Sophistique latente de l'éducation Sorbonnière, toute la bi-latéralité des cerveaux Israélites, vous le retrouverez dans cette revue." Henri de Bérenger, "La Vie contemporaine," extract cited in *Mercure de France* v. 21 (1897), pp. 208–9, and reprinted in Jackson, *La Revue Blanche*, 1960, p. 115.

21 Journal entry, December 1895, cited in Bernier, *La Revue Blanche*, 1983, p. 21; the de Goncourts' comments can also be seen in light of the anti-semitism that had accelerated since the condemnation of Captain Dreyfus in late December of 1894. See, for example, Michael R. Marrus, "Popular Anti-Semitism", in Kleeblatt, *The Dreyfus Afair: Art, Truth, Justice*, 1987, pp. 50–61, and Jackson, *La Revue Blanche*, 1960, pp. 101–9 *passim*.

22 Sert, *Misia*, 1952, p. 56 and above, ch. 2, p. 20. Misia's reverse snobbism, however, seems not to have excluded her husband's family entirely. According to Lugné-Poe, Misia and her sister-in-law, Olga, never missed a theatrical opening, took front-row seats and were the major attraction for the audience; see *Le Sot de Tremplin*, 1930, p. 233.

23 See George Painter, *Marcel Proust: a Biography* (London: Chatto & Windus, 1959), p. 92, who also suggests Mme Aubernon de Neville and the artist, Mme Lemaire, as part of the make-up of the character Mme Verdurin. According to Gold and Fizdale, *Misia*, 1980, p. 48, Proust wanted but could not meet the Natansons even though he subscribed and contributed to their magazine, because his parents disapproved of them.

24 This distinction seems to have been made first by Robert Herbert in his introduction to *Neo-Impressionists and Nabis in the Collection of Arthur G. Altshul* (New Haven: Yale University Press, 1965), p. 14.

25 For a fascinating analysis of the phenomena of "La nouvelle Femme" as a presence and threat to the male-dominated intellectual circles of the 1890s, see Silverman, "Amazone, Femme Nouvelle,

and the Threat to the Bourgeois Family," in *Art Nouveau in Fin-de-Siècle France*, 1989, pp. 63–74.

26 "Sur la table à midi les chrysanthèmes violacées et blanches. Motif ornemental sérieux et aimable à la fois. Décoration de bureau. Les fleurs après tout sont un ornement grossier, simple, je ne veux pas dire que je les méprise, mais cela ne demande aucun effort pour en saisir l'aspect, les formes et les couleurs, c'est proprement le véritable ornement naturel. Le sens ornemental en est primitif, simple, a un intérêt suffisant dans la qualité de leurs formes et de couleurs. Tout au contraire un tableau qui lui aussi se constitue de formes et de couleurs demande à l'esprit qui le contemple un effort d'imagination plus complexe. D'autres objets une figure, un pot, par exemple l'intérêt ornemental en est moins brutal, ce ne sont pas des couleurs vives, il n'y a pas une répétition multiple de formes semblables (commes les pétales). Quel danger d'attacher plus d'importance aux idées, qu'à la cause qui les fait naître." (Journal, MS 5396, *carnet* 2, pp. 50v–52r: 26 October 1894, cited and trans. in Easton, *Intimate Interiors*, 1989, p. 78).

27 Around 1900, Schopfer began writing under the pen-name, Claude Anet, and Vuillard referred to him in his journal as both Schopfer and Anet. Since his most significant role as Vuillard's patron was in 1897–8, I shall continue to refer to him as Schopfer.

28 See Veber, "Une Génération," 1938, p. 268, who cites among others, the artists, Vuillard and Maurice Denis.

29 Rasetti was a friend of the Nabis living in the suburb of Bois de Colombes (Maurice Malingue, *La Vie prodigieuse de Gauguin* [Paris: Editions Buchet/Chastel, 1987], p. 239). In May 1895, Schopfer wrote to Vuillard informing him that he was ready to go ahead with the project for the decorated dishware (letter dated 22 May [1895] from 24 avenue Wagram [letter dated by Antoine Salomon, Salmon Archives, Paris]). Vuillard recorded having finished the project in September of that year, noting on 30 October 1895: "Pour prendre date. Septembre *le service de Schopfer*" (Journal, MS 5396, *carnet* 2, p. 78r; and in his journal listing for 1895 [12 November 1908], MS 5397, *carnet* 2, p. 14, he wrote: "service de table de Schopfer.") See also Musée des Arts Décoratifs, *Exposition Vuillard*, exh. cat. (Paris: June 1938), no. 132, as "Service de porcelaine, 1898 à Galerie Druet, Paris." There is, however, no mention of a later commission in Vuillard's journal listings nor evidence to support a second project. The collector, Samuel Josefowitz, who owns several decorated dishes probably from the later series, says that he has not yet seen the serving dishes ("Modern Decoration," 1897, pp. 248, 253) or dishes with the squared formats published in Schopfer's article (*ibid.*, p. 250). His dishes seem to have been glazed after Vuillard painted onto the white porcelain at the ceramists' workshop. They bear the marking, as yet unidentified, of H. & Co.; see correspondence between author and Samuel Josefowitz, 30 May 1990.

30 Schopfer "Modern Decoration," 1897, p. 254. The article is illustrated primarily with photographs of Vuillard's decorated dishware series, nos. 5–11, pp. 248–54. Under the editorship of Henry Crofts, *The Architectural Record* began publishing on a quarterly basis in July 1891, then in April 1902, as "A Monthly Magazine of Architecture and the Allied Arts and Crafts."

31 The dining-room featured also a mantlepiece by Van Rysselberghe and stained-gass window by Ranson. The dishes were not mentioned in the

catalogue for the first or second exhibition at Bing's 22 rue de Provenance gallery, but can be seen in the photograph of the dining-room as it looked for the 26 December opening (pl. 124). For Bing's inaugural exhibition, see Silverman, *Art Nouveau in* Fin de Siècle *France*, 1989, p. 274, and pp. 270–83 *passim*. See also Gabriel P. Weisberg, "The Creation of l'Art Nouveau," chapter 2 in his, *Art Nouveau Bing: Paris Style 1990* (New York: Harry N. Abrams, 1986), pp. 44–95, 69, fig. 57, and color photographs of the plates in the Samuel Josefowitz Collection, pls. 17–19, pp. 94–5.

32 Edmond Cousturier, "Galerie S. Bing: Le mobilier," *La Revue Blanche*, v. 10 (January 1896), p. 93.

33 In late May 1894, Vuillard Learned that Ibels had met Bing, had received a commission, and that Bing was interested in the Nabi artists (letter dated 30 May 1894, in Maurice Denis Archives, Saint-Germain-en-Laye, cited in Weisberg, *Art Nouveau Bing*, 1986, p. 49). With the exception of Besnard, all of the artists (including Bonnard, Denis, Ibels, Ranson, Roussel, Toulouse-Lautrec, and Vallotton) commissioned by Bing for this project were associated with the Nabis.

34 See René de Cuers, "Domestic Stained Glass in France," *The Architectural Record*, v. 9 (July–September 1899) p. 115, fig. 18, and pp. 137–8. Both Vuillard and Roussel painted park scenes with chestnut-tree leaves as the decorative motif.

35 Jacques-Emile Blanche, "Les Objets d'art," *La Revue Blanche*, v. 8 (1895), pp. 266–7: "Depuis longtemps à chaque ouverture des Indépendants, nous avons regretté que ces peintres si décorateurs et simplificateurs ne se'occupassent pas de faire des modèles pour renouveler ou rajeunir l'ameublement. Ils ont tout pour y rèussir: une intelligence très vive de la ligne, déformée et réformée en arabesques, l'accord entre la figure et le paysage . . . un goût décidé pour les grandes teintes plates . . . parmi tant de tempéraments que groupe ensemble un amour inconscient de l'ornementation, on trouvera, peut-être la formule d'art la plus fraîche et la plus élevée de la vie contemporaine."

36 Journal, MS 5397, carnet 2, p. 12.

37 See, for example, Maurice Devaldes, "L'Art Nouveau," *La Revue Rouge*, v. 2 (February 1896), pp. 21–2; anon, "L'Art Nouveau," *l'Art et la Curiosité* (4 January 1896), p. 11.

38 ". . . descendons au salon en rotonde décoré par M. Besnard. Une antichambre le précède où les panneaux de M. Vuillard mettent en scène des femmes d'intérieur . . . M. Vuillard est un harmoniste rare: il sent le charme de l'intimité, l'énigme où semble vivre tout être solitaire. il vocalise en mineur: ses tons neutres et sourds, ses combinaisons subtiles" (Cousturier, "Galeries S. Bing: Le mobilier," 1896, p. 93).

39 ". . . lustre absurde où des grosses mouches tournaient en nous éclairant avec leur derrière transparent" (Arsène Alexandre, review of Bing's exhibition for *Le Figaro* [28 December 1895], cited in Victor Champier, "L'Exposition de l'art nouveau," *Revue des Arts Décoratifs* [January 1896], p. 16).

40 Segard, *Les Peintres d'aujourd'hui*, 1914, v. 2, p. 320.

41 "Le dessin, où la détermination des objets, n'a dans les tableaux que sa valeur plastique d'arabesque . . . Le plaisir de nommer des objets intervient sans doute dans celui que donnent les images, mais il n'en est pas l'essentiel, qui est abstrait" (see Hôtel Drouot, Paris, *Collection Thadée Natanson*, 1908, p. 27, no. 51).

42 "Une symphonie sourde où s'harmonisent des rapports jamais vus et qui vibrent plus profondément à mesure qu'on les contemple, éclats mélodieux, attitudes liées savamment et qui se composent d'après celles que sa tendresse a saisies et que son souvenir ému a retenues. C'est une profusion magistrale de splendeurs colorées harmonieuses où se drape une âme tendre" (in Thadée Natanson, "Peinture: A propos de MM. Charles Cottet, Gauguin, Edouard Vuillard et d'Edouard Manet," *La Revue Blanche*, v. 11 [February 1897], p. 518). According to Jean-Jacques Bernard, Tristan's son, Thadée was one of the few of their circle who could actually read Mallarmé: "N'importe quel poème de Mallarmé commenté par lui, devenait lumineux" (in his *Mon Père Tristan Bernard* [Paris: Albin Michel, 1955], p. 463). One can compare, in fact, Thadée's metaphors of the symphonic vibrations and harmonies in Vuillard's paintings with his similar comments regarding Cézanne's landscapes and still lifes exhibited that December at the Galerie Vollard which he considered pretexts for *embroideries*, *festoons*, and *arabesques*; see Thadée Natanson, "Paul Cézanne," *La Revue Blanche*, v. 9 (December 1895), p. 498.

43 See, for example, Fénéon's description of *The Striped Blouse*, in Hôtel Drouot, Paris, *Collection Thadée Natanson*, 1908, no. 55: "Deux dames respirent des fleurs disposées en bouquets dans des vases. Un enfant entre, au fond. L'effet général, ici plus ramassé [than in *La Tapisserie*], n'en paraît que plus précieux. L'élément nouveau serait, avec un éclat jaune et rose à droite en haut, une tache tissée de rouge et de beige."

44 ". . . quelques panneaux qui ne se lient à rien, qui n'ont pas de sens relativement aux éclairages de la pièce, et qui rééditent, en un empâtement de taches disgracieuses, un motif banal de femmes émergeant de fouillis de fleurs sans caractère . . ." (Camille Mauclair, "Choses d'art," *Mercure de France*, v. 18 (February 1896), p. 264. See also the same opinion expressed thirteen years later at the sale of Thadée's collection, when *The Stoneware Vase* was described as "un fouillis de choses informes. Quelle peine faut-il pour découvrir des visages humains et des fleurs! Tout est sur le même plan. Et quel coloris monochrome et laid!" (Jacques Daurelle, "Curiosités," *Mercure de France* (1 July 1908), p. 188.

45 An example of the critics' proclivity to equate Vuillard's mysterious imagery with literary symbols can be seen in Léon-Paul Fargue's review of the fifth exhibition of "Impressionists et symbolists" (see his "Peinture chez le Barc de Boutteville," *L'Art littéraire*, no. 13 (December 1893), pp. 49–50).

46 Quoted in Weisberg, *Art Nouveau Bing*, 1986, p. 274, and n. 48. See also Wattenmaker, *Puvis and the Modern Tradition*, 1976, p. 46, no. 99.

47 See above, p. 220, n. 101. Compare, for example, Denis's preface to the "IXe exposition des peintres impressionnistes et symbolistes," cited in Ciaffa, *Portraits*, 1985, p. 148, and n. 38: "il y aura plus d'analogie entre l'objet et le sujet, entre la création et l'image qu'ils en auront reconstituée." See also Vuillard's journal comment that a room could be decorated with flower pots, since even the most humble object could be used for the decorative effect (Journal, MS 5396, carnet 2; p. 44r: 16 July 1894, and above, p. 217, n. 89).

48 Nancy Troy, "Interiorization in French Art and Design of the 1890s." 1981, pp. 8–12. Troy asserts that art-nouveau designs and Vuillard's encompassing patterns were all "intended in part to provide a secure interior retreat from the problematic confusion of the modern world outside" (*ibid.*, p. 12).

49 Jacob von Falke, *Art in the House: Historical, Critical and Aesthetic Studies* (Boston: Charles C. Perkins, 1879), p. 270.

50 "Aussi, l'arrangement du *home* dépend-il de son [the woman's] action; il est ce qu'elle le fait, agréable ou maussade, élégant ou vulgaire . . . un intérieur peut ne rien apprendre sur l'homme qui l'habite; il révèle toujours la caractère et les goûts de la femme qui l'a combiné" (Gustave Larroumet, "L'Art Décoratif et les femmes," *Revue des Arts décoratifs*, 1896, p. 101).

51 "Même lorsqu'elles demeurent tapiés dans leur intérieur, elles s'efforcent de peupler leur solitude de bibelots gais et éclatants. . . ." Uzanne, *Etudes de sociologie féminine*, 1910, pp. 346–7).

52 Silverman, *Art Nouveau in Fin-de-Siècle France*, 1989, p. 74. A much different form of this type of analogy (woman to fashion to home) was made by the arch misogynist Edmond de Goncourt, who remarked in his journal for 15 November 1888, upon the positive factor of having women at the literary soirées he hosted in his Auteuil pavillon, because "les femmes font très bien sur les fonds et entrent tout à fait dans l'harmonie du mobilier" (*ibid.*).

53 Schopfer, "Modern Decoration", 1897, p. 254.

54 Larroumet, "L'Art décoratif et les femmes," 1896, p. 103.

55 For Courbet, see Sara Faunce and Linda Nochlin, *Courbet Reconsidered*, exh. cat. (Brooklyn Museum of Art, 1988), no. 41; for Degas, see *Degas*, exh. cat. (Paris: Galeries Nationales du Grand Palais, 1988), no. 60.

56 In March–April 1894 an important retrospective of Redon's works, including nine paintings and ten pastels, was held at the Durand-Ruel galleries.

57 See Redon's lithographic program published in March 1892 for Edouard Schuré's *Vercingétorix* (known as *La Druidesse*) in Aitken, *Artistes et théâtres d'avant-garde*, 1991, p. 49, no. 52. Vuillard owned also one of Redon's albums, *Les Origines* (1883), which he lent to the 1894 exhibition at The Hague (Haag Kunstkring, May-June 1894), no. 54. I am grateful to Redon scholar Ted Gott for these references (in correspondence with author, 11 June 1989).

58 Edmond Pilon, "Un Nouvel Album d'Odilon Redon," *La Revue Blanche*, v. 11 (1896), p. 135.

59 Aitken, *Artistes et théâtres d'avant-garde*, 1991, p. 77, no. 85.

60 See Douglas W. Druick, *The Lithographs of Henri Fantin-Latour: their place within the context of his oeuvre and of his critical reputation*, diss. Yale University, 1979 (Ann Arbor: University Microfilms International, 1984), p. 87, no. 58.

61 Segard, *Les Peintres d'aujourd'hui*, 1914. v. 2, p. 248.

62 "Le propre de l'art décoratif est-il de s'adresser à tout le monde? Ce n'est pas nécessairement son caractère. Il est hors de doute que ces tableaux ne peuvent plaire à des collectivités composées d'hommes sans éducation mais il suffit que des élites puissent se complaire dans l'atmosphère que ces peintures créent en des intérieurs ou sur les murs d'un édifice pour qu'on ne puisse pas leur dénier le caractère décoratif" (*ibid.*).

63 ". . . ont une âme secrète, une puissance de suggestion, une force de propagande d'autant plus persuasive qu'elles sont plus discrètes" (*ibid.*, p. 278). "Il émane de ces peintures des ondes qui ne peuvent ébranler que des organismes nerveux très sensibles mais qui s'inscrivent cependant sur certaines sensibilités comme s'inscrivent à travers l'espace sur des enregistreurs ultra-sensibles les ondes immatérielles qui se propagent à travers

l'espace." For a fascinating discussion of this newly popularized malady and the idea of the interior as the "chambre mentale," see Deborah Silverman, "Revialism to Modernism: 'psychologie nouvelle,' The Goncourts and Art Nouveau," *Gazette des Beaux-Arts*, v. 109 (May–June 1987), pp. 217–22, and her discussion in *Art Nouveau in fin-de-siècle France*, 1989, pp. 79–91 passim. Ker, Vuillard's brother-in-law, was a victim of this nervous disorder and was hopitalized in Switzerland in 1906 and again in 1914 (conversation between author and Antoine Salomon, 15 September 1983). See also Vuillard's convalescent portrait of Ker in Jacques Salomon, *Vuillard admiré* (Paris: Bibliotheque des Arts, 1961), p. 91.

64 Silverman, *Art Nouveau in fin-de-siècle France*, 1989, pp. 158–9. Writing to Zola, Edmond de Goncourt declared that "Our entire work, and perhaps this is what constitutes its originality, is built on nervous illness" (trans. and excerpted in Anita Brookner, "The Brothers Goncourt," in *The Genius of the Future*, 1981, p. 123, and pp. 121–4 passim for the correlation between "nervousness" and genius). For a vivid description of Huysman's heightened perceptivity to color nuances, see William Rubin, "Shadows, Pantomimes and the *Fin de Siècle*," *Magazine of Art*, v. 46 (March 1953), p. 118.

65 Journal, MS 5396, *carnet 2*, pp. 51v–52r: 26 October 1894.

66 Or, at least, the apartment was not listed under the Natansons' name. The fact that the "annex" was passed on later to Misia's half-brother, Cipa, suggests that it may have been owned by a member of that family. Jean Godebeski, Misia's nephew and Cipa's son, remembers living with his sister Mimi in this apartment when he was around five, but does not recall whether or not they owned it (conversation with the author in Paris, 12 October 1981). It is his sister pictured with Misia in plate 143.

67 As was Alexandre's second home in the former Hôtel Dufayel. Apartments were rented with three-year leases. For a discussion of apartment living and the rise of the *maison à loyer*, see Lipstadt, "Housing the Bourgeoisie," 1977, pp. 35–47.

68 One of the most famous of these reduction-reconstruction projects was Boni de Castellane's "Palais Rose," which was divided into luxury apartments with a ground-floor, fashionable restaurant after his divorce from the American Anna Gould; see Hillairet, *Dictionnaire historique des rues de Paris*, 1964, v. 1, p. 253.

69 The only cadastral record at the Archives de la Seine for the apartment at 9 rue Saint-Florentin, is for the years 1862 (DP 1 Vo 11) with additions noted in 1864–76: "Propriété ayant entrée de porte cochère, composée d'un corps de logis sur rue, double en profondeur, ayant 5 croisées de face avec retour en aile à droite de cour, service double, et petite cour dans laquelle sont des constructions pour écuries.

"Le bâtiment sur rue est double en profondeur, il est élevé sur caves, d'un rez-de-chaussée, Entresol, 2 étages carrés, 3e mansarde, 4e dans la pointe du comble, l'aile et le bâtiment du fond ont le 4e de moins." The larger apartments on the *premier* and *deuxième* floors were luxury apartments owned in the Second Empire by Comtesse Hallez-Claparede among others. I am grateful to Elizabeth Easton and Juliet Bareau for sharing with me the results of their research on the Natansons' "annex," which has never been precisely identified in the Vuillard literature. For a description of the original building, see Hillairet, *Dictionnaire historique des rues de Paris*, 1964, v. 1, pp. 406–7.

70 See Archives de la Seine, DP 1 Vo 11, 1862 (1864): "Elévation d'un étage sur la façade et sur l'aile droite." Although there is no mention of the addition to the "fond," the listing of the "bâtiment du fond" in the same cadastral record indicates that there was an addition in 1864 or later. Unfortunately, lacking the cadastral records for the later years, it is unclear exactly how these apartments were distributed and by whom they were owned.

71 Archives de la Seine, DP 1 Vo 11 (1862). The description for the building in 1862–76 shows that it consisted of the following: *palier*, 1 (entryway); double antichambre[?], 1 (either an *entrée* doubling as ante-chamber or a two-roomed ante-chamber); *cuisine*, 1 (kritchen); *salle à manger*, 1 (dining-room); *p. sf.* [*pièce sans feu*], 1 (room without fireplace); *ch. à c.* [chambre à coucher], 1 (bedroom).

72 In an insightful essay on "the orderly household" in nineteenth-century France, Eran Olafson Hellerstein argues that, far from being a frivolous or inconsequential occupation, womens' role as creators and controllers of household order filled a real social need ("French Women and the Orderly Household, 1830–1870," in Brison D. Gooch (ed.), *Proceedings of the III Annual Meeting of Western Society* (Western Society for French History, December 1975), p. 383. Hellerstein concludes that, while the outside world of the man was thought to be in opposition to the "inside" world of the woman, they were both fulfilling social needs and were the tightly structured. She goes so far as to compare the prison system and the corset to the structures of the male and female world. See also Pollock's analysis of bourgeois and feminine spaces in *Vision and Difference*, 1988, pp. 50–85.

73 See, for example, Toulouse-Lautrec's *Misia at the Piano* (1897, oil on cardboard, Musée des Beaux-Arts, Berne) and Vallotton's woodcut, *The Symphony* (1897; Maxime Vallotton and Charles Georg, *Félix Vallotton: Catalogue raisonné de l'œuvre gravé et lithographié*, Geneva, 1972, no. 186).

74 Misia's use of large ferns as decoration was in keeping with the late nineteenth-century vogue for flowers and plants and the style of *jardin d'hiver* or winter gardens which prevailed in the mainstream of bourgeois homes. According to Burnand, *La Vie quotidienne en France de 1870 à 1900*, 1947, pp. 119–20: "Nos parents avaient, pour ce qu'on nomme les jardins d'hiver, les vitrages, les vérandas, un goût qu'on retrouve, à des degrés divers, dans tous les milieux. Ils aimaient les plantes vertes et, par extension, les cachepots qui les enserrent. Le contraste les séduisait de la vie paisible et du décor exotique . . . Ainsi les intérieurs, au temps de notre jeunesse, tenaient à la fois du repoussoir et de la serre. Un jardin d'hiver, avec les frondaisons prolongeant le capitonnage du salon, c'est l'idéal de toute femme élégante." For a description of the exotic interiors of *cocottes* and *grandes mondaines*, see Yvonne Michell, *Colette: A Taste for Life* (New York), London: Harcourt Brace Jovanovich, 1975), pp. 40–1. For the history of the bentwood (Thonet) rocker and Vuillard's use of it as a decorative arabesque in paintings during the 1890s, see Easton, *Intimate Interiors*, 1989, pp. 125–6.

75 It is interesting that Misia is given a backseat to the more prominent figure of Thadée in this portrait-photograph. In the majority of Vuillard's paintings, it is Misia who presides over Thadée (see pl. 161).

76 Sometimes mistakenly titled *Déjeuner à Villeneuve* (*Luncheon at Villeneuve*); see Ritchie, *Edouard Vuillard*, 1954, p. 60, and Russell, *Vuillard*, 1971,

no. 41.

77 Sert, *Misia*, 1952, p. 20.

78 *Ibid.*, p. 21. When Misia's second mother (Mme Natanson, sister-in-law to Adam) died, her father and his third wife, Mme Ganville, moved to the rue de la Pompe, and the mansion on the rue Prony was given to her two older half-brothers, Cipa and Ernest.

79 Adam owned the Château de Méréville from 1889 to 1890, and Alexandre was married there; see Vaillant *Le Pain polka*, 1974, p. 68, and below, ch. 6, p. 124.

80 One wonders, too, whether their decorative schemes were not also a question of practicality, since it was not uncommon that the family's fortune would remain with the patriarch until his death and then be passed on to the eldest son. A similar custom required the woman to inherit only at her marriage. According to Misia, on her wedding day she received 300,000 francs from her grandmother which she immediately spent on her trousseau and decorative accessories; Sert, *Misia*, 1952, p. 38.

81 *Ibid.*, p. 32. For an historical presentation of the evolution of patterned wallpaper and its vogue in the nineteenth century, see Catherine Lynn, *Wallpaper in America: From the Seventeenth Century to World War I* (New York: Cooper-Hewitt Museum Book/W.W. Norton & Co., 1980), esp. chapter 16, "The 1870's and 1880's: A Major change in Taste," pp. 367–443.

82 See Sert, *Misia*, 1952, p. 36 and below, ch. 6, n. 103.

83 *Ibid.* The decorative ensembles seen at Bing's art-nouveau gallery were also very elitist in price. As Camille Mauclair complained in 1895, the "modern style" was too extravagant and too incomprehensible to merit the banner of "democratic" art under which it stood., cf. Camille Mauclair, "La réforme de l'art décoratif," *La Nouvelle Revue* v. 98 (15 February), p. 736, cited in Williams, *Dreamworlds*, 1982, p. 164.

84 See Charlotte Gere, *Nineteenth-Century Decoration: The Art of the Interior* (London: Weidenfeld and Nicolson, 1989), no. 341, pp. 291–2. Who describes the "flamboyant Morrisian method" as creating "a restlessness which makes the room far less than the sum of its parts."

85 Correspondence from B. Thomson, 29 January 1992, citing information from French wallpaper curator, Bernard Jacqué.

86 Vaillant, "Livret de famille," 1956, p. 27.

87 In a letter to Vallotton written from Villeneuve, Vuillard wrote childishly about the good time he was having with the Natansons, concluding: "She [Misia] is sporting the violent colors that delight you as much as they do me. Perhaps you will come back soon? . . ." (letter dated 23 October 1897, trans. in Gold and Fizdale, *Misia*, 1980, p. 70). See also Guisan and Jakubec, *Vallotton: Documents*, 1973, v. 1, no. 104, p. 164.

88 *The Vanity Table* was recently sold at Christies, *Impressionist and Modern Painting and Sculpture* (Part I), (New york, 14 November 1989, no. 55). *The Stoneware Vase* has remained in the Hessel family collection.

89 A date of *c.*1896–7 can be determined by the scratched surface rendered with the point of a paintbrush – a technique that Vuillard was experimenting with at that time.

90 For a discussion of the portrait, see Ciaffa, *Portraits*, 1985, p. 254. Interestingly, *The Vanity Table* does not appear in any of Vuillard's pictures within pictures executed between 1896 and 1901 when Thadée and Misia moved from the "annex" into Adam's *hôtel privé* on the rue Jouffroy.

91 For another type of perceptual "integration," see Raoul Sertat, "Quatre panneaux décoratifs de Jules Chéret," *Revue des Arts décoratifs*, v. 12 (1891–2), pp. 207–10. Sertat praised Chéret's decorative lithographs and recommended that they be framed with tiny silver bands to integrate better the panels with the gold and white architectural framework of the interior.

92 I am grateful to Mme Ducrey of Galerie Vallotton, Lausanne, for calling to my attention the connection with Vallotton's painting and the Vuillard *décoration*.

93 See Hedy Hähnloser-Bühler, *Félix Vallotton et ses amis* (Paris; Editions A. Sedrowski, 1936), "Livre de Raison," no. 391. Vallotton moved from the rue Jacob apartment to the rented apartment at 6 rue de Milan after his marriage to Gabriella Bernheim Rodriguez in May 1899; see correspondence from Mme Ducrey, Lausanne, 29 September 1988.

94 Jean and Henry Dauberville, *Bonnard: Catalogue raisonné de l'oeuvre peint* (Paris: Editions J. and H. Bernheim-Jeune), v. 4 (1962), no. 01940, *Femme dans un intérieur*, c.1908, oil on canvas, showing *Femme au lapin*, no. 1716a from the series, *Femmes dans un jardin*, 1891.

95 "Quand donc ces peintres comprendront-ils que la présentation rectangulaire d'un cadre isolé sur un mur exclut tout ordre de déformations et de simplifications qui sont essentielles à la décoration murale, à la tenture ou à la frise?" (Mauclair, "Choses d'art," *Mercure de France*, v. 17 (March 1896), p. 418).

96 "Et met-on dans un cadre une chose peinte à plats et dans un sentiment de tapisserie à tons juxtaposés? Une décoration n'est pas un tableau, et voilà une différence que personne des jeunes peintres n'aperçoit." (Mauclair, "Choses d'Art," *Mercure de France* (December 1894), p. 384).

97 Anon., "Beaux Arts," *La Revue Blanche*, v. 9 (15 December 1896), p. 618.

98 See M. Perrot, *From the Fires of Revolution*, 1990, v. 4, pp. 378–9. One can think of Degas's painting of the billiard-room, done as a favor for his friend, Paul Valpinçon, while visiting his château at Ménil; see Theodore Reff, *Degas: The Artist's Mind* (New York: Harper and Row, 1976) p. 14. See also Roger Marx, "Une Salle de Billiard et une Galerie Moderne," *Art et Décoration*, v. 12 (July 1902), pp. 1–13, for an illustrated account of the billiard-room and its *décorations* by Alexandre Charpentier, Félix Bracquemond, and Jules Chéret commissioned by the wealthy banker and art patron, Baron Vitta for his villa.

99 Adam Natanson owned Flemish early sixteenth-century tapestries that probably inspired Vuillard's decorative paintings *Landscape Overlooking the Woods* and *The First Fruits*; see below, p. 231, n. 54.

100 Indeed Vuillard may also have been thinking of the shadow-box theatre of the Chat Noir, or Ranson's and Bonnard's "Théâtre des Marionnettes," which began in January 1896. For a discussion of this painting, see Ciaffa, *Portraits*, 1985, p. 250. The tapestry resembles none of the "modern" tapestries that were manufactured at the Gobelins beginning in 1897–8. In the spring of 1895, both Ranson and Maillol exhibited tapestries at the Salon de la Société National des Beaux-Arts (also known as the Salon du Champs de Mars), although they were very different in style and composition from Vuillard's "painted tapestries." See H. Fiérens-Gevaert, "Tapisseries et broderies," *Art et Décoration*, v. 1 (1897) pp. 85–6, and below, chs. 6 and 9, pp. 127–8 and 186–8.

101 A curious description of the Natansons' rue Saint-Florentin apartment is offered by Paul Leclerq in his monograph on Toulouse-Lautrec, where he describes the party thrown at Thadée's and Misia's residence, with the rooms "disposées en enfilade, meublées de vastes fauteuils de cuir . . ." Paul Leclerq, *Autour de Toulouse-Lautrec* (Geneva: Pierre Cailler, 1954), pp. 111–12. Leclerc seems an unreliable witness since his description of the "annex" refers to the soirée where Toulouse-Lautrec served as bartender. This event is recorded by several people as having taken place at the Alexandre Natansons (see above, ch. 3, p. 64). I am grateful to Belinda Thomson for calling my attention to this reference.

102 Lucien Muhlfeld, "A Propos de peintures," *La Revue Blanche*, no. 20 (June 1893), p. 460.

103 Sérusier, *ABC de la peinture*, [1903], p. 106, cited and trans. in Boyle-Turner, *Paul Sérusier*, 1980, p. 279, n. 2.

104 *Ibid.* It would be useful to make a chart of Vuillard's representations of the Natansons' interiors which include decorative paintings to figure out their exact installations during the year.

105 See Burnand, *La Vie quotidienne en France*, 1947, pp. 124–6, who describes the sweet, discreet glow of oil lighting which was easy on the eye and which the French were slow to abandon for electricity. Oil lamps were also the stars of several lithographs dating from 1896–7 and published in the Vollard album, *Paysages et intérieurs*, 1899, nos. 36, 37.

106 Roger-Marx, *Vuillard*, 1946, p. 188.

107 Lhôte began his description of the paintings (already in the Hessel collection) by comparing Vuillard with Renoir: "Ce que Renoir fit de cette époque, dont il spiritualisa les goûts mièvres, c'est Vuillard qui le fit de l'époque suivante, celle où fleurit le Modern Style. *La Tasse de café, Dans les fleurs*, ces deux panneaux décoratifs éxécutés pour M. Jos. Hessel, et réalisés dans ces tons de bois, de cuir et de vin de Bordeaux si fort à la mode, sont des merveilles de transposition de l'ambiance" (see André Lhôte, "De 1900 au Baroquisme," [1929] in *Parlons peinture: essais* (Paris: Les Editions Denoël et Steele, 1936), p. 157.

108 The combination of idealist and materialist aesthetics is apparent in Thadée's love for the art of Renoir, perhaps the most sensual of the Impressionists.

109 Thadée is listed at 23bis rue de Constantine, in *Paris-Bottin*, 1903, "Nouveaux abonnés," for August 1903.

110 "On était donc 'ému' et 'recueilli' devant les choses, comme devant les êtres vaquant aux quotidiennes tâches du traintrain domestique. Le 'foyer' reprenait son sens auguste" (Jacques-Emile Blanche, "Les Intimistes," in *Les Arts plastiques* (La Troisième république: 1870 à nos jours) (Paris: Les Editions de France, 1931), p. 117.

111 In Segard, *Les Peintres d'aujourd'hui*, 1914, v. 2, p. 266, as *Intimité*; Roger-Marx, *Vuillard*, 1946, p. 125, as *La Lecture*; Salomon, *Vuillard*, 1968, no. 66, as *La lecture*; Russell, *Vuillard*, 1971, p. 225, as *The Drawing Room*.

112 In Segard, *Les Peintres d'aujourd'hui*, 1914, v. 2, p. 266, as *Le Travail*; Salomon, *Vuillard*, 1968, no. 67[a], as *La Couture*; Russell, *Vuillard*, 1971, p. 225, as *Dressmaking*.

113 In Segard, *Les Peintres d'aujourd'hui*, 1914,v. 2, p. 266, as *Le Choix des livres*; Salomon, *Vuillard*, 1968, no. 67[b], as *Dans la bibliothèque*; Russell, *Vuillard*, 1971, p. 225, as *The Library*. The title is a semantically confusing, since "bibliothèque" can refer either to the actual bookcase or shelves, or to the office where the books are shelved. *Catalogue de peinture, dessin, sculpture, gravure . . .* (Grand Palais des Champs-Elysées, 18 October–25 November 1905), nos. 1597–1660, "panneaux décoratifs" (figures dans un intérieur, appt. à Vaquez).

114 See Denis, "Salon d'Automne," 1905, in his *Du symbolisme au classicisme: Théories*, 1920, p. 108.

115 "Août Visite att. Vaquez. Paresse complète" (Journal, MS 5396, *carnet* 2, p. 49r).

116 "1896 *panneaux de H. Vaquez* Mois de juillet à Valvins, Mois d'août *panneau de Vaquez*" (Journal, MS 5396, *carnet* 2, p. 78r).

117 Vaquez' parents lived at 26 rue Clichy and owned a silk manufacturing factory, called "LaSoie" (typescript of family history by Mme Jean Guillois, Vallée Mont Dol, 35,000 Rennes, 25 November 1977, p. 1). According to Mme Guillois (daughter of Mme Benard, second cousin to Vaquez), the homeland for the Vaquez was Crouy-en-Thelle, near Creil, where Henri Vaquez' parents had a button industry which expanded into the larger silk factory of "LaSoie," eventually run by the doctor's brothers, Albert and Lucien.

118 Among his published studies are: "Causes de la mort qui survient à la suite d'accouchement chez les femmes atteintes d'affection cardiaque" (1897) and "Du coeur dans la grossesse normale" (1898). See C.-E. Curinier, *Dictionnaire national des contemporains*, v. 2 (Paris: Office Général d'Editions, B. Brunel & Co., [1899–1905], pp. 179–90; A. Clerc, "Notice nécrologique sur M. Henri Vaquez," de M. Henri Vaquez," *Académie Nationale de médecine: Bulletin*, v. 115 (1936), pp. 685–95; Henry Talbott, *A Biographical History of Medicine* (New York: Grune and Stratton, 1970), pp. 1156–8. It is also possible that Vaquez may have known about Vuillard through Henri Delavallée (1862–1946), a painter associated with Emile Bernard and the Pont-Aven artists and related to Vaquez by marriage, who had exhibited in the Durand-Ruel gallery in 1890 and at the *Peintres-Graveurs* exhibition held there in the spring of 1892 (Guillois, typescript, 25 November 1977, p. 4). See also Musée de Pont Aven, *Aquarelles, pastels, dessins, objets de l'Ecole de Pont-Aven*, 30 June–30 September 1985, p. 37.

119 Near to his professional office on the boulevard Haussman (Roger-Marx, *Vuillard*, 1946, p. 124).

120 Talbott, *History of Medicine*, 1970, pp. 1157. In addition, Vaquez was a writer and editor of the journal, *Archives des maladies du coeur et du sang*, which he founded in 1908.

121 Later this was redescribed, almost rediscovered, and called "true polychemia" by Dr. Osler, in the belief that he had made an original discovery (known thereafter as Osler-Vaquez disease); see *ibid*. While still a student, he had already published several articles on tuberculosis and hemorrhaging; see Curinier, *Histoire des médecins*, 1899–1905, pp. 179–80; Talbott, *History of Medicine*, 1970, p. 1157; Clerc, "Notice nécrologiques," 1936, p. 688. Vaquez's most important book, *Maladies du coeur* (Paris: J.-B. Baillière, 1921), was translated into English as *Diseases of the Heart* (Philadelphia: W.B. Saunders & Co., 1924).

122 I am grateful to Dr. Jorge Soni, Director General of the Instituto Nacional de Cardiología, for having provided the color photograph of this mural.

123 For Vaquez, see description in Clerc, "Notice nécrologique," p. 694: "sensible à la beauté de l'art le plus moderne comme du plus classique; lecteur insatiable, d'une culture prodigieuse, mais ayant horreur de la pédanterie, il nous charmait par l'esprit étincelant de ses causeries, la netteté de ses jugements, l'imprévu de ses paradoxes."

124 See Albert Boime on Dr. Pozzi, "Sargent in Paris and London," in Particia Hills (ed.), *John Singer Sargent* (New York: Harry N. Abrams, 1986) pp.

85–6, fig. 55. For Misia's father's friendship with the doctor, see Gold and Fizdale, *Misia*, 1980, p. 24.

125 See Philip Kolb *Proust: Correspondance* (Paris: Plon, 1976), v. 2, pp. 97–8, no. 46, letter to his mother, 15 August 1902, referring to Dr. Vaquez's reassurance that his heart was not damaged and his recommendation that Proust stay in bed and take periodic doses of Trional, a cure he decided not to try. Three days later, Proust informed his mother that the Doctor Vaquez "est un bon garçon, intelligent et sérieux" (*ibid.*, p. 110, no. 54, dated 18 August 1902); On 1 September 1902, Proust wrote to his mother that he could not sleep well and that perhaps he should have listened to the doctor (*ibid.*, p. 123, no. 62). The son of the actress Réjane recorded that in July [1911], his mother went to Royat for a cure prescribed by Dr. Vaquez, "the heart specialist who sent her there" ("le spécialiste du coeur, qui l'y avait envoyée"); see Jacques Porel, *Fils de Réjane* (Paris: Plon, 1951), p. 240. For Léon Daudet and Dr. Vaquez, see Edmond and Jules de Goncourt, *Journal: Mémoires de la vie littéraire* (Monaco: Les Editions Imprimerie Nationale de Monaco, 1958), v. 22 (1896), p. 8: entry for 25 April 1895.

126 Interview with M. le Docteur Valentin, Président, Académie de Médecine, Paris (23 May 1982).

127 *Dr. Viau opérant*, c.1914, *à la colle* on canvas, repr. in Russell, *Vuillard*, 1971, pl. 77 (note the old-master drawings in the background); *Portrait of Dr. Viau* (the son), 1937, rep. in Ritchie, *Vuillard*, 1954, p. 89; and *Dr. Gosset opérant* (1912, 1936), New York, repr. in Roger-Marx, *Vuillard*, 1946, p. 160. For a description and a discussion of the d'Espagnat panels, together with Vuillard's decorative paintings, in 1898, see below, ch. 5, p. 106, and pls. 172–3.

128 See "Acte de Succession, Dr. Henri Louis Vaquez, 6 Square Debussy, 20 April 1936, [Archives des directions de l'enregistrement, Saint-Sulpice]: "(2) de caisser après ma mort mes quatre panneaux de Vuillard, soit au musée du Louvre, soit au Musée des Arts Décoratifs, ou, à son gré de les donner de son vivants. (3) de faire de même pour mon estampe de Toulouse-Lautrec, l'Album du Cirque à attribuer au musée de Toulouse-Lautrec à Albi..." Another "Acte de Succession," for the doctor, bequeathed to his brother, Lucien, a "Tableau de Carrière, *Le Dos de femme nue de peintre*" (estimate: 9,000 francs); to the Académie de Médecine, a *Portrait à l'hôpital par Vuillard* (estimated by M. Damidot at 15,000 francs); and to his wife, other general "objets mobiliers, tapisseries, tableaux garnissant l'appartement à Paris no. 6 Square Debussy." In 1906, Vaquez exhibited a Redon pastel (?)*Geranium* (no. 20) at the exhibition held at the Durand-Ruel galleries, 28 February–15 March 1906. At one time, he owned also Vuillard's small oil-on-cardboard panel from 1895, *Sur le Banc* (and subsequently in the Georges Renard Collection); see Ritchie, *Vuillard*, 1954, p. 53. Mme Guillois believes that Dr. Vaquez also owned a Manet portrait of a woman in a yellow dress, present location unknown (interview with Mme Guillois, 21 November 1981).

129 Journal, MS 5397, *carnet* 2, n.p.: July 1913. For *Portrait of Mme Vaquez*, 1918 (Paris, Musée d'Orsay), see Roger-Marx, *Vuillard*, repr., p. 102.

130 See also the study for *Le Professeur Henri Vaquez et son assistant, Docteur Parvu, à l'hôpital*, c.1917, *à la colle* and pastel, 64.1 × 49.5 cm., A. Tooth and Sons, London (May 1969, no. 26).

131 Vaquez also may have commissioned two large rectangular paintings in distemper inspired by the

place Augustin, *Le Siphon* and *Femme à la rose*, which were sold shortly afterwards; see Thomson, *Vuillard*, 1988, pl. 98 and Salomon, *Vuillard*, 1968, pp. 130–1. When Vuillard's client, Henri Larouche, refused to pay for his commission of three violon-shaped *trumeaux* showing the place Vintimille, on which the artist had worked from May 1917 to February 1918, it was Vaquez who stepped in to purchase them; see Thomson, *Vuillard*, 1988, p. 130, pl. 110, and p. 120.

132 See Thadée Natanson, "Peintre à propos de Mme Charles Cottet," 1896, p. 518. For a formal and iconographical discussion of this enigmatic painting see Dennis Farr *et al.*, *Impressionist and Post-Impressionist Masterpieces: The Courtauld Collection* (New Haven and London: Yale University Press, 1987), no. 3; *Manet: 1832–1883*, exh. cat. (New York: Metropolitan Museum of Art, 10 September–27 November 1982), no. 211.

133 See Wharton and Codman, Jr., *The Decoration of Houses*, 1910, p. 130: "an expanse of beautiful bindings is as decorative as a fine tapestry." In July 1896, Bing's Maison de l'Art Nouveau hosted an international exhibition of "The Book from Modern to Art Nouveau." Reviewing the exhibition for *La Revue Blanche*, v. 11 (1896), pp. 43–4, Edmond Cousturier noted the importance of bindings, "le vêtement du livre," citing Edmond de Goncourt's extreme affectation, "... lui, fait peindre ses livres à l'huile! En attendant qu'il les encadre, je pense qu'il doit les lire, selon un usage assez répandu, ce qui est bien compromettant pour leur avenir."

134 See analysis of these panels in Curt Schweicher, *Die Bildraum Gestaltung das Dekorative und das Ornamentale im Werke vom Edouard Vuillard*, diss., Universität Zürich, 1947 (Trier: Paulinus Druckerei GMBH, 1949), pp. 76–7. See also Klaus Berger, *Japonisme in Western Painting from Whistler to Matisse*, trans. David Britt (Cambridge University Press, 1992, reprint of German ed., Prestel Verlag, 1980), pp. 221–3, for discussion of these paintings and their affinities with the design qualities of Ukiyoe prints.

135 Segard, *Les Peintres d'aujourd'hui*, 1914, v. 2, p. 267.

136 Compare, for example, *Scene in a Courtyard*, East Persian miniature, sixteenth century, Fogg Art Museum, Harvard University, repr. in *The Sources of Modern Painting*, exh. cat. (New York: Wildenstein and Co., Inc., 25 April–30 May 1939), no. 52. For the first comparison with medieval tapestry, see Chastel, *Vuillard*, 1946, p. 51.

137 See Roger-Marx, *L'Oeuvre gravé de Vuillard*, [1948], nos. 36 and 37. Curiously, in the lithographs, space is expanded and one can well imagine the two settings for the pink wallpaper, for example, transformed into broadly painted set décors, which the compressed and overworked interiors of the Vaquez panels could never suggest.

138 See Elizabeth Chave, "The Lamp and Vuillard," *Yale University Art Gallery Bulletin*, v. 30 (Fall 1980), pp. 12–15.

139 See, for example, Achille Segard, "Octave Mirbeau Chez lui," *Revue Illustrée* (1 January 1898), n.p.

140 Roger-Marx, *Vuillard*, 1946, p. 124.

141 Although anti-clerical in his general philosophy, in his novels, Zola was an arch bourgeois in his treatment of womanhood and praised motherhood as a sacred function and virginity and sterility as calamities. For a good discussion of Zola's ambivalent attitudes towards the bourgeois woman, see Brian Nelson, *Zola and the Bourgeoisie: A Study of the Themes and Techniques in "Les Rougon-Macquart"* (Totowa, New Jersey: Barnes

& Noble Books, 1983), esp., pp. 48–59 *passim*.

142 Jean-Pierre Peter, "Les Médecins et les femmes", in Aron, *Misérables et glorieuses*, 1980, p. 88.

143 *Ibid.*, pp. 83, 94–5. See, for example, Goncourt's assessment of the "female condition," in his journal entry for 1 July 1893: "Quand une femme est arrivée au moment où l'essai des ses robes ne lui prend plus tout son temps, où l'amour ne l'amuse plus, où la religion ne s'en est emparée, elle a besoin de s'occuper d'une maladie, et d'occuper un médecin de sa personne," in *Journal*, édition définitive (Paris: Flammarion) v. 9 (1892–5), p. 109.

144 For the woman as "angel of the house," see Adrian Forty, *Objects of Desire* (New York: Pantheon Books, 1986), pp. 104–15. See also Linda Nochlin, "A House is Not a Home: Degas and the Subversion of the Family," in Richard Kendall and Griselda Pollock (eds.), *Dealing with Degas* (London: Pandora Press, 1991), especially her summary of the making of the bourgeois codes defining masculine and feminine, pp. 49–53.

145 Conversation with Mme Guillois, 21 November 1981. Marie's artistic disinterestedness is also implicit in the fact that the doctor's will and testament offered detailed instructions on how his wife should distribute his art collection. Only the Vuillard panels were left in question, and Mme Vaquez was given the choice of donating them to a museum or giving them to "ses vivants" ("Acte de Succession," above, n. 12).

146 "Les salles de repos où le travailleur intellectuel, dans les intervalles des ses recherches, se berce de vagues sensations heureuses dont la nature fournit le motif" (Segard, *Les Peintres d'aujourd'hui*, 1914, v. 2, p. 253).

147 André Gide, "Promenade autour du salon," *Gazette des Beaux-Arts*, v. 31 (1 December 1905), pp. 475–85, trans. in Russell, *Vuillard*, 1971, p. 96.

148 "Dans ces panneaux exposés ici ... developpés d'harmonies mattes d'une telle fantaisie ... s'il s'agit de la couleur, l'étoffe de dix, de vingt tapisseries décoratives, les plus rares du monde" (see François Monod, "Le Salon d'Automne," *Art et Décoration*, v. 18 [November 1905], p. 200).

149 "C'est vrai, du reste ... Mais où est le mal? Et si on les faisait exécuter tels quels, sur les bords de l'illustre et puante Bièvre, – où il reste d'excellents ouvriers–peut-être que cela nous donnerait enfin une décoration moderne" (P.-J. Toulet, "Au Salon d'Automne," *La Vie Parisienne* [11 November 1905] p. 13).

150 "Vuillard, exagérant son procédé fait avec impatience des tromp-l'oeil de tapisserie, gâte par sa facture un joli sentiment décoratif" (Maurice Guillemot, "Salon d'Automne, III," *L'Art et les artistes*, v. 2 (October 1905), p. 51).

151 Journal, MS 5397, *carnet* 2: November 1907: "Chez Vaquez ... Emplacement des panneaux, Salle à manger. Salon. Demande nouvelle de panneaux."

152 See Journal, 22 January 1908: "Retour chez Vaquez ... Je prends les mesures dans le salon." But see also 20 November 1908: "Chez Vaquez. abandon de la commande de panneaux nouveaux pour le salon."

153 Vaquez, "Acte de Succession." The works were not allowed to enter the Louvre, and, upon the suggestion of a sculptor friend of the doctor, M. Rudier, the four panels were given directly to the Ville de Paris, to the collection of the Petit Palais; see "Rapport," by M. Darra, Conservateur des collections de la ville de Paris, 12 June 1936. I am indebted to Mme Cacan-Bissy of the Musée du Petit Palais for having provided me with this information (communication, 9 May 1983).

154 Salomon, *Vuillard*, 1968, p. 69.

155 Roger-Marx, *Vuillard*, 1946, p. 124.

156 "À propos de la réalité. Ils ne prétendent pas à recopier la réalité. Ils non [sic] proposent un thème initial et servent de guide à notre plaisir" (Segard, *Les Peintres d'aujourd'hui*, 1914, v. 2, p. 272.

157 See Vaquez, "Acte de Succession." There are no less than four pages of the different stocks and dividends he owned and the investments in companies such as Banque de l'Union Parisienne, Austrian and Argentinian banks, stocks in Shell-Transport, Java United Plantations, Ltd. Agricole Florestole de Ferro Mantu Alergre (Brazil), Chemins de Fer, Russia, Compagnie Chemin de Fer de l'Ouest et de l'Oural (one of Thadée's enterprises) and shares in his family's business, Société Anonyme "les textiles à coudre" LaSoie, at Lyon.

158 One can think, too, of Degas's ambition, expressed in his notebooks, to do an allegorical decorative work with figures half the size of real life, and to create for a library, "Portrait d'une famille dans une frise" (see *Degas*, 1988, nos. 204, 206, pp. 318–20).

159 Thomson, *Vuillard*, 1988, p. 44.

160 Unfortunately, while the recent exhibition catalogue includes one of Vallotton's pictures of the *Large Interior*, no further information about its acquisition or meaning to the artist (or to Vuillard) is provided; see Newman, *Vallotton*, 1991, p. 29, no. 27, pl. 27, and checklist, p. 297.

161 Ursula Perruchi-Petri, *Bonnard und Vuillard im Künsthaus Zürich*, (Zurich, 1972), Sammlungsheft 3, p. 25, no. 1. According to Mme Ducrey of the Galerie Vallotton, Lausanne (correspondence with author, 14 November 1988), the misidentification of figures may have come from an earlier confusion. Roussel may have told Maxime Vallotton that it was the Ranson family and Maxime could have made the mistake, telling Felix Andrea Baumann, ("Hinweis Auf Einige Neuerbungen," *Zürcher Künstgesellschaft*, 1966, pp. 61–6), who in turn told Perruchi-Petri. Unfortunately, no photographic or biographical documents exist that would identify the figures.

162 The panel is indirectly referred to by Thadée in his review of the exhibition, "Petite Gazette d'Art," *La Revue Blanche*, v. 12 (April–May 1897), p. 186: "Tel avouera ses préférences pour les délicieux petits tableaux de M. Vuillard qui sont comme des creusets où il éprouve des harmonies toujours nouvelles, toujours plus intenses, dont il sait à merveille meubler, emplir des surfaces étendues— la plus grande toile en témoigne."

163 As has been suggested, it is even possible that the picture grew out of his involvement with Antoine's modern "realist" theater for which full interiors were sometimes reconstructed on stage (1887–93); see Aitken, *Artistes et théâtres d'avant-garde*, 1991, p. 10.

5 Portraiture as Decoration

1 As shown, Vuillard's circle of friends was largely drawn from the theater, including playwrights Alfred Natanson (and his actress-wife Marthe Mellot), Tristan Bernard, Romain Coolus, and Georges Feydeau. See below, ch. 7, for theatrical contacts after 1900.

2 Larousse, *Grand Dictionnaire universel du XIXème siècle*, v. 15, 1878, p. 1059: "Cette petite ville est très agréablement située sur la rive droite de l'Yonne." See also Sert, *Misia*, 1952, pp. 66–8.

3 "Exposition Vollard. Lithographies. Villeneuve-sur-Yonne" (Journal, MS 5397, *carnet* 2, p. 16r).

4 Vuillard exhibited eleven small *intimiste* canvases with titles such as *Intérieur*, *La Table*, *La Cuisine*, etc., as well as "affiches et lithographies" (*Exposition de Oeuvres de Bonnard, Maurice Denis, Ibels, Lacombe, Ranson, Rasetti, Roussel, Sérusier, Vallotton et Vuillard* (6–30 April 1897), Galerie Vollard, 6 rue Laffitte). Writing for the *Mercure de France*, André Fontainas's review of the notable artistic events of the year singled out Vollard's efforts to promote the younger artists: "A.M. Vollard, le premier, notre gratitude est due pour nous avoir convié à admirer les plus beaux van Gogh, et cette exposition de dix où se sont manifestés dans la plénitude de leurs talents originaux des peintres tels que MM. Vuillard, Bonnard, Roussel, les décorateurs comme M. Ranson" ("Art," *Mercure de France* v. 23 [August 1897], pp. 374–6). See Roger-Marx, *L'Oeuvre gravé de Vuillard*, no. 29. For the album of the series, see Ambroise Vollard, *Souvenirs d'un marchand de tableaux* (Paris: Editions Albin Michel, 1937), p. 298. See also Vuillard's letter to Vallotton in Guisan and Jakubec, *Félix Vallotton: Documents* v. 1 (1973), p. 176, no. 118.

5 Journal, MS 5397, *carnet* 2, p. 12r.

6 If a *villégiature* symbolized one's economic success, Vuillard did not qualify, since he was never an urban or rural home-owner. For an illustrated survey of notable artists and their country residences at the turn of the century, see Maurice Guillemot, *Villégiatures d'artistes* (Paris: Ernest Flammarion, *c.*1905).

7 Schopfer, "Modern Decoration," 1897, pp. 243–55.

8 Jean Edouard Schopfer [pseud. Claude Anet], b. 28 May 1868, Morges, Switzerland. See *Qui êtes-vous? Annuaire des contemporains français et étrangers, 1909–1910* (Paris: Librairie Ch. Delagrave, n.d.), p. 9, and p. 512 under "Etrangers" at the end of the book; see also "Extrait des minutes des Actes de Mariage du 8e arrd. de Paris," 15 February 1910. For Schopfer's tennis career, see *The New Encyclopaedia Britannica*, 1988, v. 2, p. 169.

9 Newspaper clipping, unidentified source, New York, 1895 kindly brought to my attention by Leila Mabilleau, and repr. in her unpubl. MS "Claude Anet, my Father," 1989, p. 2.

10 The fact that Alice owned the pendants *Woman Reading on a Bench* and *Woman Seated in a Garden* after their divorce in 1903, suggests that they were bought with her money; see below, p. 151.

11 Schopfer (Anet after 1899) was, even by nineteenth-century standards, an eclectic and prolific author. Among his extensive bibliography are: *Notes sur l'amour*, 1908, illustrated by Bonnard (2nd ed., Paris: G. Crès, 1924); a documentary biography on the celebrated tennis player, Suzanne Lenglen (Paris: Simon Kra, 1927); and a number of non-fiction works on subjects ranging from the Bolshevik revolution to Persian miniatures. His most famous romantic novel, *Mayerling*, was later made into a film with Catherine Deneuve. In addition to his articles on art, architecture, and interior decoration for the American art-related journals including *The Architectural Record*, *The Craftsman*, and *The Book Buyer*, Schopfer was also a popular lecturer in East Coast universities; see response [by Gustave Stickley] to Schopfer's article, "L'Art Nouveau: An Argument and Defense" (*The Craftsman*, v. 4 [July 1903], no. 41, pp. 229–38), in *The Craftsman*, v. 7 (December 1903), p. 15.

12 Sert, *Misia* 1952, pp. 105–6.

13 See Veber, "Une Génération," 1938, pp. 265–7.

14 Schopfer, "Modern Decoration," 1897, p. 253, and above, ch. 3, p. 61 and ch. 4, pp. 74–5, 78.

15 Schopfer, "Modern Decoration," 1897, p. 245.

16 *Ibid.*, p. 255.

17 *Ibid.*, p. 243. In the previous year, Schopfer had written a series of articles for *La Revue Blanche* with the ambitious title, "L'Art moderne et l'histoire." *La Revue Blanche*, v. 2 (1896), pp. 68–74, cited also in Thomson, *Vuillard*, 1988, p. 50; see also Schopfer's articles for *La Revue Blanche*: "Origines de l'art français," v. 10 (1896); "L'Art moderne et l'Académie," v. 12 (1897). Two of his earliest articles for the *La Revue Blanche* were "Réflexions sur l'art et la sculpture," v. 4 (1893), and "Civilisation byzantine," v. 7 (1894). After 1900, Schopfer wrote for Thadée's column, "Petite Gazette d'Art," although he did not review the Nabi exhibitions. He did write on "The Woodcuts of Félix Vallotton," for *The Book Buyer*, v. 20 (May 1900), and there is an unpublished manuscript by him for an article on Ker-Xavier Roussel (unfinished?) in the collection of the Humanities Research Center, University of Texas at Austin.

18 Typescript of a letter from Schopfer, dated 4 August 1896 from Morges, Switzerland, Salomon Archives, Paris. *La Revue Franco-Américaine* was a short-lived periodical directed by Prince André Poniatowski and intended to rival the *La Revue Blanche*. During its brief duration it boasted woodcut illustrations by Vallotton and articles by Proust and Jules Renard; see Bernier, *La Revue Blanche*, 1983, p. 58.

19 "Voyage Italie. Venise et Florence. Denis et Schopfer. *panneaux Schopfer*" (Journal, MS 5397, *carnet* 2, p. 12r.) The rest of the listing refers to personal events: "28 jours Nancy [?] et Stéphane [?]. Naissance d'Annette [Vuillard's niece] à Levallois. Novembre rue des Batignolles." The fact that Vuillard, who had heretofore limited his travels to the brief (and necessary) trip to London and Brussels with Roussel (see above, p. 216, n. 61), agreed to travel to Italy with Schopfer indicates their growing friendship. From this trip Schopfer published *Voyage Idéal en Italie: l'art ancien et moderne*, first published in the *La Revue Blanche*, v. 16 (15 August 1898), p. 561, republished by F. Payot (Lausanne, 1899). See also the review of Schopfer's book by Léon Blum in *La Revue Blanche*, v. 19 (May–August 1899), pp. 554–5. Given Schopfer's educational background in art history, one can presume he discussed with Vuillard some of the aesthetic issues concerning the large paintings in progress.

20 I am deeply indebted to James Dugdale, now Lord Crathorne (former owner of the panels), for having given me family notes used for his article on these panels, "Vuillard the Decorator – The First Phase" 1965; see above, p. 209, n. 14 (conversation, 1 December 1982). Condition reports made for the panels in 1975 by A.W. Lucas, National Gallery of Art, London, indicate that small paint losses have occurred and that they have been inpainted around Marthe's head and in the garden area. The ground is a light green, which shows through in areas where flaking and cupping has occurred. Dust has been removed from both paintings by rolling putty rubber over structurally sound parts and spraying with P.V.A. which acts as a varnish. The two are in relatively good condition (copy of Conservator's Report, Department Files, Kimbell Art Museum, Fort Worth, 9-17-83).

21 The revival of *Ubu Roi* took place in April at Bonnard's and Ranson's Théâtre des Pantins, 6 rue Ballu. Thadée, who reviewed the program for the "Petite Gazette d'Art," recorded only that Vuillard "made a very pretty panel" *La Revue*

Blanche, v. 15 (February 1898), p. 213. See also André Fontainas, "Art," *Mercure de France,* v. 26 (May 1898), p. 599.

22 See Thadée's review, "Petite Gazette d'Art," *La Revue Blanche,* v. 16 (May 1898), pp. 65–8 and below, p. 121.

23 The exhibition was organized by Julien Leclercq in collaboration with the Bernheim-Jeune gallery at the beginning of 1898. Vuillard was represented by three paintings: *Aftenstemning,* (*Evening Meal*), *Havescene* (*Garden*) and *Interior,* cf. catalogue *Udstilling at Franske Kunstneves Arbeider* (Kristiana: Blomquists Kunstudstilling, 1898) nos. 54–6. In Stockholm, the same paintings were exhibited, in addition to a lithograph, *Lekande barn* (*Girl lying down*); see *Utstilling at Arbeten af Fransk Konstnarer* (Stockholm, 1898) paintings nos. 68–70, lithograph, no. 101. Among the Nabis participating were Bonnard, Denis, Ranson, Roussel, and Sérusier. I am grateful to Marja Supinen, Finland Sinebryof Museum of Art, for providing me with programs and catalogues from these exhibitions.

24 On the recommendation of Théodore Duret, who had been the champion of the Impressionists, cf. Thomson, *Vuillard,* 1988, p. 76. For a review of the exhibition see G. Sauter, "The International Society of Painters, Sculptors, and Gravers," *The Studio* v. 14 (1898), pp. 109–20. Vuillard is not mentioned personally but listed with the "others" in what seemed, to have been a wide assortment of styles and talents, pairing for example, Manet and Sandys, Degas and Hans Thoma, Giovanni Segantini and Georg-Henrik Breitner, James Guthrie and Albert Besnard, Jan Toorop and J.-L. Forain, and others (*ibid.,* p. 110).

25 A commission that was, unfortunately, aborted by the poet's death in September of that year, cf. Mondor, *Vie de Mallarmé,* 1941, p. 791; and Una Johnson, *Ambroise Vollard, Editeur: Prints Books Bronzes* (New York: The Museum of Modern Art, 1977), no. 155: 2.

26 Roger-Marx, *Vuillard,* 1946, p. 127; Salomon *Auprès de Vuillard,* 1953, p. 32; and Salomon, *Vuillard admiré,* 1961, p. 64.

27 See also Johnson, *Vollard, Editeur,* 1977, no. 155: 2.

28 In a few strokes, Vuillard has managed to suggest the fashion-plate images found in *La Mode illustrée, Le Moniteur de la mode, La Vie élégante,* and the popular *L'Illustration;* see Steele, *Paris Fashion,* 1988, esp. ch. 6, "Art and Fashion," pp. 97–132.

29 Annette Vaillant, *Bonnard ou le bonheur de voir* (Neuchâtel: Editions Ides et Calendes, 1965), p. 78.

30 Roger-Marx, *Vuillard,* 1946, p. 127.

31 For a recent study of the panels, which were never installed and which were divided and sold separately by 1880, see Hélène Adhémar, "Décorations pour le château de Rottenbourg à Montgeron," in *Hommage à Claude Monet,* exh. cat., (Paris: Orangerie des Tuileries, 1980), pp. 168–83.

32 Galerie Georges Petit, *Vente Théodore Duret: Tableaux et pastels,* 1894 March 19 (Paris, 1894): *Les Dindons,* no. 24 (bought in), and *La Chasse* or *Avenue du Parc, Montgeron,* no. 24 (acquired by Durand-Ruel).

33 Apparently, the drawing was originally a single sheet torn in two and now reconstructed and heavily hatched. The line down the center indicates a tear that has since been mended. The hatched lines at the outer margins indicate the uneven edges of the sheet of paper that has been reapplied to another support. I am once again indebted to Juliet Bareau for bringing this drawing to my attention.

34 One can compare, for example, Jean-Baptiste Oudry's popular *Chasses royales de Louis XV* (1734–46), with identifiable nobility and specific geographic sites. See Hal Opperman, *J.-B. Oudry, 1686–1755,* exh. cat. (Fort Worth, Texas: Kimbell Art Museum, 1983), pp. 54–62 *passim.* For Monet, see Wildenstein, *Monet: catalogue raisonné,* 1974, v. 1, nos. 416, 418, 420, and 433 for description of topographical allusions.

35 For a thorough discussion and chronology of this ensemble which was commissioned in 1895–6, see Katherine Aichele Porter, *Maurice Denis and George Desvallières: From Symbolism to Sacred Art,* diss., Bryn Mawr College (Ann Arbor, Mi: University Microfilms International, 1976, 1975), pp. 88–100, and Appendix 1, pp. 329–31.

36 *Ibid.,* pp. 39–40. Denis's dedication to the revitalization of Christian art and his opinion of Vuillard's artistic evolution will be discussed below, ch. 7, pp. 160–2.

37 See the listing of d'Espagnat's decorative projects 1898–1901 in *Georges d'Espagnat,* exh. cat. (Alençon: Musée des Beaux-Arts et de la Dentelle, 29 June–28 September 1987), p. 30.

38 "Dans le grand panneau de la salle à manger du boulevard Haussmann, c'est la terrasse du moulin de Beaulieu, la propriété de M. Viau à Vilenne, qui forme le fond du décor" (Octave Maus, "Un décorateur nouveau: Georges d'Espagnat," *Art et Décoration,* v. 6 [Summer 1899], p. 122).

39 *Ibid.,* pp. 120–3 *et passim.*

40 Preston, *Vuillard,* 1985, p. 101.

41 "Il y a bien la peinture pour vous embêter, mais la gentillesse de Thadée et de Misia répare bien des avariés" (letter postmarked 23 October 1897 from Villeneuve, in Guisan and Jakubec, *Félix Vallotton: Documents* v. 1 (1973), no. 104, p. 164).

42 "Vuillard me sert de mari comme vous voyez, mon Cher Vallo, en aucun bien, aucun honneur naturellement" (*ibid.,* pp. 164–5).

43 "One day in 1898, at Villeneuve-sur-Yonne, the first echoes of the Dreyfus affair incited my husband to return to Paris earlier than usual. Vuillard had spent the summer in the Villeneuve house. He wanted to have a last walk with me. We left at the decline of the day. Grave and drawn, Vuillard took me along the river ringed with high birch trees and silver trunks. I think that we did not speak. He advanced slowly through the yellowing grass and I unconsciously respected his silence. Day fell fast and we took a short cut to return across a field of beetroot. Our silhouettes, side by side, were no more than calm shadows against the pale sky. The earth reddened under our path. I caught my foot in a root and half fell. Vuillard stopped short to help me to regain my equilibrium. Our looks met suddenly. I only saw his sad eyes brilliant in the obscurity. He burst into tears. It is the most beautiful declaration of love that a man ever made to me" (Sert, *Misia,* 1952, pp. 66–8, trans. Lord Crathorne, typescript copy).

44 For casual family photographs of the different visitors to Villeneuve-sur-Yonne, see Vaillant, "Livret de famille," 1956, *L'Oeil,* pp. 27–35 *passim* and Bareau, "Vuillard et les Princes Bibesco," 1986, pp. 38–9, 42–5 *passim.*

45 See Salomon, *Vuillard et son Kodak,* 1963, p. 2. For the use of photography for later decorative projects, see Bareau, "Vuillard et les Princes Bibesco," 1986, pp. 37–47 *passim.*

46 According to Naomi Mauner, of the several portraits Lautrec painted of Misia that summer, this was her favorite; see Charles F. Stuckey, *et al., Toulouse-Lautrec: Paintings,* exh. cat. (Chicago: The Art Institute of Chicago, 1979), p. 283, no.

92. For a description of Lautrec's relationship with Misia and his portraits of her, see Stuckey in *ibid.,* pp. 285, 287, nos. 93, 94. Vuillard's soft focus close-ups can be contrasted, too, with Vallotton's severer image of Misia painted in that year, *Misia à sa coiffeuse,* 1898, repr. in Hedy Hahnloser-Bühler, *Félix Vallotton et ses Amis* (Paris: Editions A. Sedrowski, 1936), "Livre de Raison," no. 310, pl. 21.

47 *Alice Hoschedé au jardin,* 1881, was exhibited at the Monet-Rodin exhibition in 1889 as no. 52; see Wildenstein, *Monet: catalogue raisonné,* v. 1, no. 681. The other version of exact dimensions and subject, *La Terrasse à Vétheuil,* 1881, was owned by and periodically exhibited at the Durand-Ruel Gallery, in *ibid.,* no. 681.

48 See *Exposition Renoir* (Paris: Galeries Durand-Ruel, 28 May–20 June 1896). *Tableaux de Monet, Pissarro, Renoir et Sisley* (Paris: Galeries Durand-Ruel, April 1899).

49 "Il se peut qu'on soit surtout attentif cette année à une évolution particulière de son talent: il demeure le plus délicieux et le plus raffiné des analystes sensuels mais on voit qu'il s'efforce de donner à l'expression de sa pensée plus de généralité et d'ampleur" (Natanson, "Petite Gazette d'Art," *La Revue Blanche* [1898], p. 618).

50 Denis's letter to Gide, dated 18 December 1901, *Journal,* v. 1 (1957), p. 176.

51 According to Annette Vaillant, Vuillard used a photograph of Bonnard for this panel; see her *Bonnard,* 1965, p. 5.

52 See also Toulouse-Lautrec's lithograph of Tristan Bernard at the Buffalo de Veladrome, published in the satirical supplement to *La Revue Blanche,* "Le Nibs," repr. in Bernier, *La Revue Blanche,* 1983, p. 16. Tristan later married Mme Hessel's cousin, Marcelle (Mme Sam Aron), and became even more entrenched in Vuillard's circle; see below, ch. 7.

53 "Mme Mabilleau sur Jean Schopfer," 9 January 1967 (extract from the partially illegible typescript [photocopy], Salomon Archives, Paris).

54 Segard, *Les Peintres d'aujourd'hui,* 1914, v. 2, p. 320, simply refers to it as one of the three decorative panels executed for M. Claude Anet [Schopfer].

55 See Journal, MS 5397, *carnet* 2, p. 12, cited in Easton *Intimate Interiors,* 1989, "Appendix A," p. 143. The panels are listed following his exhibition at the Salon des Indépendants and preceding a visit to the Redons' *villégiature* in the Normandy town of Saint-Georges-de-Didonne. Further evidence that the panels represent a Normandy rather than Villeneuve site is their title given for the artist's retrospective (which Vuillard helped organized) at the Musée des Arts décoratifs in June 1938, no. 54, as "Deux panneaux décoratifs": (a) *Personnages dans un jardin en Normandie,* and (b) *Le Déjeuner dans un jardin en Normandie* appartient à M. Raphaël Gérard.

56 See Journal, MS 5396, *carnet* 2, p. 78r, which lists him in 1901 at Vasouy, and Saint-Georges; 1902, at Les Etincelles (Normandy); 1903, Vasouy; 1904, Vasouy; and in 1904, 1905, 1906, and 1907, at Amfreville (Normandy), the Hessel's next residence. For Vuillard's relationship with Mme Lucie Hessel, see Ciaffa, *Portraits,* 1985, pp. 342–5 *et passim;* and below, ch. 7, pp. 147–8.

57 Vuillard noted having had his "1er Déjeuner chez Hessel rue d'Argenteuil" in 1895 (Journal, MS 5397, *carnet* 2, p. 12v; see Easton, *Intimate Interiors,* 1989, "Appendix A," p. 144). But it was not until 1899–1900 that he became friendly with Lucie and her husband.

58 As shown, Vuillard's most dramatic transfor-

mation of the original luncheon panel was to replace Mme Blum with Lucie Hessel. The Jewish Léon Blum (1872–1950) was a longtime friend of the Natansons and from 1891 onwards had been a frequent contributor to *La Revue Blanche* and other literary publications. An anarchist in the 1890s when it fashionable to be so called, Blum became an ardent Dreyfusard. In June 1936, Blum was made leader of the Popular Front government and the first socialist and the first Jew to become Prime Minister of France. During his term, he introduced "social reforms" to a reluctant upper middle class. Although Vuillard was sympathetic to Blum's policies, which included the establishment of effective state controls over private industry and finance (which prompted his detractors to say, "Better Hitler than Blum"), it is conceivable that, given Vuillard's decidedly non-socialist clientele, he may have been reluctant to include a reference to the highly visible and controversial party leader. For an amusing and highly personalized account of Blum's political career, see Thadée Natanson and Geoffroy Fraser, *Léon Blum, Man and Statesman; The Only Authorized Biography* (London: Victor Gollancz Ltd., 1937).

59 According to Schopfer's daughter, Mme Mabilleau, it was Vuillard who asked her mother if he could divide the panel and thus prevent her from having to sell it when she moved from the large rue du Bac apartment to a smaller one on the place Breteuil; see Mabilleau, "My Father, Claude Anet," 1989, p. 18. However, the fact that it was sold by 1938 at least (when it was exhibited as belonging to M. Gérard), suggests the other explanation – that Mme Anet asked Vuilllard to divide it to increase its saleability.

60 Segard, *Les Peintres d'aujourd'hui*, 1914, v. 2, p. 281.

61 For Manet, see David Bomberg, *et al.*, *Art in the Making: Impressionism*, exh. cat. (London: National Gallery, 1990), pp. 112–19, esp. pls. 71, 72.

62 "Les visages n'existent guère. Ce sont des taches colorées . . . Dans une certaine mesure le dessin n'existe pas non plus, à moins que l'on ne concède que le dessin en soi ne consiste qu'en des traits expressifs concordant à un but déterminé. En ce cas, le dessin est très beau puisqu'il est éminemment expressif bien qu'il ne soit ni précis, ni souple, ni pittoresque, bien qu'il n'épouse pas la forme et qu'il ne vise en aucune façon à fixer exactement la réalité" (Segard, *Les Peintres d'aujourd'hui*, 1914, v. 2, p. 281).

63 *Ibid.*, p. 279.

64 A second version of *The Afternoon of a Bourgeois Family*, exhibited at the Salon d'Automne in 1903, was highly provocative and seen as a symbol of the fight between the bourgeoisie and the artists; see *Hommage à Bonnard* exh. cat. (Bordeaux: Galerie des Beaux-Arts 1986) p. 64, no. 18, ill. p. 63.

65 François Daulte, *Renoir: catalogue raisonné de l'oeuvre peint* (Paris: Editions Durand-Ruel, 1971), v. 1, no. 208. See also Thadée Natanson, "Spéculations sur la peinture, à propos de Corot et les Impressionnistes," *La Revue Blanche*, v. 19 (May–August 1899), p. 133.

66 Natanson, "Spéculations sur la peinture," 1899, pp. 121–33. Thadée commented on the happy combination of paintings by Corot in a room next to works by Monet, Pissarro, Renoir, and Sisley from the gallery's permanent collection. See also "De M. Renoir et de la beauté," *La Revue Blanche* v. 21 (January–April 1900), pp. 370–6.

67 The Bernheim-Jeune gallery with whom Vuillard contracted in 1900 also regularly highlighted the impressionists in addition to the younger painters, Bonnard and Vallotton.

68 Weber, *France: Fin de siécle*, 1985, p. 101.

69 The apartment had been completed only in March of the previous year; see "Rapport de l'architecte voyeur," document for permission to realign the property (25 February 1893) and to continue construction, from the Préfecture du département de la Seine (20 March 1897, signed Dardouze), cadastral record VO 11 3882, and DP.P 1900, Archives de la Seine, Paris.

70 See Maurice Saglio, "City Apartment Houses in Paris," *The Architectural Record*, v. 6 (1896), pp. 351–3. Saglio opined that the Luxemburg area was passed over by foreigners who preferred to settle in the Champs-Elysées and Bois de Boulogne districts. These newer mansions were frequently featured along with annotated floor plans in reviews like *The Architectural Record*.

71 The same sentiment was expressed by two different authors; see Saglio, "City Apartment Houses in Paris," 1896, p. 354, and Prisson and Hoddick, "New York Flats and French Flats," *The Architectural Record*, v. 2 (1892), p. 58.

72 Saglio, "City Apartment Houses in Paris," 1896, p. 354. For "théâtre-phones," see Weber, *France: Fin de siècle*, 1985, p. 74. In direct proportion to the numbers of luxury apartment homes being built near the Bois de Boulogne and around the Arc de Triumph, were the numbers of existing apartment houses in the more densely populated districts of the city being subdivided into smaller residences; see Norma Evenson, *Paris: A Century of Change, 1878–1978* (New Haven and London: Yale University Press, 1979), pp. 199–200.

73 From the dimensions indicated on the floor plan, one knows that the apartment measured 3.23 m. floor to ceiling, which would allow the 1.61 m. panels a 1.12 m. margin, as indicated in the photograph.

74 Schopfer's gallery, "Le Vieux Perse," was located off the place Vendôme on the rue Maurot-Godoy; see *Didot-Bottin* (Paris: Didot-Firmin, 1910).

75 Correspondence with Mme Mabilleau, 3 April 1988, who identified both the room as well as the objects and furnishings from her childhood.

76 Saglio, "City Apartment Houses in Paris," 1896, p. 351: "All these materials are of good quality and copied from good historical examples."

77 "Il nous mène d'abord visiter la plus récente. Et dès l'entrée dans ce salon, nous sommes saisis par l'harmonie de ses deux panneaux. Vraiment, jusqu'ici, n'ayant vu de lui que les bouts de toiles ou des panneaux, dans des arrière-boutiques de marchands de tableaux, je n'avais pu apprécier son talent. Je lui dis: je ne le connais que d'aujourd'hui. Ce qu'il y a surtout de remarquable dans ces deux panneaux, c'est l'intelligente façon dont ils se relient à la décoration de la pièce. Le peintre est parti des teintes dominantes des meubles et des teintures qu'il a répétées dans ses toiles et harmonisées avec leurs complémentaires. Ces panneaux sont faits à la colle et des tapis.[?] Il semble que la peinture à l'huile détonnerait davantage. – Vraiment, ces panneaux ne semblent pas être de la peinture: on dirait que toutes les teintes de l'ameublement se sont réunies là, sur ce coin de mur, et précisées en belles formes et en beaux rythmes. C'est à ce point de vue absolument réussi, et c'est la première fois que dans un intérieur moderne je ressens cette impression . . . Vuillard cause de tout cela très intelligemment. On voit qu'il aime son art et qu'il sait où il va. – Véritablement, jusqu'ici je n'avais pas compris le grand artiste qui est en lui, et cette leçon me sera utile" (see Signac's journal entry for 16 December 1898, in John Rewald, "Extraits du journal inédit," intro. John Rewald, *Gazette des Beaux-Arts*, v. 42 [July–August 1953], pp. 35–6).

78 See also Signac's very non-laudatory remarks in regard to two panels he saw at Thadée's and Misia's apartment (presumably from *The Album*): "à contre-jour, absolument invisible, car il n'a pas tenu compte de l'obscurité causée par le contraste lumineux de la fenêtre – et s'en est tenu à une gamme trop foncée" (*ibid.*, p. 36).

79 In 1900, Signac did a sketch for a mural competition for the Mairie of Asnières which was unsuccessful; see Cachin, *Signac*, 1982, p. 66.

80 Segard, *Les Peintres d'aujourd'hui*, 1914, v. 2, p. 283: "Et c'est éminemment de l'art décoratif. Ces panneaux ne se suffisent pas à eux-mêmes. Ils exigent autour d'eux de l'espace. On a le sentiment que la bordure d'or les limite arbitrairement. Ils ont besoin de s'adapter à un mur, de s'encaster dans une boiserie. Il ne faut pas qu'on les empêche de rayonner."

81 Letter from P.-L. Cornu, Président, Etat Civil du canton de Vaud [Morges], Switzerland, dated 29 June 1983, stating that the divorce Schopfer-Wetherbee, was granted on 23 January 1903, with no outstanding circumstances: "Les époux ont simplement déclaré, devant le juge, qu'ils avaient géré entre eux les problèmes relatifs à leurs intérêts civils." By May that year, the musician Ricardo Viñes was already referring to Alice as "la belle divorcée, Mme Schopfer" (see entries for 3 and 16 May in Ricardo Viñes, *Journal Inédit*, ed. Suzy Levy, 1988, pp. 56, 57.

82 The marriage took place on 24 February 1908; see Marquis of Ruvigny, *The Titled Nobility of Europe: an International Peerage or "Who's Who," of the Sovereigns, Princes and Nobles of Europe.* (London: Burke's Peerage, [1914] 1980), p. 645.

83 *The Lilies* (pl. 240). This was an uncommissioned project, executed around 1897–8 and purchased by the Bibescos in 1900. See Bareau, "Vuillard et les Princes Bibesco," 1986, pp. 41–4 *passim* and below, ch. 7.

84 See letter from Schopfer to Vuillard asking him to "abriter le dernier grand panneau . . . mon coeur se fend à l'idée d'abandonner les deux autres panneaux que j'aimais tant – mais je ne peut pas les réclamer" (letter dated 7 October 1902, cited in Bareau "Vuillard et les Princes Bibesco," 1986, p. 43, and no. 29). Photographs of the *Vasouy* panel in Vuillard's rue de la Tour and subsequently rue Truffaut studios shows that the enormous panel (not yet cut into two) did return there until Schopfer's second marriage and his remove to a larger *hôtel* on the rue du Bac in 1910.

85 "Voici les nouvelles que vous me demandez. Notre ami Schopfer, a divorcé avec sa femme, quelques jours après son père est mort ruiné, ce qui fait que le pauvre garçon est bien abattu" (letter from Maillol to Rippl-Ronaï, undated [*c.*early 1903] in Klára Werthheimer, "Aristide Maillol levelei Rippl-Rónai Józsefhez," *Müvészettörténeti Értesíto* (1953), p. 115.

86 See for example, the catalogue of his first sale in 1909, *Vente C.A. [Claude Anet], Catalogue des objets d'art orientaux faïences, miniatures et dessins de la Perse* (Hôtel Drouot, Paris, 12 June 1909).

87 Correspondence from Mme Mabilleau, 29 October 1988, identifying the furnishings from rue Chaillot that dated to before 1911 (and that were transplanted in the rue du Bac apartment).

88 Journal, MS 5397, *carnet* 7, n.p.: 11 October 1911, and interview with Mme Mabilleau, Paris, 16 October 1982. I was fortunate to be able to arrange for Mme Mabilleau to visit her childhood en-

vironment, "au fond de la cour," where we were invited by the present owner of the rue du Bac apartment (11 December 1982). Mme Mabilleau pointed out to me the inside wall (now torn down), which had been built specially for the Vuillard *Luncheon* panel, and the placement of the other paintings by Roussel and Bonnard. It was an evening in the spirit of *A la Recherche du temps perdu*, since the current owner is a cosmopolitan, American-educated, musician, scientist, and "homme de lettres," whose collection consists of modern paintings and exotic artifacts from his travels around the world. In the hallway, he had just recently commissioned an artist to paint *trompe-l'oeil* murals of colonnades from which hung vines and violins, in reference to his musical interests.

89 According to Mme Mabilleau (conversation, 16 October 1982), Roussel was commissioned by Schopfer in 1909 to make decorative paintings for the rue Chaillot apartment. The almost square canvases *Nausicaa*, *Naissance de Vénus*, and *La Chute d'Icare*, were hung in the salon of the rue du Bac apartment where they fitted between the top of the oak bookcase and the cornice of the wall. Roussel was asked to help install them and to sign them (with a matchstick!). The panels were sold before Schopfer's death in 1931. I am currently preparing an article that will discuss several projects resulting from the "shared patronage" of Vuillard, Denis, Roussel and Bonnard after 1900.

90 "Bonne impression des tableaux de Roussel . . . mauvais effet de mon panneau avant le portrait de Bonnard. mon ignorance du dessin" (Journal, MS 5398, *carnet* 16, n.p.: 28 February 1919.

91 Diary entry for Thursday, 3 June 1926, in Comte [Harry, Graf von] Kessler, *The Diaries of a Cosmopolitan, 1918–1937*, trans. and ed., Charles Kessler (London: Weidenfeld and Nicolson, 1971), p. 302.

92 "Ses personnages sont informes – il sait admirablement dessiner et s'il ne fait ni bouches, ni mains, ni pieds, c'est qu'il ne le veut pas. Ses tableaux ont plutôt l'air d'esquisses. S'il lui fallait réaliser de grandes toiles, il serait forcé de préciser, et comment alors s'en tirerait-il?" (Signac, journal entry for 16 February 1898, in "Extraits du journal inédit de Paul Signac," *Gazette-des Beaux-Arts*, v. 39 (January–June 1952), p. 277).

93 Anne McCauley, *A.A.E. Disderi and the Carte de Visite Portrait Photograph* (New Haven and London: Yale University Press, 1985), pp. 200–3.

6 Landscape as Decoration

1 "Exposition Durand-Ruel. Voyage à Londres avec Bonnard Bibesco, les Bernheim. panneaux de la rue Jouffroy [Adam Natansan's *hôtel*]. les Roussel à Levallois et juin à l'Etang la Ville. en mars 99 rue Truffaut. automne merveilleux à Villeneuve voyage en avril à Milan et à Venise avec Bonnard et K[er]" (Journal MS 5397, *carnet* 2, p. 12: [11–12 November 1908], cited in Easton, *Intimate Interiors*, 1989, p. 144. In addition, Vuillard listed a trip to London with Bonnard to see his paintings exhibited at Knightsbridge in the Second International Exhibition of Modern Art; an introduction (possibly through Schopfer) to his future patrons, the princes Emmanuel and Antoine Bibesco; and an introduction to Josse and Gaston Bernheim, the young art dealers with whom he would sign a contract in 1900.

2 Galeries Durand-Ruel, 11 rue Le Pelletier, 16 rue Laffitte, *Exposition*, 10–31 March 1899. See also Thadée Natanson, "Une date de l'histoire de la peinture française: mars 1899," *La Revue Blanche*, v. 18 (March 1899), p. 504, n. 3, who lists the exhibition dates as 10 March–2 April.

3 Paul Signac, journal entry for 15 March, 1899, in "Extraits du journal inédit," 1953, p. 44.

4 "Ils s'éprenaient de l'aspect décoratif, recherchaient, l'accord des couleurs et des formes composant une surface agréable à l'oeil en même temps que significative à l'esprit. Ils pensaient qu'une tradition avait existé chez les maîtres de la peinture, ils s'efforçaient de la comprendre et de la renouveler" (Mellerio, préface, *Exposition*, 1899, p. 3).

5 *Ibid.*, nos. 71–4, "pas à vendre." According to one family member, it is possible that Vuillard's *Large Interior with Six Figures* was exhibited (correspondence between author and Mme Ducrey, Galerie Vallotton, Lausanne, November 1988).

6 Signac, "Extraits du journal inédit," 1953, p. 46.

7 Yvanhoe Rambosson, "La Promenade de Janis: causeries sur l'art," *La Plume*, v. 11 (June 1899), p. 383: "M. Edouard Vuillard est parmi les rares qu'on sent en marche vers du mieux ou du nouveau. C'est une vraie nature de peintre et il dissimule habilement sa gaucherie sous l'harmonieuse finesse des tons."

8 In contrast to Vuillard, "doué de grandes qualités de finesse, de distinction," Denis was disappointing: "Denis n'a plus, hélas, sa nobilité et sa grâce d'autrefois. Il 'pousse' davantage ses toiles, toujours hardiment comprises, mais s'objectivant trop à mon goût" (Antoine de la Rochefoucauld, letter to Emile Bernard, 28 March 1898, in Signac "Extraits du journal inédit," 1953, p. 48).

9 Natanson "Une date de l'histoire de la peinture française," 1899, p. 505. The article, in fact, may have been intended as a review as well as a preview for the exhibition of Corot, Manet, and the impressionist painters which had opened a few days after the close of the "Ecole moderne"; see Signac, "Extraits du journal inédit," 1953, p. 52 and n. 22.

10 "Groupe Vuillard, Bonnard, Vallotton: 1. Petits tableaux; 2. sombres; 3. d'après nature; 4. faits de souvenir, sans modèles; 5. petite importance des figures, et par conséquent du dessin; 6. doivent mieux faire dans un appartement petit et peu éclairé que dans un atelier ou une exposition; 7. matière compliquée–goût sémite . . . Groupe Sérusier, moi, Ranson: 1. grands tableaux; 2. peints avec quelques couleurs pures plus ou moins foncées; 3. symboliques; 4. usage de quelques documents, mesures géometriques ou modèles; 5. grande importance de la figure humaine; 6. ont dû être exécutés dans les ateliers; 7. matière très simple et unie–goût latin–article de Geffroy qui fait l'éloge d'un autre caractère du premier groupe; 8. sujets modernes" (Denis, *Journal*, v. 1 [1957], p. 150: March 1899).

11 "Je crois que nous avons tort de demander à l'oeuvre d'art un plaisir immédiat, un agrément extérieur, et qu'aussi nous avons tort de trop songer en travaillant à ces qualités d'aspect que réunissent au plus haut point quantité d'oeuvres médiocres, éphémères et vaines, et dont au contraire des choses profondément belles sont tout à fait depourvues. Il y a là une erreur, une mode, une réaction exagérée contre une décadence académique, et il faut que nous nous en apercevions" (letter to Vuillard from Rome, 19 February 1898, reprinted in Denis, *Journal*, v. 1 [1957], pp. 133–4.

12 For the revival of antisemitism and how the bitter aftertaste of the Panama Scandal of 1892 fueled the distrust of Jewish people two years prior to the Dreyfus affair, see "L'Exploitation du Krach: l'antisémitisme de 1882–1892," in Verdés-Leroux, *Scandale financier et antisémitisme*, 1969, pp. 9–142

et passim.

13 "La 'Libre Parole' a ouvert une souscription au bénéfice de la veuve du Colonel Henry, et en quatre jours a reçu plus de 70,000 francs. L'argent afflue toujours, avec des cris de mort contre les juifs et contre ceux qui essayent de réagir contre l'antisémitisme. Nous en sommes là! Pour tâcher d'oublier et pour sortir de tant de merde, je passe mon après-midi au Panthéon devant les nouvelles décorations de Puvis" (see Signac, entry dated 20 December 1898, in "Extraits du journal inédit," 1953, p. 37, in reference to the subscriptions for contributions to Henry's widow, begun in 1898 by Edouard Drumont, editor of the anti-Dreyfusard newspaper, *Libre Parole*.

14 Until that time, *La Revue Blanche* had remained out of the controversy: "Nous nous sommes abstenus jusqu'à ce jour, à *La Revue blanche*, de commenter le lamentable procès en cours et qui menace de devenir le procès éternel" ("Protestation," *La Revue Blanche*, no. 112 (February 1898), repr. in Olivier Barrot and Pascal Ory, *La Revue Blanche: Histoire, anthologie, portraits* (série: "Fins de siècles") (Paris: Christian Bourgeois, 1989), pp. 264–74. See also "Hommage à Zola," *La Revue Blanche* (March 1898), no. 114, and reprinted in Barrot and Ory, *La Revue Blanche*, 1989, p. 275.

15 Denis, letter dated 19 February 1898, in *Journal*, v. 2 (1957), pp. 136–8. See also Signac's journal entry for 7 February 1899, in "Extraits du journal inédit," 1953, pp. 42–3. After comparing what Signac believed to be Denis's confident and calculating manners with Vuillard's, he concluded: "Il est logique que Denis ait signé la liste de la 'Libre Parole,' et Vuillard celle de 'L'Aurore' [a pro-Dreyfus publication]."

16 See Journal, 10 April 1909 and 13 February 1911.

17 *Journal* (Daybook), Durand-Ruel Archives, Paris: "[April] 1899 Stefan, 49 rue de la Faisanderie Vallotton (no. 21)" (p. 67); "April 1899 Thadée Natanson, 88 [*sic*] rue Jouffroy Redon 'La Chaîne' (no. 77)" (p. 21); A. [Alfred] Natanson 1 rue Laffitte, Bonnard (no. 18)" (p. 67).

18 Thadée is listed under 1898 in the Durand-Ruel *Brouillard* and *Grand Livre* as the purchaser of Cézanne's painting and as living at 88 [*sic*] rue Jouffroy. In her memoirs (Sert, *Misia*, 1952, p. 35), Misia confused her own father's address with Adam's, writing that she and Thadée moved into her father-in-law's home on the rue Prony. By this time, however, her father was living in Brussels with Misia's second stepmother. Mme Ganville.

19 Unless one includes in this category the large-scale double portrait *The Tennis Court* (portrait of Alexandre and Olga Natanson) (pl. 251), painted in 1907; see below, ch. 7.

20 An interior, "typique de cette époque: murs chargés de cadres dorés, objets d'art imprécis" (Vaillant, *Le Pain polka*, 1974, p. 56).

21 *Ibid.*

22 On these paintings, see John D. Bandiera, "Form and Meaning in Hubert Robert's Ruin Caprices: Four Paintings of Fictive Ruins for the Château de Méréville," *The Art Institute of Chicago Museum Studies*, 15, 1 (1989), pp. 20–37.

23 The region between the Seine, Oise, and Marne rivers, where L'Etang-la-Ville was located, is known as the Ile-de-France. The Roussels did not buy a house until April 1901; see Journal, MS 5397, *carnets* 8–9; see also Thomson, *Vuillard*, 1988, p. 49.

24 Vuillard repeated the theme of the view from the open window in his canvases from 1900, inspired by the time spent at Vallotton's home in Lausanne; see *Window on Lac Leman*, 1900, 62 × 49 cm., repr.

25 A photograph in the Salomon Archives, taken by Vuillard and showing a well-dressed main leading a horse and cart in a landscape of vineyards, may also have been used for the man leading the horse in the center of the *Window* painting.

26 According to the Art Institute's conservation report for *Window Overlooking the Woods*, dated 14 May 1981, the paint has been applied quite thinly in areas and the canvas weave is showing. The same does not appear to be the case for the companion picture in the Norton Simon Museum, Pasadena. Graham Liner, Curator of Paintings at the Norton Simon, has indicated that the surface paint of *The First Fruits* is applied rather thickly over the ground layer (communication with author, 16 November 1990).

27 The exhibition ran from 10 to 29 April; see Julien Leclerq, "Petites Expositions: Galerie Durand-Ruel," *La Chronique des arts et de la curiosité* (April 1899), pp. 130–1.

28 Hôtel Drouot, Paris, *Vente Victor Choquet* (1–4 July 1899), no. 6.

29 See, for example, Pissarro, *View from my Window in Cloudy Weather*, 1886–8, oil on canvas, 65 × 80 cm., Ashmolean Museum, Oxford, exhibited as no. 148 in the eighth impressionist exhibition; see Charles Moffet *et al.*, *The New Painting*, 1986, p. 461, no. 148.

30 "Entre ces arbres et au pied d'une forêt couronnant une colline, les murs et les toits d'un village dévalent du clocher lointain vers le premier plan de droite. L'état des verdures, les nuages gris qui compromettent la pureté du ciel, la qualité particulière de l'atmosphère très transparente datent le paysage du commencement de la belle saison, mais pluvieuse . . . L'harmonie générale comprend une infinité de nuances de vert, mais les distribue de façon à opposer les plus sourdes et les plus sombres, qui occupent le milieu de la composition, aux plus claires et plus vibrantes" (see Fénéon, catalogue entry, in Hôtel Drouot, Paris, *Collection Thadée Natanson*, 1908, p. 36, no. 64. See also Lionello Venturi, *Cézanne: son art–son oeuvre* (Paris: Paul Rosenberg Editeur, 1936), v. 1, p. 135, no. 323; v. 2, pl. 87, who described the painting as having "Couleurs vives, mais sans lumière." Vuillard, who had purchased a small painting by Cézanne, *Still Life–Apples and Pears*, after his one-man exhibition at the Vollard gallery in late 1895, would have known of Vollard's inventory of other works by the artist. For Vuillard's purchase, see Sterling and Salinger, *French Paintings*, 1967, v. 3, p. 109.

31 They were also largely successful in finding buyers. See Slatkin, *Maillol*, 1976, pp. 51–7. Ranson's tapestry, *Femmes vêtues de blanc*, was exhibited at the Vollard gallery along with the Nabis in April 1897 (no. 30). Maillol exhibited tapestries at the Libre Esthétique, Brussels, in 1894, and from 1893–1900 at the Salon National des Artistes français.

32 H. Fierens-Gevaert, "Tapisseries et broderies," *Art et Décoration*, v. 1 (January–June 1897), pp. 85–6, and Lucien Magne, "La Tapisserie à la Manufacture des Gobelins," *Art et Décoration*, v. 2 (July–December 1897), pp. 33–42, which reproduced Ranson's cartoon for the tapestry *Tiger in the Jungle*. With the exception of their floral or ornamental borders, however, most of these designs were not particularly suited for loom-woven tapestry and were basically easel paintings rendered in a different medium; see Slatkin, *Maillol*, 1976, p. 56.

33 Charles Blanc, *Grammaire des arts du dessin: Architecture, Sculpture, peinture* (Paris, 1867), discussed in Slatkin, *Maillol*, 1976, pp. 51–7, and Jeroen Stumpel, "The *Grande Jatte*, that Patient Tapestry," *Simiolus* 14 (1984), pp. 209–24. Stumpel argues that there is a direct and important link between Seurat's technique and the art of tapestry.

34 Galeries Durand-Ruel, *Exposition tableaux, esquisses, dessins de Puvis de Chavannes*, June–July 1899, "Compositions pour l'Hôtel de Ville." Often the decorative borders were added by a professional *peintre-décorateur*, as they were for l'*Été* and *L'Hiver*; see Tapley, *The Mural Paintings of Puvis de Chavannes*, 1981, p. 188. Thomson (*Vuillard*, 1988, p. 49) has pointed out the overwhelmingly positive critical reaction to the "paysage Puvis" after his death, especially concerning his murals.

35 Salon d'Automne, October 1904, nos. 1287 and 1288. Salon reviewers seem to have passed over these enormous panels in their critical texts. See, for example, Charles Ponsonailhe's review for the popular *Revue Illustrée*, lumping Vuillard with flower painters and commenting only on his "vase de oeillets"; see "Le Salon d'Automne," *Revue Illustrée*, no. 21 (15 October 1904), n.p.

36 See Fritz von Ostini, "Die Frühjahrsausstellung der Münchener Sezession," *Die Kunst für Alle*, v. 15 (May 1908), p. 349, and Hôtel Drouot, Paris, *Collection Thadée Natanson*, 1908, nos. 63–4.

37 "Un tapis fond bleu, trente francs" (in "Inventaire après le décès de M. Natanson" [d. 4 June 1904], 92 Blvd. Malesherbes, 12 November 1906, p. 5, no. 53 [notorial records]). Thadée and Misia may have acquired their collection of wall-size tapestries from Adam Natanson. Fragments of these are frequently represented in Vuillard's many paintings of their interior on the rue Saint-Florentin (pls. 134, 139, 154).

38 "Parler d'un travail 'd'après nature', serait peut-être puéril. Cependant aucun promeneur habitué aux environs de Paris ne peut manquer d'en reconnaître au moins les villages et les plis de terrain" (Hôtel Drouot, Paris, *Collection Thadée Natanson*, 1908, p. 36, no. 64).

39 Segard, *Les Peintres d'aujourd'hui*, 1914, v. 2, pp. 46–8 *passim*, 260–1, and 305–7. I am grateful to Jean-Claude Amiel, Curator of the Salle des Illustres, Capitole de Toulouse, for his assistance in obtaining photographs of the three-paneled *décoration* which can still be seen.

40 Segard, *Les Peintres d'aujourd'hui*, 1914, v. 2, pp. 259–60: "Cependant on devine que ce paysage a été vu par un citadin accoutumé à s'analyser lui-même et à se rendre compte du pourquoi de ses émotions. On sent qu'il a été peint dans une grande ville et pour un appartement de grande ville. On n'y respire pas l'odeur rustique de la terre qu'on retrouve dans certains tableaux de peintres-paysans qui ne raffinent jamais sur leurs émotions et disent d'un coeur candide leur attachement pour le pays où ils peignent et leur amour pour la terre et pour les choses. La vision de la nature de M. Vuillard se propose à nous comme la récompense possible du travail intellectuel que l'on poursuit devant elle. Elle s'associe étroitement à un état d'esprit citadin."

41 *Ibid.*, p. 261.

42 Entry for Monday, 16 October, in *Journal*, 1948, p. 332.

43 Segard, *Les Peintures d'aujourd'hui*, 1914, v. 2, p. 259.

44 Described by Segard as "le décor par excellence d'un cabinet de travail, asile de la meditation"

(*ibid.*, pp. 258–9).

45 As Annette Vaillant remembers: "Je suis repassée bien souvent, au cours des années devant l'Hôtel du 85 rue Jouffroy, qui, depuis, a fait place à un immeuble de bureaux, particulièrement hideux. Du jardin disparu, sans doute très petit avec son bassin, je garde le souvenir de ce que j'imagine alors une nuée bruissante de moustiques au dessus de l'Etang immobilier abrite de verdures sans fin" (Vaillant, *Le Pain polka*, 1974, p. 14).

46 *Ibid.*, p. 141. Thadée is also listed at this address in 1906 in the "Inventaire après le décès de M. Natanson" (12 November 1906), and below, n. 54.

47 "La peinture collaborant simplement, comme l'ébénisterie ou les étoffes, à embellir l'habitation des plus modestes citoyens" (Jacques-Emile Blanche, "Notes sur le Salon d'Autome," *Mercure de France* (December 1904), p. 682).

48 Segard, *Les Peintres d'aujourd'hui*, 1914, v. 2, p. 247.

49 Silverman, *Art Nouveau in Fin-de-Siècle France*, 1989, pp. 111–18 *et passim*.

50 "Une des particularités de cette décoration est qu'elle juxtapose à certaines parties si largement traitées, maints details ornementaux qui ont retenu l'attention la plus minutieuse du peintre, comme tel liason parmi tout un champ où, dans une bande de feuillage, le fichu à pois d'une paysanne" (Hôtel Drouot, Paris, *Collection Thadée Natanson*, 1908, p. 35, no. 63).

51 The vogue for decorative tapestries and decorative wall painting had reached a much wider public by the end of the century. The *Annuaire-Almanach du commerce et de l'industrie* (Paris, 1896), pp. 1993–4, for example, advertised numerous painting supply shops under the categories "Peintres en décors" and "Peintres-décorateurs," specializing in paintings imitating ancient tapestries or, as listed for Hardy-Alan on the rue de Cherche-Midi, "fabrication de toiles et couleurs fines, toiles et couleurs spéciales pour peinture décorative de plafond et panneaux d'appartements de 2, 3, 4, 5, 6, 7, et 8 mètres de largeur (Marouflage).

52 "Sans l'avertissement de mon grand-père, je continuerais à ratisser à la fourchette mes épinards détestés et à m'égarer dans ce paysage peint, plus vrai que le vrai, présent, illimité, avec ses peupliers et ses coteaux. Le toit pointu d'une église, et, au second plan, la blancheur d'une maison aux volets ouverts éclairent les verdures épaisses. Maison de l'Ogre ou du Petit Poucet, rassurante en tout cas d'offrir en plein midi sa fenêtre. Fenêtre où une femme se penche sur des géraniums éclatants. Est-ce moi qu'elle appelle ou ce laboureur à l'ouvrage, cet homme heureux de la campagne, abreuvé de vin rouge, dans un verre . . ." (Vaillant, *Le Pain polka*, 1974, pp. 41–2).

53 Fénéon, editor of *La Revue Blanche* after 1894, would have visited Roussel as well as Maillol and Denis, who lived in the same northwestern region of the Ile-de-France. Annette Vaillant remembered visiting the Roussels many times as a child and playing with her "best friends," Annette Roussel and her brother, Jacques; see Vaillant, *Le Pain polka*, 1974, p. 23.

54 In Adam's inventory papers, the Art Institute panel was appraised at the rather low estimate of 150 francs and described simply as "a large painting by Vuillard," among the other furnishings, including armchairs, copper table, bentwood rocker and chairs, gilded-bronze candelabras, and a small rosewood and bronze cabinet (*chiffonier*) seen in the 1906 photograph. Its pendant, *The First Fruits*, appraised slightly higher at 200 francs, was described together with the dining-room furnishings

of a glass armoire, a bronze and inlaid mantelpiece clock, and the above-mentioned blue and green *verdure*; see "Inventaire après le décès de M. Natanson" (12 November 1906).

55 Vaillant, *Le Pain polka*, 1974, p. 141. For a description of the residence which was part of a larger complex of artist's studios, see "25 Blvd Montparnasse," *L'Architecture*, v. 38 (1925), p. 437. In the Didot-Bottin for 1910, Blum is listed with five other artists, including Maxime Maufra and René Ménard.

56 Vaillant, *Le Pain polka*, 1974, p. 141: "Dans le cabinet de travail de Léon Blum, immense atelier sur deux étages, je retrouvais les deux grands panneaux de Vuillard, ceux de notre salle à manger du 92, qui n'auraient pu tenir au 169 [rue de Courcelles]."

57 Natanson and Fraser, *Léon Blum, Man and Statesman*, 1937, p. 88. Here a typo makes Vuillard into Edouard Vaillard, the politician.

58 Décorations ayant orné une bibliothèque" (in Hôtel Drouot, Paris, *Collection Alexandre Natanson*, 1929, nos. 126 and 127.

59 At that time, the panel *The First Fruits* was sold to Walter J. Chrysler Jr. The pendant remained with Blum's son, Robert, who was living on the quai Bethune (d. 1974). In Vuillard's important retrospective in 1938, they were exhibited as *Paysages de l'Ile de France*," executed for M. Adam Natanson and belonging to a private collector," in *Exposition Vuillard*, 1938, no. 69.

60 "Exactement il s'y adapte comme une tapisserie qu'on fixe avec quatre clous et qui semble avoir été placée de tout temps à l'endroit où on la pose" (Segard, *Les Peintres d'aujourd'hui*, 1914, v. 2, pp. 262–3).

61 Considered by the de Goncourt brothers as the superior art form, since tapestries resemble paintings "seen in a dream"; see Edmond and Jules de Goncourt, *Journal* (Paris, 1975), v. 8, p. 202.

62 Letter to Paul Vallotton, Paris, 1899, in Guisan and Jakubec, *Félix Vallotton: Documents*, v. 1 (1973), p. 188, no. 126.

63 Segard, *Les Peintres d'ajourd'hui*, 1914, v. 2, p. 320.

64 See Klaus Jürgen Sembach, in "Fünf Villen des frühen 20. Jahrhunderts," *Du*, v. 35 (September 1975), pp. 26–33. Hohenhof, the Osthaus residence, was owned the city of Hagen from 1927, taken over by the National Socialist Party in 1933–44, served as a women's clinic, and, in the same year, as a teacher's college (Hofschule ruhe Abteilung). At the time of Sembach's article, the fate of this artistic house was again in question.

65 See *Herbst vor Paris*, Van de Velde's title for the painting exhibited in *Der Jubilaum Katalog* (Essen: Folkwang Museum, 1912), no. 195; *Spaziergang* in Sembach, "Fünf Villen des frühen 20. Jährhunderts," 1975, p. 10. In the important Vuillard retrospective (1971), the painting, called *Le Picque-Nique*, was catalogued as an easel painting and was not included in the special section on Vuillard's decorative projects; see Russell, *Vuillard*, 1971, no. 28, p. 229.

66 "Exposition en avril chez les Bernheim. Panneau Aghion Atelier Rue Mollet 6 mois. Etang la Ville, La Suisse et Romanel. Misia à Cannes Hôtel" (Journal, MS 5397, *carnet* 2, p. 12r, cited in, Easton, *Intimate Interiors*, 1989, p. 144). Vuillard's reference to Cannes is to Adam's property at Croix des Garde near that town; see below, ch. 7, p. 146.

67 "La peinture me semble sourire. Cela commence à être temps. Je n'y croyais plus. Nous avons fait poser les panneaux Aghion et vous savez qu'il est question de vous demander à vous et à Ranson si vous vouliez faire des ornements aux deux

extrémités de la pièce, qui donneront avec un rappel des tons des toiles un peu d'ensemble décoratif à cette bienheureuse pièce" (letter sent from L'Etangla-Ville to Vallotton in Paris, 9 July 1900, in Guisan and Jakubec, *Félix Vallotton: Documents*, v. 2 (1974), p. 42. In the same letter that Vallotton mentioned Vuillard's successful career ("il gagne beaucoup"), he added that "j'en suis heureux pour lui, mon mariage l'a estomaqué, il n'aura d'idée précise là-dessus que dans quelques jours" (*ibid.*, v. 1 [1973], p. 188).

68 No pendant to the Aghion commission is mentioned in Segard's inventory. The only two candidates for decorative panels painted around 1897–9, *The Small House at L'Etang la ville* (pl. 210) and *The Lilies* (pl. 240; see ch. 7), have smaller dimensions and were painted in distemper not oil.

69 One of the few contemporary remarks about Jack Aghion is provided in the publication of the results from the sale of Alexandre Bernheim's collection (July 1917), "dont la collection est bien connue (Van Goghs, Vuillard, Marquet, etc.)"; see "Vente Alexandre Bernheim-Jeune, 1839–1915," Hôtel Drouot, Paris, 15–16 May 1917, in Hôtel Drouot, Paris, *Gazette* (15 July 1917).

70 "Elle s'appelle Gabriella Rodriguez, a 35 ans, elle est fille de M. Bernheim qui habite 51 rue Pierre Charon. Ils sont les plus honorables et riches. Les deux frères continuent la maison installée rue Laffitte. L'autre soeur est mariée avec un Monsieur Aghion qui est très riche et sans importance autre . . ." (letter from 11 rue Jacob, Paris, to Paul Vallotton, Lausanne, in Guisan and Jakubec, *Félix Vallotton; Documents*, v. 1 [1973], p. 187).

71 Unfortunately, there is no evidence of Vuilard's trip, however brief, to the Bernheim *villégiature* in September 1899. Perhaps Vallotton's caricatural painting *Baignade à Etretat*, 1899, oil on carboard, 52 × 66 cm., formerly Collection of Mme Partouche-Vallotton, Paris, at Hirshl and Adler in April 1958, is a tongue-in-cheek "souvenir" of this vocation spent with his newly acquired family circle?

72 Jos Hessel was originally a journalist and editor for *Le Temps* where he had been responsible for the column, "Objets d'art." Later, in Alexandre Bernheim's gallery on the rue Laffitte, he was charged with the business education of Alexandre's two sons, Josse and Gaston. Vuillard's first mention of the Hessels is April 1895 when he recorded having lunched with them in their rue d'Argenteuil residence (Journal, MS 5397, *carnet* 2, p. 14: [11–12 November 1908], cited in Easton, *Intimate Interiors*, 1989, p. 144). Salomon (*Vuillard*, 1968, p. 23) claims that it was Vallotton who introduced Vuillard to the Hessels.

73 Walter Feichenfeldt refers to Aghion (along with Schuffenecker, Fabre and A. de la Rouchefoucauld) as *marchand-amateurs* or speculators; see his "Vincent van Gogh and Paul Cassirer, Berlin," in *Cahier Vincent van Gogh* (Zwolle: Uitgerverg Waandes, 1988), p. 13.

74 See Walter Feichenfeldt, "Vincent van Gogh – his Collectors and Dealers," *Vincent van gogh and the Modern Movement, 1890–1914*, exh. cat. (Essen: Museum Folkwang, 1990), p. 42.

75 On 15 March 1901, Aghion is recorded to have purchased works by Vuillard, Bonnard, Denis and Roussel totalling 3,800 francs (account book, *c*.1899–1901, p. 46). Another undated entry in the account book, 1894–1900, p. 136, records a purchase: "Aghion par Bernheim 3 Van Gogh et 1 Renoir, 1,240 francs"; These are possibly the Van Goghs that Meier-Graefe cites in the Aghion collection in his listing of the most significant Van

Gogh collectors, *Entwicklung* (1905); cited in Feichenfeldt, *Vincent Van Gogh and the Modern Movement*, 1990, p. 43. Another reference can be found in Vollard's account book (1894–1900), p. 129, for April: "Aghion reçu à compte 3 Vuillard 200 francs."

76 Hôtel Drouot, Paris, *Catalogue des tableaux modernes par Boudin, Caillebotte, Guillaumin, Guilloux, Marquet, Nonell, Van Gogh, Vignon, Vuillard, Wilder; Pastels, Gouaches, aquarelles par Chéret, Guillaumin, Pissarro, Sisley, Somm, composant la collection de M.A.* (29 March 1918). Included in the sale were Vuillard's *Intérieur* (no. 26, for 2,650 francs); *Femme veillant près d'un lit* (no. 27, for 1,500 francs; also called *La Jeune malade*, 1892 [Arthur Tooth and Sons, Paris/London, May 1969, no. 5 ill.]); *La Cuisinière* (no. 28, for 1,010 francs); and *La Veillée* (no. 29, for 2,500 francs). Apparently, there were hard feelings between Aghion's family and the Bernheims after his death. Aghion's collection was sold for the ridiculously low sum of 20,000 francs to Jos and Gaston, who had convinced Marguerite to let them handle it.

77 Photographs, in Salomon Archives, Paris, with handwritten title: "Excursion 'les Coteaux' or Hillsides, *c*.1898–1899."

78 Letter from Vuillard to Vallotton from Villeneuve, 27 November 1899, in Guisan and Jakubec, *Félix Vallotton: Documents*, v. 1 (1973), p. 191.

79 ". . . automne merveilleux à Villeneuve" (see Journal, MS 5397, *carnet* 2, p. 12).

80 Letter, 27 November 1899: "Je reste encore une 8e," in Guisan and Jakubec, *Félix Vallotton: Documents*, v. 1 (1973), p. 191.

81 Handwritten notes on photocopy of album sheet of photographs, Salomon Archives, Paris.

82 Handwritten notes on photocopy of album sheet of photographs, Salomon Archives, Paris.

83 Conversation with Josette Aghion, 16 May 1982. Vuillard, who had no family was, nevertheless, a "family man." He attended the weddings of both Germaine and Marie-Louise Aghion. Although he mentioned Jack Aghion only once in his journals, the girls are frequently cited after 1920.

84 See Roger-Marx, *L'Oeuvre gravé de Vuillard* [1948], no. 41. See also *Femme sous les arbres: décor champêtre*, *c*.1912(?), détrempe on paper laid down on canvas, 35 × 39 cm., repr. in Christies, New York, *Impressionist and Modern Paintings*, 27 March 1973, lot 19.

85 She appears possibly as well in the far righthand corner of the *Large Interior with Six Figures* (pl. 162). For *The Lilies*, see Bareau, "Vuillard et les Princes Bibesco," 1986, pp. 41–4 *passim*, and below, ch. 7, pp. 151–3.

86 Chastel, *Vuillard*, 1946, p. 64.

87 "C'est la rigueur synthétiste dans une liberté nouvelle, transposant dans une scène de genre les effets harmonieux d'une composition symétrique et contrastée" (*ibid*. The author not only knew Vuillard, but had the authority to catalogue the works left in the Paris studio at his death in 1940 [conversation between author and André Chastel, Paris, 12 November 1983]).

88 Conversation between author and Emile Gruet of the Galerie Bernheim-Jeune, Paris, 12 November 1983, and with Colette Partouche-Vallotton, niece of Josette Aghion, 15 May 1982. That address is also listed in "Extrait des minutes des actes de naissance," for Henriette Charlotte Aghion, "b. 18 July 1906, to Isaac [Jack] Aghion and Marguerite Bernheim, 143 rue de le Pompe" (photocopy of "Extrait de minutes," Marie Annexe, 16ème arrondissement, Paris). Colette's father, the son of Madeleine-Rodriguez Vallotton (Vallotton's step-daughter), claims his grand-

father died sometime before 1914 in the rue de la Pompe apartment.

89 Conversation between author and Emile Gruet of the Galerie Bernheim-Jeune, Paris, 10 November 1981.

90 Conversation between author and Josette Aghion, 16 May 1982. According to Josette, her father spent thousands on art purchased primarily from the Bernheims and was the first to own a Van Gogh. He eventually lost everything. Josette claimed that the Bernheims were "pas très correct," and that her mother was persuaded to sell the entire collection for a mere 20,000 francs. According to Patrice Dauberville, grandson to Gaston Bernheim and M. Gruet (27 October 1982), Aghion went mad sometime after 1900 and may have died at that time. He left many debts behind that were paid off with the paintings, for which he still owed money. The Aghion family never forgave the Bernheims who "did what they could" for the widow. The only Aghion daughter who remained on good terms was Janine, an accomplished artist, who died in 1975.

91 Letter to Paul Vallotton, 28 April 1910, in Guisan and Jakobec, *Félix Vallotton: Documents*, v. 2 (1974), p. 170.

92 "J'ai bien peur de l'avenir, car je sens la poussée lente des Bernheim qui cherchent à nous repasser les Aghion. Et ceux-la après les Rodriguez ce serait le bouquet. Il est vrai qu'il me resterait la fuite, et je t'assure que j'y pense souvent" (letter to Paul Vallotton, 28 July 1912, in Guisan and Jakubec, *Félix Vallotton: Documents*, v. 2 (1974), p. 187.

93 Alan Windsor, "Hohenhagen," *Architectural Review*, v. 152 (September 1981), p. 169. The two most important biographical accounts for the young collector can be found in the publications by the former curator of the collection at Osthaus, Herta Hesse-Frielinghaus, "Karl Ernst Osthaus-Museum: Hagen," *Wallraf Richartz Jahrbuch*, v. 33 (1971), pp. 371–5, and the fully illustrated collection of essays that she edited in the same year, *Karl Ernst Osthaus: Leben und Werk* (Recklinghausen: Verlag Aurel Bongers, 1971).

94 For a complete history of the Folkwang Museum at Hagen and at its present site in Essen, see Paul Vogt, *Das Museum Folkwang Essen: Die Geschichte einer Sammlung junger Kunst im Ruhrgebiet* (Koln: Verlag. M. Dumont, 1983).

95 Sembach, "Fünf Villen des frühen 20. Jahrhunderts," 1975, pp. 10–18.

96 "Da der Verfasser sich entschloss, auf seine bisherige Einrichtung zu verzichten, konnte der Hohenhof bis herunter auf das Petschaft auf dem Schreibtische einheitlich durchgebildet werden. Er ist in dieser Beziehung eine der vollständigsten Schöpfungen des Künstlers geworden und bis zum heutigen Tage (1920) auch unberührt erhalten. Einige Kunstwerke von Bedeutung, so der *Auserwählte* von Hodler, der *Spaziergang* von Vuillard, ein Fliesentriptychon von Matisse, boten Augangspunkte für die dekorative Ausgestaltung, für den Garten entwarf gleichzeitig Aristide Maillol eine *Sérénité* . . . Thorn-Prikker entwarf später die farbige Treppenhausverglasung und das eingelassene Eulenbild im Herrenzimmer. Diesem Zusammenwirken lag ein starkes Gefühl für die Notwendigkeit einer Konvergenz des künstlerischen Schaffens beim Verfasser und beim Architekten zugrunde . . . Wand und Möbelstoffe, Holzwerk, Teppiche und Vörhange wurden nach ihnen abgestimmt, während umgekehrt weitere Kunstwerke nach den ornamentalen Bedürfnissen der Räume augewählt und eingestimmt wurden . . ." (excerpted from Karl Ernst Osthaus,

Henry Van de Velde: Leben und Schaffen des Künstlers (Hagen, 1920), in Hans Curjel, *Henry van de Velde Geschichte: meines Lebens* (Munich: R. Piper & Co., 1962), pp. 75–6.

97 See letter to Vallotton, Paris, 9 July 1900, cited above, n. 67.

98 Private collection, Bern, Switzerland. Also called *Nouveau né* (*New Born*); see Susan Hirsch, "Ferdinand Hodler's 'The Consecrated One,'" *Arts Magazine*, v. 52, pp. 122–9, no. 5.

99 Hesse-Frielinghaus, *Karl Ernst Osthaus: Leben und Werk*, 1971, p. 201.

100 It is also possible that Osthaus knew of Vuillard's six panels, exhibited and given critical attention at the Salon d'Automne in 1905 where Maillol's *Sérénité* was also exhibited.

101 The price paid, 1,800 francs, was the equivalent of what Vuillard's other large-scale painting, *Window Overlooking the Woods*, sold for at the sale of Thadée's collection, also in 1908. For Van de Velde's purchase, see his *Meines Leben*, cited in Curjel, *Henry van de Velde Geschichte*, 1962, p. 284. See also Hôtel Drouot, Paris, *Collection Thadée Natanson*, 1908, no. 63, *Les Premiers fruits*, 1,200 francs, p. 35, as listed in Fénéon, *Félix Fénéon*, 1970, pp. 262–3.

102 For Van de Velde's Parisian offices, see Abraham Marie Hammacher, *Le Monde de Henry van de Velde* (Paris: Librairie Hachette, 1967), pp. 157–60.

103 Weisberg, *Art Nouveau Bing*, 1986, p. 274, n. 55. Misia, as will be remembered, claimed to have befriended Van de Velde and to have been introduced to the "modern style" under his tutelage. It is also possible that he frequented the Natansons' rue Saint-Florentin apartment.

104 Hammacher, *Le Monde de Henry van de Velde*, 1967, p. 162. Denis, who visited the Kessler's residence (in Berlin) in 1909, recorded his impression of the decorative ensemble: "La Maison de Kessler, très bien arrangé par Van de Velde sur les tableaux de moi. Bibliothèque en bois clair pour ma 'mise au tombeau' blanc et gris lié de vin pour 'La Grande Forêt au Jacinthes.' Blanc et bleu sur fond rosé pour mes panneaux de Bing" see *Journal*, v. 2 [1957], p. 62). Van de Velde's path would briefly cross that of Vuillard's in 1912 when both were commissioned by Gabriel Thomas to participate in the project for the Théâtre des Champs-Elysées; see below, ch. 10, p. 201.

105 These artists included Chéret, the de Goncourts, Emile Gallé, *et al.*; see Henry van de Velde, *Déblaiment de l'art*, [1894], repr. ed. (Brussels: Archives d'Architecture, 1979), pp. 20–1. For an analysis of his objections to the "hyperaestheticized" interiors characterizing French art nouveau, see Silverman, *Art Nouveau in Fin-de-Siècle France*, 1989, pp. 211, 272–3. Interestingly, in the second edition, Van de Velde corrected his narrow pairing of decadence in art with Jewishness.

106 "Mon cher van de Velde, Excusez-moi de ne pas vous avoir accusé réception plus tôt de votre envoi et de l'aimable lettre qui l'a suivi. Ne croyez pas surout que j'aie été indifférent à votre témoignage de sympathie, le plus précieux peut-être nous venant, n'est-ce pas? de ceux qui vivent loin de nous et contrôlent plus faiblement les opinions bienveillantes de ceux avec qui l'on est. Mais je tenais à voir votre exposition et les entours du jour de l'an sont terriblement occupants. Je vous ai dit combien j'étais peu enthousiaste des productions soi-disant 'modern style': aussi ai-je été bien content de trouver toute autre chose chez Druet- particulièrement un petit service à thé, je crois, au milieu argent et ivoire dont l'accolement[?] est très heureux à mon goût. J'ai une tendance à préférer les formes comblées regulières . . ." (photocopy of

manuscript letter addressed to Van de Velde, Cranachsträsse 11. Weimar, Allemagne. Document FSX/837. Fonds Henry Van de Velde. My sincere thanks to Madame Claudine Lemaire, curator and archivist at the Bibliothèque Royale Albert ler, Brussels, for having made this available to me).

107 "Je ne désespère pas d'aller un jour vous voir à Weimar, vous et vos ouvrages, mais peut-être reviendrez vous avant de mon côté?" (*ibid.*).

108 See Donald E. Gordon, *Modern Art Exhibitions* (Munich: Prestel Verlag, 1974), v. 1, pp. 240, 241, 249, 251.

109 For a discussion of the room, see Sembach, "Fünf Villen des frühen 20. Jahrhunderts," 1975, p. 32. I am grateful to Mme Hesse-Frielinghaus for having sent me samples of the material used in the original chair upholstery.

110 "L'ombilic qui rattache le tableau au monument dont il est la réduction imaginaire" (*Deblaiement d'art*, [1894], p. 20).

111 "Les monstruosités pompeuses, en faux or, qui cadrent les oeuvres modernes, les rattachent-ils assez à nos 'grands cafés' à nos 'salles de concert' et de spectacles?" (*ibid.*, p. 21).

112 "Il est heureux que le grand tableau de Hodler, réprésentant les anges entourant l'enfant élu ait trouvé sa place dans le hall de van de Velde. Il est de huit ans antérieur au Musée, mais les deux oeuvres sont spirituellement très proches" (Hammacher, *Le Monde de Henry van de Velde*, 1967, p. 271).

113 For the ceramic triptych of Matisee, see John Neff, "An Early Ceramic Triptych by Henri Matisse," *Burlington Magazine*, v. 114 (1972), pp. 849–52.

114 Bonnard, cited in Doris Wild, "L'Intimiste Vuillard et la peintre monumentale," French resumé in *Werk*, no. 12 (1947), p. 400, and Roger-Marx, *Vuillard*, 1946, p. 107.

115 "Die Maler der offiziellen Ausstellungen treiben seit lange ähnlichen Vergrösserungen. Haben sie uns nicht gerade genügend den Abscheu vor der grossen Malerei beigebracht? Die einzigen französischen Maler, die einigen Vorteil aus derartigen Vergrösserungen haben ziehen können, und denen es gelungen ist, köstliche Kunstwerke zu schaffen, Bonnard und Vuillard, konnten nur dank ihrer ausserordentlichen Begabung jener Klippe entgehen" (see Henry van de Velde, "Ferdinand Hodler," *Die Weissen Blätter*, v. 5 [1918], p. 131).

116 "Aber weder der eine noch der andere konnte die Grenze der Dekoration eines Boudoirs oder eines Salon überschreiten. Hodler hob sich auf eine Höhe, die sie nicht erreichen konnten gerade auf Grund der Idee, die sie von der dekorativen Malerei und ihrer Formel haben. Ihre Formel unterscheidet sich in nichts von der Formel des Staffeleibildes" (*ibid.*, p. 131).

117 The majority of the buildings, including Behrens's famous Cuno House, were completed between 1907 and 1910; see Windsor "Hohenhagen," 1981, pp. 169–75, and his *Peter Behrens* (London: Architectural Press, 1983), pp. 58–61.

118 See Curjel, *Van de Velde Geschichte*, 1962, p. 76, and Vogt, *Das Museum Folkwang Essen*, 1983, p. 9.

119 *Herbst vor Paris*, oil on canvas, no. 195, exhibited with a smaller drawing, *Garten*, no. 679 in *Der Jubilaum Katalog* (Essen, 1912); in Frielinghaus, *Karl Ernst Osthaus*, p. 524. Correspondence between author and Eric Steibel, 11 September 1984.

120 [Maurice Denis], "Notes sur l'exposition des Indépendants," *La Revue Blanche* (1892), p. 232, and above, ch. 1, p. 14.

7 Of Lilies, Haystacks, and Garden Paths

1 Hôtel Drouot, Paris, *Collection Thadée Natanson*, 1908. None of the elaborate preparations went unnoticed by Vuillard, who wrote bemusedly of the fuss and of "l'importance que cela [the exhibition] prend, articles, etc." (Journal, 10 June 1908).

2 Fifty-two of the sixty-one paintings were by Vuillard (26 paintings, 1 pastel), Bonnard (19 paintings) and Roussel (7 paintings). Other artists represented were Albert André (1 painting), Cézanne (1 painting), Delacroix (1 painting), Daumier (1 painting), Constantin Guys (2 watercolors), Albert Marquet (1 painting), Odilon Redon (1 painting), Seurat (1 conté crayon drawing), Vallotton (1 painting), and Louis Valtat (2 paintings).

3 Among those in attendance were artists Maurice Denis and Théo van Rysselberghe, writers Claude Anet [Jean Schopfer], Octave Maus, Octave Mirbeau, Romain Coolus, André Gide, and Tristan Bernard, and composers Claude Terrasse and Claude Debussy; see Valemont, "Les Grandes Ventes," *Le Figaro*, 14 June 1908.

4 "Il faut constater que les amateurs et le public n'ont pas mordu à la collection Thadée Natanson. Sans les parents et les amis du collectionneur, les oeuvres de MM. Bonnard, Vuillard et Roussel ne se seraient pas vendues 150f l'une dans l'autre. Le commissaire priseur obtint 60,000 francs grâce à des précieux dévouements" (Jacques Daurelle, "Curiosités," *Mercure de France* [1 July 1908], p. 188).

5 Mirbeau's bid for Vallotton's portrait was equal to the price paid for Vuillard's large decorative painting *L'Album*; see "Collection Thadée Natanson," *Le Chronique des Arts et de la curiosité*, no. 24 (20 June 1908), p. 246, and Daurelle, "Curiosités," 1908, p. 188.

6 See nos. 56, *Le Jardin de Cannes*, and 57, *Déjeuner du matin*, in Hôtel Drouot, Paris, *Collection Thadée Natanson*, 1908, pp. 56 and 57. While at the Bernheim's rue Richepanse gallery, Fénéon organized one-man exhibitions for Henri Cross (1906), Van Dongen (1909), and in 1912, the first exhibition of the Futurists. He was never as supportive of these artists as he had been of the Neo-Impressionists. Nor was he a champion of Vuillard and Bonnard, although he played a financial and sometimes personal role as advisor to the former.

7 "Tous ces objets ont été réunis par quelqu'un qui les aimait et l'a prouvé, puisqu'il est le premier qui ait osé et peut-être le seul jusqu'ici qui ait su en parler. Je ne saurais ni ne voudrais pour ma part rien dire d'autre de Vuillard, de Bonnard, de Roussel, ou de Vallotton que ce que Thadée Natanson en a écrit au jour le jour dans ces pages de la *Revue Blanche*, souvent difficiles, toujours ingénieuses et, par-dessus tout, clairvoyantes" (Octave Mirbeau, "Préface," in Hôtel Drouot, Paris, *Collection Thadée Natanson*, 1908, p. viii).

8 See "Collection Thadée Natanson," *Chronique*, 1908, p. 246, and "Notes d'un curieux," *Le Gaulois*, 14 June 1908, p. 3. The purchase price of 5,300 francs for the large landscapes for Adam Natanson was still less than the 6,000 francs paid for the early Cézanne landscape, *Auvers*, which may have inspired the Adam panels; see above, p. 127 and pl. 205.

9 "Il semble demeurer d'autant plus abstrait d'intention qu'il est plus délicieusement, plus somptueusement sensuel" (Mirbeau, "Préface," 1908, p. xv).

10 "Vuillard n'est jamais plus à l'aise et qu'on ne le goûte jamais mieux que quand son imagination – je la voudrais dire musicale – peut se donner carrière sur d'assez amples surfaces: il faut des murs à sa magie" (*ibid.*, p. xv).

11 André Salmon, *Souvenirs sans fin: Première époque, 1903–1908* (Paris: Gallimard, 1955), ch. 4, "*La Revue Blanche* va crever!" pp. 57–79 and 72–3.

12 "Les Natansons ont fait aussi de mauvaises affaires, voilà pourquoi ils ne répondent pas. La Revue Blanche est finie" (letter, *c.*January 1903, in Wertheimer, *Müvészettörténeti Ertesítö*, 1953, p. 116).

13 See "Comment meurt une revue," in Barrot and Ory, *La Revue Blanche*, 1989, pp. 22–4.

14 See Vallotton's letter to Alfred Natanson: "I go regularly to the *Revue*, almost every afternoon to look around the office. I have only regret for not having seen you [there.] Thadée is invisible too" (letter on *Revue Blanche* letterhead, 1899, in Guisan and Jakubec, *Félix Vallotton: Documents*, vol. 1 (1973), p. 289, trans. in Waller, *Artists of La Revue Blanche*, 1984, p. 22.

15 Additionally, Alexandre had served on the "comités d'admission et d'installation," for the Exposition Universelle in 1900; see his dossier for candidacy, Légion d'Honneur, Archives de France, Document F^{12}5222.

16 "L'argent n'avait représenté pour lui qu'un moyen indispensable au triomphe d'une cause qu'il brulât defendre" (Sert, *Misia*, 1952, p. 93). In 1917, Thadée launched another project for a munitions plant in Lyon, borrowing again from his family. According to Annette Vaillant, by 1920, the strain on her own family's fortune was so tremendous that her father was forced to sell his collection of paintings and go to work at the Galerie Druet; see her "Livret de famille," 1965, p. 35. See also Barrot and Ory, *La Revue Blanche*, 1989, p. 26, who attribute the review's demise as much to Thadée's financial as to his marital difficulties.

17 Gold and Fizdale, *Misia*, 1980, p. 83.

18 "Changeant de femme comme chemise, cousu d'or et de pierreries" (Lucien Daudet, *Pais Vécu*, 1ère série, Paris, 1929, pp. 93–5, cited in Kolb, *Proust Correspondance*, v. 7 [1907], p. 246, n. 7).

19 For Misia's account, see Sert, *Misia*, 1952, pp. 81–98.

20 Journal: ". . . La Suisse et Romanel, Misia près de Bâle. Déc. à Cannes Hôtel . . ." See Gold and Fizdale, *Misia*, 1980, p. 82, for a description of Thadée's development activities at Cannes and the villa that Misia decorated out of boredom.

21 In his journal summary for 1903 (MS 5397, *carnet* 2, p. 12: 11–12 November 1908), Vuillard's involvement is only alluded to: "Voyage à Vienne. Misia et Thadée" (cited in Easton, *Intimate Interiors*, 1989, p. 144). For an entertaining retelling of the Misia-Edwards affair, see Gold and Fizdale, *Misia*, 1980, pp. 82–90.

22 *Ibid.*, pp. 93–4.

23 Misia's divorce from Thadée was legalized in June 1904. Misia and Edwards were married in February 1905; see "Extrait de minutes des actes de mariage du 17ème arr.," nos. 171 (27 January 1904) and 623 (27 June 104).

24 And where Annette Vaillant has, coincidentally, lived for many years; see *Le Pain polka*, 1974, p. 196.

25 In the triple portrait, as in so many of Degas's portraits, the figures exist in a companionship that is psychologically if not physically distant. The wall mirror is set slightly higher so that Vuillard is looking down and into the scene in what Roger-Marx refers to as an artistic conceit comparable to Velázquez's self portrait in *Las Meninas* (Roger-Marx, *Vuillard*, 1946, p. 89). For an insightful analysis of Vuillard's portrait of Thadée and its suggested meanings, see Ciaffa, *Portraits*, 1985, pp. 244–6.

26 In Misia's own words, "C'est probablement l'époque de ma vie où j'ai été le plus comblée de tout ce qu'une femme peut souhaiter. Il ne me restait vraiment rien à désirer" (*Misia*, 1952, pp. 109–10). And, as observed by Jules Renard, "Elle ne sait plus s'habiller que richement" (*Journal inédit*, in *Les Oeuvres complètes de Jules Renard (1864–1910)* [Paris: Bernouard, 1975], v. 4 [1903–8], p. 1231). There are two other versions of this portrait in the Barnes Foundation (Merion, Pa) and the Ralph M. Coe Collection (Cleveland, OH); see Martin Davies, *French School: Early 19th Century Impressionists, Part-Impressionists, etc.* (London: The National Gallery, 1970), no. 6306, p. 122.

27 As described in Roger-Marx, *Vuillard*, 1946, p. 89.

28 As one observer of the art world put it, the Galerie Bernheim-Jeune had become "de plus en plus acceuillante aux audacieux de talent" (*Cri de Paris* [8 April 1900], p. 5). See the catalogue published by the Editions de Bernheim-Jeune, *Une Grande Maison française d'art moderne*, n.d., pp. 8, 16, *et passim*. See also Henry Dauberville, *La Bataille de l'impressionnisme* (Paris: Editions J. et H. Bernheim-Jeune, 1967), pp. 28–31, 165–7, *et passim*.

29 Bonnard exhibited with the Bernheims beginning in 1900 and more regularly beginning in November 1906; see "Chronology," in Sasha Newman and Antoine Terrasse, *The Late Bonnard* (Washington, D.C.: The Phillips Collection, 1984), p. 253.

30 Shortly after the marriage, Vallotton rented a studio at 6 rue de Milan (1900–2) and moved to the rue des Belles Feuilles, where Gabriella lived with her three children from the first marriage.

31 Journal, MS 5397, *carnet* 2, p. 12v: 11–12 November 1908, listing for 1895: "1er déjeuner chez Hessel rue d'Argenteuil," and above, ch. 5, p. 109. Hessel knew Vuillard's work as early as 1892, when he purchased several small pictures from an exhibition at the *Revue Blanche* offices. Hired by his uncle, Alexandre Bernheim, Hessel was co-manager and the voice of experience for the younger Bernheims. It was Hessel who had gone after the Nabis and persuaded the Bernheim brothers to host a group exhibition at their gallery in the spring of 1900.

32 See Vaillant, *Le Pain polka*, 1974, pp. 96–7, who describes a shouting incident between Vuillard and Lucie that she witnessed in 1909 at Saint-Jacut which Ciaffa (*Portraits*, 1985, p. 344) reads as a lover's spat. The pun on "Vuillard-Villars" was pointed out by Angelica Rudenstein in her entry for one of Vuillard's more powerful and telling portraits of Lucie, *Portrait of Mme Lucie Hessel* (also called *Portrait of the Lady in a Green Hat*), in *Paintings from the St. Louis Art Museum* (St. Louis: St. Louis Art Museum, 1971), p. 555, no. 238.

33 His monograph is dated at the conclusion, 1940–5; see *Vuillard*, 1946, p. 203.

34 "Influences esthétiques créatrices"; "chapitre de l'amitié, (surtout Bonnard, Ker [Roussel] Denis [Pierre] Hermant)"; "rapports familiaux: apport milieu: la maman, son rôle, influence sur vie et caractère" (Journal, p. 90v, 2 single sheets, perforated). It is interesting that, despite the Natanson's early role in his art production, at least in this chapter of the biography, neither Thadée nor Misia is listed as an influence.

35 "De Lucie *boussole qu'elle est* – domination – . . . envoûtement et aveuglement par elle – absolu."

36 The "annex" and summer home of Thadée and Misia had likewise provided the physical context

of a second family and enabled him to "continue to live as agreeable a life possible," which for Vuillard was the "only reasonable goal" (see letter to Vallotton, 27 November 1899, in Guisan and Jakubec, *Félix Vallotton: Documents*, v. 2 (1974), p. 191, and trans. in Thomson, *Vuillard*, 1991, p. 43. See also Vuillard's letter to Vallotton, 23 July 1900, in Guisan and Jakubec, *Félix Vallotton: Documents*, v. 2 (1974), p. 45.

37 "Cela vous paraîtra fad peut-être à vous qui avez tout, femme, maison, campagne, voisinage agréable" (letter in *ibid.*, p. 55). Vuillard was accompanied by his mother that summer, which perhaps added to the completeness he felt. At this time, also, he and Redon seemed to have sealed their friendship. Vuillard would praise Redon as full of charm and resources which he benefited from (*ibid.*, p. 54). Redon, in turn, wrote to Maurice Fabre after Vuillard's visit the following summer, that the artist was "charmant, causeur, liseur, promeneur et peintre" (letter, dated 6 August 1901 from Saint-Georges-de-Didonne, in *Lettres d'Odilon Redon*, ed. Ari Redon (Paris and Brussels: Librairie Nationale d'Art et d'Histoire, G. Van Oest et Cie, 1923), p. 49.

38 Journal, 17 February 1908: "Entre à mon exposition un peu furieux. grippe. trouve Lucie très gentille. m'assoit à côté d'elle à l'abri de son chapeau regarde entre les gens." For a possible analogy to the Vuillard-Lucie relationship, see R.W.B. Lewis's description of the supposed but never proven affair between the lifetime friends, Edith Wharton and Walter Barry (*Edith Wharton: A Biography* [New York: Harper & Row, 1975, 1977], see esp. pp. 458–79).

39 In 1912 Jos had a disagreement with his nephews and opened his own gallery the following year on the rue de Boétie; see Henry Dauberville, *Bataille de l'Impressionnisme* (Paris: Bernheim-Jeune, 1967), p. 364.

40 See Jos Hessel, candidacy, Chevalier of the Légion d'Honneur, Archives Nationales, Document F¹² 8622, 1er pièce (1923). Jos was made Officier in 1932; see Document F¹² 8622, 2éme (1932).

41 "Il n'admet pas que le ciel, en sa présence, soit de méchante humeur" (Tristan Bernard, quoted in Imbert, *Dictionnaire des contemporains*, 1930, v. 1, p. 328).

42 "...à l'oeil de vautour, la main molle,...un petit homme crochu, ventru, aux brefs accès de gaieté, mais aux silences effrayants," one who adored "la chasse, le jeu, les jolies filles, les beaux objets et sa volière" and whose greatest love was "l'argent" (Vaillant, "Livret," *L'Oeil*, 1956, p. 32).

43 Henry Dauberville, grandson of Josse Bernheim, tells the story of having overheard Hessel reassuring Lucie about this very matter: "Ma chère, tu peux être encore heureuse d'avoir eu Edouard – si tu ne l'avais pas eu, c'était Bonnard que je t'imposai!" (in his *Bataille de l'Impressionnisme*, 1967, p. 367).

44 *Du Mariage*, trans. as *Marriage* by Warren Bradley Wells (Philadelphia: J.B. Lippincott Co., 1937), p. 221. According to Barrot and Ory, *La Revue Blanche*, 1989, p. 89, the text was in the making by the late 1890s. Although Blum was never separated from his wife, he argued against bourgeois morality and called for fulfillment on a larger scale than that of being man and wife, recommending "marriages of reason" over "love marriages." For Bourget's *Le Divorce* which opened in January 1908 at the Théâtre de Vaudeville, see S.-J. Turcotte, *Les Gens d'Affaires sur la scène française* (Paris: Librairie Nizet & Bastard, 1936) pp. 133–5. Turcotte's study obstensibly

focusses on the bourgeois entrepreneur and businessman, yet almost every plot described deals with an unfaithful husband or wife.

45 See Ciaffa, *Portraits*, 1985, pp. 347–8, who points out that Vuillard's portraits of the couple express a restraint and delicate balance.

46 Nor are any decorative projects listed in a later account of the salient events of those undocumented years; see Journal, MS 5397, *carnet* 2, p. 12. Thomson, *Vuillard*, 1991, p. 11, suggests that Vuillard may have had personal reasons (Misia and Lucie in particular) for not making more detailed entries and that he may even have destroyed the *carnets* for those years. See also Ciaffa, *Portraits*, 1985, n. 25, n. 54.

47 See Journal, recapitulation of commissions, 1895–1902, 11–12 November 1908. Begining in February 1907, the Prince de Wagram was briefly in unofficial partnership with the Bernheim-Jeune gallery and was building up a substantial collection of modern art. By May 1907, however, the prince, financially troubled, was already trying to end the partnership; see Feichenfeldt "Vincent van Gogh: His Collectors and Dealers" (Essen, 1990), p. 44. Vuillard had met Fontaine in 1897 through Maurice Denis. State Conseiller and later Minister of Labor, Fontaine was related to Ernest Chausson and Henri Lerolle. With Denis, he helped found *L'Occident*, the conservative Catholic literary review (designed to promote western art); see Salomon, *Auprès de Vuillard*, 1953, p. 34.

48 For references to these exhibitions and the titles exhibited, see Gordon, *Modern Art Exhibitions*, 1974, pp. 17, 26, 35, 56, 58, 67, 69, 73, 76, 89, 91, 94, 105, 115, 131, 141, 150, 157, 160, 166, 178, 193, 210, 218, 241. In November 1903, Vuillard was listed among the founding members of the first juried "indépendants" for the Salon d'Automne, at the Grand Palais, although he never became a full member. Vuillard also showed at the Henry Graves gallery ("Les Intimistes," 1905 and 1906) and, in 1907, at the Cercle d'Art Moderne organized by G. Jean Aubrey with Bonnard, Denis, Redon, *et al.*; see *L'Art Moderne*, v. 27, no. 25, (June 23, 1904), p. 199.

49 Matisse was one of the last of the artists among the Fauves to sign a contract; see Gee, *Dealers, Critics and Collectors*, 1981, p. 214, and Appendix E, pp. 11–13. See also Roger Benjamin, "The Fauves in the Landcape of Criticism," in Judi Freeman, *The Fauve Landscape*, exh. cat., Los Angeles County Museum of Art (New York: Abbeville Press, 1990), pp. 257 and 265, n. 50.

50 "Me couche ravi de l'à propos." Vuillard kept a separate running account of important artistic and personal events covering the years between the suspension and recommencing of his journal (1897 or 1898 and 1907). See, for example, Journal, MS 5397, *carnet* 2, p. 15, where the Bibescos feature prominently among the events of the year: "Commande Emmanuel. commande à Bibesco 2 panneaux. photographies."

51 Emmanuel (1877–1917) and Antoine Bibesco (1878–1951) were both born in Corcova Romania. Antoine (but not Emmanuel) is listed along with the Swiss-born Schopfer (Anet) in the section "Les étrangères," in the *Qui est vous? 1909–1910*, 1910, pp. 514 and 512 respectively.

52 The fact that Pierre Veber ("Une Génération," 1938, pp. 266–70) makes no mention of the Bibescos' having attended the Schopfers' early salons on the Quai Voltaire, nor their appearance at the Natansons' "annex" suggests that the brothers were latecomers to Vuillard's circle.

53 Marthe had an unhappy marriage with Prince Georges, an unrequited love for Emmanuel and a

lifelong friendship with his brother; see Ghislain de Diesbach, *La Princesse Bibesco, 1886–1973* (Collection Terre des femmes) (Paris: Librarie Académique Perrin, 1986) p. 89.

54 After the 1848 revolution, the family Europeanized their name from Bibescu to Bibesco. See Ruvigny, *The Titled Nobility of Europe*, 1914, p. 346.

55 Jean Loize, *Les Amitiés du peintre Georges Daniel de Monfreid et ses reliques de Gauguin* (Paris, 1951), p. 147, no. 448.

56 Diesbach, *La Princesse Bibesco*, 1986, p. 97.

57 See Philip Kolb, (ed.), *Marcel Proust: Correspondance*, v. 4 (1904) (Paris: Librairie Plon, 1975), letters nos. 85 (p. 164) and 86 (p. 165.) See also André Maurois, *The World of Marcel Proust*, trans. Maura Budberg (New York: Harper and Row, 1974), p. 119.

58 "Dans la haute société parisienne où ses alliances Montesquiou, Caraman-Chimay, Murat, Noailles, lui font une place de choix, il est très recherché, mais redouté plus encore;...Car son esprit délicieux est cruel. Ce n'est certes pas un bienveillant qui sera joué ce soir pour la première fois au Théâtre de l'Oeuvre" for *Le Figaro*, signed "Serge Basset," cited in full in *Cahiers de Marcel Proust* [1904], ed. Phillip Kolb (Paris: Plon, 1975), p. 351. I am grateful to Lord Crathorne for having brought this reference to my attention.

59 For Maillol's early career and his tapestries, see Humbert, *Les Nabis* 1955, pp. 57–8, and Slatkin, *Aristide Maillol in the 1890s*, 1982, pp. 64–7, 70, 98–9 (cat. nos. 5 and 6). See also p. 99, nos. 7–9, for tapestries and chair upholstery made by Maillol and belonging to Antoine Bibesco; see Judith Cladel, *Aristide Maillol: sa vie, son oeuvre, ses idées* (Paris: Editions Bernard Grasset, 1937), pp. 53–4.

60 Conversation between the author and the present Princesse Bibesco and her husband, Simon Hodgson. The Princesse, separated but not divorced from Prince Alexandre Bibesco, lived most of the year at the family's estate in Corvova (Strahaia), Romainia.

61 See also Bareau, "Vuillard et les Princes Bibesco," 1986, p. 39. I am grateful to Simon Hodgson and Princesse Bibesco for having shown me the photograph album of their ancestor, now in the Maillol Museum, directed by Dina Vierny who kindly permitted me to publish several of the photographs.

62 Bareau, "Vuillard et les Princes Bibesco," 1986, pp. 39, 46.

63 Letter from Schopfer to Vuillard dated 7 October 1902, cited above ch. 5, n. 84.

64 "M. Vuillard's, von dem mansechs Dekorationen aus dem sitze des Prinzen Bibesco. Aber wie schöen ist das, war gemacht hat! Man gerät nicht Versuchung, dis Eindrücke, man von diesen gemalten Panneaux empfängt, sich flarzumachen, di Gartenszenen mit modernene Menschen, diese Zimmer, wo Blumenstrüasse und zuzende Frauenköpfe in eines verschmelzen, vom Standpunkt di Möglishchen, der Wahrschein-lichken zu betrachten" (Franz Ostini, "Die XI Austellung der Berliner Sezession," *Die Kunst für alle*, v. 21, 15, June 1906, p. 418, *Woman in a Garden* repr. p. 426, and "Aus der Elften Ausstellung der Berliner Secession," *Kunst und Künstler*, v. 4 (1905–6), pp. 395–6. See also Gordon, who lists only two works, nos. 295–296, *Dekorationsbilder [aus dem Besitze des Prinzen Bibesco, Paris]*, both of which were for sale at this time. No further description has been found for the other *décorations*, which may have been used generically to refer to Vuillard's style more so than to the actual projects.

65 Dugdale, "Vuillard the Decorator – Last Phase,"

1965, pp. 94–101. This author would argue, however, that Vuillard's "Last Phase," was equally experimental.

66 Bareau, "Vuillard et les Princes Bibesco," 1986, p. 40.

67 "Merci de votre lettre et des photos. Elles font mon bonheur et me font voir encore plus la vanité de certaines idées de peintures . . . Des nouvelles ici? Nous sommes dans une Thélème à peu près parfaite, chacun travaille et est de bonne humeur même moi, excepté depuis quelques heures où j'ai pris un dégoût subit de mon panneau. J'ai fait des excès dessus et je les paie. Je me rappelle en avoir été assez content et comme vous en êtes un peu l'inspirateur, j'ai eu beaucoup la tête occupée de vous, de votre manière d'être plutôt que des traits de votre visage et cela me donnait un peu de sagesse." Letter Vuillard to Vallotton, Villeneuve 23 November 1899, in Gilbert Guisan and Doris Jakobec, *Félix Vallotton, Edouard Vuillard et leurs Amis de la Revue Blanche* (Paris: Etudes de Lettres, 1975), p. 19.

68 An interesting smaller panel shows a similar confrontation or conversation among the foliage, and probably represents Marie, Vuillard's sister, and Roussel; see Dumas and Cogeval, *Vuillard*, 1990, no. 52: *Homme et femme près d'un arbre*, 1893, oil on cardboard, 40 × 51 cm., Galerie Jan Krugier, Geneva.

69 See Segard, *Les Peintres d'aujourd'hui*, 1914, v. 2, p. 286, n. 1: "Chez le même amateur trois autres panneaux exécutés à la colle et rehaussés de pastel représentent ici une jeune femme en violet sur un fond de parc [*The Alley*, pl. 244], là, une jeune femme en robe sombre tachetée de jaune faisant un geste vers les passants. Ils se détachent tous les trois sur un fond de parc jaune et vert." The final version of the painting is reproduced in Besson, *Peintres français*, n.d., no. 21 as "panneau décoratif."

70 Bareau, "Vuillard et les Princes Bibescos," 1986, pp. 41–2.

71 "Rehaussés en pastel" (See Segard, *Les Peintres d'aujourd'hui*, 1914, v. 2, p. 286, n. 1).

72 See for example, *Le Figaro* (9 January 1904), when the Bibescos left for Egypt, and 12 January when they arrived in Cairo; see Kolb, *Proust: Correspondance*, v. 4 (1904), p. 26, n. 5. See also *Le Figaro* (10 June 1904), announcing the Bibescos' tea at the Hôtel Ritz, and, on 24 June 1904, under "déplacements et villégiatures:" "M. le Prince Bibesco à Londres" (*ibid*, p. 224, n. 3). The Bibescos' social successes were jealously recorded by Proust for his future masterpiece; see Kolb, *Proust: Correspondance*, v. 8 (1908), 1983, pp. 299–301.

73 The actress, like Alexandre's mother, was called Hélène. According to Annette Vaillant, whose actress mother was a friend of Hélène, the sons could not accept their stepmother whom they considered inferior to their own mother, who had died in 1902; see Vaillant, *Le Pain polka*, 1974, pp. 101–2. See also "Echos" in *Comoedia* (24 November 1908): "La nouvelle princesse Bibesco, qui a été souvent applaudie, sous le nom d'Hélène Réyé, sur plusieurs scènes parisiennes, notamment à l'Ambigu, où M. Decourcelles lui fit créer l'un des *Deux Gosses*" (cited in Kolb, *Proust: Correspondance*, v. 10, 1983, p. 331, n. 3.

74 Journal, 11 June 1907.

75 "J'ai ce matin vu Vuillard chez lui, il a rapporté beaucoup d'études, ce qui représente son travail de l'été qui est considérable, il dois je crois faire des grands panneaux ce temps-ci" (letter from Vallotton to his brother, 15 November 1907, in Guisan and Jakobec, *Félix Vallotton: Documents*, v. 2 (1974), p. 126, no. 206.

76 Journal, 4 November 1907: "enchanté de ces photos qui me réveillent mille souvenirs." The Bibescos owned also a pastel by Vuillard of the Hessels' Château Rouge, presumably from 1907 or from one of Vuillard's earlier visits in 1905 and 1906; see Huguette Berès, *Peintres et dessins des XIX et XX siècles* (Paris, 1990), n.p.

77 See Bareau, "Vuillard et les Princes Bibesco," 1986, pp. 41–3. Tristan (Paul) Bernard has already been mentioned for his involvement with *La Revue Blanche* and especially as co-editor of the "Chasseur des chevalures," the *Revue*'s humorous supplement illustrated by Toulouse-Lautrec. During his multi-varied career, he was director of an aluminum plant, lawyer, Director of the Vélodrome, editor for the *Echo de Paris*, and finally, and most successfully, a dramatist; see *Qui est Vous* (Paris: Ch. Delagrave, 1924), pp. 65–6.

78 Bernard Dorival, "Vuillard," *Revue des Beaux-Arts de France* (October–November 1942), p. 6: "Le plus souvent pourtant l'effort du peintre réussit, et à *La Meule aux trois promeneurs* se situe mi-chemin etre celles de Monet et celles de Gauguin. L'impressionnisme s'enrichit du style de la synthèse, et la synthèse reçoit celles de l'impressionnisme."

79 According to Bareau, "Vuillard et les Princes Bibesco," 1986, p. 42, the path led from the house to the sea. In another photograph from that same summer in Amfreville (*ibid.*, p. 39, fig. 10) Lucie stands with Vuillard in an open field wearing the same formless, summer dress that Vuillard uses for the lavender frock in the painting (see also below, n. 92).

80 Bareau (*ibid.*, p. 42, fig. 23) reproduces another study for the painting, "L'Etude, II" and gives its location as "private collection." A possible third study, oil on board of approximately the same dimensions as "L'Etude II" (103.5 × 78.1 cm.), is reproduced in *Burlington Magazine* (June 1959), pl. XII.

81 Vaillant, "Livret," *L'Oeil*, 1956, pp. 31–2.

82 At the most recent sale of *The Tennis Court* at Christie's, London, 27 March 1973, no. 57 (A. Tooth), the canvas had been wrapped around 12½ inches on the left, hiding the signature and date (*Vuillard 1907*) and further cutting off the profile of Alexandre.

83 "Attends Olga Natanson qui ne vient que vers 11 heures et 20 minutes. Son manque d'élégance. peu ennuyeuse . . ." (Journal, 26 December 1907).

84 Journal, 29 January 1908: "levé reposé, fais porter le portrait d'Olga avenue du Bois, Enfin!"

85 This involved making a (second?) set of overdoor panels (still unidentified); see Journal, 3 and 6 April 1908, and above, chapter 3, p. 64.

86 See Journal, 12 December 1907, listing the prices paid by Bibesco: "gouache, 35; petit bouquet 30; pastel-15; pastel-15; fleurs corbeil. 18." One of these may have been the small oil-on-board still life, *Intérieur avec géraniums* (17 × 13 cm.) *c*.1905–7; see A. Tooth, London, 1969, no. 10.

87 "Beaucoup de monde, satisfaction de vanité. me sens butor et violent . . ." (Journal, 11 December 1907). It is possible that the Bibescos paid him at this time, enabling him to buy a Renoir still life for 400 francs at the end of January from the dealer Dubourg – a purchase Vuillard referred to in his journal as a "folie" (31 January 1908).

88 Journal, 16 December 1907.

89 "Séance importante sur les arbres. fin de panneau. épuisement" (Journal, 14 January 1908).

90 "Sa visite assez réservée d'abord . . . je le crois satisfait" (Journal, 20 January 1908).

91 Journal, 3 February 1908: "à l'atelier. reprends le panneau Misia et Vallotton."

92 See Journal, 22 January 1908: "vais un moment à l'atelier. Violet de la robe (le mauve de la nature me revient dans l'imagination en regardant la photo)."

93 Journal, 2 February "séance à l'atelier – dernier sur la meule."

94 Journal, 15 February 1908.

95 "*L'Allée, La Meule, Les Lilas*, ne satisfont point à cette exigence, à ces besoins, et c'est sans doute pourquoi ces trois panneaux . . . nous imposent la sensation de tableaux de chevalet exagérés bien plutôt que de compositions décoratives . . . Si l'artiste *moderne* parvient . . . à créer la forme *moderne* de la grande décoration, ce ne sera point par l'amplification matérielle des thèmes familiers à des observations quotidiennes et dans lesquels ils ne devrait chercher . . . Combien je préfère, aux vastes panneaux les petites études à la gouache, au pastel, à l'huile, exposées auprès d'eux, plus vibrantes, plus complètes – plus grandes qu'eux! C'est là le Vuillard que nous connaissions, que nous aimons à reconnaître" (Charles Morice, "Revue de la quinzaine," *Mercure de France*, v. 76 (16 March 1908), p. 358.

96 "Petites notations d'intérieurs et de natures mortes à ses grands panneaux décoratifs, qui, malgré des bonheurs de tons, restent toujours, faute de dessins, des essais très incomplets, et empêtrés" (F.M. [François Monod] *Art et Décoration*, v. 23, supplement [March 1908], p. 3).
Among the many negative comments, only one brief announcement for the upcoming exhibition, in *L'Art décoratif*, viewed favorably the three decorative panels: "parmi les pastels et peintures à l'huile de Vuillard, ses trois panneaux, *L'Allée, La Meule* et *Le Lilas* sont puissemment décoratifs" (1 April 1908, p. 5). This, however, reads as an announcement rather than a fully fledged review.

97 *Exposition Vuillard*, Galeries Bernheim-Jeune, 19 May–2 June 1906, no. 10 *Femme et enfant*, or no. 11, *Confidence* (also exhibited at the Salon d'Automne, no. 1744). By the time Vuillard painted the youngest Bernheim, Gaston had added the "de Villers," to his name (derived from the town of Villers-sur-mer where the Bernheims had their summer home), to distinguish between his budding career as an artist and his profession as a picture dealer; see Gaston de Villers, *Un Ami de Cézanne: Gaston Bernheim de Villers* (Paris: Editions Bernheim-Jeune, 1954) n.p.

98 ". . . qu'il se contente plutôt de rester, pour notre plaisir, l'homme de petits cadres et des sujets bornés, le peintre de petites salles à manger et des bouquets de fleurs" (F.M. [François Monod] "Chronique: Une Nouvelle exposition de M. Vuillard," *Art et Décoration*, v. 21, supplement [1908], pp. 1–2).

99 The "retour à l'ordre" or call to order affecting art and literature by the first decade of the century is a complex issue that will not be discussed here. Denis's 1902 article, "Les Elèves d'Ingres," stressed that artists were on the verge of a new classical period, "the necessary reaction against excess, whether the frivolities of impressionism, or against the vain theories that hold up any expression of individual emotion for a manifestation of beauty" (in *Théories*, [1912] 1920, p. 89, reprinted and translated in Marlais, *Conservative Echoes*, 1992, p. 198). See also Denis's stress on the revival of classicism in "De Gauguin et de van Gogh au classicisme," *L'Occident* (May 1909), reprinted in *Théories*, 1920, pp. 254–70. For a summary of the aesthetic arguments raised by the first Salon d'Automne, see Phoebe Poole, "Picasso's Neo-classicism: First Period, 1905–1906," *Apollo*, v. 81 (February 1965), pp. 123–6.

100 Denis was "romanized" by 1897 when he made

his first trip to Italy with Ernest Chausson. This trip was followed by those with Gide and members of the Catholic review, *L'Occident*. For the return to stylistic conservatism among Denis, Roussel, and even Bonnard to some extent, see Theodore Reff, "Cézanne and Poussin," *Journal of the Warburg and Courtauld Institutes*, v. 23 (1960), pp. 162–4. See also Ciaffa, *Portraits*, 1985, p. 154.

101 The full title was *Dans l'éternal été retentira le chant nouveau*. See Arsène Alexandre, "Maurice Denis," *L'Art et les Artistes*, v. 8 (November 1908), p. 164.

102 See above, n. 99. "Les Arts à Rome, ou la méthode classique" was published in *Le Spectateur catholique*, no. 22, 24 (1896), and reprinted in *Théories*, pp. 45–56.

103 See Benjamin, "Fauves in the Landscape of Criticism," 1990, p. 246. See also Marlais, who argues that Denis was first a Catholic and artist who allowed his love for Latin tradition to make him political (*Conservative Echoes*, 1992, pp. 217–19).

104 "Mouclier dit de la peinture de Vuillard à son exposition que c'est très bien, mais qu'il a un peu l'air de danser devant son tableau. C'est une façon drôle de dire qu'il y a de l'affectation dans le negligé de son exécution: ça papillotte et ça papillonne" (see Denis, *Journal*, v. 2 [1957], p. 36: April 1906). At the Indépendants (20 March–30 April 1906), Vuillard exhibited *Paysage, Rose*, and *Intérieur* (nos. 5124–6). See also Denis's journal entry in which he talks about the problems of "le joli" (*Journal*, v. 2 [1957], p. 21).

105 Denis, *Journal*, v. 2 (1957), p. 199.

106 "Faire des choses que Vuillard déteste. Plutôt Sérusier que le joli. Tâcher de se tirer du joli" (*Journal*, v. 2 [1957], p. 83). It is interesting to recall Denis's earlier remarks about the appeal of the intimate scenes by Vuillard, Vallotton, and Bonnard to the "goût sémite," in contrast to the clear lines of Sérusier and Ranson which appealed to the "goût latin" (see above, ch. 6, pp. 121–2).

107 Among his many contributions to fin-de-siècle society, he founded the Musée Grevin wax museum in 1882, subsidized the Eiffel Tower to prevent its destruction after the 1889 Exposition universelle, and invented the *trottoir roulant*, or moving sidewalk, which was successfully implemented at the next Exposition Universelle in 1900; see Claude Loupiac, "Le Ballet des architectes," in *1913: Le Théâtre des Champs-Elysées* (Les Dossiers du Musée d'Orsay, 15), 1987, pp. 42f. In 1911, Thomas was one of the principal investors for the Théâtre des Champs-Elysées, along with Arthur Meyer, Gabriel Astruc, and Henri van de Velde – an involvement that directly impacted upon Vuillard's life when he was asked to paint the foyer decorations in 1911–12; see below, ch. 10.

108 Conversation between author and Dominique Denis (3 March 1983). Until 1986 and the death of Thomas's grandson, these murals remained *in situ*. They have been dismantled and are now in storage at the Musée Départemental de Prieuré, Saint-Germaine-en-Laye. I am grateful to Claire Denis and Anne-Marie Anquetil for bringing these to my attention.

109 "Les Fontaines, Redon, bon effet de la grisaille et des derniers dessus de portes. Monde bourgeois riche" (*Journal*, 10 October 1908). For the Bellevue panels, see Marie-José Salmon, *L'Age d'Or de Maurice Denis*, exh. cat. (Beauvais, 1983), p. 69, no. 195. This catalogue contains valuable information about the most active period in Denis's decorative career, working for private patrons (1907–8), and focusses on the *décorations* on the theme of the "Golden Age" for the Prince

110 de Wagram's Paris *hôtel* near the Parc Monceau. "Jolies couleurs. aucune expression. Irritation gêne de ce monde. peintures laides au murs de Besnard ... bons souvenirs d'Alexandre Natanson" (Journal, 12 October 1908). See E. Bellerville, "Un Hôtel particulier à Paris," *L'Art décoratif* (August 1908), p. 41. See also Alexandre, "Maurice Denis," 1908, p. 166.

111 "La Décoration, est le but, la raison d'être et la sanction de tous les efforts dans le domaine de l'art" (Morice, "Revue de la quinzaine," 1908, p. 1). Morice was including not only decorative work in a variety of media, but also the work of Matisse's group, and the "paysage décoratif" associated with their high-keyed canvases. Indeed, for Matisse, the exhibition constituted a mini-retrospective; see Benjamin, "Fauves in the Landscape of Criticism," 1990, p. 261.

112 For Piot's frescos, which were destroyed in 1910, see Rodolphe Rapetti, "René Piot et le renouveau de la fresque" (Dossiers du Musée d'Orsay, 42), 1991, p. 10, fig. 5. Earlier that year, for example, Vuillard had visited Gide's house in Auteuil to see Piot's work in progress on the fresco painting *Le Parfum des nymphes*; see *ibid.*, p. 9, fig. 4, nos. 41–5. The murals still exist Gide's former residence, at 18 bis avenue de Sycomores, known as the Villa de Montmorency. For Denis, see Alexandre, "Maurice Denis," 1908, p. 166.

113 For Bonnard, see Bacou, *Décors d'apartements*, 1964, p. 202. For Roussel's *Rape of the Daughters of Leucippus*, see Stump, *Roussel*, 1983, pp. 98–101, and below, ch. 9, p. 182.

114 Journal, 11 March 1908: "... rais sur la rive gauche voir les Puvis du Panthéon. Les peintures de Besnard. Ecole de pharmacie. Souvenirs de jeunesse. Musée du Luxembourg. Pas trop mauvais effet. Delacroix de St. Sulpice ..."

115 See, for example, Vuillard's journal for 27 January 1911: "Vais déjeuner chez Antoine Bibesco. mes anciens panneaux. les plus récents. Amère constation"; 30 October 1912: "Visite d'Antoine Bibesco chez lui. Content aspect panneaux Schopfer mais saisi noirceur. manque d'intérêt de valeurs et de couleurs de ceux de la salle à manger"; and 14 December 1912: "déjeuner chez Emmanuel Bibesco. Mauvais effet de mes peintures." These unfortunately were never photographed *in situ*.

116 Typescript letter from Madame la Princesse Marthe Bibesco to Baroness Elliot of Harwood, 17 Lord North Street, London S.W.1, undated, postmarked 3 July 1962.

117 *Ibid.*

118 *Ibid.*

119 The date of Alexandre's death is not clear. According to Ruvigny, *The Titled Nobility of Europe* [1914], p. 346, Alexandre Bibesco, died 18 October 1912. Kolb argues that neither Ruvigny nor the verbal communication with Antoine (ascribing a date of 5 July 1912) is correct. Kolb cites instead an annoucement published in *Le Figaro*, 12 August 1912, "pour le repos de Prince Alexandre ..." (see Kolb, *Proust: Correspondance*, v. 10 [1983], p. 331, n. 2). See Ruvigny, *The Titled Nobility of Europe* [1914], p. 346, listing the brothers at 20 rue Vineuse (formerly 14 bis) and in Corcova (Romania). The cadastral records for 20 rue Vineuse, 16ème arr. (Sommier, 45, Cadastres Saint-Sulpice), date the purchase of the property to 7 March 1914, "à Prince Antoine qui élève la maison susdesignée."

120 In the same letter in which Princesse Bibesco recalled having seen the Villeneuve panels at the Commandant-Marchand apartment (see above, n. 116), she noted their subsequent reinstallation in

the "petit hôtel particulier" on the rue Vineuse without mentioning *The Haystack, The Alley*, or *The Lilies*.

121 See Enid Bagnold, *Autobiography* (London: Heinemann, 1969), p. 118, for the complete description of the Bibescos' London residence, which faced the embankment of the Thames and which no longer exists.

122 For "Salon Redon," see Suzy Lévy, *Journal inédit de Ricardo Viñes: Odilon Redon et le milieu occultiste, 1897–1915* (Paris: Aux Amateurs de Livres, 1987) p. 68, n. 7, and p. 208. Lévy also cites the exhibition catalogue *Filiger, Moreau et Odilon Redon* (Galerie d'Art, "L'Oeil," 1972), which listed several of Redon's works owned by Antoine (nos. 26, 27, and 31). For *Red Screen*, see Komanecky, "A perfect Gem of Art," 1984, pp. 80, 82–3, and p. 81, fig. 84.

123 An emotional blackmailer, Emmanuel used his increasingly despondent and suicidal mental state to manipulate Antoine into doing whatever he wanted. See Bagnold, *Autobiography*, 1969, p. 119, and Diesbach, 1986, p. 266.

124 See Bagnold, *Autobiography*, 1969, pp. 122–3 for Emmanuel's call to her that day at lunch and his order that she find her brother and stay with him. See also Diesbach, *La Princesse Bibesco*, 1986, pp. 266–7.

125 *Ibid.*, p. 432. The sale of the rue Vineuse residence is listed in Archives des Directions de l'Enregistrement, sommier 34, 16ème arr., where it is listed as having been sold on 9 March 1919 for 80,000 francs.

126 "Antoine Bibesco, sa gêne, ses difficultés à s'expliquer. Déjeuner Meurice – proposition pour ses vieux panneaux. explication chagrin. lettre de Fénéon. lettre de Bernheim, rue Vineuse, atelier" (Journal, 5 October 1918, cited in Bareau, *Vuillard et les Princes Bibesco*, 1986, p. 44). The only clue that there was ever a rift between Antoine and himself is his journal entry for 9 April 1908, when he recorded his feelings after visiting Bibesco in London at the Carlton, resulting in a "longue dispute, rentre 1½ heure, gorge sèche."

127 See, for example, Journal, 11 October 1918, comparing the recent *verdure* (Foliage – Oak-Tree and Fruit Seller [*Verdure – chêne et fruitière*] for Georges Bernheim, now at the Sara Lee Collection, Chicago (see Richard Brettell, *An Impressionist Legacy: The Collection of the Sara Lee Corporation* [New York: Abbeville Press, 1986], pp. 98–9, repr.): "à côté de vieux panneaux," and 26 August 1919: "Sors vieux panneaux Bibesco affreux." As late as 1923, Vuillard was still rethinking the panels: at a dinner party at the Hessels' summer house, Clos Cézanne, he noted Lucie "au ruban vert, croquis que me remet en tête décor Schopfer, Bibesco." (Journal, 10 June 1923, suppl. MS 5398; and 14 August 1928: "revois panneaux Bibesco, causes de leur manque d'intérêt").

128 Bareau, "Vuillard et les Princes Bibesco," 1986, p. 44.

129 The fact that the two panels, *The Haystack* and *The Alley*, were listed with no owner is curious and may indicate that they were in the possession of the Bernheims at this time, or that Vuillard had found a potential buyer.

130 Bareau, "Vuillard et les Princes Bibesco," 1986, p. 44.

131 I first saw the painting lying flat in the Conservation Department at the Louvre in September 1981. Since then, it has been transferred to the conservation studios at Versailles, where a number of restorers have been working to understand Vuillard's technique in order to clean and consolidate the painting for exhibition. I am grateful

to Carol Juillet, one of the restorers currently involved in the Vuillard project, for her information on the painting. For the condition of *The Alley*, see also Bareau, "Vuillard et les Princes Bibesco," 1986, p. 46, n. 34.

132 The marriage took place on 28 April 1919 in London; see Diesbach, *La Princesse Bibesco*, 1986, p. 282. Shortly before the Bibescos' marriage, Vuillard and Lucie were invited to lunch, during which he noted the "effect magnifique, les fenêtres, les grands arbres" (Journal, 16 April 1919). Yet on another occasion, three months later, without Lucie, he noted miserably: "vais déjeuner chez A. Bibesco, notre Dame . . . les panneaux . . . décor neuf. Diplomates romains et anglais: grande gêne, difficulté de me mêler; préoccupation partout" (Journal, 9 July 1919). Several of the smaller easel paintings in the 1938 retrospective at the Musée des Arts décoratifs, for example, were from Antoine's collection (nos. 35, 91, 96, 211).

133 Vuillard finished this only in 1934; see Bareau, *Vuillard et les Princes Bibesco*, 1986, p. 46, n. 33.

134 Mina Curtiss, *Other People's Letters: A Memoir* (Boston: Houghton Mifflin Co., 1978), pp. 82–3. In 1937, Antoine lent these earlier panels to the "Exposition internationale de l'art et technique industriel dans la vie moderne," where they were installed in the *grand salon* on the *rez-de-chaussée* in the Pavillon de l'Architecture privée; see *Catalogue officiel*, v. 2, p. 394.

135 Denis, "L'Epoque de symbolisme," *Gazette des Beaux-Arts*, 1934, p. 178.

136 "Demain peut-être il variera ses modèles et il n'est pas si limité" (Thadée Natanson, "Des Peintres intelligents," *La Revue Blanche*, v. 22 [May 1900], p. 54).

8 Of Avenues, Streets, and Squares

1 Galeries Bernheim-Jeune on the rue Richepanse. *Exposition Edouard Vuillard*, 11–24 November 1908. This was one of the largest of Vuillard's retrospectives to date, showing seventy-five of his works.

2 "Mes 40 ans. Vais chez les Bernheim. Voir mon exposition" (Journal, 12 November 1908), and five days latter his comment "assez bon effet" (Journal, 16 November 1908).

3 See above, ch. 1, pp. 8–9. On Christmas Day 1907, he noted 'tous les jours préoccupé d'argent et de mon travail."

4 ". . . inquiet de mon oisiveté. Réfléchis si peu tranquillement. Pourtant retrouve le goût d'analyse d'autrefois. Suffit à me donner l'espoir. Question des rapports de mon travail ou plutôt des mes préoccupations et des rapports avec le public. Marchands ou autre. Tourmenté de ne pas trouver la discipline qu'il me faut. L'hygiène et l'indépendance. Gagner la vie comme il faudrait. Le régime actuel ne me satisfait pas. Compromis à la base qui m'exposent à toutes les mésaventures malgré l'apparence Nécessité de m'occuper *bien* de ces affaires – importance de l'état de santé aujourd'hui et hier . . ." (Journal, 22 May 1908).

5 "Le marchand, qui depuis quinze ans s'occupe des relations entre le peintre avec le public, laisse à l'artiste liberté absolue d'accepter toute commande mais le libère de toute servitude à l'égard des amateurs" (Segard, *Les Peintres d'aujourd'hui*, 1914, v. 2, p. 254).

6 Writing in his journal for November 1907, Vuillard expressed his frustration in explaining the dealers to his mother: "Cause avec maman de ma situation vis à vis des marchands et amateurs. Entente reposant sur compromis renonce à le

justifier à l'expliquer en paroles" (Journal, 2 November 1907), trans. in Thomson, *Vuillard*, 1991, pp. 30–1 and n. 9.

7 For analysis of the St. Louis portrait, see also Marc S. Gerstein, *Impressionism: Selections from Five American Museums*. exh. cat., St. Louis Art Museum, 1989, no. 85, p. 192.

8 "Me decide à aller chez les Bernheim. côté affecteux de leurs offres. Jadis [*sic*? je dis?] tout ce j'ai sur le coeur. proposition d'en finir. raison profonde de mon désir de liberté le risque et ses nécessités me forçant à produire. ma paresse. leur gentillesse et leurs regrets" (Journal, 3 July 1908).

9 For Bonnard's new contract with the Bernheims, see A. Terrasse "Chronology," in *Bonnard: The Late Paintings*, 1984, p. 250. Matisse is known to have drawn up five different contracts with the Bernheims in 1909, 1912, 1917, 1920, and 1923 owing to his extremely punctilious and businessminded way of dealing with the way his art should be handled. See Gee, *Dealers, Critics and Collectors*, 1981, Appendix E, pp. 11–13.

10 See above, n. 8, and Journal: "nouvel arrangement d'affaires avec les Bernheim à partir de Juillet." [11–12 November 1908] MS 5397, *carnet* 2, p. 12, cited in Easton, *Intimate Interiors*, 1989, p. 144. In 1913, Jos Hessel opened his own gallery on the rue de Boétie after a disagreement with his cousins. Vuillard was henceforth managed only by Hessel, although he remained on friendly terms with the Bernheims for whose summer home, Bois-Lurette, in Villerville, he painted large-scale decorations. See Dauberville, *La Bataille de l'impressionnisme*, 1967, p. 364, and below, ch. 10, p. 208, pl. 329.

11 "Votre lettre est la première qui me soit arrivée à ma nouvelle demeure; m'en ai été tout content de l'avoir louée dans un décor qui j'espère vous plaira comme à moi. J'ai le même nombre de pièces, mais un peu plus grandes et surtout beaucoup plus hautes, à votre taille enfin . . . des fenêtres que je n'aurais osé espérer, sur des espaces découverts occupés par des fleuristes, des serres et bordé au loin par les grands arbres. Ces serres, des gens qui déroulent des couvertures de paille, et des palmiers m'ont rappelé Cannes" (letter dated 14 November 1904, in Thadée Natanson, "Sur Edouard Vuillard d'après trois lettres et deux portraits," *Arts et métiers graphiques*, no. 65 (15 November 1938), p. 39.

12 Under the rubric "Rues de Paris," (1) *La Rue*, (2) *La Voiture d'arrosage*, (3) *La Tour Eiffel*, (4) *L'Enfant au ruisseau* and two others related to the topographical seris, (5) *Par la fenêtre* "1906" (probably pl. 262), and (6) *Square Lamartine*, "winter 1906–1907"; see *Exposition Edouard Vuillard*, 11–24 November 1908.

13 According to Henry's daughter, Georges Bernstein Gruber, co-author with Gilbert Maurin of *Bernstein le Magnifique: cinquante ans de théâtre, de passions et de vie parisienne* (Paris: J.C. Lattés, 1988), pp. 9–10. Ida Seligman's father (Wolf, later anglicized to William) along with his father and twelve brothers were the founders of the internationally successful bank, Joseph and William Seligmann. In 1865, William moved to Paris where he was known as the "American Rothschild." Ida's cousin and Henry's second cousin, Daniel Guggenheim, was European-educated and a frequent visitor to Paris; see Dumas Malone (ed.), *Dictionary of American Biography* (New York: Scribners, 1943), v. 8, pp. 36–8. Daniel went on to found the Daniel and Florence Guggenheim Foundation, but is most remembered as the father of the socialite collector of modern art, Peggy Guggenheim. See also Françoise Cachin, *Manet*, exh. cat. Grand

Palais, Paris (New York: Harry N. Abrams, Inc., 1983), p. 476, no. 209, where Marcel Bernstein's wife is identified as Mme Weisweiller.

14 The move motivated him to add the noble "d'Anvers" to his surname, although Henry never adopted it; see Gruber and Maurin, *Bernstein*, 1988, p. 9.

15 Jacques-Emile Blanche cites Marcel as one of Ephrussi's social group, "tous curieux d'art, riches et influents" (cited in Denys Sutton, "Jacques-Emile Blanche: Painter, Critic and Memorialist," *Gazette des Beaux-Arts*, v. 111 (January–February 1988), p. 168. See also Anne Distel, *Impressionism: The First Collectors* (New York: Abrams, 1989), p. 162.

16 See Cachin, *Manet*, 1983, pp. 474 and 478, n. 1, no. 209.

17 *Ibid.*, pp. 474 and 478, n. 1, for Tabarant's description of young Henry, presumably from Manet himself.

18 Maurice Bernstein also collected Old Master portraits and eighteenth-century paintings by Jean-Baptiste Pater and his circle, many of which were sold to the dealer René Gimpel for 200,000 francs on 27 January 1899; see Gruber and Maurin, *Bernstein*, 1988, p. 18.

19 *Ibid.*, p. 15.

20 *Le Marché* opened on 12 June 1900 at the Théâtre Antoine.

21 Gruber and Maurin, *Bernstein*, 1988, p. 43.

22 ". . . torrentielle, je veux dire bruyante et plus rapide que profonde" (see Claude Roger-Marx, review of *Après-Moi*, in *Comedia Illustré* [February 1911], p. 349). See also above, ch. 7, p. 150, for an assessment of Bibesco's "esprit délicieux et cruel."

23 In a letter from 1902, for example, Marcel (in the code that he used with his closest friends, "Lecram") reproached the Bibescos ("Les Oscebib") of going too often to Vernouillet, where Bernstein ("Nietsnreb") had a country house; see Gruber and Maurin, *Bernstein*, 1988, p. 32.

24 For Proust's change of heart, see *ibid.*, p. 69. Antoine's play adapted from Octave Mirbeau's novel *Le Calvaire* was scheduled to open in 1905 but was apparently abandoned either by the playwright or the theater; see Kolb, *Proust: Correspondence*, v. 5, p. 334, no. 168, letter from Proust to Antoine, 13 August 1905, and n. 2. The final blow to the Bibesco-Bernstein alliance seems to have come about in 1907 when Antoine's play *La Lutte* was rejected by Sarah Bernhardt, perhaps owing to Bernstein's intervention.

25 See below, n. 37.

26 And particularly those of the bourgeois professional. For a listing of plays performed between 1873 and 1914 dealing with money and sexual mores, see Turcotte, *Les Gens d'affaires sur la scène française*, 1936, and "Appendice" (of works studied but eliminated from primary theses), pp. 205–14. For a list of salacious plays on the same themes that Vallotton tried unsuccessfully to publish, see Newman, *Félix Vallotton*, 1991, p. 318.

27 *Le Bercail* dealt with fidelity, *La Rafale* analyzed the condition of "femmes fatales," and *La Griffe* explored the murderous greed of an old man and a young woman. Bernstein's harsher style was apparent in the play co-authored by Pierre Veber, *Frère Jacques* (1904) in which the critics noticed the differences between the brutal Bernstein and the "gentil" Veber; see Gruber and Maurin, *Bernstein*, 1988, p. 47.

28 Bernstein's notoriety was based as much on his written dramas as on his charismatic personality and sensuous aura. One reviewer (called "Bunch") for the *Album Comique* described the author of

L'Israël as something other than an ordinary man: "Mais est-ce bien un homme qu'il faut dire? N'est-ce plutôt un mâle tout simplement? . . . Il y a du sauvage dans M. Bernstein" (review cited in Gruber and Maurin, *Bernstein* 1988, pp. 87–8).

29 See anonymous discussion and interview with Bernstein along with several excerpts from contemporary reviews of the play (by Léon Blum, Catulle Mendès, Henri de Regnier, *et al.*), in "Israël au Théâtre Réjane," *L'Illustration Théâtrale*, 28 November 1908, no. 102, cover pages and play, pp. 3–32. In 1910, Bibesco also wrote a play about a Jew, *Jacques Abran*, which was much criticized: "En faisant de son héros un juif, M. Bibesco a tout d'abord désorienté son public. La question juive est trop importante, trop complexe pour qu'on puisse l'effleurer légèrement et sans porter des clartés nouvelles" (see Jacques Copeau, "La Vie théâtrale: *Jacques Abran*, pièce en 3 actes de M. Antoine Bibesco," *La Grande Revue* [May 1910] p. 617).

30 Vuillard frequently recorded his opinions of his friends' productions as well as of conversations having to do with the "Jewish question." In April 1909, for example, he went to see Romain Coolus's play at the Théâtre Vaudeville noting afterwards, a "Bavardage assez sinistre. anti-sémitisme." On 23 May 1910, he lunched with the Léon Blums before the funeral of the rabidly antisemitic Jules Renard: "conversation sur Renard mort la veille. Tous attristés. Racontons conflits de caractère. Léon, Thadée, Coolus. Anti-sémitisme de Renard . . . allons ensemble enterrement." At another luncheon with the Blums on 13 February 1911, he recorded the "émotion de l'anti-sémitisme."

31 Bernstein's slight to Tristan, however, was quickly overlooked, since Bernstein was at that time a major box-office draw; see Gruber and Maurin, *Bernstein*, 1988, p. 47.

32 Like Renoir, Bernstein was more attracted to Misia as Mme Edwards than as Mme Natanson. Also like the older artist, Bernstein was a frequent guest aboard the Edwardses' 120 ft. yacht, *L'Aimée*, along with the actress Réjane, the singers Caruso and Jean de Reske, the artists Sem, Forain, and Bonnard; *ibid.*, p. 74.

33 In July 1909, having divorced Misia in February, Edwards married Lantelme. Two years later, the *Figaro* announced that Lantelme had drowned in a boating accident while on a cruise along the Rhine with her husband; see Kolb, *Proust: Correspondance*, v. 10 (1983), p. 325, n. 4. Edwards died in 1914.

34 See Gruber and Maurin, *Bernstein*, 1988, pp. 74–5.

35 ". . . fort mécontents l'un de l'autre. Ils se revirent, froissés, distants" (Liane de Pougny, *Mes Cahiers bleus* (Paris: Plon, 1977) p. 190). "Lianon," as Bernstein called her, was the playwright's mistress from December 1906 to January 1908. The story of Bernstein's horror at seeing Misia at his hotel door with pillow in hand and of the first night of their tryst is comical as filtered through Liane's self-engrossed vision: " 'This is going to be hard,' Bernstein complained, '. . . all night, Zut!'. . . . This happened two more nights. Bernstein, horrified, sent me messages, letters, telegrams: 'Come, my Lianon, my only love, the only intelligent woman in the world, come and retrieve your Henry who loves you and who is dying without you' " (*ibid.*, p. 189; my translation). Bernstein attended the wedding of Edwards and Lantelme in 1909; see Gruber and Maurin, *Bernstein*, 1988, p. 91.

36 *Ibid.*, p. 76. The duel was held at 2:30 p.m. in the Parc des Princes. See also Liane de Pougny's account of the incident in *Mes Cahiers bleus*, 1977, pp. 189–90.

37 The Mirbeau-Natanson production, teeming with veiled allusions to the *ménage à quatre* of Misia, Edwards, Edwards's mistress, Lantelme, and Thadée, was finally performed in December 1908 at the Comédie Français after several lawsuits and the resignation of its then-director, Jules Claretie (Gruber and Maurin, *Bernstein*, 1988, p. 61). For a detailed account of the starts and stops for this production, see Pierre Michel, *Octave Mirbeau: L'Imprécateur au coeur fidèle* (Paris: Librarie Séguier, 1990) pp. 819–29 *et passim*. See also Gaston de Palewski, "Le Foyer," *Comedia Illustré*, no. 2 (January 1909), pp. 829–32.

38 See, for example, Journal, 14 February 1908: "Histoire Misia," and 15 February 1908: "Chez Mirbeau. réunion nombreuse. Monet, Rodin, etc. Inquiétude de Thadée au sujet de Misia."

39 Only the narrow panels *The Eiffel Tower* and *Child Playing in a Gutter* are signed and dated "1908." To these, strips of approximately 2¼ inches have been recently added, making them the same height (78¾ in.) as the other two panels.

40 I am grateful to Juliet Bareau for the information on the date of purchase and prices paid for the four panels. Given that Vuillard had only recently redrawn his contract with the Bernheims, it would be interesting to know more details about this transaction and whether or not he benefited from the profits made on the resale of his paintings. With the exception of the *Paris Streets* and landscapes under the category *Bretagne*, the catalogue was dominated by portraits and genre scenes. The names of the donors represented a veritable "Who's Who," including Anet [Schopfer], Alfred Athis [Alfred Natanson], Bonnard, Romain Coolus, Jacques Doucet, and Théodore Duret.

41 Even with the Bernheims' mark-up, in comparison to the prices obtained for works by Monet and Degas, the panels were a bargain. Matisse's large decorative panels *La Danse* and *La Musique*, commissioned by the Russian Sergei Shchukin in 1909, sold for 15,000 francs and 12,000 francs respectively; see Benjamin, "Fauves in the Landscape of Criticism," 1900, p. 265, n. 50.

42 See *Bottin*, 1909, 103 avenue des Champs-Elysées; and *Qui êtes-vous?* (1910), p. 45.

43 See "La Plaine de Passy," in *Chaillot, Passy, Auteuil*, exh. cat. (Paris: Musée Carnavalet, 1982), pp. 73–4, 76–7, and nos. 183–8. See also Jaques-Emile Blanche's charming personal memoir of the area, *Passy, Visages de Paris* (Paris: Editions Pierre Lafitte, 1928).

44 "Tandis que les hôtels privés demandent un caractère individuel, les maisons à loyer ne sauraient admettre aucune originalité marquée de physionomie" (Victor Daly, *L'Architecture privée au XIX siècle sous Napoléon III* [Paris, 1864], cited in *Chaillot, Passy, Auteuil*, 1982, p. 74. Even today, Passy and Auteuil have, as John Russell puts it, "few rewards for the casual visitor" (*Paris* [New York: Abrams, 1983], p. 23).

45 According to Dumas and Cogeval, *Vuillard*, 1990, p. 231, "Chronology," Vuillard began renting at 233bis rue du Faubourg-Saint-Honoré in 1902. For Bonnard's residences, see Terrasse, *Bonnard*, 1984, p. 250, "Chronology." For Lucie's relocation, see Journal, 13 November 1909.

46 "Rentre déjeuner à la maison. Recontre les Bernheim; les hôtels de la rue de la Faisanderie; les riches et leurs fantaisies . . . plaisirs et voluptés sensuelles bourgeoises. Les orgies qui vous esquintent. J'ai envie d'aller à l'Etang" (Journal, 5 November 1907). Both the rue de la Tour and the rue de la Faisanderie converged onto the avenue Henri-Martin where the Bernheims had built an enormous mansion for their two families that same year.

47 Cited in Jeanine Warnod, *Vuillard*, trans. Marie-Hélène Agueros (New York: Crown Publishers, 1989), p. 47.

48 Unlike Bonnard, who is known to have used photographic aids for the perspectival accuracy and documentation found in his street scenes; cited in Berès, *Au Temps de Nabis*, 1990, p. 41.

49 See *Exposition Edouard Vuillard*, 1908, nos. 7–25, "La Bretagne," including *Vue de Pouliguen*. Segard, *Les Peintres d'aujourd'hui*, 1914, v. 2, p. 321, lists this painting as "sans destination." Vuillard probably used the same heavy brown paper which, when wedded to the canvas, would be difficult to distinguish from the artist's board used also in smaller paintings. The canvas backing has since been removed.

50 ". . . monuments ou les maisons d'en bas, en dessous, de près, comme on les voit en passant dans les rues" (see notebook 39, p. 196, in Theodore Reff, *The Notebooks of Edgar Degas* [Oxford: Clarendon Press, 1976], v. 1, pp. 134–5).

51 For the *flâneur* as both observer and observed, see "Decoding Modernity," in Nicholas Green, *The Spectacle of Nature: Landscape and Bourgeois Culture in Nineteenth-Century France* (Manchester University Press, 1990), pp. 28–41 *et passim*.

52 See Roger-Marx, *Vuillard*, 1946, p. 140.

53 Between 1911 and 1913, both Bonnard and Vuillard would do large decorative street scenes painted as if from inside a restaurant or shop. Bonnard's *Matin à Paris* and *Soir à Paris* pendants were commissioned for the Moscow apartment of Ivan Morosoff; see Dauberville, *Bonnard*, v. 2 (1968), nos. 631–42. For Vuillard's panels *Le Siphon* and *Femme à la Rose*, see Salomon, *Vuillard*, 1968, pp. 130–1.

54 By the first half of the new decade, automobiles named for their inventors (Peugeot, Renault, Panhard-Levassor, Mercedes) were increasing rapidly. Buses and taxi-automobiles were running in Paris by 1905; see Hillairet, *Dictionnaire des rues*, 1960, v. 1, p. 45, "Introduction."

55 See, for example, Michael Makrius, *Vuillard*, trans. Charles Lynn Clarke (Paris: Fernand Hazan, 1979), pp. 76–7, where it is translated as the stream, not gutter. The same author has *Voiture d'arrosage* loosely translated as *Spraying Down the Street*.

56 See also Bonnard's painting, *L'Enfant de sable*, part of a now-dispersed four-panel screen, in Claire Frèches-Thory, *Sept Ans d'Acquisitions: Musée d'Orsay* (Paris: RMNF, 1983), no. 10.

57 "Me lève à 9 heures ½ l'aménagement tout prêt. Téléphone chez Bernheim. 11½ quitte la rue de la Tour avec l'idée de ne jamais revenir dans ce quartier. Plaisir de remonter à Clichy. Allons déjeuner avec maman chez Bonvin. Téléphone à Fred et à Thadée. Remontre rue de Calais. Apartement me plait. Toujours pas déçu" (Journal, 18 July 1908). In 1913, Vuillard leased an apartment on the second floor as a convenience to his mother. In 1926, when a renovation project on the building forced Vuillard and his mother to evacuate, they moved only fifty yards away to another building on the square; see Thomson, *Vuillard*, 1991, p. 29.

58 The place Vintimille was known first as the place Berlioz after the statue of the composer placed at one end. Later it was called place Vintimille, after the town of Ventimiglia on the Franco-Italian border. After the Second World War, it was renamed the place Général Adolph-Max.

59 See also Thomson, *Vuillard*, 1988, pp. 74–5.

60 For a social and analytical description of this painting, see Kirk Varnedoe, *Caillebotte*, 1987, pp. 140–1, no. 40. Caillebotte also used the device of showing only the edge of the balcony where he would be positioned (see, for example, *Le Boulevard des Italiens*, no. 135 in Marie Berhaut, *Caillebotte: Sa vie et son oeuvre: catalogue raisonné* (Paris: Fondation Wildenstein Bibliothèque des Arts, 1978).

61 The picture was shortened, presumably by a later hand, to fit it to a smaller wall space. In this earlier version, the foreground is less densely dotted with the carriages and pedestrians that form a black line up to the frontmost edges of the final painting. See *The Armand Hammer Collection: Five Centuries of Masterpieces*, exh. cat., Los Angeles County Museum of Art (Los Angeles: Armand Hammer Foundation, 1980), no. 46, p. 126.

62 See argument for this in Vivien Endicott Barnett, *The Guggenheim Museum: Justin K. Thannhauser Collection* (New York: The Solomon R. Guggenheim Museum, 1978), pp. 202, 204.

63 See *Vuillard et son Kodak*, 1963, p. 11. Salomon dates the pastel studies for Bernstein triptych to 1912 (instead of the earlier dating coinciding with the decorative paintings) without further evidence. See Barnett, *The Guggenheim Museum*, 1978, pp. 205–6 for a discussion of possible dating.

64 See Paul Morand's comments on the square and on the artist: "Je ne puis passer square Vintimille, . . . sous ces marronniers dont Vuillard a peint souvent le faîte, du haut de l'appartement familial situé à l'angle de la rue de Calais, sans penser que je suis là à un carrefour des temps, à une plaque tournante de la sensibilité parisienne et de l'art français" (Paul Morand, *Propos de 52 semaines* [Geneva: Editions du Milieu du Monde, 1943], p. 113, reprinted in Emily Daniel, *Vuillard, l'espace de l'intimité*, diss., 3ème cycle, Paris IV, 1988, "annexe," no. 9, p. 443.

65 Journal, 26 March 1910, and below, n. 81.

66 See, for example, Journal for 8 December 1909: "M'arrange panneaux de Bernstein"; 14 December 1909: "beautemps. Entrain. Passe mon temps à la fenêtre. petits pastels pour panneaux de Bernstein. griserie un peu fébrile et maladresse. pas grand train"; 11 January 1910: "détermine me faire le 4ème panneau de Bernstein. nuage de pastel. arrive à formuler péniblement, journée enfermé, excité . . ."; and 18 January 1910: "remonte rue de Calais croquis. pastel effet de pluie. coin de square." On 14 March 1910, a week before delivering the panels to Bernstein, he noted: "Levé vision revoir. mettre des retouches à feu[?] pour finir. Beau temps. Idée d'harmonie."

67 Journal, 3 December 1909: "Levé 7 heures. train avec Bonnard pour Vernon. visite à Monet. journée charmante. Monet en forme, charmant. sa peinture. sa nouveauté encore pour moi . . ."

68 "Projet pour les tableaux Bernstein. Souvenirs de Monet[?]. Idées générales, peine à me finir" (Journal, 5 December 1909). See also Thomson, *Vuillard*, 1988, p. 104.

69 "Le temps se met. Chez Lucie. croquis pastels pluie sur les trottoirs, pas d'imagination des couleurs pour des pastels" (Journal, 17 December 1909).

70 Journal, 13 February 1910: "maisons au soleil," and 13 March 1910: "personnages nouveaux sur le trottoir des grands panneaux."

71 Journal, 1 September 1909: "badigeons et pastels." For studies of the *Place Vintimille* panels, see Dumas and Cogeval, *Vuillard*, 1990, p. 44, no. 120.

72 "Vais chez Bernstein intérieur lumineux. gris peintures. lacques. M. Bathon et Mme Mayer.

Tous en habit noir avec----[?] Un peu gêné par les nouveautés. Surtout de voir mes peintures prendre un rôle dans cet milieu . . . les quitte gêné à 11 heures" (Journal, 27 October 1909.

73 See Journal, 14 December 1909: "passe mon temps à la fenêtre. petits pastels pour panneaux de Bernstein. Griserie un peu fébrile et maladresse pas grand entrain"; 15 December 1909: "temps gris. petits pastel paralytiques à la fenêtre le matin"; 16 December 1909: "tourmenté, paralysée, tristes de pastels"; but on 5 February 1910: "grande séance sur dernier panneau. effet gris. surexcitation. entreprends peinture colle panneau au large. la grille noire. beauté de la colle. la matière."

74 Journal, 15 November 1909: "Vais déjeuner 11 ⅓h chez Bernstein. mesure de panneaux. Bavardage assez agréable sur la peinture."

75 Journal, 2 December 1909: "levé préocupé de travail. achète papier. le tend sur le mur rue de Calais."

76 Journal, 25 December 1909: "Jour de Noël. Bernstein m'envoie mes panneaux." Thomson, *Vuillard*, 1988, pp. 104–5, dates the first set of panels to 1908–10 to indicate the later retouches.

77 It is not known, for example, if the first set of panels was already glued to canvas, or if Vuillard did this later when he glued the second set to canvas. The canvases in the Guggenheim panels have different weaves from the earlier ones.

78 See, for example, Journal, 8 March 1910: "Vais voir place Clichey . . . visite de Lucie inattendue. Bonne humeur, lui monte mes panneaux; pas de plaisir évident . . . difficultés après son départ de me décider . . ."

79 Journal, 20 March 1910: "Tout le matin prends détermination de faire maroufler mes panneaux d'en finir . . . retouche dernière assez misérable qui me confirme mon impuissance, ma désespoir."

80 Journal, 25 March 1910: "temps splendide . . . Article de Sickert . . . chez Marcelle. Bernstein jouer de poker. scène violent avec Lucie."

81 Journal, 26 March 1910: "levé tourmenté. Brisson rapporte mes peintures. les juge. petites retouches misérables. téléphone Gaston B. déjeune avec Annette et maman. Visite de Gaston et de sa femme. Fais transporter mes tableaux par le charbonnier chez Bernstein. Assez bon effet – décor. Bernstein en peignoir de bain! Sors nerveux, presque envie de pleurer."

82 Journal, 9 May 1910.

83 See Journal, 30 November, 1910.

84 "Le tout décoré avec goût, soie beige aux murs, rideaux épais, meubles anglais laqués de Chine, paravents de Coromandel et huit panneaux de Vuillard en guise de portes" (Gruber and Maurin, *Bernstein*, 1988, p. 158).

85 According to Mme Gruber's description of her father's interior, Bernstein's decorating scheme may have been similar to that of Charles Durand-Ruel's salon – decorated by Monet in 1883 (pl. 105) – and dining-room with door decorations by Georges d'Espagnat, painted in 1894 (pl. 173).

86 ". . . asiatiquement meublé, où des écrans de soie pâle diffusent une douce lumière" (*Le Temps* [2 February 1912], cited in Gruber and Maurin, *Bernstein*, 1988, p. 127).

87 "On peut juger un homme d'après son mobilier. M. Bernstein a sur ses murailles des Cézanne, des Renoir, des Vuillard, des Roussel. Son goût est révolutionnaire. Il a des lustres électriques perfectionnés, à lampes invisibles, dont la lumière se réverbère sur le plafond; ses fauteuils profonds viennent d'Angleterre. Il aime le confort. Il a des paravents chinois, des vases de la dynastie Ming, des grès nippons. Il adore l'Extrême-Orient. Il est anarchiste voluptueux et un peu chinois. C'est le

type même de l'homme moderne" (anon., *Cri de Paris* [15 February 1912], cited in Gruber and Maurin, *Bernstein*, 1988, p. 128.

88 See also Blanche's description of his own salon on the rue Docteur-Blanche: "Mais le salon – je l'avoue sans vantardise – aura été un des plus beaux de Paris: couleur de miel, tapis chinois jaunes et bleus, tapis de table provenant du palais impérial de Pékin; peintures or et bistre de J.-M. Sert, en écoinçons et frise, de chaque côté d'une cheminée Adam du XVIIIe siècle, venant du War Office. Tentures et rideaux de tissus chinois. Régnant autour de 2 côtés du salon, sur les bibliothèques du laqué noir et or, la collection de porcelaines chinoises, Nankin et autres, bronzes du Rodin, bustes grecs. Antiques, miniatures persanes. Paravents de Coromandel, meubles laqués noir et or vénitiens ou anglais XVIIIe siècle" (*La Pêche aux souvenirs* [Paris: Flammarion, 1949], pp. 276–7.

89 "Un chef d'oeuvre d'ameublement et de décoration où le blanc et le noir, sans avoir l'air de rien, ont la richesse, la somptuosité du plus ambitieux Louis XIV. Les laques de Coromandel, les lacques anglais du XVIIIe siècle, les Wedgwood noirs, si rares, aujourd'hui, voisinent avec les tissus gris lamés d'argent et les peintures chinoises" (Jacques-Emile Blanche, cited in Gustave Coquiot, *Paris, voici Paris* [Paris: Ollendorf, 1913], pp. 243–4).

90 "Parfait! Si M. Bernstein a encore ses Lautrec, ses Renoir et ses Bonnard, M. Blanche oublie tout à fait de nous dire quel effet ces admirables oeuvres – que certainement il n'aime pas! – font dans ce décor rare" (Coquiot, *Paris, voici Paris*, 1913, pp. 243–5 *et passim*).

91 ". . . teintes claires, chères aux écoles picturales y sont en honneur . . . l'on voit se réfugier dans les galeries d'amateur, les peintures à l'huile, exclues des salons parisiens dont les murs peints *en blanc* ne souffrent guère que les pastels, gouaches, les acquarelles" (Jacques Lux "Intérieurs Parisiens," *Revue bleue* [23 November 1907], no. 8, p. 256). It is not clear if Lux intends *galeries d'amateur* to refer to the specialist collector, meaning that the paintings would be relegated to picture galleries not reception rooms or, possibly to the galleries of the picture dealer.

92 In 1909, Bernstein had made several important purchases, including Renoir's *La Marchande des fruits*, *Baigneuses couchées*, and a pastel *Tête d'enfant*, as well as Monet's *Charing Cross Bridge, London* (Daybook, Archives Durand-Ruel, Paris).

93 Gruber and Maurin, *Bernstein*, 1988, p. 23. For Bonnards owned by Bernstein, see Dauberville, *Bonnard: catalogue raisonné*, v. 2, no. 535 (purchased 10 December 1909), no. 540 (purchased 28 July 1909), no. 543 (purchased 8 January 1910).

94 See *Catalogue des Tableaux par Besnard, Bonnard, Cézanne, Fantin-Latour, Matisse, Marquet, Monet, Redon, Renoir, Roussel, Signac, Sisley, van Dongen, van Gogh, Vuillard*, 8 June 1911, nos. 30–3. Vuillard's panel from 1909, *Devant la Porte* (no. 33), was apparently bought in. The two easel paintings by Vuillard and their prices realized were: *La Table* (no. 30; 50 × 60 cm., 1,200 francs); *La Robe noire et la robe verte* (no. 31; 46 × 56 cm., 800 francs); illustrated, p. 38. These prices reflect how undervalued Vuillard was compared with older artists like Redon, whose *Char d'Apollon* (no. 15, 65 × 81 cm.) obtained 3,800 francs. One month before the auction, Bernstein lent the panels *Place Vintimille* and *Rue de Calais* to the Galerie Allard's second group exhibition on the theme of "La Parisienne"; see announcement for the "Rues de Paris," in supplement to *L'Art Décoratif* (1911), p. 13.

95 Correspondence between author and Georges Gruber Bernstein, 19 September 1991.

96 See Gruber and Maurin, *Bernstein*, 1988, pp. 105–6 and 114–16, *et passim*.

97 Gruber and Maurin, *Bernstein*, 1988, p. 114.

98 In 1938, Bernstein lent the first series to the Vuillard retrospective at the Musée des Arts Décroatifs where they were exhibited as "Paysages de Paris" (no. 137 "à M.H.B.").

99 Roger-Marx, for example, described them as "mostly still in sketch form" (Roger-Marx, *Vuillard*, 1946, p. 140). It is not clear, however, whether he was referring to the final decorative panels or the large-scale preparatory studies, since he cites as provenance only the Salomon and J.[acques] Roussel collections.

9 An American Princess

1 Roger-Marx, *Vuillard*, 1946, p. 42, referring to the title of a conference he gave on the occasion of Vuillard's retrospective at the Musée des Arts Décoratifs in May–June 1938.

2 "Elle représente deux groupes de personnages assis, causant dans un intérieur auprès de quelques rayons de bibliothèque où se voient des livres, et se détachant sur une tenture que divise en trois parties une composition décorative exécutée dans la manière d'une tapisserie et représentant Adam et Eve dans le paradis terrestre. Au dessus de cette tenture, d'un bout à l'autre du panneau, règne une frise décorative représentant des personages debout, en des attitudes qui rappellent l'antique. Deux colonnes cannelées, coupées par la boiserie, et leurs chapiteaux composites accentuent, dans cette composition de sentiment absolument moderne, les réminiscences classiques.

La tenture du fond se joue dans les bleus et le fond d'Adam et Eve est gris et jaune pénétrés de bleu. Des trois femmes placées à notre droite l'une est brun-roux, assise dans un fauteuil bleu, la seconde est presque noire, et la troisième, derrière les autres, porte une jupe jaune et un corsage bleu.

A notre gauche le vêtement de l'homme qui porte une barbe est d'un vert très sombre presque noir, la jeune femme derrière lui est d'un autre vert-sombre et la petite fille devant eux est vert-bouteille.

Le tapis où traînent des magazines de diverses couleurs est gris-bleuté. L'ensemble se joue par conséquent dans une gamme de gris-jaune, brun-roux et vert pénétrés [*sic*] de bleu. Le tout avec une préoccupation de richesse sobre et de matité. Pas de faux brillant, pas d'éloquence, pas de pittoresque et pour ainsi dire pas de sujet" *Les Peintres d'aujourd'hui*, Segard, 1914, v. 2, pp. 275–6.

3 See also *Exposition Vuillard*, Galeries Bernheim-Jeune (15–25 April 1912), no. 28, where the painting was exhibited as a "décoration pour une bibliothèque".

4 "Déjeuner chez Mlle Chapin, Americaine, avec Bonnard et Emmanuel Bibesco. Portrait du Bonnard classique. clair, bien posé, légères touches. Farouche d'Emmanuel" (Journal, 11 March 1910).

5 Journal, 11 March 1910.

6 Born in New London, Connecticut, in 1881, Marguerite was the only child of Lindley Hoffman Chapin and Leila M. Gilbert; see Gilbert Warren Chapin, *The Chapin Book of Genealogical Data . . . of the Descendants of Deacon Samuel Chapin* (Hartford, Connecticut: Chapin Family Association, 1924), v. 2, p. 1616, Hans Friedrich von Ehrenkrook (ed.), *Genealogisches Handbuch der Fürstlichen Häuser* (Limburg a.d. Lahn: C.A. Starke Verlag, 1959), v. 5, part 1, p. 399. I would like to

thank Leland Hilligoss, History and Genealogy Department, St. Louis Public Library, for his assistance (correspondence with author, 1 October 1985). For the 8 × 7½ ft. bronze sculpture, *The Puritan*, see John H. Dryfhout, *The Work of Augustus Saint-Gaudens* (Hanover/London: University Press of New England, 1982), no. 125, pp. 162–6.

7 Marguerite's first registration as a Paris resident at 101 avenue des Champs-Elysées appears in *Annuaire Officiel des abonnés aux reseaux téléphoniques de la région de Paris* (supp. de la liste des abonnés, 1 déc. 1905), p. 4. By 1910, she is listed at 44 avenue d'Iéna.

8 These and other details of Marguerite's life are drawn from the preface by Gaston Palewski, *Hommage à Commerce: Lettres et arts à Paris, 1920–1935*, exh. cat., Palazzo Primoli Piazza, Rome, 5 December–30 January 1957, n.p. I am also grateful to the Hon. Hubert Howard, Marguerite's son-in-law and present owner of the Caetani di Sermonetta estate and archives.

9 Named after the street in which stood the Caetani *palazzo*, outside Rome, where they moved permanently in 1930; see *ibid.*, and correspondence between author and the Hon. Hubert Howard, 26 February 1983. Unfortunately, according to him, most of the correspondence and photographic materials were lost or stolen from the Bassianos. The review *Commerce* has been reprinted by Kraus Reprints, New York. The "Villa Romaine" where the review was born was also the site of the Treaty of Versailles in 1918. I am grateful to Mme Sabbagh, historian at Versailles for having guided me through the "Villa" and shown me the various newsclippings commemorating the signing of the Peace Treaty at that same residence.

10 Marguerite's familiarity with these men is proved by Vuillard's later journal references, where they are listed among the guests. Although Marguerite's connection with Bernstein is not explicit, there are several coincidences that link the American with the controversial playwright. Marguerite could have known the Bernstein *Place Vintimille* panels, either at firsthand or from the exhibition "La Parisienne" in April 1911 at the Galerie Allard. Her commission for the five-panel screen *Place Vintimille* was given to Vuillard in that same month. A year later, when Bernstein lent four of the *Paris Streets* panels to an exhibition of one hundred years of French art in St. Petersburg, Bernstein's address is given as 44 avenue d'Iéna, in the same building that in which Marguerite had lived and where, presumably, her relatives still resided; see *Exposition Centennale de l'Art Français, 1812–1912* exh. cat. (Manzi et Joyant, 1912), nos. 84–7. See also *Journal*, 15 April 1911, and below, n. 14.

11 Journal, MS 5397, *carnet* 10: 1910, inside of cover: "panneaux Bernstein livrées 26 mai portrait Chapin visite à Degas . . ."

12 Journal, 14 April 1910: "Vais chez Mlle Chapin. commence quelques choses. formes charmantes"; 15 April 1910: "séance chez Mlle Chapin. bonne disposition de travail, séance d'une heure. commence à peindre, charme" (cited and trans. in Thomson, *Vuillard*, 1991, p. 65).

13 For a discussion of Vuillard's late portraits, see Roger-Marx, *Vuillard*, 1946, pp. 89–118 *et passim*. See Salomon, *Vuillard témoignage*, 1945, p. 68, for a list of the portraits executed in the distemper technique.

14 Copy of MS letter from Vollard to Chapin in a private archive, dated 30 June 1911, Paris: "Devant quitter Paris vers le milieu de juillet pour tout l'été, je prends la liberté de vous faire pré-

senter votre facture (pour mémoire reste des mille francs) . . ."

15 My attempts to locate cadastral records for this residence have not been successful. The building at the corner of avenue d'Iéna (no. 44) and the rue Freycinet, renovated and enlarged in 1896, was owned by a M. Lagarde (see VO 11, Archives de Paris). Palewski, *Hommage à Commerce*, 1957, n.p., describes it as a room in Marguerite's rue de l'Université apartment. His description is also that on the back of a photograph in the curatorial department at the Fitzwilliam Museum in Cambridge. See also Fitzwilliam Museum, Cambridge, *Catalogue of Paintings*, v. 1 (Cambridge, 1960), pl. 106, no. 2454, listing the Iéna address and citing the Princesse Caetani as source. Yet Palewski's remembrances of Marguerite began only after her marriage and her move to the Villa Romaine. Palewski was unable to verify this fact during a phone conversation (July 1983).

16 Journal, 4 May 1910: "Retourner chez Mlle Chapin, termine tableau. déjeune."

17 Journal, 14 October 1910 "Vais chez Mlle Chapin. retouche dernière . . ."; and 19 October 1910: "Déjeuner chez Mlle Chapin. Visite d'appartement avec elle et projet de panneau."

18 Two days following the commission, for example, he noted his contemplation of "la composition de panneau pour Mlle Chapin" (Journal, 21 October 1910); see also Journal, 28 November 1910: "Descends 3 heures chez Mlle. Chapin rue de l'université. commande de panneau."

19 Journal, 28 November 1910: "Reviens [from Marguerite's] vais chez Lucie. humeur contre Mlle Chapin."

20 "à l'atelier, l'idée précise pour panneau, idée du travail et la composition" (Journal, 3 December 1910).

21 Journal, 30 December 1910: "très entrain, idée pour panneau. visite au Louvre. Enthousiasme d'enfant. Véronèse, sculpture, antiquités, proportions, formes et couleurs."

22 Schopfer had recently moved to 108, rue du Bac, after having married, on 15 February 1910, Yvonne-Jeanne-Anne-Marie Langlois (called Clarisse) who was also divorced. As witnesses, Schopfer had his two brothers, Louis and Jacques, Misia and José-Marie Sert, the Spanish mural painter who would be Misia's third husband; see "Actes de mariage du 8ème," Documents, Greffier, état civil, Palais de Justice, Paris.

23 The panels measured approximately 77 × 110 cm. each. Two of the Roussel series of panels are in private collections in Paris. A variant of *La Chute d'Icare* was sold at Versailles, Palais de Congrès, 1 June 1975, no. 72.

24 Even as a middle-aged man, Schopfer seems not to have lost his looks or charm. According to German author Henry Müller, Schopfer was a very unusual sort of *homme de lettres*: "He was famous, one attributed to him all kinds of honorable successes with women; in any case, he was self-confident [*sûr de lui*], impossibly self-confident. He was a tall man, blond, with brushed-back hair; former tennis champion in France, he still haunted the sport as a spectator . . ." (Henry Müller, *Trois pas en arrière* [Paris: Table Ronde, 1952], p. 22).

25 Vuillard, while well travelled and moving in an international social circle, was provincially French, knowing only such English terms as "hay fever."

26 Several cryptic journal remarks allude to Vuillard's emotional state, which seems not to have gone unnoticed by those closest to him; see Journal, 19 March 1911: "étranges opinions vives de Coolus en particulière du [word illegible] sur moi et Mlle

Chapin. Suis vivement touché"; 28 March 1911: "retrouve les Roussel ... détente repos. Confidences sur les caractères et opinions Claude Anet [Schopfer] – sur Mlle Chapin et moi. repos détente."

27 A month earlier, he had entered in his journal after a dinner party with Bonnard and Marthe (Bonnard's companion and future wife): "me sens subitement un peu seul" (Journal, 1 November 1910). At the end of May 1910, Louis Rouart had taken Vuillard and Roussel to visit Degas's studio; see Journal, 29 May 1910. Vuillard's description of the bachelor, as a "vieillard," followed by his reflections on "vieillesse" and the artist's "triste atelier poussière," may have also been a melancholy reminder of the consequences both of aging and of living alone.

28 "Déjeuner Mlle Chapin. diplomatie bavardage. Fénéon. un peu de coquetteries avec Mlle Chapin" (Journal, 16 December 1910).

29 Journal, 5 March 1910: "... après hésitation vais au Louvre. Watteau, Chardin, Véronèse, Rembrandt, visite heureuse."

30 See Journal, MS 5396, carnet 1, p. 33r. Later, in an interview with his first biographer, Claude Roger-Marx, he confessed that like Degas, whom he greatly admired, he would like to be considered a student of the Louvre: "I would like to say as Degas did, 'on Sundays, they took us to the Louvre – my brother slid on floors, and I looked at pictures'" (Roger-Marx, Vuillard, 1946, p. 15).

31 Journal, 4 December 1910: "Vais au Louvre, m'attends dans l'antique un peu somnolent. les marbres de [couleur? word illegible], et de décadence romaine. Les Grecs. la petite salle Olympie et la frise. Véronèse, combien rempli comprends [word illegible] cette harmonie simple enchantée ..."

32 Journal, 31 January 1911. As with his earlier drawings of objects in the Louvre's collection, Vuillard used only his 6-B Koh-noor pencil, which did not require special registration with the museum authorities, see Theodore Reff, "Copyists in the Louvre," Burlington Magazine, v. 46 (December 1964), p. 557.

33 Journal, 4 January 1911: "... à l'atelier, charbon, tendon de toile, t.[?] couleurs, blanc de meudon ... range préparatifs pour panneau"; 6 January 1911: "... journée à l'atelier, rangement préparations[.] me décide à tendre papier gris sur toile pour pochade[.] préparations[.] commence à dessiner." Whether or not this represents the final study or the final canvas itself is not clear from this last entry.

34 "... bas-reliefs antiques, les grecs lignes, proportions charmantes ..." (Journal, 7 January 1911).

35 Journal, 7 January 1911: "remonte à l'atelier dessine frise avec entrain mais pas d'ensemble. fusain [tons? tour] du fond me gêne. Utilité de la préparation. vais chez Mlle Chapin. Acceuil charmant. heure agréable ..." Vuillard's journal entry for 10 January 1911 confirms that he was working on the pochade and that he was attacking the project with an unusual level of consistency and confidence: "travail pochade avec entrain toute la journée." During the winter of 1910 and 1911, the Louvre held a special exhibition in the Salle des Antiquités devoted to the "statues, des moulages, et reproductions de l'antique, tentures, tapisseries et objets d'art réunis par le Professor Lannelongue." See announcement in L'Art et les artistes (10 December 1910), p. 1.

36 W. Frohner, Notice de la sculpture antique (Paris: Musées Nationaux, 1889), p. 350, no. 378, and Catalogue sommaire des marbres antiques, 1896. See also description and reproduction in Musée du

Louvre, les collections: Grecques étrusques et romaines (Petits Guides des Grands musées), no. 4, n.d., p. 16, fig. 26. I would like to thank François Baratte, Conservateur at the Louvre, for his identification of the sarcophagus (correspondence with author 12 July 1983).

37 Fröhner, Notice, 1889, v. 1, p. 353. Vuillard does, however, paint an empty border at the top in order, perhaps, to retain the proportions of the original.

38 See Ciaffa, Portraits, 1985, p. 49, who states that they opened the studio in order to support themselves after the death of Ranson's father in 1908. An announcement, prior to the opening of the "Académie Ranson," stated that the school would be averse to academic conventions and devoted to decorative art, since the professors were among those "qui synthétisent, en effet, l'ensemble de tendances nouvelles en art, pendant ces dernières années" (see "Divers," L'Art et les artistes [21 October 1908]).

39 See for example, Vuillard's journal entry for 9 April 1910: "vais corriger académie Ranson. Mme Ranson nous entraine"; and as late as 20 October 1911: "rue Bara Académie Ranson." Denis, on the other hand, was very actively involved with the studio which relocated to Venice and closed some twenty years later; see Salomon, Vuillard témoignage, 1947, pp. 47–8. See Denis, "L'Oeuvre de Paul Ranson," L'Occident no. 88 (March 1909), pp. 119–21, for Ranson's obituary. See also Denis, Journal, v. 2, p. 98, and Ciaffa, Portraits, 1985, p. 50.

40 Vuillard was also a great admirer of Delacroix's Saint-Sulpice décorations, which he described as en grisaille; see Journal, 15 April 1911 "travaille grosse séance. très beau temps ... St. Sulpice grisaille de Delaroix m'intéresse. finis – tour des personnages. allons goûter chez Marcelle."

41 Vuillard used the term "grisaille" to describe Denis's pastel blue and grey, seemingly décoloré or monochromatic overdoors for Gabriel Thomas. See, for example, the review of the group exhibition, "La Parisienne," at the Galerie Allard (April-May 1911) where four of Vuillard's Paris Streets panels were exhibited and described in similar terms: "Vuillard engrisaille des vues de Paris, est heureusement plus coloriste dans le Coin du Salon" (Maurice Guillemot, L'Art Décoratif [suppl. May 1911], p. 12). My use of term should also be take as a loose definition, just as the term en camiëu could be used to define a type of technique associated with copying the antique. See also Institute for the Arts, Rice University, Gray is the Color: An exhibition of grisaille painting, XIIIth – XXth centuries (Houston, 1975), p. 20.

42 Journal, November 1910: "Fénéon vient me prendre. allons chez Matisse, Issy les moulineaux voir grisaille de Puvis dans l'atelier de Matisse. Pas très enthousiasmé f[illegible] Mme Matisse. les élèves et le trait Borghini. Intérieur assez heureuse mais un peu [?] de l'aisance que cela présente." For the history of Braun's art reproductions see Pierre Tyl, Adolphe Braun Photographe Mulhousien 1812–1877 (Université de Strasbourg: Mémoire de Maîtrise d'Histoire, 1982), pp. 98–116. This work is conserved in the Bibliothèque Nationale, Paris, Cabinet des Estampes.

43 "Regard photos. Architecture de Michel-Ange, invention de proportions. Les Médicis dans leur décor me plaisent pour la première fois ... Vais au Louvre par habitude, sculpture de la Renaissance Germain Pilon. esclave. Porte. ornements des portes. cheminée [?] antique. temple d'Egine" (Journal, 24 February 1911).

44 For the map and all following comments about

the installation and arrangements of the galleries in the Louvre contemporary to Vuillard's panel for Marguerite Chapin, see Karl Baedeker, Paris and Environs, 1907, pp. 92–117 et passim.

45 Jean Goujon worked for the Medicis at the end of his life and was influenced by Primaticcio and Michelangelo.

46 See Gustave Geffroy, La Sculpture au Louvre (Paris: Editions Nilsson, n.d.), p. 116. It is not unthinkable, in fact, that Vuillard's admiration for "ornements des portes" and "cheminée antique" helped inform his own painted frieze of graceful muses derived from an ancient source; see Journal, 24 February 1911, and above, n. 34.

47 For information on photography archives in Galerie Goupil in the nineteenth and early twentieth centuries, see Pierre-Lino Renié, "Bordeaux: Création du musée Goupil, Conservatoire de l'image industriée," Revue du Louvre, v. 15 (May 1991), no. 2, pp. 10–11.

48 Letter to Vallotton, 29 July 1905, in Guisan and Jakubec, Félix Vallotton: Documents, v. 2 (1974), p. 93, no. 181, translated in Thomson, Vuillard, 1991, p. 67.

49 Reproduced in Newman and Terrasse, The Late Bonnard, 1984, p. 250.

50 See Pierre Bonnard, exh. cat., Haus der Kunst and l'Orangerie, Paris, 1966–7, no. 58.

51 See Dauberville, Bonnard: Catalogue raisonné, vol. 1, nos. 60, 131; v. 2, nos. 237, ..., 657, 641, 642, 866, 867, 867a, 868. For the Misia panels, see ibid., v. 2, nos. 432–5, and Louis Vauxcelles, "Le Salon d'Automne de 1910," L'Art Décoratif (October 1910), pp. 158–9.

52 When the panels were installed and officially inaugurated at Misia's black-tie affair on Christmas Day 1910, Vuillard described the event appreciatively in his journal as the "soirée de panneaux de Bonnard" (Journal, 25 December 1910). See also Bonnard's portraits of Misia seated in front of one of the panels, in Dauberville, Bonnard: Catalogue raisonné, v. 2, no. 499.

53 See Hans Tietze, Rubens: Catalogue Raisonné (London: Phaidon, 1950), no. 270, and Harold E. Wethey, Titian: Catalogue Raisonné, v. 1: The Religious Paintings, 1969, no. 1, pl. 162. For other artists who copied at the Louvre early and later in their careers, see Reff, "Copyists at the Louvre," 1964, pp. 552–9. Degas was particularly fond of the Venetians in the early part of his career, and even later, when he presumably advised Ernest Rouart to copy Mantegna, ibid, p. 559.

54 I am grateful to Juliet Bareau for having brought this postcard to my attention.

55 His predeliction for the Venetian master is noted also in his journal entry for 25 August 1910: "... au Louvre, le Titien me réveille [.] arabesques élégantes ..."

56 Journal, June 15 1909: "Matin départ pour Anvers à Bruxelles avec Lucie ... arrive seul à Anvers. Les Rubens ..."; 16 June 1909: "Départ pour Bruxelles. Vais voir Rubens ..."

57 Journal, 29 June 1909: 'Lève de bonne heure"; "surexcité, éreinté, vais à Saint Germain. voir Denis et ses peintures. décoration. bavardage animé sur Rubens." It is not clear from Vuillard's notes whether the décoration referred to was actually a painting project or Denis's award for becoming Chevalier of the Légion d'Honneur (an honor that Vuillard would refuse, see below, ch. 10, p. 205).

58 Vuillard chose for his subject what was already an unusual iconography for Titian, a seated Adam and a strikingly monumental Eve. The story of the Fall was also an unusual subject for tapestries which were more typically woven from New

Testament stories.

59 In the preparatory gouache (pl. 290), Eve's violent gesture is even more exaggerated. While Vuillard used live models after 1907 and especially in 1908–9 when he exhibited a number of delicate yet sensuous pastel studies of women in various stages of dress and undress in his studio (see *Exposition Vuillard*, 1909, nos. 112–18), I cannot think of an instance where he represented the full figure of a male nude, apart from his early *académies*. Left out altogether from the Vuillard's version is the small, putto-like figure of the temptor (Lilith) in the tree, and the rolling landscape of Paradise against which the drama is played out.

60 One can cite also the Bernheims' exhibition in April 1910, devoted to artists' copies, presenting copies after Titian, Rubens, and Veronese by a variety of artists such as Delacroix, Manet, and Redon; see *D'après les maîtres*, Galeries Bernheim-Jeune, Paris, 18–30 April 1910.

61 Richard Thomson, "Degas' *Torse de femme* and Titian," *Gazette des Beaux-Arts*, v. 98 (July-August 1981), pp. 45–8. The work was owned by art collector and Vuillard's dentist, Georges Viau, although when he acquired it is not clear. It would be interesting, in fact, to know if Vuillard saw this unusually large monotype when he visited the artist's studio on 29 May 1910, see above, n. 27.

62 Renoir had visited the Prado in 1892. See also Christopher Riopelle, "Renoir: The Great Bathers," *Philadelphia Museum Art Bulletin*, v. 86 (Fall 1990), nos. 367–8, and pp. 27–28 for Renoir's reinterpretation of a seventeenth-century bas-relief, *Nymphs Bathing*, by François Girardon.

63 I am grateful to Roussel scholar, Jeanne Stump, for having brought this image to my attention (correspondence with the anthor, March 1983).

64 Journal, 4 February 1911: ". . . consul de Ker, lève ton jaune gênant. Aide à retrouver l'idée d'un culte de lumière; sujet possible [pour] mon tableau . . ."

65 Journal, 6 February 1908: "Annonce de la nomination de Geffroy aux Gobelins."

66 See Gustave Geffroy, "L'Art moderne des Gobelins," *Les Arts*, no. 155 (October 1916), pp. 14–19. Geffroy is credited with having changed the policy at the Gobelins from the use of natural colors, which had become more and more ephemeral through the unrestricted use of "unstable" dyes, to colors based on chemical dyes (anthracenes), which were brighter and allowed for a variation of shades such as those used in Impressionist paintings. Unfortunately, the once subtle shades of the works made by these latter techniques have discolored and are very different from the originals (Michel Florisonne, "Classical Tapestry from the 16th to the early 20th Century," in *Great Tapestries: The Web of History from the 12th to 20th Century*, ed. Joseph Jobbe, trans. A. R. Oberson [Lausanne, 1985], p. 104).

67 "Son medaillon de la savonnerie d'après Redon que me ravit" (Journal, 20 November 1908).

68 Roger-Marx, *Vuillard*, 1946, p. 154. It is possible, in fact, that the "projet pour Geffroy" noted by Vuillard in his journal for 1914 and for a "commande des tapisseries au Louvre" noted in December of that same year may have been references to an aborted project; see Journal, 22–23 January 1914. See also Madeleine Jarry, "Les Gobelins in the Early-Twentieth Century," *Apollo*, v. 85 (March 1967), p. 197, and her tantalizing but unsubstantiated comment regarding Geffroy's success in "ordering cartoons from living painters – though the best of them, Vuillard for instance, excused themselves."

69 Journal, 28 January 1911: "une exposition tapis-

series Signac, Maillol." Signac's exhibition was not of tapestries but of watercolors; see Maurice Guillemot, "Les ponts de Paris, nouvelle série d'aquarelles de Paul Signac," *L'Art Décoratif*, v. 25 (suppl., February 1911), p. 18, and in the same column, "Les Tapisseries d'Aristide Maillol," p. 18.

70 ". . . très dérangé de mon panneau. Vais Gobelins, grande surexcitation. Geffroy confirme mes idées sur cette histoire. Tapisserie de Ferrare. Le métier d'ouvriers" (Journal, 25 March 1911). See also above, ch. 3, p. 58. Shortly before completing the Chapin panel, Vuillard recorded in his journal a visit from the secretary of Henry Bernstein and Antoine Bibesco and their "longue conversation sur mon panneau. La Tapisserie et les Gobelins"; see Journal, 15 April 1911.

71 Lynn, *Wallpaper in America*, 1980, pp. 441–4. I am grateful also to Lynn Roberts, former Curator of European Decorative Arts and Sculpture at The Art Institute of Chicago, for her suggestions regarding the unusual wall covering.

72 See Peter Thornton, *Authentic Decor: The Domestic Interior, 1620–1920* (London: Weidenfeld and Nicolson, 1984), p. 318.

73 The columns recall Renaissance models copied by the aristocratic residences in the early eighteenth century to flank the doorways, or as part of the fireplace and mirrored mantle ensemble. Vuillard may, in fact, have intended to allude to this arrangement with his vertically formatted panel, with the tapestry hanging in place of what would have been a beveled plate mirror over a magnificent fireplace, the uncontested focus of the traditional interior. In Vuillard's picture, this has been replaced by the low bookshelves.

74 Journal, 18 March 1911: "Vais au Louvre voir Vénus accroupie. Croquis. rencontre de Signac, l'invite. Mosaïques. Vais à l'Atelier séance utile. Vénus de Vienne [?] dans les lilas." The much larger antique statue, also called "Venus de Vienne," was exhibited in the center of the Galerie Denon and was a popular subject for copyists at the Louvre.

75 Marcelle separated from her husband Sam Aron in 1912; see Journal, 9 November 1912, after a soirée at the Arons' apartment: "séparation de Marcelle décidée."

76 Vuillard did two near-identical versions of this salon. The other is in the Emil Bührle Collection, Zürich.

77 Tristan's sons, by his first wife, Marie Bomsel, were Jean-Jacques, writer, playwright, and author of *Mon père, Tristan Bernard* (Paris: Edition Albin Michel, 1955); Raymond, a film-maker; and Etienne, a doctor. cf, *Qui êtes-vous?*, 1924, p. 3.

78 Maurice Hamel, *The Salons of 1905*, trans. Paul Villars (Paris/New York: Goupil & Cie [Manzi, Joyant & Cie, 1905]), pp. 15–16, identical to Maurice Hamel, "Les Salons de 1905," *Art et décoration*, v. 17 (1905), p. 179. The subjects of this night scene were actually recognizable portraits of well-known artists, including René Ménard, Denis's friend Desvallières, and Vuillard's friend, the painter of Breton subjects, Charles Cottet.

79 Journal, 23 March 1911: "mi-carême, séance le matin. atelier. hésite d'aller à l'Etang. photos d'Annette, pour la petite fille du milieu. pas grand entrain."

80 See the description written on the back of a photograph of the gouache study in the Salomon Archives, Paris, kindly made available to me by A. Salomon.

81 Henry Dauberville, son of Josse Bernheim, described his mother Mathilde as "une des plus jolies personnes de sa génération . . ." (*La Bataille de*

l'Impressionnisme, 1967, p. 501).

82 They might also be the subject of a depiction of a shopping trip, *Chez la couturière*, in which their expensive clothes and serpentine silhouettes are similar to those of the two women represented in the Chapin panel. The picture has been dated to *c.*1900, but is more likely to be *c.*1906–7; see Arthur Tooth & Sons, *Vuillard: Loan Exhibition* (April–May 1969), no. 5.

83 Salomon, *Vuillard admiré*, 1961, p. 86.

84 The display case was also near the Roman sarcophagus that he copied. The statuettes, *Deux femmes*, were reproduced and discussed in Pierre Gusman, "Tanagra," *Les Arts et les artistes* (1909), p. 9. The display case in the Salle des Antiquités would feature prominently in Vuillard's later commissioned decorative project on the theme of the Louvre for the Swiss merchant Gérard Bauer; see Thornton, "Au Louvre," 1989, pp. 20–30 and 64–8.

85 Perhaps the little figurine on the top of the bookcase in *The Library* may be by Maillol as well. For Vuillard's "mantlepiece" paintings, see Thomson, *Vuillard*, 1991, pp. 67–8.

86 Journal, 16 April 1911: "Pâques. un peu fatigué. Boa de plumes de maman me sert pour mon panneau . . ." Although Bonnard painted two portraits of Misia wearing a similar feather boa at this time, it seems out of place in *La Bibliothèque* in the context of the less formal attire of the other guests.

87 "Allons dîner chez les Bernheim. Les Frey. M. Adler, engourdi, gêne entre les B[ernheim] et moi. Merveilleux Renoir. Les regarde beaucoup. Tableau fourni par les dames. première fois impression nulle. Dérange [? word illegible] conception du panneau Mlle Chapin" (Journal, 8 December 1910).

88 ". . . utilisation de la pochade de la veille" (Journal, 9 December 1910).

89 The buckle, which does not appear in the gouache study, is exaggerated in the final panel. It may be a visual pun not only on her Puritan ancestral ties, but even on Saint-Gaudens's eight-foot bronze statue of Marguerite's seventeenth-century progenitor, Deacon Samuel Chapin, which had a large bronze buckle on the hat – a statue that was, coincidentally, exhibited at the 1900 Exposition Universelle. See Dryfhout, *St. Gaudens*, 1982, p. 162.

90 See Journal, 3 April 1911: "vais 4 heures chez Mlle Chapin. Déménagements . . . lui parle tapisseries préoccupation: ses yeux clairs, bouche sensuelle, croquis bavarde . . ."

91 "Un dessin nouvel. proportion Mlle Chapin" (Journal, 1911); and "bonne séance tranquille, lente, refais silhouette de Mlle Chapin . . ." (Journal, 1911).

92 Journal, 19 April 1911: "séance après midi, peins le chien, la figure, détails . . ."

93 "Reprise de travail, entrain details, imageries. faire des valeurs, taches de tapis, savonnerie, et un à peu près ornement des fruits, effet dentelle. Bordure de la tapisserie, préoccupé de l'effet de soie, dessin" (Journal, 7 April 1911).

94 "Otez vite ce pot de vaseline, le maître serait capable de le peindre!" (Salomon, *Vuillard témoignage*, 1945, p. 144, n. 13).

95 "Je suis allé voir ce matin Vuillard qui est plongé dans une grande décoration, très bien partie; il y est très absorbé, et nous n'avons guère parlé d'autre chose" (letter dated 21 March 1911, in Guisan and Jakubec, *Félix Vallotton: Documents*, v. 2 (1974), p. 178, no. 250. The authors are unable to identify the decorative project.

96 22 April: "Après déjeuner, emmène Pierre [Veber],

Adrian [?] et Mme Ranson voir mon panneau. Effet nul sur A.... Visite de [Romain] Coolus effet de peinture nul, sujet ne l'enthousiasme pas." 23 April: "Travaille atelier, entrain, bibliothèque de droite, visites de Jos Hessel compliments." 24 April: "... retouche gauche statue, roses partout. Visite de Fénéon et de Gaston [Bernheim]. Pas d'enthousiasme." 25 April: "Matin à l'atelier. petite séance. Visites [Arthur] Fontaine, Mme Chausson, [Georges] Viau, Misia, Paul [Hermant] Visite de Tristan [Bernard], utilisation de la peinture. Marcelle [Aron], s'intéresse. Mme Erlanger, Clarisse Anet, Marthe [Mellot], Grande française (?), les [Alfred] Savoir." 26 April: "Atelier 11 h., M. Elias Julien, critique allemagne."

97 Journal, 27 April 1911: "... transporter de mon panneau. gentille causerie avec Mlle Chapin pendant la pose. Décide arrangement de la pièce."

98 Série topographique, VA2701, micro. no. H51054. The address was originally the eighteenth-century "petit hôtel du Président Jean Tombonneau." See also Hillairet, *Dictionnaire de Paris*, v. 2, p. 682, and Victor Cailliat, "Parallèle des maisons de Paris construites depuis 1830 jusqu'à nos jours" (Paris: Bance éditeur, 1850) I am grateful to Laure Beaumont-Maillet at the Bibliothèque Nationale, Paris, for this reference.

99 "... charmant jardin au soleil..." (Journal, 5 May 1911) and 29 May 1911: "retouche paravent dernier omnibus. Visite de Fénéon vais le porter au rentoiler. beau temps. Train heure de déjeuner chez Chapin avec Maman. bon effet de mon panneau en plein jardin." The building is the present location for the Fondation Hugot du Collège de France. The enclosed garden designed by Le Nôtre still exists in the heart of what is now one of the busiest areas in Paris, behind the Musée d'Orsay. I am grateful to Monsieur Pietrasanta, architect for the Sociéte Immobilière du Preaux Clerc, for conducting me through Marguerite's former residence.

100 When these bookshelves were built in, however, are not known.

101 Also called *La Barque*, the panel was acquired by the state in 1942. Dauberville, *Bonnard: Catalogue raisonné*, v. 2, no. 463, who gives no prior provenance for the panel. While often included in monographs and exhibitions on the artist, this painting is rarely mentioned as a decorative panel destined for Marguerite Chapin. For Palewski's recollection of the panel, see below, n. 116.

102 One of the children in the boat has been described (erroneously) as representing the Swiss artist Balthus (b. 1908); see Palewski, *Hommage à Commerce*, 1957, n.p.

103 See, for example, Journal, 18 April 1911: "séance à l'atelier ... allons chez Bonnard–fraîcheur de son projet pour Mlle Chapin."

104 Journal, 5 May 1911: "... chez Mlle Chapin. charmante jardin au soleil. pas mauvais effet de ma peinture." See also Journal, 29 May 1911, cited above, n. 99.

105 See, for example, Journal, 14 May 1914: "meilleur disposition pour reprendre travail paravent. dessin feuillages ton ombre à gauche remise en train." See also Thomson, *Vuillard*, 1988, p. 104, who claims Vuillard used photographs taken from a single spot in slightly different directions.

106 See journal entries for 1911: 9, 10, 11, 14, 15, 16, 18, 19, 22, 23, 26, 29 May; and 9 June 1911: "Vais chez Mlle Chapin, paravent pas fini..."; 12 June: "... monte paravent dressé. papier peint." The screen was exhibited along with *The Library* in 1912; see *L'Art Décoratif* (suppl., 5 may 1912), p. 8.

107 When Marguerite visited his studio on 23 May 1911, after having stood him up the day before, he noted in his journal: 'Oh! mourir vraie gentillesse."

108 "Mlle Chapin charmante. sens distance sur mon échelle" (Journal, 3 May 1911).

109 Journal, 3 May 1911: "Lucie... toujours grattante. Bonne entente moins prudente me dit l'amour Chapin..." It is not clear whether Vuillard told Lucie about his attraction for Marguerite, or whether Lucie was accusing the American of being in love with Vuillard.

110 "... reste seul, pris pour mes pensées de mon panneau lâché par Mlle Chapin. Silence âpre et fou rire. Essais de voir pourquoi elle n'y tenait pas" (Journal, 4 October 1911).

111 See Journal, 5 October 1911. The official announcement of the engagement, "le mariage du Prince de Bassiano et de Mlle Chapin, fille de feu Lindley Chapin, de New York...," was printed on the front page of the popular daily *Gil Blas* on 1 October 1911.

112 Palewski, *Hommage à Commerce*, 1957, n.p.

113 Conversation between the author and Monsieur Emile Gruet, formerly at the Galeries Bernheim-Jeune, Paris, 13 October 1983. The title of 'prince' was conferred on Roffredo Michele Angele Francesco Caetani on 17 April 1903. He was nephew to the Duc de Sermonetta whose title he would assume by 1916, when he took over the ownership of the di Sermonetta estate "Botteghe Oscure" fifteen miles northwest of Rome; see *Almanach Goltha*, annuaire généologique, diplomatique et statistique (Goltha, Germany: Justus Perthes), 1916, pp. 293–4, and 1920, p. 294.

114 I am grateful to Topazia Markevitch, daughter of Roffredo's brother, Michaelangelo, and wife of the late conductor Igor Markevitch, for her memories of Marguerite and her husband. See also Gabriel Pringue, *Trente Ans de dîners en ville* (Paris: Reune Adam, 1950), p. 133, who describes a dinner party at which was present "tout l'élite de la société cosmopolitan européene," including the Prince Roffredo Caetani, "fils du duc de Sermonetta, qui ressemblait trait pour trait à Lamartine..." See also Alex Ceslas Rzewuski (second cousin to Roffredo), *A Travers l'invisible cristal: Confessions d'un Dominicain* (Paris: Plon, 1976), p. 164, who describes Roffredo as having a mixture of Italian, English and Polish blood, "prestance racée et une distinction incomparable."

115 Vuillard's sense of abandonment by the young American and the impossibility of his relationship with Mme Hessel seems evident from his journal entry shortly after Marguerite's wedding: 'Soirée chez Lucie. Sortons 11 heures. traine finis lamentablement seul" (Journal, 24 October 1911, cited in Ciaffa, *Portraits*, 1985, p. 45).

116 "Avec Lucie. La conduis avenue Drouot. Passe Hôtel [Drouot], Bernheim, événements, mon panneau Chapin par terre décloué. celui de Bonnard" (Journal, 9 October 1911). It is possible that Vuillard's reference to Bonnard's panel was to yet another painting for Marguerite, possibly the portrait mentioned from 1909. The panel *In the Boat* was exhibited at the Bernheim-Jeune gallery in the summer of 1912 (no. 29) and is mentioned in several descriptions of her next home with the Prince, the Villa Romaine at Versailles; conversation between author and Gaston Palewski, 17 July 1983, who recalled that he remembered the *décoration* by Bonnard and Vuillard at their Versailles residence. See also his *Hommage à Commerce*, 1957, n.p.

117 Vuillard's notation of having received a check

from Mlle Chapin on 22 November 1911, may refer to the payment for the screen. In 1912, Jos was already taking steps to establish himself independently of the Bernheims. According to Antoine Salomon, Jos Hessel paid 2,000 francs for his half of the panel in 1913 (entrée no. 20.006) and in 1917 paid 22,050 francs for the remaining half.

118 This opinion is shared by contemporary scholars; see Thomson, *Vuillard*, 1991, p. 65, who labels *The Library* one of the artist's least successful *décorations*.

119 See *Exposition Vuillard*, Galeries Bernheim-Jeune, Paris (15–25 April 1912), exhibition of 29 works: no. 28, *Panneau décoratif pour une bibliothèque*; no. 29, *Paravent*.

120 Journal, 10 February 1914: "atelier. commence à retoucher le fond du panneau Chapin qu'on me demande à exposer chez Manzi."

121 As he had done for *The Luncheon at Vasouy*, when he added the standing woman in white in the left-hand panel when the panel was divided into pendants in 1935; see above, ch. 5, pls. 177, 180.

122 "Transport panneau Chapin chez Manzi; déception désarroi; manque de singularité de signification colorée; mesquinerie; effet de l'atelier amorti; enterrement frère de Vaquez" (Journal, 20 February 1914).

123 New York, Rockefeller Center, 5–38 February 1935, no. 95. Paris, "Les Amis de l'art contemporain," 20 avenue Georges V, no. 8, *Panneau décoratif pour une bibliothèque*.

124 The four-meter-high panel, *Les Filles de Leucippe*, was originally commissioned for the Bernheims' *porte-cochère* on the avenue Henri-Martin. See Stump, *Roussel*, 1972, pp. 98–101 for a chronology of events leading up to the painting's purchase in April 1935 for 35,000 francs. For Vuillard, see letter from the Directeur Générale des Beaux-Arts (Ministère de l'Education Nationale) to Hessel, 23 January 1935, asking him to inform Vuillard of their plans and to obtain the documents for the painting; see also letter from the same Directeur Générale des Beaux-Arts (Ministère de l'Education National), 28 January 1935, to Vuillard establishing the price as 45,000 francs ("Achats de peintures suite de 1929 à 16 fév 1930," 17 January 1935: "Vuillard *La Bibliothèque*, 45000 payé," 28 January 1935, Archives Nationales, F^{21} 4158^3, copy in Departmental Archives, Musée d'Orsay, Paris).

125 Bonnard's portrait was sold back to the Bernheims in 1917, one year after it was painted; see Dauberville, *Bonnard: Catalogue raisonné*, v. 2, p. 387, no. 870.

126 For Marguerite's salon, see Rzewuski, *A Travers l'invisible cristal*, 1976, pp. 162–4 *et passim*. See also Gide, *Journal*, 1951, entry for 28 May 1921, p. 694, and September 1929, p. 934. The Count Kessler was also one of Marguerite's intimates and recorded having attended the first performance of Roffredo's opera *Hypatia*; see his *In the Twenties*, 1976, 21 May 1926, pp. 295–6.

127 For a description of Marguerite's collection, see Rzewuski, *A Travers l'invisible cristal*, 1976, pp. 163–4. Vuillard mentions working on "des calques" for the "petits Bassiano," 31 October 1921. Roffredo died in 1961 and Marguerite two years later. Their son, Camillo, was killed during World War Two. Leila died in 1977.

128 "... le seul problème est dans la volonté–pourquoi je me suis arrêté dans le panneau Chapin?... penser à ce qui rappelle sensations vraies de détails–d'étude de précision d'objets..." (Journal, 13[?] March 1915). A few days later, he copied a Latin quotation on Beauty: TUM VARIAE VENERE ARTES; LABO OMNIVIA VIET IMPROBUS ET

DURIS IN REBUS EGESTAS ("Then various are the means towards Beauty: I weave together everyting poor and rough, pressing in whatever is needed"). I am indebted to the late Ilse Hecht, curator emeritus at The Art Institute of Chicago, for the translation of phrase.

129 "J'ai tout en moi. Ceux qui n'ont pas cette richesse intérieure ont besoin de l'apport des belles oeuvres créés par des gens comme nous." As retold by Gaston's nephew Henry Dauberville in *La Bataille de l'impressionnisme*, 1967, p. 32.

10 Painting as Decoration and Decoration as Painting

1 *Exposition Edouard Vuillard*, Galeries Bernheim-Jeune (15–27 April 1912). This was to be Vuillard's only one man show until, a few months after his nomination and acceptance into the Académie, 1938, he was given a retrospective at the Musée des Arts Décoratifs, with over 300 of his works, including numerous decorative paintings. For Gabriel Thomas's proposition, see Journal, 25 May 1912: "offre de décor foyer." Frèches-Thory believes Vuillard's first offer was given by Mme Chausson. It was not until 13 June 1913 that Vuillard was visited by Thomas and Perret; see Chaire Frèches-Thory, "Roussel and Vuillard à la Comédie des Champs Elysées: Histoire d'une décoration," *1913: Le Théâtre des Champs-Elysées* (Les Dossiers du Musée d'Orsay, 15) (Paris: Edition de la Réunion des musées nationaux, 1987), p. 95.

2 "Un édifice destiné au public, ouvert à la vie sociale" (Geneviève Aitken, "La Peinture au Théâtre des Champs-Elysées," *L'Oeil* (April 1938), p. 42.

3 On 31 March 1913, the theatre opened to a particularly fashionable crowd in attendance at the performance of Berlioz's "Benvenuto Cellini," dating from 1838; see Aitken, "La Peinture au Théâtre des Champs-Elysées," 1938, p. 42.

4 For a most interesting chronology of the building, as told through the eyes of Henry van de Velde, see "Lettres de Van de Velde to his wife, 1910–1911," extracts in *Architecture d'Aujourd'hui*, no. 174 (July–August) 1974, pp. 115–25.

5 Denis, *Journal*, v. 2 (1957), p. 63, entry for 1907: "Ce serait bien pour tenter les commandes d'Etat, d'avoir l'an prochain au Salon un grande toile avec de grandes figures."

6 See Denis, "Du 1er au 8eme mai" (1912), *Journal*, v. 2 (1957), p. 146. This work included panels for L'Orchestique Grecque, Drame Lyric, La Symphonie, etc., all of which are discussed and illustrated (by the maquettes) in Thérèse Barruel, "La Coupole de Maurice Denis," in *1913: Le Théâtre des Champs-Elysées*, 1987, especially pp. 78–81, with an identification chart for the individual members within each panel. See also the stage-curtain design for the main hall, in Warnod, *Vuillard*, 1989, pp. 77–8.

7 "Je reçois des compliments, même de Vuillard" see Denis, "1913" *Journal*, v. 2 (1957), p. 147, and Journal, 13 December 1912: "harmonie plus fine que l'énorme esquisse. enorme travail, bien fait."

8 According to postcards published by the Société Immobilière du Théâtre des Champs-Elysées (Salmon Archives, Paris).

9 Other artists invited to work on the project included Sem, who drew caricatures of Lucien Guitry, Jean Cocteau, and Collette at the bar, Henry Lebasque, with five panels, and Jacqueline Marval, who painted the tale of Daphnis and Chloe in the dancer's rehearsal room; see Warnod, *Vuillard*, 1989, pp. 77–8.

10 "décision de la matinée. abandon sujets antiques" (Journal, 26 September 1912), and "description de Foyer Théâtre – décide sujet moderne" (Journal, 17 October 1912).

11 Jacques Salomon, *Les Décorations de Edouard Vuillard à la Comédie des Champs-Elysées* (Paris: W. Fischer, n.d.), n.p.

12 For specific journal references, see Frèches-Thory, "Histoire d'une décoration," 1987, pp. 98–101.

13 Louis Schneider, "Théâtre du Palais Royal," *Le Théâtre*, no. 309 (October 1911), p. 8.

14 The title was derived from a famous military battle with the Prussians on 25 October 1747; see *Journal du siège de Bergopzoom en 1747* (Amsterdam and Leipzig, 1750). In the play this date was the deadline by which Paulette had to make her decision whether to accede to her lover.

15 *Exposition Vuillard*, Galeries Bernheim-Jeune (13–25 February 1911), no. 9. See also Bareau, "Vuillard et les Princes Bibesco," 1986, p. 46.

16 "Echos: Décor d'un *Beau Mariage*," *Gil Blas*, November 1911.

17 *Ibid.*: "Ces toiles, Sacha Guitry les a empruntées et non acquises... Tandis que Lysés et Sacha créeront les premiers rôle, Bonnard et Vuillard créeront une atmosphère sympathique autour des personnages..."

18 "Ler acte. ma peinture ne me fait pas mauvais effet" (Journal, 16 October 1911).

19 "Un gros garçon, qui s'amuse et qui a des manies, comme celle de découper des silhouetes en bois et de faire de la peinture; il est original et bon vivant" (Raoul Aubry, "La Prise de Berg-op-Zoom," *Le Théâtre*, no. 332 (11 October 1912), pp. 4–5 (photo p. 11).

20 Thomson, *Vuillard*, 1988, p. 98, mentions another (and later) instance when a Vuillard still life was lent by Hessel for a stage set at the Comédie Française, and described by the playwright, Paul Géraldy, as a way of "being precise about the tone of the people living there and also... of paying discreet homage to Vuillard."

21 Blanche, "Salon d'Automne 1904," *Mercure de France*; see above, ch. 6, p. 132.

22 Built for the Exposition Universelle of 1937 on the top of the Trocadéro; see Thomson, *Vuillard*, 1988, p. 98.

23 See Stump, *Roussel*, 1971, pp. 127–8.

24 "Ils refusèrent gentiment avec des façons courtoisés et sans vouloir quoiquoi leur geste fût une manifestation. Même, très aimables, ils remercièrent" (in "Echos: Les rubans dédaignés," *Gil Blas* (25 October 1912). See also Segard, *Les Peintres d'aujourd'hui*, 1914, v. 2, p. 255, who described Vuillard as "preferring not to accept the honor."

25 "Leur refus risque de décourager les ministres qui ont de bonnes intentions. Ils vont à nouveau décorer les Madeleine Lemaire." Another critic cited it as an example of the "best argument" against the actions of Roussel, Bonnard, and Vuillard, in Léon Werth, "A travers la quinzaine: Le Refus de la décoration," *La Grande Revue*, November 1912, p. 163.

26 "À une condition, c'est que votre livre ne paraisse qu'après ma mort" (Claude Roger-Marx, "Dans l'intimité d'un grand intimiste: Vuillard," lecture, 21 January 1969, to the Académie des Beaux-Arts, published in *Institut de France* (Paris: Firmin-Didot, 1969), p. 6, and cited in Ciaffa, *Portraits*, 1985, p. 53.

27 "Le peintre des intérieurs parisiens aura été M. Vuillard. Il a façonné de fragiles bibelots, parfois des panneaux décoratifs qui tiennent de l'affiche, de l'estampe, de la vignette de la crétonne, mais avec tant d'à propos et d'adresse, que ses ouvrages prendront dans l'avenir une valeur documentaire, à côté de ceux de son camarade Pierre Bonnard, peut-être plus peintre que lui – et de Maurice Denis, le décorateur attitré de nos églises, de nos théâtres, et de nos monuments publics, aussi bienque la chambre d'enfant. Maurice Denis est à Puvis ce que Vuillard est à Degas" (Jacques-Emile Blanche, "Notes sur a peinture. moderne" [December 1912, published 1913], *Propos de peintre: de David à Degas*, v. 2 (Paris, 1927), pp. 31–2.

28 *Ibid.*: "Leur art répond si bien aux désires des amateurs d'aujourd'hui qu'ils obtienrent dès leur apparition le succès unanime, le prestige, jusqu'ici récompense d'une longue vie obscure d'artiste, quand cette récompense ne venait pas après la mort."

29 See for example, Pissarro's restating of Degas's remarks to Mary Cassatt in a letter dated 2 October 1892: "I am wholly of his [Degas's] opinion; for him it [decorative painting] is an ornament that should be made with a view to the ensemble, it requires the collaboration of architect and painter. The decorative piece [*tableau-décoration*] is an absurdity, a picture complete in itself is not a decoration" (Pissarro, *Letters to his Son Lucien*, 1981, p. 259.

30 Curtiss, *Other People's Letters*, 1978, pp. 82–3, and above, ch. 7, pp. 163–4.

31 See above, ch. 6, p. 142.

32 "Enfin comprehension de question de couleur à propos de la décoration" (Journal, 26 April 1912).

33 "Avec Bonnard. Trocadero. la peinture décorative, murs clairs. s'imposent colorations claires. Puvis. Véronèse. les décorations autre chose que les peintures de chevalet" (Journal, 2 January 1938).

34 Van de Velde, "Ferdinand Hodler," *Die Wiessen Blätter*, 1918, p. 131.

35 See Roger-Marx, *Vuillard*, 1946, p. 142; Kunsthaus, Munich, *Vuillard und Roussel*, 1968, pp. 114–15, nos. 146, 147, and 148; and Thomson, *Vuillard*, 1988, p. 119.

36 As quoted in Peter Selz, *Art in Our Times: A Pictorial History* (New York: Harry N. Abrams, 1980), p. 417.

37 Before accepting the honor, Vuillard had to be pressured by fellow academicians Jacques-Emile Blanche and Maurice Denis into accepting the nomination to the Institut; see Ciaffa, *Portraits*, 1985, p. 54. See also *Correspondance: J.-E. Blanche-Maurice Denis* (Geneva: Droz, 1989), pp. 78–9, no. 30, letter from Denis to Blanche, 1 August 1924.

38 *Exposition Vuillard*, Musée des Arts Décoratifs, Paris; see nos. 32 (Triptych. *Jardins publics*, now Luxembourg); 33 (*La Promenade sous les arbres* à M. Henri Blum); 27 (*Dans les fleurs. Conversation* à M. Jos Hessel); 45 (*Personnages dans les intérieurs* au Petit Palais); 54a (*Personnages dans un jardin en Normandie*); 54b (*Le Déjeuner en Normandie*); 69 (*Paysage de l'Ile de France* [coll. particulière]); 135 (Paravent à cinq feuilles, *La Place Vintimille, rue des fenêtres de l'*... M. A. S. H[enroux]).

39 "Ses dessins, gouaches, pastels, exposées en ce moment à l'Orangerie sont, dit-on l'ebauche d'une future salle Vuillard au Musée d'Art Moderne. Pour l'instant elles constituent un commentaire plutôt que l'oeuvre elle-même. Il ne saurait y avoir de salle Vuillard sans ces grands panneaux qui marquent l'apogée de son génie, ceux de Claude Anet, d'Antoine Bibesco, de Vacquez [sic], de Natanson et de Léon Blum. Souhaitons qu'ils ne passent pas les mers" (Paul Morand, *Propose des 52 Semaines* [Geneva: Editions

du Milieu du Monde, 1943], p. 115, reprinted in Daniel, "Vuillard, l'espace de l'intimité," 1987, pp. 443–6, "Annex." The "Donation Roussel" of Vuillard's works given to the state was exhibited in 1941 and 1942 at the Orangerie des Tuileries. At that time Roussel also gave Vuillard's journals to the Institut de France without having looked at them; see Stump, *Roussel*, 1971, p. 187.

40 ". . . que ses ouvrages prendront dans l'avenir une valeur documentaire" (J.-E. Blanche, "Propos du peintre: La Peinture moderne," [1913] p. 31).

Selected Bibliography

Archival Sources

Archives Nationales, Paris:
 AJ 52 488 (IV) 480
 S.I. 16 Candidatures: Légion d'Honneur
 BB³³49
 BB³³60
 Actes de Sociétés, Microfilm 261 (130/AQ/104)
Archives de la Ville de Paris:
 Série VO 11 DP
Archives des directions et de l'enregistrement, Saint-Sulpice
Archives Durand-Ruel, Paris
Archives Bernheim-Jeune, Paris
Archives Antoine Salomon, Paris
Archives de Mairies d'arrondissement
Archives de l'Etat Civil du Canton du Vaud, Switzerland
Fonds Henry Van de Velde, Bibliothèque Royale Albert 1er, Brussels
Humanities Research Center, University of Texas at Austin
Institut de France: Journal of Edouard Vuillard, MSS. 5396–9, 1880–1940 (see p. 209, n. 17).
Secretariat-Greffe du Tribunal de Grande Instance de Paris (Palais de Justice)

Important Interviews Conducted

Mme Stéphane Desmarais, Paris
Robert Fizdale and Arthur Gold, New York and Paris
Jean Godebeski, Paris. Son of Cipa Godebeski
Gilbert Gruet, Bernheim-Jeune, Paris
Lucie Klene, Paris. Adopted daughter of Lucie and Jos Hessel
Mme Jean Mabilleau, Paris. Daughter of Jean Schopfer (Claude Anet)
Antoine Salomon, Paris
Annette Vaillant, Paris. Daughter of Marthe Mellot and Alfred Natanson

Unpublished Sources

Aitken, Geneviève. "Les Peintres et le théâtre autour de 1900 à Paris." Diplôme de l'Ecole du Louvre, 1978.
Ballew, Emily. "Edouard Vuillard's 'Jardins publics': The Subtle Evocation of a Subject," M.A. thesis, Rice University, Houston, 1990.
Daniel, Emilie. "Vuillard, l'espace de l'intimité." Thèse. Paris. Université de la Sorbonne, 1987.
Guillois, Mme Jean. "Geneology," unpubl. MS of the Vaquez, Bénard and Delavallée families, dated 25 November 1977.
Mabilleau, Mme Jean. "My Father, Claude Anet," unpubl. MS, 1989.
Thornton, Charlotte, "Au Louvre: The Creative Process of Edouard Vuillard," M.A. thesis, University of Texas at Austin, 1989.
Troy, Nancy. "'Interiorization' in French Art and Design of the 1890s." Paper given, CAA Session, 27 February 1981.

Published Sources

Adam, George and Pearl. *A Book about Paris.* New York: Harcourt, Brace and Co., 1926.
Aitken, Geneviève. "La Peinture au Théâtre des Champs-Elysées," *L'Oeil* (April 1988), 42–7.
———. *Artistes et théâtres d'avant-garde: Programmes de théâtre illustrés, 1890–1990,* exh. cat., Musée de Pully, 1991.
Alexandre, Arsène. "Maurice Denis," *L'Art et les Artistes,* v. 8 (November 1908), 161–6.
Annuaire-Almanach du commerce de l'industrie de la magistrature et de l'administration. Paris: Didot-Bottin, 1890–1906.
Aron, Jean, ed. *Misérable et glorieuse, la femme aux XIX siècle.* Paris: Librairie Arthème Fayard, 1980.
Asquith, H.H. *Letters of the Earl of Oxford and Asquith to a Friend.* 2 vols. London: Geoffrey Bles, 1934.
Aubry, Raoul. "La Prise de Berg-op-Zoom," *Le Théâtre,* no. 332 (11 October 1912), 5–11.
Aurier, G.[eorge]-Albert. "Le Symbolisme en peinture: Paul Gauguin," *Mercure de France,* v. 2 (March 1891), 155–65.
———. "Les Symbolists," *Revue Encyclopédique,* v. 2 (April 1892), 474–86.
Autographes, Lettres-Documents-Photos. Geneva: L'Autograph, 28 June 1989.
Bacou, Rosaline. "Décors d'appartements au temps des Nabis," *Art de France,* v. 4 (1964), 196–205.

Baedeker, Karl. *Paris and Environs with routes from London to Paris.* 10th rev. ed. Leipzig: Karl Baedeker, 1891
———. *Northern France.* New York: Charles Scribner's & Sons, 1909.
Bagnold, Edith. *Autobiography,* London: Heinemann, 1969.
Barazzetti-Demoulin, Suzanne. *Maurice Denis.* Paris: Grasset, 1945.
Bareau, Juliet Wilson, "Edouard Vuillard et les Princes Bibesco," *Revue de l'Art,* no. 4 (1986), 37–46.
Barnett, Vivien Endicott. *The Guggenheim Museum: Justin K. Thannhauser Collection,* New York: The Solomon R. Guggenheim Museum, 1978.
Barrot, Olivier, and Pascal Ory, *La Revue Blanche: Histoire, anthologie, portraits* (Série: "Fins de siècles"), Paris: Christian Bourgeois, 1989.
Benjamin, Roger. "Fauves in the Landscape of Criticism: Metaphor and Scandal at the Salon," in Judy Freeman, *The Fauve Landscape,* exh. cat., Los Angeles County Museum of Art. New York: Abbeville Press, 1990, 241–67.
Berger, Klaus. *Japonisme in Western Painting from Whistler to Matisse.* Trans. David Britt. Cambridge University Press, 1992, reprint of German ed., Prestel Verlag, 1980.
Bernard, Jean-Jacques. *Mon Père Tristan Bernard.* Paris: Albin Michel, 1955.
Bernier, George. *La Revue Blanche: Paris in the Days of Post-Impressionism and Symbolism.* New York: Wildenstein Foundation, 1983.
Billy, André. *L'Epoque 1900, 1885–1905.* Paris: Editions Jules Tallandier, 1951.
Blanc, Charles. *Grammaire des arts du dessin.* Paris: Renouard [1867], 1880.
———. *Art in Ornament and Dress,* London: Chapman and Hall, 1877.
———. *Grammaire des arts décoratifs: décoration intérieure de la maison.* 3rd ed. Paris: Renouard, 1886.
Blanche, Jacques-Emile. "Les Objets d'art au Salon," *La Revue Blanche,* v. 3 (1895) 483–9.
———. "Notes sur le Salon d'Automne," *Mercure de France* (December 1904), 681–90.
———. "Salon d'Automne," *Mercure de France,* v. 12 (October 1905), 337–50.

247

———. "Notes sur la peinture moderne, à propos de la collection Rouart et de M. Degas" (Extrait de la *Revue de Paris*, 1er et 15 janvier 1913). Coulommiers: Imprimerie Paul Brodard, 1913.

———. *Les Arts plastiques* (Troisième République, 1870 à nos jours). Paris: Les Editions de France, 1931.

———. *La Pêche aux souvenirs*. Paris: Flammarion, 1949.

Blondel, Spire. *L'Art intime et le goût en France*, Paris: Ed. Rouveyre et G. Blond, 1884.

Boime, Albert. "Entrepreneurial Patronage in Nineteenth-Century France," in Edward C. Carter, Robert Forster, Joseph Moody, eds., *Enterprise and Entrepreneurs in Nineteenth- and Twentieth-Century France*. Baltimore: The Johns Hopkins University Press, 1976, 137–91.

Bonnard, Vuillard, et les Nabis, 1883–1903, exh. cat., Musée Nationale d'Art Moderne, Paris, 1955.

Bottin Mondain: Tout Paris, toute la France. Paris: Société Didot-Bottin, 1895–1910.

Bottin-Paris. Paris: Société Bottin, 1894–1900.

Bouyer, Raymond. "L'Art et la beauté aux Salons," *L'Artiste*, v. 68 (1898), 128–35.

Boyer, Patricia Eckert, ed., *The Nabis and The Parisian Avant-Garde*. New Brunswick and London: Rutgers University Press, 1988.

Burnand, Robert. *La Vie quotidienne en France de 1871 à 1900*. Paris: Librairie Hachette, 1947.

Cachin, Françoise. "Un Défenseur oublié de l'art moderne," *L'Oeil* (June 1962), 50–7, 75.

———. *Paul Signac*. Trans. Michael Bullock. Greenwich, Conn.: New York Graphic Society, 1982.

Cardon, Emile. *Le Snobisme et les lettres françaises de Paul Bourget à Marcel Proust, 1884–1914*. Paris: Librairie Armand Colin, 1966.

Chadwick, Charles. *Verlaine*. London: University of London/The Athlone Press, 1973.

Chaet, Bernard. "Studio Talk: Potentialities of Distemper Illustrated in Vuillard's Works," *Arts*, v. 31 (December 1956), 67.

Chaillot, Passy, Auteuil, exh. cat., Musée Carnavalet, Paris, 1982.

Champeaux, A. de. *Histoire de la peinture décorative*. Paris: Librairie Renouard, Henri Laurens, Editeur, 1890.

Champier, Victor. "Les Expositions de l'art nouveau," *Revue des Arts Décoratifs* (January 1896), 1–6.

Chapin, Gilbert Warren, *The Chapin Book of Genealogical Data . . . of the Descendants of Deacon Samuel Chapin.*, Hartford, Conn.: Chapin Family Association, II, 1924.

Chassé, Charles. *The Nabis and Their Period*. Trans. Michael Bullock. New York: Frederick A. Praeger, 1969.

Chastel, André. *Vuillard, 1868–1940*. Paris: Librairie Floury, 1946.

Chave, Elizabeth. "The Lamp and Vuillard," *Yale Art Gallery Bulletin*, v. 30, no. 1 (Fall 1980), 12–14.

Ciaffa, Patricia. *The Portraits of Vuillard*. (Diss., Columbia University, 1985). Ann Arbor: University Microfilms International, 1985.

Cladel, Judith. *Aristide Maillol: sa vie, son oeuvre et ses idées*. Paris: Grasset, 1937.

Clarke, T.J. *The Painting of Modern Life: Paris in the Art of Manet and his Followers*. New York: Alfred A. Knopf, 1985.

Clerc, A. "Notice nécrologique sur M. Henri Vaquez," *Académie Nationale de Medecine: Bulletin*, v. 115 (1936), 685–95.

"Les Concours de façades de la ville de Paris, 1898–1905," *Habitation Pratique* (1903), 19.

"Les Concours de façades, 1903 à 1908," in *L'Architecture Moderne à Paris*. Paris: E. Thezard, 1908.

Coquiot, Gustave. *Paris, voici Paris!* Paris: Ollendorf, 1913.

Cousturier, Edmond. "Galerie S. Bing: Le mobilier," *La Revue Blanche*, v. 10 (January 1986), 92–5.

———. "Exposition Internationale du livre moderne à l'Art Moderne," *La Revue Blanche*, v. 11 (July 1896), 42–4.

Cuers, René de. "Domestic Stained Glass in France," *The Architectural Record*, v. 9 (July-September 1899) 115–41.

Curinier, C.E., *Dictionnaire National des contemporaines*. 5 vols. Paris: Office Général d'Editions, B. Brunel & Co., 1899–1905.

Curjel, Hans. *Henry van de Velde Geschichte: meines Lebens*. Munich: R. Piper & Co., 1962.

Curtiss, Mina. *Other People's Letters: A Memoir*. Boston: Houghton Mifflin Co., 1978.

Dauberville, Henry. *La Bataille de l'impressionnisme*. Paris: Editions J. et H. Bernheim-Jeune, 1967.

Dauberville, Jean and Henri. *Bonnard: Catalogue raisonné de l'oeuvre peint*. 4 vols. Paris: Editions J. and H. Bernheim-Jeune, 1966–74.

Daulte, François. *Renoir: Catalogue raisonné de l'oeuvre peint*. 1 vol. Lausanne: Editions Durand-Ruel, 1971.

Daurelle, Jacques. "Curiosités," *Mercure de France* (July 1908), 186–8.

Davies, Martin. *French School: Early 19th Century Impressionists, Post-Impressionists, etc.* London: The National Gallery, 1970.

Degas, exh. cat., Galeries Nationales du Grand Palais, Paris; National Gallery of Canada, Ottawa; The Metropolitan Museum of Art, New York. New York: Metropolitan Museum of Art, 1988.

Delacroix, Eugène. *The Journal of Eugène Delacroix*. Trans. and ed. Walter Pach. New York: Crown Publishers, 1948.

Denis, Maurice [pseud. Pierre Louis]. "Définition du néo-traditionnisme," *Art et Critique* (23 August 1890), 540–3.

———[pseud. Pierre Louis]. "A M. Germain," *Art et Critique* (18 October 1890), 668.

———[pseud. Pierre Louis]. "Pour les jeunes peintres," *Art et Critique* (20 February 1892), 94.

———[pseud. Pierre Louis]. "Notes sur l'exposition des Indépendants," *La Revue Blanche*, v. 3 (April 1892), 232–4.

———. "L'Epoque du symbolisme," *Gazette des Beaux-Arts*, v. 11 (March 1934), 165–79.

———. *Journal*. 3 vols. Paris: La Colombe, Ed. du Vieux Colombier, 1957–9.

———. *Du Symbolisme au classicisme: Théories*. Ed. Olivier d'Allonne. Paris: Hermann, 1964.

Didot-Bottin. Paris: Didot-Firmin, 1910.

Diesbach, Ghislain de. *La Princesse Bibesco, 1886–1973* (Collection Terre des femmes). Paris: Librarie Académique Perrin, 1986.

Distel, Anne. *Impressionism: The First Collectors*. New York: Abrams, 1989.

Dorival, Bernard. "Vuillard: portrait d'artiste," *Revue des Beaux-Arts de France* (October-November 1942), 3–8.

Dugdale, James. "Vuillard the Decorator – The First Phase: The 1890s," *Apollo*, v. 36 (February 1965), 94–101.

———. "Vuillard the Decorator – Last Phase: The Third Claude Anet Panel and the Public Commissions," *Apollo*, v. 68 (October 1967), 272–7.

Dumas, Anne, and Guy Cogeval. *Vuillard*, exh. cat., Musée des Beaux-Arts, Lyon. Paris: Flammarion, 1990.

Duncan, Carol. *The Pursuit of Pleasure: The Rococo Revival in French Romantic Art*. New York and London: Garland Publishing, Inc., 1976.

Easton, Elizabeth. *The Intimate Interiors of Edouard Vuillard*, exh. cat., Museum of Fine Arts, Houston. Washington, D.C.: Smithsonian Press, 1989.

"Echos: Décor d'un *Beau Mariage*," *Gil Blas*, (November 1911).

Edouard Vuillard – K.-X. Roussel, exh. cat., Orangerie des Tuileries, Paris, 1968.

Edouard Vuillard, exh. cat., Palazzo Reale, Milan, 1959.

Edouard Vuillard, 1868–1940: Centennial Exhibition, Pennsylvania State University, 1968.

Erhlich, Blake. *Paris on the Seine*. New York: Athenum, 1926.

Evenson, Norma. *Paris: A Century of Change, 1878–1978*. New Haven and London: Yale University Press, 1979.

Exposition Centenaire de Gauguin, Orangerie des Tuileries, Paris, 1949.

Exposition Centennale de l'Art Français, 1812–1912. Paris: Galerie Manzi et Joyant, 1912.

Exposition des Oeuvres de Bonnard, Maurice Denis, Ibels, Lacombe, Ranson, Rasetti, Roussel, Sérusier, Vallotton et Vuillard, Galerie Vollard, Paris, 6–30 April 1897.

Exposition Vuillard, Galeries Bernheim-Jeune, Paris, 19 May – 2 June 1906.

Exposition Vuillard: Panneaux décoratifs, pastels, portraits, peintures à l'huile, Galeries Bernheim-Jeune, Paris, 17–29 February 1908.

Exposition Edouard Vuillard: oeuvres récents, Galeries Bernheim-Jeune, Paris, 11–24 November 1908.

Exposition Vuillard, Galeries Bernheim-Jeune, Paris, 3–15 May 1909.

Exposition Vuillard, Galeries Bernheim-Jeune, Paris, 13–25 February 1911.

Exposition Vuillard, Galeries Bernheim-Jeune, Paris, 15–27 April 1912.

Exposition Vuillard, Musée des Arts Décoratifs, Paris, June 1938.

Falke, Jacob von. *Art in the House: Historical, Critical and Aesthetic Studies.* Boston: Charles C. Perkins, 1879.

Feichenfeldt, Walter. *Vincent van Gogh and Paul Cassirer, Berlin: The Reception of Van Gogh in Germany from 1901 to 1914* (Cahier Vincent van Gogh, 2). Zwolle: Uitgerverg Waandes, 1988.

———. "Vincent van Gogh–his Collectors and Dealers," in *Vincent van Gogh and Early Modern Painting, 1890–1914*, exh. cat., Museum Folkwang, Essen, 1990, 39–46.

Fénéon, Félix. "Quelques peintres idéistes," *Le Chat Noir* (19 September 1891), 202.

———. *Félix Fénéon: Oeuvres plus que complètes.* Ed. Joan U. Halperin. 2 vols. Geneva: Librairie Droz, 1970.

Fiérens-Gevaert, H. "Tapisseries et broderies," *Art et Décoration*, vol. 1 (1897) 85–6.

Fitzwilliam Museum, Cambridge. *Catalogue of Paintings*, v. 1. Cambridge: Syndics of the Fitzwilliam Museum, 1960.

Fontainas, André. "Art," *Mercure de France*, v. 25 (August 1897), 374–6.

Frèches-Thory, Claire. "*Les Jardins publics* de Vuillard," *Revue du Louvre*, v. 4 (1979), 305–12.

———. "Roussel and Vuillard à la Comédie des Champs Elysées: Histoire d'une décoration," in *1913: Le Théâtre des Champs-Elysées* (Les Dossiers du Musée d'Orsay, 15). Paris: Editions de la Réunion des Musées Nationaux, 1987, 90–103.

Fröhner, W. *Notice de la sculpture antique.* Paris: Musées Nationaux, 1889.

Galerie Bellier, Paris. *Oeuvres choisies, XIX–XX siècles*, Summer–Fall 1988.

Galerie Georges Petit, Paris. *Vente Théodore Duret: Tableaux et pastels*, 19 March 1894.

Galeries Durand-Ruel, Paris. *Expositions*, 10–31 March 1899. Preface by A. Mellerio.

Gauguin, Paul. "Armand Seguin," *Mercure de France*, v. 13 (February 1895), 222–4.

———. *Intimate Journals.* Trans. of *Avant et après* by Van Wyck Brooks. Bloomington, Indiana: Midland Book Edition, 1958.

Gee, Malcolm. *Dealers, Critics, and Collectors of Modern Painting: Aspects of the Parisian Art Market Between 1910 and 1930.* New York and London: Garland Publishing, Inc., 1981.

Geffroy, Gustave. "De Paris à Saint-Germain-en-Laye," *Journal des Artistes*, v. 10 (September 1891), 303.

———. *La Vie artistique.* 8 vols. Paris: E. Dentu, 1892–1903.

———. "L'Art moderne des Gobelins," *Les Arts*, no. 155 (October 1916), 14–19.

Gere, Charlotte. *Nineteenth-Century Decoration: The Art of the Interior*, London: Weidenfeld and Nicolson, 1989.

Germain, Alphonse. "Du Tempérament peintre," *Art et Critique* (27 September 1890), 618–20.

———. "Théorie des déformateurs exposé et réfutation," *La Plume* (September 1891), 289–90.

———. "La Décoration de l'intérieur," *L'Ermitage* (March 1892) 65–7.

Gide, André. "Promenade autour du Salon," *Gazette des Beaux-Arts*, v. 31 (December 1905), 475–85.

———. *Journal: 1889–1939.* Paris: Bibliothèque de la Pléiade, 1939.

Gold, Arthur, and Robert Fizdale. *Misia: The Life of Misia Sert.* New York: Alfred A. Knopf, 1980.

Gooch, Brison D., ed. *Proceedings of the Third Annual Meeting of the Western Society for French History* (December 1975), Lubbock: Western Society for French History, 1976.

Gordon, Donald E. *Modern Art Exhibitions.* 2 vols. Munich: Prestel Verlag, 1974.

Grandes et petites heures du Parc Monceau, exh. cat., Musée Cernushi, Paris, 1981.

Gruber, Georges Bernstein, and Gilbert Maurin, *Bernstein le Magnifique: cinquante ans de théâtre, de passions et de vie parisienne.* Paris: J.C. Lattés, 1988.

Guicheteau, Marcel. *Paul Sérusier.* Paris: Editions Side, 1976.

Guisan, Gilbert, and Doris Jakubec. *Félix Vallotton: Documents pour une biographie et pour l'histoire d'une oeuvre.* 3 vols. Lausanne and Paris: La Bibliothèque des Arts, 1973–5.

———. *Félix Vallotton, Edouard Vuillard et leurs Amis de la Revue Blanche*, Paris: Etudes de Lettres, 1975.

Hähnloser-Bühler, Hedy. *Félix Vallotton et ses amis.* Paris: Editions A. Sedrowski, 1936.

Hamel, Maurice. "Les Salons de 1905," *Revue de Paris*, v. 2 (June 1905) 625.

———. *The Salons of 1905.* Trans. Paul Villars. Paris/New York: Goupil & Cie (Manzi, Joyant & Cie, 1905), pp. 15–16.

Hammacher, Abraham Marie. *Le Monde de Henry van de Velde.* Trans. Claudine Lemaire. Paris: Librairie Hachette, 1967.

Hamon, Ludovic George, "Les Dames de Luxembourg: photographies instantanées," 2ème partie, *Revue Illustré*, no. 22 (1 November 1904), n.p.

Havard, Henry. *L'Art dans la maison: grammaire de l'ameublement.* 2 vols. Rev. ed. Paris: E. Rouveyre, 1887.

———. *Dictionnaire de l'ameublement et de la décoration depuis le XIIIe siècle jusqu'à nos jours.* 4 vols. Rev. enl. ed. Paris: Quantin Libraries, 1887–90.

Hellerstein, Eran Olafson. "French Women and the Orderly Household, 1830–1870," in Brison D. Gooch, ed., *Proceedings of the Third Annual Meeting of the Western Society for French History* (December 1975), 1976, 378–9.

Herbert, Robert L. *Neo-Impressionists and Nabis in the Collection of Arthur G. Altschul*, exh. cat., Yale University Art Gallery, New Haven, Conn., 1965.

———. "The Decorative and the Natural in Monet's Cathedrals," in John Rewald and Frances Weitzenhoffer, *Aspects of Monet.* Papers presented at a symposium held in Paris, September 1981. New York: Harry N. Abrams, 1984, 160–79.

———. *Impressionism: Art, Leisure, and Parisian Society.* New Haven and London: Yale University Press, 1988.

Hesse-Frielinghaus, Herta. *Karl Ernst Osthaus: Leben und Werk.* Reitlinger: Verlag Aurel Bongers, 1971.

Hillairet, Jacques. *Dictionnaire historique des rues de Paris.* 2 vols. Paris: Editions de Minuit, 1964.

Hôtel Drouot, Paris. *Vente Victor Choquet*, 1–4 July 1899.

———. *Collection Thadée Natanson*, 13 June 1908.

———. *Catalogue des tableaux modernes par Boudin, Caillebotte . . . composant la collection de M. A. [ghion]*, 29 March 1918.

———. *Collection Alexandre Natanson. Tableaux modernes, . . . oeuvres importantes d'Edouard Vuillard*, 16 May 1929.

———. *Panneaux décoratifs d'Alexandre Natanson*, 19–20 February 1934.

Humbert, Agnes. *Les Nabis et leur époque, 1888–1900.* Geneva: P. Cailler, 1954.

"Israël au Théâtre Réjane," *L'Illustration Théâtrale*, no. 102 (28 November 1908), 3–32.

Jackson, A.B. *La Revue Blanche, 1889–1903: Origine, influence, bibliographie.* Paris: M.J. Minard, 1960.

Jarry, Madeleine. "Les Gobelins in the Early Twentieth Century," *Apollo*, v. 135 (March 1967), 192–7.

Jasper, Gertrude. *Adventure in the Theater: Lugné-Poe and the Théâtre de l'Oeuvre to 1899.* New Brunswick: Rutgers University Press, 1947.

Jaubert, Alain. *Les Jardins Publics: Les Allées du Souvenir.* Video produced for the Musée d'Orsay, 1992. English version, Astro Video/Enclopedia Britannica Education Corp., 1992.

Jirat-Wasiutynski, Vojtech. "Paul Gauguin's Paintings, 1886–91: Cloisonism, Synthetism and Symbolism," *RACAR*, v. 9 (September 1982), 35–46.

Kleeblatt, Norma, ed. *The Dreyfus Affair: Art, Truth, Justice.* New York: The Jewish Museum, 1987.

Kessler, Graf von. *The Diaries of a Cosmopolitan: Count Harry Kessler, 1918–1937.* Trans. and ed. Charles Kessler. London: Weidenfeld and Nicolson, 1971.

Kolb, Phillip, ed. *Marcel Proust: Correspondance.* 10 vols. Paris: Plon, 1976–85.

———. ed. *Cahiers de Marcel Proust.* Paris: Plon, 1975.

Komanecky, Michael, and Virginia Fabbri Butera. *The Folding Screen: Screens by Western Artists of the Nineteenth and Twentieth Centuries*, exh. cat., Yale University Art Gallery, New Haven, Conn., 1984.

Lancien, Paul. "Réflexions sur le Salon d'Automne," *La Rénovation d'Art et d'esthètique* (1905), 21–22.

Larroumet, Gustave. "L'Art décoratif et les femmes," *Revue des Arts décoratifs*, v. 16 (1896), 100–5.

Laver, James. *Tastes and Fashions from the French*

Revolution until Today. London: George G. Harrap & Co., 1937.

Leclerc, Paul. *Autour de Toulouse-Lautrec*. Geneva: Pierre Cailler, 1954.

Legrand, Catherine. "Le Café du Bois de Boulogne d'Edouard Vuillard," *Revue du Louvre* (1987), 326–8.

Levine, Steven. "Decor/Decorative/Decoration in Claude Monet's Art," *Arts*, v. 51 (February 1977), 136–9.

Leymarie, Jean. *Fauves and Fauvisme*. Trans. of *Le Fauvisme* (Paris, 1959). Geneva/New York: Skira and Rizzoli, 1987.

Lhôte, André. *Parlons peinture: essais*. Paris: Les Editions Denoël et Steele, 1936.

Lipstadt, Helene. "Housing the Bourgeoisie: César Daly and the Ideal Home," *Oppositions*, no. 8 (Spring 1977), 35–47.

Loize, Jean. *Les Amitiés du peintre Georges Daniel de Monfreid et ses reliques de Gauguin*. Paris: Galerie J. Loize, 1951.

Lugné-Poe, Aurélien. *Le Sot de tremplin*. Paris: Gallimard, Editions de la Nouvelle Revue Française, 1930.

Lux, Jacques. "Chronique: Intérieurs Parisiens," *Revue bleue*, no. 8 (23 November 1907), 255–6.

Lynn, Catherine. *Wallpaper in America: From the Seventeenth Century to World War I*. New York: Cooper-Hewitt Museum Book/W.W. Norton & Co., 1980.

Magne, Lucien. "La Tapisserie à la manufacture de Gobelins," *Art et Décoration*, v. 2 (July–December 1898), 33–42.

Makrius, Michael. *Vuillard*. Trans. Charles Lynn Clarke. Paris: Fernand Hazan, 1979.

Malingue, Maurice. *Paul Gauguin: Letters to his Wife and Friends*. Trans. Henry J. Stenning. Cleveland and New York: The World Publishing Co., 1949.

Manet, 1832–1883. exh. cat., Galeries Nationales du Grand Palais, Paris, and The Metropolitan Museum of Art, New York, 1983.

Marcou, Paul Frantz. "The Modern House in Paris," *The Architectural Record*, v. 2 (1893), 324–31.

Marlais, Michael. *Conservative Echoes in Fin de siècle Parisian Art Criticism*. University Park, Pa: Pennsylvania State University Press, 1992.

Marx, Roger. "Les Arts décoratifs et industriels aux Salons du Palais de l'Industrie et du Champs-de-Mars," *Revue Encyclopédique*, v. 1 (15 September 1891), 826–8.

———. "Mouvement des arts décoratifs," *Revue Encyclopédique*, v. 2 (15 October 1892), 1486–1505.

Masheck, Joseph. "The Carpet Paradigm: Critical Prolegomena to a Theory of Flatness," *Arts* (September 1975), 82–109.

Mauclair, Camille. "Exposition des portraits du prochain siècle," *Essais d'Art* (October 1893), 117–26.

———. "Choses d'Art," *Mercure de France*, v. 15 (December 1894), 384–6.

———. "Choses d'art," *Mercure de France*, v. 17 (February 1896), 264–5.

———. "Choses d'Art," *Mercure de France*, v. 17 (March 1896), 418–20.

———. "Le Salon d'Automne," *Revue Bleue: revue politique et litteraire*, v. 4 (21 October 1905), 521–5.

———. *Le Soleil des morts*. 1897. Reprinted with presentation by Raymond Trousson. Paris and Geneva: Slatkine Reprints, 1979.

Mauner, George L. "Vuillard's Mother and Sister Paintings and the Symbolist Théâtre," *Arts Canada*, v. 28 (December 1971–January 1972), 124–6.

———. *The Nabis: Their History and Their Art, 1886–1896*. New York and London: Garland Publishing, Inc., 1978.

Maus, Octave. "Un Décorateur nouveau: Georges d'Espagnat," *Art et décoration*, v. 6 (1899), 121–3.

Mazade, Fernand. "A French Dining Room of the Upper Middle-Class Type," *The Architectural Record*, v. 5 (July–September 1895), 33–45.

McBride, Theresa M. "A Woman's World: Department Stores and the Evolution of Women's Employment, 1870–1920," *French Historical Studies* (Fall 1978), 664–83.

McCauley, Anne Elizabeth. *A.A.E. Disderi and the Carte de Visite Portrait Photograph*. New Haven and London: Yale University Press, 1985.

McClelland, Nancy. *Historic Wall-Papers: From their Inception to the Introduction of Machinery*. Philadelphia: Lippincott, 1924.

McManus, Barbara. *Royal Palaces and Parks of France*. Boston: L.C. Page & Co., 1910.

Mellerio, André. Préface, in *Exposition*, Galeries Durand-Ruel, Paris, 10–31 March 1899.

Mellot, Denise. "Vuillard dans ses lettres," *Arts* (2 April 1948), 8.

Miller, Michael B. *The Bon Marché: Bourgeois Culture and the Department Store, 1869–1920*. Princeton, N.J.: Princeton University Press, 1981.

Milner, John. *The Studios of Paris: The Capital of Art in the Late Nineteenth Century*. New Haven and London: Yale University Press, 1988.

Moffett, Charles S., et al. *The New Painting: Impressionism 1874–1886*, exh. cat., The Fine Arts Museum of San Francisco, 1986.

Mondor, Henri. *Vie de Mallarmé*. Paris: Gallimard NRF, 1941.

Monneret, Sophie. *L'Impressionnisme et son époque: Dictionnaire international illustré*. Paris: Denoël, 1979.

Monod, François. "Le Salon d'Automne," *Art et Décoration*, v. 18 (November 1905), 198–200.

———. "Chronique: Une Nouvelle exposition de M. Vuillard," *Art et Décoration*, Suppl., v. 23 (March 1908), 1–4.

———. "Le Mois artistique: Exposition Vuillard chez MM Bernheim," *L'Art et les artistes*, v. 8 (November 1908), 176–7.

Morice, Charles. "Revue de la quinzaine: Exposition Vuillard," *Mercure de France*, v. 72 (March 1908), 358.

———. "Revue de la quinzaine," *Mercure de France*, v. 76 (1908).

Muller, Henry. *Trois pas en arrière*. Paris: Table Ronde, 1952.

Muhlfeld, Lucien, "A Propos de peintures," *La Revue Blanche*, v. 4 (June 1893), 453–60.

Natanson, Thadée. "Petite Gazette d'Art," *La Revue Blanche*, v. 2 (January 1892), 64–7.

———. "Petite Gazette d'Art," *La Revue Blanche*, v. 6 (April 1894), 376–8.

———. "Paul Cézanne," *La Revue Blanche*, v. 9 (December 1895), 496–500.

———. "A Propos de MM Charles Cottet, Gauguin, Edouard Vuillard et d'Edouard Manet," *La Revue Blanche*, v. 12 (January 1897), 526–18.

———. "Petite Gazette d'Art," *La Revue Blanche*, v. 12 (February 1897), 192–4.

———. "Petite Gazette d'Art," *La Revue Blanche*, v. 12 (April–May 1897), 484–7.

———. "Petite Gazette d'Art," *La Revue Blanche*, v. 16 (May 1898), 65–8.

———. "Petite Gazette d'Art," *La Revue Blanche*, v. 16 (1898), 168; v. 15, 213–16.

———. "Une Date de l'histoire de la peinture française: mars 1899," *La Revue Blanche*, v. 18 (January – April 1899), 504–12.

———. "Spéculations sur la peinture à propos de Corot et les Impressionnistes," *La Revue Blanche*, v. 19 (May-August 1899), 123–39.

———. "De M. Renoir et de la beauté," *La Revue Blanche*, v. 21 (January-April 1900), 370–6.

———. "Des Peintres intelligents," *La Revue Blanche*, v. 22 (May-August 1900), 53–6.

———. "Sur Edouard Vuillard d'après trois lettres et deux portraits," *Arts et métiers graphiques*, no. 65 (15 November 1938), 38–40.

Nattier-Natanson, Evelyn. *Les Amitiés de La Revue Blanche et quelques autres*. Vincennes: Les Editions du Donjon, 1959.

Newman, Sasha, and Antoine Terrasse. *Bonnard: The Late Paintings*, exh. cat., The Phillips Collection, Washington, D.C. New York and London: Thames and Hudson, 1984.

———. *Félix Vallotton*, exh. cat., Yale University Art Gallery, New Haven, Conn. New York and London: Abbeville Press, 1991.

1913: Le Théâtre des Champs-Elysées. (Les Dossiers du Musée d'Orsay, 13). Paris: Editions de la Réunion des Musées Nationaux, 1987.

Olin, Charles H., and Alexandra Riddleberger, "The Special Problems and Treatment of a Painting Executed in Hot Glue Medium, *The Public Gardens* by Edouard Vuillard," *Preprints* of papers presented at the eleventh annual meeting of the American Institute for Conservation of Historic and Artistic Works, Baltimore, Maryland, 25–29 May 1983, 97–103.

Ostini, Fritz von. "Die Frühjahrsausstellung der Münchener Sezession," *Die Kunst: Monatshefte für Freie und Angewandte Kunst*, v. 15 (May 1908), 337–50.

Painter, George. *Marcel Proust: A Biography*. London: Chatto & Windus, 1959.

Palewski, Gaston. *Hommage à Commerce: Lettres et arts à Paris, 1920–1935*, exh. cat., Palazzo Primoli Piazza, Rome, 1957.

Paul Sérusier, 1764–1927, exh. cat., Musée des Jacobins, Morlaix, 1987.

Perucchi-Petri, Ursula. *Bonnard und Vuillard im Kunsthaus Zurich*. Sammlungsheft 3. Zurich: Kunsthaus, 1971.

———. "Les Nabis et le Japan," in *Japonisme in Art: An International Symposium*. Ed. Yamada Chisaburo. Tokyo: Kodansha International, Ltd., 1980.

Perrot, Michelle. *From the Fires of Revolution to the Great War*, (trans. A. Goldhammer), v. 4 of Philippe Ariès and Georges Duby, eds., *History of Private Life*, Cambridge, Mass.: The Belknap Press of Havard University Press, 1990.

Pilon, Edmond. "Un Nouvel Album d'Odilon Redon," *La Revue Blanche*, vol. 11 (1896), 135–7.

Pissarro, Camille. *Letters to his Son Lucien*. Ed. John Rewald, with the assistance of Lucien Pissarro. (Reprint of 3rd ed., rev. and enl., pub. in 1971 by P.P. Appel, Manaroneck, New York). Santa Barbara and Salt Lake City: Peregrine Smith, 1981.

Pollock, Griselda. *Vision and Difference: Feminity, feminism and histories of art*. London: Routledge, 1988.

Poniatowski, Prince André. *D'Un Siècle à l'autre*. Paris: Presses de la Cité, 1948.

Porel, Jacques. *Fils de Réjane: souvenirs*. 2 vols. Paris: Plon, 1951.

Porter, Katherine Porter, "Maurice Denis and George Desvallières: From Symbolism to Sacred Art" (Ph.D. diss., Bryn Mawr College). Ann Arbor: University International Microfilms, 1985.

Pougny, Liane de. *Mes Cahiers bleus*. Paris: Plon, 1977.

Praz, Mario. *An Illustrated History of Furnishing from the Renaissance to the 20th Century*. Trans. William Weaver. New York: George Braziller, 1964.

Preston, Stuart. *Edouard Vuillard*. New York: Harry N. Abrams, 1985.

Qui êtes-vous?: Annuaire des contemporains français et étrangers, 1909–1910. Paris: Libraire Ch. Delagrave, 1909–10.

Qui êtes-vous?: Annuaire des contemporains français et étrangers, 1924, Paris: Libraire Ch. Delagrave, 1924.

Rambosson, Yvanhoe. "La Promenade de Janus: Causeries d'art," *La Plume*, v. 11 (June 1899), 382–3.

Redon, Odilon. *Lettres d'Odilon Redon, 1878–1916*. Ed. Ari Redon. Paris and Brussels: Librairie Nationale d'Art et d'Histoire, 1923.

Reff, Theodore. *Degas: The Artist's Mind*. New York: The Metropolitan Museum of Art/ Harper & Row, 1976.

———. *The Notebooks of Edgar Degas*. 2 vols. Oxford: Clarendon Press, 1976.

———, ed. *Post-Impressionist Group Exhibitions*. New York and London: Garland Publishing, Inc., 1982.

Rewald, John. *Post-Impressionism from Van Gogh to Gauguin*. New York: The Museum of Modern Art, 2nd ed., 1962.

———. *John Hay Whitney Collection*. Washington, D.C.: National Gallery of Art, 1983.

Riley, F. "An American Home in Paris," *The Architectural Record*, v. 13 (February 1903), 97–118.

Risler, Claude. "Hôtels particuliers," *L'Architecture*, 1925, 433–9.

Ritchie, Andrew C. *Edouard Vuillard*, exh. cat., The Museum of Modern Art, New York, 1954.

Robichez, Jacques. *Le Symbolisme au Théâtre: Lugné-Poe et les débuts de l'Oeuvre*. Paris: L'Arche, 1957.

Robinson, Lionel. "The Private Collections of London: The Late Mr. Frederick Leyland's in Prince's Gate," *Art Journal*, v. 44 (May 1892), 129–38.

Robinson, William. "Vuillard's *Under the Trees* from the Nabi Cycle *The Public Gardens*," *The Bulletin of the Cleveland Museum of Art*, v. 79, no. 4 (April 1992), 111–27.

Roger-Marx, Claude. *Vuillard et son temps*. Paris: Arts et métiers, 1945.

———. *Vuillard: His Life and Work*. Trans. E.B. d'Auvergne. London: Editions de la Maison Française, 1946.

———. *L'Oeuvre gravé de Vuillard*. Monte-Carlo: A. Sauret, 1948.

Rouart, Denis, and Daniel Wildenstein. *Edouard Manet: catalogue raisonné, I: Peintures*. Lausanne and Paris: Bibliothèque des Arts, 1975.

Roussel, Georges. "Les Impressionnistes et Symbolistes à l'exposition de Saint-Germain," *La Plume*, 1 October 1891, 341.

Rubin, William. "Shadows, Pantomimes, and the Art of the 'Fin de Siècle,'" *Magazine of Art*, v. 46 (1953), 114–22.

Russell, John. *Vuillard*. Greenwich, Conn.: New York Graphic Society, 1971.

———. *Paris*. New York: Harry N. Abrams, 1986.

Ruvigny, Marquis of. *The Titled Nobility of Europe: An International Peerage or "Who's Who" of the Sovereigns, Princes and Nobles of Europe*. London: Burke's Peerage, [1914] 1980.

Saglio, Maurice. "City Apartment Houses in Paris," *The Architectural Record*, v. 6 (1896), 351–6.

Salmon, André. *Souvenirs sans fin: Première époque, 1903–1908*, Paris: Gallimard, 1955.

Salomon, Jacques. *Les Décorations de Edouard Vuillard à la Comédie des Champs Elysées*, n.p. [Paris: W. Fischer], n.d.

———. *Vuillard témoignage de Jacques Salomon*. Paris: Albin Michel, 1945.

———. *Auprès de Vuillard*. Paris: La Palme, 1953.

———. *Vuillard admiré*. Paris: La Bibliothèque des Arts, 1961.

———. "Vuillard and His Kodak," in *Vuillard et son Kodak*, exh. cat., The Lefevre Gallery, London, 5–26 March, 1964, 2–15.

———. *Vuillard*. Paris: Gallimard, 1968.

———, and Annette Vaillant. *Edouard Vuillard: Cahier de dessins*. Paris: Les Quatre-Chemins, [1950].

Schneider, Louis. "Théâtre du Palais Royal," *Le Théâtre*, no. 309 (October 1911), 8.

Schopfer, Jean. "Modern Decoration," *The Architectural Record*, v. 6 (January–March 1897), 243–55.

Schweicher, Curt. *Die Bildraum Gestaltung, das Dekorative und das Ornamentale im Werke von Edouard Vuillard*. (diss., University of Trier). Trier: Paulinius-Druckerei GMBH, 1949.

Segard, Achille. *Les Peintres d'aujourd'hui: les décorateurs*. 2 vols. Paris: Ollendorf, 1914.

Selz, Peter. *Art in Our Times: A Pictorial History* (New York: Harry N. Abrams, 1980)

Sembach, Klaus-Jurgens. "Fünf Villen des frühen 20 Jahrhunderts," *Du*, v. 35 (September 1975), 10–49.

Sert, Misia. *Misia*. Paris: Gallimard, 1952.

Sérusier, Paul. *ABC de la peinture suivi d'une correspondance inédite*. Paris: Librairie Floury, 1950.

[Signac, Paul]. "Extraits du journal inédit," intro. John Rewald. *Gazette des Beaux-Arts*, v. 36 (1949), 97–128; v. 39 (1952), 265–84; v. 42 (1953), 27–57.

Silverman, Deborah. "The Paris Exhibition of 1889: Architecture and the Crisis of Bourgeois Individualism," *Oppositions*, no. 8 (Spring 1977), 72–91.

———. "Revivalism to Modernism: 'psychologie nouvelle,' The Goncourts and Art Nouveau," *Gazette des Beaux-Arts*, v. 109 (May–June 1987), 217–22.

———. *Art Nouveau in Fin-de-Siècle France: Politics, Psychology and Style*. Berkeley: University of California Press, 1989.

Simoneton, Adrien. *La Décoration intérieur*. Paris: Guerinet, 1894–5.

Slatkin, Wendy. *Aristide Maillol in the 1890s*. (Studies in the Fine Arts, Avant-Garde, no. 30). Ann Arbor: UMI Research Press, 1976.

"Smart." "La Salle à manger," *Cri de Paris* (January 1899), 7–8.

Spencer, Robin. *The Aesthetic Movement*. London: Studio Vista, 1972.

Steele, Valerie. *Paris Fashion: A Cultural History*. New York and Oxford: Oxford University Press, 1988.

Société des artistes français. *Explication des ouvrages de peinture, sculpture, architecture gravure et lithographie . . .*, 1–27 May 1889.

Société du Salon d'Automne. *Catalogue du peinture, dessin, sculpture, gravure . . .*, 15 October – 15 November 1904.

———. *Catalogue du peinture, dessin, sculpture, gravure . . .*, 18 October – 25 November 1905.

———. *Catalogue du peinture, dessin, sculpture, gravure . . .*, 6 October – 15 November 1906.

Sterling, Charles, and Margaretta M. Salinger. *French Painting: A Catalogue of the Collection of the Metropolitan Museum of Art*. 3 vols. Cambridge, Mass.: Harvard University Press, 1955–67.

Stump, Jeanne Alice Gass. *The Art of Ker-Xavier Roussel*. (Ph.D. diss., University of Kansas, 1983). Ann Arbor: University Microfilms International, 1983.

Stumpel, Jeroen. "The *Grande Jatte*, that Patient Tapestry," *Simiolus*, v. 14 (1984), 209–24.

Sussman, George D. "The End of the Wet-Nursing Business in France, 1874–1914," in Robert Wheaton and Tamara K. Haraven, eds., *Family and Sexuality in French History*. Philadelphia: University of Pennsylvania Press, 1980, 224–47.

Symbolistes et Nabis: Maurice Denis et son temps, exh. cat., Musée départemental du Prieuré, Saint-Germain-en-Laye, 1980.

Talbott, Henry. *A Biographical History of Medicine*. New York: Grune and Stratton, 1970.

Tapley, George Manning. *The Mural Paintings of Puvis de Chavannes*. (Ph.d. diss., University of Minnesota, 1979). Ann Arbor: University Microfilms International, 1981.

Thiébault-Sisson. "Au Jour le Jour: les petit salons," *Le Temps* (2 December 1893), 3.

————. "Chez le Barc de Boutteville," *L'Echo de Paris*, no. 3 (December 1893).

Thomson, Belinda. *Vuillard*. New York: Abbeville Press, 1988.

————. *Vuillard*, exh. cat., Glasgow Art Gallery and Museum, Kelvingrove, and The South Bank Centre, London, 1991.

Thomson, Richard. "Degas' *Torse de Femme* and Titian," *Gazette des Beaux-Arts*, v. 98 (July–August 1981), 45–8.

Thornton, Peter. *Authentic Decor: The domestic interior, 1620–1920*, London: Weidenfeld and Nicolson, 1984.

Three Centuries of French Art: Selections from the Norton Simon, Inc., Museum of Art and The Norton Simon Foundation, exh. cat., The Fine Arts Museums of California, San Francisco, 1975.

Tilly, Louise A., and Joan W. Scott. *Woman, Work and Family*. New York: Holt, Rinehart and Winston, 1978.

Toulet, P.-J. "Au Salon d'Automne," *La Vie Parisienne* (11 November 1905), 13.

Turcotte, S.J. *Les Gens d'affaires sur la scène française de 1870 à 1914*, Paris: Librairie Nizet & Bastard, 1936.

Uzanne, Octave. "Préface," *L'Art et l'idée: revue contemporaine de la dilettantisme littéraire et de la curiosité* (January–December 1892) i–xii.

————. "Les Idées du jour et les echoes d'art," *L'Art et l'idée: revue contemporaine de la dilet-tantisme littéraire et de la curiosité* (January–December 1892), 74–5.

————. *Etudes de sociologie feminine: Parisiennes de ce temps en leurs divers milieux, états et conditions*. Paris: Mercure de France, 1910.

Vaillant, Annette. "Livret de famille," *L'Oeil*, no. 24 (December 1956), 24–35.

————. "Some Memories of Vuillard," in *Vuillard et son Kodak*, exh. cat., The LeFevre Gallery, London, 5–26 March [1963], 16–23.

————. *Bonnard ou le bonheur de voir*. (Neuchâtel: Editions Ides et Calendes, 1965.

————. *Le Pain polka*. Paris: Mercure de France, 1974.

Van de Velde, Henry. *Déblaiement d'Art*. Brussels: Archives d'architecture moderne, [1894] 1979.

————. "Ferdinand Hodler," *Die Weissen Blätter*, v. 5 (1918), 127–37.

————. "Lettres de Van de Velde à sa femme, 1910–1911," *Architecture d'Aujourd'hui*, no. 174 (July–August 1974), 115–25.

Varnedoe, Kirk. *Gustave Caillebotte*, New Haven and London: Yale University Press, 1987.

————. *Northern Light: Nordic Art at the Turn of the Century*. New Haven and London: Yale University Press, 1988.

Venturi, Lionello. *Cézanne: son art–son oeuvre*. 2 vols. Paris: Paul Rosenberg Editeur, 1936.

Verdés-Leroux, Jeannine. *Scandale financier et antisémitisme catholique: Le Krache de l'Union générale*. Paris: Editions du Centurion, 1969.

Verkade, Dom Willibrod. *Yesterdays of an Artist-Monk*. Trans. John L. Stoddard. New York: P.J. Kennedy & Sons, 1930.

Villers, Gaston de. *Un Ami de Cézanne: Gaston Bernheim de Villers*, Paris: Editions Bernheim-Jeune, 1954.

Vogt, Paul. *Museum Folkwang Essen: die Geschichte einer Sammlung junger Kunst im Ruhrgebiet*. Koln: Dumont Buchverlag, [1963] 1983.

Waller, Bret, and Grace Seiberling. *Artists of La Revue Blanche*, exh. cat., Memorial Art Gallery of the University of Rochester, Rochester, New York, 1984.

Wang, Robert. *The Graphic Art of the Nabis, 1888–1900*. (Ph.d. diss., University of Pittsburgh, 1974). Ann Arbor: University Micro-films International, 1984.

Ward, Martha. "Impressionist Installations and Private Exhibitions," *The Art Bulletin*, v. 73 (December 1991), 599–622.

Warnod, Jeanine. *Vuillard*. Trans. Marie-Hélène Agueros. New York: Crown Publishers, 1989.

Weber, Eugen. *France: Fin de siècle*. Cambridge, Mass. and Oxford: Belknap Press of Harvard University Press, 1985.

Weisberg, Gabriel. *Japonisme: Japanese Influence on French Art, 1854–1910*, exh. cat., Cleveland Museum of Art, 1975.

Weisberg, Gabriel P. *Art Nouveau Bing: Paris Style 1900*, exh. cat., Smithsonian Institution, Washington, D.C. New York: Harry N. Abrams, 1986.

Werth, Léon. "A travers la quinzaine: Le Refus de la décoration," *La grande Revue* (November 1912), 161–4.

Werthheimer, K. "Aristide Maillol levelei Rippl-Rónaï Józsefhez" (Lettres d'Aristide Maillol à Josef Rippl-Ronäi), *Müvészettörtenéti Ertesíto* (1953), 110–18.

Wharton, Edith, and Ogden Codman Jr. *The Decoration of Houses*. (Reprint of 2nd ed., New York: Charles Scribner's & Sons, 1902), New York: W.W. Norton & Co., 1978.

Whelan, Richard. "'Le Roi' Fénéon and the Neo-Impressionists," *Portfolio* (March–April 1981), 46–55.

Wichman, Siegfried. *Japonisme: The Japanese Influence on Western Art in the 19th and 20th Centuries*. New York: Harmony Books, 1981.

Wild, Doris. "Der 'Intimist' Vuillard als Monumental Maler," *Werk* (December 1947), 400–4.

Wildenstein, Daniel. *Claude Monet: biographie et catalogue raisonné*. 4 vols. Lausanne and Paris: Bibliothèque des Arts, 1974.

Williams, Rosalind. *Dream Worlds: Mass Consumption in late Nineteenth-Century*. Berkeley, Los Angeles, and London: University of California Press, 1982.

Windsor, Alan. "Hohenhagen," *Architectural Review*, v. 152 (September 1981), 169–75.

Wyzewa, T. de. "Le Nouveau Salon du Champs-du-Mars," *L'Art dans les deux mondes* (13 June 1891), 39–41.

Index

Photograph Credits